Being an islander

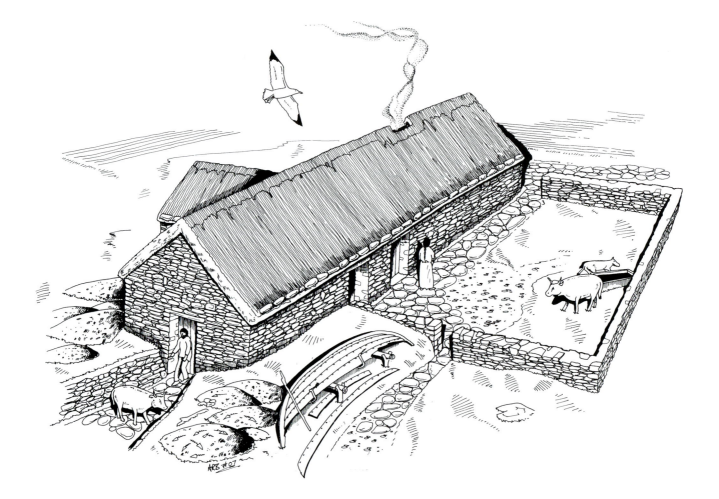

Reconstruction of House 1 at Quoygrew. (Image: Alan Braby.)

Being an islander

Production and identity at Quoygrew, Orkney,
AD 900–1600

Edited by James H. Barrett

Published by:

McDonald Institute for Archaeological Research
University of Cambridge
Downing Street
Cambridge, UK
CB2 3ER
(0)(1223) 333538
(0)(1223) 339336 (Production Office)
(0)(1223) 333536 (FAX)
dak12@cam.ac.uk
www.mcdonald.cam.ac.uk

Distributed by Oxbow Books
United Kingdom: Oxbow Books, 10 Hythe Bridge Street, Oxford, OX1 2EW, UK.
Tel: (0)(1865) 241249; Fax: (0)(1865) 794449; www.oxbowbooks.com
USA: The David Brown Book Company, P.O. Box 511, Oakville, CT 06779, USA.
Tel: 860-945-9329; Fax: 860-945-9468

ISBN: 978-1-902937-61-8
ISSN: 1363-1349 (McDonald Institute)

The site archive for Quoygrew is accessible on-line through DSpace@Cambridge at
http://www.dspace.cam.ac.uk/handle/1810/243446.

The McDonald Institute for Archaeological Research gratefully acknowledges
grant-aid towards the publication of this volume from Historic Scotland.

Cover design by Dora Kemp.
Cover image: *The Orcadian sea. (Image: Anne Brundle.)*
Inset image on back cover: *Aerial view of House 1, Quoygrew. (Image: Ben Gourley.)*

Edited for the Institute by James Barrett (*Series Editor*) and Dora Kemp (*Production Editor*).

Printed and bound by Short Run Press, Bittern Rd, Sowton Industrial Estate, Exeter, EX2 7LW, UK.

Contents

Contributors vi
Figures viii
Tables xi
Appendices xii
Preface and Acknowledgements xiii

Chapter 1 Introduction: the Study of Island Societies 1
 JAMES H. BARRETT

Chapter 2 Viking Age and Medieval Orkney 11
 JAMES H. BARRETT

Chapter 3 Quoygrew and its Landscape Context 25
 JAMES H. BARRETT, LUCY R. FARR, DAVID REDHOUSE, SUSAN RICHER, JERAD ZIMMERMANN,
 LORNA SHARPE, SUSAN OVENDEN, JAMES MOORE, TESSA POLLER, KAREN B. MILEK,
 IAN A. SIMPSON, MARCUS SMITH, BEN GOURLEY AND TERRY O'CONNOR

Chapter 4 The Quoygrew Sequence 47
 JAMES H. BARRETT AND JAMES F. GERRARD

Chapter 5 Ecofact Recovery and Patterns of Deposition 97
 JAMES H. BARRETT AND JENNIFER F. HARLAND

Chapter 6 The Maritime Economy: Mollusc Shell 103
 NICKY MILNER AND JAMES H. BARRETT

Chapter 7 The Maritime Economy: Fish Bone 115
 JENNIFER F. HARLAND AND JAMES H. BARRETT

Chapter 8 Animal Husbandry: the Mammal Bone 139
 JENNIFER F. HARLAND

Chapter 9 Fowling: the Bird Bone 155
 JENNIFER F. HARLAND, REBECCA A. BENNETT, JAMIE I. ANDREWS,
 TERRY O'CONNOR AND JAMES H. BARRETT

Chapter 10 Arable Agriculture and Gathering: the Botanical Evidence 161
 CATRINA T. ADAMS, SANDRA L. POAPS AND JACQUI P. HUNTLEY

Chapter 11 Feeding the Livestock: the Stable Isotope Evidence 199
 JAMES H. BARRETT AND MICHAEL P. RICHARDS

Chapter 12 Local Availability and Long-range Trade: the Worked Stone Assemblage 207
 COLLEEN E. BATEY, AMANDA K. FORSTER, RICHARD E. JONES, GEOFF GAUNT,
 FIONA J. BRECKENRIDGE, JUDITH BUNBURY AND JAMES H. BARRETT

Chapter 13 Evidence of Exchange Networks: the Combs and other Worked Skeletal Material 229
 STEVE P. ASHBY *with a contribution by* COLLEEN E. BATEY

Chapter 14 The Metal Finds and their Implications 245
 NICOLA S.H. ROGERS, COLLEEN E. BATEY, N.M.McQ. HOLMES AND JAMES H. BARRETT

Chapter 15 Interpreting the Ceramics and Glass 255
 DEREK W. HALL, LYN BLACKMORE, GEORGE HAGGARTY, SIMON CHENERY,
 DENNIS GALLAGHER, COLLEEN E. BATEY AND JAMES H. BARRETT

Chapter 16 Being an Islander 275
 JAMES H. BARRETT

Appendices 293
References 329
Index 357

CONTRIBUTORS

CATRINA T. ADAMS	The Botanical Society of America, St Louis MO, USA
JAMIE I. ANDREWS	Museum of London Archaeology, London, England, UK
STEVE P. ASHBY	Department of Archaeology, University of York, York, England, UK
JAMES H. BARRETT	McDonald Institute for Archaeological Research, Department of Archaeology and Anthropology, University of Cambridge, Cambridge, England, UK
COLLEEN E. BATEY	Archaeology, School of Humanities, University of Glasgow, Glasgow, Scotland, UK
REBECCA A. BENNETT (née BRISCOE)	The School of Applied Sciences, Bournemouth University, Poole, England, UK
LYN BLACKMORE	Museum of London Archaeology, London, England, UK
FIONA J. BRECKENRIDGE	Formerly Division of Archaeology, Department of Archaeology and Anthropology, University of Cambridge, Cambridge, England, UK
JUDITH BUNBURY	Department of Earth Sciences, University of Cambridge, Cambridge, England, UK
SIMON CHENERY	Analytical Geochemical Laboratories, British Geological Survey, Environmental Science Centre, Nicker Hill, Keyworth, Nottingham, England, UK
LUCY R. FARR	McDonald Institute for Archaeological Research, Department of Archaeology and Anthropology, University of Cambridge, Cambridge, England, UK
AMANDA K. FORSTER	Institute for Archaeologists, School of Human and Environmental Sciences, University of Reading, Reading, England, UK
DENNIS GALLAGHER	Edinburgh, Scotland, UK
GEOFF GAUNT	Leeds, England, UK (British Geological Survey - retired)
JAMES F. GERRARD	School of History, Classics and Archaeology, Newcastle University, Newcastle, England, UK
BEN GOURLEY	Department of Archaeology, University of York, York, England, UK
GEORGE HAGGARTY	Department of Scottish History and Archaeology, National Museum of Scotland, Edinburgh, Scotland, UK
DEREK W. HALL	Perth, Scotland, UK
JENNIFER F. HARLAND	Department of Archaeology, University of York, York, England, UK
N.M.McQ. HOLMES	Department of Scotland and Europe, National Museum of Scotland, Edinburgh, Scotland, UK

JACQUI P. HUNTLEY — English Heritage, Newcastle upon Tyne, England, UK

RICHARD E. JONES — Archaeology, School of Humanities, University of Glasgow, Glasgow, Scotland, UK

KAREN B. MILEK — Department of Archaeology, School of Geosciences, University of Aberdeen, Aberdeen, Scotland, UK

NICKY MILNER — Department of Archaeology, University of York, York, England, UK

JAMES MOORE — Department of Archaeology, Orkney College, University of the Highlands and Islands, Kirkwall, Orkney, Scotland, UK

TERRY O'CONNOR — Department of Archaeology, University of York, York, England, UK

SUSAN OVENDEN — Rose Geophysical Consultants, Orphir, Orkney, Scotland, UK

SANDRA L. POAPS — Formerly Department of Geography, University of Toronto, Toronto, Ontario, Canada

TESSA POLLER — Archaeology, School of Humanities, University of Glasgow, Glasgow, Scotland, UK

DAVID REDHOUSE — Division of Archaeology, Department of Archaeology and Anthropology, University of Cambridge, Cambridge, England, UK

MICHAEL P. RICHARDS — Department of Anthropology, University of British Columbia, Vancouver BC, Canada

SUSAN RICHER — Worcestershire Wildlife Trust, Hindlip, Worcester, England, UK

NICOLA S.H. ROGERS — York Archaeological Trust, York, England, UK

LORNA SHARPE — Formerly Archaeology, School of Humanities, University of Glasgow, Glasgow, Scotland, UK

IAN A. SIMPSON — Biological and Environmental Sciences, University of Stirling, Stirling, Scotland, UK

MARCUS SMITH — Riksantikvarieämbetet, Visby, Gotland, Sweden

JERAD ZIMMERMANN — Formerly Department of Archaeology, University of York, York, England, UK

Figures

1.1.	Orkney and Shetland in their northern context, including places mentioned in the text.	2
1.2.	George Drever and Jerry Wood discuss the logistics of building a sea wall along the wave-cut bank.	3
2.1.	Stable isotope (δ¹³C) values and two-sigma radiocarbon (or grave-good) date ranges for burials from Westness and Newark Bay, Orkney.	14
2.2.	Part of the Skaill hoard from Mainland Orkney, deposited between c. 950 and c. 970.	15
2.3.	St Magnus Cathedral, Kirkwall.	16
2.4.	The Brough of Deerness, a probable chiefly citadel of the late Viking Age.	19
3.1.	Westray (a) and the township of Rackwick (b) showing locations discussed in the text.	26
3.2.	Township of Rackwick (1870s) from the Ordnance Survey's (1882a,b) first edition six inch to one mile maps.	28
3.3.	Nineteenth-century settlement infilling in the township of Rackwick around sites that may be earlier.	29
3.4.	Topographic model of the landscape around Quoygrew based on survey by total station theodolite.	32
3.5.	Model of the depth of midden and/or anthrosol around Quoygrew based on auger and test-pit survey.	33
3.6.	Sediment inclusions present in auger and test-pit profiles examined around Quoygrew (at varying scales).	34
3.7.	Basal material present in auger and test-pit profiles around Quoygrew (at varying scales).	35
3.8.	Model of the depth of sand around Quoygrew based on auger and test-pit survey.	36
3.9.	Aerial photographs of Quoygrew during the 1997 (a) and 2004 (b) field seasons.	37
3.10.	Site plan of Quoygrew showing the archaeological interventions, the ruins of the croft and field boundaries.	38
3.11.	Pre-excavation resistance survey of Quoygrew north of the extant northeast/southwest field boundary.	39
3.12.	Pre-excavation resistance survey of Quoygrew south of the extant northeast/southwest field boundary.	40
3.13.	Higher-resolution, pre-excavation resistance survey of features 4 and 5 from Figure 3.11.	40
3.14.	Pre-excavation gradiometer survey of features 4 and 5 from Figure 3.11.	40
3.15.	Resistance survey of the top of the inland settlement mound at Quoygrew.	41
3.16.	Resistance survey of the eastern edge of the inland settlement mound at Quoygrew (see Fig. 3.10).	42
3.17.	Gradiometer survey of the eastern edge of the inland settlement mound at Quoygrew (see Fig. 3.10).	42
3.18.	Plan of the 1997 tapestry excavation of the wave-cut bank at Quoygrew.	43
3.19.	Areas A and B of the tapestry excavation of the eroding Fish Midden.	44
3.20.	Nomenclature of the main archaeological buildings and deposits discussed in the text.	45
4.1.	South-facing section of Area G1.	49
4.2.	South- and east-facing sections of Areas G1 and G2, including locations of soil micromorphology samples.	49
4.3.	Top plan of Area G3 showing parts of Houses 6 and 7 and associated contexts.	50
4.4.	West-facing section of the wave-cut bank.	51
4.5.	West- and north-facing sections of Area A in the coastal Fish Midden.	52
4.6.	House 5 in Phase 2.2.	60
4.7.	House 5 in Phase 2.3.	61
4.8.	House 5 in Phase 2.4.	62
4.9.	House 1 in Phase 3.2.	65
4.10.	Room 1 of House 1 in Phases 3.3 and 3.4.	68
4.11.	Room 1 of House 1 in Phases 3.5 and 3.6.	69
4.12.	Rooms 1 and 2 of House 1 in Phase 4.1.	71
4.13.	Rooms 1 and 2 of House 1 in Phases 4.2.1 and 4.2.2.	72
4.14.	Rooms 1 and 2 of House 1 in Phase 4.3.	74
4.15.	House 1 in Phase 4.4.	75
4.16.	Heavily robbed flagstone floor (Phase 4.4) in Room 2 of House 1.	76
4.17.	Stone-robbing cut (F392/F604) left after the removal of the wall between Rooms 1 and 3 of House 1.	77
4.18.	Stratigraphic model and calibrated radiocarbon dates for Areas G1 and G2.	78
4.19.	Stratigraphic model and calibrated radiocarbon dates for interventions in the wave-cut bank.	78
4.20.	Stratigraphic model and calibrated radiocarbon dates for House 5, House 1 and associated contexts in Area F.	79
4.21.	Unmodelled calibrated dates for radiocarbon samples from context A004 near the top of the Fish Midden.	79
4.22.	Unmodelled calibrated dates for radiocarbon samples that are difficult to place in a stratigraphic sequence.	79
4.23.	Hearths F071 and F010 (Phases 4.3 and 4.4 respectively) in Room 1 of House 1.	80
4.24.	House 5 in Phase 2.3, when only the northern side aisle remained in use.	81
4.25.	North-facing elevation of a well-preserved section of the internal stone facing of House 5.	82

4.26.	*Antler comb (Sf. 61509) found against the western gable of House 1.*	83
4.27.	*Hearth G100/G101 built in a semi-subterranean niche of House 7.*	83
4.28.	*Photograph and interpretation of the west-facing section of the wave-cut bank.*	84
4.29.	*Room 1 of House 1 in Phase 3.2, showing the remnants of grooves cut to hold edge-set stones.*	85
4.30.	*Perforated flagstone (Sf. 61914) near the southwest entrance of Room 1 in House 1 early in Phase 3.2.*	85
4.31.	*Room 3 (the byre) of House 1.*	86
4.32.	*Curved passage originally leading from the shore to the western entrance of House 1.*	86
4.33.	*Traditional flagstone animal stalls in the byre of the Corrigall Farm Museum on the island of Mainland.*	87
4.34.	*Edge-set stones demarcating probable animal stalls in Room 3 of House 1.*	87
4.35.	*Room 1 of House 1 in Phase 3.3, showing the stone 'high seat' (F511).*	88
4.36.	*External elevation of the south wall of Rooms 1, 2 and 3 of House 1.*	88
4.37.	*Aerial photograph of House 1.*	89
4.38.	*Four-sided steatite vessel (Sf. 60672) used as rubble in a Phase 4.2.1 levelling deposit in Room 2 of House 1.*	89
4.39.	*'Anvil' stones of Phase 4.2.2 in Room 2 of House 1.*	89
4.40.	*Midden fill (F602) in Room 4 of House 1 deposited during Phase 4.*	90
4.41.	*Blockage (with drain) of the western entrance to Room 3 of House 1.*	90
4.42.	*Kelp burning pit (D004) of Phase 5 or 6 exposed in Area D.*	91
4.43.	*Area G showing wall G033 that demarcated the southern boundary of the garden over the Farm Mound.*	91
4.44.	*Living and working spaces at Quoygrew in the 1930s superimposed on the ruins visible prior to excavation.*	92
4.45.	*Photographs of Betty Stinear at Quoygrew in the early 1930s prior to its abandonment and the present day.*	93
4.46.	*Reconstruction of House 5 in Phase 2.3.*	94
4.47.	*Reconstruction of House 1 in Phase 3.2.*	95
4.48.	*Reconstruction of House 1 in Phase 4.1.*	95
5.1.	*James Gerrard (top left) supervises the collection of flotation samples from House 1.*	97
5.2.	*Catrina Adams and Jennifer Harland operate the flotation tank.*	98
5.3.	*David Andrews operates the coarse-sieving frame.*	99
5.4.	*Box plots of the density of marine shell, fish bone and mammal bone in all sieved samples (by phase).*	100
5.5.	*Box plots of the density of marine shell, fish bone and mammal bone in midden samples from Area G.*	100
5.6.	*Box plots of the density of marine shell, fish bone and mammal bone in midden samples from Areas A–F.*	101
6.1.	*Limpet with three visible external growth checks.*	104
6.2.	*Limpet shell attached to the rock.*	105
6.3.	*Scooping periwinkles off the rocks.*	105
6.4.	*Percentages of main species from the middens of Areas G (Phase 1), G (Phases 2–3) and A (Phases 2–3).*	107
6.5.	*Proportion of species from contexts in and around House 1 containing substantial quantities of shell.*	108
6.6.	*Scattergraph to show the size of limpets from Phase 1 and Phases 2 to 3 of Area G.*	109
6.7.	*Scattergraph to show the size of limpets from Phases 2 to 3 of Areas G and A.*	109
6.8.	*Average length and standard deviations for limpets from Area A.*	110
6.9.	*Average length and standard deviations for limpets across the site.*	110
6.10.	*Boxplot showing the height:length ratio of modern limpets collected from the upper and lower shore.*	111
6.11.	*Ratio of height:length for Area G Phase 1, Area G Phases 2 to 3 and Area A Phases 2 to 3.*	111
6.12.	*Average periwinkle lengths and standard deviations for each analysed context with a sample size of >30.*	111
6.13.	*Histograms of the age classes of limpets from contexts within the Farm Mound and Fish Midden.*	112
7.1.	*Photographs showing the abundance of fish bone in Phase 2 and Phases 2 to 3 at Quoygrew.*	115
7.2.	*Gadid NISP data divided by quantification code.*	121
7.3.	*Cod total-length distributions based on the comparison of archaeological specimens with reference ones.*	123
7.4.	*Cod total-length estimates based on premaxilla measurement 2.*	125
7.5.	*Saithe total-length distributions based on the comparison of archaeological specimens with reference ones.*	125
7.6.	*Saithe total-length estimates based on quadrate measurement 1.*	125
7.7.	*Ling total-length distributions based on the comparison of archaeological specimens with reference ones.*	126
7.8.	*Norwegian stockfish photographed in Tromsø (1996) and Orcadian salt cod photographed in Kirkwall (c. 1900).*	127
7.9.	*Butchery of cod family fish for the production of 'stockfish' of* rotskjaer *type.*	129
7.10.	*Cod and saithe MNE by deposit/phase group.*	132
7.11.	*Cut marks on cod caudal vertebrae of group 1.*	136
8.1.	*Butchery evidence on cattle bones from the Farm Mound.*	146

8.2. *Butchery evidence on caprine bones from the Farm Mound.* 147

8.3. *Bi-perforated caprine metacarpal from Phases 2 to 3 of the Farm Mound.* 148

8.4. *Example of longitudinally perforated cattle long bone from Phases 2 to 3 of the Farm Mound.* 148

8.5. *Cattle, caprine and pig ordinal age categories for all QC1 specimens.* 149

8.6. *Approximate fusion ages by element for cattle and caprines for major deposit and phase groups.* 150

8.7. *Cattle and caprine mortality profiles based on dental evidence from the major deposit and phase groups.* 151

9.1. *The cliffs of Noup Head on Westray attract large colonies of seasonally nesting seabirds.* 158

10.1. *Images of recovered botanical remains.* 167

10.2. *Density of macrobotanical remains by ecological group: middens by area and phase.* 172

10.3. *Density of barley and oats by phase and area (midden contexts).* 175

10.4. *Density of macrobotanical remains by ecological group: hearth, pit fill/dump and floor layer contexts by phase.* 176

10.5. *Density of barley and oats by phase and context type (non-midden contexts).* 177

11.1. *Sheep grazing on seaweed in North Ronaldsay, Orkney.* 199

11.2. *Scatterplot of the bone collagen $\delta^{13}C$ and $\delta^{15}N$ data regarding fauna from Quoygrew.* 203

11.3. *Scatterplot of the bone collagen $\delta^{13}C$ and $\delta^{15}N$ data regarding caprines from Quoygrew, by phase.* 203

11.4. *Scatterplot of the bone collagen $\delta^{13}C$ and $\delta^{15}N$ data regarding cattle from Quoygrew, by phase.* 204

11.5. *Scatterplot of the bone collagen $\delta^{13}C$ and $\delta^{15}N$ data regarding pigs from Quoygrew, by phase.* 204

12.1. *Locations of the Shetlandic and Norwegian steatite sources included in the chemical characterization study.* 208

12.2. *Results of a principal component analysis of the Quoygrew steatite REE composition data.* 210

12.3. *Discriminant analysis of the Quoygrew samples and three Shetland reference groups.* 210

12.4. *Discriminant analysis of the Quoygrew samples and other Shetland and Norwegian reference groups.* 210

12.5. *Schematic representation of the steatite vessel forms represented at Quoygrew.* 214

12.6. *A selection of the 111 steatite vessel sherds from Quoygrew.* 215

12.7. *Base of four-sided vessel (Sf. 60672) from a floor-levelling context of Phase 4.2.1 in Room 2 of House 1.* 216

12.8. *A selection of the 18 stone spindle whorls from Quoygrew.* 217

12.9. *Probable fishing weights from Quoygrew.* 218

12.10. *Fragmented schist bake stone of Norwegian type.* 219

12.11. *A selection of the 23 hones from Quoygrew.* 220

12.12. *Micrographs of thin sections from Eidsborg quarry samples.* 221

12.13. *Micrographs of thin sections of Quoygrew hones.* 224

12.14. *Micrograph of thin section of Quoygrew hone 6590.* 225

12.15. *Micrographs of thin sections of Dunrossness Phyllite samples 12404 and 27141.* 225

13.1. *Reference specimens of red deer and reindeer antler.* 230

13.2. *European distributions of comb types relevant to the discussion.* 232

13.3. *Typical examples of comb types, together with schematic representations of their cross-sections.* 233

13.4. *A selection of the 34 antler and bone comb and comb case finds from Quoygrew.* 234

13.5. *A selection of the 47 worked bone objects from Quoygrew.* 241

13.6. *A selection of the five bone spindle whorls from Quoygrew.* 242

14.1. *A selection of the 530 iron finds from Quoygrew.* 247

14.2. *A selection of the knife finds from Quoygrew.* 248

14.3. *The decorative handle of a post-medieval knife or fork from Quoygrew.* 249

15.1. *A selection of the 1632 finds of pottery fabrics 1 to 3 from Quoygrew.* 260

15.2. *Example rim and base profiles of fabric 5.* 263

15.3. *Find 62083, the unique example of an organic tempered (fabric 2) sherd with stabbed decoration.* 263

15.4. *Examples of German proto-stoneware, fabric 8, fabric 9 and fabric 11.* 264

15.5. *A selection of the 50 finds of pottery fabric 6 (Scottish redware).* 266

15.6. *Glass beads from Phase 1.2 and Phase 2–3.* 271

16.1. *The distribution of selected categories of artefact from the interior of House 5 in Phase 2.* 278

16.2. *Local and imported cod bones in England and Flanders based on $\delta^{13}C$ & $\delta^{15}N$ measurements on 129 samples.* 281

16.3. *The distribution of selected categories of artefact from the interior of House 1 in Phase 3.* 284

16.4. *A small subfloor pit from Phase 3.5 of House 1 with sherds of soapstone and ceramic vessels.* 285

16.5. *The distribution of selected categories of artefact from the interior of House 1 in Phase 4.* 286

Tables

4.1.	The Quoygrew phasing.	48
4.2.	Radiocarbon dates from Quoygrew.	54
4.3.	Selected artefactual dating evidence from Quoygrew.	56
4.4.	Optically stimulated luminescence dates from Quoygrew.	58
6.1.	List of shellfish taxa from the Fish Midden and Farm Mound samples.	104
6.2.	Summary of the MNI for each taxon in each area or context (and phase).	106
6.3.	The MNI for each taxon per context in Area A and the percentage of the total MNI per context.	107
7.1.	Ordinal fish total-length categories attributed by comparing archaeological specimens with reference specimens.	117
7.2.	Fish texture and percent completeness data for all QC1 elements.	117
7.3.	Identified fish bone from Quoygrew (by NISP, see also Appendix 7.1).	119
7.4.	Cod, saithe and ling NISP by element.	129
7.5.	Summary of cut-mark evidence.	135
8.1.	NISP of QC1 mammal bones by major deposit and phase groups, divided by recovery method.	142
8.2.	Bone surface texture and percent completeness data for all identified mammal QC1 elements.	144
8.3.	NISP of QC1 cattle elements for major deposit and phase groups, divided by recovery method.	145
8.4.	NISP of QC1 caprine elements for major deposit and phase groups, divided by recovery method.	146
8.5.	NISP of QC1 pig elements for major deposit and phase groups, all recovery methods combined.	148
8.6.	Summary of pathological lesions on mammal bones.	152
9.1.	NISP of bird bones from all deposit and phase groups.	156
10.1.	Summary of contexts analysed for botanical remains.	163
10.2.	Summary of differences in sampling and sorting procedures by area.	163
10.3.	Seed remains found at Quoygrew.	170
10.4.	Count and density of carbonized botanical remains from midden contexts by phase and area.	186
10.5.	Count and density of carbonized botanical remains from hearth, fill/dump, and floor layer contexts.	192
11.1.	Collagen $\delta^{13}C$ and $\delta^{15}N$ values for samples of caprine, cattle and pig bone from Quoygrew.	200
12.1.	Quoygrew steatite samples characterized by ICP-MS.	209
12.2.	Summary of the steatite assemblage.	210
12.3.	Worked stone by general phase.	211
12.4.	Worked stone from Area G by detailed phase.	212
12.5.	Worked stone from Areas A to F, H and J by general phase.	213
12.6.	Descriptions of thin sections of Eidsborg schist and Dunrossness Phyllite, and four hones from Quoygrew.	222
13.1.	Distribution of comb finds by type, raw material and phase.	230
13.2.	Distribution of combs (after cross-mending) by type, raw material, phase and location.	231
13.3.	Distribution of other worked bone objects by type, raw material and phase.	240
14.1.	Iron finds from Quoygrew by phase.	246
14.2.	Copper-alloy and lead finds from Quoygrew by phase.	252
15.1.	The pottery from Quoygrew by general phase.	256
15.2.	Inferred vessel groups based on cross-joins, fabric and decoration.	257
15.3.	The pottery from Area G by detailed phase.	257
15.4.	The pottery from Areas A–F, H and J by general phase.	258
15.5.	A selection of comparative evidence for the Quoygrew pottery assemblage.	259
15.6.	Clay tobacco pipes.	270
15.7.	Glass by general phase.	271
16.1.	Radiocarbon dates from other fish midden sites in Orkney and Caithness.	277

Appendices

4.1. *Concordance of context numbers assigned to the recorded wave-cut bank and Areas A to E.* 293

4.2. *Phasing and brief descriptions of all recorded contexts at Quoygrew.* 294

7.1. *Fish NISP for minor phases.* 310

7.2. *Common and scientific names (or analytical categories) of identified fish taxa.* 311

7.3. *Cod total-length estimates, determined using a regression equation applied to premaxilla measurement 2.* 312

7.4. *Saithe total-length estimates determined using a regression equation applied to quadrate measurement 1.* 313

7.5. *Results of statistical tests of characteristics of the fish-bone assemblage that yielded significant differences.* 314

8.1. *Common and scientific names (or analytical categories) of identified mammals.* 315

8.2. *Bone surface texture data for identified mammal QC1 elements, divided by ordinal age categories.* 315

8.3. *Results of statistical tests of characteristics of the mammal-bone assemblage that yielded significant differences.* 315

8.4. *Assessment of large and medium mammal bone fragmentation in Phases 1 and 2 to 3 of the Farm Mound.* 316

8.5. *Cattle measurements.* 317

8.6. *Caprine measurements.* 319

8.7. *Pig, horse and cat measurements.* 321

9.1. *Common and scientific names (or analytical categories) of identified birds.* 322

12.2. *Concentrations of fourteen rare earth elements for a selection of steatite finds from Quoygrew.* 323

12.3. *Worked stone by detailed phase.* 324

15.1. *Summary description of pre-industrial pottery fabrics.* 325

15.2. *The pottery from Quoygrew by detailed phase.* 326

15.4. *Concentrations of elements in redware (fabric 6) samples from Quoygrew.* 328

On-line Digital Appendices (http://www.dspace.cam.ac.uk/handle/1810/243446)

3.1. *Topographic survey data (based on TST measurements).*

3.2. *Auger and test pit survey data.*

5.1. *Sieved and sorted flotation and coarse sieving samples from Quoygrew.*

12.1. *Catalogue of worked stone, worked bone, worked antler, non-ferrous metalwork and other miscellaneous finds from Quoygrew.*

14.1. *Catalogue of iron finds from Quoygrew.*

15.3. *Catalogue of pottery from Quoygrew.*

Preface and Acknowledgements

I complete this book at a time of economic and social upheaval. Many nations are struggling under the threat or reality of unsustainable debt and civil unrest. Others have already succumbed. The single European currency has an uncertain future and standards of living are falling in the United Kingdom. Even in Cambridge, with its own microclimate, I had to weigh the ethics of crossing picket lines in order to drop off the initial manuscript with the production editor. The boom years of the world economy are at least temporarily over. Yet boom and bust cycles are nothing new. The perfect storms of the twentieth century are still written on our personal or inherited memories, despite the ever-changing baseline of each generation's experience. Little economic spirals are also conjured or dispelled on a daily basis — the products of shifting control over resources, power and violence, often played out on a global mosaic of regional specializations of labour.

Cycles of economic and political change were also the norm rather than the exception in the ancient and medieval world. The period considered in this study is framed by the crises of the Viking Age (conquest and colonization) and the late Middle Ages (famine, plague and economic stagnation). It considers the boom years in between, and how the ebb and flow of economic production and long-range trade influenced the construction of local identities. Ultimately it is about the complex and fluid — yet powerful — articulation between rural producers of the north and distant urban centres of consumption. It is about being an islander, and it is dedicated to the residents of one: Westray, Orkney, with a community of *c.* 600 cosmopolitan individuals.

Like all archaeological excavation projects this publication has been hard won by the dedication of a large team. It represents the harvest of eight seasons of excavation followed by five years of post-excavation research. The chapters draw on three PhD theses (by Catrina Adams, Steve Ashby and Jennifer Harland), two postdoctoral fellowships (Jennifer Harland and James Gerrard) and numerous smaller research projects (Jamie Andrews, Fiona Breckenridge, Rebecca Bennett (née Briscoe), Sandra Poaps, Susan Richer, Marcus Smith, Jon Welsh and Jerad Zimmermann). The work has also been generously contributed by university- and unit-based specialists with busy lives and their own projects to run. Overall the text was edited and written in the hours I've stolen from days

and nights filled with the usual competing demands of multiple research projects, fund-raising, teaching, administration and life.

Why do it, with journal articles and single-authored books rather than excavation monographs now constituting the standard currency of academic life? When confronted with a blank screen in the spring of 2008 I had to choose between writing a thematic text on economic production and insular identity or the ethical imperative of bringing Quoygrew to timely publication. I decided to try both within the same hybrid volume. It has been an interesting and rewarding experiment.

The project was made possible by the core backing of Historic Scotland, but important funding was also provided by the Andrew W. Mellon Foundation, the Arts and Humanities Research Board (now the Arts and Humanities Research Council), the British Academy, the Hunter Archaeological Trust, the Leverhulme Trust, the National Lottery (Big Lottery Fund), the Orkney Archaeological Trust, Orkney College, Orkney Islands Council, the Society for Medieval Archaeology, the Social Sciences and Humanities Research Council (Canada) and the Universities of Cambridge, Glasgow and York.

In the field we had invaluable assistance from George and Margaret Drever (who own the site of Quoygrew), Julie Gibson (the Orkney Archaeologist), Sam Harcus (then of the Westray Development Trust) and the late Anne Brundle (of Orkney Museum). Rod McCullagh, Noel Fojut, Allan Rutherford and John Raven of Historic Scotland helped us navigate the project to completion. Those who fed our bodies, minds and souls while in Orkney are too numerous to name, but no less appreciated.

Ben Cartwright helped with study of the textile equipment and Pieterjan Deckers assisted with the final finds catalogue. My other post-graduate students, past and present, have weathered the project with great forbearance and frequent insight. Elizabeth Ashman Rowe and Sheila Watts provided assistance with the translation of primary historical sources. Judith Jesch helped with the skaldic poetry. Rachel Ballantyne commented on Chapter 10. The entire manuscript was improved by the advice of Magdalena Naum and an anonymous external reader. Its final form was also heavily influenced by participation in research projects coordinated by the Universities of Bergen and Oslo. I thank Anne Karin Hufthammer,

Dagfinn Skre and other friends and colleagues in both institutions for their inspiration and assistance. David Orton has been instrumental in collaborative fish-trade research that has similarly informed this work. Production of the book has been made possible by the good-humour and expertise of Dora Kemp and Liz Farmar of the McDonald Institute. Nothing would have been possible without the patience of Sarah, Ella and Alexander. Nor, of course, without the super-human efforts of the training excavation staff and crews (especially James Gerrard who supervised from 2002 to 2005) — sometimes grudgingly cooperative, often lightning in a bottle.

J.H. Barrett
29 May 2012

Quoygrew Excavation Teams

1997 Season
Kristján Ahronson
James Barrett
George Clark
Andrew Griffin
Jerry Hamer
Karen Milek
Jayne Oltmann
Sandra Poaps
Tessa Poller
Lorna Sharpe
Ian Simpson
Vicki Szabo

1999 Season
Kelly Armstrong
Amanda Badawoy
James Barrett
Olaf Bond
Malcolm Hope
Heather James
Donna Maguire
Chad Marshall
Karen Milek
Tessa Poller
Brian Rahn
John Roppa
Darren Sabo
Prabakar Sri Ranganathan
Julian Weinrib
Simon Whitelaw

2000 Season
James Barrett
Vicky Birch
Claire Corkill
Steve Dobson
Jennifer Harland
Rose Lock
Donald Makin
Craig McKibbin
Sarah Murgatroyd
Terry O'Connor

2000 Season *(cont.)*
Tom Riley
Sven Schroder
Marcus Smith

2001 Season
Jamie Andrews
James Barrett
Catherine Bertrand
Debs Butterworth
Nick Coakley
Tim Cornah
Steve Dobson
Mags Felter
Vicki Fox
Jen Harland
Anthony Haskins
Sarah King
Alix Lee
Martha McAulay
Alex McGregor
Craig McKibbin
Steve Miles
Ray Moore
Kathy Morrison
Sarah Murgatroyd
Cath Neal
Tessa Poller
Suzi Richer
Tom Riley
Lucy Roberts
Sven Schröder
Eva Sköld
Laura Smith
Marcus Smith
Zoë Sutherland
Emily Thornton

2002 Season
Catrina Adams
Lennard Anderson
Jamie Andrews
Steve Ashby

2002 Season *(cont.)*
James Barrett
Geoff Birchenall
Laura Bolan
Tom Canning
Leslie Catt
Tim Cornah
Dave Fell
Mags Felter
Vicki Fox
James Gerrard
Jen Harland
Anthony Haskins
Matt Hodkin
Kate Keys
Ken Leach
Laura Murray
Cath Neal
Terry O'Connor
Lou Pegler
James Ratcliffe
Suzi Richer
Eva Sköld
Marcus Smith
Mike Sowden
Hannah Stone
Zoë Sutherland
Tim Tatliogu
Nick Trustram-Eve
Mari Whitelaw

2004 Season
Catrina Adams
Dan Adams
Even Andersen
David Andrews
Jamie Andrews
Jo Atha
Mick Atha
James Barrett
Fiona Breckenridge
Tim Cornah
Eva Fairnell

2004 Season *(cont.)*
James Gerrard
Ben Gourley
Holly Gourley
Jen Harland
Sarah King
Shannon Lewis-Simpson
Caz Mamwell
Gemma Midlane
Sally Mills
Ian Milsted
Nicky Milsted
Sean Mullan
Sarah Murgatroyd
Chris Reid
Tom Riley
Eva Sköld
Diane Siebrandt
Mike Sowden
Sarah Thomas
Rona Thompson
Kate Towsey
John Welch
Mari Whitelaw

2005 Season
David Andrews
James Barrett
Fiona Breckenridge
Tim Cornah
Eva Fairnell
James Gerrard
Jen Harland
Shannon Lewis-Simpson
Jessica Mou
Eva Sköld

2006 Watching Brief
James Barrett
Joffy Hill

Chapter 1

Introduction: the Study of Island Societies

James H. Barrett

1.1. Why? The research questions

How does one make a living, and how does one imagine one's place in the world, in a landscape with both the most limited and limitless boundaries on earth? These questions, which pervade much island and coastal archaeology (e.g. Boomert & Bright 2007; Rainbird 2007; Broodbank 2008; Fitzpatrick & Anderson 2008; Van de Noort 2011, 125–45), are the foundations of this study of a rural island settlement in an archipelago off the northern tip of mainland Scotland. The settlement (a farm of no more than a few households) is Quoygrew, the island (*c.* 16 km in length) is Westray and the archipelago (of *c.* 16 inhabited islands, stretching *c.* 80 km from north to south) is Orkney (Fig. 1.1). The most meaningful answers will be both historically contingent and relative (cf. Barrett & Anderson 2010). Thus the questions must be addressed using a diachronic and comparative approach, charting trends through time *vis-à-vis* the concurrently changing 'outside' world. Quoygrew was continuously occupied from the tenth century AD until 1937, with the present study focusing on the first *c.* 700 years of this millennium-long chronology.

Why Orkney, why Quoygrew and why AD 900 to 1600? The answers depend on one's vantage. From a medievalist's perspective the central questions are how did 'small worlds' reflect and/or impact fundamental pan-European socio-economic watersheds: the growth of population, economic production, trade and urbanism from the tenth to thirteenth centuries and the subsequent economic and demographic retrenchment of the fourteenth to fifteenth centuries. These issues inspired the Viking Age Transitions Project that culminates with this book. As the excavation, sample sorting and post-excavation analyses progressed the issues have become ever more pressing. Patterns of iron production, reindeer and elk hunting (for antler used in comb making), fur trapping and walrus hunting (for ivory) in the *utmark*, outlands or 'liminal landscapes' of Scandinavia, Russia and Greenland

have raised the likelihood that insular regions were integral to widespread social and economic trajectories in medieval Europe (Andersson *et al.* 1998; Svensson *et al.* 2001; Arneborg 2003; Holm *et al.* 2005; Ljungqvist 2005; Svensson 2007; Holm *et al.* 2009; Larsen 2009; Keller 2010). Concurrently, this research has illuminated important regional divergences from the traditional chronology of medieval expansion and collapse — and shown that highly variable expressions of local identity can emerge in similar cases of changing long-range interaction. The end of large-scale iron production in Norway, for example, predates rather than postdates the demographic crash of the mid-fourteenth century (Larsen 2009; Stene 2010). Moreover, it has made it clear that 'outland' settlement and land-use systems had their own resilience, rather than simply being pressed into service during episodes of medieval population expansion (cf. Bailey 1989; Holm *et al.* 2005).

The study of Orkney (which functioned as a semi-independent principality for most of the period under consideration) can contribute to this emerging understanding of the role of small-scale societies in the medieval world. The particular importance of the Quoygrew excavation is its opportunity to explore, at a single settlement using comparable methods, how the local and extra-local intersected over the entire putative cycle of boom and bust between the tenth and fifteenth centuries. Insofar as the more limited sixteenth- to seventeenth-century evidence allows, it also provides a window on the subsequent episode of recovery that briefly benefited a new Orcadian elite (see Chapter 2). Overall this book offers both a contingent history *vis-à-vis* traditional macroeconomic perspectives and an example of how regionally and temporally sensitive meta-narratives might be built one case study at a time.

It was to address these issues that the work began, initially funded by the Social Sciences and Humanities Research Council of Canada. For Historic Scotland, the national heritage agency that

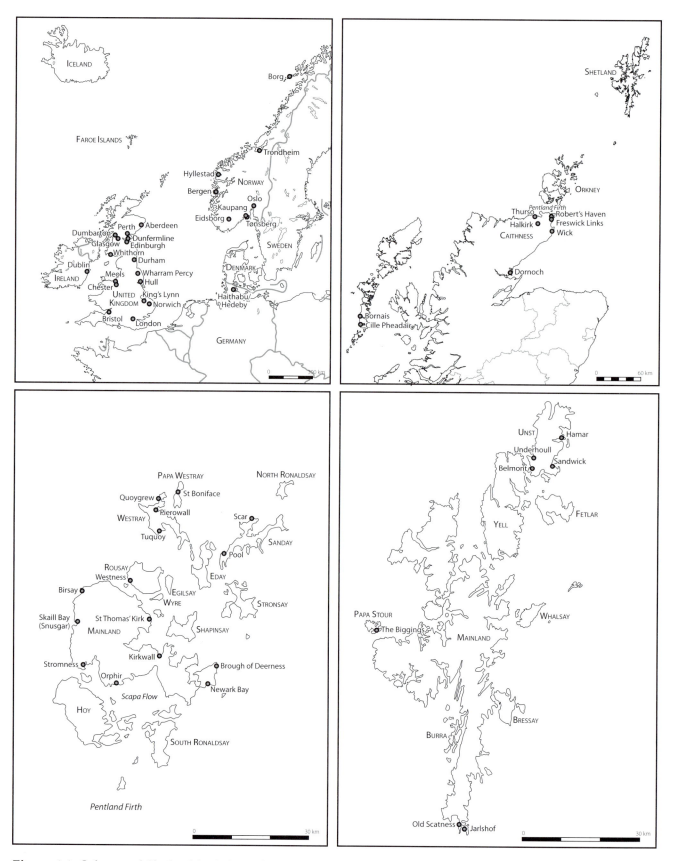

Figure 1.1. *Orkney and Shetland in their northern context, including places mentioned in the text. (Image: Dora Kemp.)*

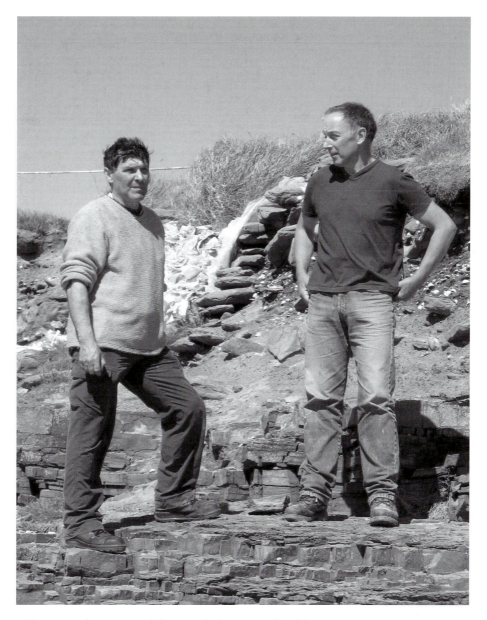

Figure 1.2. *George Drever and Jerry Wood discuss the logistics of building a sea wall along the wave-cut bank as part of a community heritage project to protect Quoygrew for public display. (Image: James Barrett.)*

co-sponsored the project from 2000 to 2007, an additional goal was to rescue an eroding settlement that represented a chronological and functional gap in the Scottish archaeological record (cf. Gibson 2008, 62–4). Few medieval rural sites had previously been excavated and fishing settlements — Quoygrew was clearly one based on a trial trench dug by Sarah Colley in 1978 (1983; 1984) — had been investigated mainly by studying middens eroding from the wave-cut bank (e.g. Owen 1993; Barrett 1997; Lowe 1998). It was thus impossible to ascertain how aspects of the maritime economy fit into their wider landscape context.

For the residents of Westray and Orkney, who supported the project in cash and kind over its entire duration, the goals were unambiguous. The land owners (George and Margaret Drever), their neighbours, the Westray Development Trust, the local authority archaeologist (Julie Gibson) and the Orkney Islands Council were all committed to the display of a material expression of the community's links to the distant past (Fig. 1.2). Quoygrew was notable in this regard given its evidence of occupation from the Viking Age into living memory. These motives were partly about community itself

(cf. Jones 2004; Hastrup 2008) and partly about ensuring Westray's stake in heritage tourism, a lynchpin of Orkney's economy (Downes & Wickham-Jones 2005; Lange 2006). The latter has been dominated by the largest of the Orkney Islands, Mainland, with its UNESCO World Heritage Site including Maes Howe, the Stones of Stenness, the Ring of Brodgar and Skara Brae (Downes *et al.* 2005). The best-preserved house at Quoygrew was thus ultimately protected by a sea wall and consolidated for public display with National Lottery funding.

From thematic and theoretical perspectives, the subject matter of this book was inspired by a desire to prioritize the study of economic production over consumption, rural over urban, peasant over elite and insular over 'mainland' or continental. These points of view in part reflect my own biography: first as an academic migrant from rural Nova Scotia to Toronto, then as an urban dweller (in Glasgow, Toronto and York) engaged in frequent rural fieldwork and presently as the resident of a countryside village within commuting distance of London. They have been influenced by postcolonial scholarship, which uses specific case studies to illuminate the importance of active local and contingent responses to global trends (see below).

The prioritization of economic production is intended to balance the emphasis on consumption evident in many historical works and to confront an outmoded but still lingering and unhelpful dichotomy within archaeology as a discipline. That is between the study of ecofacts (seeds, bones, sediments, etc.) as evidence of the 'natural' world and artefacts as evidence of social and economic life. A related problem is the past relegation of both artefact and ecofact reports to unheeded appendices in publications of fieldwork. To fully illustrate these points would entail more words than are needed for present purposes and do injustice to valuable research in the fields of both palaeoecology and material culture studies. Suffice it to say that one will find comparatively few studies of medieval archaeology that explicitly combine considerations of primary economic production (such as cereal agriculture, pastoralism or fishing) with the consumption of the resulting wealth (as silver bullion, coins, imported ceramics, metalwork, etc.). Dissolving this dichotomy is an agenda characteristic of our time (e.g. Barrett *et al.* 2000a; Loveluck & Dobney 2001; Pluskowski *et al.* 2011), but no less important for that.

The emphasis on production (and thus peasants) is also based on the view that one of the major drivers of medieval socio-economic change was shifts in the creation and circulation of surpluses in the form of bulky staple goods. This perspective, ultimately grounded in historical materialism, runs counter to the common archaeological emphasis on the circulation of prestige goods. Following Wallerstein (1993, 294) and Wickham (2005, 696), luxuries are treated as only epiphenomena of elite life. To provide a modern metaphor (not intended as an historical analogy) the supply and distribution of fossil fuels has been a (the?) major driver of socio-economic change over the last four decades.

In studies of the Middle Ages the greatest transformation has often been imagined as a shift in emphasis from (non-market) trade of light prestige goods to (market) trade of bulky staples. This transition is thought to be correlated with urbanism and state formation. It has been hunted in the long eighth century (with its 'wic' sites and 'sceatta' coinage), the long eleventh century (with another boom in urbanism and minting) and the long thirteenth century (when both towns and historical records of trade in bulk staples such as dried fish become more numerous). Debate occasionally surfaces regarding which of these starting points is the more correct (e.g. Berggren *et al.* 2002; Barrett *et al.* 2004; Urbanczyk 2007; Skre 2008; Hillerdal 2010; Andersson 2011). However, many of these perspectives (including my own at times) have assumed in part that there *was* a general 'medieval' progression towards increased trade, greater urbanization and more centralized political control, whatever its precise chronology. Taking a broader perspective — including, for example, the dissolution of the western Roman Empire in the fifth century and the European economic crises of the fourteenth to fifteenth centuries — this idea is hardly justified. That urbanism and trade in staple goods may ebb and flow is an empirical reality. The challenge for medievalists is to illuminate these shifting tides, their causes and their consequences. One of the key contributions of archaeology is thus to make it possible to observe episodes of 'boom' and/ or 'bust' that predate the key sources of economic history. Based on customs records, for example, it is impossible to ascertain the details of long-range trade in northern Europe until the late thirteenth and early fourteenth centuries at the earliest (Nedkvitne 1976; Berggren *et al.* 2002; Ditchburn 2009). Of course archaeology's contribution also goes beyond extending existing chronologies, illuminating (for example) material expressions of identity in both poorly- and well-documented periods.

Much medieval archaeology has taken place in urban, ecclesiastical and elite settlements. Thus discussion of economic trends has understandably focused on the resulting wealth of evidence (e.g. Hodges 1982; Andrén 1985; Anderton 1999; Dobney *et al.* 2007; Loveluck 2007; Sindbæk 2005; 2007a; Andersson *et al.* 2008; Skre 2008; 2010; O'Connor 2010). To advocate an alternative emphasis on peasant sites should not,

however, be taken to suggest that they have been neglected. Interdisciplinary rural settlement studies were one of the foundations of the discipline (e.g. Beresford 1954; Beresford & Hurst 1990) and remain an important area of growth (e.g. Skre 2001; Lewis 2007; Holm *et al.* 2009; Klápšt & Sommer 2009; Jones & Dyer 2010; Christie & Stamper 2012). Scandinavia is a leader in this trend, but even in this context the focus has often been on wealthy central places such as Hofstaðir (Lucas 2009), Borg (Munch *et al.* 2003), Tissø (Jørgensen 2003), Lejre (Christensen 1991; 2010) and Uppåkra (Larsson & Hårdh 2007). Normal farms are not well represented among the excavated (and published!) record. In Scotland there have been very successful studies of medieval rural settlements (many of which are referred to in the chapters to follow), but the need for more has been recognized as a national research priority (Dalglish & Dixon 2007; Dalglish 2012). Ireland is perhaps better served — in part because of the ubiquitous ring forts which survive as visible earthwork monuments (Stout 1997; Fitzpatrick 2009).

Prioritizing the insular (over the mainland or continental) returns discussion to the importance of observing so-called margins in order to understand sweeping socio-economic trends (cf. Bailey 1989). The section to follow will consider this issue in detail by surveying differing approaches to the archaeology of islands and other superficially isolated regions. For the present, however, it is important to ground the issue in specifics. This book hopes to illuminate its ultimate goals by:

1. Determining whether the economic intensification thought to characterize the urbanized and densely populated regions of northern and western Europe during the transition from the Viking Age to the Middle Ages (e.g. around the southern North Sea) was also evident in a small rural island community;

2. Assessing whether any similarities and/or complementarities discovered resulted from local solutions to similar problems or direct communication and trade between regions;

3. Determining how a small island community responded to the subsequent economic and demographic crises of the fourteenth to fifteenth centuries; and

4. Evaluating the relationship between the degree of interconnectedness and the expression of distinctive insular identity over these centuries of profound socio-economic change.

Here the materialist perspective of the study must be qualified. On one hand it is heavily influenced by the 'material turn' in contemporary archaeology (cf. Hicks 2010; Barrett 2011; Solli 2011), being sympathetic with

Tim Ingold's (2007, 9) acerbic quip that 'boiling fish bones yields an adhesive material, a glue, not a fishy kind of materiality in the things glued together'. Conversely, it is equally inspired by the social preoccupations of much recent medieval archaeology (Gilchrist 2009 and references therein). Thus it sets out (adopting another metaphor) to explore when the identity of islanders cut both *with* and *across* the grain of the activities and things with which they were engaged. It is essential to discover, rather than assume, how production and trade shaped world view and *vice versa*. The existence of a dialectic between the material and the ideal (often described as materiality) is a necessary *a priori* assumption (cf. Gosden 1994, 72; Olsen 2003; Olsen 2010, 162–4).

1.2. Island societies: small worlds and big networks

Island societies have often been the focus of archaeological inquiry, but in many different ways. They have been treated as bounded social laboratories, isolated reservoirs of traditional knowledge, nodes of trading and/or raiding networks, stepping stones for diasporas, abodes of exotic 'others' and analogues for spaceship earth (see Fitzpatrick 2004; Rainbird 2007; Noble *et al.* 2008; Anderson *et al.* 2010 for recent overviews). Islands also differ greatly. In Orkney they range from skerries (rocky islets) and holms (small islands typically used only for grazing) to the island of Mainland. The latter is approximately 40 km from east to west and presently supports the towns of Kirkwall and Stromness in addition to extensive rural settlement. It is *the* mainland from an Orcadian perspective, but of course the sense of scale is very different from, for example, the much larger islands of Britain, Ireland, Iceland or Greenland. Islands have fundamentally different natural resources and cultural landscapes. Orkney was a surplus producer of grain with a largely arable landscape in the Viking Age and Middle Ages, despite its location between 58° and 59°N latitude (see Chapter 2). The same cannot be said for the Faroe Islands, Iceland and Greenland, where cereal cultivation ranged from difficult to impossible (Dugmore *et al.* 2005). Shetland, with a more rugged topography and higher latitude than Orkney, occupies a middle ground between these extremes (Johnston 1999). It would be an unrealistic task to compare and contrast Orkney with all of its neighbours. The simple point is that one generalizes about islands, even within the same cultural milieu, at one's peril.

Coastal districts may resemble islands more than adjacent mainland territories — in terms of varying combinations of environment, landscape, land use,

material culture, language and genetic ancestry (e.g. Moss 2004; Allaby *et al.* 2010; Terrell 2010). Thus they too may be islands in all but name. The earldom of Orkney controlled the northern areas of the Scottish mainland (Caithness and Sutherland) for much of its existence (Chapter 2). At a further level of abstraction, the political economy of small islands may closely resemble that of other 'outlying' regions within a wider socioeconomic network. Areas of the Norwegian, Swedish and Russian interior show surprising parallels with Orkney's cycle of medieval 'boom' and 'bust' despite dramatically different environments (Martens 1998; Svensson *et al.* 2001; Rundberget 2007; Larsen 2009; Stene 2010; Indrelid & Hufthammer 2011). Greenland is the world's largest island, but is permanently connected to the circumpolar region by sea ice (on one hand) and supported only small localized enclaves of medieval Scandinavian settlement (on the other) (Arneborg 2003; Terrell 2004, 203). Islands are not simply land surrounded by water. They are also social constructs, of their inhabitants and their archaeological observers (e.g. Moss 2004; Boomert & Bright 2007; Fleming 2008).

For present purposes it may be helpful to think instead of *insular societies*, and more generally of communities that share the dialectical relationship of heightened potential for both isolation and interconnectedness. This dialectic is usually created by human responses to the sea (e.g. Rainbird 2007, 168–9; Van de Noort 2011, 125–45), but can also result from a mosaic of bogs, mountains and/or glaciers combined with river valleys and the social imperative to trade for the agricultural products that defined medieval European life (e.g. Arneborg 1998; Martens 1998). It is central to all debates regarding the relative importance of isolation versus interconnection as the defining characteristic of islands — and as the cause of often distinctive island identities.

There is no simple name for such societies, nor should there be given their diversity. 'Liminal landscapes' works for the *utmark* fringe of agricultural settlement in mainland Scandinavia (Holm *et al.* 2009), but is less well suited to the islands of the North Atlantic. They are physically removed from centres of consumption yet potentially interconnected by the sea. In this study I will use insular societies as a convenient shorthand, without imbuing the label with more significance than any case study to which it might apply. Insofar as they often have limited (but variable) agricultural potential, low population densities, and high transportation costs to concentrations of demand, insular societies have often been categorized as marginal or peripheral. These so-called peripheries have been treated in many different ways in the

scholarship of recent decades. What follows is a brief critical survey of trends that establish the wider context of the present study.

1.2.1. *Terra incognita*

Past insular societies of the north have always been in danger of treatment as uncharted territory on the edge of mental maps — due to the comparative paucity of evidence, the assumption of irrelevance, or both. With the notable exception of the Icelandic literary and historical tradition, textual sources are rarer than for contemporary contexts elsewhere in Europe. This lacuna can probably be attributed to the prevalence of oral tradition during the Viking Age, variable aristocratic presence during the Middle Ages and episodes of rule by external elites with their own ideological agendas. The law book of Orkney, for example, probably disappeared in circumstances of the latter kind (Thomson 2008a, 277). Even in the case of the rich Icelandic material the relevant texts are often deconstructed by source criticism to the point that they may cease to be legitimate sources for the study of the real world (Rowe 2002; Friðriksson & Vésteinsson 2003; Hjaltalín 2009; Rowe 2009).

Although the problem is far less severe than for written sources, there is also a paucity of relevant archaeological evidence. Artefacts and ecofacts are simply more dispersed in rural landscapes than in towns. You get fewer finds for your excavation pound. Even in rural for rural comparisons the population densities in insular and liminal societies were low — leaving less to discover. The so-called productive sites of England and southern Scandinavia (e.g. Pestell & Ulmschneider 2003) are not known from the north.

Equally important, the dialectic of isolation and interconnection discussed above can create distinctive suites of material culture that are simply not comparable with standard find categories from elsewhere. If ever attempted, what would a pan-European survey of economic archaeology based on pottery and coinage (cf. Wickham 2005) do when faced with aceramic North Atlantic societies in Orkney or Iceland that used bullion and staple goods as standards of value? In the context of Norwegian evidence Elina Screen (2009, 112) notes that coinage is a particularly poor proxy for long-range trade with the north (see also Skre 2011). Pottery is equally unhelpful given that Orcadians used steatite rather than ceramic vessels between the tenth and twelfth centuries (see Chapter 15).

The study of insular and liminal societies also suffers from their literal or metaphorical location at the edge of (or even beyond) the modern boundaries of the countries constituting the European Union. Thus

within both national and pan-European scholarly traditions (in which much medieval archaeology and history is presently written) they are at best bit players — as rebels to be overcome in the process of state formation for example (Barrell 2000; McDonald 2003; Woolf 2007; cf. Dalglish 2012).

These problems are real, but also mitigated by other special characteristics of insular and liminal regions. Firstly, they often offer good archaeological preservation — having escaped intensive modern farming and other destructive development. Secondly, the traditional lure of island research continues to attract archaeological attention. *Discovery and Excavation in Scotland*, an annual journal surveying archaeological fieldwork, consistently demonstrates the diversity and scale of research in both the Northern Isles (Orkney and Shetland) and the Western Isles (the Hebrides). In recent years Orkney has even become the chosen home of many British archaeologists, who work in Orkney College or commute to universities as far afield as Aberdeen and York. Research on liminal landscapes is a growing field in continental Scandinavia (Holm *et al.* 2009), Icelandic archaeology has experienced very rapid growth in the last decade (Friðriksson & Lucas 2011) and international research projects such as 'Landscapes circum-*Landnám*' (Edwards *et al.* 2004) have attracted major funding. In many of these instances it is arguably the recognition of difference, even the lure of the exotic, that has drawn research to the edge of mental maps.

1.2.2. Typological analogy

Insular societies, often lying beyond the direct control of empires and states, have traditionally served as 'type-sites' in the construction of archaeological typologies of socio-economic organization. They have been perceived as 'chiefdoms' or their semantic relatives, 'despotic' societies (cf. Johnson & Earle 1987; Fitzhugh & Kennett 2010). Thus, to provide one example, eighteenth-century Hawaiians, thirteenth-century Icelanders and the Bronze Age inhabitants of Denmark can rub shoulders in the same text (Earle 1997, 158–84). Although the popularity of this approach has ebbed since the 1990s it continues to influence Anglo-American scholarship. It represents what Fabian (1983; cf. Birth 2008) described as typological analogy, ultimately reliant on an evolutionary perspective that reconfigures societies separated by *space* as cultural stages in *time*. Taking this view to the extreme, insular and liminal societies are isolated regions which have simply not yet achieved the teleological destination of incorporation into a state. They remain chiefdoms — characterized by weak kin-based hierarchies, socially motivated rather than

market economies and volatile politics — because of their isolation. They are (the myth of) the primitive isolate (cf. Terrell *et al.* 1997).

The idea of the chiefdom (*sensu stricto* or qualified and rebranded) has been resilient because there *are* useful socio-economic comparisons to be made between small-scale hierarchical societies reliant on a combination of military, economic, ideological and political power (Mann 1986; Earle 1997; Mann 2006). It provides a convenient simplification of reality. However, engaging in typological analogy imagines societies as what Eric R. Wolf (1982, 6–7) described as separate 'billiard balls' — circumscribed, homogeneous and bouncing off each other. The reality is that the 'chiefly' societies of the north — in Orkney (Barrett 2007; Chapter 2), Iceland (Harrison *et al.* 2008; Sigurdsson 2008), the Isle of Man (McDonald 2007) and elsewhere (e.g. Arneborg 2003) — were interdigitated with contemporary chiefdoms, states and empires across northern and western Europe and beyond. There were links of kinship, trade and conflict (including feud, raiding and mercenary activity). If they were chiefdoms it was in full knowledge of the alternatives (Barrett *et al.* 2000a).

1.2.3. World-systems theory

For many archaeologists world-systems theory, and its related precursor dependency theory, replaced typological analogy as a way of understanding spatial differences in socio-economic organization. Dependency theory emerged from the recognition that 'underdevelopment' was created and sustained by unequal power and trade relationships between modern nations (Frank 1966; 1979). World-systems theory began as a tool to understand how similar patterns developed during the emergence of capitalism in post-medieval Europe (Wallerstein 1974). It envisioned cores (centres of both power and demand), peripheries (exploited for their resources with limited resulting gain) and semi-peripheries (often client polities of cores that created a buffer zone). Applied to archaeology, it was possible to imagine states as cores and 'chiefdoms' as semi-peripheries or peripheries (e.g. Kristiansen 1998, 50–51). The result was of more than terminological significance. World-systems theory implied causation — that semi-peripheries and peripheries might be less developed *because of their inextricable links to a core* rather than due to relative isolation (Chase-Dunn & Hall 1991, 28; Chase-Dunn & Mann 1998, 15; Barrett *et al.* 2000a). Like most powerful ideas the influence of world-systems theory spread beyond the writings of its explicit proponents, influencing the narrative of medieval economic expansion. The exploitation and development of Europe's peripheries became part

of a teleological journey set in motion from a 'core' situated along an axis from southern England to Italy (e.g. Bartlett 1993, 20).

The popularity of world-systems theory in archaeology and history peaked in the late 1980s and 1990s (e.g. Rowlands *et al.* 1987; Champion 1989; Frank 1993; Frank & Gills 1993; Kristiansen 1998; Kardulias 1999). With notable exceptions (e.g. Lau 2005; Hall *et al.* 2011) it is now comparatively rare to see the words 'core' or 'periphery' used outside dedicated publications such as the *Journal of World-systems Research*. This decline probably resulted in part from trivial shifts in intellectual fashion. More importantly, however, it was also due to growing dissatisfaction (even among its proponents) with the elitism and ethnocentrism implicit in the theory (e.g. Frank & Gills 1993, 11–12; Stein 1999, 159; cf. Hall *et al.* 2011). While recognizing the reality of power differentials — in past and present — world-systems theory underestimated the historical significance of conscious actors in the so-called peripheries. It denied them agency (cf. Venkatesan 2009), despite clear evidence that the influence of the 'dominated' on the 'dominating', and on the entire set of relationships, could be complex and far from trivial (Wolf 1982; Bhabha 1994). More recently, the study of social networks has also contributed to an understanding of how overly simplistic the subdivision of 'core' and 'periphery' might be (e.g. Malkin 2003; see below).

1.2.4. Postcolonial and network theory

Eric R. Wolf's (1982) *Europe and the People Without History* captured a transformation in anthropological and archaeological thinking about 'peripheries'. It exploded two myths: of the isolated society and of the unidirectional influence of 'core' on 'periphery'. It did so on both theoretical and empirical grounds. The illusory billiard ball societies discussed above were reconfigured as 'bundles of relationships' (Wolf 1982, 3) and the world — at AD 1400 and beyond — was discussed in terms of the historical interaction of real groups, each defined as 'an empirically verifiable cluster of interconnections among people' (Wolf 1982, 18). The role of local elites in the unfolding of both regional and global histories was given particular attention. As organizing principles, overlapping modes of production replaced the evolutionary stages of typological analogy and the hierarchical categories of world-systems theory (Wolf 1982, 73–100). Societies might constitute themselves in kin-based, tributary or capitalist networks — with many combining the three in differing configurations. In Wolf's view most ancient and medieval societies were dominated by tributary relationships, in which the means of production (e.g. farming equipment) remained in peasant hands, but

wealth was extracted in varying forms of rent, tax, tithe, plunder, etc. One might quibble over the complete exclusion of market mechanisms from medieval societies (Barrett *et al.* 2004, 631; Skre 2008), but overall Wolf's argument cleared a very foggy landscape. Good theory is that which makes the obscure clearer (rather than the simple complicated!). The relevance of Wolf's approach to time periods before 1400 is obvious if one avoids the teleological perspective that all societies are moving inextricable from one form to another.

Although widely influential, Wolf's book was just one in a chorus of arguments against monolithic and compartmentalizing views of social interaction across space. The literature can be usefully (albeit simplistically) divided into studies of postcolonial theory and network theory. Postcolonial studies attempt to illuminate the world's diversity, fluidity, inequity and iniquity — ultimately with the goal of promoting fairer societies (e.g. Bhabha 1994, 44, 245–9). They take Wolf's arguments further by elaborating, often from viewpoints internal to subaltern societies, the creativity and contingency that exists in the colonial encounter (that is the interaction of societies of differing scale, world-view, wealth, power and/or mode of production) (e.g. van Dommelen 2006). Postcolonial theory is about the modern world, but it connects with the distant past in two ways. Firstly, the latter creates the former. In Bhabha's (1994, 10) words, the role of the past in the present '… becomes part of the necessity, not the nostalgia, of living' (see Section 1.2.5 below). Secondly, colonial encounters are hardly an innovation of the last few centuries (Given 2004; Gosden 2004). Thus we see, for example, the influence of postcolonial theory on Svanberg's (2003) study of the idea of Viking Age archaeology, on Wickham's (2005) survey of early medieval economy, on Immonen's (2007) study of 'Hanseatic' Turku in Finland, on Naum's (2010; 2012) studies of medieval migration in the Baltic Sea region and on Kristjánsdóttir's (2010) study of the late medieval monastery of Skriðuklaustur in Iceland.

Wickham's study predates the chronology of Quoygrew and is best described as influenced by rather than steeped in postcolonial theory. Yet it raises several insights that are central to the subject of the present book. Firstly, peasants are hardest pressed by local magnates, and may have much more latitude in terms of both economic production and personal freedom when responsible to distant monarchs with fewer 'middle men'. Secondly, there may have been times when disrupted authority allowed a tributary mode of production to become, at least in part, a peasant mode of production. In such circumstances the demands of elites on peasants are relaxed and, correspondingly, the local capacity to purchase expensive manufactured

and imported goods is reduced in line with aristocratic wealth. Surplus production and long-range trade may decline as peasants make the rational choice of working less. I return to this possible historical conjuncture in Chapters 2 and 16.

Other implications of postcolonial and related research are equally significant for the study in hand. They show the creative process by which interaction inspires new ways of being — often using pieces of the past. Thus, as originally articulated by Barth (1969), one might discover greater cultural distinctiveness in situations of contact than in contexts of isolation. Conversely, one might discover that new meaning is given to pre-existing practices and things in the creation of 'hybrid' cultures (Khan 2007). Or one might discover material and textual histories that are conscious falsehoods — rewriting the past and present in an effort to create or legitimize new arrangements (Bhabha 1994, 100–101). In brief, all bets are off. One is left with the need for close examination and source criticism of individual case studies through time. Perhaps ironically, one of the most abstract of social theories to influence archaeology demands a return to (qualified) materialism and empiricism.

Postcolonial theory clears many cobwebs left by culture historical approaches to medieval archaeology, but it is not a source of explanation in itself. The diversity of concepts it entails can lead to diametrically opposite conclusions depending on the thread followed. In one case study, for example, introduced forms of material culture (ceramics) become evidence for the construction of novel and liminal ethnic identities (e.g. Naum 2012). In another, they negate ethnicity, creating a shared cultural milieu among individuals of a certain socioeconomic status (Immonen 2007, 731). Clearly the details of each archaeological context remain essential to building a persuasive narrative of the past. Which pots were imports and which were local copies? In which households were imported ceramics found? Did they co-occur with other indicators of ethnic or socio-economic identity? It is by combining method and theory that Naum and Immonen succeed in their objectives.

Postcolonial scholarship is typically a qualitative exercise. Said (1994, 100–116) deconstructs novels such as Jane Austen's *Mansfield Park*. Bhabha (1994) interrogates poetry. Even Wickham (2005), who bases his study of early medieval economy on trends in ceramics and coinage, does not feel the need for tabulation or statistical analysis. There are exceptions (e.g. Immonen 2007), but as a rule postcolonial analysis is about ideas rather than numbers.

Network theory (also referred to as social network theory or, when applied, as network analysis — distinct from actor-network-theory which is closer to the archaeological concept of materiality noted in Section 1.1) is different. It too breaks down the simple categories of core and periphery, but it is ultimately based on mathematical models of how information flows within systems. Case studies include, for example, interpretations of scientific collaboration and mobile phone use (Palla *et al.* 2005; 2007). Network theory explains the small-world phenomenon in which surprisingly few points of connection (nodes) can separate any given pair of individuals (Watts & Strogatz 1998). It is quickly becoming popular among archaeologists and historians (e.g. Malkin 2003; Torrence & Swadling 2008; Terrell 2010), with Søren Sindbæk (2007a,b) leading the way within Viking Age and medieval studies.

Network theory provides valuable insights regarding how people, information and objects can move irrespective of (real or aspirational) hierarchical superstructures. It shows how networks grow, transform and dissipate. It provides comparative support for theories which view islands as foci of interaction rather than lands of isolation. It illustrates how easily distant places within medieval Europe could have been in contact.

The tenets of network theory are thus essential *a priori* assumptions for the archaeologist. The *methodology* of network analysis, conversely, can be problematic when applied to the material record (cf. Brughmans 2010). Sites with more artefacts (e.g. towns), and with objects similar to their neighbours near and far, will seem more networked than sites with few artefacts of idiosyncratic style. As discussed in Section 1.2.1 above, the latter is exactly what one might expect in the insular and liminal societies of the north — despite evidence that they may sometimes have had more long-range connections than densely populated regions with higher agricultural productivity (Solli 1996, 242). To provide one well-documented example, the medieval expansion of fishing villages in Arctic Norway relied on long-range exchange relationships that provided imported grain from sources such as the Baltic ports of the Hanseatic League (Nielssen 2009).

Equally important, applications of network theory typically ignore the essential dimension of time. Connections between the nodes of long-range exchange were not instantaneous in the Viking Age and Middle Ages. They were journeys beyond the horizon (cf. Helms 1988), the significance of which was amplified in contexts with short life expectancies. Medieval Europeans might expect to live to an age of between 40 and 50 years if they survived childhood (e.g. Roberts & Cox 2003, 226), making long travel times a potentially significant element of an individ-

ual's life history. Thus network theory, based on data from (for example) mobile phones, and employed by a long-lived generation accustomed to instantaneous on-line social networking media, will (like a strictly formalist approach to economic history) often be an inappropriate analogue for Viking Age and medieval communication and trade. The journey from Norway to Orkney by sail could be short, taking days rather than weeks, but one had to wait out adverse conditions (e.g. Dasent 1894a, 365) or face possible catastrophe (e.g. Dasent 1894a, 158). The recent reconstruction of the eleventh-century Skuldelev 2 ship had to make the crossing under tow due to poor weather (Hvid 2007). For longer trips, such as Earl Rognvald of Orkney's expedition from Orkney to Jerusalem and back between 1151 and 1153, invoking a small number of network links between Scandinavia and the Mediterranean (cf. Sindbæk 2007b) would be entirely misleading. Based on the broadly contemporary testimony of *Orkneyinga saga* the expedition was a major undertaking that concurrently won Rognvald much prestige, lost a significant proportion of his retinue (having set out with 15 ships the earl's remaining entourage returned on one) and resulted in civil war at home (Guðmundsson 1965, 208–67). Many other examples could fill the spatial, temporal and transformational distances between these extremes.

This is not to imply that journeys were considered uncommon in Viking Age and medieval Europe. The opposite is clearly true (e.g. Berggren *et al.* 2002; Bately & Englert 2007; Reynolds & Langlands 2011). It is likely, however, that both people and objects changed qualitatively during their travels. Archaeologists might be better equipped to comprehend this reality if we spent more time in danger of hypothermia, being seasick over the sides of boats, falling off bolting horses and reading runic inscriptions about drownings at sea (cf. Jesch 2001, 178; Barrett & Anderson 2010). Nevertheless, we must balance an appreciation of real journeys with the risks of overdramatizing voyages that did happen on a routine basis, of ignoring

important changes through time (such as the declining symbolic role of seafaring in medieval Scandinavia: see Bill 2002) and of discarding baby with bathwater when it comes to network theory.

Despite the best of intentions, this book is unlikely to advance the agenda of postcolonial theory — which prioritizes study of the past as a route to political action over the search for understanding alone. Nor, for the reasons just explained, can it be an archaeological application of network theory. It is, however, a product of both these theories and their undermining of core-periphery models. It can also help fill the resulting void.

1.2.5. The present past

The link between past and present is critically important, particularly for the inhabitants of ancestral lands (Brody 1988; Bhabha 1994, 10; McGuire 2002, 213–45). The past, often materialized in the landscape, can be central to both community and individual identity. It was so in the Middle Ages and, with exceptions (e.g. Lillehammer 2007), it remains so in the present. The link can be indelible, as it clearly is in Orkney and other areas of the northern world discussed in this book (e.g. Jones 2004; Lange 2006; Hastrup 2008). Yet popular ideas about the past can be mythical (Hobsbawm & Ranger 1992) and our scholarly aspirations to achieve understanding (albeit always from a particular vantage point) can become muddled with the contingencies of academic fashion, political context and funding priorities. The result can be stories that are misleading, even destructive as in contexts of intolerance or war (Geary 2002). These are the challenges archaeology faces — as real as excavating 1466 layers (Chapter 4), sieving 16,391 litres of sediment (Chapter 5) or identifying 22,094 fish bones (Chapter 7). There can be no eureka moment of definitive insight. Nevertheless, we can aspire to clarity (of goals, motives, methods and results), attention to detail and (in the end) open-mindedness. It is with these aims in mind that this study now commences.

Chapter 2

Viking Age and Medieval Orkney

James H. Barrett

2.1. Introduction

The earldom of Orkney was a semi-independent principality based in the archipelagos of Orkney and Shetland. It was a small world in comparative European perspective, yet it is often perceived as having been disproportionately wealthy and powerful (e.g. Barrell 2000, 76–7, 79–80; Hudson 2005, 96–8; Oram 2008, 199–200). This affluence is traditionally attributed to the archipelago's geographical position at the hub of maritime traffic between the North Sea, the Irish Sea and the North Atlantic (Small 1968, 5; Wilson 1976, 110–11; Kaland 1982, 93–4; Morris 1985, 233–4; Graham-Campbell & Batey 1998, 62). Building on past research (e.g. Barrett et al. 2000a; Williams 2004; Barrett 2007), the chapters to follow explore exactly how this could have worked. What political economy could have generated the wealth and power of this small and largely rural community on the 'edge' of medieval Europe? More holistically, how can the ebb and flow of this political economy help illuminate the paradox of island isolation and interconnection — and contribute to the economic archaeology and history of the Viking Age (AD 750–1050) and Middle Ages (AD 1050–1560)?

The present chapter has four main goals. Firstly, it provides a chronology for everything that follows. This framework relies in part on biographies of the earls of Orkney — not because I assume that elite agency was always the motor of socio-economic change, but because dynastic history is how time was reckoned in medieval northern Europe. Secondly, the chapter aims to illustrate how the potential wealth of the archipelago was recognized by aspiring magnates throughout the centuries under consideration. This is important given the potential danger of assuming (from an outside perspective) that a small northern archipelago must be marginal. Thirdly, it charts the long-range economic and familial connections that characterized this island world. Connectedness is a running theme from the beginning of the Viking Age

until 1615, when Earl Patrick Stewart was executed in Edinburgh by order of a king of both Scotland and England, originally crowned by a bishop of Orkney (see below). The breadth and depth of Orkney's networks were not, however, consistent through time. A military economy which saw Orcadians active as pirates and/or mercenaries in England, Ireland, Norway, Scotland and Wales ceased to be viable around the end of the twelfth century. The succeeding thirteenth century may thus have been one of the least connected periods in the history of the archipelago (see below and Chapter 16). The level of mobility rose again thereafter, but appears to have been increasingly restricted to the elite (often migrants from mainland Scotland).

Lastly, the chapter sets the scene for discussion of production. Many of the sources discussed are dominated by elite consumption in various forms. However, they provide a consistent set of island products extracted as renders of varying kinds (e.g. rent, tax and/or tithe) and often subsequently exported. Although not an exhaustive list, the main examples are cereal products, butter, meat, hides, woollen cloth, dried fish and oil. These staple goods could have been produced in both Orkney and Shetland, but a degree of regional specialization is evident. Exports of cereal products and woollen cloth (wadmal) were specifically associated with Orkney and Shetland respectively in fifteenth-century records (e.g. Ballantyne & Smith 1999, 17; DN II, 691) — and the trade of dried fish was of greatest importance in Shetland when first systematically recorded by Hanseatic merchants (Friedland 1983). Nevertheless, archaeological evidence implies that the relative importance of different products changed through time (see below). Thus it would be unwise to make too many assumptions before visiting Quoygrew, a working farm where wealth of this kind was created.

The chronological boundaries of the chapter, from the Viking Age (750–1050) until just beyond the end of the Middle Ages (1615), are set to bracket major phases of economic intensification and collapse in

northern and western Europe. The tenth to thirteenth centuries are typically seen as a time of growth (be it continuous or punctuated), the fourteenth to fifteenth centuries as years of crisis and retrenchment, and the sixteenth to seventeenth centuries as a period of slow recovery (e.g. Fossier 1999; Dyer 2002; Epstein 2009). The chapter's geographical boundaries are defined by the polity of the earls of Orkney. This was a fluid entity, including shifting areas of both direct control and tributary status. From some point in the eleventh century it was subdivided into the earldom of Orkney (including the archipelagos of Orkney and Shetland) and the earldom of Caithness (originally including the later counties of Caithness and Sutherland). These earldoms, ruled together until 1375, were nominally subject to the kings of Norway and Scotland respectively (Crawford 1993, 130).

The degree to which Orcadian influence may at times have extended to the Western Isles and into the Irish Sea is more controversial. The later Icelandic saga tradition alleges that the eleventh-century earls of Orkney collected tribute in Man and the Hebrides (Sveinsson 1954, 208; Sveinsson & Þórðarson 1935, 76). Etchingham (2001, 178) dismisses this late evidence, but the contemporary poetry of Arnor *jarlaskáld* does attribute Earl Thorfinn Sigurdsson with influence as far south as Dublin (Whaley 1998, 263). Moreover, the distribution of ring-money finds (see below) in the Isle of Man has been interpreted as evidence for Orcadian domination in the late tenth and/or early eleventh centuries under earls such as Sigurd Hlodversson (died 1014) (Dolley 1981, 175; Crawford 1987, 134; Williams 2004, 78). Later the sphere of influence of the Orkney earls slowly contracted — with key changes occurring in 1195, 1231–1232, 1375, 1468–1472 and 1615 (see below).

As part of the same process of contraction the status of the earls of Orkney was also transformed. During the Viking Age, *jarl* was a Scandinavian term used of essentially independent rulers who were not descended from ancestral kings and/or were nominally tributary to over-kings (e.g. Sawyer 1991, 279). Norway, for example, was ruled by Jarl Hakon of Lade during the late tenth century (Krag 2003, 190–93). When the rulers of Orkney emerge from legend in the eleventh century we know that were already styled as jarls (MacAirt & MacNiocaill 1983, 447; Whaley 1998, 127). At this date the term probably reflected the dynasty's view of its ancestry — that is not from Harald Fairhair, the semi-mythical founder of the Norwegian royal lineage. Certainly by the thirteenth century royal ancestry was a sufficiently important prerequisite to kingship that the mother of Hakon Hakonsson was willing to face ordeal by iron — wit-

nessed by Earl John of Orkney among others (Dasent 1894a, 42–5). By the twelfth and thirteenth centuries the title of jarl was also understood to imply that the Viking Age rulers of Orkney had accepted tributary status *vis-à-vis* Harald Fairhair in the decades around AD 900 (e.g. Guðmundsson 1965, 7–8), although the historicity of this origin story cannot be proven (cf. Sawyer 1976; Helle 2005, 19; Woolf 2007, 277–8). Whatever the initial connotations of their title, in the course of the Middle Ages the earls were increasingly made the real subordinates of neighbouring Norwegian (or Kalmar Union after 1397) and Scottish monarchs. At times Orkney, Shetland and/or Caithness were even taken under direct royal control. This complicated process must have altered how wealth was created, distributed and consumed.

2.2. Sources

The historical sources for study of Viking Age and medieval Orkney are limited in comparative perspective, but nevertheless diverse. The most important single text is *Orkneyinga saga*, which was composed around AD 1200 and updated early in the thirteenth century. Sagas differ widely in their reliability, but this account of the earls of Orkney was clearly written with historical intent (Jesch 1992; 1996). Its treatment of twelfth-century events is considered broadly reliable and some of its eleventh-century details can also be corroborated in contemporary sources such as the Irish annals (see Etchingham 2001; Hudson 2005) and Adam of Bremen's *History of the Archbishops of Hamburg-Bremen* (Tschan 2002). For the eleventh to thirteenth centuries other Icelandic kings' sagas (Dasent 1894a; Sephton 1899; Aðaldbjarnarson 1941; 1945; 1951; Andersson & Gade 2000; Finlay 2004) and the Norwegian synoptic histories (Driscoll 1995; McDougall & McDougall 1998; Ekrem & Boje Mortensen 2003) are also crucial. They require source criticism, but were not intended to be fiction. Many details, such as the role of Orcadians in the Norwegian invasion of England in 1066, can be crosschecked against insular sources (see below). The more literary family sagas (e.g. Sveinsson 1954) include frequent mentions of Orkney, but must be used with even greater caution.

Many of the above-mentioned sources preserve stanzas of earlier poetry which have been among the most critical raw materials for both medieval and modern scholars (e.g. Bibire 1988; Whaley 1998; Gade 2009). The *Icelandic Annals* (Storm 1888) provide less evocative but more closely dated sparks of illumination and the *Sturlunga saga* compilation (McGrew 1970; McGrew & Thomas 1974) mentions Orcadians active

in thirteenth-century Iceland. Within the Scandinavian tradition the missing ingredient is a law book — Orkney's was lost in antiquity, possibly destroyed for political reasons (Thomson 2008a, 277). This lacuna is compensated to a small degree by the *Hirdskrá*, which delineated the powers of an earl within the kingdom of Norway in the 1270s (Imsen 2009, 17).

Diverse Viking Age and/or medieval Irish, Scottish, Manx, English, Welsh and continental chronicle and literary sources also provide glimpses of the inhabitants of northern Scotland. A selection of examples regarding the first five centuries under consideration includes the various Irish annals (e.g. MacAirt & MacNiocaill 1983), the *Cogadh Gáedhel re Gallaibh* (Todd 1867), *The Chronicle of the Kings of Alba* (Hudson 1998; Woolf 2007, 88–93), John of Fordun (Skene 1872), the *Anglo-Saxon Chronicle* (Whitelock et al. 1961), *The Battle of the Standard* by Aelred of Rievaulx (Freeland & Dutton 2005), *The Deeds of the Normans in Ireland* (Mullally 2002), *The Conquest of Ireland* (Scott & Martin 1978), the *Chronicles of the Kings of Man and the Isles* (Broderick 1996), the *Life of St Gwynllyw* (Hudson 2005, 182–3), the *Life of Findan* (Christiansen 1962) and, as mentioned above, Adam of Bremen's *History* (Tschan 2002).

The historicity of these narrative sources various tremendously (compare, for example, the differing versions of the Battle of Clontarf analysed by Ní Mhaonaigh 2007, 53–99). More reliable historical evidence derives from royal, ecclesiastical, aristocratic and commercial administrative records — and a varied collection of surviving correspondence. Unfortunately, however, sources of this kind relevant to northern Scotland only survive from the twelfth century or later. They vary from systematic series of royal documents (e.g. the exchequer rolls of Scotland; Stuart & Burnett 1878), to major one-offs (e.g. the Treaty of Perth; Donaldson 1974, 36), to incidental letters (e.g. regarding an elopement in 1325/26; DN VII, 107).

Moving forward in time, the fifteenth century is comparatively well documented. This is due in part to the beginning of direct trade with the Hanseatic League around 1416 (Friedland 1983, 88), to events associated with the transfer of the earldom of Orkney from Scandinavian to Scottish control in 1468 (Crawford 1985a) and to the existence of the earliest surviving rental of Orkney from 1492 (Thomson 1996). In the sixteenth and seventeenth centuries the islands became an even more frequent matter of record, given their often idiosyncratic roles in the complicated Scottish politics of the day (Anderson 1982; 1992; Thomson 2008a; see below). For present purposes the final centuries of the Middle Ages (and beyond) therefore suffer from too much documentation rather than too little. Thus it is necessary to rely increasingly on secondary sources.

The archaeological evidence is equally diverse. It includes obvious categories like burials, hoards, settlements and monumental architecture, but also less tangible sources such as fish bones, the chemistry of human skeletal remains and the characteristics of arable soils. Like the textual evidence it also varies over time. Very little archaeological evidence can be absolutely dated to the early Viking Age (approximately AD 750 to 850). Thus the years preceding this study are grounds for much interesting speculation regarding the original Scandinavian diaspora in Scotland, as elsewhere in Britain and Ireland (e.g. Morris 1998; Graham-Campbell 2003; Barrett 2003b; Owen 2004; Jennings & Kruse 2005; Barrett 2008; 2010). Between approximately 850 and 950, however, there was a florescence of burial in northern and western Scotland that adhered to non-Christian Scandinavian ritual practice and included grave goods of Scandinavian, British and Irish type (Graham-Campbell & Batey 1998, 113–54; Owen & Dalland 1999). Similar objects — such as Scandinavian antler combs, Irish ringed pins and more elaborate insular metalwork — were concurrently used in settlement sites (e.g. Curle 1982; Ashby 2009; Fanning 1983; 1994). They probably represent the widespread movement of goods as personal possessions of migrants, objects of exchange and plunder — various facets of the Viking Age Scandinavian diaspora. The earliest known occupation at Quoygrew is contemporary with this horizon of non-Christian burial and more widespread Scandinavian influence (Chapter 4).

Around the time that burial with 'Viking' grave goods was abandoned in the Scottish isles the building of domestic architecture had completed a transformation from indigenous traditions of predominantly cellular and curvilinear construction (e.g. Ralston 1997) to three-aisled rectilinear houses of Scandinavian style (e.g. Stummann Hansen 2003a). At Buckquoy in Orkney an abandoned Pictish and early Viking Age settlement combining cellular and rectilinear architecture was capped by a burial with grave goods in the middle of the tenth century (Ritchie 1977). Poorly dated but broadly contemporary houses of Scandinavian style, sometimes including two rows of internal roof-supporting posts, are known from Jarlshof (Hamilton 1956, 108), Pool (Hunter 2007a, 124, 128–30), the Brough of Birsay (Emery & Morris 1996), Snusgar (Griffiths & Harrison 2011) and the Brough of Deerness (Barrett & Slater 2009; Gerrard & Barrett 2010). Subsequent medieval houses continued to develop this tradition, typically with the roof now supported on the external walls. Examples from the Northern

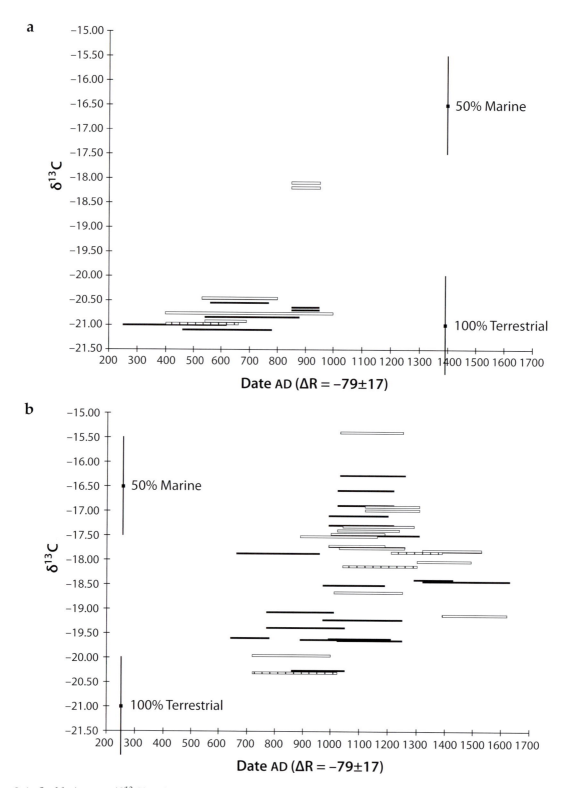

Figure 2.1. *Stable isotope (δ¹³C) values and two-sigma radiocarbon (or grave good) date ranges for: (a) Pictish to Viking Age burials from Westness, Orkney, and (b) Viking Age to late medieval burials from Newark Bay, Orkney. Each bar represents one skeleton: solid = females; open = males; hatched = child. These results illustrate the increasing consumption of marine protein in the Viking Age and early Middle Ages — and its declining importance in the late Middle Ages. The error ranges for 100% and 50% terrestrial protein are approximations. (Image: After Barrett & Richards 2004.)*

Isles include Hamar (Bond *et al.* 2008), Underhoull (Small 1966; Bond *et al.* 2008), Sandwick (Bigelow 1987; Stummann Hansen & Waugh 1998, 130–34), Belmont (Larsen 1996; Bond *et al.* 2008), Jarlshof (Hamilton 1956); Pool (Hunter 2007b), Langskaill (Moore & Wilson 2003), Tuquoy (Owen 1993; 2005), Westness (Kaland 1993, 308–11; 1996, 64–5), Beachview (Morris 1996a, 101–32), the Brough of Birsay (Emery & Morris 1996) and Quoygrew itself (Chapter 4). These buildings (Viking Age and medieval) find parallels across the North Atlantic, implying widespread exchange of ideas (Myhre *et al.* 1982; Price 1995; Komber 2002; Stummann Hansen 2003a; Vésteinsson 2004; Skaaning Høegsberg 2009; Solli 2006). In the case of wooden features the raw materials must sometimes represent imports (cf. Crawford & Ballin Smith 1999; Owen 2002), although driftwood and recycled ship timbers could also have been used. The deposits associated with these houses have produced objects indicative of varying degrees of contact with Scandinavia, Scotland, Ireland, England and occasionally further afield (e.g. Ashby 2009; Barrett & Slater 2009; Curle 1982; Forster 2006; 2009a; Hamilton 1956; Griffiths & Harrison 2011; Smith 2007a, 437).

The ecofactual (bone, plant and sediment) and biomolecular (stable isotope) evidence from northern Scotland also changed in the course of the Viking Age and early Middle Ages. More neonatal (new-born) cattle bones, more flax seeds and more fish bones were discarded in middens (Bond 1998; Barrett *et al.* 1999; Simpson *et al.* 2005; Bond 2007a,b; Nicholson 2007; 2010; Bond & Summers 2010, 192–3). Concurrently, stable isotope analysis of human bone indicates increasing proportions of marine protein in the diet (Barrett *et al.* 2001; Barrett & Richards 2004; Fig. 2.1). The significance of these changes is discussed below and developed further in Chapters 5 to 11.

Silver hoards, mostly of mid-tenth- to mid-eleventh-century date, are another important source of evidence for Orkney and other areas that may have come under the influence of its earls (Graham-Campbell 1995). The wealth represented by these deposits is not trivial. The Skaill hoard deposited in Orkney between *c.* 950 and *c.* 970 is among the largest known in Scandinavia (Graham-Campbell 1993, 180; 1995, 34–48; Fig. 2.2). The dry-land locations of these hoards imply that they were intended to be recovered, rather than to be irrevocable votive offerings (Niven 2003). They contain bullion as ingots (often in the form of plain arm rings known as ring-money), jewellery, coins (from a variety of distant mints) and hack-silver (fragments of larger objects). Based on stylistic and numismatic evidence the sources of this silver are extremely diverse, including (for example) Ireland,

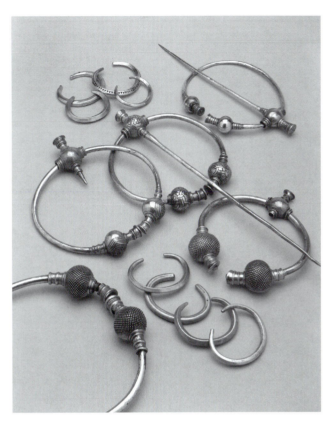

Figure 2.2. *Part of the Skaill hoard from Mainland Orkney, deposited between c. 950 and c. 970 (Image: © NATIONAL MUSEUMS SCOTLAND).*

Scotland, Anglo-Saxon England, Frankia, the Baltic Sea region and the Islamic world. The fragmentation and frequent nicking or bending (to test the purity of the silver) of much of the material also indicates the extent of its circulation (Kruse 1993, 187). The objects of the Skaill hoard from Orkney have an average of four nicks each, and one ingot terminal has 34 nicks (Graham-Campbell 1995, 47). Finds of bullion weights and scales in Orkney and elsewhere in northern and western Scotland confirm the degree to which this medium of wealth and exchange changed hands (e.g. Hamilton 1956, 174; Hedges 1987, 73, 87; Graham-Campbell & Batey 1998, 92, 119; Owen & Dalland 1999, 118–20; Maleszka 2003). Hoards of later (medieval) date are also known from northern Scotland — associated with the fourteenth-century Scottish wars of independence for example (Archibald & Woodhead 1975, 94) — but after the eleventh century very occasional finds of isolated coins is the norm (Barrett 2007, 318–19).

For the twelfth century, monumental architecture (particularly church building in the pan-European Romanesque style) replaces hoards as evidence of elite investment. The twelfth-century phases of St Magnus

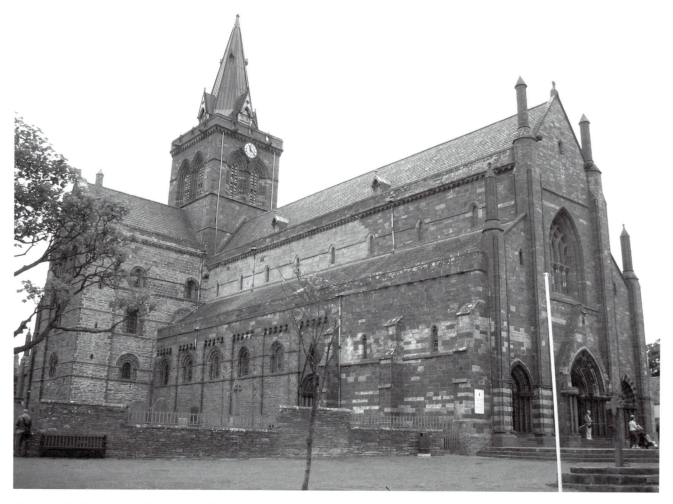

Figure 2.3. *St Magnus Cathedral, Kirkwall. Its twelfth-century phases were comparable in scale and ambition to contemporary building projects in Norway and lowland Scotland. (Image: James Barrett.)*

Cathedral in Kirkwall were comparable in ambition to major contemporary building projects in Scandinavia and lowland Scotland (Cambridge 1988, 122–4; Fig. 2.3). The cathedral is thought to have been built with the help of masons from Dunfermline and/or Durham. A number of smaller twelfth-century Orcadian buildings are also notable. The round-towered church of St Magnus Egilsay was modelled on a contemporary tradition best known in southern Scandinavia, northern Germany and East Anglia (Fernie 1988; Wienberg 2009). In this age of crusade and pilgrimage the round chapel at the elite settlement of Orphir was one of several in Britain and south Scandinavia modelled on the Church of the Holy Sepulchre in Jerusalem (Fisher 1993). Concurrently, or a little later, there was a florescence of stone castle building — Kolbein Hruga's keep on Wyre, the bishop's castle near Thurso and the Castle of Old Wick are well-known examples (Talbot 1974; Gifford 1992, 113, 377).

St Magnus Cathedral continued to grow until the reformation (with a probable hiatus in the fourteenth to fifteenth centuries) (Fawcett 1988) and castles of later medieval date are known (e.g. Batey 1991; Gifford 1992, 107; Lamb 2010, 202). In general, however, the thirteenth to seventeenth centuries are very poorly represented in the archaeological record of Orkney and elsewhere in the realm of its earls. Excluding Quoygrew for the moment, exceptions include evidence for expansion of the (initially twelfth-century) town of Kirkwall (McGavin 1982; Lamb 2010), for the gradual improvement of agricultural soils (Simpson 1993; 1997; Simpson *et al.* 2005; Guttmann *et al.* 2006), for human mobility and diet based on stable isotope analysis of burials (Barrett *et al.* 2008b; Evans *et al.* 2008) and for aristocratic building projects of the sixteenth- to early seventeenth-centuries (e.g. Pringle *et al.* 1996; Cox *et al.* 1998; Pringle 1999). Additional evidence exists for late medieval and post-medieval

Shetland (e.g. Bigelow 1987; Crawford & Ballin Smith 1999; Owen & Lowe 1999), but postdates the separation of this archipelago from the earldom of Orkney in 1195 (see below). Discussion of late medieval and early renaissance Orkney is thus heavily based on a synthesis of textual evidence in the present chapter — an imbalance addressed in part by the remainder of the book.

2.3. Seven centuries: a narrative framework

Despite divergent perspectives regarding the best way to combine archaeological and textual evidence (e.g. Carver 2002; Staecker 2005, 3) the narrative form remains the most resilient and effective way to contextualize our understanding of the past (Solli 2011, 43). What follows is offered in this mode. From the late eighth to the tenth centuries there was episodic raiding and warfare in northern and western Scotland involving migrant groups of Scandinavian ancestry and the indigenous kingdoms of Pictland, Dál Riata and Strathclyde (Broun 1994, 27–9; Downham 2007, 137–70; Driscoll 1998; Woolf 2007). By the end of the tenth century this violence culminated in the creation of a self-conscious Scandinavian colonial identity among the northern Scottish elite (Barrett 2008). Changes in domestic architecture and (over an unknown period of time) the replacement of virtually all indigenous place-names with Scandinavian alternatives indicate that this ideology was also emulated by the indigenous population (Wainwright 1962; Barrett 2003b). Genocide has been raised as an alternative interpretation (e.g. Smith 2001), but is highly improbable even without considering recent genetic evidence for very mixed historical population structures in the Scottish islands (e.g. Goodacre *et al.* 2005; Bowden *et al.* 2007, 304–5). The 'Vikings' and the pre-existing 'Picts' lacked the fundamental immunological, demographic, technological and military differences that led to such atrocities in other historical contexts (cf. Diamond 1999; Day 2008).

The contents of tenth- and eleventh-century silver hoards from northern Scotland suggest that the political economy of this new society was heavily dependent on the maintenance of war bands (cf. Reuter 1985; Crawford 1987, 135–6; Graham-Campbell 1995; Barrett *et al.* 2000a, 4; Williams 2004, 80; Fig. 2.2). Gifts of rings, for example, created the stereotypical bond between lord and retainer in both skaldic poetry and (later) Old Norse prose sources (Hedeager 1994). The diverse origins of the material culture in hoards (Graham-Campbell 1995), burials (Graham-Campbell & Batey 1998; Owen & Dalland 1999) and settlement sites (e.g. Curle 1982) speaks to the widespread activities of these warrior bands. We first witness them in

contemporary historical sources with the presence of Earl Sigurd Hlodversson of Orkney at the Battle of Clontarf in 1014 (MacAirt & MacNiocaill 1983, 447), but later also find them in England — in 1058 (Etchingham 2001, 153) and 1066 (Driscoll 1995, 58–9; Guðmundsson 1965, 86–7; Whitelock *et al.* 1961, 142) — and in Wales (Hudson 2005, 182–3).

There is concurrent evidence for Viking Age changes in the arable, pastoral and maritime economies. Increases in flax finds imply that more linen was made, more bones of neonatal cattle suggest a greater demand for butter (latter known for its role in the payment of dues to superiors), fishing for species such as cod became more common and stable isotope analysis indicates that more marine protein was consumed (Bond 1998; Barrett *et al.* 1999; 2001; Barrett & Richards 2004; Bond 2007a, 181; 2007b, 216–19; Nicholson 2007; 2010; Bond & Summers 2010, 192; Fig. 2.1). Some of these changes (increased sea fishing and flax cultivation) were probably provoked by the introduction of a Scandinavian world view. They may also have been related to the increased demands of a new elite, to a net population increase in a migrant context and/or to a pan-European population boom of the centuries around AD 1000 (Barrett 2003b, 88–90; cf. Barrett *et al.* 2011).

By the eleventh century the earls of Orkney were enmeshed in regional dynastic politics, with Earl Sigurd Hlodversson married to the daughter of King Malcom II of Alba or Malcom *Mac Máel Brigti*, the independent king or moramer of the northeast Scottish dynasty of Moray (Guðmundsson 1965, 27; see Hudson 2005, 133, 135; Woolf 2000, 162). Ingibjorg, the widow of Earl Thorfinn Sigurdsson may also have been the first wife of the later King Malcom III of Scotland (Guðmundsson 1965, 84; Oram 2008, 22). Better documented later marriages with the Scottish elite are also known (see Barrett 2007, 304 and references therein).

Looking east, the above-mentioned Ingibjorg was the niece (Guðmundsson 1965, 63) or sister (Andersson & Gade 2000, 104) of Kalf Arnesson, one of Norway's most powerful eleventh-century magnates. Norwegian links were also created by fictive kinship and ties of personal loyalty. Earl Rognvald Brusisson of Orkney was a comrade-in-arms of King Magnus Olafsson (who inherited the Norwegian and Danish parts of Cnut's northern empire) — having shared exile with him in Novgorod (Andersson & Gade 2000, 98–9; Guðmundsson 1965, 54–6; McDougall & McDougall 1998, 33).

In the middle of the eleventh century Earl Thorfinn Sigurdsson founded an Orcadian bishopric at Birsay (Guðmundsson 1965, 80–81; Tschan 2002, 216). It is uncertain whether elements of Christianity had

survived the archipelago's ninth- to tenth-century phase of paganism evident from the burial record — perhaps as hybrid belief or the ideology of specific factions (Morris 1996b; Barrett 2003a; Barrett & Slater 2009). Regardless, however, Thorfinn (who made a personal pilgrimage to Rome) consolidated the local church on a European model (Crawford 2003, 143–4; 2005).

At the transition from the eleventh to the twelfth centuries the earldom briefly fell to the direct military control of a Norwegian monarch, probably for the first time (Sawyer 1976). King Magnus Barelegs was active in the west between 1098 and his death in Ireland in 1103. He replaced the earls of Orkney with his son, Sigurd (Guðmundsson 1965, 94; Driscoll 1995, 74–5; Power 1986; 1994). However, Sigurd returned to Norway as king after his father's death and subsequently embarked on an expedition to Jerusalem. Thus the Orcadian dynasty regained its position under Earl Hakon and Earl (later saint) Magnus (Antonsson 2007, 92–3).

Our understanding of the eleventh and twelfth centuries is improved by archaeological evidence from two nucleated settlements on islets, the Brough of Birsay (possibly the site of the above-mentioned bishopric) and the Brough of Deerness (Fig. 2.4). Both sites were once thought to be monasteries, but are more likely to be the citadels of earls or magnates (Morris 1996c; Barrett & Slater 2009). These concentrations of settlement probably speak to the continued importance of war bands. They concurrently illuminate the maritime orientation of Orcadian society, having been placed on the limits of the land with an eye to seeing and being seen.

Based on ecofactual and stable isotopic evidence the eleventh and twelfth centuries also witnessed an increase in primary economic production. The importance of dairying (Chapter 8) and fishing (Barrett 1997; Cerón-Carrasco 1998; Barrett *et al.* 1999; Barrett & Richards 2004; Harland 2007; Chapters 5–7) appears to have increased well beyond Viking Age levels (Fig. 2.1). Concurrently (or perhaps a little later) arable fields were enhanced by redepositing turf from uncultivated land and fertilizing using combinations of seaweed, animal dung, ash and other farmyard refuse. Orkney's thin natural soils had been improved by careful management since prehistory (e.g. Simpson *et al.* 1998; Dockrill & Bond 2009). However, palaeoecological research at the landscape scale suggests that this practice expanded substantially during the Middle Ages (Simpson 1993; 1997; Simpson *et al.* 2005; Guttmann *et al.* 2006).

It is arguable that these archaeological patterns help substantiate anecdotal historical evidence for exports from the territories of the earls of Orkney during the first two to three centuries of the Middle Ages.

Destinations included Norway, Iceland and England. *Sverris saga*, a late twelfth- and early thirteenth-century source, notes unnamed Orcadian and Shetlandic imports to Bergen immediately before criticizing German merchants for exporting butter and dried fish from the city (Sephton 1899, 129). Orcadian cereal products were known in Iceland by the beginning of the thirteenth century (McGrew 1970, 129–30; see also Porter 1994, 110) and *Orkneyinga saga* places Orcadians in the English fishing port of Grimsby in the twelfth century (Guðmundsson 1965, 130). The archaeological evidence of imports to Orkney is consistent with this list of probable destinations for the surplus goods of the north — while also adding lowland Scotland (based on white gritty ware pottery) and the Irish Sea province (based on pins and combs) (Barrett 2007, 315–19; see Chapters 12–16).

The substantial wealth and cosmopolitan tastes of the twelfth-century Orcadian elite is demonstrated by the archipelago's Romanesque ecclesiastical architecture (Crawford 1988; Fig. 2.3). A renaissance in the composition of courtly skaldic poetry tells much the same story, with the addition of an emphasis on Scandinavian aristocratic traditions (Bibire 1988; Jesch 2009). The twelfth century is also well served by broadly contemporary narrative sources such as *The Battle of the Standard*, *Orkneyinga saga* and *Sverris saga* (see Section 2.2 above). Different elements of these texts vary in their historicity, but together they produce a remarkable portrait of an insular society trying to make the most of its position on or beyond the margins of competing and often expanding kingdoms in Norway, Scotland, Ireland, England and Wales. Politics were volatile and the earl or earls (brothers or more distant relatives often shared the earldom in varying configurations) survived by extracting surplus from an unruly stratum of magnates involved in mercenary service, piracy and trade (Barrett 2007).

Leaders challenged the independence of these magnates at their peril. In addition to killing each other, earls were frequently replaced through the violent interventions of their nominal subordinates. One of the centrepieces of *Orkneyinga saga* was the replacement, in 1136, of Earl Paul Hakonsson with a distant relative and Norwegian usurper Kali Kolsson — through the intervention of the semi-legendary mercenary warlord Svein Asleifsson (Barrett 2004a; 2005b; Beuermann 2009). In a remarkable example of medieval ideological pragmatism, Kali adopted the name of Rognvald (the eleventh-century earl with close Norwegian associations discussed above), supported the emerging cult of his murdered uncle Magnus, founded a cathedral in Magnus' honour and (it has been reasonably argued) placated the long-

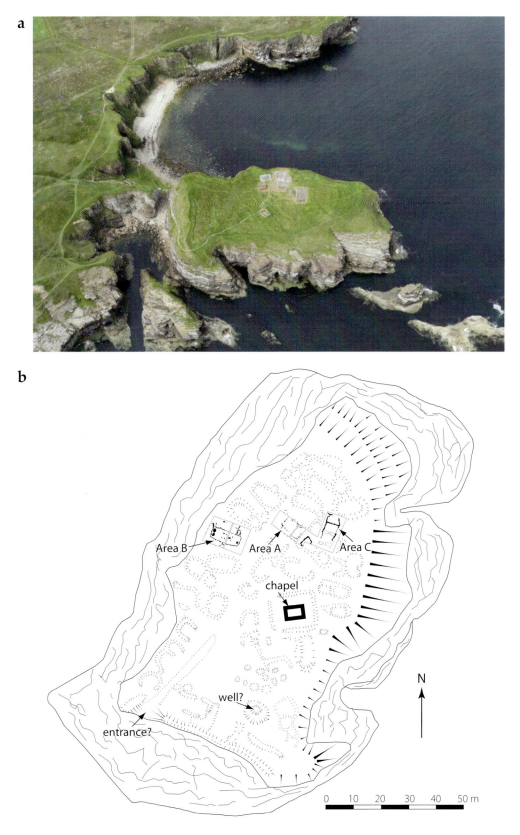

Figure 2.4. *The Brough of Deerness, a probable chiefly citadel of the late Viking Age: (a) under excavation in 2008 and (b) showing the settlement plan based on excavation and high-resolution GPS survey. (Images: (a) Vicki Herring; (b) Mary Saunders, David Redhouse and Dora Kemp.)*

serving bishop of Orkney by granting large tracts of newly conquered land to the church (Crawford 2003: 145–6; Antonsson 2007, 79–84). Parishes may have been created as part of the same ecclesiastical reorganization based on Gibbon's (2007) study of landscape boundaries. With his power consolidated, and a new patron saint to rival those of the kingdoms of Norway and Denmark, Rognvald Kali imitated King Sigurd *Jórsalafari* with his own expedition to the Holy Land (Bibire 1988, 218). Yet Rognvald too ultimately died at the hands of a disaffected magnate — killed on a farmyard path in the Caithness countryside (Guðmundsson 1965, xc, 276–8).

At the turn of the twelfth and thirteenth centuries opportunities for mercenary service and piracy in the centralizing kingdoms of the northern world were shrinking. Svein Asleifsson may have died fighting as a mercenary during an attempt to retake Dublin from English occupying forces in 1171 (MacCarthy 1893, 166–9; Guðmundsson 1965, 28-89; Mullally 2002, 111–16; Scott & Martin 1978, 76–7). Support for rivals of the Canmore dynasty of Scotland between 1196 and 1202 ended in military defeats, large fines and the mutilation of the heir to the earldom of Orkney while in captivity as a hostage (Topping 1983; Crawford 1985b; McDonald 2003, 39–41). In 1194 an attempted coup in Norway supported by the Northern Isles ended in disaster at the Battle of Florvåg (near Bergen) (Sephton 1899, 146–52, 156; Guðmundsson 1965, 297). Many islanders died and the earl, Harald Maddadsson, (not a direct participant in the campaign) was obliged to make abject submission to King Sverre of Norway. In result Shetland was placed under direct Norwegian rule, lands of the combatants were confiscated, elements of the earl's income in Orkney were at least temporarily expropriated and the relationship between monarch and earl was recast in an irrevocably hierarchical way (Imsen 2003, 66–9). Harald Maddadsson had the Norwegian administrator appointed for Orkney killed when Sverre died (Dasent 1894b, 235), but the landscape of power was nevertheless rapidly changing. In 1231 Harald's son and successor was himself murdered in a dispute with followers of a new Norwegian administrator (Dasent 1894a, 156). The surviving members of the Orcadian elite took the resulting case to Bergen, but were drowned *en masse* in a shipwreck during their return journey in 1232 (Dasent 1894a, 158). The capacity of the islanders to engage in an independent military economy after this date must have been severely limited by the cumulative loss of wealth, leadership and opportunities for elite patronage. In the treeless landscape of northern Scotland it must also have been difficult to build warships after the events of the late twelfth and early thirteenth centuries. Access to Norwegian and Scottish timber appropriate for this purpose would have become very problematic (cf. Crawford 1995a; Sigurdsson 2008, 105–7).

The Scottish king took advantage of this trouble in Orkney by turning the southern portion of Caithness into a new earldom, Sutherland, to be governed by a loyal dynasty (Crawford 1985b, 33). Earlier in the thirteenth century a member of the same family had already been installed as bishop of Caithness and the episcopal seat moved south to Dornoch. These developments are not surprising given that one pro-Scottish bishop had been mutilated near Thurso in 1201 by followers of Harald Maddadsson and another was burned alive at Halkirk in 1222 when a later earl refused to stop a mob of farmers angry about increases in the tithe of butter (and perhaps also hay) (Crawford 1974, 19–20; 1985b, 28–9). It is thought that the separate bishopric of Caithness had initially been carved from the diocese of Orkney during the reign of David I of Scotland (1124–1153), presumably with the intention of expanding Scottish royal influence (Crawford 1985b, 27–8; 1993; Oram 2008, 106–7).

After the shipwreck of 1232 the earldom was eventually granted to a distant heir from the family of the earls of Angus in central Scotland. This did not, however, immediately increase Scottish royal power. The later decades of the thirteenth century were instead marked by the expansion and consolidation of Norwegian hegemony in the North Atlantic region — including the submission of Iceland and Greenland (Sigurdsson 2008, 112–16). Orkney's elite adopted a low profile during the resulting clash of Scandinavian and Scottish interests, particularly in the context of King Hakon Hakonsson's invasion of Scotland in 1263 (Thomson 2008a, 138–47). Despite having been gifted a ship, Earl Magnus III of Orkney absconded from the campaign. Thus Hakon died while his crew were overwintering in the Northern Isles with the bishop of Orkney rather than the earl (Dasent 1894a, 345, 365). In 1266 Hakon's son ceded the Western Isles to Scotland with the Treaty of Perth (Donaldson 1974, 36). The Northern Isles were confirmed as Scandinavian royal possessions, but the earls were side-lined in the process. Their legal powers were limited even further by the Norwegian *Hirdskrá* of the 1270s (Imsen 2009).

Between *c.* 1300 and 1379 Orkney was frequently governed by administrators, of Scottish or Norwegian origin, acting on behalf of the Norwegian crown (Imsen 1999; Thomson 2008a, 181). There were brief periods of rule by earls, but for the first time they included individuals whose main properties were elsewhere (Crawford 1982, 68). Malise, earl of Strathearn in Scotland, ruled Orkney from *c.* 1336 to *c.* 1353.

However, his relevance to local events (other than as an absentee landlord) may have been comparatively limited (Thomson 2008a, 152). Between 1353 and 1357 the Orkney earldom passed (apparently ineffectually) to a Swedish magnate. From then until 1379 the islands were back in the hands of royal administrators (Thomson 2008a, 153–9).

For much of the fourteenth century the resident bishops of Orkney, like earlier bishops of Caithness, were sources of increasing Scottish influence in the north. Thus the administrators for the Norwegian crown found themselves at odds with Bishops William III (1310–pre 1369) and William IV (pre-1369–1382/83) (Thomson 2008a, 153–9). The Williams appear to have combined a Scottish approach to ecclesiastical management (including the promotion of Scottish immigrants) with personal aristocratic interests ranging from hawking to expropriating tax or rent in butter intended for payment to the crown (DN I, 404; Crawford 2003, 148–51). Political circumstances changed in the late fourteenth century, due to both the papal schism (which resulted in competing, often absentee, Norwegian and Scottish claimants to the bishopric) and the appointment of an aggressive earl intent on controlling local government (Crawford 2003, 151; Thomson 2008a, 160–71). Henry Sinclair (an heir of Malise of Strathearn) received the title from King Hakon of Norway in 1379, contingent on the payment of 1000 gold nobles (Thomson 2008a, 160–62). He also held major lands in lowland Scotland, but aggressively pursued his interests in the north — including the violent elimination of rivals (Thomson 2008a, 166).[1]

Leaving the subtleties of political history aside, it is inconceivable that the Northern Isles could have escaped the great European famine of 1315–22, or the immediately following cattle murrain (thought to be akin to rinderpest) that caused a mass mortality of livestock (cf. Oram & Adderley 2008). Moreover, in 1349 the disease now known as the Black Death reached Orkney (Storm 1888, 224). This pandemic resulted in rapid and large population losses in most parts of Europe where its impact can be quantified. Deaths typically reached over 50% of the population (Benedictow 2004, 382–3). Its effect on Scotland is known to have been significant (Oram & Adderley 2008, 81) and Norway suffered badly (Benedictow 2004, 146–58). Later episodes of plague led to further population losses. The causes of these events, particularly the Black Death, remain matters of debate. One variable, undoubtedly with its own direct con-

sequences on primary economic production, was the fourteenth-century climatic decline indicated by poor tree growth and other palaeoecological proxies (Oram & Adderley 2008, 77–9).

Over the course of the following century large areas of marginal farmland were gradually deserted in many parts of Europe. Sooner or later people gravitated to more productive lands, better terms of tenancy and towns (Dyer 2002, 349–53; Epstein 2009, 164). Approximately 65% of Norwegian farm holdings were abandoned between 1349 and 1520 (Lunden 2004, 144). By 1492, the date of the first surviving rental document from Orkney, rents had declined to *c*. 62% of their traditional value due to the amount of land out of cultivation (Thomson 2008b, 109). It must also be significant that Earl William Sinclair (see below) was able to amass a personal estate totalling approximately 12% of Orkney by acquiring scattered parcels of land in the middle decades of the fifteenth century (Thomson 1984, 136–41; 2008a, 226). It would seem that labour was scarce and land cheap in the lengthy wake of the crises of the fourteenth century.

Orkney was a changing and fluid world in the 1300s. A significant proportion of the population must have succumbed to famine or plague, and there was probably also increased mobility of various kinds compared with a nadir of connectedness in the thirteenth century. Opportunities certainly emerged for the Scottish followers of bishops and earls — and for Scottish administrators acting for Scandinavian monarchs. The resulting impact on the character of the local gentry is illustrated by the existence of Scottish personal names (probably representing migrants) among the Orcadian witnesses to an agreement between Bishop William IV and the Norwegian sysselman (royal administrator) Hakon Jonsson in 1369 (DN I, 404; Imsen 2009, 20). References to trade between lowland Scotland and the territories of the earls of Orkney also became common for the first time. In one example, from 1329, payment for 15,000 dried fish from Caithness was noted by the Scottish exchequer (Stuart & Burnett 1878, 239). Direct contacts also existed with Scandinavia. In addition to the presence of appointees such as Hakon Jonsson, the Orcadian gentry continued to seek status as royal liegemen (Imsen 2009, 17). Moreover, there are fleeting records of what must have been more widespread incidental mobility — as in 1329 when a Norwegian widower sold land in South Ronaldsay and the Pentland Skerries inherited from his Orcadian wife (Thomson 2008a, 149–50) or in 1325/26 when a woman named Allicia left her Orcadian husband to elope with a man from Bergen (DN VII, 107). Social networks and mobility reconnected the northern world. Many individuals lived a transnational existence and must have quickly

1. A considerable mythology has grown around this earl, incorrectly attributing him with an early voyage to North America among more otherworldly claims (Oleson 1966; Smith 2002).

adopted hybrid identities (cf. Immonen 2007). Yet isotopic analysis of thirteenth- to fourteenth-century human burials from St Thomas' church in Mainland Orkney implies that many people were both born and buried in the Scottish isles (Evans *et al.* 2008). Thus the mobility of the extant historical record may predominantly represent the wealthy — and established or aspiring members of their households.

Earl Henry Sinclair was killed in Orkney between 1396 and 1402 (Thomson 2008a, 170). His son and successor, Henry II, was an active and cosmopolitan member of the Scottish royal court — but probably an absentee landlord from an Orcadian perspective (Thomson 2008a, 172). Local management eventually fell to his representative and brother-in-law, David Menzies of Weem, who continued in this role for several years after the death of Henry II. Menzies was, however, resisted by an Orcadian faction who accused him of misusing his ideological, economic and military power (DN II, 691). He apparently imprisoned the Lawman (a locally appointed judicial officer) until the law book and the seal of the community of Orkney were surrendered, exported several shiploads of grain during a period of local famine and confiscated or destroyed the property of his enemies, who were occasionally subjected to violence. Menzies' administration also engendered continued dissatisfaction with the influence of Scottish migrants. One cargo of imports he confiscated included wheat meal, beer, tar, iron, wax, hemp, kettles, pans and ceramics — providing a useful glimpse of fifteenth-century trade.

Concurrent with these political developments, merchants of the Hanseatic League began direct trade with Orkney and Shetland for the first time. German merchants had been active in Norway since at least the twelfth century (e.g. Sephton 1899, 129). By the late fourteenth century they controlled much of Norway's long-range trade (Gade 1951; Dahlbäck 2003, 620–24), but were legally restricted from travelling beyond Bergen which acted as a transhipment port for both northern Norway and the Scandinavian settlements of the North Atlantic (Friedland 1983, 87). From *c.* 1416, however, the Hansetag's decrees that such voyages were forbidden were increasingly ignored (Friedland 1973; 1983). The impact of this trade is best documented in Shetland, but initially it probably also included Orkney. The latter archipelago was the destination of the earliest documented Hanseatic visit to the Northern Isles (Friedland 1983, 88). The beginning of direct German trade also coincided with a general opening of the North Atlantic. English ships, for example, began fishing and trading in Iceland from *c.* 1412 (Gardiner & Mehler 2007, 398) — sometimes raiding in Orkney along the way (Anderson 1982, 32; Thomson 2008a, 246).

Hanseatic shipping in the North Atlantic was organized primarily for trade — unlike English voyages to Iceland, which combined fishing with buying local goods, or the activities of later Scottish and Dutch fishermen who made their own catches around the Northern Isles (see below). German trade in medieval Iceland, for example, typically involved direct exchange with primary producers at agreed ports (Gardiner & Mehler 2007, 395–405). One can observe a similar pattern in later, seventeenth-century, records of Hanseatic trade in Shetland. Here merchants occupied specific bays and exchanged their goods directly with the producers of the products they sought. Dried fish were the most important export, but butter, fat, wool and feathers were also purchased (Friedland 1983, 92–3). Trade was conducted with peasant farmers and fishermen (a specialization that probably only emerged in late or post-medieval times in the Northern Isles). The local political authority derived an income by taxing this trade in a variety of ways (Friedland 1983).

David Menzies was eventually outmanoeuvred and replaced by William Sinclair, son of Henry II, who was officially recognized as the earl of Orkney in 1434 (Thomson 2008a, 177–9). William was heavily involved in the Scottish court, but had poor relations with Christian I of the Kalmar Union. In 1462 Christian made the bishop of Orkney, rather than the earl, his representative in the islands (Thomson 2008a, 198). Thus William Sinclair was out of the negotiations in 1468, when Orkney was pledged to Scotland in lieu of 50,000 florins promised as dowry when King James III of Scotland married Margaret of Denmark (Thomson 2008a, 199–200). Shetland was similarly pledged (for 8000 florins) in 1469. James III helped secure his new possessions in the north by buying out William's theoretical right to the earldom in 1470, and formally annexing the earldom estate to the crown in 1472 (Crawford 1985a, 238–9; Thomson 2008a, 203–4).

The bishop of Orkney continued to administer the archipelago throughout this period — and subsequently until 1489 when the tack (right to administer land in exchange for an annual fee, but not the title of earl, was granted to Lord Henry Sinclair, Earl William's grandson (Thomson 2008a, 221–7). In 1492 and 1500 Henry oversaw production of Orkney's first surviving rentals (Thomson 1996; 2008a, 206–19). They provide much information regarding settlement organization, the products of exchange (principally butter, grain, meat and oil at this date) and the cumulative impact on agriculture of fourteenth-century famine, plague and climate change (see above).

Lord Henry Sinclair was killed in 1513, fighting with King James IV at the Battle of Flodden in northern

England (Thomson 2008a, 232), after which his widow, Margaret Hepburn, managed the Orkney tack until 1540. In that year the archipelago was visited by King James V and a new administration was established. The traditional office of Lawman was replaced by a sheriff, continuing the shift from Scandinavian to Scottish institutional practice (Thomson 2008a, 244; Imsen 2009, 21). The annual payment from the islands to the crown was increased from £433 1/3 to £2000 and it was estimated that Orkney might ultimately be able to yield as much as £9750 (Thomson 2008a, 243–4). The first half of the sixteenth century was thus a period of economic recovery, as also evidenced by ecclesiastical building projects — including additions to St Magnus Cathedral and the bishop's palace in Kirkwall (Simpson 1961, 72; Fawcett 1988, 109–10; Cox et al. 1998; Gifford 1992, 327–9).

The Scottish reformation of 1560 instigated further social and economic changes. Large estates held by the bishopric were granted by feu to incoming Scottish magnates with the right connections — particularly Gilbert Balfour, master of the household of Queen Mary of Scotland and brother-in-law of the new bishop of Orkney (Adam Bothwell) (Thomson 2008a, 253–61). Balfour received properties in Westray on which Quoygrew lays (see Chapter 3), and on which he built Noltland Castle (Gifford 1992, 343–6). In 1566 he was briefly sheriff of Orkney (Anderson 1982, 54). He died by execution during a misadventure in Sweden (Anderson 1982, 80), but his Westray lands, probably including Quoygrew, remained in the hands of his descendants (Fereday 1990).

Control of Orkney then passed to Robert Stewart, an illegitimate son of King James V of Scotland. Robert formally became earl of Orkney in 1581 and his son Patrick succeeded him until executed in Edinburgh in 1615. Both Stewart earls were viewed as hard masters, making significant new demands on their tenants and perhaps failing to recognize the rights of independent landowners under local (still Norse) law (Anderson 1982; 1992). They had many local enemies — having independent magnates such as the Balfours of Westray for neighbours (Anderson 1999, 46) — and Patrick's cosmopolitan aspirations ultimately led to both bankruptcy and treason. The reigns of father and son are notorious in local history (Thomson 2008a, 262–300).

The restoration of the earldom under the Stewarts was nevertheless a period of wealth and heightened international connections in Orkney — albeit built on a mixture of local peasant labour and external credit (Thomson 2008a, 262–300). Robert and Patrick Stewart had building programmes rivalling those of the early sixteenth-century bishops. Dutch tiles were used in Robert's palace in Birsay (Pringle et al. 1996, 194) and Patrick's grand house in Kirkwall is still considered one of the finest Renaissance buildings in Scotland (Cox et al. 1998; Pringle 1999; Thomson 2008a, 279). Other building projects included Scalloway Castle and Sumburgh House (re-coined Jarlshof by Walter Scott) in Shetland (Fojut & Pringle 1993, 48–55; Pringle 1999). In the sixteenth century the Dutch herring fishery was developing in northern Scottish waters, offering opportunities for onshore provisioning and trade (Smith 1984, 25–8; Robinson 2009, 139–42). Concurrently, Scottish east coast fishermen began to work in Orkney and Shetland in exchange for payments to the earl (Thomson 2008a, 284). Hanseatic trade was also still significant, particularly in Shetland, resulting in additional income from dues for the use of bays and the provision of facilities (Friedland 1983). Piracy, both of and by Orcadians, was common and increased the horizons of the islanders in various welcome and unwelcome ways (Anderson 1982, 54; 1992, 22–3; Thomson 2008a, 285–6). The products of rent and tax were exported. Remarkably Orcadian grain was even shipped to Flanders on one occasion (Thomson 2008a, 266).

How much of the wealth resulting from these activities remained in Orkney is another question. During Patrick's reign — and long before — much of it was channelled to creditors, absentees and/or royal treasuries. Orkney had thus changed fundamentally from when piracy and mercenary activity bled the south. This is not to say that there had been an end of a golden age. Orkney's sixteenth-century architecture rivalled its twelfth, and there is little romanticism in the violence of either century. Yet the structure of the political economy did vary through time, and these changes must have impacted the lives of farmers and fishermen in settlements like Quoygrew.

Chapter 3

Quoygrew and its Landscape Context

James H. Barrett, Lucy R. Farr, David Redhouse, Susan Richer,
Jerad Zimmermann, Lorna Sharpe, Susan Ovenden, James Moore,
Tessa Poller, Karen B. Milek, Ian A. Simpson, Marcus Smith,
Ben Gourley and Terry O'Connor

3.1. Introduction

Quoygrew faces the sea from the shore of Rack Wick[2] on the northwestern coast of Westray (Fig. 3.1). This chapter introduces the landscape and settlement context of the site at various scales. It has two main aims: to illuminate how Quoygrew may have functioned within larger social units and to provide a metaphorical site tour to orient the reader. We address these goals using cartographic, rental and archaeological survey evidence.[3]

3.2. The township of Rackwick

The ruined settlement now known as Quoygrew was part of the township (or toun) of Rackwick. Scottish townships could vary enormously through time and space, but a toun can be broadly defined as 'a multi-occupancy settlement with its related enclosures, fields and lands' (Dalglish & Dixon 2007, 8). Medieval townships in Orkney could include tenants, owner-occupiers, or any combination of the two (Thomson 1996). Based on Lord Henry Sinclair's rental of 1492

(the earliest for Orkney) Rackwick was held by tenants of the bishopric of Orkney and, to a lesser degree, the earldom of Orkney. As a whole it was assessed at 35.25 pennylands (c. 2 ouncelands of 18 pennylands each), a high value in comparative perspective (Thomson 1996, 61, 66, 87–90). Of these, 28 pertained to the bishopric and 7.25 to the earldom. A pennyland was a unit of taxation and rent that can be 'approximately equated' to a household, albeit only notionally and with much variability (Thomson 2008b, 92–6).

The antiquity of Rackwick's late medieval status is difficult to know. Neither pennyland assessments (Williams 2004) nor grants to the bishopric (Crawford 2003) are conceivable before the eleventh century in an Orcadian context — and a later date is equally possible. Earlier we cannot be certain of Quoygrew's role within the hierarchical administrative landscape of Viking Age and medieval European life. It may already have been under the control of powerful owners (the earls of Orkney and/or other magnates) in the Viking Age — given the scale of the township and its later donation almost *en bloc* to the church. This interpretation is made more likely by references in *Orkneyinga saga* to the existence of three twelfth-century magnates based in Westray (Guðmundsson 1965, 120–21). Comparing the saga and rental evidence, Thomson (2008b, 32) has argued that the three held southern, western and northern Westray respectively, either independently or as appointees of an earl.

Regardless of the details, it is probably safe to assume that Quoygrew was always dependent on a social hierarchy to whom goods had to be paid. By the fifteenth century — and perhaps as early as the eleventh or twelfth centuries — these dues had been formalized as skat (tax), rent and teind (tithe) throughout the earldom of Orkney (Andersen 1988;

2. Wick derives from Old Norse *Vík*, a bay.

3. Topographic survey was conducted principally by Marcus Smith and Ben Gourley. Auger and test-pit survey was the responsibility of Ian Simpson, Karen Milek, Tessa Poller and Terry O'Connor. The geophysical surveys were done by Lorna Sharpe, Susan Ovenden and Marcus Smith. Susan Richer and James Barrett carried out the cartographic and census research. Post-excavation mapping was the responsibility of Lucy Farr, David Redhouse, Jerad Zimmermann, Marcus Smith and James Barrett. The work was coordinated by James Barrett who has written the text, with input from Lorna Sharpe and James Moore regarding the geophysics results.

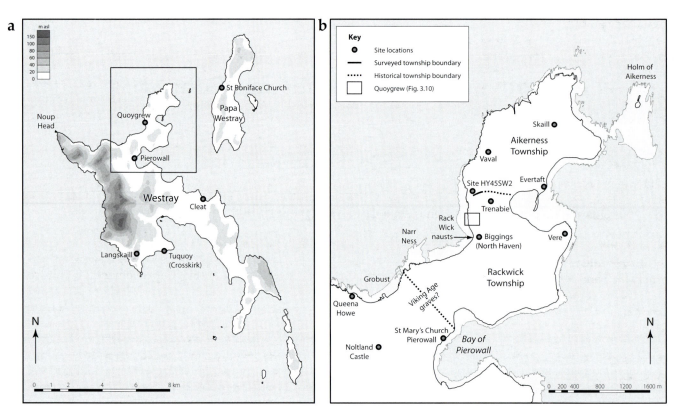

Figure 3.1. *Westray (a) and the township of Rackwick (b) showing locations discussed in the text. The boundaries of Rackwick are derived from earthwork survey and the plans of Miller (1859) and Mackenzie (1750). (Image: Lucy Farr and Dora Kemp.)*

1991; Thomson 1996; Williams 2004; Gibbon 2007). Even independent landowners, holders of 'udal' tenure, were only spared rent. Dues were paid mostly in butter, grain (or grain products such as malt), meat and oil (usually rendered from fish livers), but differed according to location, date and social circumstances. As noted in Chapter 2, an increase in the butter tithe in the early thirteenth century led to the murder of the bishop of Caithness by an angry mob (Crawford 1985b 28–9; Guðmundsson 1965, 298–300). Conversely, the proportion of skat to be paid in butter was reduced in the 1492 rental (Thomson 1996). In Shetland, part of the earldom until 1195 (Imsen 2003), wool cloth was probably also used to pay renders based on analogy with later practice (see McNeill 1901, 325–7; Ballantyne & Smith 1999, 17).

Rackwick was part of St Mary's parish, with the church located in the village of Pierowall (with its excellent natural harbour) immediately adjacent to the southern boundary of the township (Fig. 3.1). None of the surviving church fabric predates the thirteenth century (Gifford 1992, 350), but the village itself was already known (as *Hǫfn*) when *Orkneyinga saga* was composed (Guðmundsson 1965, 162). When parishes were formed in Orkney is a matter of debate,

but the twelfth century is a reasonable assumption (cf. Andersen 1988; Helle 1988, 53; Gibbon 2007). Before the first church was built in Pierowall a ritual landscape in the same general area was demarcated by a cemetery of at least 16 burials of ninth- to tenth-century date, with grave goods characteristic of pagan Scandinavian practice.[4] The precise locations of these finds are not known, having been excavated between the seventeenth century and 1863, but they were almost certainly somewhere in the links (grass-covered sand-dunes) between Pierowall and Quoygrew (Thorsteinsson 1968; Graham-Campbell & Batey 1998, 129–35; Fig. 3.1).

Rackwick probably entered private hands *c.* 1560, when church lands in Westray were granted to the colourful Gilbert Balfour (Anderson 1982, 33–4, 54–5; 1992, 30; Gifford 1992, 343; Thomson 2008a, 254–5). The identity of the township later became subsidiary to that of its largest farm, Trenabie, which emerged as an economic unit in 1706 when John Balfour, 1st of Trenabie, inherited only part of his father's more extensive Westray property (Fereday 1990, 4). The

4. Unlike Scandinavia, non-Christian ritual landscapes in Viking Age Orkney are seldom if ever demarcated by place names (cf. Brink 2001; Thomson 2008b, 45–50).

original eighteenth-century mansion house stood at the crest of a low hill 400 m northeast of Quoygrew. It was burned in 1746 (Fereday 1990, 6) in reprisal for the Jacobite sympathies of the second laird, William Balfour, but appears on Murdoch Mackenzie's hydrographic chart of Westray published in 1750 (Thomson 1996, xxii, 59). Its replacement in the same approximate location, built in 1754 (Fereday 1990, 17), still stands as a converted outbuilding within the modern steading of Trenabie (Scott *et al.* 2003, 7; see Fig. 3.1). The subsequent financial success of the Balfour family, players in the growing world economy of the British Empire, led to Trenabie once again becoming a tenanted farm of a large inter-Island estate (Fereday 1990). Like most Orkney property it became owner-occupied in the twentieth century — and remains so today as a cattle farm in the hands of George and Margaret Drever (who patiently welcomed our archaeological endeavours).

3.3. Maps, settlement patterns and land use

It is beguiling to attempt to describe Viking Age and medieval life in Orkney in terms of what is known about later townships — for example with reference to run-rig agriculture which involved small interspersed strips of land allocated in rotation to differing shareholders within a township. However, the dangers of such an anachronistic approach are well known (Dalglish 2002). Townships in Orkney (Thomson 2008b, 25–36) and elsewhere in the Scottish Highlands and Islands (Dodgshon 1998) showed fundamental changes in settlement pattern and land use through time — in response to both pan-European and local developments. To provide one example, the 1492 rental records that much traditionally cultivated land was untenanted — probably due to abandonment in the wake of famine, plague and the resulting demographic and economic downturn of the fourteenth to fifteenth centuries (Thomson 1984). On a more local level, the same rental notes that several pennylands of the three main townships of northern Westray — Brough, Rackwick and Aikerness — were 'blawin to Birrowne' (blown to Bergen) (Thomson 1996, 61). This entry probably refers to the erosion of sandy soils from links, the most extensive of which run from Rack Wick itself (beginning immediately south of Quoygrew) to Grobust beach in the west and Pierowall in the south (Fig. 3.1).

Despite these caveats, there is value at a very general level in extracting multi-period landscape evidence from post-medieval cartographic and census data. Starting with first edition Ordnance Survey (1882a,b) maps, we observe Quoygrew (then called Nether Trenabie) as a marginal croft on the fringe of Trenabie farm (Fig. 3.2). It occupies a treeless land-scape, known to have been characteristic of most of Orkney since the Neolithic (Berry 2000, 52–4). A cluster of (still extant) nausts, open shelters for boats above the high-water mark, at the head of Rack Wick indicate the area's potential for fishing. Features like these secured the kind of small rowing and sailing vessels used in Orkney and Shetland from the Viking Age until the twentieth century (Morrison 1992; Allen 2002). Local oral history suggests that the landing place may have been more sheltered in the distant past, with existing shallows off Narr Ness (United Kingdom Hydrographic Office 1993), once being a sandy holm (islet) or spit.

Other aspects of the first edition OS maps are less informative *vis-à-vis* earlier centuries. The comprehensive coverage of squared fields was an innovation of nineteenth-century improvement agriculture (Thomson 2008a, 385–8). Similarly, the high density of dispersed households was in part a reflection of the economic and demographic impacts of an eighteenth-to nineteenth-century boom and bust cycle in the production of seaweed by-products ('kelp') for industries such as glass, soap and dye making (Thomson 1983). Comparative study of cartographic evidence from 1866 and 1882 (Miller 1866; Ordnance Survey 1882a,b) and household level census returns for 1841 and 1881 (now available in electronic format, see ScotlandsPeople 2011) illustrates how new settlements filled in the landscape of Rackwick and the neighbouring township of Aikerness (Richer 2003; Fig. 3.3).

An imperfect impression of the pre-existing settlement pattern can instead be provided by the distribution of sites on the first edition OS maps with place-names derived from Norn and Scots (Fig. 3.3). Norn was the Scandinavian dialect of the Northern Isles. It was spoken into the eighteenth century and is still represented by loanwords in local speech (Barnes 1998). The Scots language (rather than Gaelic, unlike the Western Isles and Sutherland) slowly replaced Norn in Orkney starting in the late Middle Ages (Knooihuizen 2005; Sandnes 2010).

Place-names have often been used in this way to help interpret Viking Age and medieval settlement patterns, with appropriate caveats regarding the often recent date at which they were first recording (e.g. Marwick 1952; Nicolaisen 1976; Crawford 1995b; Jennings 1996). Nevertheless, the onomastic record is fluid rather than representing a fossilized medieval settlement pattern (Thomson 1995). The history of Quoygrew illustrates this process. Its name changed from Nether (lower) Trenabie to Quoygrew between the first and second editions of the relevant OS maps (Ordnance Survey 1882a; 1903). Variant forms of the new name (Quegro and Quoygrene) first appeared in

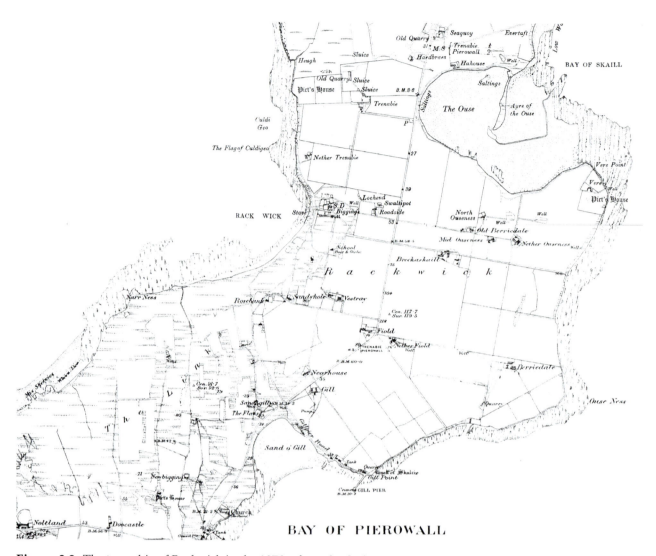

Figure 3.2. *The township of Rackwick in the 1870s, from the Ordnance Survey's (1882a,b) first edition six inch to one mile maps. (Image: © Crown Copyright 1882.)*

census records around the same time, in 1891 and 1901 (ScotlandsPeople 2011). One can only speculate regarding the reason for this change, but 'Quoy' (originally from Old Norse *Kví*, meaning an animal enclosure) is a name element associated with small, often outlying, farms in Orkney. Conversely, the generic place-name element of Trenabie (variously represented as *bœr*, *bý(r)*, by, bay, bae, bea and bie) implies a substantial farm as used in both medieval and post-medieval Orkney (Marwick 1952, 43, 227–8, 243–7; Taylor 2004; Thomson 2008b, 9–12, 21–3). The highest-status examples are the Houseby settlements, which may have been the administrative farms of king or earl in medieval Orkney on the basis of comparison with Norwegian and Swedish naming practices (Stylegar 2004, 11–12; Crawford 2006, 196–208; Thomson 2008b, 37). To place this nomenclature in hierarchical context there are only *c.* 40 *bý* names

known in Orkney, of which five are Houseby (Crawford 2006; Taylor 2004; Thomson 2008b, 37).

The modern hilltop site of Trenabie itself has produced no evidence of a medieval precursor. It has no visible settlement mound and neither past building work nor our own informal archaeological investigations (by auger) have discovered pre-eighteenth-century deposits. Thus Quoygrew may originally have been Trenabie, making it (and perhaps the rest of the nearby settlement cluster to be discussed below) the focus of the medieval *bý*. Following this hypothesis, the site would have acquired the prefix 'Nether' after Trenabie itself was relocated — perhaps in the eighteenth century when it became the main estate of John Balfour (see Section 3.2 above). By the end of the nineteenth century the suitability of the name Nether Trenabie for what had become a croft of only a few

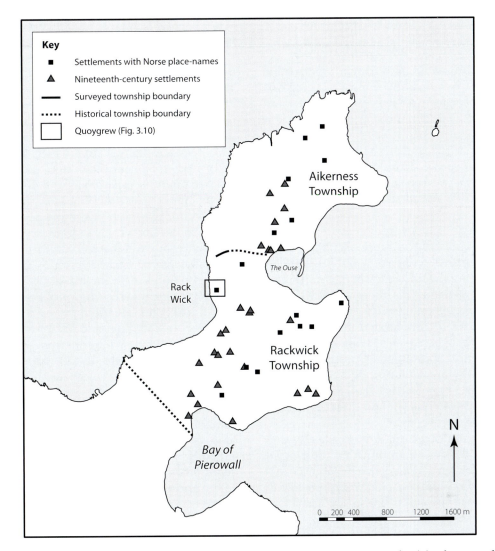

Figure 3.3. *Nineteenth-century settlement infilling (based on cartographic and census data) in the township of Rackwick around sites that may be earlier (based on Norse place names) (Richer 2003).*

acres may have faded along with the distant memory of the site's former role. This interpretation of change in status is not, however, intended to suggest that the Viking Age and medieval settlement at Quoygrew was ever exceptionally wealthy. Neither the architecture nor the small finds to be discussed in this book would sustain such an idea. Nevertheless, the site may once have belonged to a prosperous tenant household that formed part of the core of a large medieval farm.

Maps of Rackwick predating the Ordnance Survey are rare. There is one mid-nineteenth-century survey of the Trenabie estate (Miller 1866), but it is very similar in content to the later sources already discussed. More useful are earlier plans by Miller (1859) and Macken-zie (1750) which record the southern and northern boundaries (demarcated by turf walls) of the township respectively. These are transcribed onto Figures 3.1b

and 3.3, with an inevitable margin of error given the differing scales and accuracies of the maps. A section of the northern boundary still survives as an earthwork and has been added from our own survey. In Orkney these dykes marked the boundary between cultivated fields and communal hill land utilized for activities such as summer grazing, peat extraction (for fuel) and the flaying of turf (for fuel, building material, animal bedding and agricultural manure). Both the sediment and archaeobotanical evidence from Quoygrew indicate that these practices can be extrapolated back in time (Simpson *et al.* 2005; Chapter 10). Mackenzie's chart, part of a hydrographic survey, provides the additional information that there were fishing grounds for cod and ling nearby (accessed in part, no doubt, from the head of Rack Wick where the nausts discussed above are located).

3.4. Archaeological survey around Quoygrew

The settlement landscape in the vicinity of Quoygrew can be further illuminated by our own topographic and sediment surveys,[5] and by information regarding previously recorded archaeological sites (Moore & Wilson 1998; Royal Commission on the Ancient and Historical Monuments of Scotland (RCAHMS) 2010). The evidence is summarized in Figures 3.4 to 3.8 and the raw data provided in Appendices 3.1 to 3.2. Geophysical survey was concentrated in the immediate vicinity of the excavated site and is discussed in Section 3.5 below.

The settlement of Quoygrew is evident as two low mounds with adjacent anthrosols (cf. Figs. 3.4 & 3.5). It lies to the north of an area of windblown calcareous sand, including the fill of a basin that must once have been a small wetland. This interpretation is based on auger survey (which produced highly organic silty clay deposits under a considerable depth of sand) and topography (cf. Figs. 3.4, 3.7 & 3.8). Areas of wet meadow were critical in traditional Orcadian agriculture as sources of winter fodder (bog hay) for cattle (Fenton 1978, 423–5, 428). Grass was not cultivated as a field crop in the archipelago until the eighteenth century (Thomson 2008b, 269).

Like Quoygrew, other settlements are also evident as mounds clustering around this focal point at the head of Rack Wick (Fig. 3.4). The largest, now called North Haven, is still occupied. In the nineteenth century it was part of a multi-house site known as Biggings (e.g. Ordnance Survey 1882a; cf. Figs. 3.1 & 3.2). This Scots name (meaning buildings) is unlikely to have been coined before the late Middle Ages, but

could represent modification of a Scandinavian original (cf. Crawford 1999, 28–9).

We opened a small intervention (Test Pit 7) on the eastern side of the mound at Biggings (Fig. 3.4). The excavation could only safely be dug to a depth of 1.8 m, which may be nowhere near the base of the mound. Nevertheless, the test pit produced a stratified sequence of five optically stimulated luminescence (OSL) dates ranging from AD 1640–1700 near the top to AD 1415–1535 near the bottom (Sommerville 2003, 296; Sommerville *et al.* 2003; the date ranges are given at one sigma following OSL convention, see Chapter 4 for a discussion of the method). Single sherds of probable German/Scandinavian redware pipkin (*c.* seventeenth to eighteenth century) and of probable Scottish redware (*c.* thirteenth to fifteenth century) were also found near the top of the sequence (Derek Hall pers. comm.). The origins of Biggings thus lies in the Middle Ages or earlier.

Between Biggings and the sea is a cluster of small irregular settlement mounds (one disturbed by the vehicle track along the shore), the edge of which is beginning to be cut by coastal erosion (Fig. 3.4). Here, in Test Pit 108, we recorded an eroding midden section 1.35 m deep that produced a basal angle sherd of a straight-sided Scottish white gritty ware pot (*c.* twelfth century, Derek Hall pers. comm.). This find suggests a medieval rather than prehistoric origin for a previously recorded site (cf. Moore & Wilson 1998, 231). To the north, between Biggings and Quoygrew, auger survey has produced midden material that may imply the location of yet more (albeit undated) occupation in the area (Fig. 3.6). Cumulatively we can envision a multi-focal medieval settlement around the head of Rack Wick — perhaps the original *bý* of later Trenabie (cf. Stylegar 2009). Based on the earliest dates from Quoygrew it may owe its origins to the late Viking Age (see Chapter 4), but the basal layers at Biggings do remain to be explored and could thus extend back to the Iron Age or earlier.

North of Quoygrew a localized exposure of coastal midden was examined in Test Pit 106 (Fig. 3.4). It is undated, but was composed of fish bone and shell very analogous to the much larger shoreline middens at Quoygrew itself. In the absence of evidence for a settlement mound, thickened anthrosols or eroding architecture it is tentatively interpreted as a Viking Age or medieval activity area.

Recent settlements, evidenced as upstanding buildings or ruins, also exist within a few hundred metres of Quoygrew. With the exception of the examples discussed thus far, however, we have not discovered additional archaeological sites of Viking Age or medieval date. There is also no clear indication

5. The topographic survey (Appendix 3.1) was conducted by total station theodolite (TST). It is likely to be precise to within several centimetres (allowing for the vagaries of surface vegetation and atmospheric conditions – particularly wind speeds). The sediment survey was conducted using a 'Dutch-type' soil auger and soil test pits of varying dimensions. The precision of the auger survey points varies. The locations of those within and near Quoygrew, Biggings, Evertaft and other sites discussed in the text were determined precisely by TST. Some more distant points in the hinterlands of these sites were surveyed by global positioning system (GPS) in 1999, prior to the end of signal scrambling, with a correction applied based on real-time radio transmissions from navigation beacons. The locations of a third group of hinterland auger points were based on field sketches of paced grids aligned with field boundaries. These last two groups of 'off-site' data may have spatial errors of several metres in the horizontal plane and are not associated with elevations. The method used to locate each auger point is indicated in Appendix 3.2.

of pre-Viking Age occupation near the site. One settlement mound *c.* 450 m east of Quoygrew yielded only industrial pottery of nineteenth-century date when investigated by Test Pits 5 and 6 (Fig. 3.4) (Derek Hall pers. comm.). Another possible settlement mound, site HY45SW2 in the RCAHMS (2010) data base, produced no evidence of associated midden based on auger survey (cf. Figs. 3.1b & 3.6). Moreover, it exhibited a simple dipolar anomaly when we conducted a gradiometer survey. It may thus be a burnt mound — a deposit of fire-cracked stones representing a special purpose, be it domestic or ritual, typically of Bronze Age and Iron Age date (Card 2005, 56–7). Lastly, a small patch of midden and anthrosol discovered *c.* 200 m northeast of Quoygrew may represent settlement, but it is not associated with a mound (cf. Figs. 3.4–3.6). Overall, if there was extensive prehistoric occupation in the vicinity of Quoygrew it has left little archaeological signature — unless it lies deeply buried under the mounds and wind-blown sand around Biggings. There are prehistoric dates on inclusions from an anthrosol adjacent to Quoygrew, but these are most likely to represent residual material transported with turf fuel or manure (see Chapter 4).

At a greater distance from Quoygrew there are prehistoric *funerary* monuments in the township of Rackwick (Fig. 3.1b). The main example is a Neolithic chambered cairn at Vere, site HY45SE19 in the RCAHMS (2010) data base. It may have served a role in the Viking Age and medieval cultural landscape (cf. Driscoll 1998; Semple 2009), but is not of central present concern. More directly relevant to Quoygrew may be a mound, known as Vaval, of unidentified (but probably prehistoric funerary) origin on the crest of a hill that Rackwick shares with the neighbouring township of Aikerness (Fig. 3.1b; site HY45SW3 of the RCAHMS (2010)). Today it is surmounted by a modern navigation cairn. In earlier centuries the mound alone probably helped define the approach to Rack Wick, or even the location of fishing grounds. Marks of this kind, sometimes known as meiths, were central to defining the maritime (and terrestrial) cultural landscapes of medieval and post-medieval Scotland (e.g. Fenton 1978, 587–9) and Scandinavia (e.g. Aldred 2010, 71–2).

Beyond Rackwick there are known Viking Age and medieval sites on Westray (Fig. 3.1). Well-investigated examples include the settlement and twelfth-century church at Tuquoy (Owen 1993; 2005) and a settlement at Langskaill (Moore & Wilson 2003; 2005a). Test pits have also been excavated in an eroding late Viking Age/medieval fish midden site at Cleat (Colley 1983; Barrett *et al.* 1998). On the neighbouring island of Papa Westray another medi-

eval fish midden has been excavated adjacent to St Boniface church (Lowe 1998).

More poorly understood are the Pierowall cemetery discussed above and sites known locally to have produced medieval artefacts during construction work — such as Skaill in Aikerness north of Quoygrew. The name of the latter settlement is also suggestive. Skaill (from Old Norse *Skáli*) was employed to indicate an elite hall in medieval Orkney — perhaps originally with ironic intent given use of the same term to mean a hut in other Scandinavian contexts (see Thomson 2008b, 15–17). Skaill was marked as the principal settlement in the township of Aikerness on Mackenzie's 1750 survey.

One must also look beyond Rackwick to find settlements that clearly pre-date Quoygrew. The closest sites in both time and space are the Iron Age mounds at Evertaft in Aikerness and at Queena Howe across the water to the west — sites HY45SE18 and HY44NW11 respectively of the RCAHMS (2010) data base (Fig. 3.1b; Barrett *et al.* 2000b; Moore & Wilson 1998, 222, 234). A sample of cereal grain we recovered from low in the eroding cliff section at Evertaft produced a radiocarbon date of AD 135 to 404 (AA-39134, 1750±55 bp, calibrated at 95.4% probability) and five OSL dates through the exposed sequence ranged from AD 125±195 to AD 1090±200 (at one sigma following OSL convention, see Sommerville 2003, 311). Queena Howe has no absolute dates, but its visible ruins are characteristic of a broch (a complex roundhouse typical of Orkney's Middle Iron Age) with an associated later settlement.

Both of these sites — and Biggings which may overlie older settlement — occupy areas of windblown calcareous sand. Based on extensive landscape survey this kind of environment was the preferred location for settlement throughout the Iron Age, Viking Age and early Middle Ages in the Outer Hebrides (Parker Pearson *et al.* 2004b; Sharples & Parker Pearson 1999). In the late Middle Ages, conversely, Hebridean settlement moved off the links (known locally as machair) onto heavier soils. It is possible that we are observing a similar pattern in Westray, albeit with an earlier, *c.* tenth-century, chronology based on the dating evidence from Quoygrew (see Chapter 4).

3.5. Archaeological survey of Quoygrew: deposit modelling

Prior to excavation, Quoygrew was visible as a partially upstanding cluster of ruins (dismantled for building stone after their abandonment in 1937) on the side of a low settlement mound located approximately 50 m from the shore (see Figs. 3.9 & 3.10). The mound

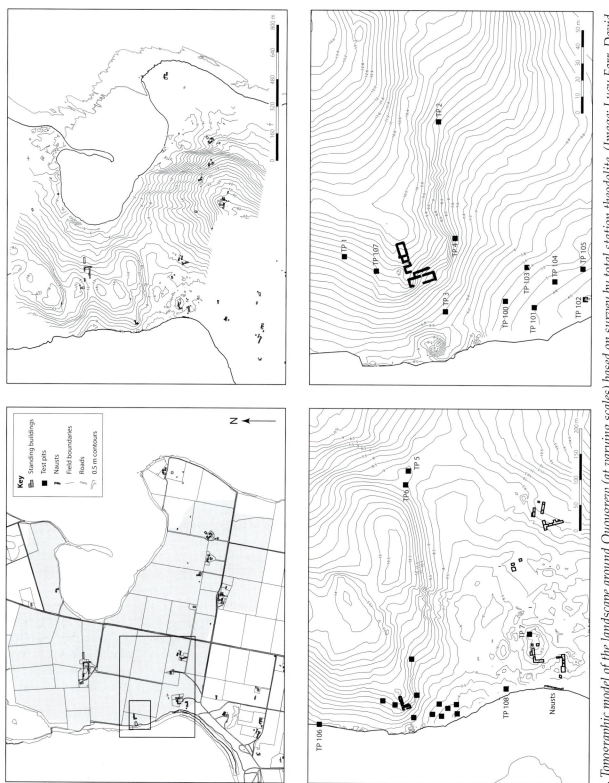

Figure 3.4. *Topographic model of the landscape around Quoygrew (at varying scales) based on survey by total station theodolite. (Image: Lucy Farr, David Redhouse and James Barrett; © Crown copyright/data base right 2011. An Ordnance Survey/EDINA supplied service.)*

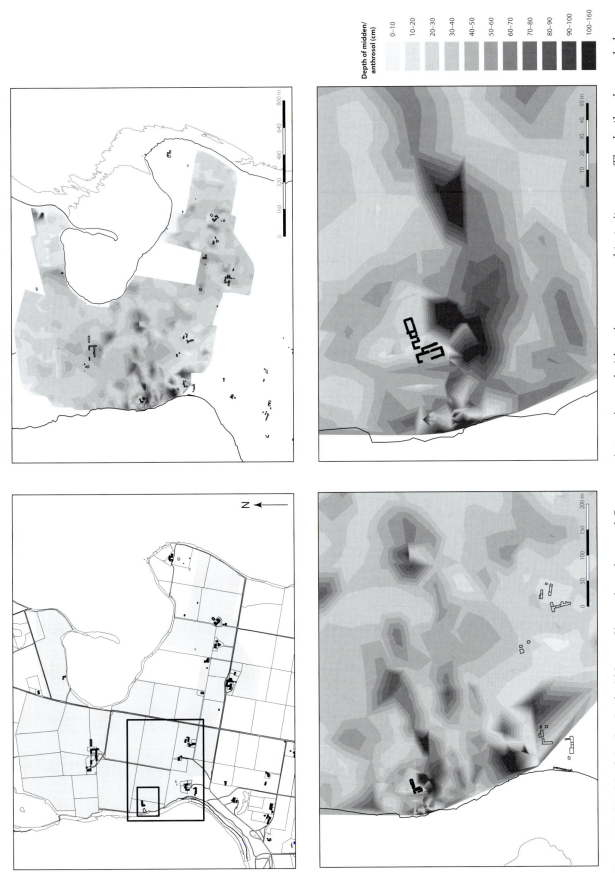

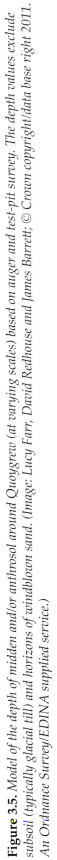

Figure 3.5. *Model of the depth of midden and/or anthrosol around Quoygrew (at varying scales) based on auger and test-pit survey. The depth values exclude subsoil (typically glacial till) and horizons of windblown sand. (Image: Lucy Farr, David Redhouse and James Barrett; © Crown copyright/data base right 2011. An Ordnance Survey/EDINA supplied service.)*

Figure 3.6. *Sediment inclusions present in auger and test-pit profiles examined around Quoygrew (at varying scales). Midden was identified by the presence of animal bone in association with other anthropogenic material such as ash, shell or artefacts. (Image: Lucy Farr, David Redhouse and James Barrett; © Crown copyright/data base right 2011. An Ordnance Survey/EDINA supplied service.)*

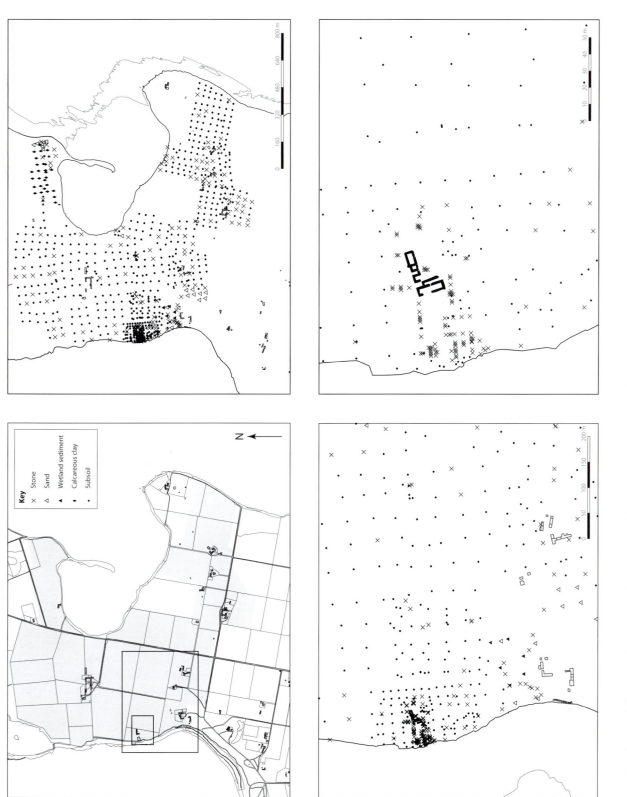

Figure 3.7. *Basal material present in auger and test-pit profiles around Quoygrew (at varying scales). (Image: Lucy Farr, David Redhouse and James Barrett; © Crown copyright/data base right 2011. An Ordnance Survey/EDINA supplied service.)*

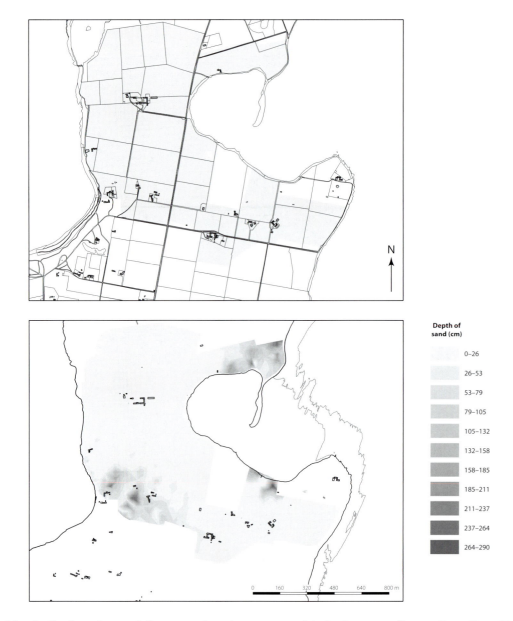

Figure 3.8. *Model of the depth of sand around Quoygrew based on auger and test-pit survey. (Image: Lucy Farr, David Redhouse and James Barrett; © Crown copyright/data base right 2011. An Ordnance Survey/EDINA supplied service.)*

exaggerates the western terminus of a natural ridge to the northeast (Fig. 3.4). Our excavations (Chapter 4) discovered it to have a maximum thickness of *c.* 1.6 m of archaeological deposits. A second settlement mound was located at the shoreline. Although difficult to discern from the surface topography it was clearly evident as eroding midden deposits and features in the wave-cut bank (cf. Figs. 1.2 & 3.4). The archaeological layers, approximately 1 m thick, had accumulated over a thin subsoil of boulder clay on top of what is now a low bedrock cliff. The intertidal zone below is presently also exposed bedrock (of 'Rousay Flags', consisting of alternating siltstones, silty mud-

stones and fine-grained sandstones: see Mykura 1976, 9–10, 77), but it was a more gently sloping shingle beach before the loose stone was removed for use in construction during the 1970s.

We initially characterized the site using the same combination of topographic and auger survey employed at the landscape scale (Figs. 3.4–3.8) — with the addition of geophysical survey and 'tapestry excavation' (recording and limited excavation of the eroding wave-cut bank). Topographic survey shows the inland mound best, with the coastal deposit having partly levelled previously sloping terrain (Fig. 3.4). The auger survey, which entailed a combination

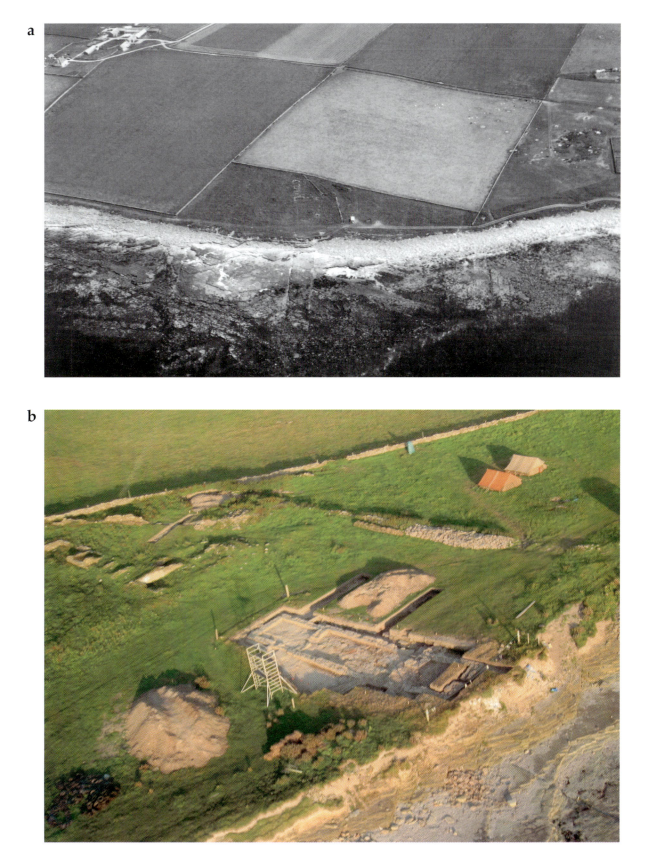

Figure 3.9. *Aerial photographs of Quoygrew during the 1997 (a) and 2004 (b) field seasons. (Images: James Barrett.)*

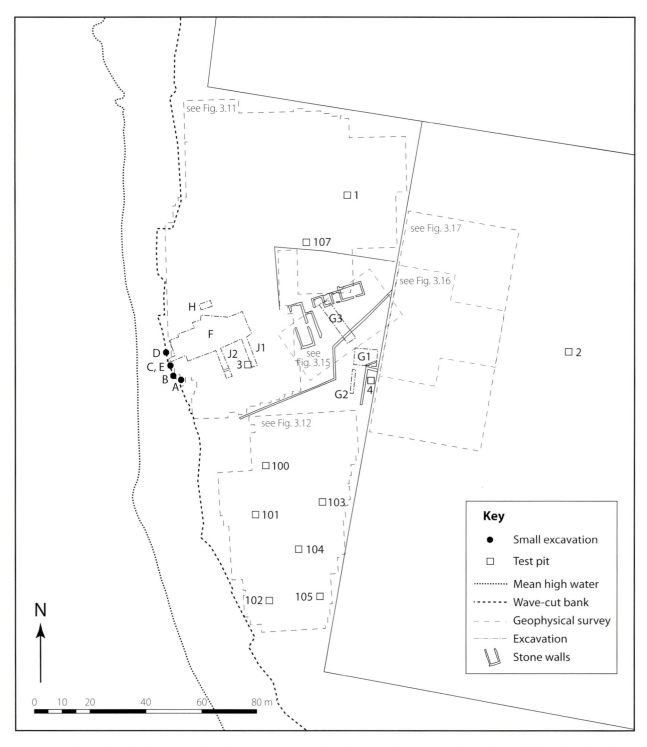

Figure 3.10. *Site plan of Quoygrew showing the archaeological interventions, the ruins of the croft abandoned in 1937 and the extant field boundaries. (Image: Lucy Farr, Dora Kemp and James Barrett.)*

of grid-based and judgemental sampling, shows both the coastal and inland settlement mounds (Figs. 3.5–3.7). They were characterized by deep anthropogenic sediments, midden inclusions (usually bone and shell) and stony ground. Combining both surveys, the maximum horizontal dimensions of the inland and coastal mounds are approximately 50 m and 40 m respectively.

The auger and topographic surveys show that thickened anthrosols (with peat flecking, but little

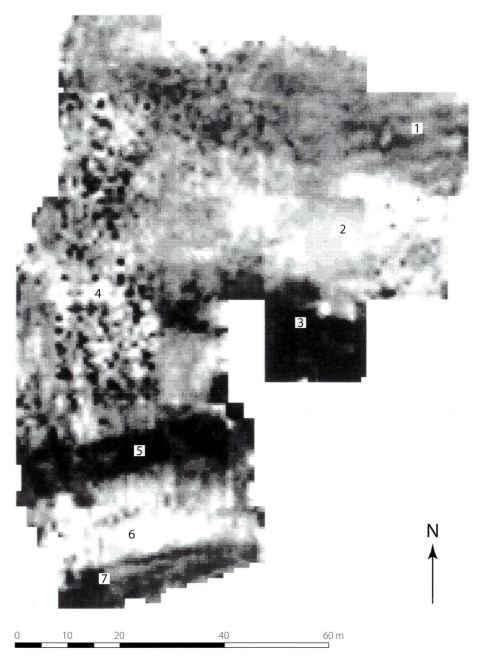

Figure 3.11. *Pre-excavation resistance survey (using a 1 m sampling interval) of Quoygrew north of the extant northeast/southwest field boundary (see Fig. 3.10). Darker shading indicates higher resistance. Numbered features are discussed in the text. (Image: Lorna Sharpe.)*

or no midden material) also surround the settlement mounds themselves — to the north, east and south (Figs. 3.5 & 3.6). The eastern soil is deepest and most clearly defined. It is interpreted as a medieval infield for continuous cereal cultivation (Simpson *et al.* 2005; Chapter 4). Based on post-medieval analogy (Thomson 2008b, 119–33) there would have been other, less intensively fertilized, agricultural land between this infield and the rough grazing of the hill.

An initial geophysical survey was done by Lorna Sharpe and Jerry Hamer in 1997. It took the form of an area-resistivity survey, using a Geoscan Research RM15 resistivity metre with a twin probe electrode configuration of 0.5 m separation. Thirty-three 20 m by 20 m grids were surveyed at a sampling interval of 1 m (Figs. 3.11 & 3.12). Areas of special interest were investigated further at a sampling interval of 0.5 m (Fig. 3.13), and were also surveyed using a Geoscan

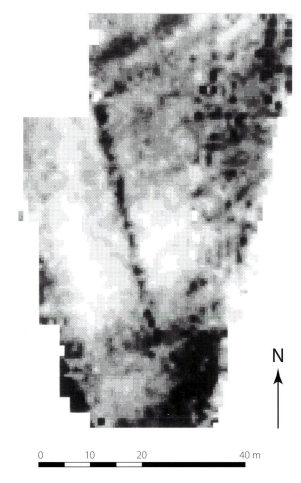

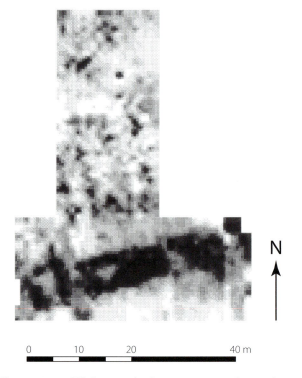

Figure 3.13. *Higher-resolution, pre-excavation resistance survey (using a 0.5 m sampling interval) of features 4 and 5 from Figure 3.11. Darker shading indicates higher resistance. (Image: Lorna Sharpe.)*

Figure 3.12. *Pre-excavation resistance survey (using a 1 m sampling interval) of Quoygrew south of the extant northeast/southwest field boundary (see Fig. 3.10). Darker shading indicates higher resistance. (Image: Lorna Sharpe.)*

Research FM36 fluxgate gradiometer (Fig. 3.14). The horizontally bedded sandstones of Westray provided a quiet background for both methods.

Figure 3.11 plots the northern portion of the main area resistance survey from 1997. Seven features are of special note:

1. An area of probable ridge and furrow cultivation. The high-resistance lines may delineate the furrows — due to wind-blown sand filling the depressions before burial by later soils;
2. An area of lower resistance material, shown by augering and Test Pit 1 to be an increased depth of cultivated soil (Simpson *et al.* 2005; see Chapter 4);
3. An area of high resistance representing rubble spread around the ruins abandoned in 1937;
4. A very chaotic area of high and low resistance that may represent a buried and poorly preserved building or buildings. A small excavation trench

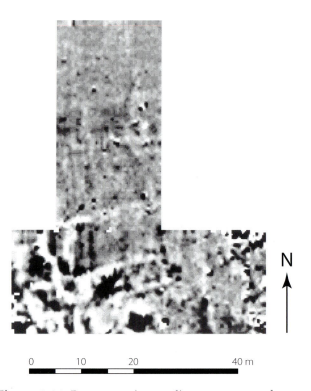

Figure 3.14. *Pre-excavation gradiometer survey of features 4 and 5 from Figure 3.11. (Image: Lorna Sharpe.)*

(Area H) failed to find corroborating evidence, but may have been too small to detect post-built architecture;

5. A wide linear high-resistance feature with an area of low resistance in the centre. Its western portion has now been excavated (House 1, see Chapter 4). Its eastern portion may represent another (unexcavated) building on the same alignment;

6. A low-resistance area now known to represent cultivated anthrosols (see Chapter 4);

7. Three lines of higher resistance material thought to represent buried field boundaries. They are parallel to an upstanding stone wall that still divides the site from northeast to southwest.

Figures 3.13 and 3.14 show the results of the higher-resolution resistance survey (0.5 m interval) and of the gradiometer survey of features 4 and 5 from Figure 3.11. They do little to clarify the character of feature 4, but feature 5 resolves into what we discovered to be House 1 with its central hearth area. The high-resistance feature east of House 1 does not register clearly in the gradiometer survey, making it difficult to interpret in the absence of subsequent excavation here.

Figure 3.12 plots the less-complicated southern portion of the 1997 resistance survey. It shows ridge and furrow cultivation, areas of low resistivity (interpreted as cultivated anthrosols based on auger survey and test pits), linear high-resistance features interpreted as buried field boundaries and a large area of high resistance at the south of the field that is likely to represent a dump of stone.

During the 1997 season the ruins abandoned in the 1930s discouraged work on the inland mound, and the field immediately east of Quoygrew (into which the inland mound continues) was initially under crop. Thus supplementary survey was coordinated by Susan Ovenden in 2004. It included resistivity survey using a Geoscan RM15 and MPX-15 multiplexer with a twin probe configuration of 0.5 m separation, a 1 m sampling interval and a transverse separation of 1 m (Figs. 3.15 & 3.16) — and gradiometer survey using a Bartington Grad 601–2 with a sampling interval of

Raw data

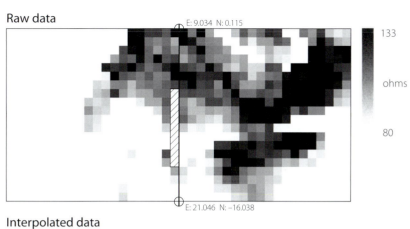

Interpolated data

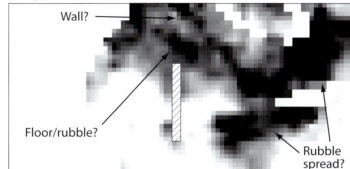

High pass filtered data

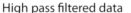

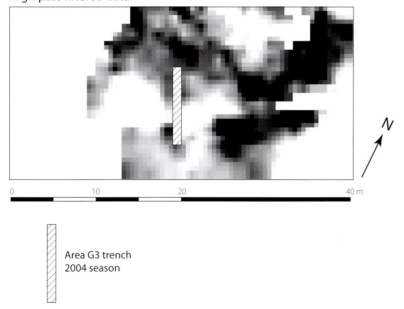

Figure 3.15. *Resistance survey (using a 1 m sampling interval) of the top of the inland settlement mound at Quoygrew (see Fig. 3.10). (Image: Susan Ovenden.)*

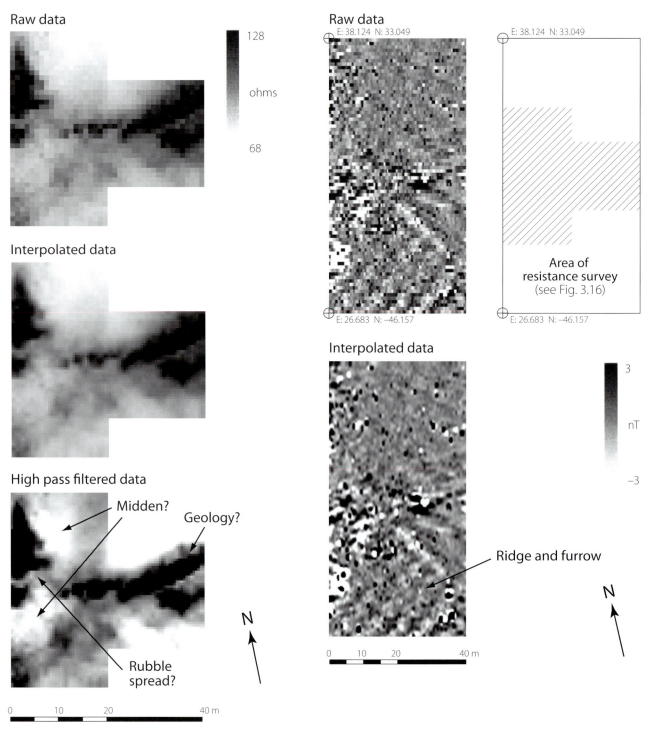

Raw data

Interpolated data

High pass filtered data

Midden?

Geology?

Rubble spread?

Raw data
E: 38.124 N: 33.049

E: 38.124 N: 33.049

E: 26.683 N: −46.157

E: 26.683 N: −46.157

Area of resistance survey (see Fig. 3.16)

Interpolated data

Ridge and furrow

128

ohms

68

3

nT

−3

Figure 3.16. *Resistance survey (using a 1 m sampling interval) of the eastern edge of the inland settlement mound at Quoygrew (see Fig. 3.10). (Image: Susan Ovenden.)*

Figure 3.17. *Gradiometer survey of the eastern edge of the inland settlement mound at Quoygrew (see Fig. 3.10). (Image: Susan Ovenden.)*

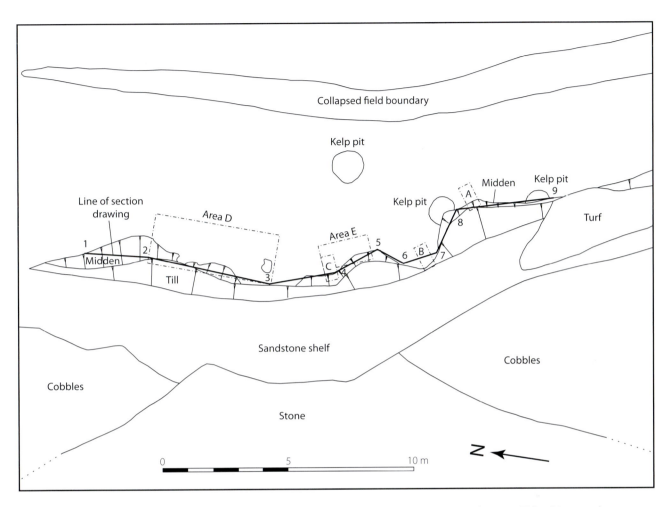

Figure 3.18. *Plan of the 1997 tapestry excavation of the wave-cut bank at Quoygrew. (Image: Toby Simpson.)*

0.25 m and a transverse separation of 1 m (Fig. 3.17).

Figure 3.15 shows the results of resistance survey on the top of the inland settlement mound, around a trial trench that became Area G3 of the excavation (see Section 3.6). The survey shows high-resistance features that may be walls, floors and demolition rubble, consistent with the evidence for buildings found during excavation.

Figure 3.16 shows the resistance survey of the inland mound, where it extends into a cultivated field to the east. Modern ploughing has removed any surface traces of settlement here, but an area of high resistance implies the existence of buried building rubble. The surrounding halo of low resistance is consistent with the presence of a deep anthrosol as identified by auger survey and in Test Pit 2. The linear high-resistance feature running northeast/southwest is interpreted as a geological ridge. Figure 3.17 illustrates the results of gradiometer survey covering a larger area than Figure 3.16. It adds little additional insight other than to reveal possible buried ridge and furrow.

3.6. The excavation: a site tour

The archaeological deposits at Quoygrew were first recorded during coastal survey in 1977 (Hope & Wickham-Jones 1977), with a 1 m by 2 m test pit subsequently excavated by Sarah Colley (1983) in 1978. In result it was discovered that the site represented a fishing community of Viking Age and/or medieval date. Based on this background research one of us (JHB) assessed the site in 1996, following which the Viking Age Transitions Project was begun in 1997. In the first year we focused on the eroding wave-cut bank (Figs. 3.18 & 3.19). An approximately 20 m length of the exposed section was cleaned and drawn. Three 50 cm sample columns (Areas A to C) were then excavated, with all material sieved using fine mesh for recovery of fish bone and botanical remains (see Chapter 5). A 2 m by 5 m trench, Area D, was concurrently opened over a stone-built feature later discovered to be the western entrance passage into House 1 (see Chapter 4). A 1 m by 2 m trench,

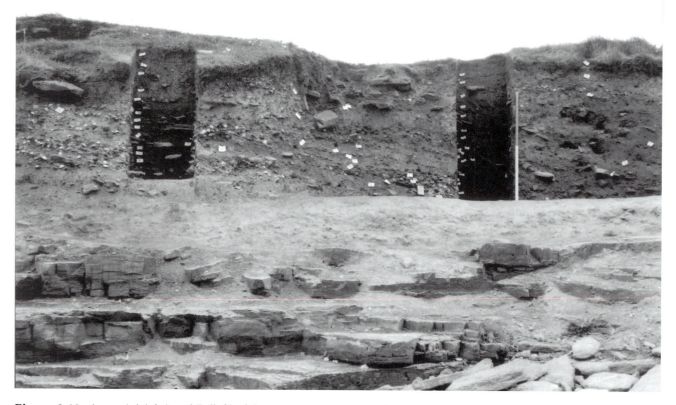

Figure 3.19. *Areas A (right) and B (left) of the tapestry excavation of the eroding Fish Midden. (Image: James Barrett.)*

Area E, was also excavated through the midden to provide mammal bone for zooarchaeological analysis. Collectively this work was intended to provide a relative chronology for the coastal settlement mound, to provide finely stratified samples for radiocarbon dating, to collect material for palaeoeconomic and palaeoenvironmental study and to clarify what the eroding stone structure was (it first looked like a small naust or a very large drain).

The concurrent survey work inland from the eroding section helped clarify that the coastal deposits were indeed part of a larger settlement (Section 3.5 above). Returning to the site in 1999 we thus opened Area F over the building originally identified as feature 5 during geophysical survey (Fig. 3.11). This intervention was expanded incrementally (to approximately 13.8 m by 31.3 m in maximum size) in subsequent field seasons until the entirety of what we now refer to as House 1, and most of underlying House 5, could be excavated (Chapter 4). We also turned our attention to the inland settlement mound, beginning Area G (of approximately 6 m by 8 m) in what had been the garden of the croft abandoned in 1937. Here auger survey had demonstrated that there was little rubble or masonry, allowing us to excavate

to the base of the mound in a realistic timeframe — and to recover large amounts of midden material for ecofact analysis. We later extended Area G to both south and north. The southern extension (of 0.7 m by 8 m, known as Area G2 when referred to separately from Area G in general) was dug to explore the stratigraphic relationship between the middens of the inland settlement mound and anthrosols to the south and east. The northern extension (of 3.5 m by 16.6 m, known as Area G3 when referred to separately from Area G in general) was dug in a successful attempt to locate the buildings from which the middens we were excavating had probably come. The original central intervention of Area G is designated Area G1 when specific reference is called for.

Area H was a small and uninformative intervention of approximately 2 m by 4 m (Fig. 3.10). It was dug to investigate feature 4 of the geophysical survey (Fig. 3.11). It is not discussed further, but the excavation of Areas A to G is considered in detail in Chapter 4. The final trenches, Areas J1 and J2 (Fig. 3.10), were dug to investigate what emerged to be an enclosed yard south of House 1.

Early in the excavation process it became clear that the coastal and inland settlement mounds at

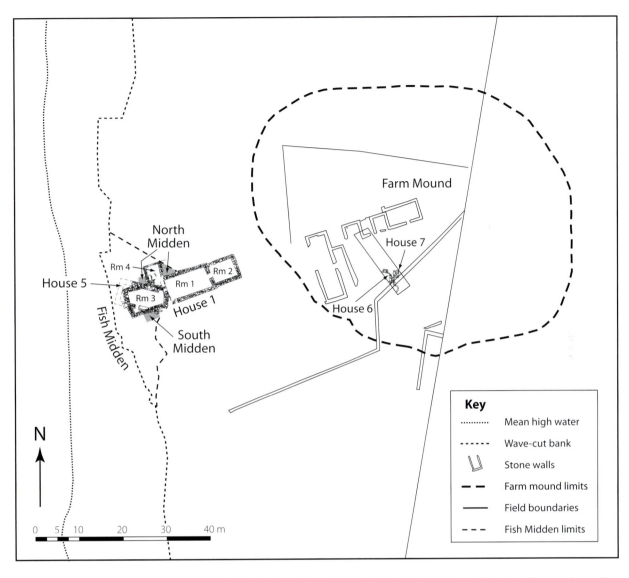

Figure 3.20. *Nomenclature of the main archaeological buildings and deposits discussed in the text. (Image: Lucy Farr, Dora Kemp and James Barrett.)*

Quoygrew differed in terms of their sediment characteristics and ecofact inclusions. Moreover, within each mound there were buildings, middens and anthrosols (each comprising many stratigraphic events or contexts — see Chapter 4) that could be defined as discrete deposits to a greater or lesser degree. In most instances the distinctive character of these deposits has been corroborated by post-excavation analysis. Thus they have served as units of analysis throughout the project — and acquired convenient names (e.g. Barrett 2005a; Simpson *et al.* 2005) that are retained in this publication (Fig. 3.20). The inland settlement mound in its entirety — composed of diverse household and farmyard refuse and the remains of buildings — is referred to as the 'Farm Mound', following

Norwegian terminology (Bertelsen & Lamb 1993; Østmo & Hedeager 2005, 156–7; see also Vésteinsson 2010). Conversely, the deposit exposed in the wave-cut bank at the shoreline — composed mostly of fish bone, marine shell and peat ash — is known as the 'Fish Midden' for self-explanatory reasons. The four houses identified by excavation are numbered 1, 5, 6 and 7. Walled spaces originally labelled structures 1, 2, 3 and 4 during excavation are all parts of House 1. Thus it has *Rooms* 1 to 4, and there are no houses numbered 2, 3 or 4.

The houses and rooms in turn defined deposits associated with both their use (e.g. floors) and disuse (e.g. midden fills). Most notable are the middens that accumulated in Rooms 2, 3 and 4 of House 1 during

the latest phases of its existence as a standing building. The chapters to follow will thus sometimes discuss the 'midden fill of Room 4', for example. Other deposits clearly accumulated against the outside walls of the buildings. The 'North Midden' and 'South Midden' of Area F were deposited around House 5 (and the South Midden continued to accumulate against later House 1). Unlike the deposits defined by rooms, the North and South Middens both gradually merged with the Fish Midden of the wave-cut bank. The absence of a clear archaeological boundary in this case is irrelevant, however, because safety concerns prohibited continuous excavation between the investigated portions of the middens adjacent to the walls of Houses 5 and 1 (to the east) and the cliff face (to the west) where the Fish Midden was principally sampled. When distinguishing the Fish Midden from the North and South Middens one is thus referring to two ends of a spatially structured continuum of refuse disposal. To put it simply, waste associated with fishing was predominately, but not exclusively, discarded at the seaward end of Houses 1 and 5.

Another kind of ambiguity applies to Houses 6 and 7 on the Farm Mound. They have not been excavated completely enough to always be sure what midden belongs with what building (or even to be certain of the number of buildings present). The refuse deposits associated with these houses are simply designated by their intervention (Area G3), to distinguish them from the main middens of the Farm Mound (in Area G1).

Lastly, as noted in Section 3.5 there were extensive areas of anthrosol to the north, east and south of the coastal and inland settlement mounds. The deepest and oldest of these, to the east, was probably an 'infield' associated with medieval Quoygrew (Simpson *et al.* 2005; Chapter 4). It is occasionally named as such in the pages to follow — reflecting both an interpretation and terminological convenience.

3.7. Conclusions

The landscape archaeology of Quoygrew, and the history of its change in name, suggest that it was part of a substantial multi-focal settlement around the head of Rack Wick during the Viking Age and Middle Ages. Collectively this settlement probably formed the nucleus of the *bý* farm later known as Trenabie, which was in turn the core of the substantial (*c.* 35 pennyland) township of Rackwick. Later, probably in the eighteenth century, the principal household of Trenabie was relocated to its present hilltop site and

Quoygrew began its transformation to a small croft.

Quoygrew's occupants were tenants of either the bishopric or earldom of Orkney in the fifteenth century. It is likely that this situation had existed for several hundred years. Moreover, before the granting of most of the township of Rackwick to the church the site was probably already part of a large property held by the earls and/or other magnates.

Quoygrew was part of a landscape that included a landing place (for transportation and fishing), a rocky foreshore (for collecting shellfish and seaweed), cultivated fields (for barley, oats and flax, see Chapter 10), wet meadows (for fodder), uncultivated hill land (for grazing, peat and turf), navigational landmarks (perhaps for locating fishing grounds in addition to safe passage) and reminders of the distant past (the Neolithic cairn at Vere). It was also connected to an explicitly ritual landscape to the south, marked first by pagan Viking Age graves and later by the parish church in Pierowall.

Quoygrew appears to have been a new foundation of the late Viking Age, reflecting an expansion or shift of settlement from pre-existing occupation in areas of calcareous sand (at sites such as Evertaft, Queena Howe and perhaps also Biggings). The settlement pattern also changed radically in post-medieval times, with a more dispersed distribution of houses created by infilling in the context of an eighteenth- to nineteenth-century population boom (Thomson 2008a, 378–83). More subtle variations in settlement must also have occurred between these major episodes of change, but they are beyond the resolution of the existing landscape evidence.

Quoygrew itself comprised two settlement mounds, one coastal and one *c.* 50 m inland. Each was composed of superimposed building remains and middens — and both were surrounded by cultivated anthrosols. Full details of the relevant stratigraphy, phasing and dating are considered in Chapter 4. For terminological convenience, however, the excavated portions of the mounds can be described as a series of houses and middens. Excavation of the coastal mound has revealed Houses 1 and 5, associated with the Fish Midden (at the shore), the North and South Middens (which mainly accumulated around House 5) and the midden fills of Rooms 2, 3 and 4 (in House 1). Work on the inland mound has exposed parts of Houses 6 and 7, associated with the Farm Mound middens (in general terms) and with the Area G3 middens (more specifically). The most substantial deposit of anthrosol, east and southeast of the Farm Mound, is interpreted and labelled as Quoygrew's infield.

Chapter 4

The Quoygrew Sequence

James H. Barrett and James F. Gerrard

4.1. Introduction and terminology

This chapter describes the settlement sequence at Quoygrew and provides the dating evidence that underpins the phasing of the excavation. The resulting chronology runs from Phase 1 (around the tenth century) to Phase 6 (the nineteenth to twentieth centuries), with Phase 0 indicating 'natural' (e.g. subsoil) and Phase 7 representing disturbed topsoil (Table 4.1). The results provide an interpretative framework for the excavated evidence.

Archaeological reporting is a balancing act. Firstly, there must be a compromise between clarity of presentation and attention to detail. We attempt to strike this balance by explaining problematic aspects of the sequence in some detail, but otherwise focusing on the description of things that constituted meaningful fixtures of daily life — be they houses, rooms, hearths, middens or yards. Secondly, it is essential to document both the archaeology that is central to one's research questions and the other irreplaceable evidence uncovered in the process. Thus this chapter considers the entire site sequence, from the occupation of the settlement in the Viking Age to its abandonment in 1937. Having said this, the majority of the excavated remains relate to Phases 1 to 4 (from the tenth to sixteenth centuries). The transitions from Phase 1 to 2, 2 to 3 and 3 to 4 are of greatest relevance to our goals of understanding identity and connectedness during periods of economic expansion and contraction in the Viking Age and Middle Ages. However, the later occupation of the site is no less interesting and must also be understood in order to avoid conflating separate phases of activity into a 'flat history'.

In some instances single *general* phases (e.g. Phase 2) could be subdivided into multiple *detailed* phases (e.g. Phase 2.1). Detailed phases were further subdivided in turn where stratigraphic resolution differed either side of a doorway. In House 1, for example, Phase 4.2 in Room 1 is equivalent to superimposed Phases 4.2.1 and 4.2.2 of Room 2. In other cases a given archaeological deposit could only be attributed to a group of phases (e.g. Phases 2 to 3 or Phases 2.2 to 2.4). The distinction between general phases was made on the basis of fundamental discontinuities in the character of deposition, episodes of building and/or episodes of demolition. Detailed phases were differentiated based on less dramatic changes in sediment characteristics and/or the laying of new internal features such as a hearth or floor.

Quoygrew was not without its stratigraphic puzzles. The robbing of stone from House 1 in antiquity provides several examples that will be discussed below. Nevertheless, the major phase transitions were all unambiguous. Interpretation has also been eased by circumstances that allowed JHB to be on-site during all of the field seasons and JFG to be consistently responsible for the stratigraphy of House 5 and Rooms 1, 3 and 4 of House 1.

Throughout this book each stratigraphic event (layer, cut, fill or structural feature) is described as a context — and referred to by a context number prefixed with the letter of the intervention from which it came (e.g. F001 is the topsoil in Area F).[6] Overall, 1466 contexts were identified and recorded. Each artefact (or 'small find') has also been given a number, preceded by the word 'find' or the abbreviations 'Sf.' (singular) or 'Sfs.' (plural). There are 4894 recorded finds from the excavation (excluding ecofacts and unworked materials such as fuel ash). Samples (volumes of sediment removed from a context for subsequent analysis) were also individually numbered (see Chapter 5). They do not figure in the present chapter, but elsewhere it is always made clear when a sample number is being referred to.

6. The drawn section of the wave-cut bank has context numbers without a letter prefix.

Table 4.1. *The Quoygrew phasing.*

Phase 1, *c.* tenth century
1.	Undifferentiated *c.* tenth-century contexts
1.1.	Palaeosol with some midden inclusions at base of Farm Mound in Areas G1 and G2
1.2.	Lower block of Farm Mound midden in Areas G1 and G2

Phase 2, *c.* eleventh–twelfth century
2.	Undifferentiated *c.* eleventh- to twelfth-century contexts
2.1.	Pre-House 5 deposits in Area F
2.2.	Earliest phase of House 5
2.3.	Middle phase of House 5
2.4.	Latest phase of House 5

Phase 2–3, *c.* eleventh–thirteenth century
Fish Midden and Farm Mound contexts with abundant fish bone and marine shell

Phase 3, *c.* thirteenth–fourteenth century
3.	Undifferentiated *c.* thirteenth- to fourteenth-century contexts
3.1.	Levelling for House 1, *c.* 1200
3.2.	Construction and lengthy initial phase of House 1, *c.* thirteenth century
3.3.	Second phase of House 1 occupation, thirteenth–fourteenth century
3.4.	Third phase of House 1 occupation, thirteenth–fourteenth century
3.5.	Fourth phase of House 1 occupation, *c.* fourteenth century
3.6.	Fifth phase of House 1 occupation, *c.* fourteenth century

Phase 4, *c.* fifteenth–sixteenth century
4.	Undifferentiated *c.* fifteenth- to sixteenth-century contexts
4.1.	Sixth phase of House 1 occupation, Room 2 added, *c.* 1400
4.2.	Seventh phase of House 1 occupation, fifteenth century
4.2.1	Second divisible phase of Room 2 occupation with an external door added
4.2.2	Third phase of Room 2 use, conversion to workshop
4.3.	Eighth phase of House 1 occupation, fifteenth–sixteenth century
4.3.1	Room 2 disuse, midden accumulation and roof collapse
4.3.2	Room 2 re-roofed and second door added
4.4.	Ninth phase of House 1 occupation, two episodes of paving in Room 2, fifteenth–sixteenth century
4.5.	Demolition of House 1, sixteenth–seventeenth century

Phase 5, *c.* seventeenth–eighteenth century
5.	Undifferentiated *c.* seventeenth- to eighteenth-century contexts, continued demolition and robbing of House 1

Phase 6, *c.* nineteenth–twentieth century
6.	Undifferentiated *c.* nineteenth- to twentieth-century contexts, including a garden in Area G and croft ruins

Phase 7
Topsoil and other disturbed contexts

4.2. Methods

4.2.1. Stratigraphic methods

The Quoygrew excavation proceeded by single observable context following a modified version of the Museum of London system (Westman 1994). Each context was described on a separate record sheet — and either drawn individually or included on a larger plan. Where groups of related contexts were very similar or disturbed they were sometimes combined as 'blocks' during post-excavation interpretation.

Stratigraphic links (direct or inferred) between these contexts and blocks make it possible to construct three main sequences for the excavation as a whole. During post-excavation analysis each of these sequences existed as a composite of Harris matrices for several discrete groups of contexts, such as the rooms of a house or layers of a sample column. One of the three main composite sequences was for Areas G1 to G3, referred to as Area G or the Farm Mound unless greater precision is called for (Figs. 4.1–4.3). A second was for the exposed section of the coastal wave-cut bank and for associated Areas A to E (Figs. 3.18, 4.4 & 4.5). A concordance of the stratigraphy of the recorded cliff face and the interventions excavated there is provided in Appendix 4.1. The third main sequence was for Areas F, J1 and J2 excavated to investigate House 1 (as identified by geophysical survey) and House 5 (discovered to underlie it). The stratigraphy of these buildings and their associated features is best illustrated as a series of phase plans (Figs. 4.6–4.15). There were a few direct stratigraphic links between the contexts of the wave-cut bank and Area F. However, the three main site sequences were

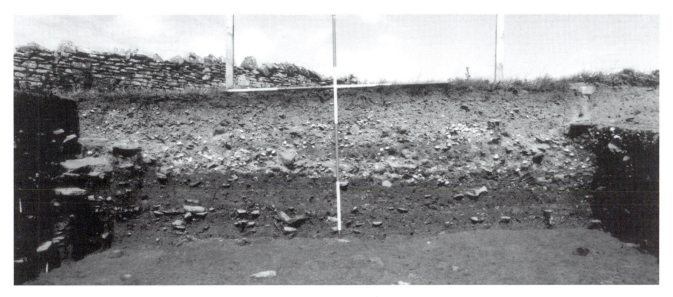

Figure 4.1. *South-facing section of Area G1. (Image: James Barrett.)*

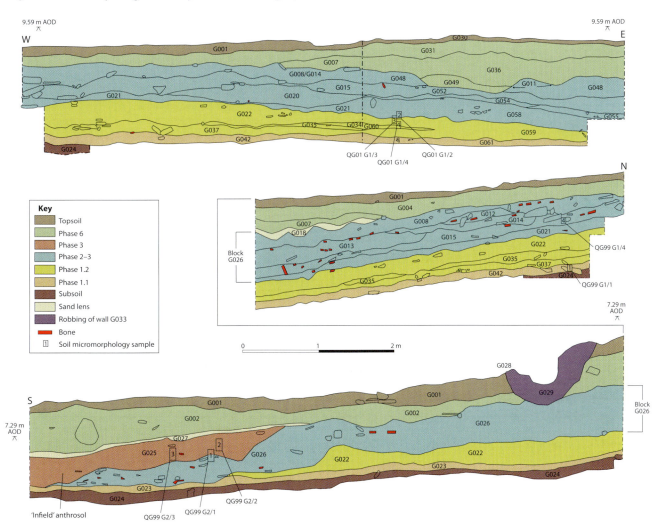

Figure 4.2. *South-facing (a) and east-facing (b) sections of Areas G1 and G2, including locations of soil micromorphology samples. (Image: Toby Simpson.)*

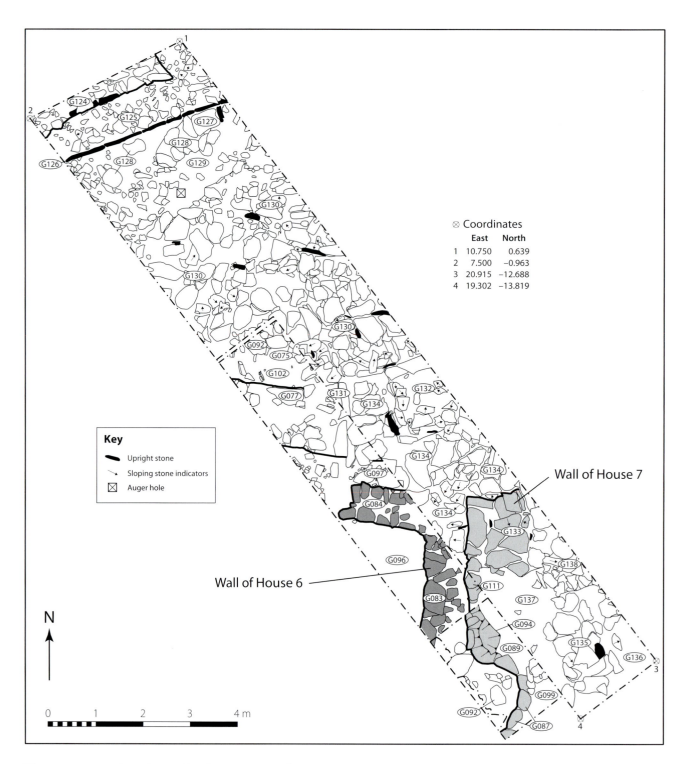

Figure 4.3. *Top plan of Area G3 showing parts of Houses 6 and 7 and associated contexts. (Image: Patrick Gibbs.)*

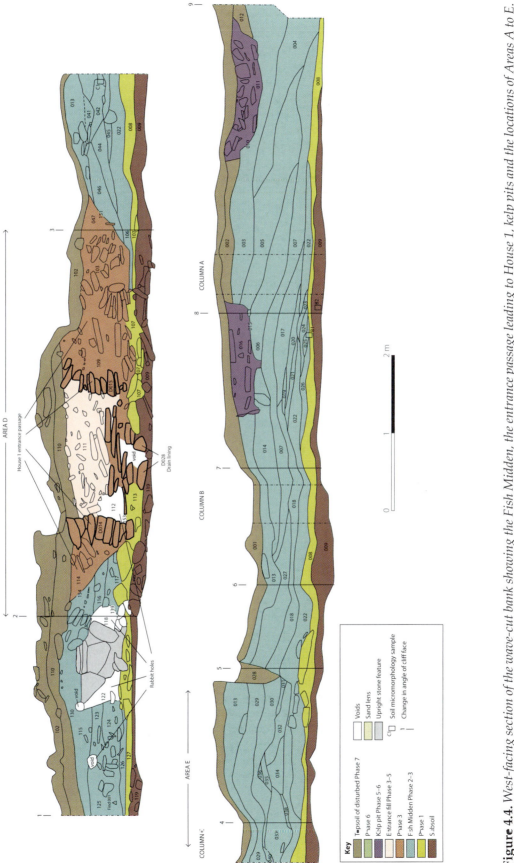
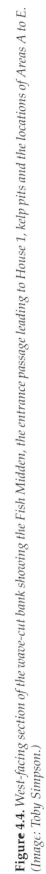

Figure 4.4. *West-facing section of the wave-cut bank showing the Fish Midden, the entrance passage leading to House 1, kelp pits and the locations of Areas A to E.* (Image: Toby Simpson.)

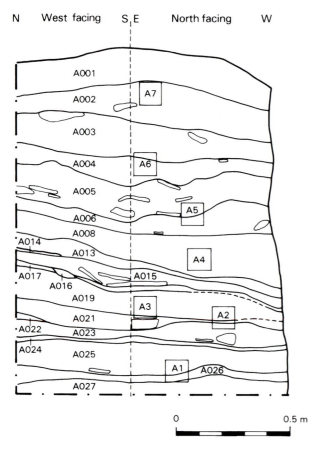

N West facing S E North facing W

A001
A002 A7
A003
A004 A6
A005
A006 A5
A008
A014 A008
A013 A4
A017 A015
A016
A019 A3
A021 A2
A022 A023
A024 A025
A1 A026
A027

0 0.5 m

Figure 4.5. *West- and north-facing sections of Area A in the coastal Fish Midden, including the locations of micromorphology samples.*

combined into an overall site phasing principally with the aid of radiocarbon and (to a lesser degree) artefactual dating evidence (see Tables 4.1–4.3 and Appendix 4.2).

Different parts of the excavation required differing approaches to stratigraphic lumping and splitting. In Areas A to C, all 50 cm sample columns, special attention could be paid to the subdivision of different dumping episodes within the Fish Midden (e.g. Fig. 4.5). Similar resolution was not possible within the open-area excavation of the Farm Mound middens, where contexts were instead groups of dumping episodes of very similar material (Fig. 4.2). In both instances, however, breaks between phases were based on clear interfaces.

House floors presented their own problems. Laid surfaces provided obvious divisions between detailed phases, but many floors had built up slowly from repeated sweepings of fireplace ash. In these instances we first identified a key feature (such as a hearth) and excavated out from it to reveal the contemporary floor plan.

The excavation and phasing of floor layers was also complicated by episodes of stone robbing in House 1. Flagstone floors were removed from Rooms 2 and 3 before the house collapsed. This was an uneven process. In Room 3, the latest central drain feature was left standing *above* the post-robbing floor surface in places. In Room 2, the latest (flagstone) floor layers were intact in some places and entirely missing in others (Fig. 4.16).

Another stone-robbing episode removed the wall between Rooms 1 and 3 (Fig. 4.17). At this time flagstones were also taken from the west end of Room 1 and parts of the walls of Room 4 were removed. This recycling of building stone obliterated most of the stratigraphic links between Rooms 1, 3 and 4. In Room 1 the flagstones were taken in a stepwise fashion, such that more of its floor survived the deeper one excavated (see Figs. 4.9–4.15). In all of these situations stratigraphic analysis was complicated and intrusive finds occurred. Similar caveats apply to the demolition and abandonment contexts at the top of the House 1 sequence in Area F. Here sixteenth- to nineteenth-century material has been mixed by ploughing and other disturbance, limiting the degree to which a coherent story can be told.

While phasing the site, efforts were also made to interpret the chronology of areas of manured and artificially thickened agricultural soils (variously known as anthrosols, plaggen soils or raised soils in the geoarchaeological literature). Radiocarbon and OSL dating were employed to help interpret these deposits (see below). In two instances they also had direct stratigraphic relationships with the main sequences.

4.2.2. Radiocarbon dating
The process of combining the stratigraphic sequences into an overall site phasing was informed by 58 accelerator mass spectrometry (AMS) radiocarbon dates. Fifty-six of these are for 'on-site' contexts and an additional two relate to an 'off-site' anthrosol (Table 4.2; Barrett 2005a; Simpson *et al.* 2005; Ascough *et al.* 2009). The samples were selected based on the following criteria. Firstly, materials were sought that, where practicable, provided boundary dates for changes in the stratigraphy and/or relatively even coverage throughout the site sequences. Thus each general phase of occupation is served by at least some absolute dating evidence and Bayesian modelling of the calibrated results is possible (Bronk Ramsey 2009). Secondly, materials were chosen in the following order of priority to maximize the stratigraphic integrity of the samples:
1. articulated groups of cattle or horse bones;

2. articulated groups of sheep bones;
3. cattle or horse bones collected as finds (with three-point provenance) in the field with a view to future radiocarbon dating — bones were only so treated if well sealed;
4. other large cattle or horse bones from clearly defined features where the above were not available;
5. charred barley or oat grains from hearths in phases where the above were not available;
6. charred barley or oat grains from floor deposits or stratified midden layers where *none* of the above were available;
7. other bone or charred botanical macrofossils.

Large cattle and horse bones were treated as the materials of first choice because they are unlikely to be very mobile within deposited sediments (although ancient re-deposition by humans is of course possible in some instances). Moreover, none of the cattle, horse or caprine bones used for radiocarbon dating have $\delta^{13}C$ values indicative of major consumption of marine fodders such as seaweed, fish waste, etc. (Table 4.2; Chapter 11). The dates on these species are thus unlikely to be biased by marine reservoir effects. The same cannot be said for the single pig bone included. With a $\delta^{13}C$ value of –19.5 it probably had a mixed diet of marine and terrestrial protein (cf. Barrett & Richards 2004; Balasse *et al.* 2005). It is thus not calibrated or considered further here. One additional date (TO-7044, 870±50 BP, published in Barrett 2005a and Simpson *et al.* 2005) produced very different $\delta^{13}C$ values on multiple measurement and is thus omitted from Table 4.2 as unreliable. Its inclusion would not, however, have altered the site chronology.

The unmodelled and modelled results, calibrated using OxCal 4.1 (Bronk Ramsey 2009) and the IntCal09 calibration curve (Reimer *et al.* 2009), are illustrated in Figures 4.18 to 4.20 in cases where the radiocarbon samples derived from clear and substantial stratigraphic sequences. Dates from layers with few or excessively complex contextual relationships are calibrated without Bayesian modelling and illustrated in Figures 4.21 and 4.22. All modelled and unmodelled calibrated results are provided in Table 4.2. Radiocarbon dates mentioned in the text are always modelled calibrations (if they have been calculated), and all results are given using the 95.4% probability range.

In almost all cases the radiocarbon dates are consistent with the site stratigraphy. The only exceptions to this rule come from contexts A004 and F238. A004 is the uppermost intact layer of the coastal Fish Midden — immediately below the zone that is obviously homogenized by soil fauna and later

human occupation (see Section 4.3.3 below). It has a wide range of radiocarbon dates suggesting mixed material (Fig. 4.21). This context is discussed further below when considering the chronology of the Fish Midden as a whole. Context F238 is redeposited subsoil laid to create the initial (Phase 4.1) floor of Room 2 in House 1. The single radiocarbon date on oat grain (SUERC-11956) from this layer is too old for its stage in the stratigraphic sequence (Table 4.2). It could thus represent an accidental recovery from the underlying ground surface or residual grain in the redeposited material.

Groups of botanical macrofossils — one of cereal grain (TO-7116) and one of heather charcoal (TO-7528) — from an anthrosol in Test Pit 2 (Simpson *et al.* 2005) also require special comment. They may be residual given the much earlier chronology implied by both samples *vis-à-vis* all other dates from Quoygrew. The heather in particular could derive from burned peat of indeterminate age. The alternative is that at least the grain implies prehistoric activity near the Viking Age and medieval settlement for which other evidence is lacking (see Chapter 3). The dates of this and other anthrosols at Quoygrew are considered further below.

4.2.3. Artefact phasing

The distribution of artefacts provides useful corroboration of the Quoygrew phasing as first determined by stratigraphy and radiocarbon dating. Table 4.3 summarizes a selection of finds that can be dated by typology and/or that demonstrate associations with particular phases (see Chapters 12 to 15 for further details). It also provides an interpretation of the phase in which a category of find first occurred, allowing for occasional intrusive examples in earlier layers. Residual material ensures that artefact types do continue to be found in low numbers after their main period of use. Nevertheless, it is clear (for example) that steatite vessels were characteristic of Phases 1 to 3, that Eidsborg hones (from the quarry of this name in southern Norway) were imported in Phases 2 and 3 and that both locally manufactured and imported ceramics were adopted in Phase 3.

Patterns of this kind confirm the overall integrity of the site phasing, but the artefact record does highlight instances that require qualification. The garden in Area G is nominally attributed to Phase 6 (the nineteenth to twentieth centuries), but also includes seventeenth-century clay pipes and ceramics of seventeenth- to eighteenth-century date. It may thus have been established earlier (see Section 4.3.8). Conversely, the layers of the Fish Midden and Farm Mound attributed to Phases 2 to 3 are virtually

Table 4.2. *Radiocarbon dates from Quoygrew.*

Context	Phase	Location	Lab code	Age BP ±1σ	δ13C	Unmodelled BC/AD (95.4%)	Modelled BC/AD (95.4%)	Material	Description and comments
Test Pit 2		Infield	TO-7116	2760±60	not reported	1049–805 BC		cereal grain	from anthrosol, possibly residual in transported sediment
Test Pit 2		Infield	TO-7528	1690±50	not reported	232–531		heather charcoal (burnt peat?)	from anthrosol, probably redeposited peat ash
G042	1.1	Farm Mound	SUERC-11924	1120±35	−21.2	782–1013	892–1014	cattle metatarsal	from palaeosol at base of Farm Mound midden, equivalent to G061
G061	1.1	Farm Mound	SUERC-11925	1045±35	−21.3	895–1034	897–1023	cattle metacarpal	from palaeosol at base of Farm Mound midden, equivalent to G042
G037	1.2	Farm Mound	AA-50702	1130±35	−19.5			pig skull	earliest context of Phase 1.2 in Farm Mound midden, δ13C shows partly marine diet so not used
F1145	2.1	Pre-House 5	SUERC-11935	975±35	−23.7	997–1156	999–1134	barley grain	from midden sealed under paving underlying the south wall of House 5
F1213	2.1–2.2	House 5	SUERC-11936	1000±35	−21.2	975–1155		cattle radius, Sf. 62253	from a pit fill predating or contemporary with the earliest occupation of House 5
F1198	2.2	House 5	SUERC-11937	990±35	−21.3	986–1155		cattle metacarpal, Sf. 62259	from the backfill of the construction cut for the south wall of House 5
F1203	2.2	House 5	SUERC-11938	980±30	−21.5	993–1155	1032–1160	neonatal calf humerus, Sf. 62249	from primary ash floor over pit fill F1213 (early occupation of House 5)
F1130	2.4	House 5	SUERC-11939	885±35	−21.5	1039–1220	1126–1212	cattle metacarpal, Sf. 62135	from one of the latest floor layers of House 5 – sealed by levelling deposit
F1115	2.4	House 5	SUERC-11943	860±35	−26.9	1046–1260	1130–1219	oat grain	from a dump of carbonised oats over the latest floor of House 5 and under the south wall of superimposed Room 3
F983	2.2–2.4	North Midden	SUERC-11969	955±35	−21.4	1019–1160	1020–1150	cow mandible	from undisturbed North Midden layer (containing articulated fish bones) cut by construction of House 1
F981	2.2–2.4	North Midden	SUERC-11968	935±35	−22.7	1022–1177	1030–1175	horse distal phalanx	from undisturbed North Midden layer (containing articulated fish bones) cut by construction of House 1
F1111	2.2–2.4	South Midden	SUERC-11966	900±35	−22.5	1038–1213	1041–1195	horse humerus, Sf. 62146	from the South Midden against House 5, overlies pre-House 5 midden dated by F1145 and underlies F653
F653	3–4	South Midden	SUERC-11967	860±35	−21.4	1046–1260	1052–1258	cattle mandible, Sf. 61573	from the South Midden against Room 3, overlies F1111
G058	2–3	Farm Mound	SUERC-11926	970±35	−21.9	999–1159	1016–1125	cattle radius from articulated group	from a midden layer at the bottom of Phase 2 to 3 of the Farm Mound
G020/G021	2–3	Farm Mound	AA-39135	905±60	−22.2	1020–1252	1025–1130	horse pelvis	early layer of Phase 2 to 3 in Farm Mound midden
G052	2–3	Farm Mound	SUERC-11927	945±35	−22.6	1020–1165	1031–1141	cattle tibia from articulated group	from a midden layer in the middle of Phase 2 to 3 of the Farm Mound
G008	2–3	Farm Mound	SUERC-11929	965±35	−22.7	1015–1160	1060–1165	cattle humerus	from the uppermost layer of the Farm Mound midden
G008	2–3	Farm Mound	SUERC-11928	925±35	−21.3	1025–1185	1051–1187	cattle metacarpal, Sf. 7094	from the uppermost layer of the Farm Mound midden
G101	2–3	Farm Mound	SUERC-11933	865±35	−25.2	1045–1258		oat grain	from the hearth of House 7
G090	2–3	Farm Mound	SUERC-11934	905±35	−22.8	1036–1210		horse mandible, Sf. 70256	from the sealed post-abandonment midden fill of House 6
G025	3	Farm Mound	AA-54914	685±55	−24.8	1228–1401	1186–1393	cereal grain	from anthrosol over Farm Mound midden
A026	1	Wave-cut bank	TO-7118	1220±50	not reported	674–940	730–991	barley grain	from palaeosol under the coastal Fish Midden
E034	2–3	Fish Midden	SUERC-11923	990±35	−21.4	986–1155	972–1097	cattle rib	from the earliest lens of the coastal Fish Midden
E030	2–3	Fish Midden	TO-7529	970±40	−21.4	994–1160	1020–1143	articulated calf	early layer of the Fish Midden, above E034

Table 4.2. (cont.)

Context	Phase	Location	Lab code	Age BP ±1σ	δ13C	Unmodelled BC/AD (95.4%)	Modelled BC/AD (95.4%)	Material	Description and comments
A023	2–3	Fish Midden	AA-52332	945±55	–22.4	996–1213	1047–1193	barley grain	early undisturbed layer in Fish Midden, stratigraphically above E034
A023	2–3	Fish Midden	SUERC-3160	940±35	–22.7	1021–1173	1047–1188	barley grain	early undisturbed layer in Fish Midden, stratigraphically above E034
A023	2–3	Fish Midden	SUERC-3161	940±35	–24.5	1021–1173	1047–1188	barley grain	early undisturbed layer in Fish Midden, stratigraphically above E034
A023	2–3	Fish Midden	AA-52329	875±45	–24.0	1039–1252	1046–1203	barley grain	early undisturbed layer in Fish Midden, stratigraphically above E034
A023	2–3	Fish Midden	AA-52330	835±40	–24.1	1051–1273	1047–1204	barley grain	early undisturbed layer in Fish Midden, stratigraphically above E034
A023	2–3	Fish Midden	AA-52331	835±40	–22.0	1051–1273	1047–1204	barley grain	early undisturbed layer in Fish Midden, stratigraphically above E034
A005	2–3	Fish Midden	TO-7530	860±40	not reported	1045–1261	1061–1264	barley grain	penultimate undisturbed layer of Fish Midden
A004	2–3	Fish Midden	AA-52325	710±80	–23.1	1164–1410		barley grain	latest layer of Fish Midden below homogenized topsoil zone
A004	2–3	Fish Midden	AA-52326	520±40	–24.5	1316–1448		barley grain	latest layer of Fish Midden below homogenized topsoil zone
A004	2–3	Fish Midden	AA-52327	585±65	–25.0	1285–1433		barley grain	latest layer of Fish Midden below homogenized topsoil zone
A004	2–3	Fish Midden	AA-52328	720±40	–28.4	1220–1387		barley grain	latest layer of Fish Midden below homogenized topsoil zone
A004	2–3	Fish Midden	SUERC-3149	980±40	–23.8	991–1157		barley grain	latest layer of Fish Midden below homogenized topsoil zone
A004	2–3	Fish Midden	SUERC-3542	875±35	–24.7	1040–1251		barley grain	latest layer of Fish Midden below homogenized topsoil zone
A004	2–3	Fish Midden	SUERC-3150	960±40	–24.7	996–1166		barley grain	latest layer of Fish Midden below homogenized topsoil zone
A004	2–3	Fish Midden	SUERC-3151	925±40	–24.1	1024–1206		barley grain	latest layer of Fish Midden below homogenized topsoil zone
A004	2–3	Fish Midden	TO-7117	800±50	not reported	1054–1287		barley grain	latest layer of Fish Midden below homogenized topsoil zone
F740	2–3	Fish Midden	SUERC-11944	900±35	–20.9	1038–1213		sheep vertebra	from an articulated group in a Fish Midden layer cut by construction of Room 3
F502	3.2	Room 1	SUERC-11945	980±35	–20.9	993–1155		cattle radius, Sf. 61172	from the rubble fill of a lintel-covered eves-drip drain south of Room 1
F946	3.2	Room 1	SUERC-11947	850±35	–21.1	1048–1264	1180–1255	neonatal cattle scapula, Sf. 61901	from a primary floor of Room 1
F960	3.2	Room 1	SUERC-11948	825±35	–21.6	1155–1275	1182–1255	cattle rib, Sf. 61907	from a primary floor of Room 1
F885	3.2	Room 1	SUERC-11949	805±35	–21.4	1170–1275	1211–1276	cattle rib, Sf. 61684	from an upper floor of Phase 3.2 in Room 1
F564	3.5	Room 1	SUERC-11954	570±35	–24.9	1300–1427	1296–1400	barley grain	from the fill of a small sub-floor pit (dug and filled in Phase 3.5)
F462	3.6	Room 1	SUERC-11955	590±35	–24.1	1296–1415	1320–1414	barley grain	ash from the central hearth of Room 1
F238	4.1	Room 2	SUERC-11956	775±35	–24.6	1189–1285		oat grain	from redeposited subsoil spread to level the earliest floor of Room 2, residual?
F206	4.2.1	Room 2	SUERC-11957	460±35	–24.1	1407–1485	1414–1478	barley grain	from an ash floor of Room 2
F129	4.3.1	Room 2	SUERC-11959	345±35	–25.7	1462–1640	1451–1567	barley grain	from midden during disuse of Room 2, sealed by roof-collapse
F071	4.3	Room 1	SUERC-11958	330±35	–24.6	1470–1644	1452–1565	barley grain	ash from the central hearth of Room 1
F011	4.4	Room 1	SUERC-11963	325±35	–21.7	1472–1645	1472–1630	barley grain	ash from the last central hearth of Room 1
F796	3.2	Room 3	SUERC-11946	800±35	–22.0	1175–1277	1219–1282	cattle calcaneus, Sf. 62200	from a primary floor of Room 3 (gnawed as a dog's 'worry bone')
F1060	3	Room 3	SUERC-11953	685±35	–21.9	1264–1391	1261–1321	horse metacarpal, Sf. 62199	from an articulated group in an ash dump overlying the Phase 3.2 flagstone floor in Room 3
F761	3–4	Room 3	SUERC-11964	595±35	–22.7	1296–1412	1285–1400	horse atlas, Sf. 61964	dump of sand and stone, pre-dates main midden fills
F602	4	Room 4	SUERC-11965	300±35	–21.7	1483–1660		cattle tibia	from midden fill of Room 4

Table 4.3. *Selected artefactual dating evidence from Quoygrew (see Chapters 12 to 15). An asterisk indicates presence.*

Phase in which finds first appear (allowing for probable intrusive and residual specimens)

General phase	Detailed phase	Major stratigraphic events	Nail-headed pins (c. tenth century?) [1]	Type 6 combs/comb case (c. tenth century) [1]	Iron mounts (c. tenth–c. thirteenth century) [1]	Hemispherical steatite vessels [2]	Four-sided steatite vessels [2]	Ceramic Fabric 4a [2]	Intensive fish-bone deposition [2]	Eidsborg hones [2]	Type 9 combs (late tenth–thirteenth century) [2]	Type 8a combs (tenth–twelfth century) [2]	Type 8c combs (c. twelfth–thirteenth century) [2]	White gritty ware (c. twelfth-century type) [3]	Coil-built organic-tempered wares (fabrics 1–3) [3]	Type 13 comb (twelfth–fifteenth century) [3]	White gritty ware (mid twelfth–fifteenth/sixteenth century) [3]	German proto-stoneware? (late thirteenth century+) [3]	Schist bake stones (twelfth century+) [4]	Scottish redware (thirteenth–fifteenth century) [4]	German stoneware (mid fourteenth century–fifteenth/sixteenth century) [4]	Clay pipes (seventeenth-century types) [5]	Pipkins (seventeenth- to eighteenth-century types) [5]	Tin-glazed earthenware (eighteenth century) [5]	Pearlwares (late eighteenth–early nineteenth century) [5]	Lead-glazed redware (eighteenth–nineteenth century) [6]	White earthenwares (nineteenth century+) [6]
1	1.1	Palaeosol and midden	2	1	1			1																			
	1.2	Midden			1	3		3																			
2	2.1	Pre- House 5 paving																									
	2.2	House 5: construction and initial occupation				1	1			1																	
	2.3	House 5: second occupation level									3																
	2.4	House 5: third occupation level				4	1			1					1												
		House 5: north midden and associated features					3		*	3	1				8												
2–3		Farm Mound and Fish Midden		2	1	8	15	1	*		1	3	4	1	2												1
		Contexts around Houses 1 and 5				3	4		*						9					1							
3	3.1	Demolition of House 5 to accommodate House 1					4								3			1									
	3.2	House 1: construction and lengthy initial occupation				1	1	1		2					26	1	1	1									
	3.3	House 1: second occupation level								2					5		1										
	3.4	House 1: third occupation level								1					36		1		2								
	3.5	House 1: fourth occupation level				2				2					64						1						
	3.6	House 1: fifth occupation level													9												
		House 1: pre-extension occupation				3	2				1				56					1							
3–4		Life-span of House 1				1									144		1			1							
4	4.1	House 1: Room 2 added and sixth occupation level					1								28					1						1	2
	4.2	House 1: Room 2 altered and seventh occupation level													93					2							

Table 2.3. (cont.)

Phase in which finds first appear (allowing for probable intrusive and residual specimens)

General phase	Detailed phase	Major stratigraphic events	Nail-headed pins (c. tenth century?) [1]	Type 6 combs/comb case (c. tenth century) [1]	Iron mounts (c. tenth–c.thirteenth century) [1]	Hemispherical steatite vessels [2]	Four-sided steatite vessels [2]	Ceramic Fabric 4a [2]	Intensive fish-bone deposition [2]	Eidsborg hones [2]	Type 9 combs (late tenth–thirteenth century) [2]	Type 8a combs (tenth–twelfth century) [2]	Type 8c combs (c. twelfth–thirteenth century) [2]	White gritty ware (c. twelfth-century type) [2]	Coil-built organic-tempered wares (fabrics 1–3) [3]	Type 13 comb (twelfth–fifteenth century) [3]	White gritty ware (mid twelfth–fifteenth/sixteenth century) [3]	German proto-stoneware? (late thirteenth century+) [3]	Schist bake stones (twelfth century+) [3]	Scottish redware (thirteenth–fifteenth century) [4]	German stoneware (mid fourteenth century–fifteenth/sixteenth century) [4]	Clay pipes (seventeenth-century types) [5]	Pipkins (seventeenth- to eighteenth-century types) [5]	Tin-glazed earthenware (eighteenth century) [6]	Pearlwares (late eighteenth–early nineteenth century) [6]	Lead-glazed redware (eighteenth–nineteenth century) [6]	White earthenwares (nineteenth century+) [6]
	4.2.1	House 1: second floor & external door of Room 2			1		1								36					11	3						
	4.2.2	House 1: Room 2 converted to workshop													12					5							
	4.3	House 1: Room 2 disuse and eighth occupation level													25		2			2							1
	4.3.1	Midden accumulation and roof collapse in Room 2													31					1							
	4.3.2	Room 2 re-roofed and second door added																									
	4.4	House 1: paving in Room 2 and ninth occupation level													43					1							
	4.5	Demolition of House 1								1					139					9							
		House 1: post-extension occupation					1								303												
4–5		Latest use, demolition and robbing of House 1				1									352					12	2	2			1	2	8
5		Continued demolition and robbing of House 1																									
5–6		Post-abandonment of House 1				1									47					2			4		2	16	39
6		Post-medieval garden in Area G																		1	1	4	6	3	1	54	128
7		Topsoil and other disturbed contexts								1					66					1	1	2	12	2	18	151	405
Other						1	2								94		1							1	2	15	14
Totals			2	3	3	29	37	5	0	14	6	3	4	1	1632	1	6	1	2	50	7	8	22	6	24	239	598

Table 4.4. *Optically stimulated luminescence dates from Quoygrew (after Sommerville et al. 2003). The Area G samples date the base of the garden associated with the post-medieval croft. The test-pit samples date recent anthrosols south of the main settlement focus.*

Intervention	OSL sample	Field gamma dose rate (m Gya–1)	Effective dose rate (m Gya–1)	Wtd mean stored dose (Gy)	Age (years before AD 2000)	Date AD (68.3%)
Area G	703	0.335±0.005	1.022±0.076	0.49±0.02	480±40	1480–1560
Area G	704	0.335±0.005	1.148±0.09	0.6±0.04	520±55	1430–1530
Test Pit 101	101 (layer 1)	0.625±0.07	1.118±0.1	0.31±0.04	275±45	1680–1770
Test Pit 102	901 (layer 3)	0.449±0.05	0.921±0.116	0.21±0.03	260±45	1695–1785
Test Pit 102	902 (layer 5)	0.31±0.03	0.8±0.087	0.11±0.01	120±20	1860–1900

aceramic. What little pottery they do contain is either industrial (thus clearly intrusive), from upper contexts, or of very early type. These observations make it likely that 'Phases 2 to 3' of the Fish Midden and Farm Mound actually accumulated mostly in Phase 2, as discussed further in Section 4.3.3.

4.2.4. Optically stimulated luminescence (OSL) and archaeomagnetic dating

Although the site chronology is based primarily on the stratigraphic and radiocarbon sequences (qualified by the artefact record), the techniques of archaeomagnetic and optically stimulated luminescence (OSL) dating were also employed where relevant. Archaeomagnetic dating was attempted on seven hearth contexts from the House 1 sequence. Five of these yielded measurements (one being too friable and one lacking high-intensity magnetization). However, they produced a reverse stratigraphic sequence. Given that the substantial hearth features in question (e.g. Fig. 4.23) cannot have been intrusive or residual, Outram and Batt (2005; pers comm.) conclude that a methodological problem must be responsible — probably the exposure of early hearth deposits to intense heat from overlying fireplaces. The results are thus not discussed further here.

OSL dating was carried out as a collaboration with the Scottish Universities Environmental Research Centre (Sommerville 2003; Sommerville *et al.* 2003). This method, which dates the time since sediment was last exposed to light, was employed where buried layers of windblown sand had a direct stratigraphic relationship with one or more archaeological contexts of interest. Within the main interventions there was one relevant sand layer — in Area G where it separated the medieval middens of Phases 2 to 3 from an overlying garden soil nominally attributed to Phase 6. Sand horizons also underlay and/or overlay an anthrosol that stretched south of Area F. They were dated by OSL in Test Pits 101 and 102. The results (68.3% probability range) are provided in Table 4.4 and discussed below in stratigraphic context.

4.3. The occupation phases

4.3.1. Phase 1

The earliest well-dated contexts at Quoygrew were at the base of the Farm Mound in Area G (Figs. 4.1 & 4.2). They included a palaeosol with some midden inclusions (Phase 1.1) and an overlying deposit of *c.* 0.3 m of undisturbed midden (Phase 1.2). At their broadest these layers are of late ninth- to eleventh-century date, but both the radiocarbon (Fig. 4.18) and finds (Table 4.3) evidence is most indicative of the tenth century. The buildings from which the midden material derived have not yet been found. They probably underlie more recent examples on the Farm Mound — including Houses 6 and 7 in Area G3 (see below). Nevertheless, it is safe to say that the settlement at Quoygrew was established by the tenth century. It is notable that Phases 1.1 and 1.2 produced four sherds of an organic-tempered ceramic with quartz grits. These may represent the last expressions of a Pictish and/or early Viking Age ceramic tradition in Orkney (see Chapter 15).

A palaeosol under the Fish Midden at the shoreline has also been attributed to Phase 1 based on a radiocarbon date of AD 730–991. It produced no finds and few ecofacts.

4.3.2. Phase 2

Phase 1 ended at an abrupt interface with a series of midden layers dominated by high concentrations of fish bone and marine shell (see Fig. 4.1). These were encountered in the Farm Mound (where the relevant contexts are grouped as block G026) and near the shoreline. In the latter case they comprised the Fish Midden, the North Midden and Phase 2 of the South Midden. These deposits were extensive and thick. The Fish Midden, the largest example, stretched for *c.* 40 m along the wave-cut bank and was *c.* 1 m in thickness (in its central 20 m which were recorded in detail, see Figs. 3.18, 3.19 & 4.4). The North and South Middens are inland extensions of the same large deposit, with slightly different compositions having accumulated immediately around a dwelling

(see below). In the Farm Mound, block G026 reached c. 0.5 m in depth in Area G1. It was exposed for c. 15 m north–south in Area G (Fig. 4.2), and may cover a much larger area based on auger survey (Chapter 3).

Although these deposits shared an abundance of shell and fish bone they did differ in other ways. Soil micromorphology has been used to characterize the Fish Midden and block G026 of the Farm Mound (Simpson *et al.* 2005). In the former, the fish bones and shells were held within sediment composed mostly of peat ash, whereas the matrix of the latter was consistent with the deposition of turf construction material, animal bedding and peat and turf fuel residues. There were also subtle differences between the fish bones found in the Fish Midden, the North Midden, the South Midden and the Farm Mound (see Chapter 7). It is likely, for example, that fish *processing* waste made up a major component of the Fish Midden whereas fish *consumption* refuse was discarded in the other middens. The ash matrix of the Fish Midden may result from the boiling of fish livers to produce oil, a major source of lamp fuel in Atlantic Scotland and also a potential export product in the Middle Ages (see McGregor 1880; Vollan 1959, 343–4; Fenton 1978, 527–31; Nicholson 2004).

The radiocarbon dates from all of these 'maritime' deposits suggest that they first began to accumulate within the eleventh to twelfth centuries — perhaps in the eleventh century based on the earliest date from the Fish Midden (AD 972–1097) (Table 4.2, Figs. 4.18 & 4.19). The artefactual evidence is consistent with this chronology (Table 4.3). The date at which they ceased to accumulate is considered below.

The start of Phase 2 was also marked by the building of House 5 (Fig. 4.24) — and by paving episodes and midden spreads (Phase 2.1) that predated it on stratigraphic grounds but produced indistinguishable radiocarbon dates (Table 4.2). The house was built in the eleventh to twelfth centuries based on both the radiocarbon and small finds evidence (Tables 4.2 & 4.3, Fig. 4.20). It had three phases of use (2.2, 2.3 & 2.4), but by AD 1130–1219 (the date of a dump of charred oats, chaff and ash) the house was abandoned. The style of the house — including side aisles, but with the roof supported on the walls rather than two rows of internal posts — is consistent with this chronology. It is characteristic of late Viking Age and early medieval architecture in Scandinavia (including the North Atlantic colonies). The trend away from using internal posts is dated to approximately the tenth and eleventh centuries in Denmark, Norway and the Norse colonies of the North Atlantic (Hvass 1993; Skov 2002; Norr & Fewster 2003, 116–17; Lucas 2009, 373–4). However, these features did continue later in the related Hiberno-Norse architecture of urban Ireland (Wallace 1992a, 22) and in Icelandic outbuildings (Berson 2002, 42–3).

There was no stone demolition rubble of any kind, indicating that the superstructure must have been of other materials. It is thus interpreted as a turf building constructed on a clay foundation with a low internal facing of stone. It also had some external stonework around the entrances. The interior lining may originally have been five courses high — based on the best-preserved section of the surviving wall (Fig. 4.25). The internal floor space was c. 3.9 m wide and probably c. 10 m long (based on remnants of the western gable wall of the house observed in the eroding cliff section when the site was being consolidated for public display in 2006) (Fig. 4.6).

In Phase 2.2 the living surface began as natural subsoil, but was quickly augmented with deposits of ash and burnt peat in the east (F1171, F1172, F1173, F1180, F1181, F1182 and F1184) and more midden-rich layers in the west (F1203). A lintel-covered central drain (F1174 and F1175) ran through most of the length of the house, flanked by gullies holding edge-set stones that demarcated side aisles. The only unequivocal access in Phase 2.2 was through a doorway in the south wall (F1087) paved with sandstone slabs (F1190). There might also have been an entrance in the centre of the eastern gable, but the wall was robbed to only one to two courses of stonework during the subsequent building of House 1 so this must remain conjectural. A central arrangement of sandstone slabs (F1175) may represent a hearth. The stones were not obviously burnt, but were covered by a spread of ash c. 0.1 m thick, with occasional flecks of charcoal (F1167). The ashy composition of the floor layers also makes it clear that this house had a fireplace.

In Phase 2.3 (Fig. 4.7) the southern doorway acquired new flagging (F1156) associated with a pivot stone (Sf. 62134). Central paving (F1166) perpetuated the line of the drain and the northern side aisle was maintained (F1177 and F1216). The southern side aisle no longer functioned, having been covered by layers of ash floor (F1152, F1164 and F1184). The eastern end of the room was demarcated instead — by the terminus of the northern side aisle and by a stone setting to the south (F1160 and F1168). Swept peat ash continued to form floor layers in the eastern half of the house. Moreover, two heavily burnt sandstone slabs (F1154 and F1161), overlain by a yellow and brown deposit of peat ash (F1153), were being used as a hearth by the end of Phase 2.3. In the western part of the building the floor deposits (F1159) contained more fish bone, shell and other midden material than

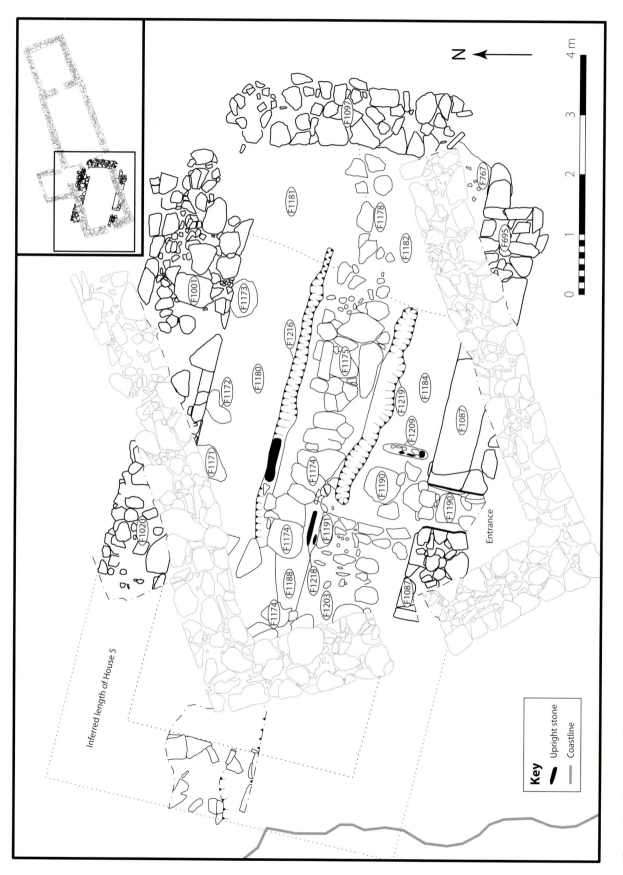

Figure 4.6. *House 5 in Phase 2.2. (Image: Patrick Gibbs.)*

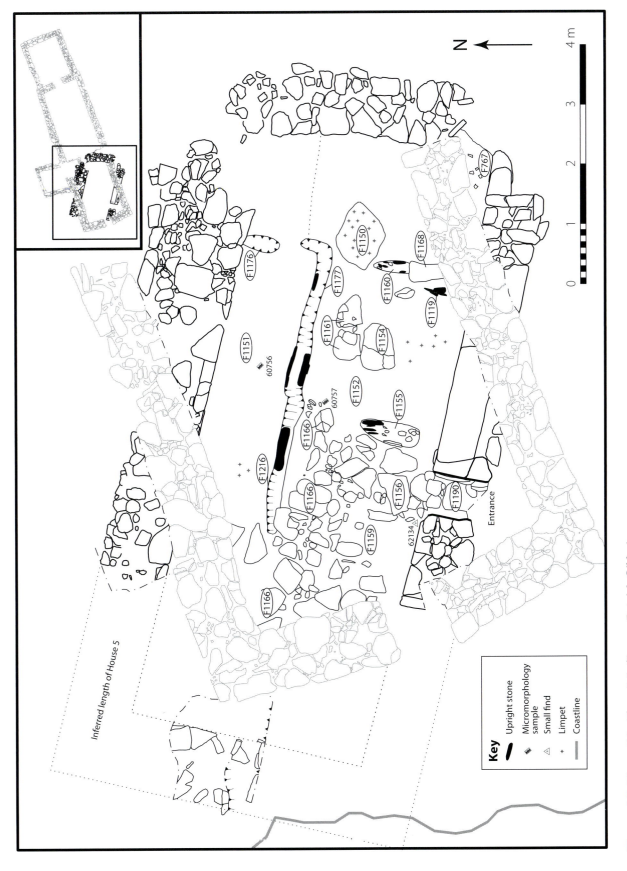

Figure 4.7. *House 5 in Phase 2.3. (Image: Patrick Gibbs.)*

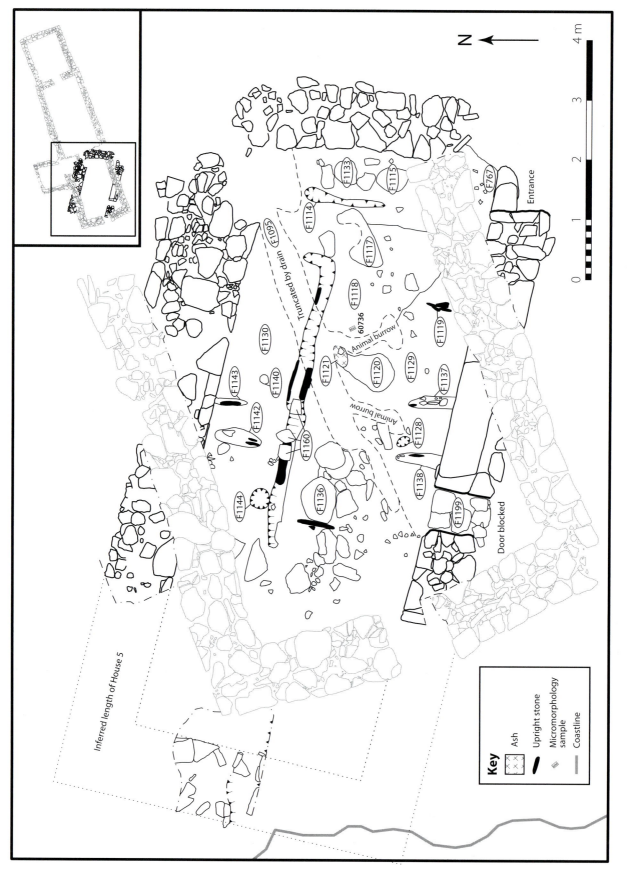

Figure 4.8. *House 5 in Phase 2.4. (Image: Patrick Gibbs.)*

elsewhere — perpetuating the different use of space observed in Phase 2.2.

Understanding House 5 in its final Phase (2.4) is complicated by the construction of a drain (F1095) for House 1 in Phase 3.2 — and the modification of this feature by rabbits that used it as a burrow (Fig. 4.8). Thus a complete floor plan could not be recovered and stratigraphic links have been severed. Nevertheless, features of the final floor are discernible. The entrance in the centre of the south wall was blocked with stone (F1199) and a new doorway (F767) placed in the southeast corner of the house. A flagstone path (F1133) inside this new door was flanked by the groove for a stone setting (F1114) — perhaps serving as a threshold into the main living area. The northern side aisle was maintained, as was paving over the central portion of the drain (F1136). Curiously, a large edge-set stone was inserted across the drain in this paved area. It would have impeded drainage, but an identical feature has been observed in a medieval house at Belmont in Shetland.[7] It could conceivably represent an effort to keep fluids from the downhill (byre?) end of the house from backing up into the living space. A small pit with a charcoal-rich fill (F1144) was placed just inside the edge of the northern side aisle. Several settings of upright stones against the north and south walls represent minor subdivisions of the internal space. Also notable is the truncated edge of a probable hearth (F1121) with associated ash (F1120).

One of the latest discernible acts within House 5 was the deposition of a dump of charred oats, chaff and ash (F1115, noted above in the context of radiocarbon dating the house) in the entrance vestibule defined by F1114. This soft deposit showed few signs of having been trampled or disturbed, suggesting that there was little traffic through the southeast door after its deposition. It was sealed by the overlying wall of Room 3 in House 1.

The artefact assemblage from Phases 2.2 to 2.4 of House 5 is worthy of special note. Firstly, it is virtually aceramic, including only a single sherd of pottery (Sf. 62141, a coil-built and organic-tempered fragment from Phase 2.4). Secondly, it is dominated by objects of Norwegian provenance and/or style (an issue to be discussed further in Chapter 16). These included five hones from the Eidsborg quarry in southern Norway (Sfs. 62133, 62142, 62143, 62145 and 62238), four combs of Ashby type 9 that are likely to be imports from Norwegian towns such as Bergen, Trondheim or Oslo (see Chapter 13) and a reworked

section of a whale bone weaving sword of Norwegian type (Sf. 62136). Two sherds of steatite cooking pot (Sf. 62137 and 62154) were also attributed to Norway based on chemical characterization (Chapter 12). House 5 did, nevertheless, contain some objects of more local origin. Four steatite vessel sherds (Sfs. 62127, 62138, 62234 and 62255) were attributed a probable Shetlandic origin by chemical analysis (Chapter 12) and an iron fish hook (Sf. 62231) could have been either imported or manufactured locally.

4.3.3. Phase 2–3

The Fish Midden, the South Midden and the North Midden all accumulated around House 5 during its use — it was the South Midden that overwhelmed the original door in the south wall of the house. Of these, the North Midden ceased to accumulate by the end of Phase 2. Its uppermost stratum was cut during the construction of House 1 at the start of Phase 3 (see below). Similarly, the contexts of the South Midden that were rich in fish bone and marine shell were cut by the southern wall of Room 3 of House 1. Conversely, the Fish Midden along the shoreline probably continued to accumulate for a brief time into Phase 3. It covered the west end of House 5 after it was abandoned (as observed in the wave-cut bank during the watching brief in 2006) and its uppermost context (F647) accumulated against the western gable of House 1.

It is difficult to suggest precisely when the Fish Midden stopped being deposited. The radiocarbon dates are uninformative in this regard. As noted in Section 4.2.2 above, the dates from context A004 (the uppermost layer of the Fish Midden that was not clearly homogenized by later disturbance) are very diverse. It is likely that material from the occupation of House 1 (thirteenth to sixteenth centuries) has been mixed into this context.

It is therefore the stratigraphic evidence noted above and the artefact record that provide the best indication that the Fish Midden went out of use near the start of Phase 3. The deposit contains only two sherds of pottery (one of fabric 4 and one of fabric 5, see Chapter 15). Both are from upper contexts (B003 and F647) and thus probably intrusive. If the Fish Midden had accumulated for any length of time in Phase 3 it would instead have included many sherds of fabrics 1 to 3 — the organic-tempered wares that were common by Phase 3.2 in House 1 (Table 4.3). An early Phase 3 date is also suggested by an antler comb of Ashby (2007) type 9, Wiberg (1977) type E5-3, found discarded or lost adjacent to the western gable of House 1 at the top of context F647 (Sf. 61509, see Figure 4.26). It is broadly datable to the tenth to

7. As observed by JHB during a conference excursion in 2009 (see Bond *et al.* 2008 for an interim report on this site).

thirteenth centuries, with a floruit in the twelfth century (see Chapter 13).

Turning to the Farm Mound, the middens rich in fish bone and shell (block G026) probably ceased to accumulate around the same time as the Fish Midden. The earliest overlying date, on cereal grain from an anthrosol deposited along the southern margin of the mound, is AD 1186–1393. However, the latest radiocarbon dates for contexts of block G026 itself (in Area G1) are of the late eleventh and twelfth centuries (Table 4.2, Fig. 4.18). It is possible that the Area G1 deposits were truncated by the digging of an overlying garden (see Section 4.3.8 below), but the uppermost excavated deposit of the Farm Mound middens is likely to be the *in situ* fill of House 6 in Area G3 — outside the walled garden area — which produced a radiocarbon date of AD 1036–1210 (Table 4.2; see below). Like the Fish Midden, the relevant layers of the Farm Mound are also virtually aceramic (see Table 4.3, Chapter 15). What little pottery they do contain is either industrial (six sherds) and thus clearly intrusive, from an upper context (four sherds of organic-tempered wares from G048) or of very early type (one sherd of white gritty ware of probable twelfth-century form).

Taking a cautious approach, the Fish Midden and block G026 of the Farm Mound are attributed to Phases 2 to 3. It is evident, however, that all but the uppermost contexts of both deposits accumulated in Phase 2 (the eleventh and twelfth centuries). Thus for purposes of comparison they are essentially contemporary with House 5, the North Midden and the South Midden.

The main structural remains and middens of Area G3 (Fig. 4.3) are similarly attributed to Phases 2 to 3 with the caveat that most belong to Phase 2. This trench was opened to see if a flagstone pathway (G016) sandwiched by the middens of block G026 in Area G1 implied the existence of houses to the northwest. It was closed (due to limited resources) after the existence of medieval buildings was confirmed.

The earliest layers were middens (G105 and G089) broadly equivalent to the adjacent deposits of block G026 in Area G1. Into these was inserted a revetment wall of upright and coursed stonework (G087, G103, G111 and G133) that forms a possible corner niche within a semi-subterranean building (House 7). Several superimposed hearths (G100, G101, G107 and G110) were constructed in this niche (Fig. 4.27). The use of upright stones and semi-subterranean construction are typically considered to be pre-Viking Age building techniques in Orkney (e.g. Graham-Campbell & Batey 1998, 161), but the style was continued into the Middle Ages at Quoygrew

(both here and in Room 4 of House 1). The corner feature may have been intended as a kiln for drying grain, by analogy with a broadly contemporary building at Beachview in Birsay, Orkney (Morris 1996a, 111). Based on the archaeobotanical evidence, however, it may also have been used for lye production in one instance (see Chapter 10).

A new building, House 6, was superimposed on House 7 by adding revetment wall G083 against G111. Only the corner of House 6 is presently exposed, where G083 is keyed into G084. Inside the angle of G083/G084 a series of midden deposits (e.g. G090 and G096) were excavated that have been interpreted as post-abandonment fills. These included a horse mandible (Sf. 70256) radiocarbon dated to AD 1036–1210, providing a *terminus ante quem* for the underlying sequence (Table 4.2). No pottery was found in these layers, consistent with a date in Phase 2 or (at latest) the earliest years of Phase 3.

North of House 6, a series of large flat stones (G097) were keyed into both G084 and a further wall (G077). G077 bounds a series of undisturbed midden layers (e.g. G102). Any interpretation of G077 and other possible lengths of wall (e.g. G132) would be ambiguous. They represent a palimpsest of building and destruction episodes that require open-area excavation to disentangle — as also implied by resistivity survey of the Farm Mound (Chapter 3). Like the post-abandonment deposits inside House 6, most of these layers are aceramic and have thus also been dated to Phases 2 to 3, with the caveat that they are most consistent with Phase 2.

The remaining contexts attributed to Phases 2 to 3 at Quoygrew are ambiguously stratified layers such as contexts F053 and F054 north of House 1. It is these deposits that produced finds characteristic of Phase 3 (e.g. ceramics) that were rare or absent from the 'Phase 2 to 3' contexts of the Fish Midden and Farm Mound discussed above.

4.3.4. Phase 3

The levelling of House 5 (Phase 3.1) and subsequent construction of House 1 (Phase 3.2) define the transition to Phase 3. In its initial configuration, House 1 consisted of Rooms 1, 3 and 4 — a living room or 'hall', a byre and a probable store room respectively (Fig. 4.9). The maximum internal dimensions of Room 1 were 4.9 m by 9.9 m. Room 3 was 4.9 m by 8 m and Room 4 was 3.0 m by 3.4 m. The maximum external length of the house in Phase 3.2 was 20.6 m.

The western end of House 1 (comprising Rooms 3 and 4) was semi-subterranean, having been dug into the pre-existing contexts of the North Midden, the South Midden, the Fish Midden, House 5 and

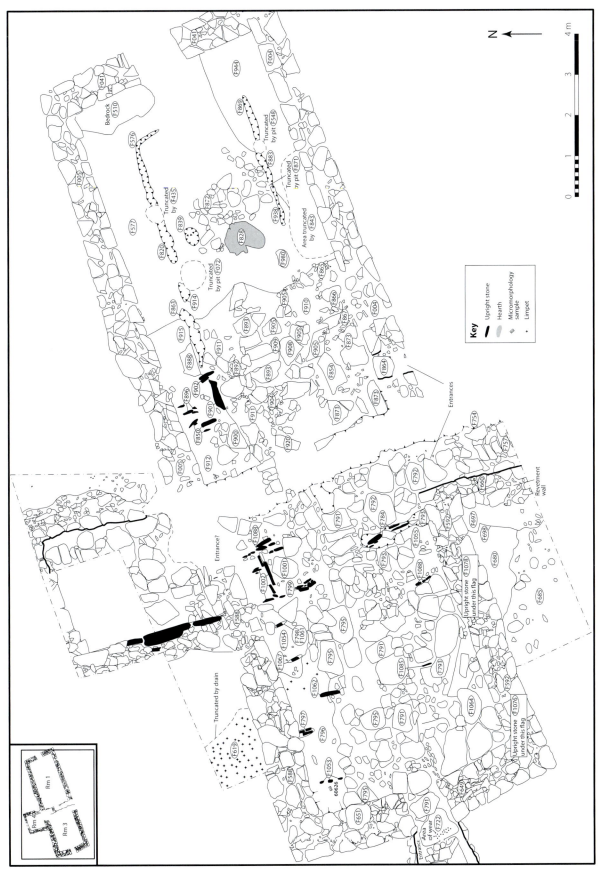

Figure 4.9. *House 1 in Phase 3.2. (Image: Patrick Gibbs.)*

the levelling deposits of Phase 3.1. This major stratigraphic event was best observed in the wave-cut bank during the 2006 watching brief. Room 3 had clearly been constructed by digging into layers of Fish Midden (that had accumulated over House 5) and then lining the resulting hollow with masonry (Fig. 4.28). The rest of the house was of free-standing dry-stone construction, with some use of clay bonding and an internal skin of lime plaster made from burned shells.

The construction of House 1 can be narrowed to the decades around AD 1200 based on Bayesian modelling of the relevant radiocarbon dates (Fig. 4.20). The few small finds from the earliest phases of the building are consistent with this chronology. Most notably, a double-sided comb (Sf. 61910) found in one of the earliest contexts of Phase 3.2 is of twelfth- to fourteenth-century type (see Chapter 13). Phase 3.2 was probably very long-lived. It included several episodes of paving and other modifications in the western end of Room 1. These events are all attributed to a single detailed phase because the house was served by the same hearth throughout the time in which they occurred.

Room 1, the eastern (uphill) end of the house, was an open living space or hall. It had a central hearth (F828, just mentioned) showing extensive burning, side aisles demarcated by slots (e.g. F576, F863, F869 and F938) for edge-set stones (Fig. 4.29), external entrances in the eastern gable and southwest corner and a paved area (e.g. F893) overlying a drain at the west end. There were two small pits (F839 and F980) filled with charcoal near the hearth and a rectangular feature of upright stones near the northwest corner of the room (F850, F896, F901 and F902). Early in Phase 3.2 (and thus not shown in Figure 4.9) a large flagstone with a small central perforation (Sf. 61914) was placed near the entrance in the southwest corner — and replaced with a similar stone in the same location as the floor level rose (Fig. 4.30). It may have anchored a door stop or a tether for livestock. The eastern half of the floor was subsoil (F577 and F944) and bedrock. This area was either kept very tidy (with waste swept downhill to the west) or truncated by a cleaning episode late in Phase 3.2. The unpaved areas of the western end of the house developed more midden-like floor layers (e.g. F910 and F912).

An internal doorway in the (robbed) western wall of Room 1 led through to Room 3, which was clearly a byre — complete with edge-set flagstones serving as stall dividers and a paved central drain (Fig. 4.31). The latter was a continuation of the drain that started in the western end of the hall, providing a direct stratigraphic link between Rooms 1 and 3

(while also disturbing Phase 2.4 in underlying House 5). It exited through the seaward door, beyond which it continued as a worn flagstone path (F722) at the base of an unroofed entrance passage dug into the coastal Fish Midden (Fig. 4.32). This passage (slightly curved to deflect the worst of onshore winds and spray) has been truncated by coastal erosion, but it must originally have led down to beach level.[8] A second external entrance was located in the southeast corner of the byre, with a paved passage (F757 and F792) leading to shared doorways with Room 1 (in the centre of the robbed gable to the east) and Room 4 (directly opposite to the north).

North of the drain, spreads of peat ash (F796) were laid over the Phase 3.1 levelling deposits (e.g. F1054) and a durable surface was provided by the addition of paving slabs (F795). Dug into this surface were several north–south divisions of edge-set stone, interpreted as the bases of dismantled animal stalls of a kind common in vernacular Orcadian architecture (Fig. 4.33). The best preserved of these was near the northeastern corner of Room 3, where two linear cuts (F1082 and F1083) containing vertically set stones (F799 and F1088) had been dug into the demolished north wall of House 5 (F1001), thus utilizing the wall-head as paving in this phase (Fig. 4.34a). An ash dump (F790) near the resulting stall represents one of many similar deposits in Room 3 interpreted as animal bedding (see Chapter 10).

The space south of the drain was originally divided in a similar way, but only the easternmost stall (demarcated by F784 and F1088) continued in use for long — its eastern edge also serving to isolate the southern door (Fig. 4.34b). Other stall divisions could not be adequately bedded because of a large single stone (from the underlying wall of House 5) that formed part of the floor in the southwest corner of Room 3. Abandoned attempts to seat upright stones (e.g. F1076 and F1078) were instead covered with flagging (F793 and F1064).

North of Room 3, accessed only by an internal doorway, was Room 4. It was a small semi-subterranean annex (built of combined orthostatic and coursed masonry) interpreted as a store. This room first contained only a setting of upright stones (F734, F735 and F736) intended to demarcate a rectangular bin or (more likely) to support a raised floor suitable for storing dry fodder. Regardless, it soon acquired a flagstone floor (F729) that was renewed on five separate occasions (F711, F703, F702, F696 and F693)

8. Erosion aside, there was a gentler slope down to the waterline until the shingle below Quoygrew was removed for use in construction over a seven year period in the 1970s (George Drever pers comm., June 1997).

before the room was relegated to midden deposition. These paved surfaces cannot be tightly phased given the absence of datable material within them and/or of stratigraphic links to other rooms. Nevertheless, they span the use-life of House 1. The best-preserved paving (F703) is shown in Figure 4.9 to give an impression of the room's appearance, accepting that it is probably later than Phase 3.2.

Although the earliest use of the hall and byre can be linked by a shared drain it is not possible to match the floor layers of these rooms to a single stratigraphic sequence after Phase 3.2. Subsequent links between them were severed in antiquity during post-abandonment robbing of the wall that they shared (see Section 4.2.1). Later flagged surfaces of the byre were also robbed for stone in antiquity, making detailed phasing impossible for Room 3. Circumstances are more fortunate in Room 1, where hearths were often replaced after being engulfed by rising floor levels. These fireplaces provide the key to recognizing superimposed living surfaces from Phases 3.2 to 3.6 — and into Phase 4 when Room 2 was added to the eastern end of House 1.

Focusing on Room 1, Phase 3.3 (Fig. 4.10a) was characterized by a new hearth (F831), the replacement of the southern side aisle with a central stone-built bench (F511, see Fig. 4.35) and the insertion of a timber partition that subdivided the room into eastern and western ends — indicated by a row of two stone post pads (F805 and F848) and a post hole (F849). F511 may have served as a high seat, reserved for the head of the household (male or female), based on analogy with later practice in the Northern Isles (Fenton 1978, 191). A small pit (F871) was cut through the line of the earlier southern side aisle. Its fill (F870) included a sherd of Scottish white gritty ware pottery (Sf. 61650).

In Phase 3.4 (Fig. 4.10b) a new hearth (F816) was established closer to the centre of the room and the southern seat was extended slightly (F833). The internal partition from Phase 3.3 was maintained (e.g. F492, F569, F807 and F848), but may have been temporarily replaced by a similar feature further to the east (indicated by F551, F827 and F830).

During Phase 3.5 (Fig. 4.11a) the hearth was moved in three stages (F517, F518 and F520), without sufficient floor accumulation between them to distinguish separate living surfaces. The northern side aisle went out of use (being covered with hearth ash) and a box-like feature of edge-set stones was built in the southeast corner (defined by F530, F531, F532 and pre-existing F534). A stone bench was also built along the south wall, west of where a perishable internal partition is still envisioned. A small pit (F549) was dug east of the central seat and covered by a flagstone (F539). Its fills included both local organic-tempered pottery (Sfs. 61542, 61543, 61544, 61546 and 61801) and a large piece of a steatite pot (Sf. 61545) — confirming the concurrent use of these different vessel types in this phase.

In Phase 3.6 (Fig. 4.11b) the hearth was moved yet again, with the new fire (F462) set closer to the southern 'high seat'. The contemporary floor plan is very incomplete because it was partly truncated by a drain built to serve Room 2 at the beginning of Phase 4 (see below). Nevertheless, it is evident that earlier features in the eastern end of the room had gone out of use. Several new stone settings (e.g. F468, F480, F481 and F491) were built elsewhere instead, but all have ambiguous functions.

Based on the radiocarbon sequence Phases 3.3 to 3.5 in Room 1 are all likely to have accumulated in the thirteenth and fourteenth centuries, with Phase 3.6 being of *c.* fourteenth-century date (Fig. 4.20). Finds of medieval pottery (Chapter 15), schist bake stones and Eidsborg schist hones (Chapter 12) are all consistent with this chronology (Table 4.3). The single sherd of German stoneware from Phase 3.4 (Sf. 62264) is, however, probably intrusive. This fabric is otherwise first found in Phase 4.2.1 and the piece in question is a tiny flake weighing only 0.6 g.

Returning to Room 3, although it is less clearly stratified one can be reasonably confident that it continued in use as a byre during Phases 3.3 to 3.6. Its floor was raised gradually by layers of flagging, by discrete dumps of ash, midden and other sediment (interpreted as animal bedding) and by on-going attempts to maintain effective drainage. A partial internal cross-wall, built in two episodes (F603 and F672), replaced the original edge-set flagstone divider (F784) that demarcated the southeast entrance passage. The stall in the northeast corner of the room (F799 and F1088) was maintained. Radiocarbon dates place the relevant post-Phase 3.2 and pre-abandonment layers in the thirteenth to fourteenth centuries (Table 4.2). Concurrently, Room 4 was continually resurfaced with flagstones as discussed above. There is no direct dating evidence for this room until its abandonment in the fifteenth century or later. In neither room is it possible to clearly demarcate the transition between the latest contexts of Phase 3 and the beginning of Phase 4.

Outside Room 3, Phase 3 of the South Midden (F659, F671 and F680) accumulated against the byre — behind a wall (F660) built in part to keep the southeast doorway from becoming blocked with refuse. Aside from this deposit there is surprisingly little midden of Phase 3 from the entire excavation.

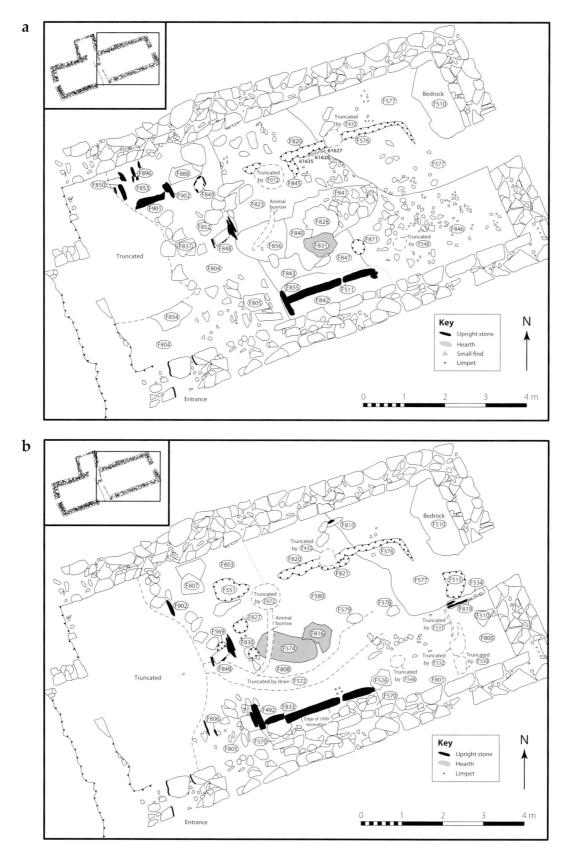

Figure 4.10. *Room 1 of House 1 in Phases 3.3 (a) and 3.4 (b). (Images: Patrick Gibbs.)*

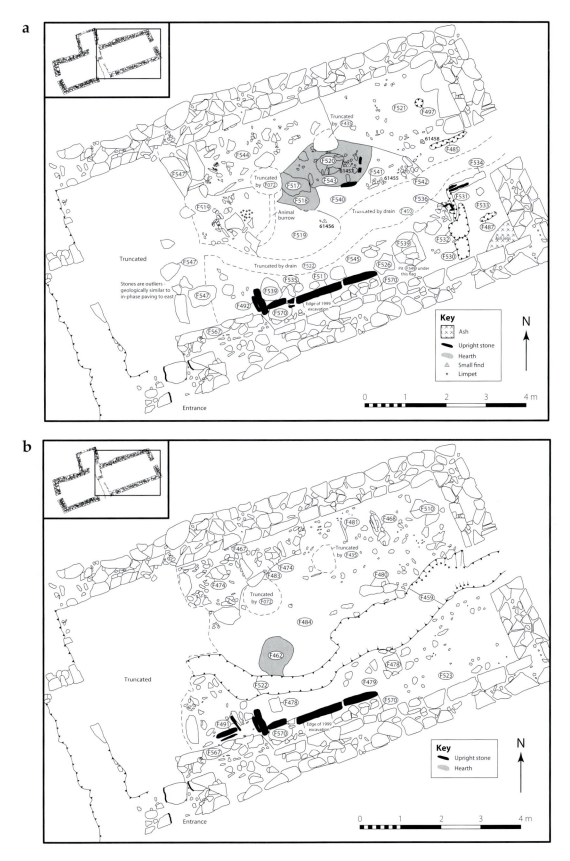

Figure 4.11. *Room 1 of House 1 in Phases 3.5 (a) and 3.6 (b). (Images: Patrick Gibbs.)*

Wall F660 also formed the western edge of a yard south of House 1. The southern extent of this enclosure, which was 7.3 m wide north–south, is indicated by another wall (J005/J018), by paving (F463, J006 and J007) and by a spread of midden (J009) — all best (if broadly) dated to Phase 3 on the basis of stratigraphy and a few associated finds. The eastern boundary of the yard is unclear, but wall J005/J018 did not continue as far as Area J1 so it is assumed to be co-terminus with the end of Room 1.

A little further east, in Area J1, a rectilinear flagstone setting edged with small upright stones (J110/ J113) was set into the basal palaeosol. It was at least 1 m per side, but only partly exposed by the excavation trench. There was a discrete patch of ash (J114) on the flagstones, but the stones themselves were not obviously burnt. This feature could have served as a little-used external hearth, or as a base for a grain- or hay-stack later covered by a dump of ash. Its phasing is unclear, but the feature seems likely to relate to the yard just a few metres away.

The last significant deposit attributed to Phase 3, at least in part, was an area of anthrosol comprising a probable infield of *c.* 1.5 ha (*c.* 3.7 acres) that stretched south and east of the Farm Mound. The extent of this field was identified by auger survey (Simpson *et al.* 2005; Chapter 3), and it has been investigated by excavation in Test Pit 2 and Area G2. Samples of charred heather and cereal grain from the test pit produced prehistoric dates (Table 4.2). As discussed in Section 4.2.2 above, however, these results could represent redeposited residual material. In Area G2 the field soil (context G025) was clearly stratified over block G026 of the Farm Mound middens — of Phase 2 to 3 date (Fig. 4.2). Charred cereal recovered from context G025 also produced a radiocarbon date of AD 1186–1393 (Table 4.2). If the field was prehistoric in origin, the Area G2 evidence shows that it was at least enlarged, and thus still cultivated, into Phase 3 (see Simpson *et al.* 2005). Other anthrosols at the site are of more recent date (see below).

4.3.5. Phase 4
The start of Phase 4 (detailed Phase 4.1) is defined by the addition of Room 2 to the eastern end of House 1 — and of an associated internal drain (cuts F459 and F522, lined by stones F461 and F470) running from the doorway between Rooms 1 and 2 to join the pre-existing drain in the western end of the house. Room 2 was 4.3 m by 5.6 m in internal dimensions. After its addition the total external length of House 1 was *c.* 27 m. An elevation drawing of this (final) configuration of the building is provided as Figure 4.36.

Room 2 had a beaten earth floor composed of redeposited subsoil (e.g. F238) and ash (e.g. F200, F221, F230 and F236). Initially it had no external entrance. Its floor surfaces can be broadly correlated with contemporary developments in Room 1 based on contexts such as paved surfaces that run through their shared door (e.g. F433 and F453). The uses of Room 2 varied through time, however, sometimes leading to subdivision of what were single detailed phases in Room 1.

Phase 4.1 includes the construction of Room 2 and the occupation that immediately followed in both rooms (Fig. 4.12). In Room 1 the hearth was moved again (F473) and the lintels of the drain (F433) formed a pathway that was renewed in subsequent phases. Otherwise the floor surface was unchanged from Phase 3.6. In Room 2 the only discernible internal features were the ash floor itself and a hard standing of two large flagstones (F235). This addition to House 1 may initially have served as a bedroom (cf. Fenton 1978, 191) — an interpretation made more likely by the observation that the northern side aisle in Room 1 (a potential sleeping area) went out of use during Phase 3.5. On the north side of Room 2 an eaves-drip drain (F168) was cut into subsoil and bedrock. Another drain (F202) was cut into the bedrock outside the southern wall of the room, joining the ditch (F502) that already flanked Room 1.

The only radiocarbon date from Phase 4.1 is probably residual (being on charred grain from redeposited soil). However, bracketing dates from Phases 3.6 and 4.2.1 suggest that it can be attributed to the decades around AD 1400 (Fig. 4.20). Phase 4.1 produced the first well-stratified find of probable Scottish redware (Sf. 60790) from Quoygrew — continuing a pattern of trade with lowland Scotland evidenced by a few sherds of white gritty ware in Phase 3.

Phase 4.2 shows continuity of function in Room 1 (Fig. 4.13). Yet another new hearth (F412) was established, and a stone cross wall (F017/F034) was built where the timber partition had existed in earlier phases. Two unlined subfloor pits were also dug (F072 and F435). F072, *c.* 0.4 m deep, probably replaced F435 which hit bedrock at 0.27 m.

In Room 2, Phase 4.2 could be further subdivided into Phases 4.2.1 and 4.2.2, each of which marked changes in the use of space (Fig. 4.13). In Phase 4.2.1 an external entrance was added in the centre of the north wall, with a flagged and kerbed entrance feature (F196 and F213). Two bins of edge-set stones (probably chocking upright flags) were built in the northeast corner (F175 and F178) and very large flagstones were laid flat in the southeast

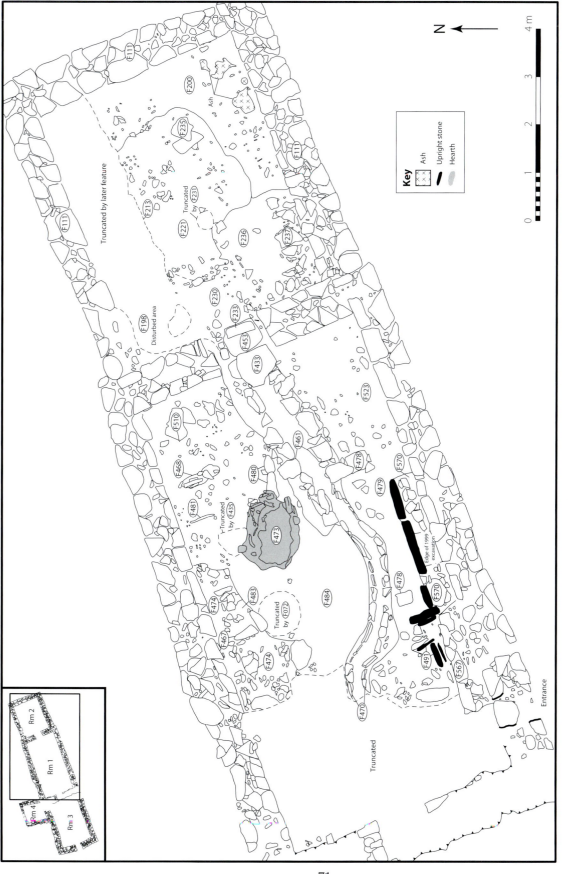

Figure 4.12. *Rooms 1 and 2 of House 1 in Phase 4.1. (Image: Patrick Gibbs.)*

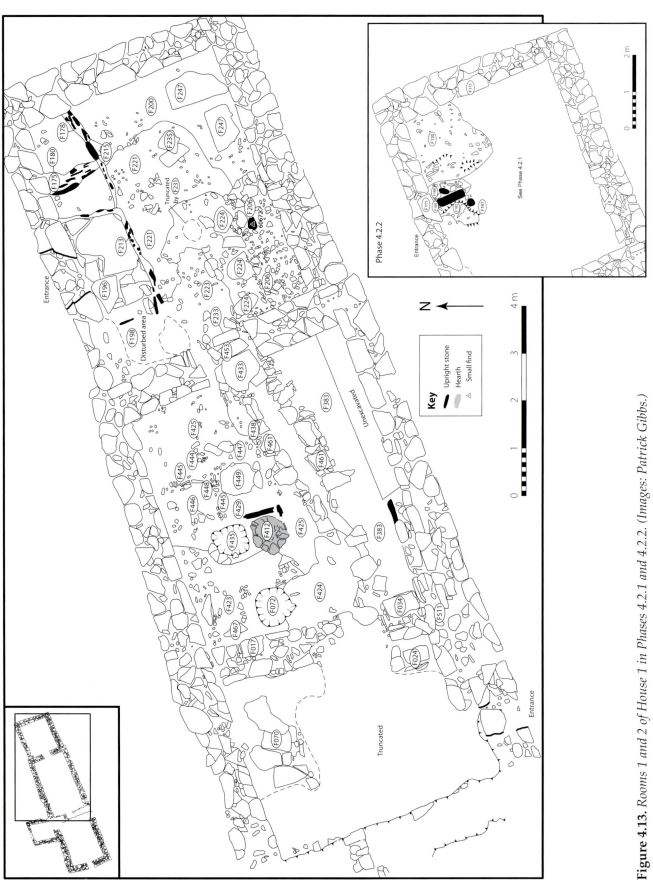

Figure 4.13. *Rooms 1 and 2 of House 1 in Phases 4.2.1 and 4.2.2. (Images: Patrick Gibbs.)*

corner (F247) to serve as hard standings. Dumps of sediment and stone were added to the southwest corner (F206 and F224) to help level the surface. One of these levelling deposits contained a broken four-sided steatite vessel (Sf. 60672, see Fig. 4.38). This is the latest well-stratified example of a soapstone pot at Quoygrew, and it may be residual given its context. Phase 4.2.1 produced a radiocarbon date of AD 1414 to 1478. It also included many sherds of probable Scottish redware and three finds of German stoneware — a combination consistent with a fifteenth-century date (Table 4.3).

In Phase 4.2.2 large spreads of ash 8 cm to 10 cm thick (F130 and F183) were dumped in the northeast corner of Room 2 and three 'anvil stones' were seated in the floor just east of the entrance (Fig. 4.39). The 'anvils' included an unworked rectangular stone (F165), a groove-marked oval stone (F166) and a heavily peck-marked spherical stone (F167). These deposits and features suggest that the room had been converted into a workshop of some kind. Despite the ash, however, there was no hearth and no direct evidence of metalworking (e.g. hammer scale).

In Phase 4.3 a single occupation surface in Room 1 can again be correlated with two different Phases (4.3.1 and 4.3.2) in Room 2 (Fig. 4.14). In Room 1 the hearth was renewed yet again (F071) and the seat against the southern wall was extended as a longer stone bench (F027). A secondary hearth against the north wall (F384) was used for at least a short time. Pit F072 was backfilled with large beach stones (F066). In its place a substantial piece of internal furniture was added against the internal cross wall — evidenced as grooves and chock stones to hold upright flags or planking. It could have been a storage feature — a cupboard or girnel (grain store) for example — or even a box bed (cf. Fenton 1978, 136–53, 191–4). Charred barley from the ash of the main hearth produced a radiocarbon date of AD 1452–1565.

In Room 2, Phase 4.3.1 was a period of disuse, midden accumulation (F129, F164 and F226) and stone roof collapse (e.g. F151, F152 and F193). The collapsed roof was probably partly salvaged, but one stone with an intact suspension perforation (Sf. 60612) remained in what was left behind. Thus by this phase House 1 had a flagged roof, presumably covered in turf and/or thatch as in later Orcadian vernacular architecture (Fenton 1978, 175–90).

Phase 4.3.1 is radiocarbon dated to AD 1451–1567 based on barley from undisturbed middens (containing articulated groups of fish bones) and sealed by the roof collapse. The same phase also yielded a Dutch duit/doit of Batenburg, struck between 1616 and 1622 (N. Holmes pers comm.; Appendix 12.1). If in situ it brings the latest occupation of House 1 into the seventeenth century. However, the overlying phases were robbed above the location where this coin was found. It is thus likely to be intrusive, having originally been associated with the seventeenth- to eighteenth-century pipkins that first appear in overlying contexts of Phases 5 to 7.

In Phase 4.3.2 the collapse deposits in Room 2 were reorganized as an irregular flagstone floor, and a central post hole (cut F231, fill F204) was inserted to help support a new roof. A second external entrance was also added (in the south wall). Edge-set and blocky stones (F116, F118, F119, F213 and F124) were laid to mark thresholds and internal subdivisions of space, but there is otherwise little to indicate the use of the room in this phase.

Phase 4.4 (Fig. 4.15) represents the last occupation of House 1 before its ultimate collapse. In Room 1, a substantial kerbed flagstone hearth (F010) was established just east of its predecessor (Fig. 4.23). Charred barley from the ash of its last fire produced a radiocarbon date of AD 1472–1630. Concurrently, Room 2 was given two superimposed layers of well-laid flagstone floor (F115, F117, F121, F127 and F147) — most of which was later robbed (Fig. 4.16). The southern external door added to this room in Phase 4.3.2 was maintained but modified. The addition of paved surfaces to a building with two opposing (if staggered) doorways suggests use as a winnowing barn at this time (Fenton 1978, 372).

Phase 4.5 in Rooms 1 and 2 nominally represents the demolition of House 1. However, it cannot be stratigraphically distinguished from Phase 5. It is therefore discussed below in the context of Phases 5 to 6.

Rooms 3 and 4 offer little chronological resolution in Phase 4. As discussed above, it is even impossible to define a specific boundary between contexts of Phases 3 and 4. Nevertheless, both rooms probably did retain their original uses into at least the early decades of the 1400s. Room 3 probably continued as a byre based on careful attention to maintaining and adding drains (including F1041, inserted through the north wall). Whatever its function, Room 4 retained its characteristic paved surface until late in its life.

However, at some point in Phase 4 both rooms were relegated to spaces for dumping midden (F688, F691, F1016, F1019 and F1030 in Room 3; F602, F661, F662, F676, F677 and F689 in Room 4). Several of these contexts (F016, F019 and F1030) were discrete dumps of cockle shells, otherwise uncommon on the site. This change in use is directly dated only by a very broad radiocarbon assay (AD 1483–1660) on a

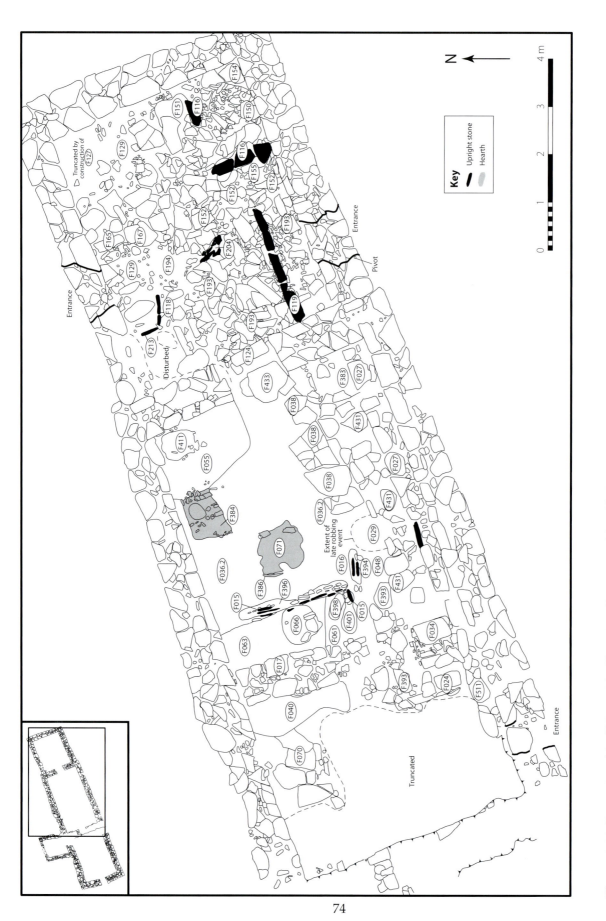

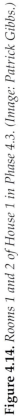

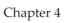

Figure 4.14. *Rooms 1 and 2 of House 1 in Phase 4.3. (Image: Patrick Gibbs.)*

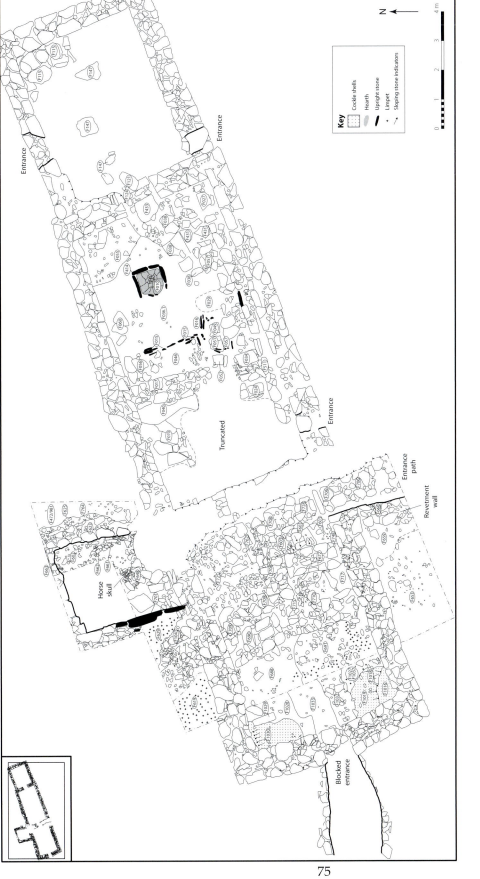
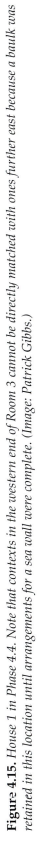

Figure 4.15. *House 1 in Phase 4.4. Note that contexts in the western end of Room 3 cannot be directly matched with ones further east because a baulk was retained in this location until arrangements for a sea wall were complete. (Image: Patrick Gibbs.)*

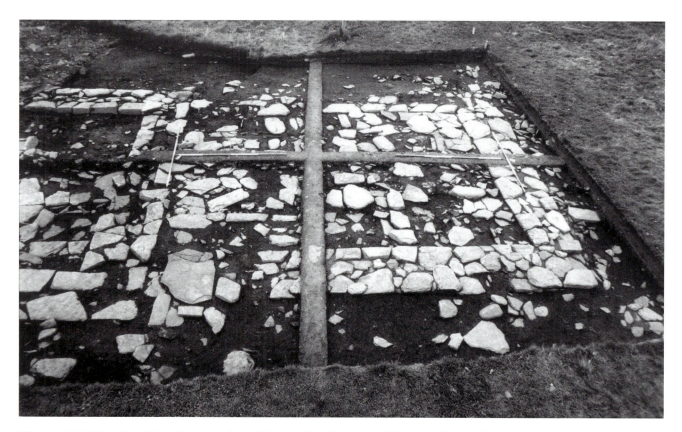

Figure 4.16. *Heavily robbed flagstone floor (Phase 4.4) in Room 2 of House 1. (Image: James Barrett)*

cattle bone from the fill (F602) of Room 4. By proxy, the dumping in Rooms 3 and 4 may have been contemporary with the brief use of Room 2 for midden deposition (in Phase 4.3.1, radiocarbon dated to AD 1451–1567). Regardless, the absence of post-medieval ceramics (e.g. pipkins) argues in favour of the Room 3 and 4 middens having accumulated no later than the 1500s. Instead they contain large quantities of organic-tempered pottery of fabrics 1 to 3 (characteristic of Phases 3 and 4) and a single sherd of probable Scottish redware (Sf. 61512 from context F602 in Room 4) characteristic of Phase 4.

In Room 3 the middens were dumped towards the west, while the eastern end acquired newly paved working surfaces (e.g. F690, F708 and F710). In Room 4 the middens filled the entire excavated area (Fig. 4.40). Figure 4.15 shows House 1 immediately prior to demolition, including the internal middens that had accumulated in Rooms 3 and 4.

A few external deposits could be attributed to Phase 4. A ground surface (F109) outside the northern entrance of Room 2 yielded two billon pennies of James IV's second issue, c. 1500–1510 (N. Holmes pers. comm.; Appendix 12.1). One of the uppermost

layers of the South Midden (context F637) and various cuts and fills associated with the drain inserted through the north wall of Room 3 must also be of Phase 4 date on stratigraphic grounds.

More often, however, external contexts could only be broadly attributed to Phases 3 to 4, 4 to 5 or 4 to 6. For example, intermediate contexts of the South Midden (F642 and F653) accumulated during Phases 3 to 4. The western entrance passage into the byre from the shore was also filled with midden in Phases 3 to 4. Prior to this the floor layers of the byre had accumulated to the point that the western doorway was blocked (F719), with a new drain (F727) exiting through the inserted stonework (Fig. 4.41). The southern entrance to Room 3, and its sequentially resurfaced external pathway (e.g. F706), remained in use until the house was demolished.

4.3.6. Phases 4.5 to 6 (Areas A to F)
For most contexts in Area F there is little or no stratigraphic evidence to differentiate the initial abandonment and demolition of House 1 (nominally Phase 4.5) from subsequent disturbance during the seventeenth to nineteenth centuries. Thus many

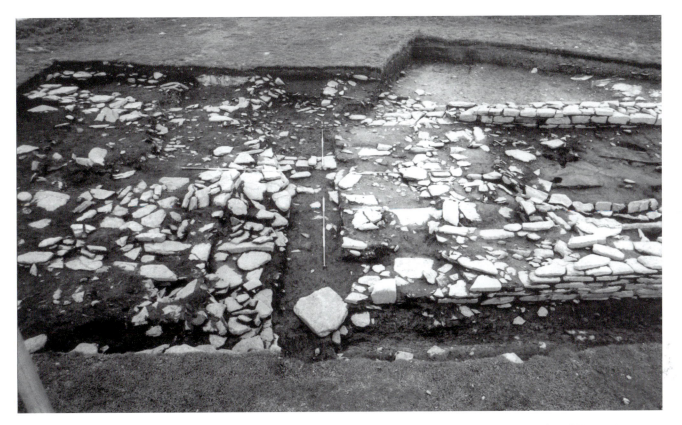

Figure 4.17. *Stone-robbing cut (F392/F604) left after the removal of the wall between Rooms 1 and 3 of House 1.* *(Image: James Barrett.)*

deposits from the upper strata of this area can only be grouped as Phases 4.5 to 5, Phases 4 to 5, Phases 5 to 6 or even Phases 4 to 6. The use of 'Phase 5' and 'Phase 6' nomenclature here is thus a matter of interpretational convenience. It recognizes that the post-medieval finds can be subdivided into seventeenth- to eighteenth-century groups (e.g clay pipes, pipkins, tin-glazed earthenware) and nineteenth- to twentieth-century groups (e.g. white earthenware) — indicating occupation at Quoygrew in both two-century phases.

The ineffectiveness of radiocarbon dating the disturbed upper layers of the site was demonstrated by context A004 of the Fish Midden (Fig. 4.21). The method has thus not been applied to contexts of Phases 4.5 to 7 anywhere on the site. Other reasons for lumping the uppermost phases of Area F vary between the rooms of House 1. There is little post-abandonment activity over Rooms 1 and 2, leading to few stratigraphic relationships and some mixing of finds between layers. Over Rooms 3 and 4, conversely, major robbing episodes have jumbled the post-abandonment deposits. Thus it is worth discussing each room in turn.

The last hearth of Room 1 (F010 of Phase 4.4) was found with a deposit of *in situ* soft peat ash (F011) on its surface, suggesting that there was little activity in the building between its abandonment and destruction. This suggests rapid demolition, an interpretation corroborated by occasional large sandstone blocks and slabs (F028, F059 and F060), probably demolition rubble, sitting on the latest house floor. These deposits and the hearth ash were sealed by a layer of loose, angular sandstone fragments (F012), clearly debris from the demolition of the building. This layer was in turn overlain by a brown sandy loam with fewer sandstone fragments (F003). In Room 2 the unrobbed remnants of the last flagstone floor (F115, F121 and F147) were immediately superseded by destruction rubble (F112) equivalent to contexts F012 and F003 over Room 1.

Dating this demolition is very difficult. Contexts F012 and F121 included only organic-tempered pottery of fabrics 1 to 3 that had been ubiquitous since Phase 3. Context F003 produced a mix of the same material and industrial ceramics, the latter of which are almost certainly intrusive from the overlying topsoil (F002). The topsoil itself may be

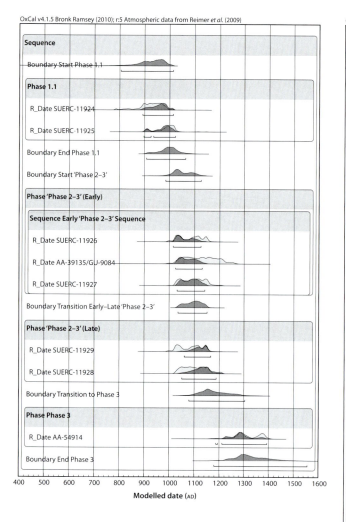

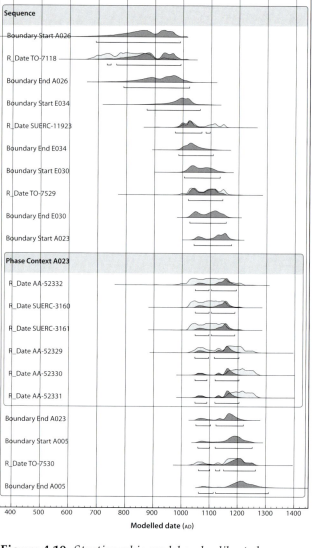

Figure 4.18. *Stratigraphic model and calibrated radiocarbon dates for Areas G1 and G2.*

Figure 4.19. *Stratigraphic model and calibrated radiocarbon dates for interventions in the wave-cut bank, excluding context A004.*

most revealing, containing as it does both German/Scandinavian redware pipkins of seventeenth- to eighteenth-century date and later (eighteenth to twentieth century) industrial ceramics. The earliest of these finds are consistent with the Dutch coin of 1616 to 1622 from Room 2 (see above) that is interpreted as a post-abandonment loss (perhaps during stone robbing). Thus Rooms 1 and 2 were demolished by the seventeenth century, with an earlier date (perhaps the sixteenth century) more likely.

Room 3 requires separate treatment. Near the end of Phase 4 or early in Phase 5 most of its interior was sealed by spreads of rubble, stone and midden (F675, F678. F679, F681, F682, F683, F684, F686, F687, F692, F1011, F1012, F1013, F1014, F1015, F1017, F1024,

F1025 and F1026). Over these layers in the west end of the room a large stretch of collapsed wall, evidently from the western gable, provided a coherent demolition layer (F1009 and F1010). Elsewhere, further dumps of stone and midden (F608 and F626) accumulated which overlay the truncated wall heads. Collectively these deposits mark the final abandonment and demolition of Room 3. Like the initial collapse contexts of Rooms 1 and 2, however, all of the above included only organic-tempered ceramics of fabrics 1 to 3. Lacking post-medieval ceramics, they probably also predate the seventeenth century. Various midden, rubble, robbing and sand-blow contexts followed that take the site chronology into the twentieth century. The uppermost meaningful

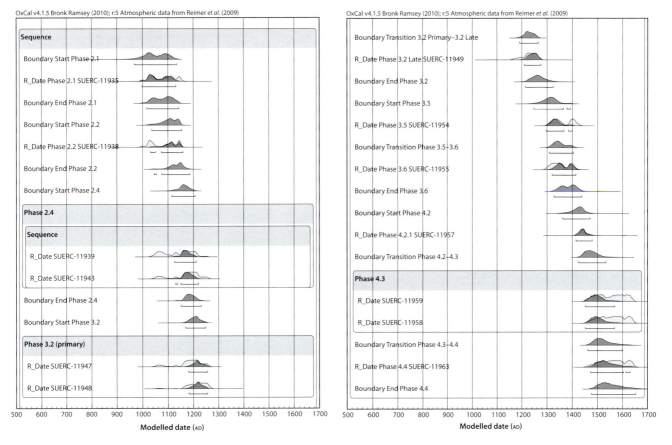

Figure 4.20. *Stratigraphic model and calibrated radiocarbon dates for House 5, House 1 and associated contexts in Area F.*

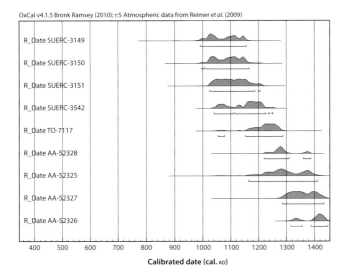

Figure 4.21. *Unmodelled calibrated dates for radiocarbon samples from context A004 near the top of the Fish Midden. The presence of intrusive material is implied by the highly variable results.*

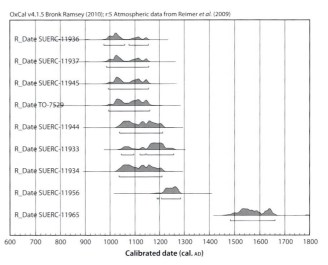

Figure 4.22. *Unmodelled calibrated dates for radiocarbon samples that are difficult to place in an unambiguous stratigraphic sequence (see Table 4.2).*

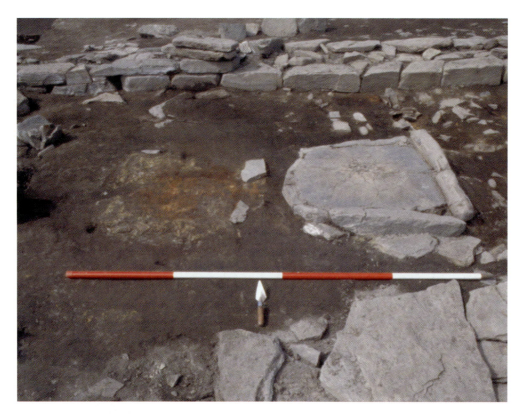

Figure 4.23. *Hearths F071 and F010 (Phases 4.3 and 4.4 respectively) in Room 1 of House 1. (Image: David Fell.)*

context is the collapsed remains of a coastal field boundary (F582) associated with the settlement as abandoned in 1937 (see below). Room 4 is different again. Here post-abandonment robbing truncated almost everything above the Phase 4 midden fills (e.g. F602) already discussed.

Midden F602 in Room 4 and demolition layer F003 in Room 1 were both cut by the same major stone-robbing event (F392/F604) (see Section 4.2.1). It removed the upper phases of the western end of Room 1, the cross-wall between Rooms 1 and 3, and most of the doorway between Rooms 3 and 4 (Fig. 4.17). The fills of this feature (F007, F381, F389, F408 and F409) cannot be closely dated because of the possibility that the industrial ceramics they contain are intrusive from the immediately overlying topsoil contexts (F001 and F002). Nevertheless, the only earlier ceramics found are small numbers of organic-tempered sherds (which are assumed to be residual). Moreover, an eighteenth- to twentieth-century date range is consistent with the stratigraphic position of the layers — near the top of the sequence. The robbing episode is thus attributed to late in Phase 5 or to Phase 6.

The latest distinct features along the recorded wave-cut bank were several stone-lined and flat-bottomed circular pits, 1 m to 2 m in diameter. Two (contexts 010 and 015) were eroding from the cliff face (Fig. 4.4). Another (D004) was partly exposed during the excavation of Area D (Fig. 4.42). 'Kelp pits' like these, common along Orkney's coastline, were used for burning seaweed to produce a product for the glass, soap and dye industries in the eighteenth and early nineteenth centuries. They were part of a major local industry that collapsed by 1830, due to cheaper alternative sources of alkali (Thomson 1983). Only small quantities of kelp were produced thereafter. Overlying these pits, and all other contexts in Areas A to F, was a homogenized topsoil (Phase 7) for which any stratigraphic relationships have been obliterated.

4.3.7. Phases 5 to 6 (Area J and test pits)

South of House 1, several thick homogeneous layers interpreted as augmented agricultural soils accumulated over the drains, paving, yard wall and other external features of Area F (F035 and F451) and Areas J1 and J2 (J102 and J004/J107). They underlie topsoil and turf (Phase 7). On stratigraphic grounds these anthrosols are attributed to Phases 5 or 6.

The relevant layers produced four sherds of industrial pottery of eighteenth- to twentieth-century

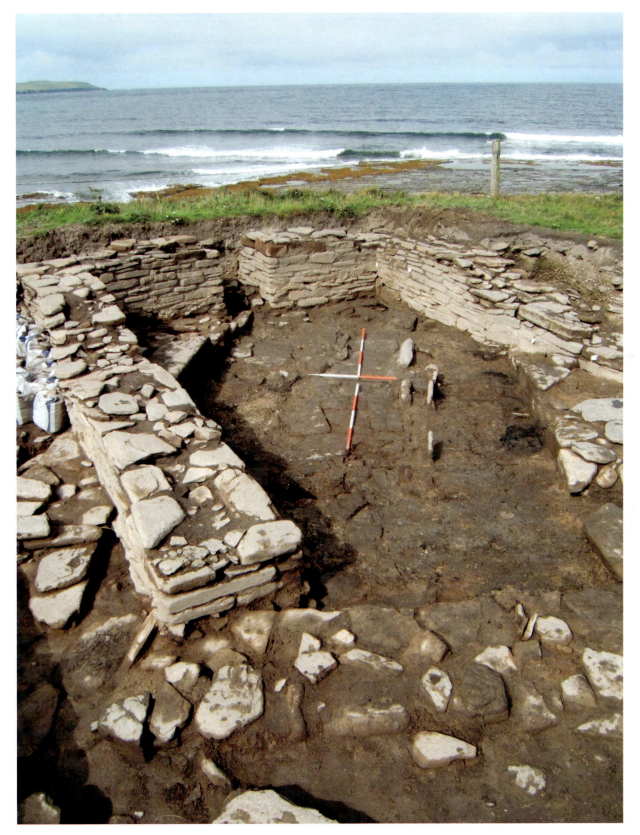

Figure 4.24. *House 5 in Phase 2.3, when only the northern side aisle remained in use. The overlying building (House 1) has been left* in situ *for public display. (Image: Tim Cornah.)*

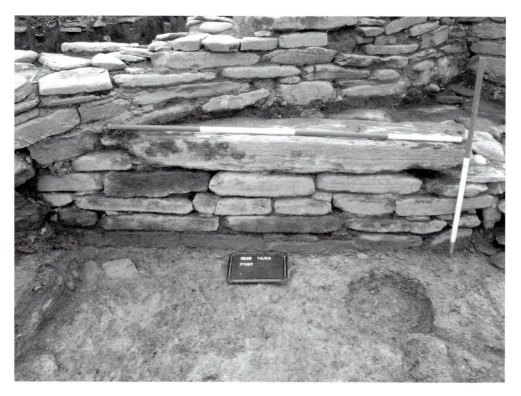

Figure 4.25. *North-facing elevation of a well-preserved section of the internal stone facing of House 5. (Image: Tim Cornah.)*

date (Sfs. 10001, 10002, 10003 and 10009) and four (probably residual) sherds of medieval organic-tempered fabrics (Sfs. 10008, 60918, 60919 and 61303). The anthrosols extended for some tens of metres to the south, thinning with distance from House 1. They could be traced by auger survey (see Chapter 3) and appeared in Test Pits 100 to 105.[9] They varied in thickness from *c.* 0.5 m in Area J1 to *c.* 0.25 m in Test Pit 102.

In Test Pit 101 the anthrosol was underlain by windblown sand, and in Test Pit 102 it was interleaved with several sand-blows. These sand layers could be OSL dated, with the results suggesting accumulation from the *c.* seventeenth to *c.* nineteenth centuries (Table 4.4; Sommerville 2003, 299; Sommerville *et al.* 2003).

In the early twentieth century, when Quoygrew was a croft of only *c.* 6 acres (2.4 hectares), the area south of the surviving northeast to southwest field wall that bisects the site (Fig. 3.10) was cultivated by the main farm of Trenabie. Conversely, the ground between this field boundary and Area F was used by the tenants of Quoygrew itself — sometimes for potatoes and other times for six-row (bere) barley

(see Section 4.3.9). The date of this field boundary is discussed under Area G below. It was certainly extant by 1882 when the first edition Ordnance Survey map of the area was published. If the anthrosol immediately south of House 1 postdates this boundary similar land-use practices must have been applied on either side of it.

There was also a smaller (*c.* 0.25 ha) and thinner (*c.* 0.2 m) area of anthrosol to the north of Area F, visible as ridge and furrow in resistivity survey (Fig. 3.11) and examined in Test Pit 2 (Simpson *et al.* 2005). It is undated at present.

4.3.8. Phases 5 to 6 (Area G and the Farm Mound)
The top *c.* 0.3 m to 0.7 m of Area G1 (between contexts G001 and G007 in the east-facing section drawing, see Fig. 4.2) was composed of garden soil. The interface between the garden and the underlying medieval midden layers of block G026 was marked by a horizon of very narrow and irregular spaded furrows (G011/G050) filled with windblown sand (G018). The garden was originally bounded to the south by a dry-stone field boundary (G033, robbed out in the east-facing section as cut G028 and G071) (Fig. 4.43). To the north, it is demarcated by a more recent wall in Area G3 (G071). It was covered only by turf (Phase 7).

9. They were also noted in Test Pit 3, later incorporated into Area J1 and thus not discussed further.

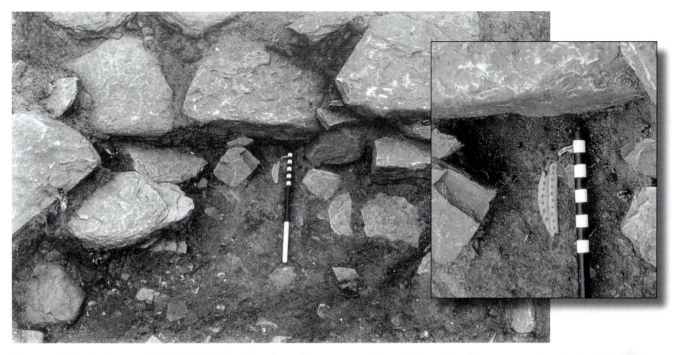

Figure 4.26. *Antler comb (Sf. 61509) found against the western gable of House 1 in the uppermost context of the Fish Midden. (Image: James Barrett.)*

The disturbed garden soils produced over 400 finds of industrial pottery. Most of these were of nineteenth- to twentieth-century fabrics such as white earthenware — indicating the main period of use. A few earlier pieces could easily represent residual material or lengthy use-life. The clearest examples are three finds of German/Scandinavian redware pipkins of seventeenth- to eighteenth-century date (Sfs. 7035, 7071 and 7747) and three finds of tin-glazed earthenware of eighteenth-century manufacture (Sfs. 7722, 7780 and 7817). Four clay pipes of seventeenth-century type (Sfs. 7001, 7791, 7916 and 7936) could also be residual, but may tip the balance in favour of some activity in this area during Phase 5. Lastly, two OSL samples collected to date context G018 produced results of AD 1480–1560 (sample 703) and AD 1430–1530 (sample 704) respectively at the 68.3% probability level (Table 4.4; Sommerville 2003, 295–7; Sommerville *et al.* 2003). These seem anomalously early given that one of the seventeenth-century clay pipes (Sf. 7936) came from the same context. Nevertheless, they also argue for an early post-medieval rather than modern origin.

Gardens are difficult to date given continuous mixing by digging. This example is nominally attributed to Phase 6 — based on its high stratigraphic

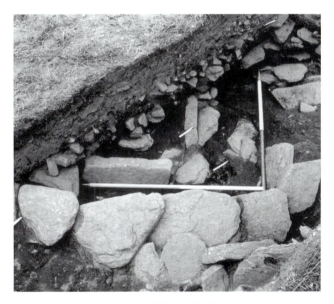

Figure 4.27. *Hearth G100/G101 built in a semi-subterranean niche of House 7. (Image: Mick Atha.)*

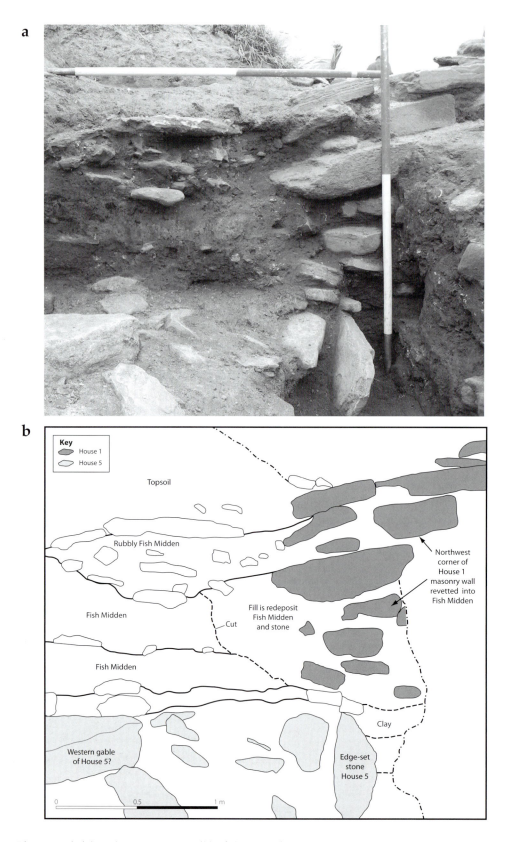

Figure 4.28. *Photograph (a) and interpretation (b) of the west-facing section of the wave-cut bank showing the exterior northwest corner of House 1 where it has been cut into layers of the Fish Midden (that in turn overlie the western gable of House 5). (Images: (a) James Barrett and (b) Dora Kemp.)*

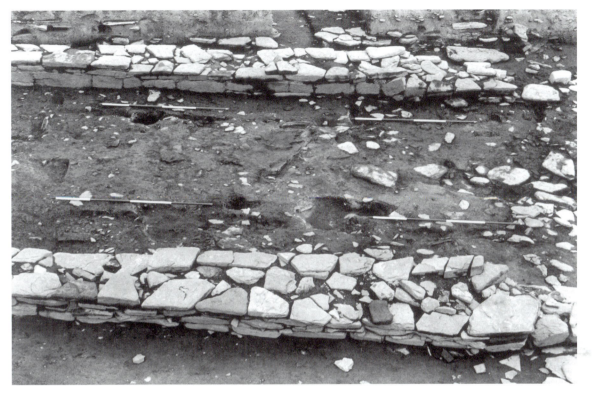

Figure 4.29. *Room 1 of House 1 in Phase 3.2, showing the remnants of grooves cut to hold edge-set stones demarcating side aisles. (Image: Tim Cornah.)*

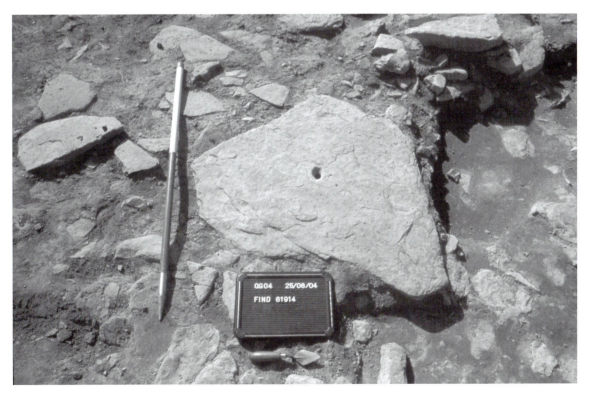

Figure 4.30. *Perforated flagstone (Sf. 61914) near the southwest entrance of Room 1 in House 1 early in Phase 3.2. (Image: Tim Cornah.)*

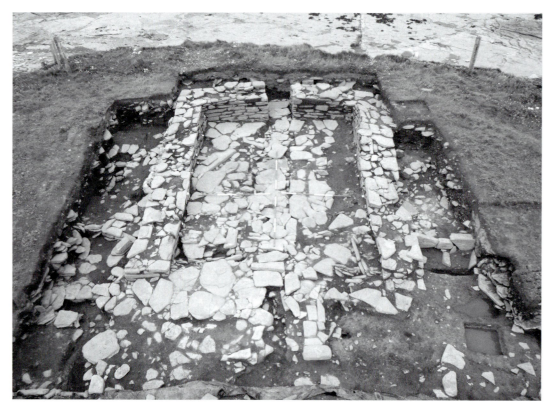

Figure 4.31. *Room 3 (the byre) of House 1. Most of the visible contexts relate to Phase 3.2. (Image: James Barrett.)*

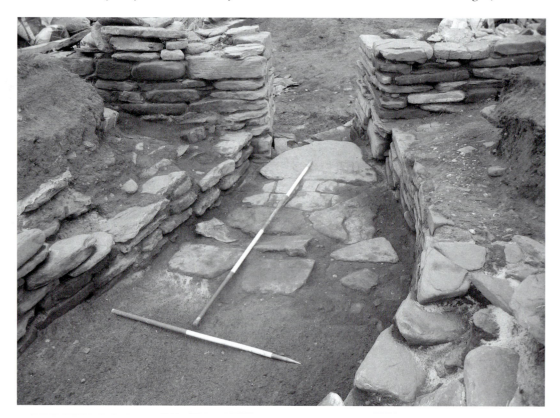

Figure 4.32. *Curved passage originally leading from the shore to the western entrance of House 1. The flagstones missing in the foreground were excavated from the wave-cut bank in an earlier field season. (Image: James Barrett.)*

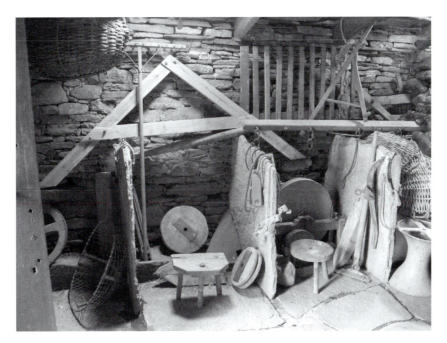

Figure 4.33. *Traditional flagstone animal stalls in the byre of the Corrigall Farm Museum on the island of Mainland, Orkney. (Image: James Barrett, courtesy of Orkney Islands Council.)*

Figure 4.34. *Edge-set stones demarcating probable animal stalls in Room 3 of House 1 (a: F799 and F1088, b: F784). (Images: Tim Cornah.)*

Figure 4.35. *Room 1 of House 1 in Phase 3.3, showing the stone 'high seat' (F511) that replaced the southern side aisle and its associated hearth. (Image: Tim Cornah.)*

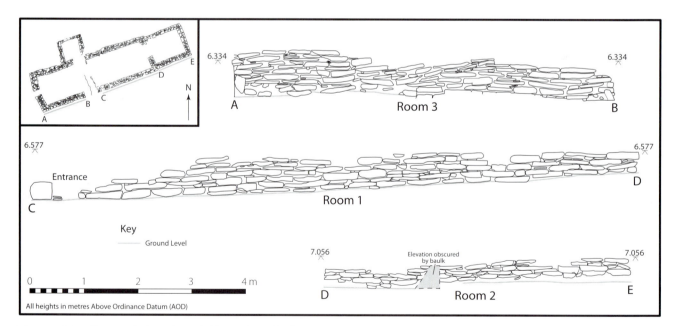

Figure 4.36. *External elevation of the south wall of Rooms 1, 2 and 3 of House 1. Note that Room 3 was semi-subterranean — its surviving external face would not originally have been visible. (Image: Patrick Gibbs and David Andrews.)*

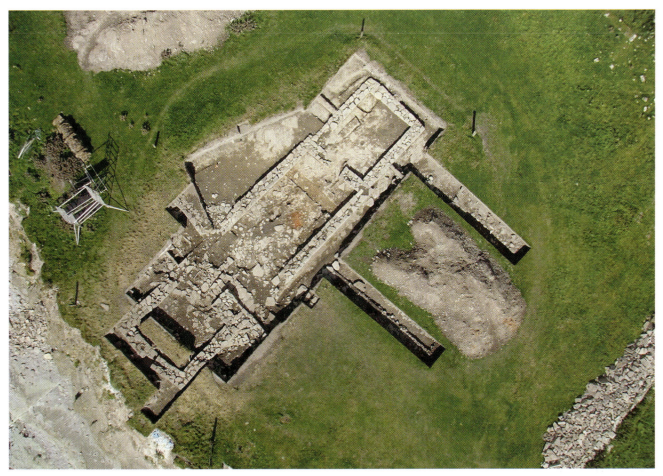

Figure 4.37. *Aerial photograph of House 1. At this stage in the excavation the interior of Room 2 has been dug to subsoil and Rooms 1 and 4 retain only early features of Phase 3.2. Room 3, conversely, shows features mostly from late in Phase 3 and Phase 4. (Image: Ben Gourley.)*

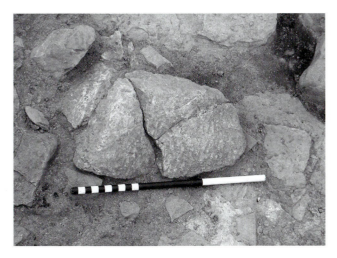

Figure 4.38. *Four-sided steatite vessel (Sf. 60672) used as rubble in a Phase 4.2.1 levelling deposit in Room 2 of House 1. It is the latest well-stratified example of a soapstone pot from Quoygrew. (Image: Lennard Anderson.)*

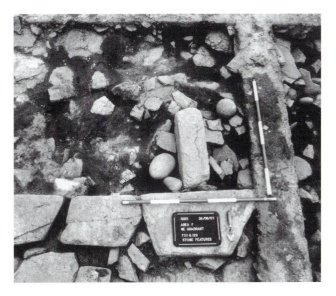

Figure 4.39. *'Anvil' stones of Phase 4.2.2 in Room 2 of House 1. (Image: Ray Moore.)*

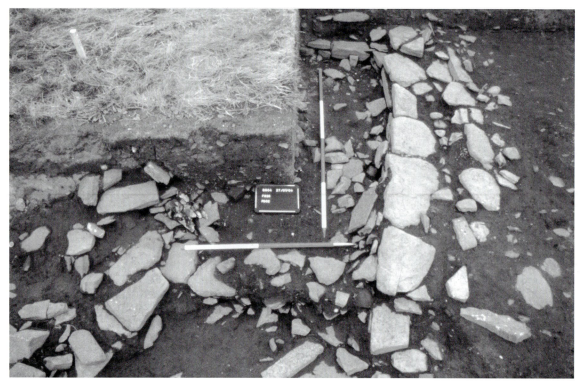

Figure 4.40. *Midden fill (F602) in Room 4 of House 1 deposited during Phase 4. (Image: James Barrett.)*

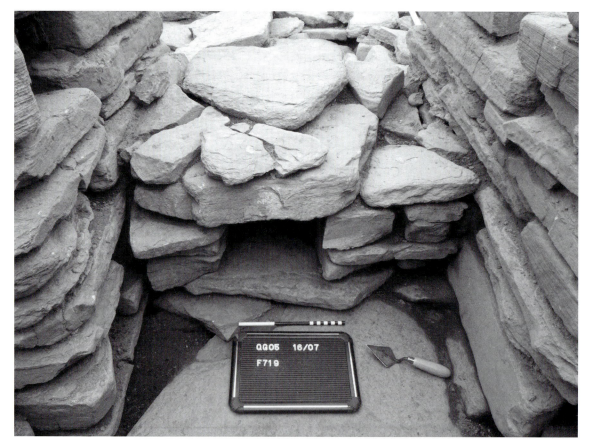

Figure 4.41. *Blockage (with drain) of the western entrance to Room 3 of House 1. (Image: Tim Cornah.)*

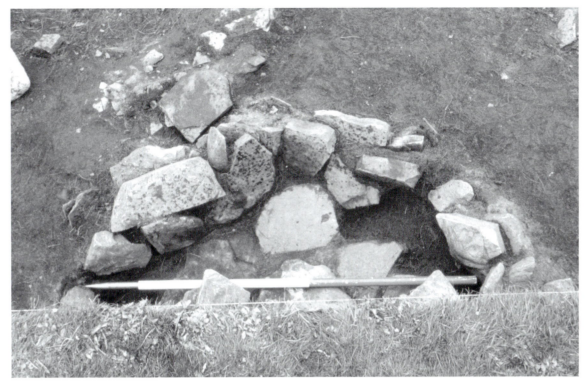

Figure 4.42. *Kelp burning pit (D004) of Phase 5 or 6 exposed in Area D. (Image: Andrew Griffin.)*

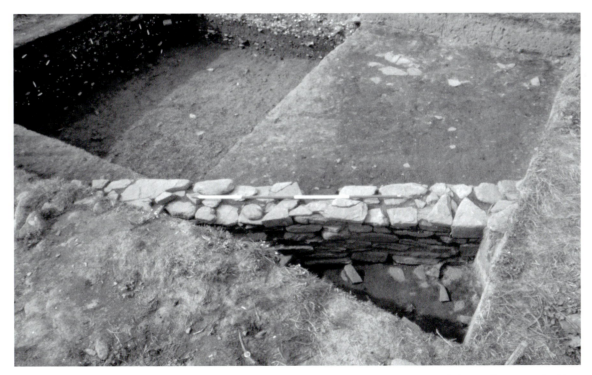

Figure 4.43. *(left) Area G showing wall G033 that demarcated the southern boundary of the garden over the Farm Mound middens. (Image: James Barrett.)*

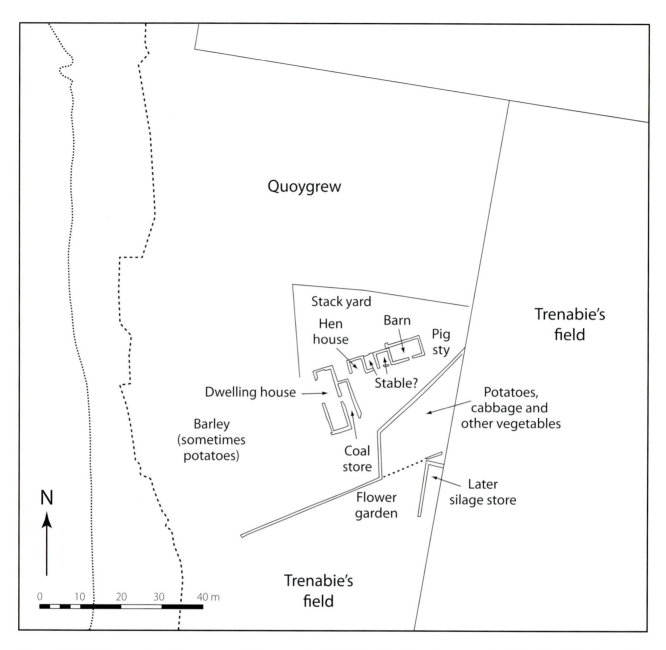

Figure 4.44. *Living and working spaces at Quoygrew in the 1930s (based on the memories of Bessie, Christina and George Drever) superimposed on the ruins visible prior to excavation. (Image: Lucy Farr and Dora Kemp.)*

position, plentiful industrial ceramics and oral history that it was still in use when the settlement was abandoned in 1937 (see below). Nevertheless, based on the earlier evidence just noted it may first have been established in Phase 5 or even (if one gives primacy to the OSL dates) in Phase 4.

The date of the garden in Area G can probably also be applied to the field boundary that divides the site northeast to southwest. As noted above, this wall (G033) bounded the garden from its inception.

4.3.9. The croft ruins and their inhabitants
Although unexcavated, the ruinous foundations of the modern croft at Quoygrew were also in use during Phase 6, with uncertainty regarding when they were first built. The surviving layout is illustrated in Figure 4.44, and can also be seen in the aerial photographs of the site (Fig. 3.9). The dwelling house, and elements of the associated outbuildings, can be traced back to at least 1866 based on a plan of the Trenabie Estate (Miller 1866). The same information

a

b

Figure 4.45. *(a) One of the few surviving photographs of Quoygrew prior to its abandonment, taken of Betty Stinear, granddaughter of James and Betsy Logie, in front of the steading in the early 1930s. (b) Betty Stinear at House 1 following its consolidation for public display. (Images courtesy of Bessie Drever.)*

is duplicated on the first edition Ordnance Survey map of 1882 (Fig. 3.2). In 1841, the date of the first relevant census, the settlement was occupied by several extended families (Ferguses, Logies, Rendalls and Seaters) totalling 12 people in all. Their members were employed as a seaman, a tailor, a teacher and a servant (ScotlandsPeople 2011). By 1881 the site was occupied (and farmed) only by William and Margaret Fergus with their five children. In 1901 the site was occupied by the next generation of Ferguses: John (a farmer and fisherman), Mary and their four children (ScotlandsPeople 2011). As discussed in Chapter 3 the name of the site changed from Nether Trenabie to Quoygrew in the last two decades of the nineteenth century, implying a decline in perceived size and/or wealth. This shift may reflect the end of memory that the settlement once formed the core of a substantial medieval farm.

The final years of Quoygrew are best informed by oral history. The last tenants were James and Betsy Logie (along with their son John and granddaughter Betty). Bessie Drever (*née* Thomson), another granddaughter, lived in the house for the first two years of her life and often stayed with her grandparents during school holidays until she was eight. She and her contemporaries, Christina and George Drever, kindly recorded their memories of the settlement during an interview in August of 2005. Based on their reminiscences the uses

of the buildings, yards and other spaces of the croft in the 1930s have been added to Figure 4.44. There was the walled garden (excavated in Area G), in which potatoes, cabbages and other vegetables were grown. There was the stack yard north of the buildings, in which the harvest was dried. There was the field between the house and the sea, in which potatoes were grown at one time, and bere barley at another. There was the steading (a farm's outbuildings), comprising the pigsty, barn, stable and hen house, built together in a row (Fig. 4.45a). There was also a flower garden, somewhere along the stone wall facing Trenabie's field to the south.

Bessie recalled that the dwelling house had three main rooms: the ben (bedroom), a small middle room and a kitchen. At the end of the kitchen there was also a dark storage space — which always frightened the children. The water was kept there, having been carried from the nearest well at the Biggings to the south. There was also a larger store room outside the door where the coal was kept. There are no surviving photographs of the house, but her mental picture provides a valuable alternative.

Bessie visited Quoygrew until 1937, when the family was evicted by the then owners of Trenabie. The Logies had farmed both the 1.7 acres (0.7 hectares) inside the field boundaries immediately surrounding Quoygrew and additional land rented from Trenabie. Overall the croft was associated with approximately six acres (2.4 hectares).

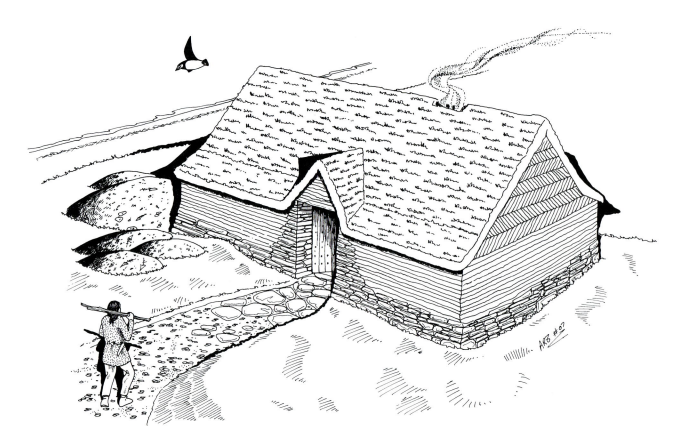

Figure 4.46. *Reconstruction of House 5 in Phase 2.3, based on the excavated evidence and analogy with Icelandic and Scottish turf architecture of more recent centuries (Fenton 1982; Ólafsson 1982). (Image: Alan Braby.)*

4.4. Conclusions: a millennium of settlement at Quoygrew

Quoygrew was occupied from the tenth century until 1937. There are ephemeral hints that crops were grown in the area early in the Iron Age, but the settlement as excavated is a foundation of the Viking Age. The focus of the site was initially the Farm Mound a few tens of metres from the shore. We have yet to excavate any houses of this first occupation (Phase 1), but middens provide a clear indication of their existence. In Phase 2, starting in the eleventh century, a small dwelling (House 5) was built near the shore (Fig. 4.46). It is here, against the seaward western gable of the house, that bait and fish were processed for approximately two hundred years. This activity created a large Fish Midden, composed mostly of limpet shells, fish bones and ash (the latter perhaps from the rendering of fish livers for oil). Other middens accumulated north and south of House 5 as its occupants dumped their household refuse.

Traces of buildings broadly contemporary with House 5 have been discovered in Area G, but not yet fully explored. Thus the Farm Mound may still have formed the domestic core of the settlement in the eleventh and twelfth centuries, with House 5 serving as the home of a separate household (be it of another generation or of a different social status).

In Phase 3, starting around 1200, a substantial new dwelling with three rooms (House 1) was built over House 5 near the shore (Fig. 4.47). With it the main focus of the farm at Quoygrew shifted for approximately 400 years. This house was carefully maintained, in its initial configuration, for two centuries. A fourth room was then added at the beginning of Phase 4 around 1400 (Fig. 4.48). Late in the life of the house some rooms were relegated to midden dumping and other secondary functions. Nevertheless, the central dwelling space (Room 1) retained its original role until the building was demolished — probably in the sixteenth century.

By the nineteenth and twentieth centuries (Phase 6) the focus of the settlement was back on the Farm Mound. Moreover, geophysical survey (Chapter 3) suggests that an unexcavated building between the inland mound and House 1 may bridge the gap in the seventeenth and eighteenth centuries (Phase

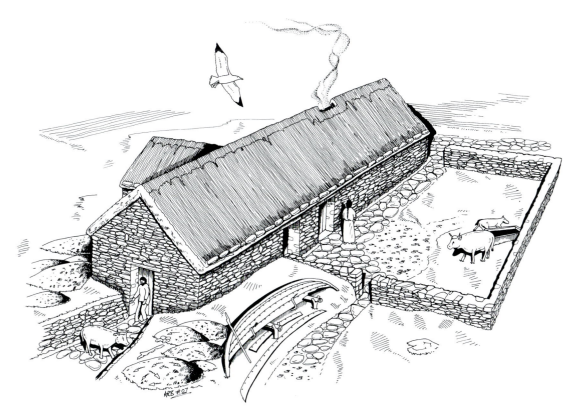

Figure 4.47. *Reconstruction of House 1 in Phase 3.2, based on the excavated evidence and analogy with Orcadian vernacular architecture (Roussell 1934; Fenton 1978; 1982). (Drawing: Alan Braby.)*

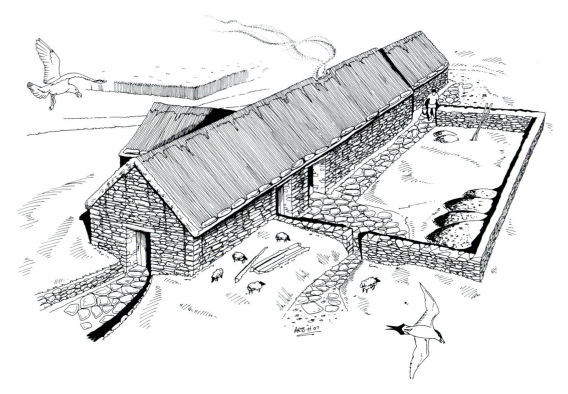

Figure 4.48. *Reconstruction of House 1 in Phase 4.1, based on the excavated evidence and analogy with Orcadian vernacular architecture (Roussell 1934; Fenton 1978; 1982). (Drawing: Alan Braby.)*

5). This putative intervening house, and/or others not yet discovered, would probably have been in use during the decline of House 1 late in Phase 4. The site was finally abandoned in 1937, having been reduced from a central part of a large medieval farm to a tiny croft of approximately six acres (2.4 hectares).

Throughout its existence the settlement shows evidence of both continuity and discontinuity in lived experience. For the present it is enough to observe that there could be fundamental shifts (e.g. the rise and fall of fishing in Phases 2 to 3, or the adoption of ceramics in Phase 3) and remarkable continuities (e.g. the *c.* 400-year life of House 1). It is these waves of time, and their implications for the understanding of islander identity and socio-economic networks, that underlie the chapters to follow.

Chapter 5

Ecofact Recovery and Patterns of Deposition

James H. Barrett and Jennifer F. Harland

5.1. Introduction

One of the central goals of the excavation was to investigate temporal changes in the intensity of economic production, on land and sea. For present purposes, economic production is defined simply as those activities that turned components of the environment into the necessities and luxuries of daily life — be they for local consumption (household use), indirect subsistence (payment of rent, tax and/or tithe for consumption elsewhere in the archipelago) or long-range exchange (either directly, or by the recipients of rent, tax and/or tithe, cf. Hoffmann 1996, 636). In a Viking Age and medieval Orcadian context these activities could involve materials ranging from limpets (perhaps used as bait) to carefully

dried stockfish — or from manure of mixed ash and dung to the malted barley used to brew the ale for a magnate's feast.

The most direct way to investigate these economic activities, and thus ultimately to illuminate the role of this small farm within a wider political economy, is to study ecofacts — the residues of fishing, agriculture and (to a lesser degree) fowling. This starts with the systematic recovery of shells, bones, botanical macrofossils and sediments — which are each the subject of specialized analyses in Chapters 7 to 11 and elsewhere (Simpson *et al.* 2005; Milek 2006). Here we outline the recovery strategy that underlies these later studies. We also summarize broad temporal trends in the importance of differing economic activities based on the density of marine shell, fish bone and mammal

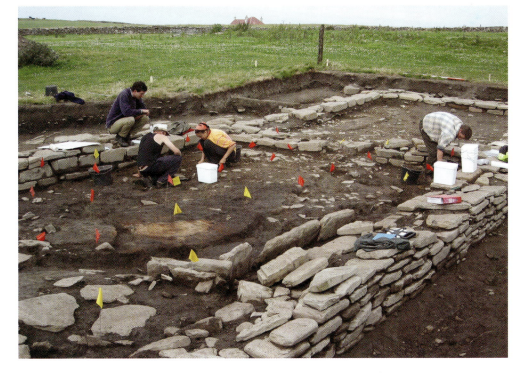

Figure 5.1. *James Gerrard (top left) supervises the collection of flotation samples from House 1. Temporary markers designate 1 m grid squares. (Image: James Barrett.)*

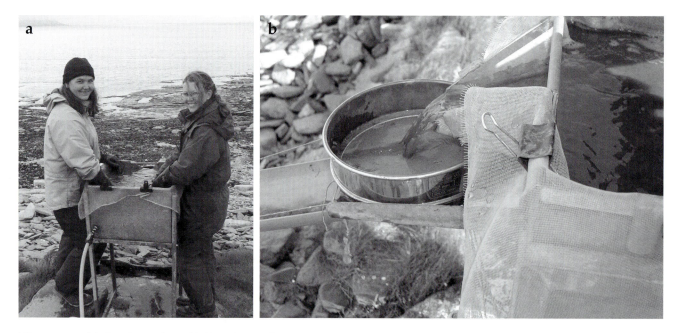

Figure 5.2. *(a) Catrina Adams (left) and Jennifer Harland (right) operate the flotation tank, fitted with (b) a 0.5 mm geological sieve to catch floating material and 1 mm mesh to collect the heavy fraction. (Images: Marcus Smith.)*

bone (in terms of grams per litre of sediment) in the many samples excavated for ecofact recovery.

5.2. The samples

Four types of samples were collected at Quoygrew (excluding Kubiena samples for soil micromorphology discussed separately by Simpson *et al.* 2005): flotation samples, coarse-sieving samples, general biological assemblage (GBA) samples and sediment samples. In all cases nothing was removed prior to processing, other than obvious artefacts and stones too large to fit in the relevant sample containers. Flotation, coarse-sieving and GBA samples were all collected in 10 litre plastic tubs with sealable lids (Fig. 5.1). The volume of these samples was recorded (to the nearest litre) using a graduated bucket and they were weighed (to the nearest 0.1 kg) using a spring balance. Sediment samples (for chemical analysis) were recovered in self-sealing plastic bags of up to *c.* 0.5 litres capacity.

Overall, 1354 flotation samples (totalling 11,085 litres and 11,657 kg) were collected and processed, excluding a few that suffered mishaps such as spillage along the way. The selection of these samples varied with the nature of the excavation. In Areas A to C (column samples in the coastal Fish Midden) all excavated material was collected for flotation. During open-area excavation of large midden deposits flotation samples were instead collected from every

second metre square, typically on a chessboard pattern. Disturbed contexts were usually left unsampled. Conversely, small but interesting deposits (such as hearth ash or discrete dumps of midden) were sometimes collected in their entirety. When house floors could be exposed, flotation samples were also taken from contiguous 1 m squares across the entire living surface.

The resulting samples were processed in a traditional flotation tank — using running water and manual agitation to separate charred botanical remains (recovered on a 0.5 mm geological sieve and referred to as the light fraction or flot) from heavier objects like bones, shells and stones (recovered on a 1 mm mesh and referred to as the heavy fraction or residue) (Fig. 5.2). Subsequent processing of the light fractions is discussed in Chapter 10. For the heavy fractions large stones were removed at the tank. The remaining residue was then dried at *c.* 30°C and divided into >4 mm, >2 mm and <2 mm components. All materials >4 mm were subsequently sorted, weighed and bagged for further study. For a small number of heavy fractions the <4 mm material was also sorted specifically for the recovery of fish bones (see Chapter 7).

610 coarse-sieving samples (totalling 5306 litres and 5706 kg) were collected and processed. All of the sediment from Area E (a small trench in the wave-cut bank) was treated in this way, mainly to increase the number of bones recovered from the coastal Fish Midden. Coarse-sieving samples were also collected

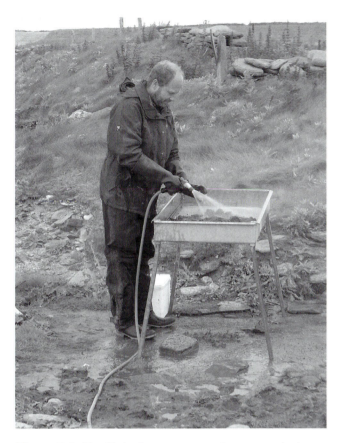

Figure 5.3. *David Andrews operates the coarse-sieving frame. (Image: Jessica Mou.)*

during the excavation of other middens, usually from alternate 1 m squares like flotation samples. After recording the volume and weight of sediment the samples were washed through a 4 mm sieve (Fig. 5.3). Large stones were removed while sieving before the retained materials were dried at *c.* 30°C, sorted, weighed and bagged for further study.

Seven GBA samples (*sensu* Dobney *et al.* 1992) were collected from contexts such as drain fills that were waterlogged when excavated. They were assessed for anoxic preservation of insect and botanical remains under the supervision of Allan Hall and Harry Keward of the University of York. They yielded no such finds, however, having clearly dried *in situ* at some point. They are thus not considered further here.

A total of 881 sediment samples were taken for geochemical analysis. They were collected judgementally from anthrosols, middens and other external deposits. For exposed house floors they were taken from contiguous 0.5 m squares insofar as stones and cut features allowed. The samples were air-dried and stored in sealed plastic bags. The resulting geoarchaeological analyses have been discussed by Simpson *et al.* (2005) and Milek (2006), and are noted where pertinent.

5.3. Patterns of deposition

The 1964 flotation and coarse-sieving samples — all sorted to 4 mm — came from 16,391 litres of sediment systematically extracted from a wide range of contexts across the site. They thus provide an invaluably large and representative data set with which to evaluate broad trends in ecofact deposition — through time and in different types of contexts (Appendix 5.1). Excluding stone, the samples were dominated by varying weights of marine shell, fish bone and mammal bone — with bird bone a more occasional inclusion. Overall they produced 526.0 kg of shell, 52.5 kg of fish bone, 20.2 kg of mammal bone and 0.5 kg of bird bone.[10]

Changing patterns of deposition — and thus changing economic activities — can be illustrated by quantifying these materials in terms of grams per litre of excavated sediment. Figure 5.4 provides box plots of the results for shell, fish bone and mammal bone divided by general phase groups for the site as a whole. Three patterns are clear. Firstly, shell is most abundant in Phases 2 to 3 and 4 to 5. Secondly, fish bone is most abundant in Phases 2 to 3. Thirdly, the abundance of mammal bone is comparatively stable across all phases — with some evidence for increased deposition in Phases 3 to 4.

These patterns corroborate what was observed during excavation: that fish bone and shell had a short period of superabundance (starting in Phase 2 and ending early in Phase 3, based on the dating of Phase 2 to 3 contexts as discussed in Chapter 4) with several shell dumps also accumulating much later. Mammal bone, conversely, was most abundant in the midden fills that accumulated as House 1 gradually went out of use.

The drop in density of fish bone and shell at some point during Phase 3 is concurrent with a wholesale reduction in the amount of midden present at Quoygrew (Chapter 4). One must therefore ask whether shell and fish bone could simply have been discarded somewhere else in the thirteenth to fourteenth centuries? To address this possibility, Figures 5.5 and 5.6 illustrate the densities of shell, fish bone and mammal bone from midden deposits alone (including, for comparative purposes, agricultural soils that might be manured with midden where more than one sample was taken). The results are divided into two main stratigraphic sequences, one for the inland Farm Mound (Area G) and one for Areas A to F near the shore (including the Fish Midden, the North Midden, the South Midden, and the

10. Additional material was collected by hand, as discussed in Chapters 7, 8 and 9.

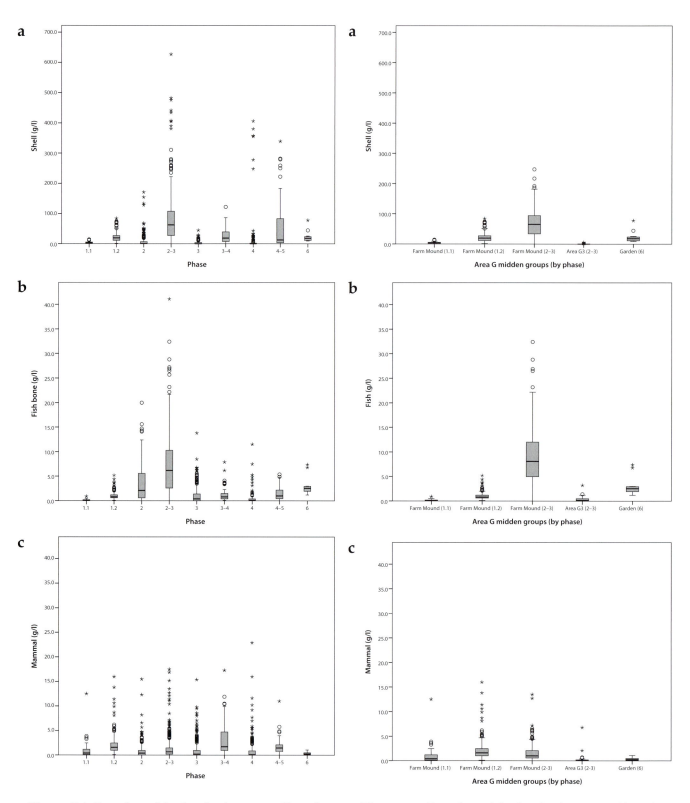

Figure 5.4. *Box plots of the density (grams per litre of excavated sediment) of (a) marine shell, (b) fish bone and (c) mammal bone in all sieved samples (by phase). Materials were sorted to 4 mm.*

Figure 5.5. *Box plots of the density (grams per litre of excavated sediment) of (a) marine shell, (b) fish bone and (c) mammal bone in sieved midden samples from Area G (by location and phase). Materials were sorted to 4 mm.*

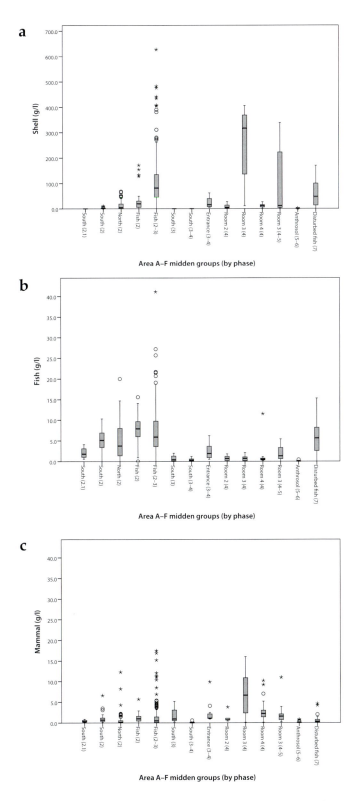

Figure 5.6. *Box plots of the density (grams per litre of excavated sediment) of (a) marine shell, (b) fish bone and (c) mammal bone in sieved midden samples from Areas A to F (by location and phase). Materials were sorted to 4 mm.*

middens that accumulated in Rooms 2 to 4 of House 1). It is clear that the abundance of shell and fish bone did increase in Phases 2 to 3 before collapsing during Phase 3. Thereafter the pattern differs for these two materials. Fish bone never returned to its former abundance whereas shell (albeit of different species, see Chapter 6) was common once again in the midden dumps of Phase 4 and Phases 4 to 5. Mammal bone was deposited in consistently low quantities with the minor exception of the Phase 4 middens in House 1.

In result it would appear that there was indeed a boom in the use of marine resources during Phase 2 and the earliest years of Phase 3, followed by a marked decline. The only alternative is that these changes in sample composition resulted from major preservation differences. This latter possibility is unlikely on the basis of further analyses of the shell and bone assemblages in the chapters to follow. For example, limpets decreased in size and age (indicating more intensive exploitation) at the same time that the weight of shell per litre of excavated sediment increased (Chapter 6).

The question nevertheless remains why comparatively little midden accumulated at Quoygrew during the latter part of Phase 3? One possibility is that it was used as manure on the anthrosol (probably an infield) that was being developed south and east of the Farm Mound at this time (see Section 4.3.4). Micromorphology and geochemistry suggest that this soil was created mainly by the addition of grassy turves, ash and organic material (such as animal manure) (Simpson *et al.* 2005, 371–2). A single flotation sample taken from this soil (in Test Pit 2) produced tiny fragments of shell (0.2 g), fish bone (0.1 g) and mammal bone (0.1 g). Multiple samples from later cultivated sediments (of Phases 5 and 6) also included small quantities of shell and bone (Figs. 5.5 & 5.6). It would thus not be surprising if diverse refuse had been used as fertilizer. Nevertheless, the medieval infield soils at Quoygrew are aceramic, implying that household waste was not the preferred agricultural manure (see Chapter 16).

Chapter 6

The Maritime Economy: Mollusc Shell

Nicky Milner and James H. Barrett

6.1. Introduction

This chapter presents the results of the molluscan analyses carried out for the site of Quoygrew.[11] The shells came from a variety of contexts ranging in chronology from Phase 1 to Phases 4 to 5. They were excavated from both the Fish Midden on the shore and inland domestic contexts (in Area F and the Farm Mound) and therefore provide the opportunity to examine how these marine resources were used in different situations and through time.

A study such as this can provide information on the environments used and how people harvested shellfish. In addition, it is possible to examine why changes in species representation or shell sizes occurred through time: do these represent changes in the environment or intensification of shell gathering strategies? Specifically, this chapter will investigate whether the molluscan evidence can support the hypothesis that there was a rise and fall in the intensity of marine resource use during the Middle Ages.

6.2. Methods

The shells from the site were extracted from the >4 mm fraction of sieved sediment samples and counted by calculating the minimum number of individuals (MNI) for each context. MNI is usually the preferred method of quantification in archaeomalacological studies: although there can be problems relating to MNI analysis of zooarchaeological assemblages, this is not the case for mollusc remains (Claassen 1998). The MNI was calculated by counting the apices for

the gastropods, and the umbones of the bivalves were sorted into left and right halves and counted, with the largest sum used as the MNI.

Measurements were taken on complete limpet and periwinkle shells to the nearest 0.1 mm using electronic callipers. For periwinkles, the height of the shell (L1) was taken, from the apex to the bottom of the aperture. For limpets, the length (L1) and height (L2) were measured. In most cases the maximum number of shells measured from a single context was 150, although in a few cases more were measured. Where the number of measurable shells was very small, closely related contexts have sometimes been grouped for analysis.

When considering the possibility of intensification of human predation a number of lines of enquiry can be made (Claassen 1998; Mannino & Thomas 2002; Milner & Laurie 2009). It is important to look for both changes in size of the shells and changes in species. A decrease in shell size through time or a change to less easily procured species may both indicate intense human predation. However, both may be a factor of environmental change. Although not always considered in studies of archaeological material, the age of the molluscs is an important variable. Marine molluscs grow throughout their lives and although the rate of growth usually decreases with age there is a broad correlation between size and age. When molluscs are intensively exploited the larger shells tend to be collected first and the younger shells have less time to mature before being gathered. Consequently the average age of the natural population is pushed down and the average size of the molluscs is reduced. Conversely, if an environmental change causes the growth rate to slow, the average size of the shells may decrease but the average age will not necessarily change.

Studies of *Patella vulgata* have shown that growth increments observed microscopically are correlated with tidal immersion and macroscopic growth checks on the exterior of the shell occur in the colder months of the year (Fig. 6.1) (Ekaratne & Crisp 1982; 1984). In a study of limpets from Asturian prehistoric

11. A preliminary study of the Quoygrew shell was published as Milner *et al.* 2007. We thank Jon Welsh and Eva Laurie for assisting with the lab work. Stable isotope analysis of the shells (Surge & Barrett 2012) was conducted after this chapter was first written, but the seasonality results have been noted below and the palaeoclimate evidence informs the overall dscussion in Chapter 16.

Figure 6.1. *Limpet with three visible external growth checks (the limpet width is 3 cm). (Image: Nicky Milner.)*

Table 6.1. *List of the main shellfish taxa from the Fish Midden and Farm Mound samples. Taxonomy follows Gibson* et al. *(2001).*

Mollusca	Gastropoda	Common names
Family Buccinidae	*Buccinum undatum* (Linnaeus)	Buckie, common whelk, edible whelk
Family Littorinidae	*Littorina littorea* (Linnaeus)	Edible/common periwinkle
	Littorina obtusata (Linnaeus)	Flat periwinkle
Family Muricidae	*Nucella lapillus* (Linnaeus)	Dogwhelk
Family Patellidae	*Patella* species	Limpet
	Helcion pellucidum (Linnaeus)	Blue-rayed limpet
Family Triviidae	*Trivia* species	Cowrie
Family Trochidae	*Gibbula cineraria* (Linnaeus)	Grey topshell
Mollusca	**Bivalvia**	**Common names**
Family Cardiidae	*Cerastoderma edule* (Linnaeus)	Common cockle
Family Glycymeridae	*Glycymeris glycymeris* (Linnaeus)	Dog cockle
Family Mactridae	*Spisula* species	Trough shell
Family Mytilidae	*Mytilus edulis* (Linnaeus)	Common mussel
Family Pectinidae	?	Scallop
Family Solenidae	?	Razor shell
Family Veneridae	?	?

middens, limpets were aged by counting the visible winter growth checks on each shell, and an average minimum age for each level was ascertained (Bailey & Craighead 2003; Craighead 1995). In this study limpets have been aged using the same method.

6.3. Results

In most areas of the site the most abundant genera were limpets and periwinkles. Sometimes there were also significant numbers of mussels and cockles. In addition to these main groups a number of other species occurred in very small numbers. Details of the species identified are presented below, with the taxonomy following Gibson *et al.* (2001) (Table 6.1).

6.3.1. The species and their habitats

In most areas the most abundant shellfish was the limpet, *Patella* sp. There are three species found on the British coastline: *P. vulgata*, *P. intermedia* and *P. aspera*. It is difficult to distinguish between the three without the animal inside or the colouring inside the shell, which archaeological specimens do not have. It is thought that the majority of specimens from this site were the most common species, *Patella vulgata*, found on the high, middle and low rocky shores in large numbers. Limpets are fairly easy to exploit but need to be knocked off the rocks where they cling tightly, particularly when the tide is out (Fig. 6.2).

Periwinkles, *Littorina* sp., also tend to be found on rocky shores or stones (Fig. 6.3). There are several different species of periwinkle, but the ones found on this archaeological site were *L. littorea*, the common or edible periwinkle, and *L. obtusata*, the flat periwinkle. The common or edible periwinkle is the larger of the two and lives on rocks and weed on the middle shore and below. The flat periwinkle is much smaller, flat-topped, and usually colourful (yellow, red, green, etc.). It is more likely to be collected because of aesthetic qualities or accidentally because it is attached to weed, rather than for consumption purposes. It lives on the middle and top shore, especially on *Fucus* weed. Periwinkles are easy to pick off the rocks and because they congregate in large numbers a great number can be scooped up at once.

The two main bivalves found at Quoygrew, mussel and cockle, are both edible. Cockles were very common in some of the shell dumps within House 1. The cockle, *Cerastoderma edule*, is harder to exploit than some of the other molluscs because it burrows superficially in sand or mud and therefore needs to be dug or raked out. It tends to be found on the middle and lower shore in immense numbers, forming dense cockle beds. The mussel, *Mytilus edulis*, is a very common shore animal found in dense beds on rocky, stony and muddy zones on the middle shore and below, attaching itself to rocks by means of byssus threads. It can easily be gathered by pulling it off the rock and many can be gathered because they

Figure 6.2. *Limpet shell attached to the rock. (Image: Nicky Milner.)*

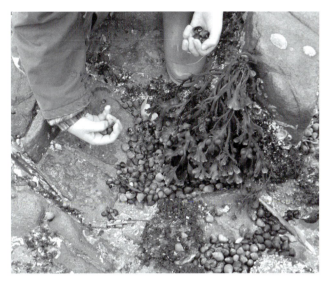

Figure 6.3. *Scooping periwinkles off the rocks. (Image: Nicky Milner.)*

occur in abundance. The mussel, however, does not usually survive well on archaeological sites and the shell is often powdery and much degraded, particularly if it has been heated. It is likely that on many archaeological sites where mussel is identified it will be significantly under-represented.

A number of other species have been identified but these only occurred in very small numbers. Dogwhelks are usually found on rocks in large numbers. They are the chief predator of barnacles. They tend to be thought inedible, although this is not actually the case. The few found have been identified as the dogwhelk, *Nucella lapillus*. The common whelk or 'buckie', *Buccinum undatum*, is much larger than the dogwhelk, sometimes reaching 15 cm in length. This is an edible mollusc and lives on the lower shore and below on muddy gravel or sand.

There are several other species present in very small quantities (not all of which are included in Tables 6.1 and 6.2). The topshell, *Gibbula* sp., is distinctive if worn down below the outer surface because it reveals layers of mother-of-pearl. It lives on rock or weed. There are many species of topshell, but the few shells that have been found on this site look to be *Gibbula cineraria*, the grey top shell. Warty venus, *Venus verrucosa*, was also present in very small numbers, as were razor shell and scallop, both unidentified to species, and a fragment of shell which may be a type of clam, possibly belonging to the family Veneridae. Some pieces of sea urchin (unidentifiable to species or genus) have also been found. *Hydrobia ulvae* is a minute species of gastropod that would have been collected unintentionally on seaweed or

in cockle gathering and was found in small numbers in the cockle-rich shell dumps.

6.3.2. Comparison of deposits

Shellfish remains have been analysed from a number of deposits belonging to different areas and phases of the excavated settlement (Table 6.2). Shells were recovered from both the lowest (Phase 1) strata of the inland Farm Mound and its later (Phase 2 to 3) layers. The distinction between these phases in Area G is very relevant to analysis of the molluscs from Quoygrew. The Phase 1 deposits are dominated by mammal bone, with comparatively little fish bone and shell, whereas the Phase 2 to 3 deposits of the Farm Mound (and of the contemporary Fish Midden closer to the sea) are dominated by fish bone and marine shell (Chapter 5). The most important aim of the present analysis is to ascertain whether this difference represents intensification in the exploitation of marine resources, or just changes in refuse disposal practices (where, for example, shells and fish bones started to be disposed of in more concentrated locations).

Closest to the shore, shells from a 50 cm column sample (Area A) in the Fish Midden have been analysed. Of the 24 contexts considered from this area, all but three were well stratified as Phases 2 to 3. The exceptions probably included intrusive shells of these phases in the underlying palaeosol (context A026) or disturbed shells of this date in the overlying topsoil (contexts A002 and A003).

Other mollusc remains have been studied from middens and discrete dumping episodes in and around Houses 1 and 5. Of these, the North Midden

Table 6.2. *Summary of the MNI for each taxon in each area or context (and phase). Presence is noted with an X where MNI could not be calculated.*

Area (Phase)	Limpet	Periwinkle	Flat periwinkle	Cockle	Mussel	Dogwhelk	Other dogwhelk	Topshell	Blue-rayed limpet	Dog cockle	Common whelk	Clam	Trough shell	Cowrie	Razor shell	Scallop
Area G (1)	5613	191	6	19	5									X	X	X
Area G (2–3)	13,998	1389	162	604	184	6		3			X	2	1	1	X	X
North Midden (2)	2192	165	14	10	2	1					1					
Area A (2–3)	4434	1000	122	103	59	6	1	2	1	1					X	
Room 2 (4.3.1)	58	9	2	14												
Room 3 (4)	122	175	6	2831												
Room 4 (4)	788	245	10	10	1	1		X			X	X				X
Area D (4–5)	310	141	4	9							2					
F586 (4–5)	982	1491	10	69												
F136 (unstrat.)	20	4		1												

(contexts F472, F475, F504, F981 and F982) is a Phase 2 deposit that accumulated against the north wall of House 5 and was subsequently cut by the building of House 1. It is therefore broadly contemporary with the middle strata of the Farm Mound and the bottom of the Fish Midden.

A Phase 4 cockle dump (comprising contexts F1019 and F1030) at the west end of Room 3 has also been analysed, as have broadly contemporary shell dumps in Room 2 (contexts F129 and F226 of Phase 4.3.1) and Room 4 (contexts F602 and F676 of Phase 4). Shells were also analysed from the western entrance into Room 3 in Area D (context D005) and from a shell dump (context F586) overlaying the collapsed wall of Room 3 — both attributed to Phases 4 to 5. Lastly, the shells from an unphased context in a disturbed area of Room 2 were analysed before stratigraphic analysis was finished and are included here for the sake of completeness.

6.3.2.1. Area G
In Phase 1 of Area G limpets were predominant in all contexts (Table 6.2). Periwinkle, flat periwinkle, mussel and cockle were also present, although the flat periwinkle, mussel and cockle occurred in very small quantities in terms of MNI. Some other species were also found in very small quantities, but were not represented by MNI: razor, scallop and cowrie. In Phases 2 to 3 of Area G there was striking homogeneity between contexts. The five main species were present and there were fewer limpets (*c.* 85%) (Fig. 6.4). Nevertheless, there were a variety of other species with very small MNI: dogwhelk, topshell, clam, trough shell and cowrie and some others not represented by MNI: scallop, razor and common whelk.

6.3.2.2. Area A
There was a relatively large number of different species in Area A of the Fish Midden (Table 6.3). Five main species were found: limpet, periwinkle, flat periwinkle, mussel and cockle. Blue-rayed limpet, dog cockle, topshell and common whelk were represented by MNIs of 1 or 2 and dogwhelks by 7. Razor shell and sea urchin were also present in very small quantities, but they have not been attributed a MNI estimate due to the lack of apices or umbones.

The relative abundance of limpets to periwinkles was lower (between 67% and 77% limpets) at the base of the midden, in contexts A026, A025 and A024. Further up, the limpets became more prevalent (up to 95%) until A008 where they began to decline again, and in layers A004, A003 and A002 they dropped off considerably (77%, 63% and 52% respectively).

6.3.2.3. North Midden
A range of species was found within the Phase 2 North Midden, but limpets were predominant (92%) (Table 6.2). Periwinkles made up about 7% of the assemblage. This composition of species is very similar to the Farm Mound midden and the Fish Midden.

6.3.2.4. House 1 (Rooms 2, 3 and 4)
The disuse Phase (4.3.1) of Room 2 in House 1 had a couple of small shell dumps mainly made up of limpets, but the MNI is very small for these contexts and no further analysis was undertaken for them. Similarly, F136, an unphased context in Room 2, was mainly limpets but is very small.

The Phase 4 shell dump in Room 3 was largely dominated by cockles (90%), although limpets (4%) and periwinkles (6%) were also present. The Phase 4

Table 6.3. *Table to show the MNI for each taxon per context in Area A and the percentage of the total MNI per context (percentages for those contexts with MNI < 30 have not been included due to the small sample size).*

Context	Limpet	Periwinkle	Flat periwinkle	Cockle	Mussel	Dogwhelk	Topshell	Blue-rayed limpet	Dog cockle
A002	213 (52%)	170 (41%)	7 (2%)	21 (5%)					
A003	70 (63%)	34 (31%)	2 (2%)	5 (5%)					
A004	85 (77%)	22 (20%)	2 (2%)	1 (1%)	1 (1%)				
A005	134 (88%)	12 (8%)	4 (3%)	3 (2%)		1			
A006	50 (85%)	9 (15%)							
A007	13	8	3						
A008	376 (71%)	129 (24%)	16 (3%)	9 (2%)	1				
A009	425 (92%)	10 (2%)	13 (3%)	2	13 (3%)				
A010	30 (94%)			2 (6%)					
A011	2								
A012	137 (95%)		3 (2%)	4 (3%)					
A013	328 (84%)	31 (8%)	12 (3%)	3 (1%)	18 (5%)		1		
A015	159 (76%)	48 (23%)	3 (1%)						
A016	2								
A017	165 (86%)	20 (10%)	4 (2%)	3 (2%)					
A018	10								
A019	306 (88%)	35 (10%)	5 (1%)	3 (1%)					1
A020	4								
A021	78 (93%)	4 (5%)		2 (2%)					
A022	25 (83%)	1 (3%)	1 (3%)	3 (10%)					
A023	121 (83%)	22 (15%)	2 (1%)		1 (1%)				
A024	138 (67%)	65 (32%)		3 (1%)					
A025	1081 (77%)	264 (19%)	17 (1%)	24 (2%)	23 (2%)	2		1	
A026	371 (74%)	110 (22%)	4 (1%)	14 (3%)	2	2	1		

shell dump in Room 4 was more similar to the North Midden in that limpets predominate, although not to the same degree: limpets (75%), periwinkles (23%). F586, the latest (Phase 4 to 5) shell dump on the site, overlaying the collapsed wall of Room 3, is largely made up of periwinkles (58%) and limpets (38%) (Fig. 6.5).

6.3.2.5. Area D
Overall there were very few shells from the Phase 4 to 5 deposits in Area D (Table 6.2). Limpets and periwinkles were most abundant; there were a few cockles, a couple of flat periwinkles, two common whelks and a few fragments of mussel. Compared to Area A (for example) there are more periwinkles, as seen in context F586 of similarly late date.

6.3.2.6. Summary
Limpets were most abundant in Phase 1 of Area G, but periwinkles (and to a lesser degree cockles and flat periwinkles) became more common in Phases 2 to 3 of the Farm Mound (Chi-square = 434.86, *df* = 3, *p* = <0.001). The coastal midden (which is contemporary with Phases 2 to 3 of Area G, but represents a more specialized accumulation of shell and fish bone) had a higher relative abundance of periwinkles and other

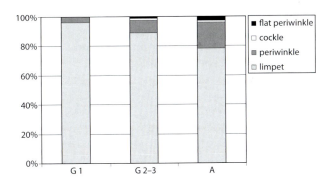

Figure 6.4. *Percentages of main species from the middens of Areas G (Phase 1), G (Phases 2–3) and A (Phases 2–3).*

secondary species than even the upper phase of the Farm Mound (Chi-square = 439.52, *df* = 3, *p* = <0.001) (Fig. 6.4). In turn, the Phase 4 to 5 deposits of Area D had an even greater proportion of periwinkles.

There was much variability between the shell dumps in Rooms 2, 3 and 4 of House 1, not only in the dominant species, but also in the overall composition of the dumps. For example, there was comparatively little overlap in the species present between the Phase 4 dumps in Room 3 and Room 4: the former contained

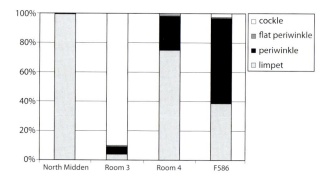

Figure 6.5. *Proportion of species from contexts in and around House 1 containing substantial quantities of shell.*

warty venus, razor shell, sea urchin and *Hydrobia ulvae* and the latter contained mussel, dogwhelk, topshell, whelk, clam, scallop and sea urchin. The explanation for this variability may be connected with the predominant species in these deposits. The dump in Room 3 was dominated by cockle and the other species found there tend to be found in similar environments and be collected in similar ways. For instance, it is typical to find *Hydrobia ulvae* in middens with cockles because they both inhabit sandy deposits. Similarly, mussels, whelks and topshells tend to be found on rocks — where limpets and periwinkles (the main species in the Room 4 dumps) were also found. Therefore the variability exhibited here is largely to do with the local environments exploited and the ways in which the predominant species were gathered.

6.3.3. Size analysis
6.3.3.1. Measurements
A change in limpet size can be assessed by comparing height and length on a scattergraph, as in Figure 6.6. Here it can be seen that the limpets from Phase 1 of the Farm Mound are on the whole large when compared to those from Phases 2 to 3 of the same area. If Area G Phases 2 to 3 are then compared with Area A in the Fish Midden, it can be seen that the plots largely overlap demonstrating a considerable degree of similarity (Fig. 6.7).

In order to compare contexts and areas the average lengths and standard deviations have been calculated. Figure 6.8 suggests that in Area A there was little difference in the average size of the limpets with the exception of A002, A003 and A005 near to the top of the midden, where the shells are smaller (possibly due to fragmentation of the largest specimens in these disturbed contexts). When explored using ANOVA, there is a significant difference between the contexts of Area A ($F = 3.25$, $df = 17$, $p = <0.001$), but if A002, A003

and A005 are omitted this difference disappears ($F = 1.24$, $df = 14$, $p = 0.24$).

The results from a selection of contexts are illustrated in Figure 6.9. The limpet size data from the Area G Farm Mound fall into three groups through time. Those in Phase 1 were much larger than elsewhere on the site, whereas those at the beginning of Phases 2 to 3 (G058/21 and G055/56/57) were significantly smaller (referred to below as 'subphase' G2–3A). Later still, in contexts G054 and above, they appear to have been slightly larger again (referred to below as 'subphase' G2–3B), but they did not reach the size of the Phase 1 limpets. The differences in size observed here are very clear: the average size of those from the lower part of the midden is as much as 10 mm larger than those from some contexts in the upper midden. Based on ANOVA and associated Scheffe *post hoc* tests of the limpet length data, all three groups are significantly different ($F = 64.99$, $df = 2$, $p = \leq 0.003$). Across space, the limpets from the coastal midden (excluding contexts A002 to A005) are smaller than those from Phase 1 of Area G (Scheffe $p = <0.001$) and G2–3B (Scheffe $p = <0.001$), but do not differ significantly from those of G2–3A (Scheffe $p = 0.773$) (overall ANOVA: $F = 78.35$, $df = 3$, $p = <0.001$).

The later (Phase 4 and Phase 4 to 5) limpets from House 1 were also quite small — comparable to G2–3A of the Farm Mound and Area A of the Fish Midden. There may be two reasons for this. Either small limpets were purposely collected because they were generally thought to be more palatable (if consumed) or intensive exploitation at the site had once again led to a decrease in average size.

In order to eliminate the possibility that the limpets in Phase 1 of Area G were being gathered from a different area of the shoreline, which could potentially have a bearing on the difference in size, the limpets have been compared with a modern sample of limpets collected from the upper and lower shore zones. It is well known that limpets do not move between zones along the shore and the shape of the shell is partly determined by the position on the shore (e.g. Orton 1928; Russell *et al.* 1995; Milner 2009). Limpets living near the upper shore have taller, more conical shells, whilst those at the lower shore have much flatter shells. The modern limpets were collected from Applecross, Scotland in 2003. There is a clear difference in length/height ratios between the two zones on the shore ($t = 8.29$, $df = 82.96$, sig <0.001; see Fig. 6.10).

If the archaeological samples from each area and phase are plotted in the same way it can be observed that there is a difference between samples (Fig. 6.11). There appears to have been a shift from Area G Phase 1 to Area G Phases 2 to 3 to Area A, with limpets being

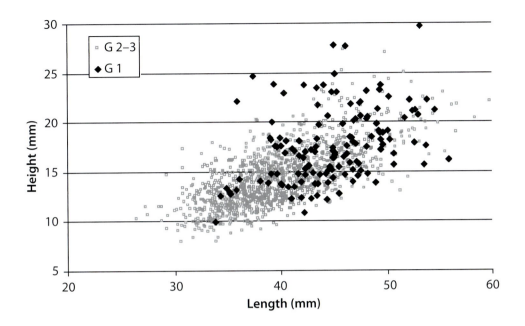

Figure 6.6. *Scattergraph to show the size of limpets from Phase 1 and Phases 2 to 3 of Area G (in the Farm Mound).*

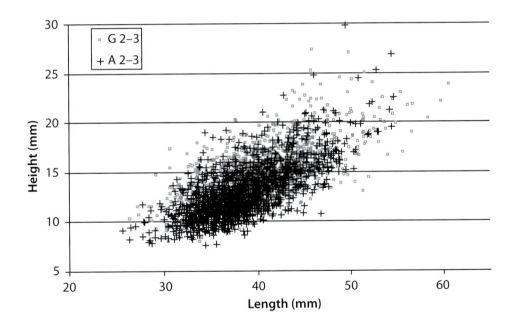

Figure 6.7. *Scattergraph to show the size of limpets from Phases 2 to 3 of Areas G (in the Farm Mound) and A (in the Fish Midden).*

progressively collected further down the shore. The significance of this pattern is confirmed by ANOVA ($F = 120.40$, $df = 2$, $p = <0.001$) and Scheffe *post hoc* tests show that there are differences between all three groups ($p = <0.001$).

Periwinkles, although not as prevalent as limpets, can also be compared between contexts and phases. However, there is less variation in their size.

Most of the average lengths fall between 26 and 27.5 mm and the standard deviations overlap (Fig. 6.12). Nevertheless, the specimens from Phases 2 to 3 of Area G and Area A are very slightly larger than the earlier ones from Phase 1 of Area G, a difference that is statistically significant (ANOVA: $F = 10.41$, $df = 2$, $p = <0.001$). This trend is opposite to, and of smaller magnitude than, the difference through time observed

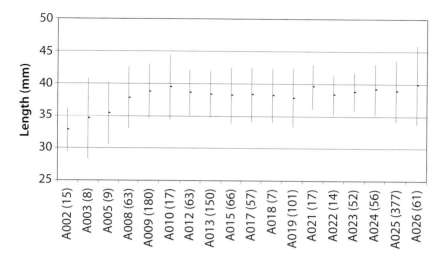

Figure 6.8. *Average length and standard deviations for limpets from Area A, plotted from the top of the midden, A002, to the bottom, A026. The size of the sample (MNI) is in parentheses.*

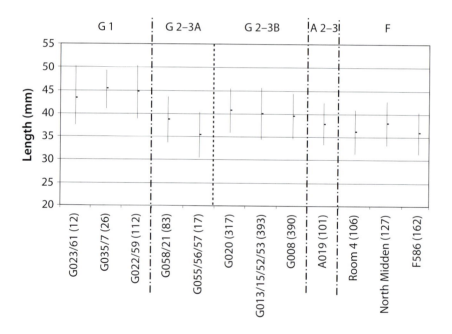

Figure 6.9. *Average length and standard deviations for limpets across the site. The size of the sample (MNI) is in parentheses.*

with the limpets. Within the phases, the periwinkles in context A015 (a reddish-brown lens in the middle of the Area A sequence) stand out as being noticeably larger than others from the site, but this group of 48 individuals may represent a single collecting event. The periwinkles from the later shell dumps in House 1 are smaller in size and more comparable with those from Phase 1 of Area G.

6.3.3.2. Ageing
Random samples of limpets were aged from contexts within Area G of the Farm Mound and Area A of the Fish Midden: from Area G Phase 1 (contexts G035 and G059); from Area G 'subphase' 2–3A (contexts G058 and G056), from Area G 'subphase' 2–3B (contexts G020 and G052) and from Area A Phases 2 to 3 (context A019; and separately A002 and A005). The

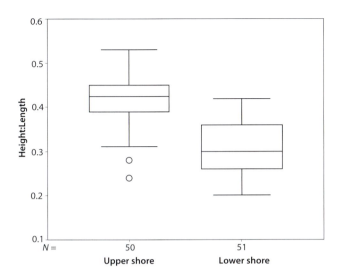

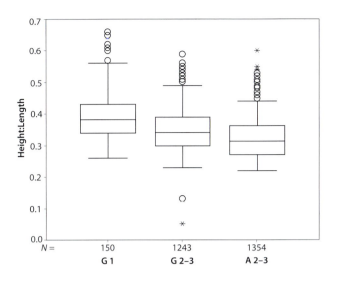

Figure 6.10. *Boxplot showing the height:length ratio of modern limpets collected from the upper and lower shore.*

Figure 6.11. *Ratio of height:length for Area G Phase 1, Area G Phases 2 to 3 and Area A Phases 2 to 3.*

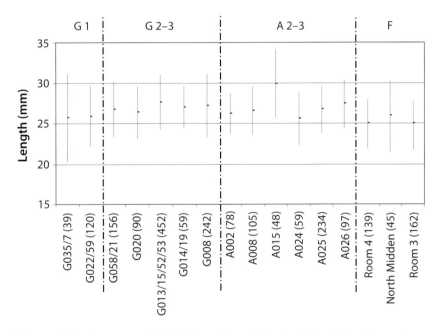

Figure 6.12. *Average periwinkle lengths and standard deviations for each analysed context with a sample size of >30. The size of the sample (MNI) is in parentheses.*

results (Fig. 6.13) exhibit statistically significant differences based on ANOVA ($F = 24.53$, $df = 4$, $p = <0.001$) and associated Scheffe *post hoc* tests. The Phase 1 limpets reached the greatest age, with a mode of four years and half the sample at five years and above. This group was statistically different from all others ($p = <0.001$). In both 'subphases' 2–3A and 2–3B of Area G there was a similar distribution of age classes ($p = 0.92$), with a modal age of 3 years, even though the average lengths seen in Figure 6.9 were shown to be different. It may be that there is no difference between these subgroups or that any difference in age is too subtle to be detected at the sample sizes considered. The limpets from A019 have a similar age profile to those in Area G Phases 2 to 3 (A019 versus G2–3A, $p = 0.99$; A019 versus G2–3B, $p = 1.00$), but

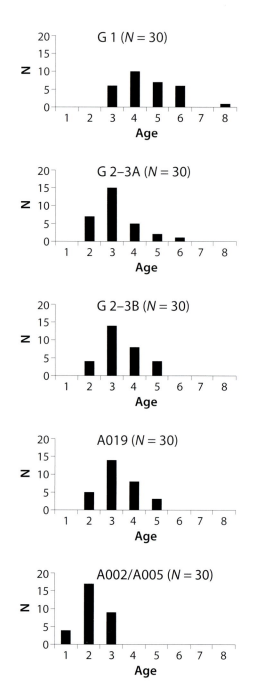

Figure 6.13. *Histograms of the age classes of limpets from contexts within the Farm Mound (Area G) and Fish Midden (Area A).*

those from A002 and A005 are younger again and only limpets of one, two and three years of age were found ($p = \leq 0.003$ in all comparisons). To sum up, it appears that the probable reason for larger-sized limpets at the base of the Area G Farm Mound is that they have a slightly older average age and that by Phases 2 to 3, in both the Farm Mound and Area A, the older limpets had decreased in number.

6.4. Discussion

The analysis of shellfish from Quoygrew has revealed some interesting and important differences between contexts. There is evidence of shell collecting from Phase 1 (in the Farm Mound). Here limpets account for 96% of the mollusc assemblage. However, in Phases 2 to 3, in both Area G and Area A, there is convincing evidence that limpets were being more intensively exploited. Not only were more species, and particularly periwinkles, being collected, but also the limpets were becoming smaller in size, which correlates with a reduction in age as well as signs that the limpets were being collected further down the shore. Under Norse law foreshore resources were formally controlled by land owners (Robberstad 1983, 61–2). Such restrictions (combined with the likelihood of widespread need) may account for the inability of Quoygrew's tenant occupants to seek out alternative sources of large limpets.

To explain why shellfish, particularly limpets, were collected more intensively beginning in Phases 2 to 3 at Quoygrew it is necessary to consider why these species were collected in the first place. There are two main propositions. The first is that shellfish were used as bait for fishing and supporting evidence for this comes particularly from analogy with the ethnohistory of more recent times in Orkney (e.g. Fenton 1978, 528, 542, 585–6). Here examples are cited where limpets were used to bait hooks for species such as cod, or were crushed and even chewed up and spat onto the water to attract inshore fish such as saithe, which were then sometimes used as bait for larger fish like cod. The second viewpoint is that shellfish were gathered for eating (e.g. Sharples 2005; cf. Wickham-Jones 2003).

Perhaps in fact we are seeing evidence of both practices. It is particularly likely that the limpets that were being processed on the shoreline and dumped in Area A of the Fish Midden alongside the fish waste were being processed for bait. It is also possible that the limpets in the Farm Mound were brought upslope and perhaps processed under shelter, again possibly for bait. The limpets from the shell dumps in and around House 1 have been shown to be slightly

smaller and it could be argued that these were consumed (being less rubbery). However, the concept that small limpets are chosen over larger ones for consumption is a modern one, and it is impossible to know whether people at this time had the same views regarding palatability!

Study of the shells alone cannot discriminate between bait or consumption, but two related bodies of evidence support a primary use as bait. Firstly, stable isotope analysis of human bone suggests that the marine protein consumed in Orkney from the Viking Age until the end of the Middle Ages was mainly from carnivores near the top of the food chain (e.g. cod) (Barrett & Richards 2004). Secondly, the increase in the intensity of shellfish collection in Phases 2 to 3 at Quoygrew was concurrent with an increase in the abundance of fish bone at the site (see Chapters 5 and 7). Most of this bone is from cod and saithe, the species traditionally fished using limpet bait in Orkney. A pilot oxygen isotope study of seven limpet shells from Quoygrew suggests that summer collecting was most common, but one specimen was probably gathered in the winter. Thus it may be premature to use these results as a proxy for the seasonality of fishing (Surge & Barrett 2012; unpublished data; see also Chapter 7).

Moving forward in time, and comparing the present results with the density of shell in samples considered in Chapter 5, it is likely that the intensity of harvesting decreased in Phase 3 before it recovered again in Phases 4 and 4 to 5. In these latter phases new mixes of taxa were collected (e.g. the cockle dump in Room 3) and many of the shells were discarded in abandoned parts of House 1 while its main room was still occupied (cf. Chapter 4). It may thus be reasonable to suggest that they were increasingly used as food rather than bait.

In conclusion, it is argued that the pressure of fish-bait harvesting during the eleventh to twelfth centuries at Quoygrew (that is, from the earliest layers of Phases 2 to 3 in the Farm Mound and the Fish Midden) led to a measurable impact on the structure of the local limpet population. After a succeeding period of comparatively little shellfish use in Phase 3, a different mix of taxa then became important in Phase 4 and Phases 4 to 5 — arguably more for human consumption than for bait.

Chapter 7

The Maritime Economy: Fish Bone

Jennifer F. Harland and James H. Barrett

7.1. Introduction, sampling and recovery

Fish remains were very abundant at Quoygrew, allowing for detailed exploration of temporal and spatial patterning — including comparisons of the Farm Mound (Phase 1 and Phases 2 to 3), the South Midden (Phase 2), the North Midden (Phase 2), the Fish Midden (Phases 2 to 3), floor deposits from House 5 and House 1 (Phases 2 and 4 respectively) and the midden infilling of Room 4 in House 1 (Phase 4). Figures 5.5 to 5.6 provide an overview of the concentration of fish bone in each phase of the main midden deposits at the site (compared with marine shell and mammal bone — based on the number of grams of each material per litre of excavated sediment). The importance of fishing is immediately obvious, as is the existence of chronological variability. The intensity of fish bone deposition peaked in Phase 2 and Phases 2 to 3, then declined during and after Phase 3. Unlike marine shell, fish bone did not return to abundance in Phase 4 and Phases 4 to 5 (cf. Chapters 5 and 6).

The large quantity of fish bone recovered during the Quoygrew excavations (Figs. 7.1a–7.1b) necessitated a sub-sampling strategy. Firstly, none of the hand-collected fish bone (more than 123 kg) was analysed, given the known biases towards larger species, sizes and elements (e.g. Zohar & Belmaker 2005; Olson & Walther 2007). However, it would also have been impossible to identify all of the sieved fish bone (totalling c. 53 kg). Consequently, a selection of samples from the deposit and phase groups noted above were chosen for detailed analysis. In total, over 86,000 fish bones (weighing 14.82 kg) were examined, of which 22,094 (weighing 7.69 kg) were identified taxonomically. These were all derived from the heavy fraction of flotation samples (sieved to 1 mm and sorted to 2 mm) or, in a single exception noted below, 'coarse-sieved' samples (sieved and sorted to 4 mm, see Chapter 5).

Midden material from the inland Farm Mound was studied to provide a chronological range including Phase 1 of the settlement, dating to the tenth century, as well as Phase 2 to 3 deposits, dating from the

Figure 7.1. *Fish bone was exceptionally abundant in Phase 2 and Phases 2 to 3 at Quoygrew. Here we see a small proportion of the over 123 kg of hand-collected fish bone (Fig. 7.1a) and part of the contents of a washed sample mostly composed of fish bone (Fig. 7.1b). (Images: (a) James Barrett and (b) Jennifer Harland.)*

eleventh to thirteenth centuries (see Chapter 4). Fish bone was particularly copious from Phases 2 to 3 of the Farm Mound, requiring substantial subsampling. Only 20 out of 149 flotation samples were examined, equating to approximately 372 kg of sediment out of approximately 2370 kg sieved. A minimum of three samples per context were chosen for analysis (with minor exceptions involving very small layers). In addition, the unstudied samples were scanned qualitatively and found to be consistent with those recorded in detail.

Fish bone was much less abundant in Phase 1 of the Farm Mound. All of the fish bones from flotation samples (2 mm recovery) of this phase were therefore identified. To ensure comparability with bones from other phases this material is used for the quantitative comparisons discussed below. However, additional fish bones from coarse-sieved samples (recovered using 4 mm mesh, see Chapter 5) of Phase 1 were also identified to increase the amount of information available for interpretation. The results are tabulated separately.

Area A was selected for detailed study of the Fish Midden, with Areas B and C assessed qualitatively to look for obvious differences in species composition, size or butchery (none were found). All of the relevant material derives from sieving with 2 mm mesh. It is from Phases 2 to 3 and probably dates to the eleventh to thirteenth centuries (Chapter 4).

Three further substantial deposits were selected for analysis: the North and South Middens (dating to Phase 2, the eleventh to twelfth centuries) and the midden infilling Room 4 of House 1 (dating to Phase 4, the fifteenth to sixteenth centuries). The North and South Middens (associated with House 5) provide the opportunity to consider spatial variation in comparison with Phases 2 to 3 of the larger Fish Midden and Farm Mound deposits, whereas the midden from Room 4 is important for understanding fishing during a later period of the site's occupation.

Several house-floor assemblages were also studied in order to illuminate taphonomic pathways — between where fish were eaten and the middens where their bones might ultimately have been discarded. Occupation surfaces did not typically contain much fish bone at Quoygrew (presumably because they were kept relatively clean), but what was recovered — embedded in trampled ash — was well preserved. Material has been studied from Phases 2.3 and 2.4 of House 5 and Phase 4.1 of Rooms 1 and 2 in House 1 (see Chapter 4). The resulting data facilitate comparisons with the main Phase 2 and Phase 2 to 3 middens (the South Midden, the North Midden, the Farm Mound and the Fish Midden) and the Phase 4 midden (infilling Room 4, which had become a dump while Rooms 1 and 2 of House 1 were still in use).

A small amount of material from the upper strata of the Fish Midden has also been recorded. These disturbed topsoil (Phase 7) contexts may contain residual material from Phases 2 to 3, or represent a small fish bone assemblage from the very end of the Quoygrew sequence. Given this ambiguity they will not be discussed in detail. Very small numbers of fish bones identified from Phase 1 of the Fish Midden and Phases 2.1 and 3 of the South Midden are included only in Appendix 7.1.

The Fish Midden was also sampled by Sarah Colley in 1978, providing the initial impetus for this work. The resulting fish bone assemblage exhibited characteristics very similar to those reported here (Colley 1983; 1984; Barrett *et al.* 1999), but the data are not directly comparable because different identification and recording procedures were employed. Thus this earlier work is not considered for the purposes of intra-site comparison. It does, however, contribute to the broader context of existing knowledge regarding fishing in medieval Orkney.

7.2. Methods

As noted above, all of the material considered was recovered using 2 mm mesh or, where indicated, 4 mm mesh. The fish bone from Quoygrew was recorded using the York System, a data base utility and zooarchaeological protocol (Harland *et al.* 2003). For fish it entails the detailed recording of *c.* 20 diagnostic elements divided into a series of quantification codes (QC0, QC1, QC2 and QC4). QC1 comprises 18 cranial and appendicular elements which are identified to the finest possible taxonomic group and recorded in detail — typically including, as appropriate, element, side, count, measurements, weight, modifications (including burning and butchery), fragmentation, surface texture and estimates of fish total length (see below for further details). QC2 includes fish vertebrae, which are recorded in slightly less detail (measurements are not taken and texture is not scored, for example). In the case of cod family fish, which dominate the assemblage, the vertebral column is divided into eight groups from anterior to posterior (as defined in Barrett 1997, 621): first vertebra, abdominal vertebrae group 1, abdominal vertebrae group 2, abdominal vertebrae group 3, caudal vertebrae group 1, caudal vertebrae group 2, penultimate vertebra and ultimate vertebra. QC0 or 'non-diagnostic' elements are only identified beyond class for special reasons. Examples include butchered specimens and bones of species otherwise missing

Table 7.1. *Ordinal fish total-length categories attributed by comparing archaeological specimens with reference specimens of known size.*

Size category	Total lengths (mm)
A	<150
B	150–300
C	300–500
D	500–800
E	800–1000
F	>1000

Table 7.2. *Fish texture and percent completeness data for all QC1 elements. Recovery is >2 mm for all groups.*

		Texture				Percent completeness				
		Excellent	Good	Fair	Poor	81–100%	61–80%	41–60%	21–40%	1–20%
Farm Mound	Ph. 1 (n = 676)	2	419	228	27	51	105	173	256	91
		0%	62%	34%	4%	8%	16%	26%	38%	13%
	Ph. 2–3 (n = 1123)	14	864	234	11	160	216	265	323	159
		1%	77%	21%	1%	14%	19%	24%	29%	14%
Fish Midden	Ph. 2–3 (n = 955)	6	727	210	12	228	215	195	253	64
		1%	76%	22%	1%	24%	23%	20%	26%	7%
	Ph. 7 (n = 114)		87	27		18	20	37	30	9
			76%	24%		16%	18%	32%	26%	8%
North Midden	Ph. 2 (n = 1045)	2	615	401	27	101	244	206	403	91
		0%	59%	38%	3%	10%	23%	20%	39%	9%
South Midden	Ph. 2 (n = 530)		314	197	19	42	144	128	184	32
			59%	37%	4%	8%	27%	24%	35%	6%
Room 4 midden	Ph. 4 (n = 1344)	1	1012	328	3	132	334	473	392	13
		0%	75%	24%	0%	10%	25%	35%	29%	1%
House 5 floors	Ph. 2.3 (n = 71)		62	9		9	31	13	15	3
			87%	13%		13%	44%	18%	21%	4%
	Ph. 2.4 (n = 122)	1	92	28	1	7	34	40	36	5
		1%	75%	23%	1%	6%	28%	33%	30%	4%

from the assemblage. QC4 elements are atypical in some way, either because they are not preserved in many burial environments (e.g. otoliths) or because they do not occur in all species (e.g. the ossified dermal denticles of some cartilaginous fish). Like QC1 elements they are identified in detail. QC3 is no longer used in the York protocol, the relevant elements now being recorded as either QC0 or QC1. The bones were identified using the reference collections held by the Department of Archaeology, University of York.

The assemblage has been quantified by number of identified specimens (NISP) and, when butchery patterns are considered, the minimum number of elements (MNE). The latter was calculated based on the most abundant diagnostic zone of each skeletal element (see Harland *et al.* 2003), taking side into consideration and providing a range of estimates for vertebrae (the number of which per individual fish can vary). A list of common and scientific names for all taxa in the assemblage is included in Appendix 7.2.

Fish total length was estimated in two ways. Firstly, all QC1 specimens were compared with reference bones from fish of known size and attributed to one of six ordinal categories (see Table 7.1). Secondly, measurements of a subset of QC1 elements were taken following Harland *et al.* (2003) using callipers precise to 0.01 mm. The most abundant resulting measurements were PX2 (premaxilla measurement 2) for cod

and QD1 (quadrate measurement 1) for saithe (after Harland *et al.* 2003, equivalent to P2 of Jones (1991, 58) and qu.gr.b of Morales and Rosenlund (1979, 25) respectively). They have been used to estimate fish total length (TL) (see Appendices 7.3 and 7.4) based on the following regression equations derived from modern reference material:

$$\text{Cod TL} = 112.202(\text{PX2})^{0.95}$$
$(r^2 = 0.96, n = 51, \text{size range} = c. 220 \text{ to } c. 1500 \text{ mm};$
based on Jones 1991, 118, 164)

$$\text{Saithe TL} = 85.114(\text{QD1})^{1.00}$$
$(r^2 = 0.976, n = 44, \text{size range} = 215 \text{ to } 1250 \text{ mm};$
Harland unpublished)

Two sample Kolmogorov-Smirnov tests were used to investigate the statistical significance of variations in ordinal categories, including fish size or texture. The results of the statistical tests are summarized in Appendix 7.5. All tests were based on groups recovered using 2 mm mesh.

7.3. Taphonomy

Bone preservation was evaluated by recording the surface texture and percent completeness of all QC1 elements. Any other taphonomic alterations were also noted, including burning, gnawing and root

etching. Table 7.2 summarizes the texture and percent completeness data for all samples recovered to 2 mm.

Bone texture was evaluated on an ordinal scale. The preservation at Quoygrew tended to be 'good' (solid, with some flaky or powdery patches) or 'fair' (solid, but with up to half of the surface flaky or powdery) for all phases, with very few bones recorded as either 'excellent' (solid, fresh and glossy) or 'poor' (very flaky or powdery). Nevertheless, two taphonomic groupings were observed. Fish bones from Phase 1 of the Farm Mound, the North Midden and the South Midden were least well preserved. In contrast, Phase 2 of House 5, Phases 2 to 3 of the Fish Midden and Farm Mound and Phase 4 of Room 4 all contained well-preserved fish bones. These differences were statistically significant for the larger deposits: Phases 2 to 3 from the Farm Mound and Fish Midden have better texture scores than Phase 1 (p <0.001), the North Midden (p <0.001) and the South Midden (p <0.001).

Percent completeness was evaluated on an ordinal scale in 20% increments by comparing each archaeological specimen with a complete bone. The resulting data provide an indication of rates of element breakage, and can be used in conjunction with texture scores to determine which phases had better preservation. Phase 1 of the Farm Mound contained the most fragmented bones (p <0.001 when compared with the other major deposits), followed by the North and South Middens (p values range from <0.001 to 0.048) — the same pattern observed based on the bone-texture evidence. However, Phases 2 to 3 of the Fish Midden had higher percent completeness scores than the contemporary phase of the Farm Mound (p <0.001), indicating that despite similar textures, the Fish Midden contained significantly more complete fish bones than the Farm Mound.

Burnt fish bones were found throughout the assemblage, although not in the relatively high proportions observed in the mammal assemblage (see Chapter 8). Very little of it could be identified to species. Overall, 6% of the fish bone showed some evidence of fire alteration (being noticeably charred or calcined). The Fish Midden and Farm Mound contained 7% to 8% burnt fish bone, whereas the South Midden contained 3% and the North Midden 4%. Evidence of other taphonomic alterations was negligible. It included fresh breakage, carnivore gnawing, root etching, crushing and acid etching — each of which was found on less than 0.1% of the recorded specimens. Together, this evidence indicates that the assemblage was the result of anthropogenic accumulation, with minimal animal disturbance.

As noted above, these taphonomic patterns must be considered when interpreting chronological and spatial trends in the character of fishing at Quoygrew. It must be asked, for example, whether the relative paucity of fish bones in Phase 1 is due to poor preservation rather than less-intensive use of the sea. This question can be answered in part by comparing Phase 1 of the Farm Mound with the poorly preserved North and South Middens of Phase 2 (rather than the well-preserved Phases 2 to 3 of the Farm Mound and Fish Midden). The North and South Middens *do* have a higher density of fish bone than Phase 1 — implying that the apparent increase in fishing intensity is not a taphonomic bias (Figs. 5.5 & 5.6). A similar conclusion can be inferred from the increasing intensity of mollusc collecting — given that species such as limpets were probably used as fish bait (Chapter 6). Most significant in the present context, however, is the observation that more intensive and extensive fishing activity can also be recognized based on the species and sizes of fish represented in the different phases (see below).

7.4. Species representation

A summary of the fish assemblage, divided by deposit and phase groups, is provided in Table 7.3, including all bones identified from the selected 2 mm sample fractions. The subset of bones (from Phase 1 of the Farm Mound) sieved to 4 mm is presented separately to avoid recovery bias. The assemblage is dominated by cod family fishes, particularly cod, saithe, specimens identified as *Gadus/Pollachius* (cod, saithe or pollack) and ling. Together they comprise 96% of all the identified fish bone. Other taxa found in more than trace quantities include needlefish or sauries, herring, dogfish, flatfish and sand eels.

The Phase 1 assemblage has higher proportions of non-gadid taxa. Phase 1 deposits from the Farm Mound are 88% gadid (based on the >2 mm data set), increasing to 96–98% by Phases 2 to 3 of the Farm Mound and Fish Midden respectively. This temporal trend shows the increasing importance of an intensive and extensive fishery for cod family fish through time (see further below). It is unlikely to result from preservation bias. Many skeletal elements of cod family fish are very robust (e.g. Nicholson 1992a) and an increase in the importance of gadids is also evident in the North Midden (99% gadid) and South Midden (98% gadid) of Phase 2 (which, like Phase 1 of the Farm Mound, are less well preserved than the Phase 2 to 3 deposits of the Farm Mound and Fish Midden).

Cod and saithe are the most commonly identified species, and much of the patterning observed in the data set relates to variability in their relative abundance through space and time. The proportion of cod

Table 7.3. Identified fish bone from Quoygrew (by NISP, see also Appendix 7.1).

Taxon	Farm Mound Ph.1 >2 mm		Farm Mound Ph.1 >2 mm & >4 mm		Farm Mound Ph.2–3		Fish Midden Ph.2–3		Fish Midden Ph.7		North Midden Ph.2		South Midden Ph.2		Room 4, Phase 4 midden Ph.4		House 5, Phase 2 floors Ph.2.3		House 5, Phase 2 floors Ph.2.4		Room 1&2 floors Ph.4.1		Total	
	n	%	n	%	n	%	n	%	n	%	n	%	n	%	n	%	n	%	n	%	n	%	n	%
Dogfish family	2	0.1%	3	0.1%							2	0.1%			3	0.1%							8	0.0%
Dogfish families	21	0.8%	35	0.9%	11	0.3%			1	0.2%			1	0.1%	9	0.2%							57	0.3%
Spurdog family			1	0.0%																	2	1.4%	3	0.0%
Spurdog	3	0.1%	4	0.1%																	1	0.7%	5	0.0%
Ray family	1	0.0%	1	0.0%					1	0.2%	1	0.0%	3	0.2%	8	0.1%							14	0.1%
Cuckoo ray															1	0.0%							1	0.0%
Herring family	24	0.9%	24	0.6%	20	0.6%	9	0.3%			1	0.0%	1	0.1%					2	0.5%			57	0.3%
Salmon & trout family									1	0.2%													1	0.0%
Eel	1	0.0%	2	0.1%			2	0.1%	1	0.2%					16	0.3%							21	0.1%
Conger eel			1	0.0%	1	0.0%	2	0.1%															4	0.0%
Needlefishes/Sauries	150	5.7%	174	4.4%	6	0.2%	4	0.1%	2	0.4%													186	0.9%
Garfish family															1	0.0%							1	0.0%
Garfish	67	2.5%	68	1.7%																			68	0.3%
Three-spined stickleback															1	0.0%							1	0.0%
Hake	1	0.0%	1	0.0%	1	0.0%	1	0.0%			1	0.0%	2	0.1%	1	0.0%							7	0.0%
Cod family	38	1.4%	43	1.1%	57	1.8%	48	1.5%	27	5.6%	37	1.3%	25	1.5%	246	4.5%	6	2.3%	22	5.1%	10	7.1%	521	2.4%
Cod/Saithe/Pollack	207	7.8%	279	7.0%	147	4.6%	131	4.0%	18	3.8%	329	11.4%	335	19.7%	1132	20.8%	62	23.4%	74	17.2%	35	24.8%	2542	11.6%
Cod	632	23.8%	1055	26.5%	1725	54.2%	1343	40.6%	90	18.8%	1419	49.1%	636	37.4%	46	0.8%	65	24.5%	93	21.6%	23	16.3%	6495	29.8%
Haddock	2	0.1%	3	0.1%	2	0.1%	4	0.1%	15	3.1%	3	0.1%	1	0.1%	63	1.2%					3	2.1%	94	0.4%
Whiting	2	0.1%	2	0.1%	3	0.1%	2	0.1%															7	0.0%
Saithe/Pollack	3	0.1%	13	0.3%																			13	0.1%
Saithe	1406	53.0%	2124	53.4%	1002	31.5%	1578	47.7%	304	63.5%	971	33.6%	595	35.0%	3667	67.3%	107	40.4%	209	48.5%	58	41.1%	10,615	48.6%
Pollack	30	1.1%	66	1.7%	15	0.5%	2	0.1%			1	0.0%							1	0.2%			85	0.4%
Norway pout/Bib/Poor-cod											1	0.0%											3	0.0%
Norway pout											3	0.1%											3	0.0%
Bib	1	0.0%	1	0.0%																			1	0.0%
Poor-cod	2	0.1%	2	0.1%																			2	0.0%
Torsk	3	0.1%	3	0.1%	4	0.1%					1	0.0%	1	0.1%	2	0.0%							11	0.1%
Rockling	1	0.0%	1	0.0%	10	0.3%	8	0.2%	2	0.4%	11	0.4%	15	0.9%	78	1.4%	13	4.9%	4	0.9%	4	2.8%	146	0.7%
Five-bearded/ Northern rockling							20	0.6%	2	0.4%	3	0.1%	1	0.1%	27	0.5%							53	0.2%
Five-bearded rockling	4	0.2%	4	0.1%	10	0.3%	8	0.2%	1	0.2%	2	0.1%											25	0.1%
Four-bearded rockling	4	0.2%	4	0.1%	7	0.2%	1	0.0%	2	0.4%	1	0.0%											15	0.1%

Table 7.3. (cont.)

| | Farm Mound | | | | | | Fish Midden | | | | North Midden | | South Midden | | Room 4, Phase 4 midden | | House 5, Phase 2 floors | | | | Room 1&2 floors | | Total | |
	Ph. 1 >2 mm		Ph. 1 >2 mm & >4 mm		Ph. 2-3		Ph. 2-3		Ph. 7		Ph. 2		Ph. 2		Ph. 4		Ph. 2.3		Ph. 2.4		Ph. 4.1			
Three-bearded rockling	3	0.1%	3	0.1%	11	0.3%	7	0.2%	2	0.4%	2	0.1%	1	0.1%	2	0.0%							28	0.1%
Ling	5	0.2%	11	0.3%	65	2.0%	75	2.3%	4	0.8%	69	2.4%	48	2.8%	6	0.1%	3	1.1%	18	4.2%	3	2.1%	302	1.4%
Seabass family	1	0.0%	2	0.1%																			2	0.0%
Atlantic horse-mackerel/Scad	1	0.0%	1	0.0%	1	0.0%																	2	0.0%
Sea bream family															1	0.0%							1	0.0%
Black sea bream															1	0.0%							1	0.0%
Wrasse family	1	0.0%	1	0.0%							1	0.0%			1	0.0%	1	0.4%					3	0.0%
Ballan wrasse	2	0.1%	4	0.1%	1	0.0%	3	0.1%					1	0.1%	1	0.0%			1	0.2%			12	0.1%
Cuckoo wrasse							1	0.0%															1	0.0%
Sand eel family	4	0.2%	4	0.1%	22	0.7%	15	0.5%	2	0.4%	6	0.2%	17	1.0%	33	0.6%	1	0.4%	6	1.4%	1	0.7%	107	0.5%
Mackerel family	1	0.0%	1	0.0%																			1	0.0%
Dragonet	2	0.1%	2	0.1%	2	0.1%																	4	0.0%
Wolf-fish							9	0.3%															9	0.0%
Snake blenny	1	0.0%	1	0.0%	3	0.1%	3	0.1%															7	0.0%
Butterfish	2	0.1%	3	0.1%	3	0.1%	12	0.4%							4	0.1%							23	0.1%
Eelpout family					5	0.2%					8	0.3%	8	0.5%	73	1.3%	3	1.1%			1	0.7%	98	0.4%
Viviparous eelpout					6	0.2%	7	0.2%	3	0.6%					1	0.0%							17	0.1%
Weever family																	1	0.4%					1	0.0%
Gurnard family	8	0.3%	8	0.2%	1	0.0%					6	0.2%	3	0.2%	5	0.1%							23	0.1%
Grey gurnard	1	0.0%	1	0.0%																			1	0.0%
Tub gurnard																							0	0.0%
Sea scorpion family	2	0.1%	3	0.1%	8	0.3%	3	0.1%							5	0.1%			1	0.2%			20	0.1%
Bull-rout	1	0.0%	1	0.0%	8	0.3%																	9	0.0%
Sea scorpion					3	0.1%	2	0.1%															5	0.0%
Flatfish order	3	0.1%	3	0.1%			1	0.0%															4	0.0%
Turbot family					1	0.0%																	1	0.0%
Halibut family	9	0.3%	10	0.3%	18	0.6%	4	0.1%	1	0.2%	10	0.3%	5	0.3%	12	0.2%	3	1.1%					63	0.3%
Dab	1	0.0%	1	0.0%																			1	0.0%
Lemon sole					3	0.1%																	3	0.0%
Flounder/Plaice			1	0.0%																			1	0.0%
Flounder			1	0.0%	2	0.1%	1	0.0%															4	0.0%
Plaice	1	0.0%	1	0.0%																			1	0.0%
Total identified	2651	100%	3976	100	3184	100%	3308	100%	479	100%	2890	100%	1700	100%	5446	100%	265	100%	431	100%	141	100%	21,820	100%
Unidentified fish	5399		9774		16,168		13,436		1451		12,279		6280		863		686		1376		486		62,799	
Total	8050		13,750		19,352		16,744		1930		15,169		7980		6309		951		1807		627		84,619	

Figure 7.2. *Gadid NISP data divided by quantification code (QC1 = cranial and appendicular elements; QC2 = vertebrae).*

increases from Phase 1 (of the Farm Mound) to Phase 2 (of the North and South Middens) and Phases 2 to 3 (of the Farm Mound and Fish Midden). In Phases 2 to 3 of the Farm Mound, cod represent 54% and saithe 32% of all identified fish. In the contemporary phases of the Fish Midden, cod represent 41% and saithe 48% — suggesting more of an emphasis on cod in the Farm Mound, and saithe in the Fish Midden. In the Phase 2 North Midden, cod represent 49% and saithe 34%,

while in the contemporary South Midden cod represent 37% and saithe 35%. Later, in Phase 4, saithe increase again while cod proportionately decrease. In the midden from Room 4 saithe comprise 67% of identified species and cod a mere 1%.

The three floor layers are similar, despite being from different phases. They contain 16–34% cod and 40–49% saithe. These floors do not have the high proportion of saithe found in the Room 4 midden, nor do they have the high quantities of cod from Phases 2 to 3 of the Farm Mound and Fish Midden. The floor assemblages are small, making further analysis difficult, but it appears deposit-type variation may account for these patterns, with fewer cod (which tend to be large individuals with large bones) accumulating on house floors than in middens.

Combining the spatial evidence, it seems likely that a ratio of approximately 1 cod per saithe was consumed at the height of Quoygrew's Phase 2 to 3 fishing boom — but that saithe bones (almost all from small fish, see below) were disproportionately lost in house floors rather than redeposited onto external middens. Overall, the ratio of saithe to cod is higher in the Phase 2 and Phase 2 to 3 deposits around House 5 near the shore (the South Midden, the North Midden and the Fish Midden) than in the contemporary layers of the inland Farm Mound. This may reflect intra-site status differences in diet. Saithe were very rare at the late Viking Age and medieval elite settlement of Orphir in Mainland Orkney (Barrett 1997; Harland 2007). It is conceivable that the occupants of House 5 were not the wealthiest household on the farm. This line of reasoning cannot be taken further, however, in the present absence of excavated houses on the Farm Mound. It is also relevant to note that saithe livers were traditionally boiled to produce lamp oil — the main source of artificial lighting — in Atlantic Scotland (McGregor 1880, 145; Nicholson 2005). The abundance of bones from this species in a semi-specialized fish-processing deposit — the Fish Midden — thus comes as no surprise. Livers of the other common species, particularly cod and ling, may also have been used in this way.

Figure 7.2 summarizes the NISP data for the most abundant gadid taxa, divided between QC1 (cranial and appendicular) and QC2 (vertebral) elements. Given the similarity between the gadid results from the >2 mm and >4 mm data sets from Phase 1 the two groups are combined in this instance. A high proportion of QC2 specimens is identified as *Gadus/Pollachius* because of similarities in the vertebral morphology of cod, saithe and pollack (particularly when found in a fragmented state). Nevertheless, the same overall temporal trends in species distribution are clear from both data sets. Cod proportions increase from Phase 1 to Phases 2 and 2 to 3 — then decrease, with saithe becoming the predominant species in Phase 4.

Within each deposit and phase group the percentage of cod is higher when considering QC1, whereas the proportion of saithe is higher using QC2. This will be partly because saithe contain a few more vertebrae per individual than cod (53–56 vertebrae per saithe compared to 49–53 vertebrae per cod) (Whitehead *et al.* 1986a, 686, 691). However, the scale of the difference cannot be accounted for by this alone. It is also possible, therefore, that some cod vertebrae were leaving the site in preserved fish (see below).

Ling represent the third most abundant gadid, albeit far less common than cod and saithe. They may have been deliberately targeted — this species was the focus of a commercial fishery in Shetland in early modern times (e.g. Smith 1984, 49). Conversely, given their modest numbers the ling from Quoygrew may represent incidental catches when fishing for large cod.

Other gadids — such as haddock, pollack and rocklings — were found in small quantities with little clear spatial or temporal patterning. However, most haddock was found in the Phase 4 deposits, reaching 2.1% of the identified specimens in the Phase 4.1 floors of Rooms 1 and 2 and 1.2% in the Phase 4 midden of Room 4. Most of these haddock were fish of 300–500 mm total length. The almost complete absence of haddock from the major Phase 2 to 3 midden deposits is surprising — in modern times haddock were fished off the coast of Westray near Quoygrew (Colley 1983, 387). However, an ethnohistoric account from the eighteenth century (published in 1813) mentioned that haddock could only *occasionally* be caught to the west of Orkney and that it was often too stormy to fish during the best season for this species (Low 1813, 192). Haddock are rare in most Viking Age and medieval assemblages from northern Scotland, but were common at the high-status site of Orphir on the Orkney Mainland. It has previously been suggested that access to this species — clearly a rare catch in pre-modern Orkney — may have been restricted to the elite in the Viking Age — although this particular

status association would be unique in a wider British, Scandinavian or European context (Barrett *et al.* 1999, 365; Harland 2007).

Most of the pollack found at Quoygrew were from Phases 1 and 2 to 3 of the Farm Mound, indicating some potential chronological patterning, but given that this species represented less than 0.4% of all identifications, this observation is incidental. The rocklings caught probably included three-, four- and five-bearded, northern and undifferentiated species, and most were between 150 mm and 300 mm in total length. Slightly higher quantities were found in the Phase 4 midden deposits of Room 4, indicating a possible correlation with the high quantities of similarly sized saithe recovered there and presumably caught in similar in-shore habitats (cf. Wheeler 1969, 274–5, 290–93).

Non-gadid species were found in very small numbers overall, although slightly higher quantities occurred in the earlier Phase 1 deposits than in those that followed. As seen in Table 7.3, many different species were nevertheless recovered. Some of these may have been deliberate catches, others accidental by-catches, and the smaller taxa may have been stomach contents of larger deliberately targeted species like cod. Stomach contents of birds may also have contributed to the assemblage in a minor way. Some sand eels, a common food of seabirds, may be best interpreted in this way (Johnston 1999, 179). Species that prefer coastal habitats, like wrasse and cottids (Whitehead *et al.* 1986a, 919; 1986b, 1243), might have been by-catches from the fishery for small saithe, while gurnards (see Whitehead *et al.* 1986b, 1230), for example, may also have been by-catches from the fishery for larger gadids. Only 1 salmonid (salmon or trout) and 21 eel bones were recovered. Both are often caught in freshwater rivers or streams, which Westray lacks.

An unusually large quantity of needlefishes/sauries and garfish were found at Quoygrew, representing just over 1% of all identified fish. Few other sites in the Northern Isles have any record of these fish, let alone in this quantity (see Barrett *et al.* 1999; Harland 2006), although this may reflect variable access to relevant reference material. They were particularly prevalent in Phase 1 of the Farm Mound, where they reached 8% of all identified species (2 mm data set). Their presence is difficult to explain, and might indicate a particular method or fishing habitat that then changed in the later phases. Most were small, which could suggest that they were the gut contents of larger fish.

Dogfish may have been deliberately targeted on a small scale. The relevant taxa represent less than 0.4% of all identifications, and most were found in Phase 1 of the Farm Mound. Historical data suggest

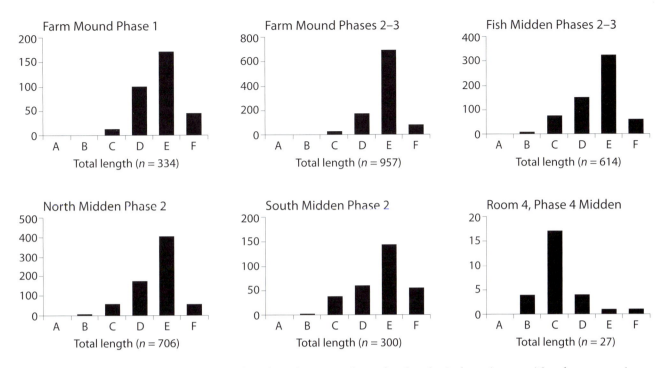

Figure 7.3. *Cod total-length distributions based on the comparison of archaeological specimens with reference specimens of known size (see Table 7.1 for key to total length categories). Recovery is >2 mm for all groups.*

they were of importance in early modern Westray (Izat 1791–99, 261).

The virtual absence of herring from Quoygrew is curious, given their later economic significance in the Northern Isles (Fenton 1978, 603–15; Smith 1984, 112–15) and their importance during the Middle Ages in the Western Isles (Cerón-Carrasco 2005; Ingrem 2005), the Firths of Clyde and Forth in Scotland (Coull 1996, 55) and eastern England (Campbell 2002; Barrett *et al.* 2004). However, the pattern observed at Quoygrew is found throughout the Northern Isles in the Viking Age and Middle Ages (Barrett *et al.* 1999; Harland 2006), suggesting either a deliberate fishing strategy or a real absence of this species in northern waters. Herring were found in very small quantities in Phase 1 and Phases 2 to 3 of the Farm Mound, representing less than 1% of the identified specimens in each phase, and at trace levels elsewhere. These small quantities may simply represent stomach contents of other fish, but they do indicate the species was locally available.

The importance of gadids rather than herring suggests an almost exclusive emphasis on line rather than net fishing — despite the fact that nets must have been widely used elsewhere in Britain at the same date (herring are caught by net or trap rather than hook). Unlike gadids, which can be successfully preserved by drying without salt (see below), herring must be heavily salted, usually barrelled in brine, to last for more than a short time (Cutting 1955). It may there-fore be reasonable to suggest that fishing practices in the Northern Isles reflected a combination of the lack of locally abundant salt supplies and distance from concentrations of potential consumers. In the Outer Hebrides and the Firths of Forth and Clyde large potential markets (e.g. Dublin and the Scottish burghs respectively) were more accessible within the narrow window of time during which lightly cured herring would be marketable — and salt was produced on a large scale in the case of herring-producing regions such as eastern England that were engaged in exten-sive long-range trade (Campbell 2002, 9–10).

7.5. Fish total-length estimates

The methods used for estimating the total length of the fish represented in the Quoygrew assemblage are discussed in Section 7.2 above. The results for the most abundant species, cod, saithe and ling, help illuminate the changing character of fishing through the chro-nology of occupation. In each case the ordinal data, available from a larger number of bones, are presented first — followed by the smaller but more precise data set based on measurements and regression equations. In all cases only material recovered using 2 mm mesh is included to avoid potential recovery biases.

Figure 7.3 displays the distribution of cod total-length estimates (ordinal data) for the five largest deposit/phase groups and the small but unusual

Phase 4 midden from Room 4. While the majority of cod were between 800 and 1000 mm in length, substantial variation is apparent. The North Midden and South Midden are very similar to Phases 2 to 3 of the Fish Midden, but the two phases from the Farm Mound are atypical. Phase 1 had more cod of 500–800 mm TL than any other deposit/phase group from the site. Conversely, Phases 2 to 3 of the Fish Midden had a much greater emphasis on cod of 800–1000 mm TL (p <0.005). The differences between the contemporary Phase 2 to 3 deposits in the Fish Midden and Farm Mound may perhaps be related to the evidence for fish processing in the Fish Midden and fish consumption in the Farm Mound (see below). The shift within the Farm Mound to an emphasis on cod of larger size is consistent with the more general observation that fishing was far more important in Phases 2 to 3 than in Phase 1.

The Phase 4 midden of Room 4 contains very few cod, compared to saithe (see above), and those cod bones that are present are from fish of unusually small size. Most represent individuals of between 300 and 500 mm TL, and might have been caught incidentally when fishing for saithe of similar size. The absence of large cod in any quantity from Phase 4 suggests an emphasis instead on shore-based or near-shore fishing for small saithe based on ethnohistoric parallels (see Section 7.6 below).

Four deposit/phase groups contained a sufficient number of measurable cod bones to warrant the determination of more precise TL estimates (see Section 7.2 above). The results (Fig. 7.4) corroborate the increase in the proportion of large fish caught from Phase 1 to Phases 2 to 3. Moreover, bimodal TL distributions are seen in Phase 2 of the North Midden, Phases 2 to 3 of the Farm Mound and, to a lesser degree, Phases 2 to 3 of the Fish Midden. In all three groupings there was a primary emphasis on cod of 800 mm and longer and a secondary emphasis on smaller cod of 400–600 mm TL. A bimodal TL distribution is a widespread characteristic of Viking Age and medieval cod bone assemblages from the Northern Isles and Caithness (Barrett *et al.* 1999; Harland 2006). It probably represents separate shore-based/ near-shore and open-sea fisheries.

Figure 7.5 shows the ordinal saithe TL evidence for the six largest deposit and phase groups. Most saithe were caught at 150–500 mm TL. Total length was also estimated for the largest sub-assemblages of saithe bones using a regression equation applied to quadrate measurement 1 (see Section 7.2 above). In result (Fig. 7.6), two size-based patterns are visible: phases with almost equal quantities of 150–300 mm and 300–500 mm fish, and those with a predominance of 300–500 mm fish. Phase 1 of the Farm Mound is the

most pronounced example of the latter pattern — it is statistically different from all others. This observation is not the result of sampling biases, as in this instance all data used were derived from 2 mm sieving. By Phases 2 to 3, more small saithe between 150 and 300 mm TL were being caught. This trend, to consume more small fish, is the opposite of that observed for cod, but may also relate to an overall increase in the importance of fishing. The outcome in both cases is to *broaden* the range of fish sizes routinely caught and thus, potentially, to increase the scale of the overall catch. Material from Phase 2 of the North and South Midden shows a pattern intermediate between that of Phase 1 in the Farm Mound and Phases 2 to 3 of the Farm Mound and Fish Midden — as makes sense if the addition of small saithe to the menu increased through time.

The deposit from Phase 4 of Room 4 has already been noted as unusual because of the large quantities of saithe found, and the virtual absence of large cod. The ordinal size data indicate that most saithe from this deposit were between 150 and 500 mm in TL, with very few or none of a larger size (Fig. 7.5). The more precise TL estimates based on osteometric data indicate that most were between 250 and 350 mm in TL (Fig. 7.6). This phase is different from all others, and indicates the exploitation of small saithe that could have been caught from or near to the shore.

Although many small saithe were caught, most of the histograms in Figure 7.6 do not show polymodality among the smallest fish that might indicate seasonal catches of distinct age classes (cf. Mellars & Wilkinson 1980; Parks & Barrett 2009). The possible exception is the Fish Midden, where the peaks around 300 mm and 400 mm could conceivable represent fish of two and three years in age (Wheeler 1969, 274). This observation may be consistent with the interpretation that this deposit represents a semi-specialized (seasonal?) fish-processing dump, whereas the other sub-assemblages from the site represent consumption waste. The possible seasonality of the saithe fishery is discussed further in Section 7.6 below.

Ling were far less abundant than cod and saithe, but four deposit and phase groups contained enough bones to merit consideration of ordinal size data (Fig. 7.7). Most individuals were >800 mm in TL. This size evidence could indicate open-sea fishing in deep water based on the modern spatial distribution of ling (e.g. Whitehead *et al.* 1986a, 703). However, ling could also be caught in bays in the past based on an eighteenth-century account regarding Shetland (Brand 1883 [1701], 193–4). Too few ling specimens could be measured to justify more precise TL estimates based on regression equations.

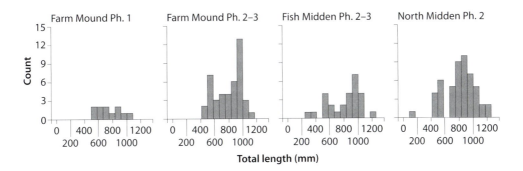

Figure 7.4. *Cod total-length estimates based on premaxilla measurement 2. Recovery is >2 mm for all groups.*

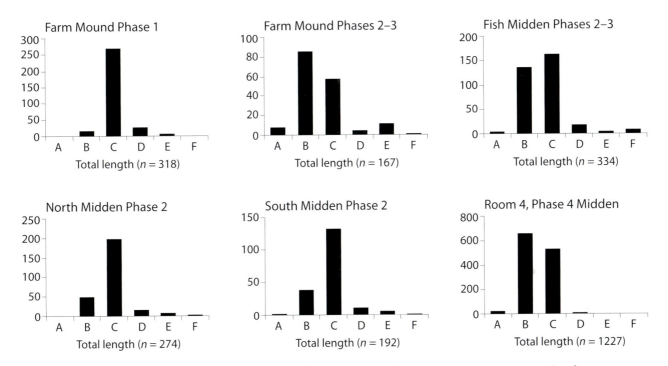

Figure 7.5. *Saithe total-length distributions based on the comparison of archaeological specimens with reference specimens of known size (see Table 7.1 for key to total length categories). Recovery is >2 mm for all groups.*

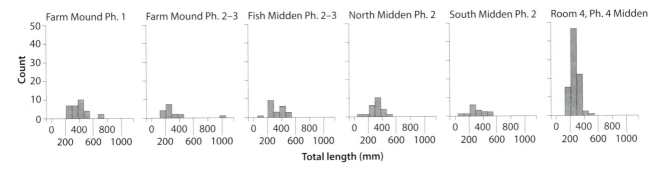

Figure 7.6. *Saithe total-length estimates based on quadrate measurement 1. Recovery is >2 mm for all groups.*

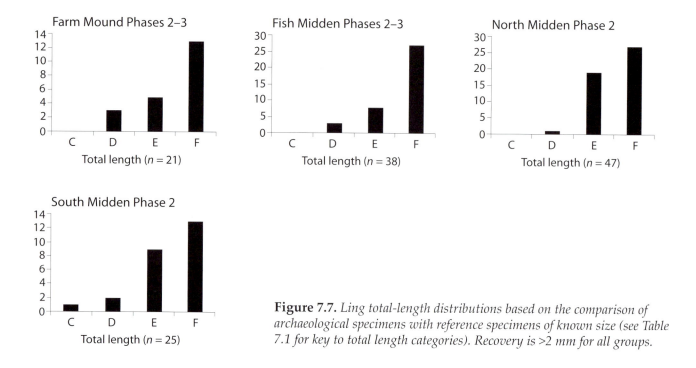

Figure 7.7. *Ling total-length distributions based on the comparison of archaeological specimens with reference specimens of known size (see Table 7.1 for key to total length categories). Recovery is >2 mm for all groups.*

7.6. Seasonality

At present, it has not been possible to infer the specific fishing season or seasons at Quoygrew using incremental growth structures. Work of this kind using fish otoliths is fraught with methodological problems (Van Neer *et al.* 2002). Oxygen isotope analysis of both otoliths and shells may help resolve this issue in due course (Hufthammer *et al.* 2010; Surge & Barrett 2012; see Chapter 6). For now, however, the best guide to the seasonality of fishing is provided by ethnohistoric accounts regarding saithe, given the estimated size distributions for this species (see Section 7.5 above). Saithe are a shoaling fish and, according to Low's originally eighteenth-century *Fauna Orcadensis*, they were targeted by two somewhat seasonal fisheries. Firstly:

> The fry of the coal-fish appear first with us in May, but small quantities, and themselves very small. About August they begin to be taken with small rods in great numbers, but still this is nothing to the shoals that set in towards winter, when the sea begins to grow stormy; then the harbours of Stromness especially, and many other places, are quite filled with them, and thus they continue for the whole winter. About this time they measure from six to ten inches [*c.* 152–254 mm], and are very much esteemed; all ranks and ages eat them under the name of Sillucks. About March, the shoal, or what is left of them, begin to retire to the deep … (Low 1813, 193).

Regarding larger saithe, Low goes on to say:

> … in May, when another fishing of them begins, under the name of kuths, they are fifteen [inches, *c.* 381 mm]; still they are tolerable for eating, either fresh, as our Orkney folks eat them, roasted with the liver, or dry (Low 1813, 194).

The size distribution of the saithe from Quoygrew (Fig. 7.6) suggests that the second of these two fisheries, in the spring when little food remained from the winter, was probably of greatest importance in all phases. Other species may, however, have been caught at other times of the year or even year-round. The most abundant species at Quoygrew, cod, is not strongly migratory in Scottish waters (e.g. Wright *et al.* 2006) and its size distribution (Fig. 7.4) does not include the young fish that can reveal seasonal age cohorts.

7.7. Butchery patterning and trade: skeletal element representation

The relative abundance of different skeletal elements within each of the most abundant species — cod, saithe and (to a lesser extent) ling — can indicate how the fish were used, as well as reflecting different taphonomic and fragmentation patterns. In particular, differences in the quantity of head, appendicular and vertebral elements allow one to infer fish processing, and the possibility that fish products were removed from (or transported to) the settlement in the context

a
b

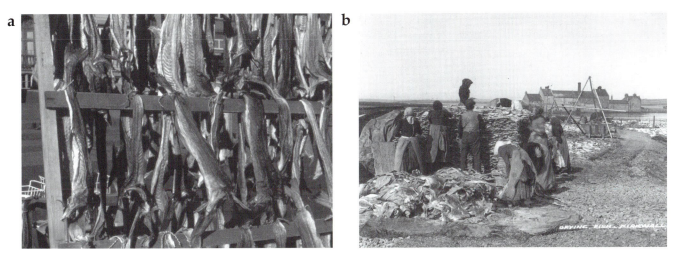

Figure 7.8. *Norwegian stockfish photographed in Tromsø in 1996 (a) and Orcadian salt cod* (klippfisk) *photographed in Kirkwall c. 1900 (b). (Images: (a) James Barrett and (b) Tom Kent, courtesy of Orkney Library and Archive.)*

of intra-regional and/or long-range networks of provisioning and exchange. Moreover, trends evident from the relative representation of skeletal elements can be further corroborated by reference to cut marks from butchery (see Section 7.8 below).

Cod family fish (particularly, but not exclusively cod) were widely preserved for storage, transport and exchange in medieval northern and western Europe. The earliest origin of European long-range trade in dried cod is a matter of debate. Nevertheless, it is evidenced by the eleventh to twelfth centuries based on anecdotal documentary records and archaeological characterization studies using stable isotope analysis (Barrett *et al.* 2008a; Starkey *et al.* 2009 and references therein; Barrett *et al.* 2011). The trade grew in the thirteenth to fourteenth centuries, by which time dried cod accounted for approximately 80% of Norway's exports to England (Nedkvitne 1976, 250; Nielssen 2009, 104) and probably represented a high proportion of the fish of this species consumed in London (Barrett *et al.* 2011). Two central goals of the present book have been to elucidate whether there was a fishing boom in Orkney from the eleventh to the thirteenth centuries (as seems likely based on the evidence discussed thus far) and if so, to discover whether it was related to the early growth of this long-range trade. Study of skeletal element patterning provides one way to help answer the second question.

Cod can be prepared for drying in many ways. Firstly, they can be dried with or without the aid of salting. Salted cures (using salt from France, Spain and Portugal, for example) were very important in the post-medieval period in the Northern Isles and elsewhere in the North Atlantic region (Smith 1984, 76; Nielssen 2009, 105). As noted above regarding herring,

however, it seems unlikely that the large quantities of high-quality salt required would have been readily available in the far north of Scotland in the eleventh to thirteenth centuries. The one relatively early reference to the shipment of salt to Orkney, in 1368, records that it was interfered with by the earl of Ross (Burnett 1878, 308) — highlighting the complexity of securing this raw material even in the late Middle Ages.

Achieving a lasting cure *without* salt (that is, producing 'stockfish') requires either ideal weather conditions (found seasonally in Arctic Norway and Iceland for example) or special facilities. In the warm and rainy weather of northern Scotland the latter were essential. Most important were drying huts traditionally known as skeos or skees. A glimpse of these in use is provided by an early eighteenth-century account by Robert Sibbald (1845 [1711], 17–18) based on a description of Orkney and Shetland written by Robert Monteith of Egilsay and Gairsay, Orkney, in 1633:

> The fishes they take for their own use, some of them they eat fresh, some they hang in skees till they be soure, and these they call blowen fish … such as they design for merchant ware, some they salt and some they hang fresh in skees till they be perfectly dry, and they call those stock fishes, whereof they have great plenty.

Use of these specialized buildings, constructed in such a way that the wind blew through gaps in the walls, made it possible to produce a surplus of stockfish for trade despite the seemingly unsuitable climate of the Northern Isles. On a domestic scale, preservation could also be achieved by smoking and drying fish inside the home, by hanging them from the rafters for example (Fenton 1978, 149), but this method is unlikely to have produced a surplus for exchange.

If gadids preserved in late Viking Age and medieval Orkney were probably stockfish (that is, dried without salt), how might they have been processed? Unfortunately for the zooarchaeologist, there is more than one way to prepare a dried cod, saithe or ling. Beginning with modern Norwegian practice (Fiskerinæringens Landsforening n.d., 77–82; Hufthammer et al. forthcoming), stockfish can be produced with the head removed or left on. Moreover, they may be prepared as 'split fish' (rotskjaer) with the anterior abdominal (and sometimes also anterior caudal) vertebrae removed, or as 'round fish' with all but the most anterior vertebrae left in the finished product. Cleithra, appendicular elements just behind the skull, are typically left in rotskjaer (Fig. 7.8a), but may be removed when making round fish. It is clear that post-medieval products from the Northern Isles could be equally diverse. George Low (1879 [1774], 120–21, 137, 187), writing in the late eighteenth century, described fish preserved with and without heads with varying quantities (none, three or half) of the anterior vertebrae removed.

Medieval descriptions of stockfish are rare and typically lacking in detail. Two well-known references are sufficient to provide examples, one from a French household management book of c. 1393 known as Le Ménagier de Paris (Power 1928; Greco & Rose 2009) and one from a Hanseatic edict of 1494 (Schäfer 1888, 285). The former explains that cod:

> when it is taken in the far seas and it is desired to keep it for ten or twelve years, it is gutted and its head removed and it is dried in the air and sun and in no wise by fire, or smoked, and when this is done it is called stockfish. And when it hath been kept a long time and it is desired to eat it, it behoves to beat it with a wooden hammer for a full hour, and then set it to soak in warm water for a full hour, and then set it to soak in warm water for a full two hours or more, then cook and scour it very well like beef, then eat it with mustard or soaked in butter (Power 1928, 272–3).

The latter, a regulation relating to direct Hanseatic trade with the Northern Isles (particularly Shetland) that had first begun c. 1416 (Friedland 1983, 88), declared that:

> de Bergerfarer sollen ok nicht menghen Hithlander vysch mangkt den Bergerfisch, schollen ok mit ernste darvor wesen, dat de Hithlander visch moge gevlaket werden unnd nicht runt vor rothscher vorkofft (Schäfer 1888, 285).

It is difficult to interpret the last crucial line of this passage, but it indicates either that Shetland's fifteenth-century products were not to be sold as rothscher (that is, large cod with some bones removed through a slit along the spine before drying — rotskjaer as defined above), or that they should be neither round fish nor rothscher. In either case they should instead be gevlaket — flattened by separating along the spine. The preferred translation of Sheila Watts (Department of German and Dutch, University of Cambridge) is:

> Those trading to Bergen are not to mix Shetland fish amongst the Bergen fish, and should ensure as a matter of great importance that the Shetland fish are to be preserved flat, and not just/carelessly sold as rothscher.

It is tempting to equate the gevlaket fish with those dried flat on rocky foreshores in the Northern Isles in recent centuries (Fenton 1978, 579–81; see Fig. 7.8b). The fish typically had skulls and anterior vertebrae removed, but cleithra and posterior vertebrae left in the finished product. However, these cures involved large quantities of imported salt (they were klippfisk in Norwegian terminology) which, as discussed above, is unlikely to have been available during the medieval fishing boom at Quoygrew.

Given the diversity evident in recent practice and the historical record it is appropriate to ask how were gadid fish processed in the Middle Ages based on the zooarchaeological record itself? Here too we see that cod (for example) could be dried with their heads on or off, that most of the anterior vertebrae could be left in the finished product or removed and that appendicular elements like the cleithra could travel with the finished product or be discarded at the processing site (cf. Colley 1986; Jonsson 1986; Barrett 1997; Perdikaris & McGovern 2008). The implications for present purposes are clear. Rather than seeking a prescribed pattern of skeletal element representation it is necessary to look for any over- or under-representation of cranial bones, cleithra, abdominal vertebrae and/or anterior caudal vertebrae in the time and place under consideration.

If, for example, a product like rotskjaer (or the more recent fish cured flat in the Northern Isles) was made one would expect more cranial bones and anterior vertebrae and fewer cleithra and caudal vertebrae left at the processing site (Fig. 7.9). This is in fact the pattern observed in a medieval fish midden at Robert's Haven in Caithness (Barrett 1997), now known to be contemporary with Phases 2 to 3 at Quoygrew (Russell et al. 2011; see Chapter 16). In this case, the evidence of relative skeletal element abundance was corroborated by a distinctive pattern of cut marks and groups of vertebrae found still in anatomical articulation (Barrett 1997). A similar picture emerged from study of a twelfth- to thirteenth-century midden at St Boniface, Papa Westray, Orkney (Cerón-Carrasco 1998). Moreover, the reverse of this pattern was observed in haddock and cod remains from the high-status Viking Age and medieval site of Orphir, Mainland Orkney, where large preserved fish were likely being consumed (Bar-

Table 7.4. *Cod, saithe and ling NISP by element.*

Cod elements	Farm Mound			Fish Midden		North Midden	South Midden	House 5 floors	
	Ph. 1 >2 mm	Ph. 1 all samples	Ph. 2–3	Ph. 2–3	Ph. 7	Ph. 2	Ph. 2	Ph. 2.3	Ph. 2.4
Articular	10	16	65	44		39	19	1	1
Basioccipital (×2)	12	18	36	22	6	34	22	6	4
Ceratohyal	10	23	65	31	2	49	21	3	3
Cleithrum	18	28	65	32	2	47	34	2	4
Dentary	26	42	106	52	2	55	28	2	8
Hyomandibular	9	20	32	28	1	31	19		
Infrapharyngeal	16	21	53	45	1	42	7	1	3
Maxilla	23	37	73	31		69	19	3	1
Opercular	21	29	30	20		22	14		5
Palatine	13	22	52	35		36	13	1	4
Parasphenoid (×2)	38	62	86	48	2	88	24		6
Posttemporal	35	54	55	24	2	39	17	6	3
Premaxilla	24	40	65	40	5	88	28	4	8
Preopercular	9	14	32	26		13	13	1	
Quadrate	35	56	62	47	1	47	13	3	1
Scapula	6	8	20	24	1	14	5	2	1
Supracleithrum	16	22	37	30	1	23	11		2
Vomer (×2)	52	64	86	64	2	62	34	2	8
Otolith	14	20	43	40	6	2		1	1
First vertebra	2	5	12	8	2	9	5		
Abdominal vertebra group 1	28	52	56	63	9	62	46	1	7
Abdominal vertebra group 2	36	60	73	77	5	66	18	4	1
Abdominal vertebra group 3	59	106	141	109	9	153	124	10	12
Caudal vertebra	1	4							
Caudal vertebra group 1	116	201	249	219	23	157	53	10	9
Caudal vertebra group 2	51	97	205	226	13	245	82	6	10
Penultimate vertebra	1	3	8	7		11	3		
Ultimate vertebra	3	3	8	10		7	4		
Total	**632**	**1055**	**1711**	**1335**	**90**	**1418**	**636**	**65**	**93**

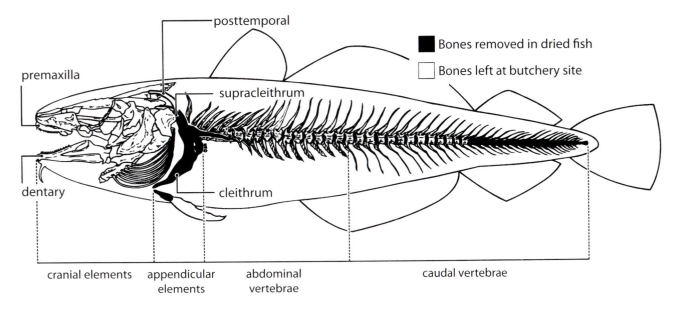

Figure 7.9. *Butchery of cod family fish for the production of 'stockfish' of* rotskjaer *type (after Barrett et al. 1999, 618).*

Table 7.4. *(cont.)*

Saithe elements	Farm Mound Ph. 1 >2 mm	Farm Mound Ph. 1 all samples	Farm Mound Ph. 2–3	Fish Midden Ph. 2–3	Fish Midden Ph. 7	North Midden Ph. 2	South Midden Ph. 2	Room 4 midden Ph. 4	House 5 floors Ph. 2.3	House 5 floors Ph. 2.4
Articular	25	45	9	25	11	24	11	83	2	4
Basioccipital (×2)	40	68	18	44	6	12	14	84	4	10
Ceratohyal	15	16	10	15	4	12	9	80	3	2
Cleithrum	8	9	3	10	1	7	4	64	1	1
Dentary	25	41	9	19	5	30	16	83	2	2
Hyomandibular	15	36	12	20	5	15	10	81	3	2
Infrapharyngeal	16	19	4	17	8	17	6	62	1	1
Maxilla	29	44	15	12	4	21	18	103	3	3
Opercular	12	15	1	7	4	6	1	32	1	3
Palatine	6	15	8	18	3	14	10	61	2	7
Parasphenoid (×2)	36	60	28	40	4	26	40	188	4	8
Posttemporal	24	31	14	19	2	10	13	109	2	4
Premaxilla	34	53	14	28	11	25	23	70	3	5
Preopercular	5	9	4	14	6	12	3	35	2	3
Quadrate	26	40	16	24	9	27	19	91	3	7
Scapula			2	4		5	2	21		
Supracleithrum	23	30	6	16	2	19	6	61		4
Vomer (×2)	28	42	26	34	2	18	26	98	8	6
Otolith	3	3	4	28	5	2	1	7		1
First vertebra	18	28	12	22	9	14	18	49	1	5
Abdominal vertebra								3		
Abdominal vertebra group 1	89	150	58	101	27	76	59	184	9	10
Abdominal vertebra group 2	129	216	78	156	30	87	49	268	7	18
Abdominal vertebra group 3	346	507	332	433	64	349	241	1447	36	89
Caudal vertebra		4						2		
Caudal vertebra group 1	311	437	211	277	54	106	36	354	18	25
Caudal vertebra group 2	194	290	142	250	33	64		131		1
Penultimate vertebra	1	1	1	3	1					
Ultimate vertebra			1	1		1		1		
Total	**1406**	**2124**	**1002**	**1578**	**304**	**971**	**595**	**3667**	**107**	**209**

rett 1997; Harland 2007). In all these cases the evidence for the production and exchange (on at least a local scale) of dried gadids existed as quantitative trends in assemblages dominated by the remains of whole fish that were presumably the remains of fresh local catches.

In sum, it is patterns in the relative abundance of cranial bones (such as the premaxilla, dentary and parasphenoid) versus appendicular elements (particularly the cleithrum, but also the supracleithrum and perhaps the posttemporal) — and of anterior versus posterior vertebrae that are most likely to indicate the production and/or consumption of dried cod at Quoygrew. The scapula is also an appendicular element, but it is very easily fragmented to the point of non-identification. Its relative abundance is therefore heavily dependent on subtle differences in preservation between the deposits. In the York System it is included among the routinely identified 'QC1' elements as a taphonomic indicator.

Ideally assessments of the relative impact of butchery strategy and differential preservation on

MNE results would be grounded in quantitative studies of bone characteristics such as density (cf. Butler & Chatters 1994; Zohar *et al.* 2001). In the case of gadid fish these have proven unhelpful, however, because of great variations in the density of different parts of single skeletal elements (e.g. Nicholson 1992b, 148) and major differences in preservation characteristics depending on which elements remain in a fish when it is cooked (Nicholson 1996, 528). Thus a more qualitative approach is essential — based on empirical study of MNE distributions and practical experience of how particular skeletal elements of cod and related species are reduced to the point of non-identification in experimental and archaeological assemblages (Nicholson 1992a; Barrett *et al.* 1999, 373).

Turning to the Quoygrew evidence, the relative representation of different skeletal elements has been quantified by both NISP (Table 7.4) and MNE (Fig. 7.10). In both cases the number of occurrences of each element within the body has been taken into account. MNE compares the most abundant diagnostic zone

Table 7.4. *(cont.)*

Ling elements	Farm Mound Ph. 2–3	Fish Midden Ph. 2–3	North Midden Ph. 2	South Midden Ph. 2
Articular		4	5	1
Basioccipital (×2)			2	2
Ceratohyal			2	2
Cleithrum		7	1	1
Dentary	3	7	8	2
Hyomandibular	1	1	3	2
Infrapharyngeal	1	1	1	
Maxilla	3	1	6	4
Opercular	1	1	1	1
Palatine	1	2	2	1
Parasphenoid (×2)	6	4	4	4
Posttemporal				
Premaxilla	4	2	7	1
Preopercular			1	1
Quadrate	1	6		3
Scapula		1	5	
Supracleithrum	1	1	1	1
Vomer (×2)	4	4	2	4
First vertebra	1		1	1
Abdominal vertebra group 1	6	1	2	5
Abdominal vertebra group 2	12	4	4	6
Abdominal vertebra group 3	6	15	3	2
Caudal vertebra group 1	3	5	8	6
Caudal vertebra group 2	12	10	4	3
Penultimate vertebra		1		
Ultimate vertebra	4			
Total	**65**	**74**	**69**	**48**

for each element, using only the maximum value recorded for left or right (for elements occurring in pairs) or a range reflecting the variable number of each type of vertebrae present in the body. The difference between minimum and maximum vertebrae MNE is represented in Figure 7.10 by the white area of each relevant bar. Using MNE ensures that elements that frequently fragment into a number of readily identifiable pieces are not over-represented compared to those that tend not to fragment.

Figure 7.10 shows the relative representation of cod elements for the deposit groups in which this species is common. In all cases cranial, appendicular and vertebral elements are well represented. Thus many whole fish were being consumed at Quoygrew. Nevertheless, variation in the relative abundance of cleithra does imply meaningful differences between the various areas of the site — particularly once taphonomy is taken into consideration.

Phase 1 is the most difficult to interpret. The sample size is small for the >2 mm data set, there is the possibility of some recovery bias in the >4 mm data set and (most importantly) it has the least well-preserved fish bone from the site (see Section 7.3 above). Cleithra are under-represented from both recovery subsets

(Table 7.4; Fig. 7.10), but this may be a taphonomic bias given that it is a fragile bone. It could be significant that posterior vertebrae (caudal vertebrae group 2) are also under-represented in both the >2 mm and >4 mm data sets, but possible alternative causes of this pattern are discussed below. Some cod processed like *rotskjaer* may have been leaving the site in the tenth century, be it for local or long-distance transport, but this is not definitive.

In contrast to Phase 1, the fish bone from Phases 2 to 3 of the Fish Midden is very well preserved and was all recovered using 2 mm mesh. Thus a more even distribution of skeletal elements would be expected if it represents the consumption of fresh whole fish. Contrary to this expectation, the cleithrum is the *least* abundant of all QC1 cranial and appendicular elements in this deposit and phase group. The posttemporal, supracleithrum and scapula (other elements that might be separated from a fish head during decapitation) are also under-represented. This evidence suggests that processed cod were transported elsewhere (on-site or off). There are also slightly more anterior vertebrae (abdominal vertebrae groups 1 and 2) than posterior vertebrae, which is consistent with this interpretation, but less

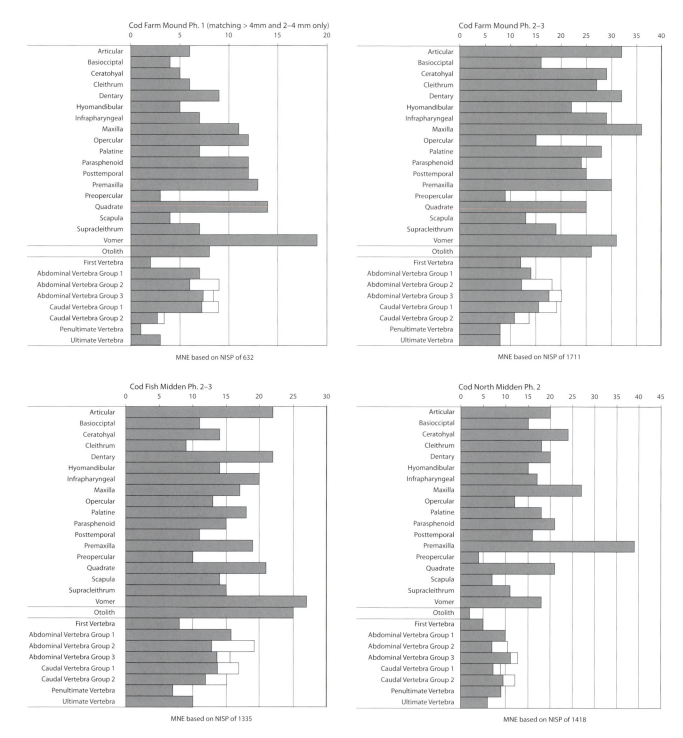

Figure 7.10. *Cod and saithe MNE by deposit/phase group. Recovery is >2 mm for all groups.*

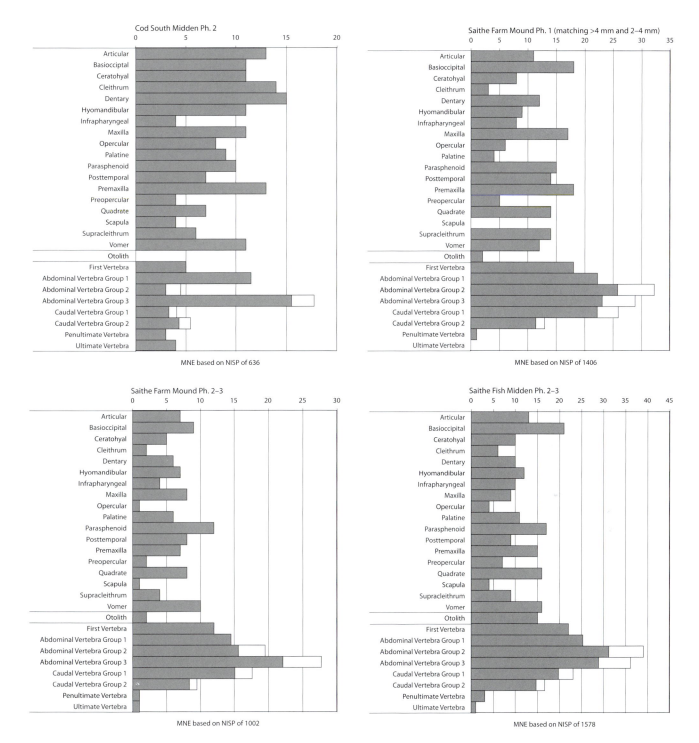

Figure 7.10. *(cont.)*

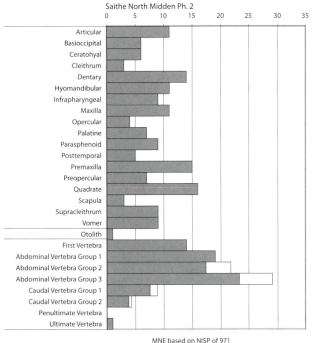

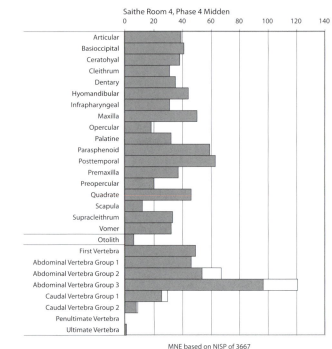

Figure 7.10. *(cont.)*

definitive for analytical and taphonomic reasons that will be discussed below. Note that the under-representation of first vertebrae in all phase and deposit groups is due to the difficulty of identifying it to species when in a damaged state.

Intriguingly, in the contemporary Phases 2 to 3 of the Farm Mound a different pattern is visible. Here cleithra are as abundant as most cranial elements (Fig. 7.10). There are also slightly elevated numbers of abdominal vertebrae group 3 and caudal vertebrae group 1 in comparison with abdominal vertebrae groups 1 and 2 (the reverse of the trend visible in the Fish Midden). Taken together this evidence could indicate the consumption of some preserved cod, presumably those whose processing remains were deposited in the Fish Midden. It is curious, therefore, that the most posterior caudal vertebrae (group 2, penultimate and ultimate) are under-represented. These bones should be present in both fresh and preserved fish. The tiniest caudal vertebrae may not have been recovered by 2 mm mesh (cf. Barrett 1997, 625), but Phases 2 to 3 of the Farm Mound had proportionately fewer of these vertebrae than even the Fish Midden (from which it is argued some fish tails were removed in a processed state). To understand this curious observation it is helpful to first consider the South and North Midden deposits.

The Phase 2 deposits from both the South and North Middens, all sieved to 2 mm, have less well-preserved fish bone than the Fish Midden and Farm Mound (Section 7.3 above). Thus fragile cleithra should be under-represented assuming the deposition of whole fish skeletons. Instead, they are surprisingly abundant. In the South Midden the cleithrum is actually the second most abundant of the QC1 cranial and appendicular elements (Fig. 7.10). It is difficult to interpret this pattern as evidence for anything other than the discard of remains from preserved cod. Here too, however, the relative abundance of posterior vertebrae is highly variable.

In light of all of the examples discussed above it seems likely that a bias unrelated to typical recovery, preservation or fish-processing factors may have been responsible for the number of caudal vertebrae recorded in each phase and deposit group from Quoygrew. By process of elimination, the most probable is the degree to which posterior vertebrae were identifiable to species. Many small vertebrae could only be attributed to the genera *Gadus* or *Pollachius* (being from cod, saithe or pollack). Alternatively, it is also possible that the smallest vertebrae were often obliterated — either during the hammering of dried cod described in *Le Ménagier de Paris* (see above) or by being cooked while still in the preserved product. It has been demonstrated that boiled fish bone preserves very poorly indeed (Nicholson 1992a; 1996).

If the evidence from posterior caudal vertebrae is disregarded as an analytical and/or atypical preservation bias the skeletal element distributions for cod seem to tell a relatively simple story. The consumption

Table 7.5. *Summary of cut-mark evidence.*

Species	Element	Farm Mound		Fish Midden	North Midden	Room 4 midden	House 5 floors		South Midden	
		Ph. 1	Ph. 2–3	Ph. 2–3	Ph. 2	Ph. 4	Ph. 2.3	Ph. 2.4	Ph. 2.1	Ph. 2.2–2.4
Cod	Basioccipital		1							1
	Cleithrum		4		2				1	3
	Dentary	1								
	Infrapharyngeal		1							
	Posttemporal	6	2	1	1		2	1		
	Premaxilla	1		1						
	Supracleithrum	1	1	7	1			1		1
	First vertebra		1							
	Abdominal vertebra group 1	3								
	Abdominal vertebra group 2	1								
	Abdominal vertebra group 3				1					
	Caudal vertebra group 1			4	1		1			4
	Caudal vertebra group 2									5
Ling	Cleithrum	1								1
	Dentary				1					
	Supracleithrum				1					
	Abdominal vertebra group 2									1
	Abdominal vertebra group 3							1		
	Caudal vertebra group 1							1		
Saithe	Posttemporal									1
	Supracleithrum							1		
	Abdominal vertebra group 3				1					
	Parasphenoid	1				1				
Cod/saithe/pollack	Caudal vertebra group 2							1		
Unidentified	Unidentified		1							
Total		15	11	13	9	1	3	6	1	17

of fresh whole fish is indicated in all areas of the settlement. At the Fish Midden near the shore, however, some cod were also processed in a manner consistent with the production of dried cod resembling *rotskjaer* — with the finished product taken elsewhere. Many of these preserved cod were probably consumed on-site, with their (incompletely preserved or identified) remains ultimately being added to the South Midden, the North Midden and Phases 2 to 3 of the Farm Mound. Having been made, it is possible that some preserved cod were also removed from the site in the context of regional or long-range exchange networks. Lastly, although poor preservation makes it difficult to interpret what was happening in Phase 1 of the Farm Mound, some dried cod may already have been produced at Quoygrew (on a small scale) in the tenth century.

In the case of saithe (the second most abundant species) some whole fish are clearly represented by the MNE data, but cleithra are infrequent in all deposit and phase groups with reasonably large samples sizes — with the exception of the Phase 4 midden from Room 4. This observation may, however, be due to an identification bias. The saithe bones from Quoygrew are almost all from small fish (see Section 7.5 above), and fragments of tiny cleithra proved difficult to identify to species. The under-representation of both the most anterior and most posterior vertebrae in all deposit/phase groups is almost certainly due to the same problem of identifying small and incomplete specimens to species. It is conceivable that saithe were prepared as dried fish at Quoygrew, as argued for the contemporary fish midden at Robert's Haven in Caithness based in part on groups of articulated vertebrae (Barrett 1997), but it cannot be certain on present evidence.

Turning to ling, the third most commonly occurring species, there were insufficient numbers to justify the interpretation of MNE data. It is sufficient to note both that all parts of the skeleton are represented (Table 7.4) and that this species has been dried for export in much the same way as cod at other times in the history of the Northern Isles (Low 1879 [1774], 120–21; Smith 1984, 49).

In summary, the vast majority of cod, saithe, ling (and other fish not discussed) caught at Quoygrew were deposited in their entirety and thus represent the consumption of locally caught fish (eaten fresh or

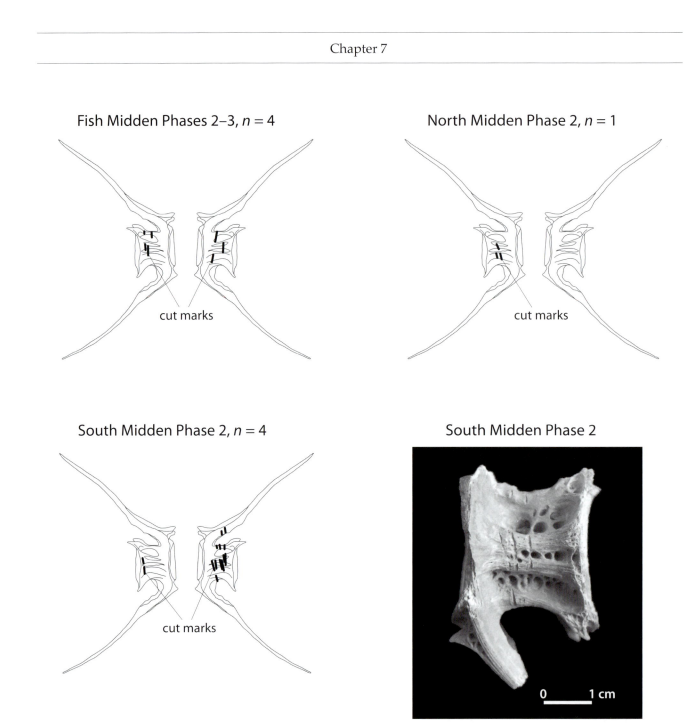

Fish Midden Phases 2–3, *n* = 4

cut marks

North Midden Phase 2, *n* = 1

cut marks

South Midden Phase 2, *n* = 4

cut marks

South Midden Phase 2

0 ___ 1 cm

Example of transverse butchery

Figure 7.11. *Cut marks on cod caudal vertebrae of group 1. (Images: Jennifer Harland, after Cannon 1987.)*

cured lightly by hanging over a hearth for example). However, cod were probably also prepared for drying at the Fish Midden in Phases 2 to 3 (and possibly at the Farm Mound in Phase 1). In Phase 2 and Phases 2 to 3 at least some of these preserved cod were consumed at Quoygrew and deposited in the South Midden, the North Midden and the Farm Mound. However, some dried cod could also have been removed from the site for exchange, be it on a local or long-distance scale (see Section 7.9).

7.8. Butchery patterning and trade: cut marks

A total of 76 fish bones exhibited cut marks — typically with the clear 'V'-shaped cross-section characteristic of a metal blade (Blumenschine *et al.* 1996). Most were from large cod or ling of at least 800 mm total length. The few butchered saithe were of similarly large size. The specimens in question are summarized in Table 7.5. The most commonly affected elements were posttemporals, supracleithra and cleithra, followed

by caudal vertebrae of group 1. There were, however, smaller numbers of cut marks on a variety of other elements. Butchery marks found on premaxillae and dentaries, for example, were probably created during hook removal or processing for the tongue.

The frequent cut marks on cleithra, posttemporals and supracleithra were probably made during decapitation. Cut marks on fish vertebrae can be the result of a variety of processes. Decapitation leaves butchery marks on the first vertebra (or basioccipital) and the first group of abdominal vertebrae, and gutting and/or filleting marks can be found on the second and third groups of abdominal vertebrae as well. Based on work at Robert's Haven (Barrett 1997), butchery to prepare a dried product of *rotskjaer* type (see above) can produce distinctive marks in the transverse plane near the middle of the vertebral column, usually on abdominal vertebrae of group 3 or caudal vertebrae of group 1. Vertebrae cut in this way might end up in either the discarded or the preserved section of the spine — depending on the contingencies of how the anterior portion of the vertebral column was pulled out after the adhering soft tissues had been severed by knife.

Transverse cut marks on caudal vertebrae of group 1 were found in Phases 2 to 3 of the Fish Midden and Phase 2 of the South and North Middens (Fig. 7.11). Two similar marks were found on cod and ling from Phase 2 floors of Room 5 (not illustrated) — suggesting that ling, like cod, may have been dried for local consumption. No similar cut marks were noted on specimens from the Farm Mound. Given the tiny proportion of the fish bone assemblage that exhibited cut marks this need not be meaningful. Overall, it is possible to infer that the limited butchery evidence is consistent with the production and consumption of some *rotskjaer*-like dried fish at Quoygrew during Phases 2 to 3.

Identical transverse cut marks on vertebrae have been noted on cod bones of thirteenth- to fourteenth-century date from Wharram Percy, an inland settlement near York in England. These specimens have stable isotope signatures that do not match the southern North Sea and are arguably imports from the Northern Isles or elsewhere in the north (Barrett *et al.* 2008a; see also Barrett *et al.* 2011).

7.9. Conclusions

Fish remains from several areas at Quoygrew were examined, permitting a detailed exploration of spatial and temporal patterning. Inter-class comparisons indicate a shift towards greater marine resource exploitation between Phase 1 and Phases 2 to 3, followed by a decrease in the exploitation of the sea in Phases 3

and 4. Both of these temporal shifts were associated with distinct patterns of fish species and sizes. Fishing was less specialized on cod family species in Phase 1 and almost exclusively focused on small saithe in Phase 4. In Phases 2 to 3 the fishery focused mostly on cod and saithe, but of a wider range of sizes than were present in either Phase 1 or Phase 4. All of this evidence — combined with the mollusc data from Chapter 6 — points to the rise and fall of an intensive and extensive fishery for cod and saithe.

In terms of spatial variation, there is qualified evidence for the production of dried cod near the shore at the Fish Midden — and the consumption of the resulting product in House 5 (with the refuse deposited in the North and South Middens) and on the Farm Mound. Some of the resulting 'stockfish' may additionally have left the site as an exchange product (intended for other, perhaps elite, consumers within Orkney and/or long-range trade). House floors produced more small saithe than large cod, which could indicate that the latter were destined for exchange. In this instance, however, it is equally or more likely that larger bones were swept up and deposited on external middens.

High-status settlements like that at Orphir, in Mainland Orkney, were likely destinations for at least some preserved fish. Element representation and cut-mark evidence indicates the import and consumption of large cod and other gadid species at this site (Barrett 1997; Harland 2007). It is therefore highly likely that dried cod from sites like Quoygrew could serve as tributary payments akin to rent, tax and/or tithe. Moreover, based on analogy with later history in the Northern Isles, it was the products of rent and tax that provided an exportable surplus for the local elite (Chapter 2). Thus some fish may also have been destined for long-range trade.

It is conceivable that saithe were also preserved by drying at Quoygrew, but both the intra-site and inter-site evidence is more equivocal than for cod. This species does not show separate production and consumption locations at Quoygrew and it was not imported to Orphir as a finished product. Saithe would, however, have been an important source of oil, produced from their livers. Fish oil, mostly from this species, served as both the main lamp fuel and a way of paying rent in the Northern Isles during later centuries (Nicholson 2004; 2005).

The temporal trends observed at Quoygrew corroborate an emerging pattern in Orkney and Caithness of substantial and diverse fishing in the Viking Age, followed by highly intensive and extensive fishing for cod and saithe in the early Middle Ages (eleventh to thirteenth/fourteenth centuries), followed by a shift

to moderate levels of inshore fishing for small saithe in the late Middle Ages. These trends are observable based on both zooarchaeological research (e.g. Barrett 1997; Cerón-Carrasco 1998; Barrett *et al.* 1999; 2001; 2004, 624–5; Harland 2006; Nicholson 2007) and stable isotope analysis of human skeletons to assess the dietary contribution of marine protein (Barrett & Richards 2004; Barrett *et al.* 2008b). It is unlikely that the known environmental changes of the fourteenth century (see Chapter 2) were the cause. Quoygrew's chronology (demonstrating a thirteenth-century 'crash') is a poor fit. Moreover, at Orkney's latitude the Little Ice Age is unlikely to have had a negative impact on cod stocks (Barrett *et al.* 2004, 628–9 and references therein.)

The pattern elsewhere in Atlantic Scotland may be similar (e.g. Bigelow 1985; Cerón-Carrasco 2005; Nicholson 2010). However, given historical evidence for the development of direct Norwegian and then Hanseatic involvement in Shetland, from the late twelfth and early fifteenth centuries respectively (Chapter 2), some regional variability should be expected even within the Northern Isles. It is possible, for example, that intensive fishing continued in Shetland (Friedland 1983; Gerry Bigelow pers comm.).

Is there any alternative to the interpretation that fishing declined or collapsed in medieval Orkney after an initial boom? One conceivable possibility is that fishing simply moved out of normal farms like Quoygrew and into specialized stations (cf. Fox 2001; Nielssen 2009, 96–101). A fish-drying hut ('skeo') now known to date sometime between the late twelfth and early fifteenth centuries (built into an earlier Iron Age site) *has* been excavated on an outlying peninsula at the Knowe of Skea in Westray (Moore & Wilson 2005b, 332; Kilroy 2006; Gordon Cook pers comm.). However, this site is entirely consistent with the kind of place fish like those processed at Quoygrew would have been hung to dry. It lacks contemporary dwellings and need not imply the development of new fishing stations separated from farms. Specialized fishing *settlements* of medieval date have not been discovered in the Northern Isles. Thus overall the studies of fish bone, marine shell and human diet discussed above do suggest that the importance of sea fishing declined in the region during the thirteenth and/or fourteenth centuries. Moreover, the chronology of the deposits at Quoygrew is most consistent with the former of these two centuries (Chapter 4), the significance of which will be considered in Chapter 16.

Chapter 8

Animal Husbandry: the Mammal Bone

Jennifer F. Harland

8.1. Introduction

Mammal bones were recovered from several areas and phases at Quoygrew, permitting intra-site spatial and temporal analysis. Most of the analysed material (85%) was from the Farm Mound and the Fish Midden. Changes through time can be examined within the Farm Mound, between the earlier Phase 1 and later Phases 2 to 3, while spatial variation can be examined between contemporary (Phase 2 to 3) layers in the Farm Mound and Fish Midden. Other deposit and phase groups examined contained only small quantities of mammal bone (the North and South Middens, the Phase 4 midden from Room 4 and the floor deposits from House 1 and House 5). In total, approximately 38,000 mammal bones were examined (weighing 60 kg), of which 8616 (weighing 45.6 kg) were identified to taxon (Table 8.1). Overall, the mammal bone evidence illuminates changes in animal husbandry at Quoygrew that are contemporary with the increase in sea fishing (Chapters 5 to 7) and implies a similar need to produce a greater storable surplus. A possible subsequent change in animal husbandry concurrent with the late medieval decline in fishing is more difficult to evaluate due to the small number of mammal bones recovered from the Phase 4 midden of Room 2.

8.2. Recovery

The analysed mammal bone was recovered predominantly by sieving to 4 mm (the Fish Midden and the relevant floor deposits of Houses 1 and 5) or by a combination of hand collecting and sieving to 4 mm (the Farm Mound, the North and South Middens and the Phase 4 midden in Room 4). A much smaller quantity of identifiable material, mainly of mice and voles, was also recovered from the 2–4 mm sieve fractions of selected flotation samples (the same ones used for study of the fish bone, see Chapters 5 and 7). The zooarchaeological evidence from each recovery method has been tabulated separately where practi-cable. When this procedure would have resulted in excessively tiny sample sizes the data are combined and potential recovery biases discussed in qualitative terms.

8.3. Methods

The Quoygrew mammal bone was recorded using the York System (Harland *et al.* 2003). Under this system, elements are divided into quantification codes (QC), with QC1 representing the suite of commonly identified elements for which all relevant information is recorded. They include long bones, mandibles, the pelvic and shoulder girdles and select regions of the cranium. Other elements, including ribs and vertebrae, were assigned to QC0 and were not identified unless of special interest (if they exhibited a cut mark, for example).

Specimens from the 'large mammal' category are likely to be cattle (with potentially some horse), 'medium mammal 1' fragments are likely to be caprine or pig, and 'medium mammal 2' fragments are from dog- or cat-sized animals. For simplicity, the very few probable identifications have been grouped with definite ones as they do not alter the overall interpretations. All sheep and goat identifications are included in the caprine total. Only one goat was positively identified at Quoygrew, so most are probably sheep.

Mammal-bone preservation was explored using bone surface texture, scored on an ordinal scale, and fragmentation, assessed as percent completeness (see Section 8.4 below). Evidence of gnawing, burning, partial digestion and/or other modification was also recorded. Phase 1 of the Farm Mound and Phases 2 to 3 of the Farm Mound and Fish Midden provide the most useful data. Only limited observations can be made regarding the other deposit and phase groups because of their smaller sample sizes. Butchery marks were recorded manually on cards, later digitized onto composite drawings of the skeleton during analysis. Butchery evidence was classed as either a 'knife' or a

'chop' mark. Knife marks are thin, shallow lines that are often relatively short. They rarely extend more than 1 mm into the bone surface. In contrast, chop marks are deeper — extending a few millimetres into the bone or even severing it completely. Both cut- and chop marks have a 'V'-shaped profile. Marrow extraction was analysed using Outram's (2001) methods.

Mammal age at death estimates are of crucial importance for understanding livestock management and dairying. A triple approach was thus taken when assessing age at slaughter. Firstly, each QC1 element was assigned a qualitative age estimate on an ordinal scale. The category 'adult' was used to describe full-sized elements with smooth and solid textures. If epiphyses were visible they were fused. 'Sub-adult' elements were just fused or in the process of fusing, but otherwise closely resembled adult bones in size and texture. 'Juvenile' elements were smaller than adult in size, but still had a fairly robust and smooth texture. If epiphyses were visible they were unfused, but with well-defined surfaces. Lastly, 'neonatal' elements were small, roughly textured, fragile and porous. If the epiphyses were present they were unfused, poorly defined and had fragile surfaces. This very 'broad-brush' approach maximizes the sample size available for intra-site comparison — particularly the analysis of change through time. Age at slaughter was also assessed based on the timing of fusion of different epiphyses and on tooth eruption and wear. The interpretation of cattle and pig fusion ages followed Silver (1969), and sheep ageing followed Moran and O'Connor (1994). Mandibular tooth wear was recorded using Grant (1982) for cattle and pigs, and Payne (1973; 1987) for sheep and goats. O'Connor's methods were used for analysis (1989; 1991).

Metrical data were recorded for all adult elements, following von den Driesch (1976), with a few additional measurements as detailed in Harland *et al.* (2003). Elements were only measured if all epiphyses were fused, meaning that early fusing epiphyses were not measured if the state of later fusing epiphyses (on the same bone) was unknown. The Quoygrew mammals only produced a small data set because few were fully adult, making it difficult to compare with other sites or to examine any potential breed or sex variation.

The assemblage is quantified by number of identified specimens (NISP), with the basic data by taxon (divided by recovery, deposit and phase groups) provided in Table 8.1. Minimum number of elements (MNE) and minimum number of individuals (MNI) estimates were not derived, partly because they are statistically problematic measures (Grayson 1984), but more pragmatically because the sample sizes were too small. A list of common and scientific names for the taxa identified is provided in Appendix 8.1. The evidence regarding bone preservation is summarized in Table 8.2 and Appendix 8.2. Tables 8.3 to 8.5 summarize the relative abundance of each major skeletal element (by NISP) for the three most abundant taxa (cattle, caprines and pigs). Table 8.6 provides an overview of the pathological specimens in the collection. The butchery evidence is summarized in Figures 8.1 to 8.4, and the ageing evidence in Figures 8.5 to 8.7. Two sample Kolmogorov-Smirnov tests were used to investigate the statistical significance of variations between deposit and phase groups for important ordinal scale measures — including bone surface texture, percent completeness and ageing categories. The results are summarized in Appendix 8.3. A summary of the fracture type evidence is in Appendix 8.4. The measurement data are summarized in Appendices 8.5 to 8.7.

8.4. Taphonomy

The surface texture of most bone specimens from Quoygrew can be categorized as 'good' (solid, with some flaky or powdery patches) or 'fair' (solid, but with up to half of the surface flaky or powdery) for all deposit and phase groups, with very little 'poor' (very flaky or powdery) or 'excellent' (solid, fresh and glossy) material recorded (Table 8.2). Phases 2 to 3 of the Farm Mound produced significantly worse texture scores than the earlier Phase 1 of this deposit, Phases 2 to 3 of the Fish Midden and Phase 4 of Room 4 ($p \leq 0.001$). However, the surface texture of mammal bone is strongly associated with age group — neonatal and juvenile specimens generally have poorer texture scores than 'adult' bones — and a substantial portion of the cattle assemblage was from very young calves (see Section 8.7 below). Thus this result could reflect both taphonomic patterning and changes in the mortality profile of livestock remains through time. The texture data were therefore also divided by ordinal age category and reanalysed (Appendix 8.2). No differences in texture scores between deposit and phase groups were found for the adult and sub-adult specimens, indicating that these more robust bones can be compared directly. However, the neonatal and juvenile bones on their own were significantly different between deposit/phase groups, with material from Phases 2 to 3 of the Farm Mound containing better texture scores than Phase 1 of the Farm Mound ($p < 0.001$), and worse texture scores than Phases 2 to 3 of the Fish Midden ($p < 0.001$) and the Phase 4 midden of Room 4 ($p < 0.001$).

Percent completeness scores provide a measure of element breakage (purposeful, for marrow extrac-

tion, or accidental). Here recovery biases apply — fewer of the 0–20% complete bones were recovered by hand, as would be expected — but the >4 mm and hand-collected data are shown separately in Table 8.2 to control for this problem. Comparing deposit and phase groups, fragments were significantly less complete in Phase 1 of the Farm Mound when compared with both Phases 2 to 3 of the Farm Mound and the Phase 4 midden of Room 4 (regardless of recovery method, see Appendix 8.3). High levels of fragmentation can relate to more intensive marrow extraction (Outram 2001). In this instance, however, few of the breaks could be classified as having occurred when the bones were very fresh so the damage is more likely to be post-depositional (Appendix 8.4).

Combining the texture and percent completeness evidence it would appear that the mammal bone from Phase 1 was least well preserved. The material from other deposit and phase groups was less fragmented, with good preservation (as implied by texture scores) of all but the neonatal and juvenile bone from Phases 2 to 3 of the Farm Mound. These observations need to be taken into consideration when interpreting other patterning in the zooarchaeological data from Quoygrew.

Evidence of burning was found on just over a quarter of all fragments. It was heavily influenced by recovery methods, with far fewer burnt fragments recovered by hand. Considering only the >4 mm material, burning was more prevalent in Phases 2 to 3 of the Fish Midden (at 53%) than in the Farm Mound (at 39% in Phases 2 to 3 and 41% in Phase 1). Although the fish assemblage generally contained much lower proportions of burnt bone (see Chapter 7), the Fish Midden did contain slightly more than the Farm Mound, mirroring the pattern found in the mammal bone. Only 8% of all burnt mammal fragments were identified to taxon and therefore little patterning was observed by species.

Other taphonomic indicators were far less prevalent. Modern breakage affected less than 0.5% of the assemblage, carnivore gnawing was found on less than 0.8% of all bone, and crushing, root etching, acid etching and rodent gnawing were each found on less than 0.1% of all bone. Some rabbit burrowing was noted during excavation in Areas D and F, but very few rabbit bones were found in the deposits (Table 8.1) suggesting that disturbance from their activity was probably limited.

8.5. Species representation

The vast majority of the mammal bone was from domestic animals (Table 8.1), as is expected for an Orcadian site of this period (cf. Harland 2006). Cattle and caprines (sheep, with one goat) dominate most phases in varying proportions, while pigs consistently represent less than 10% of the domestic mammals. Hand collecting favours large bones and therefore over-estimates the proportion of cattle. Using the >4 mm sieved material, some variation between deposits and phases can be observed. Within the Farm Mound, caprines are more numerous than cattle in Phase 1, at 34% and 14% respectively. This difference then decreases in Phases 2 to 3, with caprines representing 24% and cattle 18%. Within the contemporary Phases 2 to 3 of the Fish Midden, cattle (37%) are conversely more numerous than sheep (27%). When these values are combined with the large mammal and medium mammal 1 categories (cow- and sheep-sized respectively), this trend becomes even more evident. Large mammals represent only 23% of the Phase 1 >4 mm subset, increasing to 32% by Phases 2 to 3 of the Farm Mound and 43% by Phases 2 to 3 of the Fish Midden. This pattern could be interpreted as an increase in the usage and demand for cattle through time. This possibility is considered further below when discussing age profile changes through time.

The sample from the Phase 4 midden in Room 4 is small, but caprines once again appear to be the predominant domestic species, much more so than cattle or pigs. The high number of horse remains (55% of the hand-collected material) reflects parts of two individual animals (see below).

Phase 1 of the Farm Mound has the highest proportion of 'minor' taxa, at c. 8% of the identified bone. These include seals, cetaceans, dogs, cats, horses, red deer, voles and mice. Taxa not from the main domesticates comprise only approximately 2–3% of the bone from Phases 2 to 3 of the Farm Mound and Fish Midden. These include seals, cetaceans, dogs, cats, horses, voles, mice and (intrusive) rabbits.

The apparent decline in minor taxa from Phase 1 to Phases 2 to 3 primarily results from decreasing proportions of small mammals, including Orkney voles, wood mice, house mice, a pygmy shrew and many fragments only identified more broadly as mice or voles. House mice will live inside and readily eat stored grain, but they also survive in the wild. Wood mice live in houses, gardens or the wild — and will also eat stored produce and seeds. Orkney voles are common grassland species and were probably less of a risk to stored food than the mice (Corbet & Harris 1991). Wood mice and house mice are found in most phases at Quoygrew, but are very scarce in the Fish Midden and are rather more common in the house floors and the Phase 4 midden in Room 4 (the Room 4 midden also produced the pygmy shrew specimen, a

Table 8.1. *Number of identified specimens (NISP) of QC1 mammal bones by major deposit and phase groups, divided by recovery method (excludes 173 identified specimens from Phases 1 and 7 of the Fish Midden and 7 identified specimens from Phase 3 of the South Midden). Hc indicates hand collected.*

| | Farm Mound | | | | | | | | Fish Midden | | |
| | Ph. 1 | | | | Ph. 2–3 | | | | Ph. 2–3 | | |
Taxa	Hc	>4 mm	2–4 mm	Total	Hc	>4 mm	2–4 mm	Total	>4 mm	2–4 mm	Total
Seal species	3 (0.2%)	4 (0.7%)		7 (0.3%)	20 (0.6%)	6 (0.8%)		26 (0.6%)			
Pygmy shrew											
Cetacean	2 (0.1%)	2 (0.3%)		4 (0.2%)	9 (0.3%)	2 (0.3%)		11 (0.3%)			
Carnivore						1 (0.1%)		1 (0.0%)			
Dog	2 (0.1%)			2 (0.1%)	3 (0.1%)	1 (0.1%)	1	5 (0.1%)			
Cat	9 (0.6%)			9 (0.4%)	16 (0.5%)	4 (0.5%)	2	22 (0.5%)		1	1 (0.1%)
Horse	4 (0.3%)			4 (0.2%)	7 (0.2%)	1 (0.1%)		8 (0.2%)	1 (0.1%)		1 (0.1%)
Pig	125 (8.2%)	21 (3.6%)		146 (6.6%)	74 (2.2%)	57 (7.8%)		131 (3.2%)	19 (2.6%)		19 (2.6%)
Red deer	2 (0.1%)			2 (0.1%)							
Cattle	306 (20.1%)	83 (14.3%)		389 (17.6%)	1048 (31.1%)	133 (18.2%)		1181 (28.5%)	257 (35.5%)		257 (35.0%)
Caprine	294 (19.3%)	194 (33.5%)	5 (4.5%)	493 (22.3%)	804 (23.9%)	175 (23.9%)	2	981 (23.7%)	230 (31.8%)	1	231 (31.5%)
(of which sheep)					25 (0.7%)	6 (0.8%)		31 (0.7%)	1 (0.1%)		1 (0.1%)
(of which goat)					1 (0.0%)			1 (0.0%)			
Vole/mouse			8 (7.3%)	8 (0.4%)			10	10 (0.2%)	1 (0.1%)	3	4 (0.5%)
Vole species	1 (0.1%)	1 (0.2%)	7 (6.4%)	9 (0.4%)	1 (0.0%)		8	9 (0.2%)	1 (0.1%)		1 (0.1%)
Orkney vole		15 (2.6%)	73 (66.4%)	88 (4.0%)		14 (1.9%)	6	20 (0.5%)	4 (0.6%)		4 (0.5%)
Mouse species							2	2 (0.0%)	1 (0.1%)		1 (0.1%)
Wood mouse			4 (3.6%)	4 (0.2%)			5	5 (0.1%)			
House mouse							1	1 (0.0%)			
Rabbit					2 (0.1%)	1 (0.1%)	1	4 (0.1%)			
Small mammal		14 (2.4%)	12 (10.9%)	26 (1.2%)					1 (0.1%)	5	6 (0.8%)
Medium mammal 2	4 (0.3%)	10 (1.7%)		14 (0.6%)	2 (0.1%)	3 (0.4%)	2	2 (0.0%)	2 (0.3%)		2 (0.3%)
Medium mammal 1	506 (33.2%)	185 (32.0%)	1 (0.9%)	692 (31.3%)	1057 (31.4%)	234 (32.0%)		1291 (31.2%)	172 (23.8%)		172 (23.4%)
Large mammal	261 (17.1%)	50 (8.6%)		311 (14.1%)	327 (9.7%)	100 (13.7%)		427 (10.3%)	34 (4.7%)		34 (4.6%)
Sea mammal	5 (0.3%)			5 (0.2%)	1 (0.0%)			1 (0.0%)	1 (0.1%)		1 (0.1%)
Total identified	1524 (100%)	579 (100%)	110 (100%)	2213 (100%)	3371 (100%)	732 (100%)	40	4143 (100%)	724 (100%)	10	734 (100%)
Unidentifiable mammal	2465	8031	2	10,498	3152	5934		9086	4257	1	4258
Grand total	3989	8610	112	12,711	6523	6666	40	13,229	4981	11	4992

142

Table 8.1. (cont.)

Taxa	NM Ph.2 Hc	NM Ph.2 >4 mm	NM Ph.2 2–4 mm	NM Ph.2 Total	SM Ph.2 Hc	SM Ph.2 >4 mm	SM Ph.2 2–4 mm	SM Ph.2 Total	R4 Hc	R4 Ph.4 >4 mm	R4 Ph.4 2–4 mm	R4 Total	H5 Ph.2.3 >4 mm	H5 Ph.2.3 2–4 mm	H5 Ph.2.3 Total	H5 Ph.2.4 >4 mm	H5 Ph.2.4 2–4 mm	H5 Ph.2.4 Total	R1&2 Ph.4.1 >4 mm	R1&2 Ph.4.1 2–4 mm	R1&2 Ph.4.1 Total
Seal species	2	1		3		2		2	10 (3.5%)	2 (1.0%)		12 (2.0%)									
Pygmy shrew											1 (0.9%)	1 (0.2%)									
Cetacean					1			1		6 (3.1%)		6 (1.0%)				3		3			
Carnivore							1	1													
Dog	4	1	1	6	1			1		4 (2.1%)		4 (0.7%)									
Cat									1 (0.3%)	2 (1.0%)		3 (0.5%)									
Horse	1	1		2	1			1	159 (55.0%)	3 (1.6%)		162 (27.5%)	1		1	1		1			
Pig		2		2	3	2		3	11 (3.8%)	6 (3.1%)	1 (0.9%)	18 (3.1%)									
Red deer																					
Cattle	6	7		13	7	6		10	4 (1.4%)	7 (3.6%)		11 (1.9%)	1		1	4		4	1		1
Caprine	10	11		21	22	13		25	56 (19.4%)	50 (25.9%)	4 (3.7%)	110 (18.6%)	9		9	8		8	1		1
(of which sheep)																					
(of which goat)																					
Vole/mouse			11	11			14	14		2 (1.0%)	38 (35.2%)	40 (6.8%)		9	9		2	2	1	29	30
Vole species											1 (0.9%)	1 (0.2%)									
Orkney vole			11	11		3	18	21		6 (3.1%)	14 (13.0%)	20 (3.4%)	1	11	12		4	4	1	4	5
Mouse species			3	3			2	2		1 (0.5%)	6 (5.6%)	7 (1.2%)		6	6		1	1			
Wood mouse			3	3						2 (1.0%)	6 (5.6%)	8 (1.4%)		1	1				1	2	3
House mouse			2	2			2	2			3 (2.8%)	3 (0.5%)									
Rabbit									11 (3.8%)	33 (17.1%)	32 (29.6%)	76 (12.9%)				1		1			
Small mammal																					
Medium mammal 2	1			1						11 (5.7%)	2 (1.9%)	13 (2.2%)									
Medium mammal 1	8	7		15	6	10		13	32 (11.1%)	55 (28.5%)		87 (14.7%)	6		6	12		12			
Large mammal	7	2		9	6	3		5	5 (1.7%)	3 (1.6%)		8 (1.4%)				1		1	1		1
Sea mammal																					
Total identified	39	32	31	102	47	39	37	101	289 (100%)	193 (100%)	108 (100%)	590 (100%)	18	27	45	30	7	37	6	35	41
Unidentifiable mammal	56	402		458	52	554		566	182	2123		2305	219		219	219		219	137		137
Grand total	95	434	31	560	99	593	37	667	471	2316	108	2895	237	27	264	249	7	256	143	35	178

Table 8.2. *Bone surface texture (top) and percent completeness (bottom) data for all identified mammal QC1 elements (major deposit and phase groups only).*

Phases		>4 mm					Hand collected				
		Poor	Fair	Good	Excellent	Total	Poor	Fair	Good	Excellent	Total
Farm Mound	Ph. 1	17	66	135	4	**222**	87	155	219	42	**503**
		8%	30%	61%	2%	**100%**	17%	31%	44%	8%	**100%**
	Ph. 2–3	43	81	70	13	**207**	102	706	518	42	**1368**
		21%	39%	34%	6%	**100%**	7%	52%	38%	3%	**100%**
Fish Midden	Ph. 2–3	3	98	109	4	**214**		4	6		**10**
		1%	46%	51%	2%	**100%**		40%	60%		**100%**
	Ph. 7	1	13	23	2	**39**					
		3%	33%	59%	5%	**100%**					
Room 4 midden	Ph. 4	2	15	38		**55**	3	17	40		**60**
		4%	27%	69%	0%	**100%**	5%	28%	67%	0%	**100%**

Phases		>4 mm						Hand collected					
		0–20%	21–40%	41–60%	61–80%	81–100%	Total	0–20%	21–40%	41–60%	61–80%	81–100%	Total
Farm Mound	Ph. 1	118	33	11	21	39	**222**	198	115	47	75	68	**503**
		53%	15%	5%	9%	18%	**100%**	39%	23%	9%	15%	14%	**100%**
	Ph. 2–3	68	32	26	40	39	**205**	364	329	151	339	185	**1368**
		33%	16%	13%	20%	19%	**100%**	27%	24%	11%	25%	14%	**100%**
Fish Midden	Ph. 2–3	85	39	18	48	24	**214**	5			3	2	**10**
		40%	18%	8%	22%	11%	**100%**	50%			30%	20%	**100%**
	Ph. 7	13	8	7	6	5	**39**						
		33%	21%	18%	15%	13%	**100%**						
Room 4 midden	Ph. 4	16	16	10	11	2	**55**	11	14	12	8	15	**60**
		29%	29%	18%	20%	4%	**100%**	18%	23%	20%	13%	25%	**100%**

mandible). Orkney voles are ubiquitous, but are much more common in Phase 1 of the Farm Mound than in later phases. This may suggest the grassland environment around the Farm Mound was less intensively disturbed in this early phase of settlement. When house mice were first introduced to the Northern Isles is a matter of debate, but they were certainly present by the Viking Age — at which time it is likely that mice with a mtDNA lineage originating in Orkney were spread around the Irish Sea province (Nicholson *et al.* 2005; Searle *et al.* 2009).

Horse remains were found in most phases, but in low numbers (see Table 8.1). Most individuals were very small, of comparable size to a small pony. Phase 1 of the Farm Mound contained only juvenile bones, Phases 2 to 3 contained both juveniles and adults, and all others were from adult individuals. Teeth and fragmented maxillae and mandibles from the Phase 4 midden in Room 4 represent two adults of different size, one of which was a male of approximately 6 years with tooth wear indicating crib biting (C.J. Johnstone pers. comm. 2006). Pathologies on horse bones from Phases 2 to 3 of the Farm Mound included spavin, potential navicular bone disease and fused tarsals, all of which could be from the same long-lived individual (D.R. Brothwell pers. comm. 2004). Some horse remains were butchered (see Section 8.6), suggesting at least opportunistic consumption.

Carnivores were represented by both gnawing found on a small number of bones and by dog bones themselves (one of which, from the South Midden, displayed dog gnawing itself). Overall, however, there were very few dog remains — possibly indicating most were not incorporated into the middens. Adult and juvenile dogs were found, as were large and small individuals.

Cats were found primarily in the Farm Mound. Most were adult at death. Metrical data suggest the one measurable element was from a domestic rather than wild cat (T.P. O'Connor pers. comm. 2005). Cat gnawing was found on an unidentified mammal bone from Phases 2 to 3 of the Farm Mound, on a probable domestic fowl (chicken) bone from Phase 3 of the South Midden and on a cod bone from Phases 2 to 3 of the Fish Midden.

One probable and one definite identification of red deer bone (not antler) were made, both in Phase 1 of the Farm Mound. The probable identification was a juvenile and the definite identification was an adult, both with fresh fractures indicative of potential marrow extraction. Their presence in the earlier phase at Quoygrew is consistent with other evidence from the Northern Isles. Red deer were found in low quantities from a number of sites, decreasing in quantity from the late Iron Age to the Viking Age (C. Smith 1994; Bond 1998; Morris 2005; Bond 2007b) until, by the end

Table 8.3. *NISP of QC1 cattle elements for major deposit and phase groups, divided by recovery method. Hc indicates hand collected.*

Element	Ph. 1 Farm Mound						Ph. 2–3 Farm Mound						Ph. 2–3 Fish Midden			
	Hc		>4 mm		Total		Hc		>4 mm		Total		Hc	>4 mm		Total
Skull	18	8%	2	4%	20	7%	11	1%			11	1%		1	1%	1
Mandible	34	15%	13	24%	47	17%	84	11%	5	5%	89	11%		11	12%	11
Scapula	7	3%			7	3%	26	4%			26	3%		6	6%	6
Humerus	17	8%	2	4%	19	7%	45	6%	5	5%	50	6%		1	1%	1
Radius	16	7%	4	7%	20	7%	48	6%	4	4%	52	6%	2	12	13%	14
Ulna	2	1%	1	2%	3	1%	22	3%	2	2%	24	3%	1	6	6%	7
Metacarpal	13	6%	3	6%	16	6%	43	6%	4	4%	47	6%		1	1%	1
Pelvis	18	8%	2	4%	20	7%	42	6%	3	3%	45	5%		1	1%	1
Femur	8	4%	3	6%	11	4%	48	6%	5	5%	53	6%		6	6%	6
Tibia	14	6%	3	6%	17	6%	48	6%	4	4%	52	6%	2	9	10%	11
Astragalus	7	3%	1	2%	8	3%	33	4%	2	2%	35	4%		1	1%	1
Calcaneum	7	3%	2	4%	9	3%	28	4%	3	3%	31	4%		1	1%	1
Metatarsal	7	3%	1	2%	8	3%	35	5%	3	3%	38	5%		5	5%	5
Metapodial	22	10%	10	19%	32	12%	41	6%	13	14%	54	6%	2	6	6%	8
Phalanx 1	14	6%	4	7%	18	6%	80	11%	13	14%	93	11%		6	6%	6
Phalanx 2	11	5%	2	4%	13	5%	57	8%	17	18%	74	9%		12	13%	12
Phalanx 3	10	4%	1	2%	11	4%	48	6%	12	13%	60	7%		8	9%	8
Total	225	100%	54	100%	279	100%	739	100%	95	100%	834	100%	7	93	100%	100

of the twelfth century, historical evidence suggests none were left in Orkney (Pálsson & Edwards 1981, 209; Clutton-Brock & MacGregor 1988).

Seals and whales were found throughout all phases and areas, and were not identified to species. They may be under-represented if their bones were typically left at coastal butchery sites (cf. Smith & Kinahan 1984). Age profiles indicate exploitation of juveniles in preference to adults, and butchery evidence was found on several elements from the Farm Mound. Much higher proportions of dog gnawing were found on seal remains than on any other species, possibly indicating their use as dog food (or preferential survival when used in this way). Ethnohistoric accounts from later periods suggest that seal meat was only eaten by humans in the Northern Isles if nothing else was available (Fenton 1978, 525). The fragmented cetacean remains were not identified to species because of their lack of diagnostic features and limited reference material. These occasional finds could represent opportunistic usage of stranded individuals and (in the case of small whales) purposeful drives (Mulville 2002). The remains included ribs from small whales, a mandible from a small (toothed) whale, and a very large whale vertebra. Some elements were butchered or worked, and two were gnawed by dogs. Seals and whales could have been used for their oil and skins, as well as for their meat, while whale bone was also used for artefact manufacture (e.g. Owen & Dalland 1999, 73–86; see Chapter 13).

Rabbits were probably introduced to the Northern Isles in the seventeenth century (Booth & Booth 1994; Berry 2000) and thus the Quoygrew specimens will be intrusive. They were found in very low quan-

tities in most phases. The exception is the Phase 4 midden in Room 4, where disturbance was greater.

One human deciduous canine was found from Phases 2 to 3 of the Farm Mound, and three human bones were found in a test pit dug in the Fish Midden by Sarah Colley (1983) in 1978. The latter included a proximal left ulna, distal right humerus and right ilium — all probably from an infant based on their size (Sarah Colley pers. comm.). Formal human burial is presently unknown at the site and probably occurred elsewhere, perhaps in the 'pagan' and later Christian cemeteries known from nearby Pierowall and the links between Pierowall and Quoygrew (Chapter 3).

8.6. Skeletal element representation and butchery

The relative abundance of different skeletal elements (restricted to those routinely identified to species) is quantified by NISP for cattle, caprines and pigs in Tables 8.3 to 8.5. Overall, entire animals seem to be represented, without any clear export, import or redistribution of particular cuts of meat. For both cattle and caprines, mandibles varied the most between deposit and phase groups, likely reflecting fragmentation and preservation differences because all loose molars and fourth premolars were tabulated as parts of mandibles (see Harland *et al.* 2003). It has been suggested that cuts of meat may have been differentially redistributed between settlements in early historic Orkney (cf. Parker Pearson *et al.* 1996; Gilmour & Cook 1998), but there is no indication that this was so at Quoygrew.

Butchery marks were observed in small quantities throughout most phases, with little patterning identified through time or space (Figs. 8.1 & 8.2).

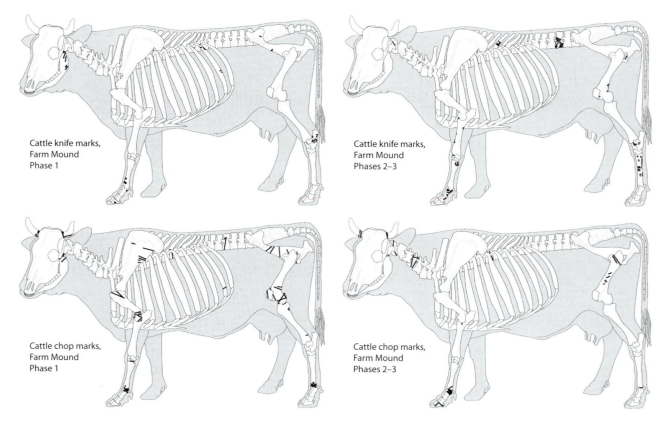

Figure 8.1. *Butchery evidence on cattle bones from the Farm Mound. Cut marks were also found on (neonatal) cattle bones from the Fish Midden and South Midden. Cut marks are indicated by the solid black areas. (Images: Jennifer Harland, after Michel Coutureau and Cedric Beauval.)*

Table 8.4. *NISP of QC1 caprine elements for major deposit and phase groups, divided by recovery method. Hc indicates hand collected.*

Element	Ph. 1 Farm Mound						Ph. 2–3 Farm Mound						Ph. 2–3 Fish Midden				
	Hc		>4 mm		Total		Hc		>4 mm		Total		Hc	>4 mm		Total	
Skull	8	4%	5	4%	13	4%	18	3%	6	6%	24	4%		4	4%	4	4%
Mandible	40	18%	24	20%	64	18%	67	13%	8	7%	75	12%		8	8%	8	7%
Scapula	19	8%	2	2%	21	6%	41	8%	4	4%	45	7%		6	6%	6	6%
Humerus	14	6%	2	2%	16	5%	47	9%	7	7%	54	8%		5	5%	5	5%
Radius	16	7%	6	5%	22	6%	48	9%	4	4%	52	8%		10	9%	10	9%
Ulna	3	1%			3	1%	9	2%	1	1%	10	2%		6	6%	6	6%
Metacarpal	12	5%	4	3%	16	5%	46	9%	7	7%	53	8%		6	6%	6	6%
Pelvis	18	8%	5	4%	23	7%	36	7%	9	8%	45	7%		2	2%	2	2%
Femur	13	6%	6	5%	19	5%	35	7%	2	2%	37	6%		8	8%	8	7%
Tibia	11	5%	6	5%	17	5%	34	6%	4	4%	38	6%		7	7%	7	6%
Astragalus	6	3%	4	3%	10	3%	17	3%	6	6%	23	4%		5	5%	5	5%
Calcaneum	8	4%	5	4%	13	4%	19	4%			19	3%		3	3%	3	3%
Metatarsal	16	7%	4	3%	20	6%	28	5%	4	4%	32	5%		6	6%	6	6%
Metapodial	11	5%	17	14%	28	8%	24	4%	7	7%	31	5%		8	8%	8	7%
Phalanx 1	17	8%	10	8%	27	8%	43	8%	14	13%	57	9%	1	6	6%	7	6%
Phalanx 2	7	3%	16	13%	23	7%	13	2%	12	11%	25	4%	1	10	9%	11	10%
Phalanx 3	5	2%	7	6%	12	4%	11	2%	12	11%	23	4%	1	6	6%	7	6%
Total	**224**	**100%**	**123**	**100%**	**347**	**100%**	**536**	**100%**	**107**	**100%**	**643**	**100%**	**3**	**106**	**100%**	**109**	**100%**

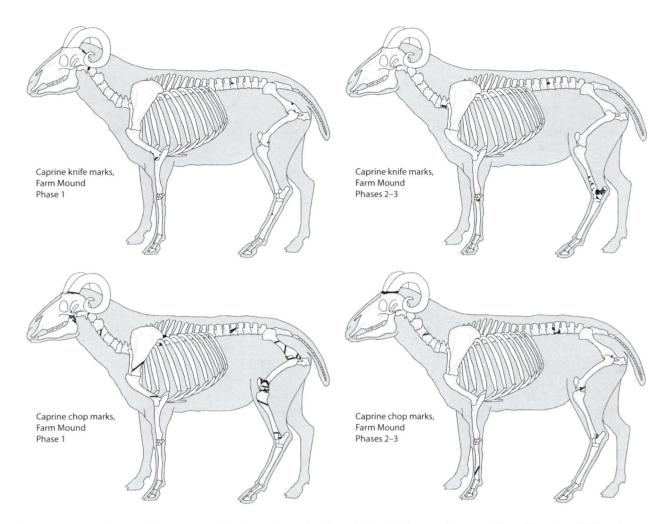

Figure 8.2. *Butchery evidence on caprine bones from the Farm Mound. Cut marks are indicated by the solid black areas. (Images: Jennifer Harland, after Michel Coutureau and Cedric Beauval.)*

Deep chop marks on cattle bones are consistent with disarticulation of the body, while shallow knife marks suggest further disarticulation and the preparation of joints of meat. Most cattle butchery marks were found on bones from adults or sub-adults, but the presence of a few butchered neonatal cattle bones indicates deliberate use (see discussion below). These were found in Phase 1 of the Farm Mound (two examples), Phase 2 of the South Midden (one example), Phases 2 to 3 of the Fish Midden (two examples) and Phases 2 to 3 of the Farm Mound (five examples).

Caprine butchery marks reflect chopping to disarticulate the skeleton, with knife marks infrequent. Butchery marks were observed on all age groups, broadly reflecting the overall caprine mortality profile. Very few pig butchery marks were found, with those present suggesting decapitation and disarticulation. Overall, evidence from the domestic species suggests non-specialized butchery of carcasses into a number

of separate pieces, followed by further processing if required. The low level of butchery overall leaves open the possibility that large joints of meat were cooked on the bone.

One adult horse humerus from Phase 2 of the South Midden contained a chop mark on the proximal epiphysis and a series of knife marks on the distal epiphysis, indicating deliberate disarticulation and butchery. This was also broken while fresh, possibly for marrow extraction. Whether this was for consumption is unclear, although the find of an astragalus (found articulating with a sub-adult distal tibia) with faint knife marks from Phase 1 of the Farm Mound does corroborate the deliberate butchery of horse carcasses. Furthermore, a few horse long bones from both Phase 1 and Phases 2 to 3 of the Farm Mound appear deliberately fractured for marrow extraction — implying at least opportunistic use of dead horses. None of these had any carnivore gnawing. Horse consumption

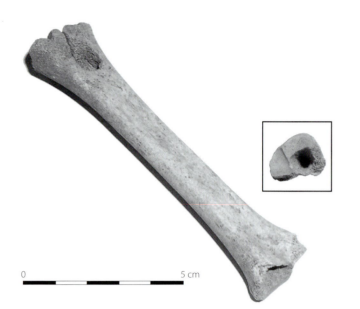

Figure 8.3. *Bi-perforated caprine metacarpal from Phases 2 to 3 of the Farm Mound. (Image: Jennifer Harland.)*

Figure 8.4. *Example of longitudinally perforated cattle long bone from Phases 2 to 3 of the Farm Mound. (Image: Jennifer Harland.)*

Table 8.5. *NISP of QC1 pig elements for major deposit and phase groups, all recovery methods combined.*

Element	Ph. 1 Farm Mound		Ph. 2–3 Farm Mound		Ph. 2–3 Fish Midden
Skull	1	3%	3	5%	
Mandible	9	24%	12	18%	1
Scapula			1	2%	
Humerus	2	5%	6	9%	1
Radius	1	3%	1	2%	1
Ulna			5	8%	
Metacarpal			1	2%	
Metacarpal 2					1
Metacarpal 3	1	3%	2	3%	
Metacarpal 4			2	3%	
Metacarpal 5					1
Pelvis	3	8%	7	11%	1
Femur			1	2%	
Tibia	2	5%			
Astragalus			1	2%	1
Calcaneum			3	5%	
Metatarsal	1	3%			
Metatarsal 3	1	3%			
Metatarsal 5			1	2%	2
Metapodial	8	22%	2	3%	
Phalanx 1	1	3%	3	5%	
Phalanx 2	5	14%	5	8%	
Phalanx 3			5	8%	
Lateral phalanx	2	5%	5	8%	2
Total	**37**	**100%**	**66**	**100%**	**11**

was discouraged during the Christianization process in Scandinavia (e.g. Sephton 1899, 32), yet eleventh- to twelfth-century butchered horse remains were found in conjunction with pendant crosses at Cille Pheadair in the Western Isles (Smith & Mulville 2004, 55; Parker Pearson *et al.* 2004a, 247–8) — and in medieval Scottish towns (C. Smith 1998, 876). Horse meat may thus have been intermittently consumed during and perhaps even after the main period of late Viking Age conversion in Atlantic Scotland, during the tenth to eleventh centuries (see Barrett 2003a; Abrams 2007).

A small number of semi-worked mammal bones were recovered from Quoygrew, including two bi-perforated caprine metapodials from Phases 2 to 3 of the Farm Mound, one of which is illustrated in Figure 8.3. Contemporary examples are known from Shetland, Iceland and the Faroe Islands (Bigelow 1993; Arge 1995; Barrett & Oltmann 2000), but these are rare Orcadian examples of this typically Norse North Atlantic tradition of marrow extraction. A group of seven cattle long bones (from animals of different ages) from Phases 2 to 3 of the Farm Mound and Fish Midden were also partially perforated, but probably not for the same reason as the modifications do not all extend into the marrow cavity. Instead, they were cut longitudinally into or through the proximal or distal epiphyses (Fig. 8.4). None of the specimens exhibit wear or polishing. The purpose or purposes of these modifications is unclear.

8.7. Ageing

As introduced in Section 8.3 above, ageing was determined through a combination of methods. From the time of excavation it was clear that the Quoygrew assemblage included a very high proportion of fragmented neonatal specimens that would not be fully represented by traditional assessments of epiphyseal fusion and tooth eruption or wear. This is because the mandibles (and often the epiphyseal ends of long bones) from young animals rarely survive intact. Identified specimens were therefore classified into broad ordinal categories (neonatal, juvenile, sub-adult and adult), based on overall size, state of epiphyseal fusion and surface texture — by comparison with reference material of known age. Although less precise than other methods, this broad classification allows easy comparison across phases and areas, as illustrated in Figure 8.5 (an almost complete articulated neonatal calf in Phases 2 to 3 of the Fish Midden has been given a count of 1 to avoid skewing the figures). Inter-analyst variability is likely to be high using this method — particularly in the division of 'sub-adult' and 'adult' specimens — but the Quoygrew material was classified by a single specialist. Moreover, for the purposes of interpretation the most important distinction is between specimens from younger ('neonatal' and 'juvenile') and older ('sub-adult' and 'adult') animals.

Using this method, over half of the cattle from Phases 2 to 3 of both the Farm Mound and Fish Midden were neonatal. Conversely, in Phase 1 of the Farm Mound there was less of an emphasis on neonatal calves and a correspondingly higher proportion of juvenile and adult bone. This change through time was statistically significant (see Appendix 8.3) and likely indicates a real increase in deaths of neonatal cattle between Phase 1 and Phases 2 to 3. In contrast, the general ageing categories for caprines indicate little spatial or temporal patterning (Fig. 8.5). For pigs, it was only possible to contrast the two main phases of the Farm Mound (Fig. 8.5). Juveniles increased in importance through time while adults and neonatal individuals decreased, but this was not a statistically significant difference (Appendix 8.3).

These ageing data combine all hand collected and sieved material to provide an adequate sample size, which will under-represent the small neonatal and juvenile elements. Phases 2 to 3 from the Farm Mound had the smallest proportion of sieved material (*vis-à-vis* hand collected bone from the same contexts), so compared to the other two major deposit and phase groups, neonatal and juvenile cattle were probably under-represented here. This provides further evi-

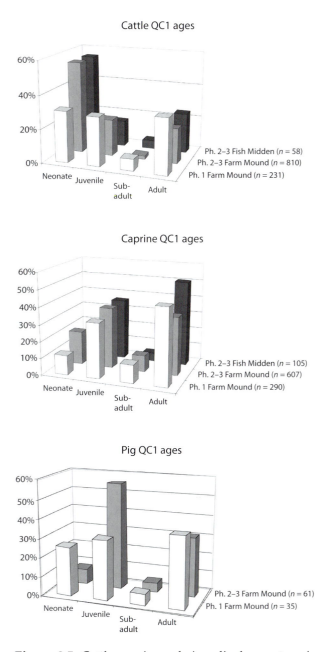

Figure 8.5. *Cattle, caprine and pig ordinal age categories for all QC1 specimens (combining hand-collected and sieved material).*

dence that cattle were killed at a younger age in Phases 2 to 3 than in Phase 1.

Epiphyseal fusion ages provide more detailed mortality profiles for the phases and areas with adequate sample sizes, as illustrated in Figure 8.6 for cattle and caprines (following Silver 1969; Moran & O'Connor 1994). For cattle, the percentage of fused epiphyses is low, even for the earlier fusing elements, thus confirming the propensity towards a young mortality profile. Moreover, Phase 1 exhibits a consistently

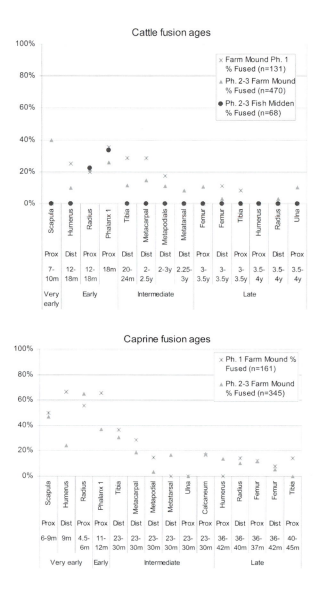

Figure 8.6. *Approximate fusion ages by element for cattle (following Silver 1969) and caprines (following Moran & O'Connor 1994) for major deposit and phase groups (combining sieved and hand-collected material).*

higher fusion rate than the later phases, indicating that the age at which cattle were slaughtered decreased through time.

Fusion ages for caprines indicate a different mortality profile, with far more individuals surviving to adulthood. Phases 2 to 3 of the Fish Midden provided too little material to include, but both Farm Mound phases had very similar profiles. Slightly higher fusion rates for most elements were noted for Phase 1, suggesting the caprines were killed at a younger age in the later period. Recovery differences likely bias the caprine data in the same way as for cattle (the smaller and younger elements are probably

under-represented in Phases 2 to 3), emphasizing the increasingly young age at death through time.

Sufficient mandibles were recovered to enable tooth eruption and wear profiles (following O'Connor 1989; 1991) to be established for the two major phases of the Farm Mound. The results for cattle (Fig. 8.7) show differences between Phase 1 and Phases 2 to 3 of the Farm Mound. Over half the cattle in Phase 1 survived to 'adult', perhaps representing 4 to 8 years, but by Phases 2 to 3 only half survived to the 'juvenile/ immature' stage. Almost 40% of the cattle in Phase 1 reached 'elderly', perhaps an age of 9 years or more, whereas in Phases 2 to 3, fewer than 10% survived to this age. The dental data thus confirm the patterns observed using other ageing methods, indicating an increase in the slaughter of neonatal and young cattle through time. Nevertheless, these results show fewer neonatal cattle than were estimated using the ordinal age category and epiphyseal fusion data. This difference is almost certainly because, although neonatal mandibles were observed in quantity, they were heavily fragmented and isolated or even broken teeth often could not be identified to specific positions within the mouth. Thus, like all of the methods employed, the analysis of dental evidence probably underestimates the importance of slaughtering calves at Quoygrew. In contrast to the cattle, the mandibular wear patterning for caprines showed little difference between the major phases of the Farm Mound. Approximately half the population reached the 'sub-adult' stage (perhaps late in the first year to two years of life).

Combining the different forms of ageing evidence, conclusions can be drawn regarding the mortality profiles of each domestic species. In the two main phases of the Farm Mound, the ordinal age categories, fusion and dental results vary (in degree rather than chronological trend) for cattle, with fewer neonatal cattle represented using tooth wear. This discrepancy likely reflects differential taphonomic biases: the identification of neonatal cattle using mandibular wear stages relies on fragile tooth rows being recovered intact, whereas the epiphyseal fusion and ordinal age categories use a wider range of elements that are more likely to survive in a recordable form. It therefore appears likely that a high proportion of all cattle in the Farm Mound were slaughtered younger than 12–18 months, with more neonates and a younger age at death found in the later Phases 2 to 3. The proportion of adults was low regardless of method, and given that adult bone survives best and is more likely to be recovered, only a small minority of the cattle at Quoygrew lived to maturity. The recovery biases present in the Farm Mound emphasize this pattern: Phases 2 to 3 had a higher proportion of hand-collected material

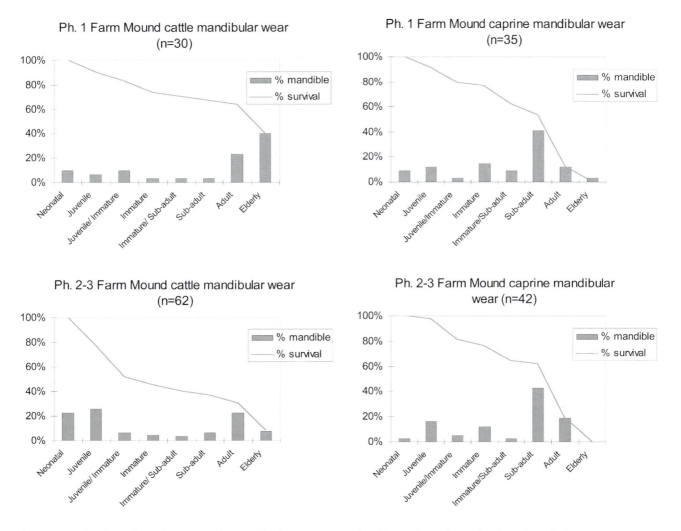

Figure 8.7. *Cattle and caprine mortality profiles based on dental evidence from the major deposit and phase groups (combining hand collected and sieved material).*

and thus the younger, fragile cattle elements are likely under-represented in this phase. Phases 2 to 3 of the Fish Midden yielded a smaller data set, but are consistent with the contemporary phases of the Farm Mound.

These age profiles suggest cattle were exploited primarily for dairy produce (Mulville *et al.* 2005), and secondarily for meat consumption. Calves were probably killed when very young to allow greater quantities of milk and milk products for human consumption, as well as providing some meat, fine skins, and rennet for cheese making. The increasing slaughter of neonatal and young calves observed in Phases 2 to 3 indicates an effort to intensify dairy production for local consumption, food renders (as rent, tax or tithe) and/or trade — a pattern also observed at other contemporary sites in the Northern Isles, including Pool in Orkney (Bond 1998; 2007b) and both Sandwick

South (Bigelow 1992) and Sandwick North (Barrett & Oltmann 2000) in Shetland. Nevertheless, the presence of immature and sub-adult specimens indicates that some cattle were slaughtered for meat, and a few older individuals would also have been essential for traction and reproduction. Thus it is not surprising to have found some age and/or stress-related pathological evidence (see below) and a few horn cores (from the Farm Mound) that are likely to derive from very old individuals (following Armitage 1982).

Caprines were probably used for a variety of purposes at Quoygrew, as reflected in the broad range of ages recovered. The majority died at an age indicative of prime meat consumption following one or two years of wool production. A few old caprines were kept, presumably for breeding purposes. Recovery of neonatal bone was subject to the same biases as

Table 8.6. *Summary of pathological lesions on mammal bones.*

Taxa	Element	Farm Mound Ph. 1	Farm Mound Ph. 2–3	Fish Midden Ph. 2–3	North Midden Ph. 2	Room 4 midden Ph. 4	House 5 floors Ph. 2
Seal species	Skull				1		
Cetacean	Sternum		1				
Horse	Incisor		1				
	Tarsal		2				
Pig	Calcaneum		1				
Cattle	Skull		1	1			
	Incisor		1				
	Maxillary molar		1				
	Hyoid	1					
	Metapodial	1					
	Tarsal					1	
	Phalanx 2	3	14				
	Phalanx 3	1	10	1			
	Caudal vertebra		1				
	Phalanx 1	5	18		1		
Caprine	Astragalus		1				
	Mandible	1	4		1		
	Radius		1				
	Tibia		1				
	Phalanx 1						1
Large mammal	Rib		1				
	Pelvis	1					
	Vertebra	1					
Medium mammal 1	Rib	5					
	Cervical vertebra		1				
Unidentifiable mammal	Shaft	2					

cattle bone, yet even accounting for these, few very young deaths occurred. These probably represented natural deaths during the lambing season, or deliberate killing of one lamb in the case of twins, as reported ethnographically (Berry 2000). In either case, lambing may have taken place close to the settlement because the dead stock were incorporated into the midden deposits.

Very little can be concluded about pig age at slaughter at Quoygrew because of small sample sizes. Little change through time or space was observed. Pigs were probably used for meat prior to reaching skeletal maturity, with a few individuals maintained as breeding stock.

8.8. Pathologies

A total of 90 pathological lesions were recorded on mammal bones. Most affected cattle, with the remaining found on other domestic animals, seals, cetaceans and unknown species (Table 8.6). Almost all of the cattle pathologies were found on the bones of adult individuals, and most were joint-based. These were probably age- and stress-related and, as noted above, may be linked to the use of cattle for traction. Several adult

phalanges from Phases 1 and 2 to 3 of the Farm Mound contained depressions of type one, two or three (*sensu* Baker & Brothwell 1980). They are included in the total counts, despite being of questionable aetiology (O'Connor 2000, 100). No dental pathologies were observed for cattle, nor was there evidence of pre-mortem tooth loss. One pathological cattle element from Phases 2 to 3 of the Farm Mound resulted from a healing infection, but otherwise the assemblage is consistent with general good health (accepting that many individuals were slaughtered very young). Caprines were also in good overall health, with one incidence of infection and one of trauma leading to joint disease. There were fewer incidences of arthropathies than in the cattle assemblage. However, pre-mortem tooth loss and dental problems were observed in Phases 2 to 3 of the Farm Mound and Phase 2 of the North Midden. Three incidences of pathology were observed on horse bones, all in Phases 2 to 3 of the Farm Mound, as discussed in Section 8.5 above.

8.9. Biometry

Withers heights could be calculated using three cattle measurements and five caprine (treated as sheep)

measurements (following von den Driesch & Boessneck 1974). Cattle ranged from 99 cm to 111 cm, and caprines ('sheep') from 46 cm to 56 cm. Full metrical data are provided in Appendices 8.5 to 8.7. Because of the small number of adults, few bones were measurable and therefore the potential for analyses of changes through time or across space is limited.

The Quoygrew cattle and caprines are similar in size to those from other sites of broadly comparable date in the Northern Isles, including Pool, Sandwick North, St Boniface, Buckquoy, Saevar Howe, Skaill and Earl's Bu (see Harland 2006 and references therein). Sample sizes are small in all cases, but the withers height estimates for caprines, for example, fall within the ranges observed elsewhere (c. 50–60 cm). They are also similar to modern primitive Sheltands (Davis 1996; 2000).

8.10. Summary and discussion

The mammal bone from Quoygrew was dominated by domestic species, predominantly caprines (mostly sheep) and cattle, as well as some pigs. This is typical of Orcadian farmsteads of this period (Harland 2006). Cattle were slightly more frequent in Phases 2 to 3 than in the preceding Phase 1, when compared with caprines. Pigs remained constant at less than 10% of the assemblage. Horse remains were found in small quantities, with butchery marks indicating that these animals were probably eaten occasionally in addition to being used for transportation. Two red deer specimens, both from the earliest phase of the Farm Mound, corroborate the pattern observed at other sites that red deer were extirpated from the Northern Isles during the Viking Age. Dogs and cats were found, as was evidence of carnivore gnawing. Sea mammal remains were recovered in small numbers. Given that they exhibited higher frequencies of carnivore gnawing than other species, they may have been preferentially used for dog food. Skeletal element and cut-mark patterns for the main domestic species indicate that all parts of animals were used at Quoygrew and butchered on site. Fragmentation patterns indicate that marrow was also routinely extracted by breaking long bones.

The majority of cattle were very young in all phases, with an increase in neonatal deposition found through time. This age profile is probably indicative of a mixed economy with an emphasis on dairying, the excess calves being killed to allow better access to milk for making dairy produce (Bigelow 1992; Bond 1998; 2007b; Craig et al. 2004; Mulville et al. 2005). Dairy products in the form of butter and cheese are easily portable and storable. They are high in calories, and are known to have played an important economic role in medieval Norway and Scandinavian Scotland, including being used to pay rent, tax and tithe (Challinor 2004; Øye 2004, 107; Critch 2011; see Chapter 2). Cattle themselves, the main milk producers, were sometimes also levied as tribute (Barrett 2007, 322). Some deaths of neonatal calves likely resulted from harsh winter conditions and lack of fodder, but ethnographic and biological studies of mortality patterns indicate far fewer new-born animals should be present if the pattern was natural (Mulville et al. 2005). High proportions of neonatal bone represent sustainable dairy herd management practices for the obvious reason that nearly 50% of calves (most of the males) can be culled without reducing production or reproduction. The intensification of dairy production through time has been observed at other sites in the Northern Isles, including Pool (Bond 1998; 2007b), Sandwick South (Bigelow 1992) and Sandwick North (Barrett & Oltmann 2000). Other sites in Caithness and the Northern Isles also contain high proportions of neonatal cattle bone, but lack the temporal resolution and/or stratigraphic superposition necessary to clarify the chronology of intensification through time (see Harland 2006). Butter-making utensils such as churns (typically made of wood) have not survived from medieval Orkney, but are well known from later ethnohistoric evidence (e.g. Fenton 1978, 440–42). At Quoygrew, the evidence for increased production of dairy produce corresponds to an increase in fishing activity (Chapters 5 to 7), making Phases 2 to 3 a period of overall economic intensification. The importance of cattle (and thus dairying?) may have declined again by Phase 4, the late Middle Ages, but as noted above the sample size is very small in this instance.

Most Viking Age and medieval sites in the Northern Isles have this distinctive high proportion of very young cattle remains, but the Birsay area in Orkney has proven an exception. Sites with very little or no neonatal cattle include the Brough of Birsay (Hunter & Morris 1982; Sellar et al. 1986), Saevar Howe (Rowley-Conwy 1983), Buckquoy (Noddle 1976–77) and Beachview Birsay (Rackham 1996). This pattern is not consistently taphonomic nor recovery based, given the variety of preservation conditions and recovery methods relevant to the Birsay sites. The Birsay Bay area was, however, known to be an important political and religious centre from at least the eleventh century (Ritchie 1983; Crawford 2005). Thus it may have received milk products as payment of rent, tax and/or tithe from farms throughout the Northern Isles. The draw of staple goods to 'central places' is paralleled in the zooarchaeological evidence from Earl's Bu, another high-status site in Mainland Orkney (Batey & Morris

1992). There, quantities of preserved cod and haddock were consumed, and these were likely imported from producer sites throughout the Northern Isles (Barrett 1997; Harland 2007; see Chapter 7). These two high-status areas may have functioned in similar ways, each receiving specialized food renders from settlements of more normal status.

Early historic rural Ireland has a wealth of historical data relating to dairying, indicating its importance, yet few neonatal calves have been found there (and certainly nothing comparable with the Northern Isles) (Lucas 1989; McCormick 1992; 1998; McCormick & Murray 2007). This difference may reflect the complex role cattle played in the Irish economy. They embodied wealth and status and were thus less likely to be deliberately killed solely to allow human access to milk.

Unlike the Northern Isles of Scotland, Viking Age and medieval settlements in Norway, Denmark and Sweden were not typically characterized by such high levels of neonatal cattle bones (Barrett *et al.* 2007 and references therein; O'Connor 2010). Nor were other Scandinavian influenced areas of Britain and Ireland (e.g. O'Connor 2004; McCormick & Murray 2007, 51–8; Dobney *et al.* 2007, 140–41). Instead, the culling of young calves may imply a husbandry strategy rooted in pre-Viking Age local practice (cf. C. Smith 1994, 144; Bond 2007b, 218–19). High levels of neonatal calves are also common in bone assemblages from Viking Age and medieval Iceland — where they are similarly interpreted as evidence for intensive dairying (McGovern 2009, 188–95). Thus this tradition ultimately became characteristic of the Scandinavian North Atlantic colonies.

Sheep were likely used for meat and wool, and potentially also for dairy products. *Contra* Noddle's (1976–77) suggestion that wool from Viking Age and early medieval sheep was of little use, parasites from a tenth-century waterlogged pit at Tuquoy in Orkney (Owen 2005) and the ubiquity of spindle whorls in the North Atlantic region (cf. Mainland & Halstead 2005; Chapters 12 and 13) indicate wool production was an important part of the economy. Woollen cloth, *vaðmál* or wadmal, was Iceland's main export and currency until the fourteenth century (Þorláksson 1991), and it is recorded as a Shetlandic product in late medieval and post-medieval sources (Chapter 2). Woollen cloth and cloth impressions have also been identified in the corrosion products of metal jewellery from Viking Age graves in Atlantic Scotland (Gabra-Sanders 1998, 179, 181–3). Ethnographic evidence from the Northern Isles and the Scandinavian North Atlantic region indicates sheep's milk was used until the recent past, albeit not as intensively as cow's milk (Bergsåker 1978; Fenton 1978, 454). Lambs were not seen as competitors to human use of the milk, so were not slaughtered in the same way as calves. Sheep's milk can be turned into cheese or butter, although the latter is generally of poor quality (Challinor 2004). At Quoygrew caprines appear to have been most important in relative terms (*vis-à-vis* cattle, for example) during Phase 1, and then again (based on a small sample size) in Phase 4 after the main period of economic intensification in Phases 2 to 3. Regarding *absolute* abundance, however, it is possible that caprine herds remained stable or even increased during Phases 2 to 3 (see Chapter 11).

Chapter 9

Fowling: the Bird Bone

Jennifer F. Harland, Rebecca A. Bennett, Jamie I. Andrews,
Terry O'Connor and James H. Barrett

9.1. Introduction

Birds were infrequent at Quoygrew, in terms of grams of bone per litre of excavated sediment and in comparison with fish or mammal bone (see Chapter 5). Consequently all bird bone from the site was studied, rather than selected phase and deposit groups as for the other classes of fauna. A total of 2800 bones (weighing 2.15 kg) were examined, of which 857 (1.15 kg) were identified to taxon. Although small, this collection provides a general impression of how birds, domestic and hunted, were used by the settlement's inhabitants. Patterns within the assemblage also reinforce intra-site spatial and temporal differences recognized based on the fish and mammal bone. Egg shell fragments were also found in many sieved samples from Quoygrew (Andrews 2005). Although not identified to taxon this diverse material probably represents a variety of species, implying that collecting and eating eggs from both domestic and wild birds also played a role in life at Quoygrew.

9.2. Recovery and methods

Most of the bird bone was recovered by hand and by sorting all flotation and coarse samples to 4 mm. A few additional specimens derived from the sub-set of flotation samples sorted to 2 mm for recovery of fish bone (see Chapter 5 and 7). Given the predominant use of hand collecting and 4 mm mesh, however, small birds are probably underrepresented in the assemblage. The material was identified by Rebecca Bennett (née Briscoe), Jamie Andrews, Jennifer Harland and Terry O'Connor using the University of York's reference collection. Jennifer Harland and James Barrett wrote the text.

The assemblage was recorded following the conventions of the York System (Harland *et al.* 2003). Taphonomic alterations, immature bones and medullary bone (deposited by laying females) were noted when present. The assemblage has been quantified by number of identified specimens (NISP) (Table 9.1). Appendix 9.1 provides a list of the common and scientific names of the taxa identified.

9.3. Taphonomy

The bird bone from Quoygrew was generally very well preserved. Evidence of burning was found on 2.4% of all identified specimens, distributed throughout most phase and deposit groups. Rodent and carnivore gnawing was likewise observed in most phases, but in total these modifications were found on only 0.6% of the assemblage. A few birds may have been captured by cats, and some of the taxa identified could have arrived on site as scavengers (e.g. rock doves, eagles, ravens and the black-headed gull: see O'Connor 1993; Serjeantson 1998). It is highly probable, however, that most of the bird remains result from intentional use by people. Some butchered specimens were found, including 13 that could be identified to species. These include cut marks (from a variety of phase and deposit groups) on domestic fowl ('chicken'), cormorant, shag, gulls, duck, guillemot and a Manx shearwater. A wide range of elements were found, representing all parts of the body. There is no indication of differential deposition or removal of parts of birds (e.g. wings).

9.4. The taxa

Table 9.1 provides NISP data for the bird bone assemblage, divided by phase and deposit group. Over 50 different taxonomic groups were identified, representing a diverse range of probable habitats, from isolated sea stacks to nearby nesting cliffs, shoreline and moorland. The assemblage is dominated by seabirds, particularly shags, cormorants, gulls, razorbills, guillemots and puffins. These taxa are well represented in most Atlantic Scottish assemblages of Iron Age to medieval date (Serjeantson 1988). The cliff-nesting birds are very abundant today at Noup Head (Fig. 9.1),

Table 9.1. *NISP of bird bones from all deposit and phase groups.*

Taxa	Farm Mound Ph. 1	Farm Mound Ph. 2–3	Fish Midden Ph. 2–3	North Midden Ph. 2	South Midden Ph. 2.2–2.4	Room 4 midden Ph. 4	Room 1&2, floors Ph. 4.1	Other Ph. 2	Other Ph. 2–3	Ph. 3	Ph. 3–4	Other Ph. 4	Ph. 4–5	Ph. 5–6	Ph. 6	Ph. 7	Mixed phases/unphased	Total
Fulmar			1											1				2
Manx shearwater	1	4	1										1		1			8
Gannet	1	15	14				1			2	1		5	4	2	1		46
Cormorant/Shag		4								1	1		15					21
Cormorant	5	18	1	1				3		3	1	2	17	2	1	1		55
Shag	8	46	2					3		8	4	5	34		3	1		114
Swan, goose & duck family										1			2					3
Geese (*Anser*)											1							1
Geese (*Anser/Branta*)	2	3																5
Greylag goose/Bean goose								2										2
Domestic/Wild greylag goose							1			1	1		1					4
Brent goose												1						1
Shelduck								1										1
Ducks	2	4			1					2					1			10
Mallard																1		1
Tufted duck								1										1
Goldeneye													1					1
Red-breasted merganser							1											1
White-tailed eagle/Golden eagle		2																2
Grouse family		1																1
Fowl (domestic)	1	14								12	4	5	4	2	3	2		47
Wader		1	2							1		2						6
Redshank												1						1
Plovers (*Charadrius*)												2						2
Plovers (*Pluvialis*)		16						1		1		4	1					23
Golden plover										1								1
Sandpiper & snipe family																	1	1
Snipes		1	3															4
Skuas																	1	1
Gull family	2	17	1							1	1	1			1			24
Common gull/Kittiwake	1	1																2
Common gull	3	1										3	1					8
Herring/Lesser black-backed gull	3	40	9								1		4		1	1		59
Herring gull	2	2					1											5
Lesser black-backed gull													2	1				3
Great black-backed gull	3	28	3		1			3					2		1	1		42
Black-headed gull	1	2	1							1								5
Kittiwake	2	13								3	1	1	2			3		25
Guillemot/Razorbill	4	38	4							1	1		11	3	3	7	3	75
Guillemot			2	1		4	1			5	1	6	17	3		3		43
Razorbill												2	3			2		7
Little auk			1								2		1	2				6
Puffin	6	27	6								1		4		4	5		53

Table 9.1. *(cont.)*

Taxa	Farm Mound	Fish Midden	North Midden	South Midden	Room 4 midden	Room 1&2, floors	Other areas and phases											Total
	Ph. 1	Ph. 2–3	Ph. 2–3	Ph. 2	Ph. 2.2–2.4	Ph. 4	Ph. 4.1	Other Ph. 2	Other Ph. 2–3	Ph. 3	Ph. 3–4	Other Ph. 4	Ph. 4–5	Ph. 5–6	Ph. 6	Ph. 7	Mixed phases/ unphased	Total
Rock dove								1		1		1	1	1				5
Passerines	9	26	12				1	1	1		13		4		1	4	1	73
Small passerines										1	2						1	4
Blackbird/Thrush						1	4	1		13	1	4		1			1	26
Blackbird		1																1
Redwing												1						1
Starling											4	1						5
Carrion crow												8						8
Raven		7								1								8
Total identified	56	331	64	2	2	1	12	19	1	62	33	53	136	20	21	32	9	854
Unidentified	84	487	163	1	8	26	10	79	6	128	107	121	545	47	36	71	27	1946
Total	140	818	227	3	10	27	22	98	7	190	140	174	681	67	57	103	36	2800

a breeding colony located approximately 5 km from Quoygrew by boat (Booth *et al.* 1984), and (in smaller numbers) along the coast just to the north of the site.

Gannets were also common at Quoygrew. The nearest major breeding ground for this species is presently Sule Stack, *c.* 95 km southwest of Westray, but more local colonies may have existed in the past (Groundwater 1974; Booth *et al.* 1984; Serjeantson 2001). Several pairs began nesting at Noup Head during our years of excavating at Quoygrew. They may also have been captured at sea given their feeding behaviour (see Groundwater 1974, 57), which could account for the higher proportions in the Fish Midden (22%) than in the contemporary phases of the Farm Mound (5%) — and their greater numbers in Phases 2 to 3 than in earlier Phase 1 or later Phases 3 to 6 (Table 9.1). If some or all of the gannets were captured at sea, or at Sule Stack, their abundance in Phases 2 to 3 would underscore the importance of seaborne activity at Quoygrew in the eleventh to thirteenth centuries (cf. Serjeantson 2001; 2007, 284).

Two fulmar elements were recovered. They could be intrusive given that this species was not historically recorded in Orkney until the late nineteenth century (Booth *et al.* 1984, 6–8). It may, however, have been present in the isles prior to that, given secure archaeological identifications from Pool (Serjeantson 2007, 280–81). No great auk remains were identified, but this is unsurprising given the paucity of this species from other contemporary sites in the Northern Isles (Serjeantson 2001). Presumably its abundance had already been impacted by prehistoric hunting pressure.

Domestic fowl (chickens) were found in small numbers from the earliest phases, increasing slightly from Phase 3 onwards. Three domestic fowl tarsometatarsi were recorded from Phases 2 to 3 of the Farm Mound — all from female birds (without spurs). Geese were present in small numbers, but could not be identified to species reliably or, in the case of *Anser anser*, attributed to domestic or wild populations. Moorland and wetland species were also utilized to a minor degree, the latter probably from the shallow and sheltered bays on the eastern side of Westray.

The predators (particularly the eagle) may represent animals killed to protect stock. Rewards were set for eagles in recent centuries (Fenton 1978, 510). As a symbol associated with Odin, the raven (and perhaps related *Corvus* species) has potential ritual importance in the pre-Christian Viking Age (Mitchell 1993, 444; cf. Serjeantson 2007, 283). However, at Quoygrew ravens and crows are absent from Phase 1, when pagan practices would be most expected. They may instead have been killed due to their predatory or scavenging activities (Fenton 1978, 510). The abundance of small bird (e.g. rock dove and starling) bones may seem surprising, but they were traditionally snared in the Northern Isles during recent centuries (Fenton 1978, 522–3)

Figure 9.1. *The cliffs of Noup Head on Westray attract large colonies of seasonally nesting seabirds. (Image: James Barrett.)*

9.5. Seasonality

Many of the species identified are only found in Orkney during the spring and summer breeding season, including the guillemot and razorbill, puffin and Manx shearwater (Buckley & Harvie-Brown 1891; Snow & Perrins 1998a,b; Booth *et al.* 1984). Some species, such as geese and ducks, are more vulnerable in the summer because of moulting (Serjeantson 1998). However, geese and ducks also migrate through Orkney in the autumn, with many overwintering in the islands (Booth *et al.* 1984, 27–63).

A small number of young or juvenile bones were found. Bird bones can appear fully formed in individuals yet to fledge (Serjeantson 1998), which probably indicates that young birds were exploited in greater numbers than is evident from the assemblage. In recent centuries in Atlantic Scotland most seabirds were captured on breeding cliffs in the spring and summer — by hand, club, snares and nets (Fenton 1978, 510–23; Serjeantson 1988, 210). Although caught seasonally, they could be used year round by drying and salting (e.g. Beatty 1992).

In contrast with the seasonal nesting birds, cormorant and shag would have been available throughout the year and were thus known historically as winter foods (Serjeantson 1998). Nevertheless, one juvenile shag specimen and a shag bone with medullary bone both imply that the genus *Phalacrocorax* was also caught during the nesting season. Two other specimens with medullary bone were noted, one unidentified and one of black-backed gull.

9.6. Discussion

Birds were not a numerically important resource at Quoygrew, a pattern typical of most contemporary sites in Atlantic Scotland (Serjeantson 1988; Barrett 1995, 128–30; Serjeantson 2001) and differing from specialized fowling communities on islands such as Foula and St Kilda (Baldwin 1974; Fleming 2005).

Nevertheless, in addition to meat they could have provided feathers and eggs (Fenton 1978, 510). Moreover, it is likely that they would have been seasonally important during the spring — a stress point in premodern European agriculture. The danger of harvesting birds and eggs on vertical cliffs like those at Noup Head — where lives could be lost — underscores the cultural significance of the resource (cf. Baldwin 1974, 63). At other times of the year (in addition to preserved birds) the few domesticates and species such as shags and cormorants would have been available from time to time. The most illuminating intra-site patterning relates to gannets. They were most common in the Fish Midden and in Phases 2 to 3 — reinforcing the interpretation based on other evidence that this deposit and these phases are characterized by an emphasis on maritime activity.

The paucity of domestic fowl and importance of wild birds provides a contrast with contemporary sites in lowland Britain and Ireland (e.g. McCormick & Buckland 1997; Dobney & Jaques 2002; Yalden & Albarella 2008, 101; Hamilton-Dyer 2007, 107) — and even continental Norway (e.g. Hufthammer 2003; Barrett *et al.* 2007). It is, however, consistent with the evidence from other Viking Age and medieval island communities in the North Atlantic (e.g. Enghoff 2003; Church *et al.* 2005; McGovern 2009, 224). It is also a pattern with continuity from the local (pre-Viking) Iron Age — with the caveats that the abundance of great auk had decreased and the importance of gannets increased by the turn of the first and second millennia AD (Serjeantson 2001; 2007). The unimportance of 'chickens' in Viking Age and medieval Orkney may thus imply some continuity of earlier indigenous tradition, but the relevance of environmental determinism cannot be discounted in this particular instance. Seabirds were locally abundant. Moreover, a brief boom in poultry-keeping in Orkney between 1880 and 1960 was ended in part when many of the unfortunate birds were blown away during severe gales in 1952 and 1953 (Thomson 2008a, 427).

Chapter 10

Arable Agriculture and Gathering: the Botanical Evidence

Catrina T. Adams, Sandra L. Poaps and Jacqui P. Huntley

10.1. Introduction

By studying botanical macroremains from middens and other selected contexts at Quoygrew this chapter interprets agricultural practices and land use across time and space — ultimately addressing the organization and transformation of economic activity within the settlement. The plant parts recovered are a selection of those originally available (locally or via exchange) that were: 1) cultivated or gathered in order to be used (as food, fodder, fuel, bedding, medicine, raw materials, etc.) or unintentionally collected with materials intended for these purposes, and which 2) have survived carbonization or mineralization and subsequent dispersal around the site. We begin by introducing the methods used, and by outlining taphonomic processes affecting the plant record at the site. We then discuss the taxa present, their ecological habitats and their potential uses. Economic plants are discussed first, followed by wild and weedy plants. Next we consider the archaeobotanical assemblages from different context types and phases to identify spatial and chronological patterns. Finally, agricultural practices, land use and gathered plant resources (including fuel) are discussed in greater detail and in comparative perspective. The chapter does not include a comprehensive study of wood charcoal — partly because fuel use at Quoygrew clearly involved peat and turf (see below) and partly because most charcoal from coastal sites in the North Atlantic region is likely to represent driftwood (cf. Dickson 1992; Malmros 1994).

Quoygrew is comprised of several buildings (principally Houses 1 and 5 in Area F, but also House 7 in Area G), a yard to the south of House 1 (in Area J2), the large Fish Midden located along the shoreline (sampled in Areas A to E), the Farm Mound midden (in Area G) and areas of enriched anthrosol (investigated in Area G2 and Test Pit 2, for example). The majority of the macrobotanical data result from analysis of material from Phase 1 and Phases 2 to 3

of the Farm Mound midden and Phases 2 to 3 of the Fish Midden. Analysis of remains from three column samples (Areas A, B and C) excavated in the Fish Midden was completed by Sandra Poaps and Jacqui Huntley (Poaps 2000; Poaps & Huntley 2001a). The Farm Mound midden was analysed by Catrina Adams, as were a selection of other contexts (including middens associated with the houses, hearths, pit fills, discrete dumps and house floors) chosen to aid in understanding activity areas and taphonomic processes occurring at Quoygrew (Adams 2003; 2009). All the data are integrated here and form the basis for chronological and spatial analysis of the site.

10.2. Recovery methods

Flotation samples of up to 10 L were taken from most contexts identified during excavation. The number of samples that could be taken from each context, as well as the volume of the samples, depended on the volume of the context (see Chapter 5). Samples for flotation were placed in labelled plastic buckets with lids and taken to a flotation area near the site. Soil weight was then measured using a spring balance, and volume was estimated by using a bucket marked in 1 L increments. The sample was then placed into a Sīrāf-style flotation machine (Williams 1973; Fig. 5.2) while the machine was off and allowed to become wet (to prevent dry sediment from blocking the light fraction collection sieve). The machine was then turned on, and the sample agitated (by a combination of gloved hands and jets of water from the perforated inlet pipes) until no more material was floating to the surface, and the heavy fraction appeared clean.

The light fraction (flot) was collected on a 0.5 mm geological sieve and the heavy fraction was collected in a 1 mm mesh. The two fractions were placed in separate plastic bags and the sieve and screen were cleaned to prevent cross-contamination between samples. The sediment was allowed to collect in the tank between samples until it reached the perforated

tubes. However, the risk of contamination was low because of the distance from the mesh, the fact that water turbulence was above the settled sediment, and because the mesh would restrict any material greater than 1 mm in diameter from entering the sample.

At the end of each day, samples were taken indoors and the contents placed, on their opened bags, onto aluminium trays. These trays were placed on galvanized steel racks, draped in heavy plastic, and dried with a heater at a temperature no greater than 30°C. When the samples were dry, they were re-bagged for storage. Analysis of samples took place at the University of Toronto and the University of Durham (Areas A, B and C) and at the Paleoethnobotany Laboratory at Washington University (all other samples). Samples were shipped in plastic bags inside padded boxes and plastic tubs.

10.3. Laboratory methods

10.3.1. Sub-sampling
Many more samples were available than could be analysed. A summary of the contexts that were analysed for plant remains is given in Table 10.1. Several sub-sampling procedures were employed when deciding which processed flotation samples to analyse (Table 10.2). All samples were analysed from Areas A, B and C (the small, but comprehensively sieved, columns excavated in the Fish Midden). Analysis of the more numerous Farm Mound midden samples was done by randomly selecting a number of samples from each context in proportion to the number of samples available from that context. Thus larger contexts are represented by more than one sample, while smaller contexts are often represented by only one sample. Judgment sampling was used across the remainder of the site to include those contexts where interesting botanical remains were likely to be found, such as pit fills, dumps, hearths and floor layers. A small selection of these contexts was chosen to provide a broader view of plant use and plant-related activity patterns across the site. At present, only the flots of samples have been systematically analysed for macrobotanical remains. Several heavy fractions were scanned in an opportunistic way, but it is not yet possible to say whether dense remains such as nutshell and fruit stones were present at Quoygrew.

10.3.2. Laboratory processing: Fish Midden samples
As noted above, the material from the Fish Midden (Areas A, B and C) was analysed by Sandra Poaps and Jacqui Huntley (Poaps 2000; Poaps & Huntley 2001a). The identification procedures employed are summarized in Table 10.2 and provided in detail in Adams

(2009, 113–15). Carbonized seeds were identified using the reference collection of the University of Durham and seed manuals (Martin & Barkley 1961; Katz *et al.* 1965; Montgomery 1977). For Areas A and B, all seeds and cereal chaff were sorted and identified to at least the 0.5 mm mesh size employed for primary recovery in the field. For Area C, however, the equivalent material was only identified from the >1 mm sieve fraction (to increase the sample size of cereal remains for further study). Thus very small seeds, including heath seeds, some arable weed seeds and some other wild seeds are likely to be under-represented in Fish Midden contexts when the data are lumped. Where relevant, this potential bias will be considered in discussions of the material below. However, it is important to note that the cereal caryopses, most cereal chaff (except oat awns), flax, woad and seaweed are not affected by the differences in sorting procedure, as these plant remains are larger than 1 mm in size and consistently appear in larger-size fractions. Seaweed was sorted and tabulated from the >2 mm fractions of all samples, and from the finer-sieve fractions of at least one sample for each stratigraphic context. Wood charcoal, plant rhizomes and non-plant components of the flots were not studied.

10.3.3. Laboratory processing: all other samples
The laboratory procedures for samples from Areas F, G and J are summarized in Table 10.2 and elaborated in Adams (2009, 115–17). All material was scanned for plant remains — including seeds, carbonized leaves, cereal chaff, wood, rhizomes and seaweed. Wood charcoal was represented primarily by small (<2.0 mm) pieces, which included small twigs and woody stems. It has not been identified as part of this study, but has been archived for future research. Non-plant remains (e.g. vitrified fuel ash) were sorted from the >2 mm size fraction, but are not analysed systematically here. Carbonized plant materials were compared with modern reference material and seed identification manuals (Beijerink 1947; Katz *et al.* 1965; Martin & Barkley 1973; Flood & Gates 1986; Hather 1993; Hillman *et al.* 1996; Stace 1997; Mason & Hather 2000; Jacomet 2006). Specific unidentified seeds were identified with help from Allan Hall (University of York) and Jacqui Huntley (University of Durham). When seeds were too damaged, or the comparative collection too incomplete, to allow species-level identifications the family level was used. Insecure identifications are prefaced by 'cf.' in the tables. These seeds were included in total seed counts of the ecological groups used for analyses, but only securely identified members of the group were counted when discussing the taxa individually, unless otherwise noted.

Table 10.1. *Summary of contexts analysed for botanical remains.*

Phase	Date range	Context type	Area	Location	No. of contexts	List of contexts
4–5	15th–18th century	midden	F	Room 3	1	F675
4	15th–16th century	floor layer	F	Room 2	1	F221
		floor layer	F	Room 1	1	F423
		hearth	F	Room 1	3	F473, F071, F011
		midden	F	Room 4	2	F602, F676
3–4	13th–16th century	midden	J2	yard south of House 1	1	J009
3	13th–14th century	floor layer	F	Room 1	1	F543
		hearth	F	Room 1	3	F840, F518, F462
		dump	F	Room 3	1	F1051
		pit fill	F	Room 1	3	F548, F550, F564
		midden	F	Room 3	1	F671
2–3	11th–13th century	midden	A	Fish Midden	25	A002, A003, A004, A005, A005/6, A006, A007, A008, A009, A010, A011, A012, A013, A013/5, A014, A015, A017, A018, A019, A020, A021, A022, A023, A024, A025
		midden	B	Fish Midden	9	B004, B005, B006, B007, B008, B009, B010, B012, B013
		midden	C	Fish Midden	20	C005, C006, C007, C008, C009, C010, C011, C012, C013, C014, C015, C016, C017, C018, C019, C020, C021, C022, C023, C024
		midden	G1	Farm Mound	12	G058, G056, G055, G054, G020, G052, G015, G013/015, G048, G016, G014/019, G008
		hearth?	G3	House 7	1	G101
2	11th–12th century	floor layer	F	House 5	1	F1129
		dump	F	House 5	1	F1115
		midden	F	North Midden	1	F475
		midden	F	South Midden	3	F685, F1111, F1125
1	10th century	midden	G1	Farm Mound	9	G023, G042, G061, G037, G035, G038, G022, G059, G060

Table 10.2. *Summary of differences in sampling and sorting procedures by area.*

Area	Description	Sampling of flot (light fraction)	On-site recovery	Sorting procedures	References
Area A, Area B	Fish Midden	total	0.5 mm sieve	Seeds and cereal chaff were sorted from >0.5 mm size fractions (and <0.5 mm for Area A). Seaweed was sorted from all >2 mm fractions and the finer fractions of at least one sample per context.	Poaps 2000; Poaps & Huntley 2001a
Area C	Fish Midden	total	0.5 mm sieve	Seeds and cereal chaff were examined from >1 mm size fractions. Seaweed was sorted from all >2 mm fractions and the finer fractions of at least one sample per context.	Poaps & Huntley 2001a
Area G1	Farm Mound	random sample, proportionate to number of samples available by context	0.5 mm sieve	Seeds, cereal chaff, moss stem and leaves were examined from all size fractions. Non-seed botanical material (charcoal, underground plant materials, seaweed) and matrix material (e.g. vitrified fuel ash) were examined from >1 mm size fractions.	Adams 2003; 2009
Area F, Area G3, Area J2	House 1, House 5, House 7, yard south of House 1	judgement sample: contexts likely to contain interesting botanical material	0.5 mm sieve	As above.	Adams 2009

10.3.4. Conventions and terminology

Raw data regarding plant remains identified from each individual sample are available in the site archive. Here samples from contexts, and meaningful groups of contexts, are combined to aid interpretation. In the figures and tables the results are placed in stratigraphic order where relevant, earliest (left or bottom) to latest (right or top). The botanical nomenclature used throughout follows the *New Flora of the British Isles* (Stace 1997). The term 'seed' is used in a loose sense to refer to all plant disseminules, including seeds, fruits and false fruits.

The scientific names, common names, and habitat groups used throughout this chapter can be found in Table 10.3. Taxa were placed into groups based on ecology and habitat preferences (after Stace 1997; Dickson 1998; Hall 2002; Hill *et al.* 2004) to facilitate analyses of crop strategies, land use and fuel use. However, it is important to note that many of the taxa that have been assigned to a particular ecological group can exist and thrive in a variety of habitats. Alternative attributions could have been adopted (van der Veen 1992; Poaps & Huntley 2001a,b), but would not have meaningfully changed the interpretations offered.

10.3.5. Counts and measurements

Cereal caryopses were counted as one if they were complete or represented more than half of a caryopsis. Cereal scutella (specialized structures in grasses representing the embryo and cotyledon) were counted separately when separated from the caryopsis. Scutella were not included in the cereal count, and not identified further. Each individual fragment of chaff was counted as one, as were seaweed fragments. Other seed fragments were counted as one unless there were several fragments that obviously came from one individual, in which case an estimated number of individuals was recorded.

Given the range of sampling strategies used, and because contexts varied widely in size, the total volume of soil analysed for each context varies. As a result, density measures (number of seeds per 10 L of sediment) are used to compare the macroremains. However, it should be noted that density comparisons will be affected by the variable volume of fine sediment, stone, bone, shell and other materials present in each sample.

10.4. Taphonomy

10.4.1. Carbonization

The vast majority of plant macroremains from Quoygrew were preserved through carbonization, with a very small number of seeds mineralized in house-floor

and pit-fill contexts. There is no evidence of catastrophic conflagration at the site. The mechanisms of carbonization therefore represent an important filter between the plant materials used and those represented in the archaeobotanical record.

Carbonization experiments (Renfrew 1973; Boardman & Jones 1990; Viklund 1998) have shown that any carbonization regime will alter the contents and potential for identification of any plant assemblage. In particular, oily seeds, chaff and fragile seeds tend to fare poorly while cereal caryopses, underground plant parts and more robust seeds (e.g. *Galium* spp., *Viola* spp.) tend to be better preserved (Viklund 1998, 102–4).

Experimental studies have shown that the type of fuel burned in a hearth can alter conditions of carbonization by altering the intensity of the heating regime. This can lead to biased preservation of a seed assemblage entering the hearth. Church and Peters (2004) conducted a study of the magnetic enhancement of soils, which showed that ash from hearths was a common inclusion in many contexts from sites in Lewis, Scotland. They also determined that peat was the most likely source of fuel at these sites. Archaeobotanical analysis showed that the ash spreads and midden contexts from the Lewis sites contained few plant remains, which were poorly preserved. Peat fuels burn hot and tend to reduce most plant remains to ash, leaving even heartier remains such as cereal caryopses in poor condition.

Turf fuels (those flayed from the land surface), on the other hand, are more likely to provide a carbonization environment conducive to preservation of fragile remains (Hall 2002, 26). The condition of the seeds at Quoygrew varied by context, but in many cases fragile remains, such as *Plantago maritima* seed capsules, small fragile seeds (e.g. *Erica* spp., *Papaver* spp.), buds, flowers, small oil seeds, such as *Capsella bursa-pastoris* and moss stems were preserved and could be identified. Many of these materials are easily consumed by flames when exposed to direct heat, and thus their presence may indicate indirect heating, such as would occur when seeds were enclosed within sediment. This suggests that many contexts at Quoygrew included input from turf fuels (see Section 10.7.7 below) — an interpretation corroborated by soil micromorphology (Simpson *et al.* 2005).

10.4.2. Mineralization

Several of the pit-fill contexts, and the Phase 2 context from the floor of House 5, included seeds and other remains preserved through phosphatization (McCobb *et al.* 2003). Remains preserved by this route include Caryophyllaceae, Centrospermae, *Stellaria*

media, Atriplex spp., an unidentified seed type, and moulds of root structures. Mineralization of seeds in archaeological deposits is rare, but occurs when abundant decaying matter creates an environment that is slightly acidic and anoxic.

10.4.3. Condition of cereal grains

Many of the cereal caryopses from the site are distorted, either shrunken or exuding a carbonized tarry material from the distal ends of the caryopses. In some cases several grains were fused together. These changes indicate that the cereals may have been charred while wet, or may represent grains that were charred while in the milk- or dough-ripe stage, which can indicate early harvesting (Hubbard & al Azm 1990).

Some seeds, of both cereals and weeds, also showed evidence of early stages of germination. However, no context showed the consistent germination of cereal indicative of malting barley for ale or beer production (see Section 10.7.1). A more likely explanation is that cereals were not dried completely for storage. An alternate explanation, for the germinating weed seeds, is that they were contained within turf burned as fuel.

10.4.4. Taphonomic pathways

We assume that most of the carbonized plants from Quoygrew derived from small-scale controlled burning events in and around the settlement. These might include indoor hearth fires and indoor or outdoor fires for processing fish livers for oil, producing charred seaweed (see below), drying grain for storage, metalworking, etc. However, it is possible that some of the carbonized heathland seed remains are the result of natural heathland or grassland burning episodes, or fire-related land-management practices. If areas of previously burned ground were gathered as turf for building materials, it is possible that carbonized seeds would be present in the seed bank of these turf blocks (Dickson 1998; Hall 2002). Still, it is likely that the majority of the seed remains from Quoygrew became carbonized in hearths or in other small controlled fires at the site. Given this mechanism, it is necessary to consider which plant seeds are likely to have been exposed to fires and why.

Unfortunately, taphonomic pathways are likely to be complicated (cf. Viklund 1998; Church & Peters 2004). Firstly, the lack of wood in Orkney means that peat, turf and dung were often the most prevalent sources of fuel (Fenton 1978, 210–13; 1985, 96–111). These fuels contain their own seed and plant-part assemblages. This is a particularly troublesome complication for determining patterns in field use,

since crop weed assemblages and turf and dung fuel assemblages can have significant overlap in terms of taxa represented. Secondly, the ash produced from fires was likely used for many things around the site, from soaking up fluids in the byre to fertilizing fields (Fenton 1978, 195–6, 281). It is therefore difficult to reconstruct what sequence of events led from hearth to midden.

Even relatively pure hearth contexts can contain plant remains from a range of sources (Minnis 1981), including waste from household activities and fuel, as well as incidental seed inputs from the environment surrounding the fire. According to ethnohistoric accounts, in an Orcadian context household activities resulting in the carbonization of plant remains might include cooking, crop processing, fibre production or textile working, woodworking, basketry, line baiting, etc. Fuel sources could include any or all of the following: turf, peat, driftwood, heather twigs, straw, dung or seaweed. Seeds could also be introduced from house building, roofing, bedding and flooring materials — and from animal fodder, bedding or waste (see Fenton 1978).

Although they may contain material from diverse sources, hearth contexts are nevertheless more likely to provide a snapshot in time — perhaps representing only a few days of activity. Pit-fill and discrete dump contexts are likely to be more variable in origin, but may similarly represent short-lived or even single depositional episodes. Conversely, house floors accumulate over time. They are likely to contain mostly ash inputs from hearths, but have the potential to also incorporate a range of other materials. Midden samples are likely to be the most mixed of all context types, and represent many depositional episodes. Midden samples are perhaps most likely to contain carbonized botanical remains from multiple hearth and other controlled fires — conflating, but also usefully averaging, the events in particular areas of the site.

10.5. Results

Botanical remains from a total of 1422 litres of soil from 100 contexts were analysed. Eighty-four of these contexts (1299 L) are from middens, and sixteen (123 L) represent non-midden contexts. A total of 14,727 plant specimens/fragments were identified, including chaff and ericaceous leaves but excluding other vegetative remains such as seaweed, wood and underground plant parts. Tables 10.4 and 10.5 summarize the data presented in the following sections, providing a total count and density (seeds/10 L) of seeds identified for each taxon by context type, area and phase.

10.5.1. Cereals and chaff

Barley (*Hordeum* spp.), oats (*Avena* spp.) and wheat (*Triticum* spp.) are the three cultivated grains identified at Quoygrew. Oats were found in samples from every area and time period of the site, while barley was identified in all but Phase 3 hearth contexts and the single yard context studied from Phases 3 to 4. Wheat was very rare at the site, found only in Phases 2 to 3 of the Fish Midden.

Barley includes the hulled six-row *bere* type (*Hordeum vulgare* ssp. *vulgare*), which is identifiable because of both its shape, and because in many cases, where preservation is good, caryopses retain fragments of the hull. Both straight and asymmetrical barley caryopses were identified, further supporting that the six-row type was present. Rachis internodes of six-rowed barley (Fig. 10.1a) are present in many areas of the site.

A few oat floret bases are well enough preserved to allow identification to species. Some have a wide articulation point, suggesting cultivated *Avena sativa*, common oat (Fig. 10.1b). Others are small and have a narrow articulation point (Fig. 10.1c). These may represent either the second floret of *A. sativa* or the first floret of *A. strigosa*, bristle or black oat. Several oat awns from the Phase 2 dump in House 5 (context F1115) are well enough preserved to show a 90 degree bend at the base (Fig. 10.1d–1e) characteristic of the geniculate awns of bristle oat *A. strigosa* and/or wild oat *A. fatua* (Dickson & Dickson 1984). It is likely that both common oat (*A. sativa*) and bristle oat (*A. strigosa*) were cultivated at Quoygrew.

One wheat (*Triticum* sp.) caryopsis and one wheat rachis internode were identified from Phases 2 to 3 of Quoygrew's Fish Midden. Although wheat is an uncommon find for this period in Orkney, it is not unprecedented, as small amounts of wheat have been identified at other sites in the region (Huntley 1994, 540; Huntley & Turner 1995; Huntley 2000; Poaps & Huntley 2001b). It is highly unlikely that wheat would typically ripen in the Orkney climate (see Barrett *et al.* 2000a, 19–22; Poaps 2000 and references therein). Environmental constraints aside, given the few finds it is unlikely that wheat was a major crop at Quoygrew. More likely the wheat was a weed in the barley fields, or was imported (after imperfect winnowing, given the chaff) rather than grown as a local crop.

The presence and wide distribution of chaff at Quoygrew indicates local cereal agriculture. It is difficult, however, to draw much information about crop processing or the amount of cereal cultivation taking place at Quoygrew from the quantitative analysis of this material for several reasons. First, the preservation of chaff has been shown to be highly dependent upon the conditions of carbonization, including the tempera-

ture and exposure to direct flame (Boardman & Jones 1990). With the variation in fuel use likely at Quoygrew, carbonization regimes were probably inconsistent, which would have the most effect on the preservation of fragile remains such as chaff. Secondly, straw was used for many purposes in Orkney, such as for thatch, baskets, mats, as tinder, and as animal bedding and fodder, and could be traded between areas (Fenton 1978, 186–90, 260–69, 337). Thus it cannot be assumed that chaff would necessarily have been treated as a crop-processing waste, and may have had other factors affecting its presence in the carbonized plant record.

10.5.2. Other economic taxa

In addition to the cereal remains found, two other species represent cultivated plants: flax (*Linum usitatissimum*) and woad (*Isatis tinctoria*). Flax is by far the more abundant of these two species, and is present in low amounts in most areas of the site — in midden, hearth, and pit-fill/dump contexts. Woad is much rarer.

Flax (Fig. 10.1f) is useful both for the plant's fibre production and for its oil seed. Flax seeds are common in the contexts at Quoygrew. Although they are never present in large amounts, most contexts contain at least a few seeds. A total of 461 flax seeds were identified, with a density of 3.24 seeds/10 L of soil. No capsule fragments or other production waste was found, so it is difficult to say for sure whether the flax was produced at the site or imported. However, the presence of gold-of-pleasure (*Camelina sativa*) (Fig. 10.1g), a common weed of flax crops, suggests local production — as does flax capsule at the nearby site of Cleat (Poaps & Huntley 2001b). Flax was likely an important crop for Quoygrew. Retting the stems (to release their fibres) is unlikely to have been done on-site as there is no source of fresh water. However, it may once have been possible in the now sand-filled wetland between Quoygrew and Biggings (see Chapter 3). Biggings was the location of the nearest well even into the twentieth century (Chapter 4).

Woad (Figs. 10.1h, 10.1i & 10.1j) is a perennial plant with a deep (*c.* 30–45 cm) taproot and yellow flowers which grows to a height of *c.* 60–120 cm. It is a member of the Brassicaceae family and is a major source of the blue pigment indigotin (Edmonds 1998). Two carbonized woad seeds were found in Phase 1 Farm Mound midden contexts, and one seed found in a Phase 3 pit-fill context from House 1. This plant and its distribution are considered further in Section 10.7.4 below.

10.5.3. Arable weeds

Arable weed taxa identified in the midden include: *Aphanes arvensis*, *Camelina sativa*, *Capsella bursa-pastoris*,

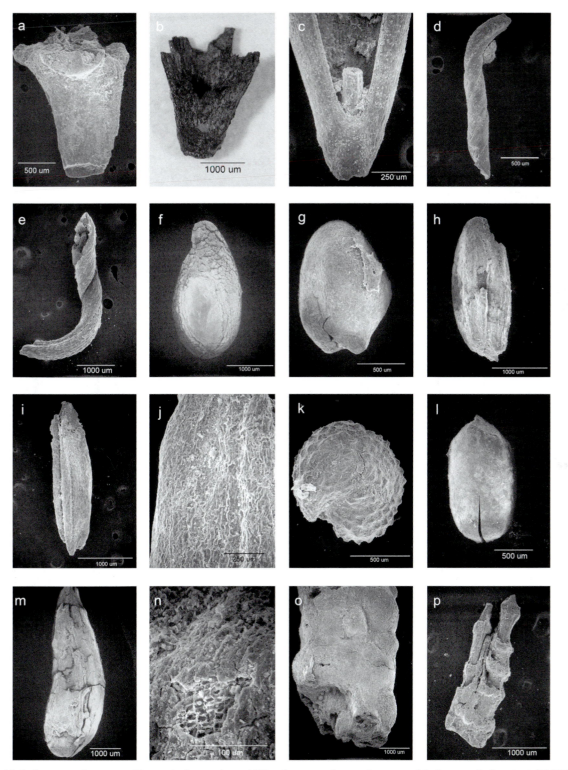

Figure 10.1. *Images of recovered botanical remains: a)* Hordeum vulgare *6-row rachis internode (context F1051, sample 60654); b)* Avena sativa *floret base (G022, 7497); c)* A. sativa/strigosa *floret base (F1051, 60625); d) geniculate* Avena sp. *awn (F1115, 60707); e) geniculate* Avena sp. *awn (F1115, 60707); f)* Linum usitatissimum *(G020, 7156); g)* Camelina sativa *(G022, 7252); h)* Isatis tinctoria *(G059,7451); i)* Isatis tinctoria *(F1051, 60625); j)* Isatis tinctoria *(F1051, 60625); k)* Stellaria media *(F1051,60654); l) unknown seed (G013/015, 7119); m)* Ranunculus ficaria *tuber (G056, 7388); n)* Ranunculus ficaria *tuber (G056, 7388); o) fucoid seaweed (G101, 7529); p) underground plant part (F671, 60208).*

167

Chenopodium album, *Chrysanthemum* spp., *Euphorbia helioscopia*, *Fallopia convolvulus*, *Papaver* spp., *Papaver rhoeas*, *Polygonum aviculare*, *Persicaria maculosa* (formerly *Polygonum persicaria*), *Polygonum* spp., Polygonaceae, *Spergula arvensis* and *Stellaria media*. The most abundant arable weed species at the site was chickweed, *Stellaria media* (*n* = 1252) (Fig. 10.1k). This species prefers areas with soil disturbance and nitrogen enrichment. These include fertilized fields, as well as shingle banks where seaweed provides nitrogen enrichment, and cliffs and coastal banks with colonies of sea birds. *Stellaria media* can also grow in areas where cattle have been enclosed. This species is a powerful competitor of barley, and grows well in wet but not waterlogged conditions (Sobey 1981). Both the leaves and seeds of this plant are edible and it is recorded as a famine food (Defelice 2004).

Corn spurrey, *Spergula arvensis* (*n* = 130), was also common, especially in the midden contexts. This species is most competitive on acidic coarse-grained soils and peat (Stace 1997; Viklund 1998). It is edible, having been used as a famine food in the Northern Isles (Darwin 1996; Donaldson & Nye 1989), and as an ingredient in a traditional *klino* bread made in Orkney (Fenton 1978, 438).

An interesting species found only in the Farm Mound midden is *Camelina sativa*, gold-of-pleasure. It is not a common find in the British Isles, as it, like woad, was originally native to southern Europe. It was grown in the medieval period as an oil-seed crop, but it is likely, given the small number of seeds on the site, that it occurred as a weed of flax. Hall and Kenward (2003) note that *C. sativa* is often found in association with flax, and was found in flax-rich samples from medieval contexts at Layerthorpe Bridge, York.

10.5.4. Grassland taxa

Grassland taxa identified include: *Danthonia decumbens*, *Danthonia* spp., *Poa annua*, large, medium and small-seeded grasses (Poaceae) and their scutellae, *Leontodon* spp., *Linum catharticum*, *Plantago lanceolata*, *Plantago maritima*, *Potentilla erecta*, *Ranunculus acris* type, cf. *Rhinanthus minor* and *Rumex acetosa*. Grassland taxa are present in every area and phase of the site. Grassland plants are often present within an assemblage of plant and matrix components that are indicative of turf, which may be composed in part or in whole of remains of turf burned as a fuel source. Grassland seeds can also be associated with crops or with animal fodder, bedding or dung, and may alternatively have come to the site by these means. Many of these taxa are also present in machair environments.

A single *Ranunculus ficaria* tuber (Figs. 10.1m & 10.1n) was found in Phases 2 to 3 of the Farm Mound. It was identified based on pictures from Hather (1993), and Mason and Hather (2000). These tubers are edible and have some medicinal properties (Darwin 1996; Dickson & Dickson 2000). However, it is most likely that the tuber arrived in the sample via the use of grassland turves as fuel (Hall 2002). Heath grasses (*Danthonia* spp., *Danthonia decumbens*) are usually considered another indicator of turf as these species are common in acidic grasslands and at the edges of heath.

10.5.5. Heathland taxa

Heathland taxa identified include: *Calluna vulgaris*, *Empetrum nigrum*, *Erica cinerea*, *Erica* spp., undifferentiated Ericaceae, *Juncus squarrosus* and cf. *Luzula* spp.

Heathland seeds were rare, and most of the seeds representing this environmental group are those of the relatively large and robust *Empetrum nigrum*. Seeds of heather species and the rushes are very small and fragile. Most were recovered from the <0.5 mm component of samples where this size fraction, smaller than the nominal field recovery, was scanned (Areas A, F, G and J). Heathland taxa were well represented by leaves and flowers, however, and it is likely that much of the 'wood and stem' category represents heather twigs.

Heather was a plant with several uses. It was gathered as floor covering, bedding, thatching, and used for making rope and baskets. Crowberry (*Empetrum nigrum*) was also used for making rope, and has an edible berry that could have been gathered for food. Both heather and crowberry plants produce a good yellow dye (Fenton 1978, 459; Dickson & Dickson 2000, 261). Heathland plants could also have been brought to the site as a component of turf fuels (Hall 2002).

10.5.6. Ruderal taxa

Ruderal taxa identified include: *Atriplex* spp., *Brassica* spp., *Euphorbia peplus*, *Fumaria* spp., *Galium aparine*, *Hypericum* spp., *Lapsana communis*, *Myosotis* spp., *Odontites* spp./*Euphrasia* spp., *Plantago major*, *Plantago media*, *Potentilla anserina*, *Raphanus raphanistrum*, *Rumex acetosella*, *Rumex obtusifolius* type, *Tripleurospermum* spp., *Tripleurospermum inodorum*, *Tripleurospermum maritimum*, *Urtica dioica* and *Viola* subgenus *Melanium*. Seeds assigned to these taxa prefer disturbed habitats, and are likely to have grown around the settlement. *Tripleurospermum maritimum* grows in sandy shore areas, and may have been present on the seaweed-rich strand lines near the site (Stace 1997). *Galium aparine* prefers nutrient-rich soils. Many of these taxa are sometimes included as arable weeds,

and indeed it is possible that these seeds came to the site along with crops (van der Veen 1992; Poaps & Huntley 2001a).

10.5.7. Wet-ground taxa

Wet-ground taxa identified include: *Ajuga* spp., *Carex hostiana*, *Carex* spp., Cyperaceae, *Eleocharis palustris*, *Eriophorum angustifolium*, *Eriophorum latifolium/vaginatum*, *Eriophorum* spp., *Littorella uniflora*, *Lychnis flos-cuculi*, *Potamogeton* spp., *Montia fontana*, *Potentilla palustris*, *Ranunculus flammula* and *Schoenoplectus lacustris*.

Many of these seeds, especially those from sedges, can occur in poorly draining crop fields and may have been discarded as a component of crop waste (van der Veen 1992; Poaps 2000; Poaps & Huntley 2001a). *Montia fontana* is a particularly quick colonizer of muddy areas exposed when water levels drop, and may have been present around water edges, especially those in pasture areas where vegetation was trampled (Geraghty 1996). Pondweed (*Potamogeton* spp.) is an aquatic genus. Some species are common in slow-running streams, others in standing pools, and so on. Lesser spearwort (*R. flammula*) commonly occurs on wet mineral soils (fen/marsh/swamp), and is another likely candidate for appearing at the wet, muddy edges of pasture near drinking areas (Stace 1997; Hill *et al.* 2004).

10.5.8. Unclassified taxa

Unclassified taxa are those that did not fit within one of the aforementioned groups. Often these taxa have broad tolerances for a variety of environments and/or were not identified to a sufficiently precise taxonomic category to make inferences about habitat preference. Unclassified taxa include: cf. *Anthemis cotula*, *Arenaria* spp., Asteraceae, Apiaceae, *Brassica oleracea*, *Brassica* spp./*Sinapis* spp., *Brassica* spp./*Cannabis* spp., *Carex* spp./*Rumex* spp., Caryophyllaceae, Centrospermae, *Cerastium* spp., *Cerastium* spp./*Stellaria* spp., Chenopodiaceae, *Chenopodium* spp., Clusiaceae, cf. *Descurainia* spp., *Euphorbia* spp., Fabaceae, *Galium* spp., Lamiaceae, *Potentilla* spp., *Ranunculus* spp., *Ranunculus repens/acris/bulbosus*, *Rumex* spp., cf. *Salvia* spp., *Scleranthus annuus*, *Silene dioica*, *Stellaria* spp., *Stellaria nemorum*, *Trifolium* spp., *Veronica* spp., unidentifiable seed fragments and unknown seeds.

The group 'Centrospermae' refers to seeds with a free-central or basal placentation, and corresponds with the order Caryophyllales (Bhattacharyya & Johri 1998). This is a group in which all of the damaged seeds that have lost seed coats but obviously had circular embryos have been placed. These may include seeds from the families Portulacaceae, Caryophyllaceae, Amaranthaceae, Chenopodiaceae and Phytolacaceae.

Unknown seeds are well-preserved, but lack matches among the comparative collections and seed manuals consulted. The most abundant of these unknown seeds, present in numerous contexts, is pictured in Figure 10.1l. In addition to these unknown seeds, many fragments of seeds were found that were too damaged, distorted or fragmented to be identified. These were labelled 'unidentifiable seed fragment'. Counts of these fragments are recorded in the tables, but not included in the total seed count.

10.5.9. Machair taxa

Machair is a special grassland ecosystem that includes the strandline, dune beaches, the machair plain (a sandy grassland with high pH) and, on the landward side, sometimes a marshy area, coastal loch or fen (Owen *et al.* 1996). Machair is an ecosystem unique to Scotland and Ireland, and is uniquely fertile because of its lime-rich sands (Gaynor 2006). Modern machair vegetation has been described by several authors (Kent *et al.* 1996; Gaynor 2006) and typically includes plants we have here classified within the grassland, wetland and unclassified categories. Grassland taxa found at Quoygrew associated with machair include: *Danthonia decumbens*, *Linum catharticum*, *Plantago lanceolata*, *Plantago maritima*, *Potentilla erecta*, *Ranunculus acris* type, *Ranunculus ficaria*, cf. *Rhinanthus minor* and *Rumex acetosa*. Wetland taxa associated with machair include: *Eleocharis palustris*, cf. *Eleocharis palustris*, *Potentilla palustris*, *Potentilla* cf. *palustris*, *Ranunculus flammula* and *Ranunculus* cf. *flammula*. Unclassified taxa include *Ranunculus repens* and *Ranunculus repens* type. These taxa are starred on the list of taxa provided in Table 10.3. Machair taxa are found in many areas of the site, but are particularly abundant in the pit-fill and dump contexts from both Phases 2 and 3.

10.5.10. Non-seed remains

Seaweed (a brown fucoid type, perhaps a bladderwrack, *Fucus vesiculosus*) is common across the site (Fig. 10.1o). Other non-seed plant remains were identified from many areas of the site (excluding the Fish Midden, where they were not recorded systematically). They include: underground plant parts (e.g. rhizomes, grass culm bases and tubers, see Fig. 10.1p), wood and stem (e.g. heather twigs, buds, prickles, undifferentiated fruits, usually with a fleshy fruit wrinkled and dried to the seed), moss stem, fungus, and heathland leaves and flowers (including *Calluna vulgaris* leaves and flowers, *Empetrum nigrum* leaves and Ericaceae leaves). Vitrified fuel ash (vitrified silica nodules of plant origin) is also prevalent, and carbonized insect remains were present in some of the pit-fill and dump contexts (see below).

Table 10.3. *Seed remains found at Quoygrew (* = species associated with machair).*

Group	Family	Scientific name	Common name	Group	Family	Scientific name	Common name
Cereals	Poaceae	*Avena* spp.	Oat	Grassland	Poaceae	*Danthonia decumbens**	Heath grass
	Poaceae	Cerealia	Cereals		Poaceae	*Danthonia* spp.*	Heath grasses
	Poaceae	*Hordeum* spp.	Barley		Poaceae	*Poa annua*	Annual meadow-grass
	Poaceae	cf. *Triticum* spp.	Wheat				
	Poaceae	*Avena* spp. awn	Oat		Poaceae	Poaceae <1 mm	Small grass
Cereal chaff and straw	Poaceae	*Avena* spp. floret base	Oat		Poaceae	Poaceae 1–2 mm	Medium grass
	Poaceae	*Avena sativa/ A. strigosa* floret base	Oat/Bristle oat		Poaceae	Poaceae 2–4 mm	Large grass
					Poaceae	Poaceae scutella	
	Poaceae	*Avena sativa* floret base	Oat		Asteraceae	*Leontodon* spp.	Hawkbits
	Poaceae	*Hordeum* spp. rachis internode	Barley		Linaceae	*Linum catharticum**	Fairy flax
					Plantaginaceae	*Plantago lanceolata**	Ribwort plantain
	Poaceae	*Hordeum* cf. *distichon* 2-row rachis internode	2-rowed barley		Plantaginaceae	cf. *Plantago lanceolata**	Ribwort plantain
	Poaceae	*Hordeum* cf. *vulgare* 6-row rachis internode	6-rowed barley		Plantaginaceae	*Plantago maritima* (capsule)*	Sea plantain
					Rosaceae	*Potentilla erecta**	Tormentil
	Poaceae	*Hordeum* spp. awn	Barley		Rosaceae	*Potentilla* cf. *erecta**	Tormentil
	Poaceae	*Triticum* spp. rachis internode	Wheat		Ranunculaceae	*Ranunculus acris* type*	Meadow buttercup
	Poaceae	Indeterminate rachis internode			Ranunculaceae	*Ranunculus ficaria* tuber*	
	Poaceae	Culm nodes			Scrophulariaceae	cf. *Rhinanthus minor**	Yellow-rattles
	Poaceae	Lemma			Polygonaceae	*Rumex acetosa**	Common sorrel
	Poaceae	Embryo/scutella		Heathland	Ericaceae	*Calluna vulgaris* leaves	Heather
	Poaceae	Chaff indeterminate			Ericaceae	*Calluna vulgaris* flowers/buds	Heather
Economic	Linaceae	*Linum usitatissimum*	Flax		Empetraceae	*Empetrum nigrum*	Crowberry
	Linaceae	cf. *Linum usitatissimum*	Flax		Empetraceae	*Empetrum nigrum* leaves	Crowberry
	Brassicaceae	*Isatis tinctoria*	Woad		Ericaceae	Ericaceae leaves	
	Brassicaceae	cf. *Isatis tinctoria*	Woad		Ericaceae	Ericaceae seed	
Arable	Rosaceae	*Aphanes arvensis*	Parsley-piert		Ericaceae	*Erica* spp.	Heaths
	Brassicaceae	*Camelina sativa*	Gold-of-pleasure		Ericaceae	*Erica cinerea*	Bell heather
	Brassicaceae	cf. *Camelina sativa*	Gold-of-pleasure		Ericaceae	*Erica* cf. *cinerea*	Bell heather
	Brassicaceae	*Capsella bursa-pastoris*	Shepherd's-purse		Juncaceae	*Juncus squarrosus*	Heath rush
	Chenopodiaceae	*Chenopodium album*	Fat-hen		Juncaceae	*Juncus* spp.	Rushes
	Asteraceae	*Chrysanthemum* spp.	Crown daisies		Juncaceae	*Juncus* spp. capsule	Rushes
	Euphorbiaceae	*Euphorbia helioscopia*	Sun spurge		Juncaceae	*Luzula* spp.	Wood rushes
	Papaveraceae	*Papaver* spp.	Poppies		Juncaceae	cf. *Luzula* spp.	Wood rushes
	Papaveraceae	*Papaver rhoeas*	Common poppy		Ericaceae	*Vaccinium myrtillus*	Bilberry
	Polygonaceae	*Polygonum aviculare*	Knotgrass	Ruderal	Chenopodiaceae	*Atriplex* spp.	Oraches
	Polygonaceae	*Fallopia convolvulus*	Black bindweed		Chenopodiaceae	cf. *Atriplex* spp.	Oraches
	Polygonaceae	cf. *Fallopia convolvulus*	Black bindweed		Brassicaceae	*Brassica* spp.	Cabbages
					Euphorbiaceae	*Euphorbia peplus*	Petty spurge
	Polygonaceae	*Polygonum maculosa* (*Polygonum*)	Redshank		Fumariaceae	*Fumaria* spp.	Fumitories
	Polygonaceae	*Polygonum* spp.	Knotgrasses		Rubiaceae	*Galium aparine*	Cleavers
	Polygonaceae	Polygonaceae			Clusiaceae	*Hypericum* spp.	St John's-worts
	Caryophyllaceae	*Spergula arvensis*	Corn spurrey		Clusiaceae	cf. *Hypericum* spp.	St John's-worts
	Caryophyllaceae	*Stellaria media*	Common chickweed		Asteraceae	*Lapsana communis*	Nipplewort
					Asteraceae	cf. *Lapsana communis*	Nipplewort
	Caryophyllaceae	cf. *Stellaria media*	Common chickweed		Boraginaceae	*Myosotis* spp.	Forget-me-nots
					Scrophulariaceae	*Odontites* spp./*Euphrasia* spp.	Bartsias/Eyebrights

Table 10.3. (*cont.*)

Group	Family	Scientific name	Common name
Ruderal (*cont.*)	Plantaginaceae	*Plantago major*	Greater plantain
	Plantaginaceae	*Plantago media*	Hoary plantain
	Rosaceae	*Potentilla anserina*	Silverweed
	Brassicaceae	*Raphanus raphanistrum*	Wild radish
	Brassicaceae	*Raphanus raphanistrum* pod	Wild radish
	Polygonaceae	*Rumex acetosella*	Sheep's sorrel
	Polygonaceae	*Rumex obtusifolius* type	Broad-leaved dock
	Asteraceae	*Tripleurospermum inodorum*	Scentless mayweed
	Asteraceae	*Tripleurospermum maritimum*	Sea mayweed
	Asteraceae	cf. *Tripleurospermum maritimum*	Sea mayweed
	Asteraceae	*Tripleurospermum* spp.	Mayweeds
	Urticaceae	*Urtica dioica*	Common nettle
	Violaceae	*Viola* subgenus Melanium	Pansies
Wetland	Lamiaceae	*Ajuga* spp.	Bugles
	Cyperaceae	*Carex hostiana*	Tawny sedge
	Cyperaceae	*Carex hostiana* type	Tawny sedge type
	Cyperaceae	*Carex* spp.	Sedges
	Cyperaceae	*Carex* spp. lenticular type	Sedges
	Cyperaceae	*Carex* spp. trigonous type	Sedges
	Cyperaceae	*Carex* spp. utricle	Sedges
	Cyperaceae	Cyperaceae	
	Cyperaceae	*Eleocharis palustris**	Common spike-rush
	Cyperaceae	cf. *Eleocharis palustris**	Common spike-rush
	Cyperaceae	*Eriophorum angustifolium*	Common cottongrass
	Cyperaceae	cf. *Eriophorum angustifolium*	Common cottongrass
	Cyperaceae	*Eriophorum latifolium/ vaginatum*	Broad-leaved/ Hare's-tail cottongrass
	Cyperaceae	cf. *Eriophorum* spp.	Cottongrasses
	Plantaginaceae	*Littorella uniflora*	Shoreweed
	Plantaginaceae	cf. *Littorella uniflora*	Shoreweed
	Caryophyllaceae	*Lychnis flos-cuculi*	Ragged-robin
	Portulacaceae	*Montia fontana*	Blinks
	Portulacaceae	cf. *Montia fontana*	Blinks
	Potamogetonaceae	*Potamogeton* spp.	Pondweeds
	Rosaceae	*Potentilla palustris**	Marsh cinquefoil
	Rosaceae	*Potentilla* cf. *palustris**	Marsh cinquefoil
	Ranunculaceae	*Ranunculus flammula**	Lesser spearwort
	Ranunculaceae	*Ranunculus* cf. *flammula**	Lesser spearwort
	Cyperaceae	*Schoenoplectus lacustris*	Common club-rush

Group	Family	Scientific name	Common name
Unclassified	Asteraceae	cf. *Anthemis cotula*	Stinking chamomile
	Caryophyllaceae	*Arenaria* spp.	Sandworts
	Caryophyllaceae	*Arenaria* spp./*Stellaria* spp.	Sandworts/ Stitchworts
	Asteraceae	Asteraceae	
	Asteraceae	cf. Asteraceae	
	Asteraceae/ Apiaceae	Asteraceae/Apiaceae	
	Brassicaceae	Brassicaceae	
	Brassicaceae	*Brassica oleracea*	Cabbage
	Brassicaceae	*Brassica* spp./ *Sinapis* spp.	Cabbages/ Mustards
	Brassicaceae	*Brassica* spp./ *Cannabis* spp.	Cabbages/Hemp
	Cyperaceae/ Polygonaceae	*Carex* spp./ *Rumex* spp.	Sedges/Docks
	Caryophyllaceae	Caryophyllaceae	
		Centrospermae	
	Caryophyllaceae	*Cerastium* spp.	Mouse-ears
	Caryophyllaceae	*Cerastium* spp./ *Stellaria* spp.	Mouse-ears/ Stitchworts
	Chenopodiaceae	Chenopodiaceae	
	Chenopodiaceae	cf. Chenopodiaceae	
	Chenopodiaceae	*Chenopodium* spp.	Goosefoots
	Clusiaceae	Clusiaceae (was Hypericaceae)	
	Brassicaceae	cf. *Descurainia* spp.	Flixweed
	Euphorbiaceae	*Euphorbia* spp.	Spurges
	Fabaceae	Fabaceae	
	Fabaceae	cf. Fabaceae	
	Fabaceae	Fabaceae pod	
	Rubiaceae	*Galium* spp.	Bedstraws
	Lamiaceae	Lamiaceae	
	Rosaceae	*Potentilla* spp.	Cinquefoils
	Ranunculaceae	*Ranunculus* spp.	Buttercups
	Ranunculaceae	cf. *Ranunculus* spp.	Buttercups
	Ranunculaceae	*Ranunculus repens**	Creeping buttercup
	Ranunculaceae	*Ranunculus repens* type*	Creeping buttercup type
	Polygonaceae	*Rumex* spp.	Docks
	Polygonaceae	*Rumex* spp. fruit (w/perianth)	Docks
	Lamiaceae	cf. *Salvia* spp.	Claries
	Caryophyllaceae	*Scleranthus annuus*	Annual knawel
	Caryophyllaceae	*Silene dioica*	Red campion
	Caryophyllaceae	*Stellaria* spp.	Stitchworts
	Caryophyllaceae	*Stellaria nemorum*	Wood stitchwort
	Scrophulariaceae	*Veronica* spp.	Speedwells

171

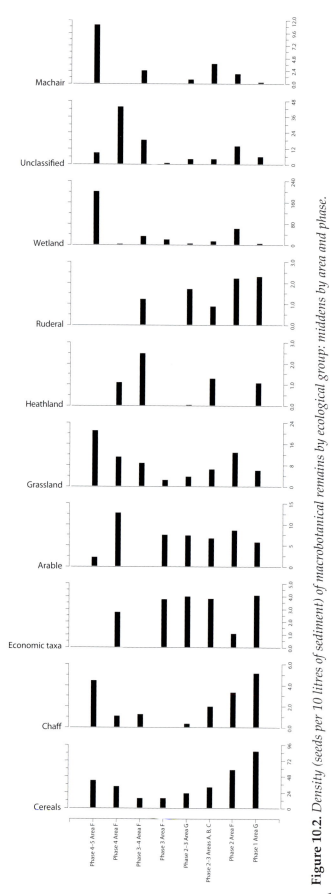

Figure 10.2. *Density (seeds per 10 litres of sediment) of macrobotanical remains by ecological group: middens by area and phase.*

10.6. Spatial and temporal distribution of plant remains

In this section the archaeobotanical assemblages are described by context type (midden, hearth, pit fill/dump, house floor). The first goal is to determine the activity or activities represented by the plant assemblages deposited in each. The second goal is to identify spatial and chronological trends in the midden contexts, and to a lesser extent in the non-midden contexts.

10.6.1. Midden contexts
The majority of the archaeobotanical data from Quoygrew are from midden contexts. Midden contexts contained representative taxa from every ecological group and included a mixture of material likely resulting from multiple activities across the site. Despite the mixed nature of middens, some contexts are noticeably different from others. Unique samples can provide insight into the taphonomy of the midden accumulation. Figure 10.2 presents the densities of each ecological group by area and phase for all midden contexts. These data are used to compare assemblages of plant remains from all areas of the site.

10.6.1.1. The Farm Mound midden (Area G)
The Farm Mound midden includes two distinct levels, assigned to Phase 1 and Phases 2 to 3 respectively. Phases 2 to 3 contained substantially more fish bone, which made the transition from Phase 1 clearly apparent during excavation (see Chapters 4 and 5). According to micromorphological analysis of sediments, the midden is likely to result from 'persistent deposition of a range of domestic occupation debris, including turf construction materials, animal bedding material, peat and turf fuel residues, deposited throughout the period of cultural sediment accumulation' (Simpson *et al.* 2005, 371).

Although much of the midden material from the Farm Mound contained similar plant remains, there are several contexts that stand out as containing exceptional assemblages. For example, several contexts (G037 from Phase 1 and G054 and G016 from Phases 2 to 3) contained higher than average amounts of wood/stem, vitrified fuel ash, underground plant parts, Ericaceae leaves and grassland seeds. These remains occur commonly in turf, and may indicate that these contexts are composed largely of residue from turf burned as fuel (Hall 2002). Seaweed appears most commonly in G037 and G016, which may mean it was also introduced to the midden as a fuel waste.

Context G022 from Phase 1 of the Farm Mound is interesting because of its extremely high cereal density. Arable weeds and chaff are also present in higher than

average density in this sample, but not high enough to be in proportion to the cereals. This context probably represents a dump of charred grain in a relatively clean stage, having had some of the weed seeds and chaff already removed. G022 also contains higher than average densities of heathland leaves, which do not fit the interpretation of crop-processing waste or uncleaned/partially cleaned grain stores. This emphasizes the problems of interpreting the almost certainly mixed nature of midden samples. In contrast, context G020 from Phases 2 to 3 includes a high proportion of arable weed seeds and chaff compared to cereals. This may indicate that this context is primarily a dump of crop-processing waste containing seeds and chaff that have been removed from a crop, or that this is a crop that has not yet been processed.

Another pattern that is worth mentioning is that, in this midden, arable weed seeds seem to follow the pattern of the cereals, and not that of seaweed. Seaweed strandlines can provide a nutrient-rich environment similar to that of a fertilized field, and thus arable weeds can sometimes arrive from activities (such as seaweed collection) on the shoreline, as seemed to be the case at the contemporary site of Robert's Haven in Caithness (Huntley 2000). This was probably not the case at Quoygrew, nor was seaweed a particularly prevalent inclusion in the Farm Mound midden contexts, in contrast to those from the Fish Midden.

10.6.1.2. The Fish Midden (Areas A, B and C)

The Fish Midden is located on the eroding shoreline and is contemporary with Phases 2 to 3 of the Farm Mound midden (Chapter 4). According to soil micromorphology, the Fish Midden is composed of peat ash, bone and shell, and is 'best interpreted as a specialized fish-processing area with intermittent but regular activity' (Simpson *et al.* 2005, 368). Area A includes two exceptional contexts, the very seed-rich context A005 and the grain-rich context A012. Otherwise, there is a small group of contexts in the centre of the midden with rather more evidence for *Empetrum nigrum* leaves (A012, A013, A015, A017). There are three clear blocks of contexts that contain more seaweed than average. The highest block includes contexts A006, A007 and A008. The second block includes contexts A013, A014 and A015. The lowest block (A021, A022, A023 and A025) of seaweed-rich contexts also contains more *Stellaria media*. In these contexts, *Stellaria media* may be associated with nutrient-rich strandlines rather than with fertilized crop fields as was the case in the Farm Mound midden. Wet ground taxa, including trigonous *Carex* spp. and *Montia fontana*, are more characteristic of the upper samples than the lower ones.

Area B is much more homogeneous, containing large amounts of seaweed, oat and barley grains with sedges, grasses, blinks and chickweed. Area C demonstrates more internal patterning. The earliest material is rather poor in remains with oat and barley grains more or less the only items recovered. The middle midden layers have higher concentrations of seeds with a block of flax-rich contexts (C012, C013, C014, C015, C016, C017, C018, C019, C020) along with the cereals. These are then all replaced in the upper levels by large numbers of seaweed fragments and rather few other items (Poaps & Huntley 2001a). However, small seeds (<1 mm) will be under-represented in Area C due to sorting methods (see Section 10.3.2 above). This does not affect cereals, flax or seaweed, all of which are recovered from larger-size fractions.

10.6.1.3. The South Midden (Area F)

Although the Farm Mound and the Fish Midden are by far the largest midden areas at Quoygrew, smaller midden accumulations were identified around the site and samples were taken from them for flotation. Three contexts (F685, F1111, F1125) were sampled for plant remains from Phase 2 of the South Midden, which accumulated against the southern wall of House 5. They contain moderate amounts of oats and barley, with slightly more barley than oats. There is little chaff, including one oat awn and two separated scutella. Flax is present but not abundant ($n = 3$). *Stellaria media* and small grasses are represented. Context F1111 has more Ericaceae and Calluna leaves than the other contexts, as well as more moss stem ($n = 11$), more *Carex* spp. ($n = 28$) and more wood, although wood and stem are abundant in all three contexts. Context F1125 contains more seaweed ($n = 16$). The contexts all have a lot of underground plant material.

Phase 3 of the South Midden (which accumulated against the south wall of Room 3 of House 1) is represented by a single context (F671). This sample contains some cereals, with more barley than oats. There is a small amount of flax ($n = 2$) and a number of *Carex* spp. seeds ($n = 17$). Many wood and underground plant parts are present.

10.6.1.4. The North Midden (Area F)

The North Midden accumulated against the northern side of House 5 in Phase 2. One context (F475) was analysed for plant remains. It contains a number of cereal caryopses, including more barley ($n = 70$) than oat ($n = 39$). Some chaff is present, most notably an *Avena sativa/strigosa* floret base and a six-row barley rachis internode. Flax is represented by a single seed. There is a small amount of heather and Ericaceae leaves in the samples, as well as 21 small grass caryopses.

Carex spp. seeds are abundant (*n* = 212), particularly the trigonous type (*n* = 165). *Montia fontana* is well represented (*n* = 16). There is some seaweed present in this sample, and moderate amounts of wood and underground plant parts.

10.6.1.5. The yard midden (Area J)

An area of midden was also recognized in Area J (sub-area J2), within the enclosed yard south of House 1. One context (J009) from Phases 3 to 4 was analysed. Oats (*n* = 11) are the only cereals present in this context. Some Ericaceae and heather leaves are present, along with some *Carex* spp. seeds (*n* = 26). This sample is also very high in wood and underground plant parts, and additionally contains a substantial amount of charred moss stem (*n* = 32) and a small amount of vitrified fuel ash (*n* = 3).

10.6.1.6. The Room 4 midden (Area F)

Two contexts, F602 and F676, were examined from the Phase 4 midden fill of Room 4 in House 1. Both of these contexts contain some flax, *Stellaria media*, small concentrations of Centrospermae and Chenopodiaceae seeds, much wood and moderate amounts of underground plant parts. Context F602 contains equal amounts of oats and barley, while context F676 contains more oats than barley and more small grasses (*n* = 12).

10.6.1.7. The Room 3 midden (Area F)

One context (F675) was analysed from Phase 4 to 5 midden fills in Room 3 of House 1. It contains moderate amounts of cereals, more oats (*n* = 19) than barley (*n* = 12). Some chaff is present, notably some awns, one oat floret base and a few scutella. There are some small grasses (*n* = 11), as well as some heather and ericaceous leaves. An assemblage of *Carex* spp. seeds (*n* = 165) was identified, and the context contains more *Montia fontana* than in many other samples (*n* = 10). A small amount of seaweed, moderate amounts of underground plant parts and a small amount of wood are also present.

10.6.1.8. Midden contexts: spatial patterns

Phases 2 to 3 at Quoygrew represent centuries when the Farm Mound, Fish Midden and Area F middens were simultaneously in use. By comparing the botanical contents of middens during this time period, the best information about potential activity areas can be gathered. In many ways plant remains from Phases 2 to 3 of the Farm Mound are similar to plant remains from contemporary deposits of the Fish Midden and the Area F middens. In all cases, barley is more prevalent than oats. In the Fish Midden, barley represents 70% of the cereals identified, and is numerically dominant over oats in 43 of 48 contexts. The density

of barley in this area is 24.80 seeds/10 L, versus 11.82 for oats. In Phases 2 to 3 of the Farm Mound, barley represents 63% of the cereals identified and is dominant over oats in 11 of 12 contexts. Here the density of barley (12.48 seeds/10 L) is also higher than that of oats (7.18). Barley is dominant over oats in all Area F midden contexts from this period, and the density of barley is higher in both Phase 2 (32.89 seeds/10 L *vs* 20.67) and Phase 3 (8.75 seeds/10 L *vs* 2.50).

Flax is represented in all areas. There is a total of 293 seeds in the Fish Midden, present in 33 of 55 contexts, with a density of 3.68 seeds/10 L. In Phases 2 to 3 of the Farm Mound, 78 seeds are present, occurring in 11 of 12 contexts, with a density of 4.01 seeds/10 L. Area F middens have less flax, four seeds (0.89 seeds/10 L) in Phase 2 and two seeds (2.5 seeds/10 L) in Phase 3. No area contained flax capsule remains or other indications of flax crop-processing waste. Arable weeds and cereal chaff were found in all areas, suggesting that crop-processing residues were a component of the waste discarded in middens across the site. Many of the same wild seeds are identified in all midden contexts at the site.

There are, however, some differences between areas. The most obvious is in the frequency and amount of seaweed present in the middens. The Fish Midden contains a density of 25.6 fragments/10 L of seaweed. Phases 2 to 3 of the Farm Mound contain a mere 21 fragments, with a density of only 1.04 fragments/10 L. The residue of some activity involving this resource was discarded preferentially in the Fish Midden. Two unusual species were found only in the Farm Mound midden: *Camelina sativa*, gold-of-pleasure, and *Isatis tinctoria*, woad. Woad was found only in one midden context, from Phase 1, and gold-of-pleasure was found primarily in Phase 1 (11 seeds total), with one seed found in Phases 2 to 3. Perhaps these seeds reflect small-scale domestic dyeing.

The Phase 2 middens in Area F have a higher density of plant remains than average (153 seeds/10 L versus the average of 106). Most of the ecological categories were represented by higher densities of seed remains than elsewhere, with the exception of economic taxa, which appeared at noticeably lower densities than in other midden contexts. In particular, *Carex* spp. seeds are much more dense in the Area F middens than elsewhere, and in the Phase 2 middens, *Montia fontana* densities were also high. This may indicate more input from byre materials including fodder (or dung) and flooring or bedding materials.

10.6.1.9. Midden contexts: temporal patterns

There are also marked differences in the site between the Phase 1 contexts of the Farm Mound and the

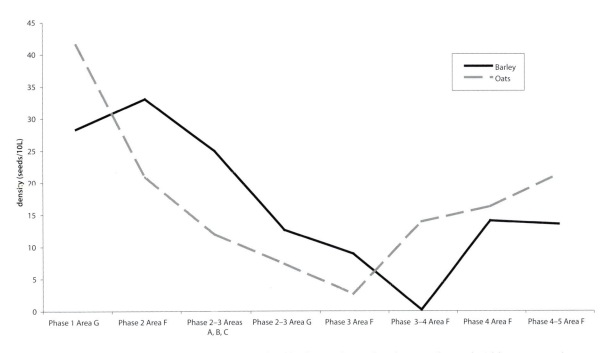

Figure 10.3. *Density (seeds per 10 litres of sediment) of barley and oats by phase and area (midden contexts).*

Phase 2 to 3 contexts represented by the Farm Mound and Fish Midden. In Phase 1, barley is much less dominant, representing only 40% of the total cereals identified. It is the dominant cereal in only one of nine contexts (the anomalous G020). This trend reverses in Phase 2 to 3 middens across the site, when barley is clearly the most abundant cereal. Oats then return to numerical dominance in Phases 3 to 4, 4 and 4 to 5 (Fig. 10.3).

Arable weeds are also less well represented in the Phase 1 midden, although they are present. Chaff is denser in Phase 1 (4.19 fragments/10 L) than in Phases 2 to 3 of the Farm Mound (0.68 fragments/10 L), Phases 2 to 3 of the Fish Midden (1.31 fragments/10 L) and the Phase 2 North and South Middens of Area F (3.33 fragments/10 L). This may indicate that more crop-processing waste was incorporated into the midden during Phase 1. It is possible that chaff was being used for animal fodder or bedding in later phases and thus less was charred and deposited in the midden.

10.6.2. Non-midden contexts
Non-midden contexts include hearths, pit fills, discrete dump contexts and house floors. Figure 10.4 describes the distribution of ecological groups by phase and feature type for non-midden contexts.

10.6.2.1. Hearth contexts
Hearth contexts were analysed from several phases and areas of the site. Most were from Phases 3

(F840, F518, F462) and 4 (F473, F071, F011) of Room 1 in House 1, and represent sequential use during subphases of the lengthy occupation of this building. In the Phase 3 hearths (F840, F518, F462) there are a few damaged Cerealia caryopses and some oats, but no identifiable barley. There are some weed seeds, especially damaged seeds identified only as Centrospermae. Overall, these Phase 3 hearths contain a very low density of seeds (23.04 seeds/10 L). There was no chaff identified, but one piece of seaweed, a little wood and a few underground plant parts are present. It is possible that the fires from these hearths were fuelled with peat, which burns very hot and may have almost completely incinerated plant remains (Church & Peters 2004). It is also possible that the hearths were kept clean by sweeping out the uncombusted materials into midden contexts and other areas of the site.

The Phase 4 hearth contexts (F473, F071, F011) contained a higher density of remains (89 seeds/10 L). One context (F071) did not contain cereals, but the other two had small amounts. The dominance of barley over oats is variable. There is one flax seed in these contexts. Context F473 includes a concentration of *Stellaria media* seeds (n = 51), Centrospermae (n = 67), and *Chenopodium* spp. (n = 32). Other inclusions include relatively high amounts of amorphous plant material (which could represent peat), some vitrified fuel ash, some wood (particularly in F011), and some underground plant materials. This combination suggests that a mixture of fuels is represented.

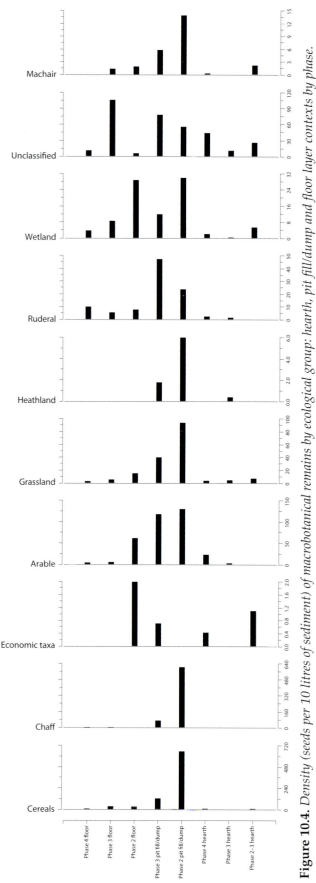

Figure 10.4. *Density (seeds per 10 litres of sediment) of macrobotanical remains by ecological group: hearth, pit fill/dump and floor layer contexts by phase.*

One context (G101), from House 7 in Area G (sub-area G3, Phases 2 to 3) was interpreted as a hearth during excavation. However, this is a very unusual context both in its appearance (as a niche within a semi-subterranean building) and because it contains a massive concentration of charred seaweed ($n = 1306$, density 1451 fragments/10 L). This is a higher density than contained in the Fish Midden, and strongly suggests the results of a specialized process. Because of the concentration of carbonized material, the on-site interpretation was that this structure may represent a grain-drying kiln, similar to one in use at the broadly contemporary site of Beachview, Birsay (Morris 1996a, 104). Given identification of the concentration as seaweed ash, however, this interpretation now seems less likely (unless it was a multi-purpose structure or seaweed was preferentially used as kiln fuel). In other sites from the same period in the Northern Isles, pits have been found with concentrations of burned seaweed, which were interpreted as features for producing lye (e.g. Dickson 1999). It is possible that this context served a similar purpose. There are few other plant remains in the context, but slightly more than are present in the Phase 3 and Phase 4 hearths from House 1. Along with seaweed, the context also contains some wood, some amorphous plant material (possibly peat), and some vitrified fuel ash. A few cereal grains are present, including somewhat more barley than oat. No chaff was identified in the context, but one flax seed is present. A few weed seeds, especially Caryophyllaceae and *Rumex* spp. are present, but there are no large concentrations of weed seeds. This context will be discussed in greater detail in the context of seaweed use at the site (see Section 10.7.8 below).

There is a trend towards greater diversity of remains (more ecological groups represented, and a more even distribution of groups as a percentage of total seeds) in the Phase 4 hearth contexts when compared with the Phase 3 hearths. It is possible that this has to do with a wider range of gathering activities or changes in the environment around the site. However, it is more likely that this is a result of changing fuel types, with more turf (which burns more slowly and tends to lead to better charred preservation) being used in preference to peat. This could be due, for example, to the depletion of local peat sources, or to increased demand for turf ash to use as a component of animal bedding and field fertilizer.

10.6.2.2. House floors

Floor contexts were analysed from Phase 2 of House 5 (F1129), Phase 3 of Room 1 in House 1 (F543), and Phase 4 of Rooms 1 (F423) and 2 (F221) of House 1. Plant remains are present in all house-floor samples,

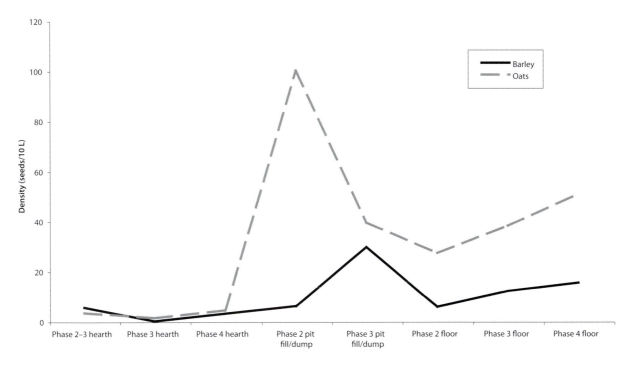

Figure 10.5. *Density (seeds per 10 litres of sediment) of barley and oats by phase and context type (non-midden contexts).*

ranging in density from 85 seeds/10 L (F221) to 266.7 seeds/10 L (F423). The Phase 2 floors from House 5 contained more barley than oats while Phases 3 and 4 of House 1 contained more oats than barley. Two seeds of flax were also present in the Phase 2 context, and seaweed was present only in this sample. Small concentrations of Centrospermae seeds, either *Stellaria media*, undifferentiated Centrospermae (possibly damaged Caryophyllaceae or Chenopodiaceae) or *Atriplex* spp. are found in house floors from all phases. Moss stem is also present in low amounts, and underground plant parts and wood are present in all floor samples, with higher concentrations in the Phase 2 floor sample. The macrobotanical contents of the house-floor samples in general are very similar to those of the hearth samples, but with higher seed densities. Presumably, the carbonized botanical remains from the house floors come from the use of redeposited hearth ash as flooring material.

The two Phase 4 contexts from Rooms 1 and 2 of House 1 are very different. They have the highest (F423, Room 1: 266.67 seeds/10 L) and lowest (F221, Room 2: 85 seeds/10 L) densities of remains of all house floors. In the field, F423 was described as a brown silt clay floor layer which built up against a fire-cracked sandstone slab that functioned as a hearth. Conversely, F221 was interpreted as a 'packed earth' floor made of ash spreads in what was probably a sleeping room (lacking a hearth) in this phase. The

chances of carbonization were presumably higher around the hearth in Room 1 than in the sleeping area of Room 2, but it is also possible that purer ash was selected for use as flooring in the sleeping room.

There is a diverse representation of plant groups throughout the house-floor assemblage, which suggests turf or dung fuels (which tend to preserve seeds) were used to produce the ash incorporated into the house floors. The earliest floor layers, from Phase 2, contain the only flax and seaweed from the floors. Thus the activities involving these materials must have occurred outdoors, or in subsidiary structures (e.g. House 7 in Area G) in later phases.

The relative density of oat and barley grain in house floors differs from the pattern observed in the midden samples, with more oats than barley in the Phase 2 and 3 floors. In Phase 4, however, the two context types match, with more oats than barley in both (cf. Figs. 10.3 & 10.5). No Phase 1 house floors were located during the excavation, so comparison is not possible for the earliest period of occupation. The differential representation of oats and barley in the middens and house floors will be discussed further in Section 10.7.1 below.

There were no undisturbed sediment contexts from the robbed flagstone floors of Phase 4.4 in Room 2 of House 1. On architectural criteria it is tentatively interpreted as a space used for winnowing cereals (see Chapter 4), but this cannot be corroborated using

archaeobotanical evidence. Even if relevant floor deposits could have been sampled, no crop-processing residues would have survived *in situ* unless carbonized by exposure to a fire.

10.6.2.3. Pit-fill and dump contexts

Individual contexts from pit fills and dumps represent what are most likely to be single depositional episodes, although none of these contexts appears to have been burned *in situ*. The botanical contents of these contexts are varied, but all include a mixture of plants from many environments. The density of plant remains in these contexts is very high. Pit-fill and dump contexts from Phases 2 and 3 were analysed and the results are as follows.

The last discernible act occurring in House 5 (Phase 2.4) was the deposition of context F1115, a dump of charcoal and ash. It is the most seed-dense context at the site, containing 814 seeds (1628 seeds/ 10 L). The context included many oat caryopses ($n = 322$) and much oat chaff, especially oat awns ($n = 257$). There were a very few barley and Cerealia caryopses, and a single six-row barley rachis fragment. The oats from this sample are likely to be *Avena strigosa*, because floret bases are all of the narrow type and the awns include some that have broken in a way to reveal the geniculate shape of the awn base. They are also somewhat small and a number of caryopses have exuded material at the distal ends, which is characteristic of unripe (milk or dough-ripe) grain (Hubbard & al Azm 1990).

The context also contains numerous weed seeds, including small grasses ($n = 42$), *Stellaria media* ($n = 33$) and moderate amounts of *Carex* spp., *Cerastium* spp. and *Chenopodium* spp. These weeds are all common species found in animal manure (Griffin 1988). An oily arable weed seed, *Capsella bursa-pastoris*, was also found in abundance in this sample ($n = 28$). This context has the highest density of seed remains associated with machair soils. Contributions from floor coverings, animal bedding, or turf or peat fuels may be indicated by a large amount of moss stem ($n = 107$), as well as by *Calluna vulgaris* and Ericaceae leaves. Underground plant parts and wood/stem are abundant, and small amounts of seaweed and fungus are included. This context also contains a number of carbonized insect remains, including a fragment of silphid (carrion beetle) pronotum (cf. *Thanatophilus* sp.) and fragments of fly puparium that have been distorted by heating (H. Kenward, pers. comm. 17 August 2007).

The combination of remains from this context — including possibly unripe, unthreshed oats along with a mixture of crop weeds, machair plant taxa, animal bedding material (heather, moss, turf) and insect remains — seems to indicate byre flooring and fodder rather than crop-processing waste or fuel. This context is similar in composition to a waterlogged pit found at Tuquoy, Westray, which was determined likely to contain an intact accumulation of byre-manure (Owen 1993). According to ethnohistorical accounts of Orkney, byre manure mixed with byre flooring material (often turf, straw and seaweed) was sometimes used as fuel which would account for the carbonization of an assemblage of this type (Fenton 1985, 98). Because of the large amount of oat awns and chaff in this sample, an alternate explanation is that this is the result of 'graddaning', which Dickson and Dickson (2000) describe as 'an ancient method of separating oat grain from chaff, in which the heads of oats were set on fire. When the grain dropped out the remaining chaff was extinguished or the chaff thrown on the fire.'. However, the means by which the weed seeds, heather leaves and moss stem entered the sample would remain unexplained in the second case.

Four dump and pit-fill contexts were analysed from Phase 3. Context F1051 is a discrete dump from Room 3 (the byre) of House 1. The remaining contexts (F548, F550, F564) are pit fills from Room 1 of House 1. The Room 3 dump (F1051) contains more barley ($n = 60$) than oats ($n = 28$), some chaff, including a six-row barley internode, some oat awns ($n = 28$), and narrow (*A. sativa/strigosa*) oat floret bases. A wide range of wild seeds indicative of well-manured or nutrient-rich soils are present, including *Capsella bursa-pastoris* ($n = 8$), *Polygonum aviculare* ($n = 19$), *Stellaria media* ($n = 186$), Poaceae ($n = 105$), *Atriplex* spp. ($n = 87$), *Tripleurospermum maritimum* ($n = 13$), *Carex* spp. ($n = 16$), Centrospermae ($n = 199$), Chenopodiaceae ($n = 71$), Polygonaceae ($n = 24$) and *Rumex* spp. ($n = 21$). Heather leaves ($n = 134$) and Ericaceae leaves ($n = 116$) are abundant. There is some moss stem, moderate amounts of underground plant parts, and a moderate amount of vitrified fuel ash. There are also insect remains in this context, including probable segments of insect larvae, a probable staphylinid (rove beetle) abdomen and a metathorax and abdomen of a beetle, probably a cryptophagid (silken fungus beetle) (H. Kenward, pers. comm., 17 August 2007). This context is most likely to represent uncleaned cereals or crop-processing waste (cereals, chaff and arable weeds) mixed with turf or peat fuels (grassland, heathland and underground plant parts) — possibly used as flooring in the byre before being burned.

From Room 1, pit fill F550 contains many cereal remains, with more oat ($n = 112$) than barley ($n = 50$). Oat awns are present as well as the narrow type of floret bases. There is a concentration of *Stellaria media* ($n = 293$), some small grasses ($n = 31$), cf. *Atriplex* spp. (n

= 105) and *Tripleurospermum* spp. (*n* = 10). The context contained moderate amounts of underground plant parts, moderate amounts of wood, a little moss stem and a little vitrified fuel ash. In this context, mineralized seeds were found which were identified as *Atriplex* spp., *Stellaria media* and an unidentified seed type. No heather or Ericaceae leaves were found in this context, although it contains two seeds of *Empetrum nigrum*. A single carbonized possible cryptophagid (silken fungus beetle) metathorax was found in this context (H. Kenward, pers. comm., 17 August 2007). This context appears to be another example of uncleaned grain or crop-processing waste (including many weed seeds and chaff) perhaps used as fodder or animal bedding, with admixtures of turf fuels.

Pit fill F548, also from Room 1, has a much lower density of seeds. There are few cereals, with equal amounts of oat and barley (*n* = 7). Two oat awns are the only chaff present. Centrospermae seeds (*n* = 10) are well represented. There is a range of other seeds, making this context similar in content to the previous context but containing fewer seeds. The moss, vitrified fuel ash, underground plant part, and wood are all similar to context F550. This context may represent a more dispersed version of the other contexts, with a mixture of uncleaned grain, crop-processing waste or fodder (cereals and arable weeds) and turf.

The final Phase 3 pit fill, F564 from Room 1, contains even fewer cereals. There is more barley (*n* = 4) than oats (*n* = 2). A few oat awns are the only chaff. There are a few heather (*n* = 11) and Ericaceae leaves (*n* = 15) and a small assemblage of *Rumex* spp. seeds (*n* = 35). There is slightly more moss stem than in the other two pit fills, but otherwise the vegetative remains are similar. There are also mineralized seeds in this context, including some unidentified seeds and some Centrospermae seeds. The mineralization is more complete, however, making it harder to identify the seeds. This context may represent turf fuel waste with some small input from crop wastes or animal byre material.

The pit-fill and dump contexts are all quite different. They contain plant taxa from many environments and probably indicate mixtures of remains, including fuel, rather than single activities such as crop processing or cereal drying. The mineralized seeds and carbonized insect remains are present mostly in the pit-fill and dump contexts of the site, with a few mineralized seeds also in the Phase 2 floor of House 5. The mineralized remains reflect areas of low elevation, correspondingly poor drainage and decaying organic material. The insect remains conversely reflect undisturbed contexts. They may also indicate that the plant materials were sitting before they were burned,

as in byre or bedding materials, but the insect groups represented are not particularly specialized in their preferred habitat, and may have been present in many areas of the house interior, in bedding, flooring, roofing, stored cereals or other contexts.

10.7. Discussion

10.7.1. Barley and oat cultivation
Cereal chaff and caryopses were common throughout the site, with especially large concentrations in several of the midden, pit-fill and dump contexts. Based on this evidence, as well as the presence of an adjacent fertilized infield (Simpson *et al.* 2005; see Chapters 3 and 4), cereal cultivation was taking place at Quoygrew. The two main crops were barley, probably primarily hulled six-row barley, *Hordeum vulgare* ssp. *vulgare*, and oat, probably both common oat *Avena sativa* and bristle oat *A. strigosa*. Bristle oat can grow on relatively nutrient-poor soils, and was historically grown as the crop of the less-fertilized 'outfield' in Scotland, while *A. sativa* and *H. vulgare* were grown on the heavily fertilized anthrosols of the 'infield' (Dickson & Dickson 2000, 233–5).

Barley and oats are both commonly recovered from Viking Age and medieval sites in Atlantic Scotland. When compared with the Pictish period, it has been argued that the growing of oats may have increased during the Viking Age. This has been interpreted as evidence that new, more marginal land was brought into cultivation (Bond 1998). However, the relative importance of different cereal crops varied both from settlement to settlement and through time. Sites with a predominance of hulled barley over oats include the Viking Age phases of Pool on Sanday (Bond 2007a, 205), the Brough Road in Birsay (Donaldson & Nye 1989) and Barvas Machair in Lewis (Dickson & Dickson 2000, 172). Settlements with a higher proportion of oats include the late Viking Age to medieval sites of Beachview in Birsay (Rackham *et al.* 1996a, table M30; 1996b, 154), Robert's Haven in Caithness (Huntley 2000), Cleat in Westray (Poaps & Huntley 2001b) — and the medieval phases of both Earl's Bu in Mainland Orkney (Huntley 1990) and Pool on Sanday (Bond 2007a, 205).

Lumping all of the analysed contexts at Quoygrew together, there is altogether more barley (*n* = 3183) than oats (*n* = 2666). However, considering the oat/barley relationship by phase reveals some interesting patterns. Figure 10.3 shows the density of oat and barley by phase for midden contexts. Non-midden contexts are presented similarly in Figure 10.5. During Phase 1 in the Farm Mound, oat is clearly dominant over barley having a density of 41.35 seeds/10 L com-

pared with 28.17 seeds/10 L. Oats are also the most abundant cereal by count in the majority of samples from this phase. These observations are in marked contrast to the situation during Phases 2, 2 to 3, and 3, when middens across the site show that barley is the dominant cereal (in terms of both grain densities per litre of sediment and the number of samples in which it is most abundant): in Phases 2 to 3 of the Fish Midden, Phases 2 to 3 of the Farm Mound and Phase 2 of the South and North Middens in Area F. In contrast, house-floor, hearth, pit-fill and dump contexts from Phases 2 and 3 of Houses 5 and 1 show higher densities of oat than barley. This curious (but potentially illuminating) difference disappears in later phases. In the few midden contexts analysed from Phases 3 to 4, 4, and 4 to 5, oat density is once again higher than barley. This pattern matches the analysed Phase 4 hearth and house-floor contexts.

The inconsistent ratio of barley to oats between context types at Quoygrew raises interesting questions. As noted, there is a decrease in the amount of cereals and chaff (especially oat) present in *midden* samples from Phase 1 to Phases 2 to 3. Because this is the period during which fishing increased at the site (see Chapters 5 to 7), it is tempting to see the decrease as a contraction of agricultural activity as labour was diverted to the sea. However, along with the decrease in cereals and chaff, there is an increase in the number of arable weed seeds present in these middens from Phase 1 to Phases 2 to 3. Thus cereal production may have increased, rather than decreased. This is unlikely to be solely a result of unequal preservation due to fuel types, because cereal grains are more likely to survive intense heat than the more fragile arable weed seeds. If a switch to hotter-burning fuels were responsible for the decline in cereals and chaff in later phases, arable weed seeds should also decline as a result of poor preservation. It is also not a result of differences in sorting procedures. Because the <1 mm size fraction was not included in analysis for Area C, it is possible that some of the arable weed seeds are under-represented in the Phase 2 to 3 Fish Midden. However, if this is the case, it only strengthens the observation that arable weeds increase at the site between Phase 1 and Phases 2 to 3.

The fact that oats show up as the predominant cereal in most house-floor, hearth, pit-fill and dump contexts from Phases 2 and 3 also supports the idea that production of this crop did not necessarily decrease. Rather, it is likely that the deposition of these cereals across the site changed in response to new demands. For example, the increase in dairy production (Chapter 8) may have necessitated better-quality fodder for cattle. If oats became a preferred fodder at Quoygrew during Phases 2 to 3, we might expect that

less would end up carbonized and in middens. The grain would not be processed to the same degree — remaining chaff and weed seeds would not need to be removed as thoroughly for animal consumption, and the grain would not need to be dried as thoroughly or roasted, lowering the chance of preservation by charring. Pit-fill and dump contexts from Phases 2 and 3 are consistent with this explanation. These contexts show large quantities of unthreshed or incompletely threshed oats (including chaff and weed seeds) amidst other botanical remains suggesting byre flooring or byre manure. This is the way we would expect to find oats, if they were being used as fodder. Following this argument, the return of oats to numerical dominance in the middens of Phases 3 to 4, 4 and 5 may imply that the demand for fodder had waned and the crop was once again prepared for human consumption (and thus exposed to fire during drying) on a larger scale, as had been the case in Phase 1. Perhaps alternative interpretations could also explain the observed patterns, but it is evident that oats and barley were treated differently in Phases 2 to 3 than in earlier and later contexts.

Ethnohistoric records from the Northern Isles can serve as a cautious guide to Viking Age and medieval practice. Barley was probably sown from late April to May and oats from February or March to April — with harvest in September to October (Fenton 1978, 335). Sowing was likely by hand, from a basket for example, and expected seed to yield ratios might be 1:4 for barley and 1:3 for oats. Barley would have provided bread and ale. Although no clearly malted grain was observed at Quoygrew, one must imagine that the production of ale was common based on both medieval (Pálsson & Edwards 1981, 70) and post-medieval (Fenton 1978, 393–5) sources. Oats were probably used for bread in addition to their role as fodder — and both barley and oats could of course have been cooked with milk or broth (Fenton 1978, 395–6). Harvest probably involved cutting close to the ground using a small sickle — or in some cases even plucking the plants by hand (Fenton 1978, 334, 337).

The arable weeds represented in the samples range considerably in height, which suggests that crops were indeed harvested low to the ground (in order to collect as much straw as possible). This was common practice in much of northern Europe, and was usually associated with manuring of fields, since removing straw had the effect of reducing the organic content of the field (Viklund 1998, 47–8). Straw cut long could be used for a variety of purposes (as thatching or to make baskets, for example), or as fodder for animals, or could be exchanged in its own right as was done later in Orkney (Fenton 1978, 186–90, 260–69, 337).

180

10.7.2. Unripe grain

The distortion of some cereal caryopses mentioned earlier is typical of grain that is roasted in the milk- or dough-ripe stage (Hubbard & al Azm 1990). There are a number of reasons why seeds might have been harvested in this state. It is possible that immature grains were gathered in small batches and roasted intentionally as a snack or to supplement food in times before the harvest was taken in. Hillman (1984) describes a Turkish dish called *friké* prepared from grain in this manner. An alternative explanation is that the season was sometimes too wet or short for the grain to ripen properly, or that in fear of gales or autumn weather setting in, grain was harvested early to cut losses. Unripe grain could have been used as a nutritious fodder. A final possibility is that tail grain, which was smaller and likely to be less developed, fell though sieves and became incorporated into crop-processing waste (later burned), leading to a disproportionately high proportion of charred green grain in the archaeological deposits. Barley caryopses with similar distortions to the ones found at Quoygrew were identified at a Viking Age site in southwest Finland (Onnela *et al.* 1996). At Cleat, Westray, cereal caryopses tended to be long and thin, which also suggests tail grain or that the grain was slightly unripe. However, none of the caryopses from Cleat showed distortion (Poaps & Huntley 2001b).

10.7.3. Flax production

Flax was present in Scotland since the Neolithic, but it appears very rarely in pre-Norse contexts from the Northern Isles. At Crosskirk Broch, an Iron Age site on Mainland, Orkney, one flax seed was found (Dickson & Dickson 1984, 152). Small amounts of flax were also found in Pictish layers at Howe, Mainland Orkney (Dickson & Dickson 2000, 254). Few sites show continuous occupation between the Pictish and Viking periods, but in two that do have continuous occupation (Pool in Orkney and Old Scatness in Shetland), flax occurs mainly in the Viking Age samples (Bond *et al.* 2004; Bond 2007a, 181, 186–8; Bond *et al.* 2010, 192).

Quoygrew has a higher density of flax than most other sites in the region, which may indicate that it played a larger role at this site (Poaps & Huntley 2001a). This is especially true since oily seeds like flax do not tend to be preserved well by carbonization, and so may be under-represented (Viklund 1998, 106). The consistency of flax remains in samples from different phases and areas (approximately 3 to 4 seeds/10 L) is also worth noting. There is no clear evidence that the importance of flax differed over time or across space at Quoygrew.

Flax prefers nutrient-rich soil that is free-draining, and not too heavy or light, and has a reputation for exhausting the soil (Turner 1972; Dickson & Dickson 2000; Smith & Mulville 2004). It is possible that flax was grown with barley on a fertilized infield where continuous manuring would allow it to grow year after year. It is also possible that Quoygrew's inhabitants grew flax on machair lands, or at the border of the machair, which would have soils similar to a sandy loam (Smith & Mulville 2004, 57).

Flax can be used for its fibre (linen), for its seeds (in bread or as oil), as a medicinal plant, and/or as a nutritious addition to fodder. Linen can be used for clothing (Gabra-Sanders 1998) and sail cloth (Cooke *et al.* 2002). Fragments have been found in association with Scottish Viking Age graves, and in a hoard containing hack-silver (Gabra-Sanders 1998). Linen thread may also have been usable for fishing line. Artefacts associated with flax production have been found at a wide range of Viking Age sites (Andersson 1999). Artefacts associated with textile manufacture (e.g. loom weights and spindle whorls) have been found at Quoygrew, but none of these is specific to linen, and all are just as likely to have been used for wool cloth production.

It is possible that flax seeds became carbonized as a result of fibre processing, because in a wet climate such as Orkney, the plants would need to be dried after retting (soaking to rot the stems). Historically, in Ireland, flax straw was often dried on a rack over fire to make it more brittle, and to facilitate separation of the fibres from the straw. An accident during this process could result in carbonized seeds. Under ordinary circumstances, the dried straw could be beaten over a stone with a wooden mallet or beetle to break up the woody outer layer (Geraghty 1996, 47). If done indoors, this process may also have led to carbonization of flax seeds in the fire. Flax seeds as a component of diet are most likely to be found in waterlogged latrine deposits, none of which exist at Quoygrew.

Evidence for flax cultivation at the nearby site of Cleat, Westray, was found in the form of adhering capsule fragments (Poaps & Huntley 2001b). At Mindets tomt and Søndre felt in medieval Oslo, flax pollen and capsule fragments indicated local production, and there was some evidence for hemp production as well (common in Viking Age and medieval Scandinavia, but not evident at Quoygrew). In this urban setting, flax was interpreted as a garden crop grown within the town (Griffin 1988). No capsule fragments came from Quoygrew, but the presence of *Camelina sativa* is also a strong indicator of local production.

10.7.4. Woad

It is very unusual to have found woad (*Isatis tinctoria*) at Quoygrew. Woad is a demanding crop that has

a tendency to strip soils of nutrients and requires multiple weeding steps. In addition, production of woad pigment from the leaves is a complicated process requiring more steps than required for dyeing with other plant materials (Hurry 1973). Woad was not originally native to the British Isles or to Scandinavia, and is a very unusual find for Orkney (Stace 1997, 252; van der Veen *et al.* 1993; Dickson & Dickson 2000, 283).

Woad leaves are a source of the rare nitrogen-containing plant pigment indigotin, which produces a lightfast blue colour and was the major source of blue dye for cloth in Europe (Davies 2004). The pigment is not present in the whole, undamaged leaves, but rather develops when cells are damaged and exposed to chlorophastic enzymes and air (Davies 2004). The pigment indigotin has been found on many Viking Age textiles, especially from Scandinavia (Walton 1988). Vegetative remains or seeds of woad plants have been noted at a number of Viking Age sites, including the Oseberg ship burial in Norway (Holmboe 1927), Coppergate in York (Walton 1989; Kenward & Hall 1995, 769) and Kaupang in Norway (Barrett *et al.* 2007, 304). The plant is also known from sites of Iron Age to Anglo-Saxon date in England and the early medieval settlement of Deer Park Farm in Northern Ireland (van der Veen *et al.* 1993).

Woad has been grown commercially in England (Wills 1970), but when semi-industrial production of woad-dyed fabric took place during the medieval period, the pigment was often imported in the form of fermented balls from France. The quality of pigment was better in leaves grown in that area (Edmonds 1998). Although archaeobotanical remains of woad (especially seeds) are seldom found in France, a recent find of carbonized woad seeds from Iron Age Gaul suggests that woad was cultivated in northern Gaul from at least the fifth–fourth century BC (Zech-Matterne & Leconte 2010). There are records of woad being traded to York from continental Europe in 1251 (Walton 1989). Modern studies show that the quality of light is important in the plant's production of indigotin and more of the pigment is produced during periods of dry, sunny weather (Stoker *et al.* 1998). In addition, the woad must be processed into balls and dried as rapidly as possible, which is difficult in the damp, rainy, climate of the British Isles, and Orkney in particular (Edmonds 1998). Overall, the presence of woad at Quoygrew is consistent with Viking Age and medieval fashion in northern Europe, but inconsistent with the ideal environmental conditions for its successful cultivation. An attempt may nevertheless have been made (presumably using imported seed)

to grow the plant locally for dyeing linen or wool. The seeds are not themselves used for dyeing, and would only accidentally have been included in the fermented leaf material used to produce the pigment (Zech-Matterne & Leconte 2010, 139). The trade of dyestuffs is also documented in other contemporary settlements in Britain. At 16–22 Coppergate in York, for example, clubmoss (used as a mordant) of probable Scandinavian origin was an abundant find (Kenward & Hall 1995, 772).

10.7.5. Land use

Common chickweed (*Stellaria media*), indicating well-fertilized soils, is very common at the site, appearing in midden contexts from Phases 1 to 3. The crops most likely to have been grown on fertilized soils are common oats (*Avena sativa*), barley (*Hordeum vulgare* ssp. *vulgare*), and possibly flax (*Linum usitatissimum*). Arable weeds in general increase slightly from early phases to later phases, which may indicate increasing use of fertilized anthrosols, perhaps infields. Interestingly, arable weeds that favour highly fertilized soil, such as *Stellaria media*, are present in some quantity from the earliest phase at the site. This is significant, since the main area of thickened (raised) anthrosol identified at Quoygrew has been tentatively dated to the medieval period, during or after Phases 2 to 3 (see Section 4.3.4; Simpson *et al.* 2005). It is possible that this was not the only manured soil at the site. Rather, fertilized infields may have been present on a smaller scale from the foundation of the farm, and expanded later to meet increasing demand (be it for food, fodder, renders such as rent, tax and tithe, or trade). Subsequent expansion would account for the increasing quantities of these seeds in later phases.

Bristle oat (*Avena strigosa*) can tolerate sandy, less well-fertilized, soils and is a likely crop to be grown on the outfield (Dickson & Dickson 2000). Outfields in Orkney are likely to have included machair soils, which are nutrient-rich enough to support agriculture, although they usually cannot support a continuous crop. Thus the area of outfield used for agriculture would probably have shifted from season to season (Smith & Mulville 2004). Flax could also have been grown on sandy machair outfields, although because it tends to use more nutrients than oats, it may have needed to be on a longer rotation to allow soil to regain fertility (Smith & Mulville 2004). Machair seeds were found in abundance at Quoygrew from the earliest phase, and seem to be associated with oats. Unfortunately, it is not possible to separate common oat from bristle oat based on the caryopsis, so bristle oat and common oat must remain mixed when looking at the association.

Nevertheless, whenever oat densities are high (as in pit-fill/dump contexts of Phases 2 and 3, and in the Phase 4 to 5 midden context), machair seed densities are higher than average. When oat densities are low (Phase 2 house floor, Phase 3 midden, Phase 3 hearth), machair seed densities are lower than average. The association is least strong in the middens of Phases 1, 2, and 2 to 3 — because oat densities fall dramatically after Phase 1 (see Section 10.7.1 above). Flax density is less well associated with machair seed density, or with oat density.

The correlation between machair seed densities and oat densities suggests that machair seeds may have come to the site along with bristle oat, as crop weeds. Alternatively, as machair areas may also have been used to pasture animals, their seeds may have become carbonized as a result of the use of dung fuels. In this instance, oats could seem associated with machair due to their use as fodder and the burning of dung or byre material as fuel.

Based on the carbonized botanical remains, it seems likely that both infields (heavily fertilized, under continuous cultivation) and outfields (sandy, naturally fertile soils, under shifting agriculture) were in use from Phase 1 at Quoygrew. Both of these areas probably saw growth throughout the phases represented, because machair seeds and arable weed seeds both tend to increase in density over time. However, it is hard to rule out alternative scenarios where changes in animal diet or the use of dung fuels obscure patterns of land use.

10.7.6. Wild plant resources

Many of the wild and weedy species identified from the archaeobotanical record are edible, or otherwise useful for medicines, textile dyeing, etc. Some of these uses have been mentioned or briefly discussed earlier. We have chosen not to place much emphasis on the uses of uncultivated plants, however, because the presence of these seeds in the contexts in which they are found at Quoygrew does not suggest that they were gathered primarily for these purposes. It is difficult to argue that wild plants were consumed, or used for craft purposes, based on the carbonized plant record, because such uses typically preclude contact with fire. More often parts from these plants end up in waterlogged or latrine deposits which were not present within the excavated areas at Quoygrew. There are also no large concentrations of wild or weedy seeds that might suggest intentional gathering and storage of these seeds.

Nevertheless, based on ethnographic accounts, edible plants and seeds were probably frequently consumed, especially during certain times of the year, or in times of food shortages. Berries, including crowberry, were likely eaten, and the arable weeds harvested with grain were probably used for supplementing human or animal food supplies (Fenton 1978, 438). However, we do not see evidence for or against this in the carbonized plant record.

Absent from Quoygrew are some gathered or imported remains sometimes found at other (particularly urban) Viking Age and medieval sites in Britain, Ireland and Scandinavia, including hazelnuts, walnuts, grape pips, figs, fruits and berries (with the exception of crowberry, *Empetrum nigrum*) (e.g. Krzywinski *et al.* 1983; Griffin 1988; Kenward & Hall 1995, 755–6; Geraghty 1996, 36–43; Dickson & Dickson 2000; Barrett *et al.* 2007). It is likely that this lacuna relates in large measure to the lack of trees in Orkney, the social status of Quoygrew's inhabitants and the settlement's rural location. However, it is also relevant that the site did not have waterlogged preservation conditions and that botanical remains have not yet been analysed systematically from the heavy fractions of the flotation samples (where more dense materials such as fruit stones and nutshell may well have ended up).

10.7.7. Fuel use

Fuel was arguably the most important gathered resource needed at Quoygrew. Turf and peat were important fuel sources in the virtually treeless environment of the Orkney Islands, and would have needed to be gathered, processed and stored for use (Fenton 1978, 210–38). Peat is the more efficient of the two fuels, but turf burns more slowly and produces more ash, which can be an important component of fertilizer to increase soil fertility. In practice, the two fuel types often grade into each other environmentally, and could be used together in proportions that varied with the purpose of the fire (Carter 1998; Church & Peters 2004).

In a midden context where remains from many fuel types are likely to be mixed, determining differences between varieties of fuel is very difficult. Allan Hall (2002) has published a list of 'turf indicator' macroremains likely to occur when turf is being utilized, and many of these species are present in contexts from Quoygrew. Seeds in turf used for purposes other than as fuel are less likely to survive, because they are less likely to be carbonized, although it is possible that seeds in turf roofing material can fall into a fire, or be burned in place (Dickson 1998). It is also possible for heathland fires to contribute carbonized plant remains in instances where turf was not directly burned as fuel.

According to the carbonized plant remains alone, plant assemblages in hearth contexts appear to become more diverse in terms of the environ-

ments represented over time. Also, preservation of fragile seeds and plant parts seems to increase in later contexts as well. This could indicate more turf fuels being used in these contexts over time. However, only a few hearth contexts have been sampled, and trends may be different if more hearths or other controlled fires were included. The midden contexts, while perhaps providing a broader view of fuel use across the site, are difficult to interpret because each individual midden context is more likely to contain a mixture of fuel types.

10.7.8. Seaweed utilization

Seaweed is common at sites in Orkney and Shetland, and was used for many things on the islands, including food, fodder, fuel and fertilizer for the fields (e.g. Fenton 1978, 207, 274, 428, 466). Relatively robust fucoid seaweed (possibly *Fucus vesiculosus*) was found carbonized in low amounts in many areas and phases at Quoygrew, but was particularly prevalent in the Fish Midden, where it was probably carbonized due to activities related to fishing and processing of fish livers for oil. It may have been used as a fuel (Hallsson 1964), or discarded as waste into the fire (perhaps while baiting lines).

The other context that contains a very dense assemblage is context G101. This context may be comparable to similar, roughly contemporaneous contexts identified from The Biggings site on Papa Stour, Shetland, and at the Brough of Birsay, Orkney (Donaldson & Nye 1989; Dickson 1999). These contexts are shallow unlined pits where large assemblages of carbonized fucoid seaweed have been identified. In later periods, stone-lined pits have been identified which relate to seaweed burning for the production of kelp ash, used in the industrial production of glass. However, these earlier pits filled with charred seaweed have been interpreted by Dickson (1999) as lye pits, where water was leached through the carbonized seaweed to produce a caustic liquid, which could then be used for scouring wool in preparation for dyeing, or, in addition to slaked lime and fats or oils, turned into soap for washing or fulling cloth. The ash of burnt seaweed was sometimes also used to preserve meat and milk products in the postmedieval period in Atlantic Scotland (e.g. Martin 1703, 186–7).

Peat was the most likely fuel source used to help burn the seaweed, and heathy turf with sods from damp areas could have been used to damp down and prevent total combustion. This combination accounts for the remains found at The Biggings (Dickson 1999), and would also account for the few seed remains seen in context G101 at Quoygrew.

Sheep were kept at Quoygrew (Chapter 8), and this interpretation would make sense as a source of lye for household soap and wool textile production. An alternative use for the lye that could have been produced using this pit would be for making lutefisk, a Scandinavian dish prepared by soaking dried fish in a lye solution. Although direct evidence of this use is lacking, stockfish were certainly produced during Phases 2 to 3 at Quoygrew (Chapter 7).

10.8. Conclusions

Quoygrew has proven rich in carbonized botanical remains, including some very fragile remains that often do not survive burning, and some unusual seeds such as *Isatis tinctoria* and *Camelina sativa* that have not previously been identified in Viking Age sites from Orkney. The extensive sampling and flotation regime provided a broad base to study the distribution of plant remains from a variety of contexts across space and time. This study of plant remains from different context types and areas highlights the importance of intra-site analysis, since the assemblages of seeds varied widely.

Nevertheless, the plant remains from Quoygrew are fairly typical of other Viking Age and medieval farm sites from Atlantic Scotland — with the exceptions of gold-of-pleasure (*Camelina sativa*) and woad (*Isatis tinctoria*) already noted. Based upon the seed remains and the non-seed plant remains and matrix materials, it is likely that the samples of plant remains from midden contexts were derived in part from a combination of crop-processing waste, grain stores at various stages of processing, household waste, house and byre floor materials (including fodder), and turf and peat fuel sources. It is possible that other sources of carbonized seeds were responsible for part of the assemblage represented as well.

Particularly unusual contexts included a dump (F1115) from Phase 2 containing the remains of unthreshed oats and weed seeds, which may represent burned fodder and byre floor contents, and a hearth context from Phases 2 to 3 (G101) which contained a high concentration of carbonized seaweed, interpreted here as intended for producing lye (used in scouring wool, producing soap, or preparing lutefisk) or a preservative.

It is clear from the botanical data that the inhabitants of Quoygrew used surrounding lands to cultivate cereals, including barley, common oat, and bristle oat. Flax was also a local crop. The pattern of crop and weed seeds suggests the use of both heavily fertilized infields and machair-associated outfields from Phase 1, with possible expansion of both field types in later phases.

The most prominent gathered wild resources (that appear in the carbonized seed record) are turf and peat fuels, and seaweed. Remains from turf fuel ash are found in most contexts at Quoygrew, and large amounts of turf were likely required to fuel the economic activities at the site. This would have required management on the part of the inhabitants of Westray, to balance fuel needs with demands for pasture and arable land. There is some indication of a shift from peat to turf in Phase 4, possibly suggesting that local sources of the former had become scarce. In the recent past, Westray often depended on peat imported from neighbouring Eday (Fenton 1978, 213) and on coal, which was such a common find in Phase 6 at Quoygrew that it was not recorded systematically during excavation.

One of the clearest and most illuminating temporal trends, evident in different ways in different context types, was the changing role of oats. In Phases 2 to 3 oats were preferentially represented in contexts likely to include byre waste that had been burnt as fuel. This crop may thus have been increasingly used for animal fodder. Conversely, in earlier and later contexts (of Phases 1 and 4) carbonized oats were more abundant in middens — perhaps implying that they were charred during drying for human consumption. It is conceivable (although by no means definitive) that these patterns relate to the demands of intensive dairy production in Phases 2 to 3 (cf. Chapter 8). In turn, an increased use of byres could have provided a greater output of dung fuel and fertilizer, allowing for more cereal production and the expansion of infields.

Fuel use is another resource activity that must have required a strategy of decision-making involving multiple aspects of the economy. Fuel procurement would have involved balancing other grassland and heathland needs of the site and the community. Otherwise whole landscapes could be stripped to bedrock, as occurred on Papa Stour in Shetland (Fenton 1986, 104). Less dramatically, the stripping of peat would need to have been balanced with the necessity of grazing livestock on hill land.

The specific mixture of fuels required would need to have been calculated depending on the temperature, speed, smoke production, and other characteristics desired of the fire. The number and types of fires at the site would be closely tied to economic activities, like drying crops and processing fish oil. The production of ash would also have been managed for animal husbandry (as bedding) and arable agriculture (as fertilizer).

The plant economy at this site was tightly linked to the resources available locally on Westray, but its success also required careful management wherein the outputs and by-products of one activity were important inputs to another. This kind of resource cycling makes interpretation of the plant remains a challenge. However, it was one of the essential features (and strengths) of the multifaceted economic strategy, and of daily rural life, at Quoygrew.

Table 10.4. Count and density of carbonized botanical remains from midden contexts by phase and area.

Group	Scientific name	Phase 1 (G)		Phase 2 (F)		Phase 2–3 (A,B,C)		Phase 2–3 (G)		Phase 3 (F)		Phase 3–4 (J)		Phase 4 (F)		Phase 4–5 (F)		Total	
		count	No./10L	count	No./10L	count	No./10L	count	No./10L	count	No./10L	count	No./10L	count	No./10L	count	No./10L	count	No./10L
	Volume	212.6		45		796.4		202		8		8		18		9		1299	
Cereals	*Avena* spp.	879	41.35	93	20.67	941	11.82	145	7.18	2	2.50	11	13.75	29	16.11	19	21.11	2119	16.31
	Cerealia	373	17.54	24	5.33	784	9.84	66	3.27	3	3.75	1	1.25	5	2.78	7	7.78	1263	9.72
	Hordeum spp.	599	28.17	148	32.89	1975	24.80	252	12.48	7	8.75			25	13.89	12	13.33	3018	23.23
	cf. *Triticum* spp.					1	0.01											1	0.01
	Avena spp. awn	27	1.27	5	1.11	35	0.44	4	0.20							3	3.33	74	0.57
	Avena spp. floret base	3	0.14			21	0.26	2	0.10			1	1.25			1	1.11	28	0.22
	Avena sativa/A. strigosa floret base	8	0.38	2	0.44													10	0.08
	Avena sativa floret base	6	0.28															6	0.05
Cereal chaff and straw	*Hordeum* spp. rachis internode																	0	0.00
	Hordeum cf. *distichon* 2-row rachis internode							1	0.05									1	0.01
	Hordeum cf. *vulgare* 6-row rachis internode	7	0.33	2	0.44	34	0.43											43	0.33
	Hordeum spp. awn					11	0.14											11	0.08
	Triticum spp. rachis internode					1	0.01											1	0.01
	Indeterminate rachis internode	1	0.05											1	0.56			2	0.02
	Culm nodes	1	0.05															1	0.01
	Lemma	51	2.40	4	0.89			1	0.05									56	0.43
	Embryo/scutella	14	0.66	7	1.56											3	3.33	24	0.18
	Chaff indeterminate	6	0.28			57	0.72											63	0.48
Economic	*Linum usitatissimum*	74	3.48	4	0.89	293	3.68	78	3.86	2	2.50			5	2.78			456	3.51
	cf. *Linum usitatissimum*	11	0.52	1	0.22	11	0.14	3	0.15	1	1.25							27	0.21
	Isatis tinctoria	2	0.09															2	0.02
	cf. *Isatis tinctoria*					1	0.01											1	0.01
Arable	*Aphanes arvensis*							1	0.05									1	0.01
	Camelina sativa	2	0.09															3	0.02
	cf. *Camelina sativa*	9	0.42															9	0.07
	Capsella bursa-pastoris	1	0.05	1	0.22					1	1.25			1	0.56			4	0.03

Table 10.4. (cont.)

Group	Scientific name	Phase 1 (G) count	No./10L	Phase 2 (F) count	No./10L	Phase 2–3 (A,B,C) count	No./10L	Phase 2–3 (G) count	No./10L	Phase 3 (F) count	No./10L	Phase 3–4 (J) count	No./10L	Phase 4 (F) count	No./10L	Phase 4–5 (F) count	No./10L	Total count	No./10L
	Volume	212.6		45		796.4		202		8		8		18		9		1299	
Arable (cont.)	Chenopodium album					2	0.03											2	0.02
	Chrysanthemum spp.					1	0.01											1	0.01
	Euphorbia helioscopia	3	0.14	1	0.22	2	0.03	1	0.05									7	0.05
	Papaver spp.																	0	0.00
	Papaver rhoeas																	0	0.00
	Polygonum aviculare	4	0.19	1	0.22	8	0.10	2	0.10							1	1.11	16	0.12
	Fallopia convolvulus					22	0.28											22	0.17
	cf. Fallopia convolvulus					2	0.03											2	0.02
	Polygonum maculosa (Polygonum)			3	0.67	1	0.01											4	0.03
	Polygonum spp.	3	0.14					2	0.10									5	0.04
	Polygonaceae	27	1.27	1	0.22			17	0.84	2	2.50			2	1.11			50	0.38
	Spergula arvensis	21	0.99	1	0.22	38	0.48	55	2.72	1	1.25							116	0.89
	Stellaria media	54	2.54	32	7.11	461	5.79	47	2.33	2	2.50			20	11.11			616	4.74
	cf. Stellaria media					1	0.01	25	1.24									26	0.20
Grassland	Danthonia decumbens					45	0.57											45	0.35
	Danthonia spp.			1	0.22											1	1.11	2	0.02
	Poa annua	1	0.05	2	0.44													3	0.02
	Poaceae <1 mm	60	2.82	44	9.78			53	2.62	2	2.50	4	5.00	17	9.44	11	12.22	191	1.47
	Poaceae 1–2 mm	46	2.16	2	0.44	314	3.94	10	0.50			1	1.25	3	1.67	2	2.22	378	2.91
	Poaceae 2–4 mm	2	0.09			129	1.62											131	1.01
	Poaceae scutellae							1	0.05									1	0.01
	Leontodon spp.					1	0.01											1	0.01
	Linum catharticum	1	0.05															1	0.01
	Plantago lanceolata	11	0.52	1	0.22	24	0.30	9	0.45			1	1.25					46	0.35
	cf. Plantago lanceolata					1	0.01											1	0.01
	Plantago maritima (capsule)							1	0.05									1	0.01
	Potentilla erecta			9	2.00											6	6.67	15	0.12
	Potentilla cf. erecta	10	0.47									1	1.25					11	0.08
	Ranunculus acris type	1	0.05															1	0.01
	Ranunculus ficaria tuber																	0	0.00
	cf. Rhinanthus minor							1	0.05									1	0.01
	Rumex acetosa					2	0.03	1	0.05									2	0.02

Table 10.4. (cont.)

Group	Scientific name	Phase 1 (G) count	Phase 1 (G) No./10L	Phase 2 (F) count	Phase 2 (F) No./10L	Phase 2–3 (A,B,C) count	Phase 2–3 (A,B,C) No./10L	Phase 2–3 (G) count	Phase 2–3 (G) No./10L	Phase 3 (F) count	Phase 3 (F) No./10L	Phase 3–4 (J) count	Phase 3–4 (J) No./10L	Phase 4 (F) count	Phase 4 (F) No./10L	Phase 4–5 (F) count	Phase 4–5 (F) No./10L	Total count	Total No./10L
	Volume	212.6		45		796.4		202		8		8		18		9		1299	
Heathland	Calluna vulgaris leaves	47	2.21	43	9.56	39		39	1.93			10	12.50			10	11.11	149	1.15
	Calluna vulgaris flowers/buds	1	0.05			39	0.49					3	3.75					43	0.33
	Empetrum nigrum	8	0.38			13	0.16	1	0.05					2	1.11			24	0.18
	Empetrum nigrum leaves	21	0.99			475	5.96	35	1.73			13	16.25			15	16.67	559	4.30
	Ericaceae leaves	82	3.86	54	12.00			16	0.79					5	2.78			157	1.21
	Ericaceae seed	1	0.05			6	0.08											7	0.05
	Erica spp.	1	0.05			1	0.01											2	0.02
	Erica cinerea	3	0.14															3	0.02
	Erica cf. cinerea	1	0.05															1	0.01
	Juncus squarrosus	4	0.19															4	0.03
	Juncus spp.					49	0.62											49	0.38
	Juncus spp. capsule							1	0.05			2	2.50					3	0.02
	Luzula spp.					34	0.43											34	0.26
	cf. Luzula spp.	5	0.24															5	0.04
	Vaccinium myrtillus	1				1	0.01											1	0.01
Ruderal	Atriplex spp.	7	0.33	7	1.56	2	0.03	23	1.14			1	1.25					40	0.31
	cf. Atriplex spp.							2	0.10									2	0.02
	Brassica spp.					6	0.08	2	0.10									8	0.06
	Euphorbia peplus							1	0.05									1	0.01
	Fumaria spp.					1	0.01											1	0.01
	Galium aparine	3	0.14											1	0.56			4	0.03
	Hypericum spp.	1	0.05			15	0.19	1	0.05									17	0.13
	cf. Hypericum spp.					2	0.03											2	0.02
	Lapsana communis					3	0.04											3	0.02
	cf. Lapsana communis	1	0.05					3	0.15									4	0.03
	Myosotis spp.	1	0.05															1	0.01
	Odontites spp./Euphrasia spp.	2	0.09															2	0.02
	Plantago major							1	0.05									1	0.01
	Plantago media	1	0.05															1	0.01
	Potentilla anserina							1	0.05									1	0.01
	Raphanus raphanistrum					1	0.01											1	0.01
	Raphanus raphanistrum pod					11	0.14											11	0.08
	Rumex acetosella	1	0.05															1	0.01

Table 10.4. (cont.)

| Group | Scientific name | Phase 1 (G) count | Phase 1 (G) No./10L | Phase 2 (F) count | Phase 2 (F) No./10L | Phase 2–3 (A,B,C) count | Phase 2–3 (A,B,C) No./10L | Phase 2–3 (G) count | Phase 2–3 (G) No./10L | Phase 3 (F) count | Phase 3 (F) No./10L | Phase 3–4 (I) count | Phase 3–4 (I) No./10L | Phase 4 (F) count | Phase 4 (F) No./10L | Phase 4–5 (F) count | Phase 4–5 (F) No./10L | Total count | Total No./10L |
|---|
| | Volume | 212.6 | | 45 | | 796.4 | | 202 | | 8 | | 8 | | 18 | | 9 | | 1299 | |
| Ruderal (cont.) | Rumex obtusifolius type | | | | | 23 | 0.29 | | | | | | | | | | | 23 | 0.18 |
| | Tripleurospermum inodorum | 6 | 0.28 | | | | | | | | | | | | | | | 6 | 0.05 |
| | Tripleurospermum maritimum | 3 | 0.14 | 1 | 0.22 | 21 | 0.26 | | | | | | | | | | | 25 | 0.19 |
| | cf. Tripleurospermum maritimum | | | | | 3 | 0.04 | | | | | | | | | | | 3 | 0.02 |
| | Tripleurospermum spp. | | | 2 | 0.44 | | | 1 | 0.05 | | | | | | | | | 3 | 0.02 |
| | Urtica dioica | 2 | 0.09 | | | | | | | | | | | | | | | 2 | 0.02 |
| | Viola subgenus Melanium | | | | | | | | | | | | | | | | | | |
| Wetland | Ajuga spp. | | | | | 4 | 0.05 | | | | | | | | | | | 4 | 0.03 |
| | Carex hostiana | | | | | 1 | 0.01 | | | | | | | | | | | 1 | 0.01 |
| | Carex hostiana type | | | | | 1 | 0.01 | | | | | | | | | | | 1 | 0.01 |
| | Carex spp. | 52 | 2.45 | 93 | 20.67 | 7 | 0.09 | 97 | 4.80 | 17 | 21.25 | 26 | 32.50 | 9 | 5.00 | 1 | 1.11 | 302 | 2.32 |
| | Carex spp. lenticular type | | | | | 5 | 0.06 | | | | | | | | | | | 5 | 0.04 |
| | Carex spp. trigonous type | | | 165 | 36.67 | 835 | 10.48 | | | | | | | | | 165 | 183.33 | 1165 | 8.97 |
| | Carex spp. utricle | | | | | 2 | 0.03 | | | | | | | | | | | 2 | 0.02 |
| | Cyperaceae | 31 | 1.46 | 1 | 0.22 | | | 4 | 0.20 | | | | | | | 1 | 1.11 | 37 | 0.28 |
| | Eleocharis palustris | 47 | 2.21 | 2 | 0.44 | 31 | 0.39 | 5 | 0.25 | | | | | | | | | 85 | 0.65 |
| | cf. Eleocharis palustris | | | | | 2 | 0.03 | | | | | | | | | | | 2 | 0.02 |
| | Eriophorum angustifolium | | | | | 3 | 0.04 | | | | | | | | | | | 3 | 0.02 |
| | cf. Eriophorum angustifolium | | | | | 1 | 0.01 | | | | | | | | | | | 1 | 0.01 |
| | Eriophorum latifolium/ vaginatum | | | | | 45 | 0.57 | | | | | | | | | | | 45 | 0.35 |
| | cf. Eriophorum spp. | | | | | 2 | 0.03 | | | | | | | | | | | 2 | 0.02 |
| | Littorella uniflora | 2 | 0.09 | 5 | 1.11 | | | 5 | 0.25 | | | | | | | 1 | 1.11 | 13 | 0.10 |
| | cf. Littorella uniflora | 1 | 0.05 | | | | | | | | | | | | | | | 1 | 0.01 |
| | Lychnis flos-cuculi | | | | | | | | | | | | | | | | | 0 | 0.00 |

Table 10.4. (cont.)

Group	Scientific name	Phase 1 (G) count	Phase 1 (G) No./10L	Phase 2 (F) count	Phase 2 (F) No./10L	Phase 2–3 (A,B,C) count	No./10L	Phase 2–3 (G) count	No./10L	Phase 3 (F) count	No./10L	Phase 3–4 (J) count	No./10L	Phase 4 (F) count	No./10L	Phase 4–5 (F) count	No./10L	Total count	No./10L
	Volume	212.6		45		796.4		202		8		8		18		9		1299	
Wetland (cont.)	*Montia fontana*	12	0.56	17	3.78	165	2.07	27	1.34			1	1.25			10	11.11	232	1.79
	cf. *Montia fontana*					6	0.08											6	0.05
	Potamogeton spp.																	0	0.00
	Potentilla palustris					1	0.01											1	0.01
	Potentilla cf. *palustris*							1	0.05									1	0.01
	Ranunculus flammula	3	0.14	4	0.89	27	0.34									3	3.33	37	0.28
	Ranunculus cf. *flammula*					2	0.03											2	0.02
	Schoenoplectus lacustris	1	0.05															1	0.01
Unclassified	cf. *Anthemis cotula*			1	0.22													1	0.01
	Arenaria spp.							1	0.05									1	0.01
	Arenaria spp./ *Stellaria* spp.			1	0.22							3	3.75					4	0.03
	Asteraceae	4	0.19	1	0.22	1	0.01	4	0.20									10	0.08
	cf. Asteraceae	5	0.24															5	0.04
	Asteraceae/ Apiaceae							1	0.05									1	0.01
	Brassicaceae					18	0.23											18	0.14
	Brassica oleracea																	0	0.00
	Brassica spp./*Sinapis* spp.	4	0.19					2	0.10					1	0.56			8	0.06
	Brassica spp./ *Cannabis* spp.	2	0.09															2	0.02
	Carex spp./ *Rumex* spp.	1	0.05			1	0.01											2	0.02
	Caryophyllaceae	23	1.08	1	0.22	9	0.11	10	0.50							3	3.33	46	0.35
	Centrospermae	3	0.14	4	0.89	23	1.14							40	22.22			70	0.54
	Cerastium spp.	2	0.09			2	0.03	1	0.05									5	0.04
	Cerastium spp./ *Stellaria* spp.	2	0.09					2	0.10									4	0.03
	Chenopodiaceae					115	1.44			1	1.25			35	19.44			151	1.16
	cf. Chenopodiaceae					2	0.03											2	0.02

Table 10.4. (cont.)

Group	Scientific name	Phase 1 (G)		Phase 2 (F)		Phase 2–3 (A,B,C)		Phase 2–3 (G)		Phase 3 (F)		Phase 3–4 (J)		Phase 4 (F)		Phase 4–5 (F)		Total	
		count	No./10L	count	No./10L	count	No./10L	count	No./10L	count	No./10L	count	No./10L	count	No./10L	count	No./10L	count	No./10L
	Volume	212.6		45		796.4		202		8		8		18		9		1299	
Unclassified (cont.)	Chenopodium spp.					15	0.19											15	0.12
	Clusiaceae (was Hypericaceae)	1	0.05															1	0.01
	cf. Descurainia spp.					1	0.01											1	0.01
	Euphorbia spp.					3	0.04											3	0.02
	Fabaceae					9	0.11	1	0.05									10	0.08
	cf. Fabaceae					0	0.00	1	0.05									1	0.01
	Fabaceae pod					1	0.01											1	0.01
	Galium spp.	1	0.05											1	0.56			2	0.02
	Lamiaceae	1	0.05															1	0.01
	Potentilla spp.	16	0.75	1	0.22	75	0.94	5	0.25									97	0.75
	Ranunculus spp.					1	0.01											1	0.01
	cf. Ranunculus spp.					1	0.01											1	0.01
	Ranunculus repens					5	0.06											5	0.04
	Ranunculus repens type					9	0.11											9	0.07
	Rumex spp.	43	2.02	1	0.22	71	0.89	21	1.04			5	6.25	2	1.11			143	1.10
	Rumex spp. fruit (w/perianth)																		
	cf. Salvia spp.					1	0.01											1	0.01
	Scleranthus annuus			1	0.22													1	0.01
	Silene dioica					5	0.06											5	0.04
	Stellaria spp.							3	0.15									3	0.02
	Stellaria nemorum	1	0.05															1	0.01
	Veronica spp.			1	0.22													1	0.01
	Unidentifiable seed fragments*	513	24.13	4	0.89			272	13.47	25	31.25	9	11.25	30	16.67	70	77.78	923	7.11
	Unidentified seeds	13	0.61					7	0.35			7	8.75			4	4.44	31	0.24
Total seeds (* excluding unidentifiable seed fragments and leaves)		2597	122.15	689	153.11	6717	84.34	999	49.46	41	51.25	62	77.50	198	110.00	255	283.33	11558	88.98
Non-seed	Seaweed	47	2.21	4	0.89	2039	25.60	42	2.08							4	4.44	2136	16.44
	Moss stem	1	0.05	5	1.11					1	1.25	32	40.00	1	0.56			40	0.31
	Underground plant part	77	3.62	103	22.89			141	6.98	116	145.00	274	342.50	54	30.00	36	40.00	801	6.17

Table 10.5. *Count and density of carbonized botanical remains from hearth, fill/dump, and floor layer contexts by phase and area.*

Group	Scientific name	Hearth Phase 2–3 (G3) count	No./10L	Hearth Phase 3 (F) count	No./10L	Hearth Phase 4 (F) count	No./10L	Fill/Dump Phase 2 (F) count	No./10L	Fill/Dump Phase 3 (F) count	No./10L	Floor Layer Phase 2 (F) count	No./10L	Floor Layer Phase 3 (F) count	No./10L	Floor Layer Phase 4 (F) count	No./10L	Total count	No./10L	Total site count	No./10L	
	Volume	9		23		23		5		41		10		7		5		123		1422		
Cereals	*Avena* spp.	3	3.33	3	1.30	10	4.35	322	644.00	161	39.27	10	10.00	19	27.14	19	38.00	547	50.65	2666	18.75	
	Cerealia	1	1.11			6	2.61	4	8.00	49	11.95	7	7.00	3	4.29			70	6.48	1333	9.37	
	Hordeum spp.	5	5.56			7	3.04	3	6.00	121	29.51	19	19.00	4	5.71	6	12.00	165	15.28	3183	22.38	
	cf. *Triticum* spp.																			1	0.01	
Cereal chaff and straw	*Avena* spp. awn							257	514.00	51	12.44			1	1.43	1	2.00	310	28.70	384	2.70	
	Avena spp. floret base							1	2.00	11	2.68	1	1.00					13	1.20	41	0.29	
	Avena sativa/*A. strigosa* floret base							5	10.00	6	1.46							11	1.02	21	0.15	
	Avena sativa floret base																			6	0.04	
	Hordeum spp. rachis internode									1	0.24	4	4.00					5	0.46	5	0.04	
	Hordeum cf. *distichon* 2-row rachis internode							1	2.00									1	0.09	2	0.01	
	Hordeum cf. *vulgare* 6-row rachis internode									4	0.98							4	0.37	47	0.33	
	Hordeum spp. awn																			11	0.08	
	Triticum spp. rachis internode																			1	0.01	
	Indeterminate rachis internode																			2	0.01	
	Culm nodes									2	0.49							2	0.19	3	0.02	
	Lemma							38	76.00	1	0.24							39	3.61	95	0.67	
	Embryo/scutella							1	2.00	3	0.73	2	2.00					6	0.56	30	0.21	
	chaff indeterminate																			63	0.44	
Economic	*Linum usitatissimum*	1	1.11			1	0.43			1	0.24	2	2.00					5	0.46	461	3.24	
	cf. *Linum usitatissimum*																			27	0.19	
	Isatis tinctoria									1	0.24							1	0.09	3	0.02	
	cf. *Isatis tinctoria*									1	0.24							1	0.09	1	0.01	
Arable	*Aphanes arvensis*																			1	0.01	
	Camelina sativa																			3	0.02	
	cf. *Camelina sativa*																			9	0.06	
	Capsella bursa-pastoris						4	1.74	28	56.00	11	2.68			1	1.43			44	4.07	48	0.34

Table 10.5. (cont.)

Group	Scientific name	Hearth Phase 2–3 (G3)		Hearth Phase 3 (F)		Fill/Dump Phase 4 (F)		Fill/Dump Phase 2 (F)		Fill/Dump Phase 3 (F)		Floor Layer Phase 2 (F)		Floor Layer Phase 3 (F)		Floor Layer Phase 4 (F)		Total		Total site	
		count	No./10L	count	No./10L	count	No./10L	count	No./10L	count	No./10L	count	No./10L	count	No./10L	count	No./10L	count	No./10L	count	No./10L
	Volume	9		23		23		5		41		10		7		5		123		1422	
Arable (cont.)	Chenopodium album																			2	0.01
	Chrysanthemum spp.																			1	0.01
	Euphorbia helioscopia									2	0.49	1	1.00					3	0.28	10	0.07
	Papaver spp.									2	0.49							2	0.19	2	0.01
	Papaver rhoeas									1	0.24							1	0.09	1	0.01
	Polygonum aviculare									19	4.63							19	1.76	35	0.25
	Fallopia convolvulus																			22	0.15
	cf. Fallopia convolvulus																			2	0.01
	Polygonum maculosa (Polygonum)	1	1.11							6	1.46							7	0.65	11	0.08
	Polygonum spp.																			5	0.04
	Polygonaceae	3	3.33			1	0.43	4	8.00	37	9.02			1	1.43	4	8.00	50	4.63	100	0.70
	Spergula arvensis									13	3.17					1	2.00	14	1.30	130	0.91
	Stellaria media					51	22.17	33	66.00	483	117.80	61	61.00	3	4.29	5	10.00	636	58.89	1252	8.80
	cf. Stellaria media			9	3.91					7	1.71							16	1.48	42	0.30
Grassland	Danthonia decumbens																			45	0.32
	Danthonia spp.																			2	0.01
	Poa annua																			3	0.02
	Poaceae <1 mm	5	5.56	12	5.22	8	3.48	42	84.00	144	35.12			4	5.71	6	12.00	221	20.46	412	2.90
	Poaceae 1–2 mm	1	1.11			1	0.43			9	2.20	14	14.00			1	2.00	26	2.41	404	2.84
	Poaceae 2–4 mm											1	1.00					1		132	0.93
	Poaceae scutellae																			1	0.01
	Leontodon spp.																			1	0.01
	Linum catharticum																			1	0.01
	Plantago lanceolata	1	1.11			1	0.43	2	4.00	7	1.71							11	1.02	57	0.40
	cf. Plantago lanceolata																			1	0.01
	Plantago maritima (capsule)																			1	0.01
	Potentilla erecta							3	6.00	5	1.22	1	1.00					9	0.83	24	0.17
	Potentilla cf. erecta									2	0.49							2	0.19	13	0.09

Table 10.5. *(cont.)*

Group	Scientific name	Hearth						Fill/Dump				Floor Layer						Total		Total site	
		Phase 2–3 (G3)		Phase 3 (F)		Phase 4 (F)		Phase 2 (F)		Phase 3 (F)		Phase 2 (F)		Phase 3 (F)		Phase 4 (F)		Total		Total site	
	Volume	count	No./10L	count	No./10L	count	No./10L	count	No./10L	count	No./10L	count	No./10L	count	No./10L	count	No./10L	count	No./10L	count	No./10L
		9		23		23		5		41		10		7		5		123		1422	
Grassland (cont.)	*Ranunculus acris* type																			1	0.01
	Ranunculus ficaria tuber									2	0.49							2	0.19	2	0.01
	cf. *Rhinanthus minor*																			1	0.01
	Rumex acetosa																			2	0.01
Heathland	*Calluna vulgaris* leaves					2	0.87	57	114.00	147	35.85	11	11.00	4	5.71	3	6.00	224	20.74	373	2.62
	Calluna vulgaris flowers/buds																			43	0.30
	Empetrum nigrum									4	0.98							4	0.37	28	0.20
	Empetrum nigrum leaves			1	0.43					15	3.66							16	1.48	575	4.04
	Ericaceae leaves	2	2.22			1	0.43	12	24.00	116	28.29	4	4.00	3	4.29	10	20.00	148	13.70	305	2.14
	Ericaceae seed																			7	0.05
	Erica spp.																			2	0.01
	Erica cinerea																			3	0.02
	Erica cf. *cinerea*																			1	0.01
	Juncus squarrosus																			4	0.03
	Juncus spp.									3	0.73							3	0.28	52	0.37
	Juncus spp. capsule							3	6.00									3	0.28	6	0.04
	Luzula spp.			1	0.43													1	0.09	35	0.25
	cf. *Luzula* spp.																			5	0.04
	Vaccinium myrtillus																			1	0.01
Ruderal	*Atriplex* spp.					4	1.74			99	24.15	6	6.00	3	4.29	20	40.00	132	12.22	172	1.21
	cf. *Atriplex* spp.			4	1.74					105	25.61							109	10.09	111	0.78
	Brassica spp.																			8	0.06
	Euphorbia peplus																			1	0.01
	Fumaria spp.									1	0.24							1	0.09	2	0.01
	Galium aparine																			4	0.03
	Hypericum spp.																			17	0.12
	cf. *Hypericum* spp.																			2	0.01
	Lapsana communis									14	3.41							14	1.30	17	0.12
	cf. *Lapsana communis*							1	2.00									1	0.09	5	0.04
	Myosotis spp.					2	0.87	6	12.00	1	0.24							9	0.83	10	0.07

Table 10.5. (cont.)

Group	Scientific name	Hearth Phase 2–3 (G3) count	No./10L	Hearth Phase 3 (F) count	No./10L	Hearth Phase 4 (F) count	No./10L	Fill/Dump Phase 2 (F) count	No./10L	Fill/Dump Phase 3 (F) count	No./10L	Floor Layer Phase 2 (F) count	No./10L	Floor Layer Phase 3 (F) count	No./10L	Floor Layer Phase 4 (F) count	No./10L	Total count	No./10L	Total site count	No./10L
	Volume	9		23		23		5		41		10		7		5		123		1422	
Ruderal (cont.)	Odontites spp./Euphrasia spp.																			2	0.01
	Plantago major							2	4.00					1	1.43			3	0.28	4	0.03
	Plantago media																			1	0.01
	Potentilla anserina																			1	0.01
	Raphanus raphanistrum																			1	0.01
	Raphanus raphanistrum pod																			11	0.08
	Rumex acetosella																			1	0.01
	Rumex obtusifolius type																			23	0.16
	Tripleurospermum inodorum																			6	0.04
	Tripleurospermum maritimum							3	6.00	14	3.41							17	1.57	42	0.30
	cf. Tripleurospermum maritimum																			3	0.02
	Tripleurospermum spp.									14	3.41	2	2.00					16	1.48	19	0.13
	Urtica dioica																			2	0.01
	Viola subgenus Melanium									1	0.24							1	0.09	1	0.01
Wet ground	Ajuga spp.																			5	0.04
	Carex hostiana																			1	0.01
	Carex hostiana type																			1	0.01
	Carex spp.					4	1.74	12	24.00	28	6.83	24	24.00	1	1.43	4	8.00	73	6.76	375	2.64
	Carex spp. lenticular type																			5	0.04
	Carex spp. trigonous type																			1168	8.21
	Carex spp. utricle																			2	0.01
	Cyperaceae																			37	0.26
	Eleocharis palustris	1	1.11					2	4.00	7	1.71			1	1.43			11	1.02	98	0.69
	cf. Eleocharis palustris																			2	0.01
	Eriophorum angustifolium																			3	0.02

Table 10.5. (cont.)

		Hearth						Fill/Dump				Floor Layer						Total			
		Phase 2-3 (G3)		Phase 3 (F)		Phase 4 (F)		Phase 2 (F)		Phase 3 (F)		Phase 2 (F)		Phase 3 (F)		Phase 4 (F)		Total		Total site	
Group	Scientific name	count	No./10L	count	No./10L	count	No./10L	count	No./10L	count	No./10L	count	No./10L	count	No./10L	count	No./10L	count	No./10L	count	No./10L
	Volume	9		23		23		5		41		10		7		5		123		1422	
Wet ground (cont.)	cf. *Eriophorum angustifolium*																			1	0.01
	Eriophorum latifolium/vaginatum																			46	0.32
	cf. *Eriophorum* spp.																			2	0.01
	Littorella uniflora	1	1.11							3	0.73			1	1.43			6	0.56	19	0.13
	cf. *Littorella uniflora*																			1	0.01
	Lychnis flos-cuculi									1	0.24							1	0.09	1	0.01
	Montia fontana	3	3.33	1	0.43	1	0.43	1	2.00	8	1.95	3	3.00	1	1.43	3	6.00	21	1.94	256	1.80
	cf. *Montia fontana*																			6	0.04
	Potamogeton spp.													2	2.86	1	2.00	3	0.28	3	0.02
	Potentilla palustris																			2	0.01
	Potentilla cf. *palustris*																			1	0.01
	Ranunculus flammula																			37	0.26
	Ranunculus cf. *flammula*											1	1.00							2	0.01
	Schoenoplectus lacustris																			1	0.01
Unclassified	cf. *Anthemis cotula*																			1	0.01
	Arenaria spp.									5	1.22							5	0.46	6	0.04
	Arenaria spp./*Stellaria* spp.									1	0.24							1	0.09	5	0.04
	Asteraceae							1	2.00											10	0.07
	cf. Asteraceae									1	0.24							1	0.09	6	0.04
	Asteraceae/Apiaceae											1	1.00							1	0.01
	Brassicaceae									1	0.24									18	0.13
	Brassica oleracea																	1	0.09	1	0.01
	Brassica spp./*Sinapis* spp.							1	2.00									1	0.09	9	0.06
	Brassica spp./*Cannabis* spp.																			2	0.01
	Carex spp./*Rumex* spp.																			2	0.01
	Caryophyllaceae	11	12.22	4	1.74	2	0.87			1	0.24			13	18.57	9	18.00	40	3.70	86	0.60
	Centrospermae	1	1.11	18	7.83	67	29.13	6	12.00	220	53.66			54	77.14	14	28.00	380	35.19	450	3.16
	Cerastium spp.					1	0.43	11	22.00	2	0.49	3	3.00	4	5.71			21	1.94	26	0.18

Table 10.5. (*cont.*)

Group	Scientific name	Hearth Phase 2–3 (G3) count	Hearth Phase 2–3 (G3) No./10L	Hearth Phase 3 (F) count	Hearth Phase 3 (F) No./10L	Hearth Phase 4 (F) count	Hearth Phase 4 (F) No./10L	Fill/Dump Phase 2 (F) count	Fill/Dump Phase 2 (F) No./10L	Fill/Dump Phase 3 (F) count	Fill/Dump Phase 3 (F) No./10L	Floor Layer Phase 2 (F) count	Floor Layer Phase 2 (F) No./10L	Floor Layer Phase 3 (F) count	Floor Layer Phase 3 (F) No./10L	Floor Layer Phase 4 (F) count	Floor Layer Phase 4 (F) No./10L	Total count	Total No./10L	Total site count	Total site No./10L
	Volume	9		23		23		5		41		10		7		5		123		1422	
Unclassified (cont.)	*Cerastium* spp./*Stellaria* spp.																			4	0.03
	Chenopodiaceae			5	2.17					71	17.32							76	7.04	227	1.60
	cf. Chenopodiaceae																			2	0.01
	Chenopodium spp.	2	2.22			32	13.91	10	20.00					3	4.29			47	4.35	62	0.44
	Clusiaceae (was Hypericaceae)																			1	0.01
	cf. *Descurainia* spp.																			1	0.01
	Euphorbia spp.																			3	0.02
	Fabaceae									2	0.49							2	0.19	12	0.08
	cf. Fabaceae																			2	0.01
	Fabaceae pod																			1	0.01
	Galium spp.									1	0.24							1	0.09	3	0.02
	Lamiaceae																			1	0.01
	Potentilla spp.									1	0.24							1	0.09	99	0.70
	Ranunculus spp.					1	0.43											1	0.09	2	0.01
	cf. *Ranunculus* spp.																			1	0.01
	Ranunculus repens																			5	0.04
	Ranunculus repens type									1	0.24							1	0.09	10	0.07
	Rumex spp.	10	11.11							68	16.59	2	2.00					80	7.41	224	1.58
	Rumex spp. fruit (w/perianth)									1	0.24							1	0.09	1	0.01
	cf. *Salvia* spp.																			1	0.01
	Scleranthus annuus			1	0.43													1	0.09	2	0.01
	Silene dioica																			5	0.04
	Stellaria spp.																			3	0.02
	Stellaria nemorum																			1	0.01
	Veronica spp.																			1	0.01
	Unidentifiable seed fragments*			11	4.78	23	10.00	50	100.00	199	48.54	28	28.00	16	22.86	2	4.00	329	30.46	1252	8.80
	Unidentified seeds									2	0.49							2	0.19	33	0.23
	Total seeds (* excluding unidentifiable seed fragments and leaves)	50	55.56	53	23.04	198	86.09	787	1574.00	1592	388.29	158	158.00	116	165.71	74	148.00	3028	280.37	14727	103.57
Non-seed	Seaweed	1306	1451.11	1	0.43			2	4.00	4	0.98	46	46.00					1359	125.83	3506	24.66
	Moss stem			3	1.30			107	214.00	41	10.00	10	10.00	2	2.86			171	15.83	211	1.48
	Underground plant part	12	13.33	6	2.61	12	5.22	179	358.00	142	34.63	71	71.00	8	11.43	17	34.00	447	41.39	1248	8.78
	Vitrified fuel ash	3	3.33	5	2.17	5	2.17	9	18.00	12	2.93			1	1.43			35	3.24	69	0.49

197

Chapter 11

Feeding the Livestock: the Stable Isotope Evidence

James H. Barrett and Michael P. Richards

11.1. Introduction

The study of livestock husbandry practices has the potential to illuminate economic continuity and change. Much information can be derived from zooarchaeology and archaeobotany. At Quoygrew it is likely that cattle were managed in large part for dairying — whereas caprines (sheep or goats, mostly sheep at Quoygrew) were multipurpose animals and pigs were providers of meat and other carcass products (Chapter 8). Oats were probably used as high-quality fodder for stalled cattle (Chapter 10). These practices showed variability through time — with dairying and possibly also the use of oats for fodder peaking in Phases 2 to 3. Thus it is possible to see the generality

of making a living in medieval Orkney and (arguably) the specifics of an episode of economic intensification.

Additional information regarding herd management can be provided by stable isotope analysis of the collagen (protein) fraction of animal bone: measures of $\delta^{13}C$ and $\delta^{15}N$ isotope ratios can inform regarding grazing and foddering. The bases of this approach are well established, albeit continually refined (e.g. Lee-Thorp 2008). It can serve to detect grazing on coastal vegetation (Britton *et al.* 2008; Balasse *et al.* 2009) and/ or manured fields (Bogaard *et al.* 2007), the provision of terrestrial animal products (e.g. meat scraps) with feed (e.g. Müldner & Richards 2005) and/or the use of fish by-products to supplement fodder (Richards *et al.* 2006, 125).

Figure 11.1. *Sheep grazing on seaweed in North Ronaldsay, Orkney. (Image: James Barrett.)*

Table 11.1. *Collagen δ¹³C and δ¹⁵N values (with associated context and ageing data) for samples of caprine, cattle and pig bone from Quoygrew.*

Taxon	Phase	Context	Location	Element	Proximal epiphysis fused?	Distal epiphysis fused?	Age	%C	%N	δ¹³C	δ¹⁵N	C:N
Caprine	1	G022	Farm Mound	Metapodial	?	y	Mature	36.9	13.7	−20.5	5.4	3.2
Caprine	1	G022	Farm Mound	Metapodial	y	?	Mature size & texture	42.9	15.6	−20.6	5.4	3.2
Caprine	1	G022	Farm Mound	Metapodial	?	?	Mature size & texture	43.6	15.9	−19.9	6.7	3.2
Caprine	1	G022	Farm Mound	Metatarsal	y	?	Mature size & texture	43.6	15.4	−21.0	5.5	3.3
Caprine	1	G022	Farm Mound	Metacarpal	?	?	Mature size & texture	42.1	15.3	−20.6	5.7	3.2
Caprine	1	G037	Farm Mound	Metacarpal	y	?	Mature size & texture	39.1	14.0	−21.2	5.2	3.3
Caprine	1	G037	Farm Mound	Metacarpal	y	?	Mature size & texture	43.9	15.6	−20.1	5.7	3.3
Caprine	1	G059	Farm Mound	Metacarpal	?	y	Mature	43.0	15.5	−20.1	5.7	3.2
Caprine	1	G059	Farm Mound	Metapodial	?	y	Mature	42.3	15.4	−20.0	5.5	3.2
Caprine	1	G059	Farm Mound	Metatarsal	y	?	Mature size & texture	43.6	15.6	−21.0	6.2	3.3
Caprine	2	F740	Fish Midden	Vertebra	n	n	Immature (articulated skeleton)	43.1	14.9	−20.7	6.5	3.4
Caprine	2	F995	North Midden	Mandible			Mature (M3 in wear)	44.6	15.1	−19.7	6.2	3.5
Caprine	2–3	G008	Farm Mound	Metacarpal	y	?	Mature size & texture	43.8	15.9	−19.7	7.0	3.2
Caprine	2–3	G008	Farm Mound	Metacarpal	y	?	Mature size & texture	42.2	14.9	−20.9	6.5	3.3
Caprine	2–3	G008	Farm Mound	Metacarpal	y	n	Immature	43.0	15.5	−20.7	7.7	3.3
Caprine	2–3	G013	Farm Mound	Metacarpal	y	?	Mature size & texture	42.5	15.1	−20.0	6.5	3.3
Caprine	2–3	G013	Farm Mound	Metatarsal	y	?	Mature size & texture	43.9	15.4	−20.4	4.9	3.3
Caprine	2–3	G014	Farm Mound	Metatarsal	y	?	Mature size & texture	43.9	15.4	−20.0	7.3	3.3
Caprine	2–3	G015	Farm Mound	Metacarpal	?	y	Mature	41.6	15.0	−21.0	5.1	3.2
Caprine	2–3	G015	Farm Mound	Metatarsal	y	?	Mature size & texture	48.8	17.6	−20.0	7.3	3.3
Caprine	2–3	G020	Farm Mound	Metatarsal	y	?	Immature (near mature size)	44.0	15.9	−21.6	7.6	3.2
Caprine	2–3	G020	Farm Mound	Pelvis	y	y	Mature	42.4	14.7	−20.4	5.9	3.4
Caprine	2–3	G048	Farm Mound	Metatarsal	?	y	Mature	35.7	13.0	−21.2	5.6	3.2
Caprine	2–3	G048	Farm Mound	Metapodial	?	y	Mature	38.9	14.0	−21.2	7.1	3.3
Caprine	2–3	G052	Farm Mound	Metatarsal	?	y	Mature	41.9	15.2	−20.7	5.1	3.2
Caprine	2–3	G052	Farm Mound	Metacarpal	y	?	Mature size & texture	42.1	14.7	−19.3	9.0	3.3
Caprine	2–3	G055	Farm Mound	Metacarpal	y	?	Mature size & texture	41.6	14.7	−20.1	8.1	3.3
Caprine	2–3	G058	Farm Mound	Metacarpal	?	y	Mature	43.4	16.0	−21.2	6.5	3.2
Caprine	2–3	G058	Farm Mound	Metapodial	?	y	Mature	42.2	15.5	−20.6	5.8	3.2
Caprine	2–3	G058	Farm Mound	Metacarpal	?	y	Mature	39.0	14.1	−20.2	5.0	3.2
Caprine	3	F489	Room 1 layer	Mandible			Immature (M3 erupting)	40.3	13.9	−20.8	6.4	3.4
Caprine	3	F911	Room 1 layer	Scapula	?	?	Mature size & texture	44.1	15.2	−20.5	6.9	3.4
Cattle	1	G022	Farm Mound	Metacarpal	y	n	Immature (near mature size)	41.8	15.0	−21.5	5.9	3.3
Cattle	1	G022	Farm Mound	Metapodial	?	?	Mature size & texture	41.2	14.8	−21.7	5.6	3.3
Cattle	1	G022	Farm Mound	Metatarsal	y	?	Mature size & texture	40.4	14.6	−21.2	5.6	3.2
Cattle	1	G022	Farm Mound	Metatarsal	y	?	Immature (near mature size)	41.0	15.1	−21.2	5.5	3.2
Cattle	1	G022	Farm Mound	Skull			Mature size & texture	43.2	15.5	−21.5	5.0	3.2
Cattle	1	G035	Farm Mound	Metapodial	?	n	Immature (near mature size)	40.8	14.9	−21.5	5.8	3.2
Cattle	1	G037	Farm Mound	Metapodial	?	?	Mature size & texture	43.8	16.4	−21.7	5.9	3.1
Cattle	1	G037	Farm Mound	Metacarpal	y	?	Mature size & texture	40.8	14.7	−21.5	5.1	3.2
Cattle	1	G059	Farm Mound	Metatarsal	?	y	Mature	42.0	14.7	−21.1	5.3	3.4
Cattle	1	G059	Farm Mound	Metatarsal	?	y	Mature	36.8	12.4	−21.4	5.8	3.5
Cattle	1	G059	Farm Mound	Metacarpal	?	y	Mature	40.0	13.6	−21.2	6.1	3.5
Cattle	1	G059	Farm Mound	Metapodial	?	y	Mature	39.5	13.5	−21.3	4.2	3.4
Cattle	2	F959	House 5 floor	Mandible			Mature	35.5	12.9	−21.3	5.9	3.2
Cattle	2–3	G008	Farm Mound	Metacarpal	y	?	Mature size & texture	41.7	14.9	−21.3	5.9	3.3

Table 11.1. *(cont.)*

Taxon	Phase	Context	Location	Element	Proximal epiphysis fused?	Distal epiphysis fused?	Age	%C	%N	δ^{13}C	δ^{15}N	C:N
Cattle	2–3	G013/G015	Farm Mound	Metacarpal	y	y	Mature	42.1	15.1	−21.2	5.0	3.3
Cattle	2–3	G013/G015	Farm Mound	Metapodial	?	?	Mature size & texture	41.6	14.9	−21.4	5.6	3.3
Cattle	2–3	G015	Farm Mound	Metacarpal	y	y	Mature	38.8	13.8	−21.3	5.2	3.3
Cattle	2–3	G015	Farm Mound	Metatarsal	y	?	Mature size & texture	42.0	15.6	−21.1	4.7	3.2
Cattle	2–3	G015	Farm Mound	Metapodial	?	?	Mature size & texture	42.0	15.7	−21.2	5.8	3.1
Cattle	2–3	G048	Farm Mound	Calcaneum	y	y	Mature	37.8	13.8	−21.2	6.3	3.2
Cattle	2–3	G051	Farm Mound	Metatarsal	?	y	Mature	42.0	14.4	−21.2	5.5	3.4
Cattle	2–3	G052	Farm Mound	Metatarsal	?	y	Mature	40.9	13.9	−21.1	4.5	3.4
Cattle	2–3	G052	Farm Mound	Metatarsal	y	?	Mature size & texture	40.8	14.7	−21.1	6.0	3.2
Cattle	2–3	G055	Farm Mound	Metacarpal	y	y	Mature	37.3	12.7	−21.2	5.0	3.5
Cattle	2–3	G058	Farm Mound	Carpal			Immature (articulated distal radius unfused)	40.9	14.7	−21.8	5.4	3.3
Cattle	3	F502	Area F drain cut	Radius	y	n	Immature (near mature size)	40.3	15.1	−20.8	5.4	3.1
Cattle	3	F910	Room 1 floor	Metapodial	?	y	Mature	37.8	13.6	−21.3	6.3	3.3
Cattle	3–4	F653	South Midden	Mandible			Mature	63.3	23.2	−21.2	5.5	3.2
Cattle	4	F135	Area F layer	Metacarpal	?	y	Mature size & texture	41.5	14.9	−21.6	6.8	3.2
Pig	1	G022	Farm Mound	Metapodial	y	n	Immature	43.5	15.8	−22.6	8.6	3.2
Pig	1	G022	Farm Mound	Metapodial	y	?	Immature? (near mature size)	44.0	15.6	−22.4	6.1	3.3
Pig	1	G037	Farm Mound	Metapodial	y	n	Immature	43.4	15.4	−17.6	10.1	3.3
Pig	1	G037/G042	Farm Mound	Tibia	n	n	Immature (near mature size)	43.3	15.7	−22.0	7.3	3.2
Pig	2–3	G013	Farm Mound	Metapodial	y	n	Immature	43.5	15.7	−22.0	7.0	3.2
Pig	2–3	G052	Farm Mound	Metapodial	y	n	Immature	43.2	15.9	−20.8	12.0	3.2
Pig	2–3	G058/G059	Farm Mound	Metapodial	?	y	Mature	44.1	16.2	−21.7	7.7	3.2
Pig	4	F036	Room 1 floor	Skull			Immature (upper M3 erupting)	42.1	15.2	−20.9	11.1	3.2
Pig	4	F046	Room 1 floor	Skull			Immature size	44.2	15.0	−21.2	10.5	3.4

In temperate European contexts which lack plants such as millet that utilize the C_4 photosynthetic pathway, enriched (more positive) δ^{13}C values are likely to indicate grazing on seaweed and/or intentional foddering with seaweed or fish products (Richards *et al.* 2006; Balasse *et al.* 2009; Mulville *et al.* 2009). Both practices are known from Atlantic Scotland in recent centuries (Fenton 1978, 428, 466, 499). The famous seaweed-eating sheep of North Ronaldsay in Orkney (Fig. 11.1) are the result of a dyke built to enclose the entire island sometime prior to 1832 (Berry 2000, 135–6). In less extreme contexts, however, Orcadian sheep are known to have grazed the shoreline less exclusively (Fenton 1978, 466). Moreover, in times of fodder shortages cattle were fed seaweed and fish (Fenton 1978, 428). Lastly, some pigs were raised within the home, subsisting on household refuse (including fish offal), rather than being set out to forage (Fenton 1978, 496, 499).

Enriched (higher) δ^{15}N values are characteristic of animals grazed or foddered on coastal terrestrial vegetation (e.g. plants of salt marshes) and/or manured fields (Bogaard *et al.* 2007; Britton *et al.* 2008). In most instances, however, elevated δ^{15}N values indicate a diet of a higher trophic level (Minagawa & Wada 1984). Thus (for example) immature animals may show the consumption of their mothers' milk, pigs may show the consumption of refuse including meat, fish or other animal by-products and (in theory) cattle may show foddering with fish products (cf. Müldner & Richards 2005; Richards *et al.* 2006, 125; Mulville *et al.* 2009).

The absolute values of δ^{13}C and δ^{15}N depend on local ecosystem baselines, the specific combination of food sources consumed and age (insofar as living bone is gradually remodelled, erasing and replacing the dietary signatures of early life) (Ambrose & Norr 1993; Heaton 1999; Hedges *et al.* 2007). Thus they are

best interpreted in comparative perspective within one or more closely related populations.

11.2. Methods and results

Here we report data regarding 32 caprine (mostly or entirely sheep rather than goat), 29 cattle and 9 pig samples from Quoygrew. We focus on comparison of Phase 1 with Phases 2 to 3 in order to evaluate whether there were any changes in husbandry practices that might imply an intensification of production — or indicate the presence or absence of economic stresses such as fodder shortages. It is important to reiterate here that contexts from 'Phases 2 to 3' at Quoygrew are predominately of Phase 2 and early Phase 3 date, being attributed to the eleventh to thirteenth centuries (Chapter 4). A few samples from Phase 3, Phase 4 and Phases 3 to 4 are also included to provider a longer-term perspective.

Most of the caprine and cattle specimens are of mature individuals — within the limits of osteological criteria such as fusion of the distal epiphyses of metapodials which is likely to occur around two to three years of age (Chapter 8). Conversely, the pig specimens are almost all from immature animals — reflecting the age at slaughter of this species at Quoygrew (Chapter 8). The sample preparation and analysis methods follow Richards and Hedges (1999) with the addition of an ultrafiltration step (Brown *et al.* 1988). All of the samples have atomic C:N ratios falling between 2.9 and 3.6, indicating satisfactory preservation of collagen (DeNiro 1985). The results are presented in Table 11.1.

Figure 11.2 plots the data by species combining all phases. Previous isotope results for cod from Phases 2 to 3 at Quoygrew (Barrett *et al.* 2011) are also shown. The sheep exhibit enriched $\delta^{13}C$ and $\delta^{15}N$ values and the pigs highly variable values. The cattle are relatively homogeneous, with little evidence of enrichment in $\delta^{13}C$ or $\delta^{15}N$ in comparison with data for this species from elsewhere in Britain (e.g. Britton *et al.* 2008, 2115).

The caprine data are best interpreted as evidence for some grazing on the shoreline (for both $\delta^{15}N$ enriched terrestrial vegetation and $\delta^{13}C$ enriched seaweed). None of the animals are likely to have fed exclusively on seaweed, however, because modern Orcadian sheep managed in this way have collagen $\delta^{13}C$ values as high as −12.9 (Barrett *et al.* 2000c, 543). When the caprine data are divided by phase (Fig. 11.3), it is evident that the Phase 2 to 3 samples have more variable $\delta^{13}C$ and $\delta^{15}N$ values and a higher mean $\delta^{15}N$ than the Phase 1 samples ($t = -2.851$, $df = 27$, $p = 0.008$). These trends could imply the expansion of grazing

land to include increasingly variable environments — including areas such as coastline with vegetation enriched in $\delta^{15}N$ (cf. Britton *et al.* 2008; Stylegar 2009, 40). The Phase 3 to 4 samples are consistent with the earlier material, but too few to show any chronological patterning.

The cattle data, as noted above, are consistent with animals grazed and/or foddered entirely on terrestrial vegetation. There is a slight increase in the mean $\delta^{13}C$ from Phase 1 to Phases 2 to 3 (−21.4 versus −21.3), but the difference is not statistically significant ($t = -1.831$, $df = 23$, $p = 0.08$) (Fig. 11.4). With more depleted $\delta^{13}C$ values than the caprines, and the lowest $\delta^{15}N$ values of all three taxa, it is unlikely that seaweed or fish were routinely required to make up for shortages of fodder.

The pig data show no clear chronological trends, but are nevertheless highly variable (Fig. 11.5). Several samples show the enriched $\delta^{15}N$ values characteristic of an omnivorous terrestrial diet — a pattern interpreted as evidence for feeding refuse to pigs (e.g. Müldner & Richards 2005). As the bones in question represent immature pigs they may also retain a pre-weaning signature. A single specimen is enriched in both $\delta^{13}C$ and $\delta^{15}N$ — characteristic of fish consumption. It may represent a scrap-fed animal raised in special circumstances (presumably in or near the home). As a single outlier, it could alternatively imply a pig brought to the site from an entirely different population. Yet other pigs have low $\delta^{13}C$ values *vis-à-vis* the cattle and sheep from Quoygrew. This pattern is not typical of Britain, including the Western Isles of Scotland (Mulville *et al.* 2009) and even elsewhere in Orkney (Richards *et al.* 2006). It has, however, been observed in a small sample of medieval material from the site of Junkarinsfløttur in the Faroe Islands (Arge *et al.* 2009). These results are difficult to interpret in the absence of research isolating the isotopic signatures of traditional foods for pigs in the North Atlantic region. Examples include tormentil roots (dug up by pigs let free on rough grazing land during the summer) and whey (Fenton 1978, 496–9; Arge *et al.* 2009, 28).

11.3. Conclusions

The stable isotope evidence suggests that caprines were sometimes grazed on the shoreline, perhaps increasingly so after the transition from Phase 1 to Phases 2 to 3. In recent centuries Orcadian sheep were often kept unherded on headlands and small islets (holms) (Fenton 1978, 446). A flock still survives on the Holm of Aikerness, *c.* 3 km northeast of Quoygrew (Fig. 3.1b). Similar practices may explain the

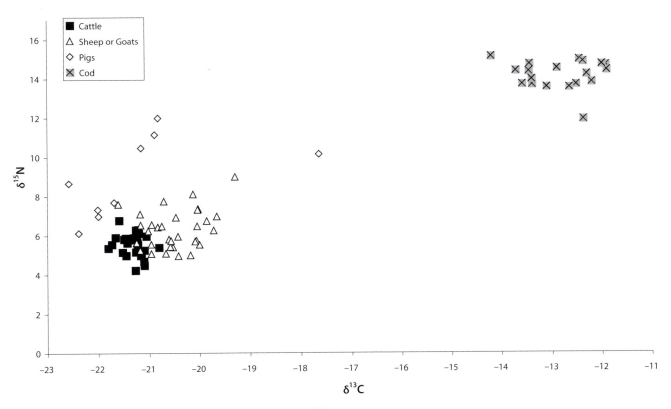

Figure 11.2. *Scatterplot of the bone collagen δ¹³C and δ¹⁵N data regarding fauna from Quoygrew.*

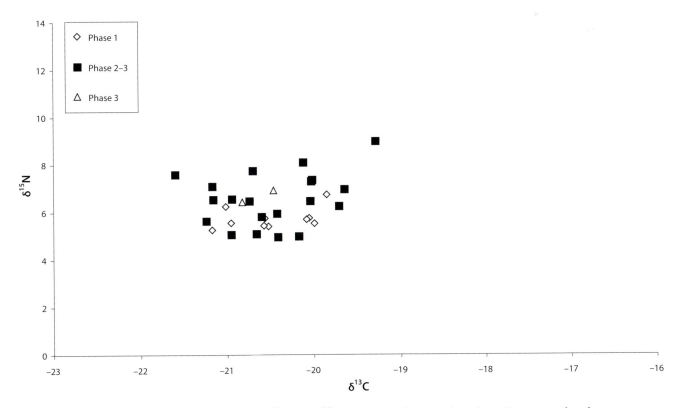

Figure 11.3. *Scatterplot of the bone collagen δ¹³C and δ¹⁵N data regarding caprines from Quoygrew, by phase.*

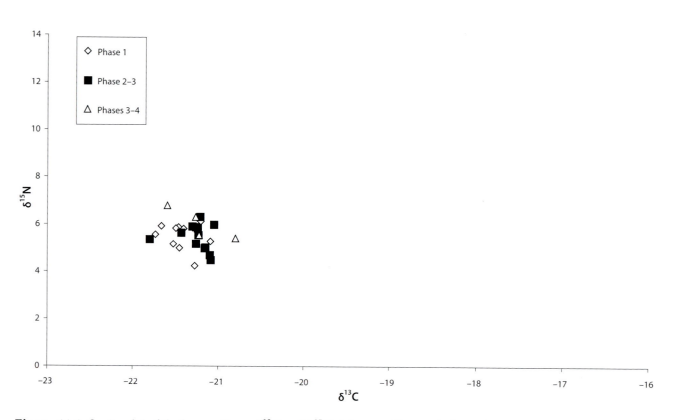

Figure 11.4. *Scatterplot of the bone collagen $\delta^{13}C$ and $\delta^{15}N$ data regarding cattle from Quoygrew, by phase.*

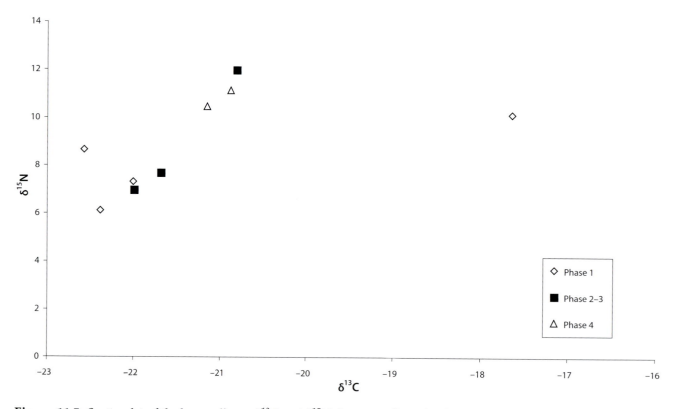

Figure 11.5. *Scatterplot of the bone collagen $\delta^{13}C$ and $\delta^{15}N$ data regarding pigs from Quoygrew, by phase.*

Quoygrew data, but grazing along the coast nearer to the settlement is equally possible. In contrast with the caprines, analysis of the cattle samples suggests no need or inclination to resort to seaweed or fish products for supplementary fodder in any phase. The results for pigs suggest highly variable husbandry practices — perhaps with some animals stall-raised in or near the home and others set loose on rough grazing land for at least part of the year.

These results are notable given the clear increase (based on other evidence) in the use of fish and shellfish during the transition from Phase 1 to Phase 2 and, to a lesser degree, a subsequent decrease in their importance after Phases 2 to 3 (see Chapters 5, 6 and 7). It is striking that there is no isotopic evidence for parallel trends in the use of marine fodder for cattle. It may thus be reasonable to suggest that the increased harvest from the sea during the eleventh to thirteenth centuries was not motivated by stress in agricultural aspects of the household economy. Certainly there is no evidence for a shortage in land-based fodder for cattle, an observation supported by the probable use of oats for animal feed (Chapter 10). In contrast, the increased variability in $\delta^{15}N$ values for the caprines in Phases 2 to 3 may imply use of a wider range of potential grazing locations — including the foreshore. This change is subtle, but in theory at least it could have allowed an increase in flock size and/or the partial freeing up of inland grazing areas for cattle. Overall, the isotopic evidence is thus consistent with the interpretations that the cattle herd was sustainable and that the caprine flock was increased (or diverted from inland areas) during the Phase 2 to 3 fishing boom at Quoygrew.

Chapter 12

Local Availability and Long-range Trade: the Worked Stone Assemblage

Colleen E. Batey, Amanda K. Forster, Richard E. Jones, Geoff Gaunt,
Fiona J. Breckenridge, Judith Bunbury and James H. Barrett

12.1. Introduction

On a site without waterlogged deposits in an archipelago without forests it is not surprising that worked stone was a significant component of the recovered portable material culture. Five-hundred objects of stone are summarized in the following chapter and itemized in Appendix 12.1. Nevertheless, it is remarkable that a high proportion of this material is demonstrably or probably imported. The steatite (soapstone) has come from Shetland and Norway, mostly in the form of vessels (the broken fragments of which were sometimes recycled as other objects). The Eidsborg schist came from Norway, in the form of hones for sharpening blades. Schist of Norwegian origin was also imported as bake stones of the kind traditionally used for making unleavened bread. Mica schist hand querns for grinding grain were also of non-local origin. They could have come from Norway, Shetland, the Scottish Highlands or the Western Isles.

Local stone was used for expedient pounders, anvils and 'pot lids'. Moreover, locally available stone replaced imported schist for use as hones in the later phases of occupation. Flakes of struck flint, probably from the use of strike-a-lights, may also have derived from locally collected material. Lastly, a few portable architectural features (such as pivot stones) were made of local stone.

The use of stone material culture at Quoygrew is indicative of networks of supply and culturally significant choices. Steatite was the favoured raw material for vessels in Viking Age and medieval Norway, but not in mainland Scotland, the Western Isles or elsewhere in the North Sea and Irish Sea regions. The use of schist hones and bake stones (and possibly also the mica schist querns) similarly indicates that access to products of Norwegian provenance and/or style was at times both possible and desirable.

This chapter discusses the stone artefacts from Quoygrew as subdivided by a combination of raw material and object type, with the goal of balancing ease of use and economy of presentation. Studies of provenance — based on ICP-MS (inductively coupled plasma mass spectrometry) analysis, the optical examination of lithology using hand specimens and thin-section analysis — are included. The basic unit of quantification is the find number, which may represent a single object or a small collection of objects (such as vessel sherds) found together.[12]

12.2. The steatite

12.2.1. Rare earth element analysis of the steatite
The largest category of worked stone (299 finds) was of steatite. This raw material is not local to Orkney, but could have come from any number of quarries in Shetland and Norway thought to have been worked during the Viking Age and Middle Ages (Forster 2004a, 2; 2009a; Fig. 12.1). Thus 31 steatite objects from Quoygrew were selected for chemical characterization by ICP-MS. The compositions were then examined in order to assess whether or not the artefacts had a similar origin and to make some statement about the

12. The objects were catalogued by Colleen Batey, Pieterjan Deckers and James Barrett. Richard Jones wrote the report on chemical characterization of the steatite finds. Geoff Gaunt identified the raw material of the hones and the quern fragments based on optical examination of lithology. Fiona Breckenridge and Judith Bunbury conducted the thin-section analysis of the hones. Amanda Forster, Colleen Batey and James Barrett wrote the section on typological analysis of the steatite. Geoff Gaunt, Fiona Breckenridge, Colleen Batey and James Barrett wrote the hones section. The remaining sections were authored by Colleen Batey and James Barrett, with raw material identifications by Geoff Gaunt.

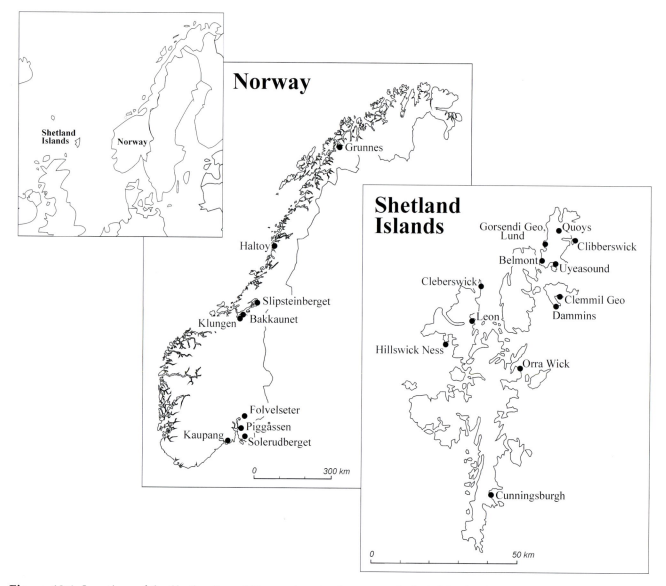

Figure 12.1. *Locations of the Shetlandic and Norwegian steatite sources included in the chemical characterization study. Not included on the map is Fluetjern which lies east of Kaupang. (Image: Lorraine McEwan and Richard Jones.)*

possible identity of their origin or origins (cf. Jones *et al.* 2007; Baug 2011, 329–31).

The analysed finds, all vessel sherds, were selected to include examples of different shape from different phases and locations (Table 12.1). After cleaning an area of the cross-section of each sherd, multiple drillings were taken with a tungsten carbide drill head (2.5 mm diameter) and the pooled powder (at least 500 mg) collected. In the case of Sf. 62127, which was too weathered for drilling, a cleaned fragment was prepared and crushed to powder in an agate mortar. In two cases — Sfs. 7929 and 60672 — the opportunity was taken to obtain samples drilled at different locations on the artefact in order to assess the extent of possible heterogeneity of composition. This exercise

was taken a step further in the case of Sf. 61998 for which there was one drilled sample and three small fragments crushed to powder. Valerie Olive carried out the analyses by ICP-MS at the Scottish Universities Environmental Research Centre, East Kilbride, using an Agilent 7500ce instrument. The analytical procedure and acid dissolution method are described by Jones *et al.* (2007).

The concentrations (in ppm) of fourteen rare earth elements (REE) are given in Appendix 12.2. Visual examination of the REE pattern and concentration range of the data in chondrite-normalized form indicates a good measure of uniformity in composition among the samples apart from Sfs. 61132, 62160, 62154 and 62137. Principal component analysis of the

Table 12.1. *Quoygrew steatite samples characterized by ICP-MS.*

Find no.	Context	Vessel form	Attributed source (Discriminant analysis)	Attributed source (Typology)	Detailed phase	Location
60909	F243	Four-sided	Shetland (Clibberswick)	Shetland	4.1	Room 2 layer
62255	F1203	Four-sided	Shetland (Clibberswick)	Shetland	2.2	House 5 layer
70093	G058	Four-sided	Shetland (Clibberswick)	Shetland	2–3	Farm Mound midden
70101	G058	Four-sided	Shetland (Clibberswick)	Shetland	2–3	Farm Mound midden
7535	G015	Four-sided	Shetland (Cunningsburgh)	Shetland	2–3	Farm Mound midden
7546	G022	Four-sided	Shetland (Cunningsburgh)	Shetland	1.2	Farm Mound midden
60604	F055	Four-sided	Shetland (Cunningsburgh)	Shetland	4.3–4.4	Room 1 layer
60672	F206	Four-sided	Shetland (Cunningsburgh)	Shetland	4.2.1	Room 2 floor layer
61685	F891	Four-sided	Shetland (Cunningsburgh)	Shetland	3.2	Room 1 paving
62138	F1130	Four-sided	Shetland (Cunningsburgh)	Shetland	2.4	House 5 floor layer
62151	F1103	Four-sided	Shetland (Cunningsburgh)	Shetland	3.1	Area F layer
62158	F1106	Four-sided	Shetland (Cunningsburgh)	Shetland	3.1	Area F dump
62459	F1103	Four-sided	Shetland (Cunningsburgh)	Shetland	3.1	Area F layer
62154	F1110	Hemispherical	Norway (Fluetjern?)	Norway?	2.2–2.4	House 5 dump
62160	F1075	Hemispherical	Norway (Fluetjern?)	Norway?	3.2	Room 3 floor layer
7654	G022	Hemispherical	Shetland (Clibberswick)	Norway?	1.2	Farm Mound midden
7966	G052	Hemispherical	Shetland (Clibberswick)	Norway?	2–3	Farm Mound midden
61471	F538	Hemispherical	Shetland (Cunningsburgh)	Norway?	3.5	Room 1 floor layer
61545	F548	Hemispherical	Shetland (Cunningsburgh)	Uncertain	3.5	Room 1 pit fill
62234	F1184	Hemispherical	Shetland (Cunningsburgh)	Norway?	2.2	House 5 floor layer
70254	G090	Hemispherical	Shetland (Cunningsburgh)	Norway?	2–3	Area G3 midden
61998	F995	Hemispherical handled	Shetland (Cunningsburgh)	Norway?	2.2–2.4	North Midden
62137	F1129	Uncertain	Norway	Uncertain	2.4	House 5 floor layer
61132	F036	Uncertain	Norway (Fluetjern?)	Uncertain	4.3–4.4	Room 1 floor layer
7952	G048	Uncertain	Shetland (Cleberswick)	Uncertain	2-3	Farm Mound midden
7640	G022	Uncertain	Shetland (Clibberswick)	Uncertain	1.2	Farm Mound midden
62127	F1159	Uncertain	Shetland (Clibberswick)	Uncertain	2.3	House 5 floor layer
7929	G048	Uncertain	Shetland (Cunningsburgh)	Uncertain	2-3	Farm Mound midden
61638	F842	Uncertain	Shetland (Cunningsburgh)	Uncertain	3.3	Room 1
61639	F842	Uncertain	Shetland (Cunningsburgh)	Uncertain	3.3	Room 1
61649	F846	Uncertain	Shetland (Cunningsburgh)	Uncertain	3.3	Room 1 floor layer

log-transformed composition data confirms that these four finds are clear outliers (Fig. 12.2).

The Quoygrew data can be compared with reference data for known occurrences of steatite in Shetland and Norway. In addition to the data presented by Jones *et al.* (2007) for some of the major Viking Age and medieval quarries on Shetland, it is now possible to add data for other Shetland quarries (including those on Fetlar) and for several quarries situated in, first, western and northern Norway, most of which have been exploited since the Viking period, and, second, east of Kaupang (Baug 2011, 329–31).

The REE pattern of the *main* group of Quoygrew samples visually resembles that of the Cunningsburgh quarry in Shetland, both in shape and in concentration ranges. Moreover, when the Quoygrew samples (excluding the above-mentioned outliers) are added to a discriminant analysis consisting of reference groups from the three main Shetland quarries (Cunningsburgh, Clibberswick and Cleberswick) all Quoy-

grew samples are assigned to Cunningsburgh apart from 7640, 7654, 7966, 60909, 62127, 62255, 70093 and 70101 (to Clibberswick) and 7952 (to Cleberswick) (Fig. 12.3). Bearing in mind the known variability in composition within the Cunningsburgh source, it is plausible that all members of the main group are from Cunningsburgh.

Turning to the four outliers from Figure 12.2, they have been added as individual samples to a discriminant analysis consisting of (a) the three Shetland reference groups, (b) four reference groups east of Kaupang in Østfold and Akershus — from Solerudberget, Fluetjern, Folvelseter and Piggåssen — and (c) *single* samples (kindly supplied by Tom Heldal of the Geological Survey of Norway) representing quarries in western and northern Norway — from Bakkaunet, Klungen and Slipsteinberget situated inland between Trondheim and Bergen, and Haltoy and Grunnes situated well to the north of Trondheim. The minimum information that can be drawn from this exploratory

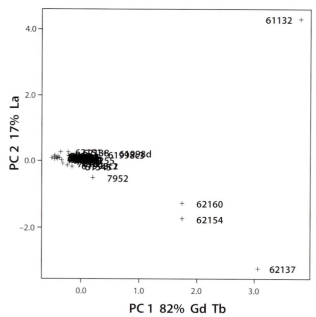

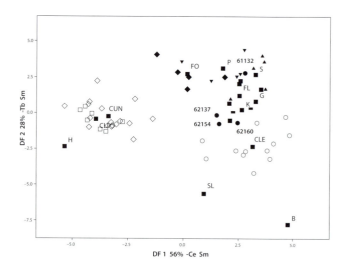

Figure 12.2. *Results of a principal component analysis of the Quoygrew steatite REE composition data in the form of a plot of the first two principal components. Note the four outliers.*

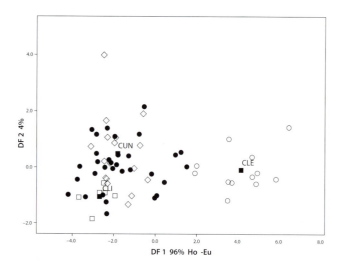

Figure 12.3. *Discriminant analysis of the Quoygrew samples (black circle) and three Shetland reference groups — Cunningsburgh (CUN diamond), Clibberswick (CLI square) and Cleberswick (CLE open circle). The centroids for the three reference groups are marked as black squares. Discrimination between Cleberswick and the two other quarries is apparent on the axis of the major discriminant function (DF1) which is dominated by the Ho and Eu contents. The distinction between the Cunningsburgh and Clibberswick quarries is along the much less powerful discriminant function DF2.*

Figure 12.4. *Discriminant analysis of: Quoygrew samples 61132, 62160, 62154 and 62137 (full circles); the three Shetland reference groups (CUN, CLI and CLE); the reference groups from Solerudberget (S full triangle), Fluetjern (FL full square), Folvelseter (FO full diamond) and Piggåssen (P inverted triangle) in Norway; several individual reference samples from Bakkaunet (B), Haltoy (H), Klungen (K full rectangle), Slipsteinberget (L) and Grunnes (G) in Norway. The principal discrimination is along DF1 dominated by the Ce and Sm contents, but there is also significant discrimination along DF2 which allows some of the Norwegian quarries to be distinguished from each other.*

Table 12.2. *Summary of the steatite assemblage.*

Find type	No. of finds	%	Weight (g)	%
Vessel	111	37.1	24,056.4	96.2
Spindle whorl	12	4.0	343.5	1.4
Line sinker	1	0.3	81.1	0.3
Worked fragment	20	6.7	318.8	1.3
Amorphous fragment	155	51.8	194.4	0.8
Total	299	100.0	24,994.2	100.0

analysis (Fig. 12.4) is that 61132, 62160, 62154 and 62137 are all likely to be Norwegian in origin. Whether the specific assignment by the discriminant analysis of 61132, 62160 and 62154 to Fluetjern is indeed a correct indication of origin must await future comparison with a larger data base.

When the discriminant analysis results are compared with typological interpretation both approaches indicate a Shetlandic origin for all of the sherds of four-sided vessels included in the characterization study (Table 12.1). Conversely, many of the hemispherical vessels were attributed a Shetlandic origin by REE analysis despite being interpreted as of possible Norwegian origin based on their form and surface treatment (see below). Either unsampled Norwegian

Table 12.3. *Worked stone by general phase.*

Find	Phase										Unphased	'Palaeosol'	Total
	1	2	2–3	3	3–4	4	4–5	5–6	6	7			
Steatite vessel: hemispherical	3	4	11	6	1		1	1				1	28
Steatite vessel: hemispherical handled		1											1
Steatite vessel: four-sided	1	5	19	7		3						2	37
Steatite vessel: bucket-shaped		1											1
Steatite vessel: uncertain form	6	6	19	9		2						1	43
Steatite vessel: uncertain form handled			1										1
Steatite vessel fragment?	4	2	10	1				1		1			20
Steatite fragment	36	24	65	18	1	5	1	1		4			155
Steatite spindle whorl		1	4	2	1	2	1			1			12
Mica schist spindle whorl						1							1
Sandstone spindle whorl				1	2	1	2						6
Steatite weight						1							1
Mica schist weight				1			1						2
Sandstone weight				3		2	1						6
Schist bake stone				2									2
Eidsborg schist hone		5		7		1				1			14
Probable Eidsborg schist hone							1						1
Probable purple phyllite hone	1												1
Sandstone hone				3		1				1			5
Sandstone hone or weight						1							1
Sandstone grinding slab						1							1
Mica schist quern				1		1							2
Mica schist quern?						1							1
Mica schist disc				1		1							2
Mica schist fragment	17		7	2		19	1				1		47
Sandstone quern?				1				1					2
Sandstone pounder	1			5	1	7	1			2	2		19
Sandstone anvil?						4							4
Pumice float						1							1
Pumice	3	3	5		4	3	2	1					21
Gunflint											1		1
Flint	3	1	5	5	1	3	3	8	1	6	4	2	42
Sandstone pivot		1						1					2
Sandstone vessel		1											1
Other		2	4	4		2	1	1		1	1		16
Total	**75**	**57**	**150**	**79**	**11**	**63**	**15**	**14**	**3**	**17**	**9**	**6**	**500**

steatite sources have a chemical signature similar to that of the Shetlandic quarries or hemispherical vessels (including examples with lug handles) were being copied by Shetlandic steatite workers. For the present, the latter interpretation is taken as the most probable.

Despite this discrepancy, both chemical and typological study are consistent with the presence of a large group of steatite vessels imported from Shetland at Quoygrew, supplemented by a smaller but nevertheless significant group imported from Norway. In terms of chronology, sherds of Shetlandic origin were recovered from Phases 1 to 4 inclusive. Although fewer in number, finds attributed to Norway were recovered from house-floor contexts of Phases 2,

3 and 4 (although the last may be residual, see below). Moreover, their absence from Phase 1 should not be seen as significant as only three finds of this date were included in the REE study. Both Shetlandic and Norwegian vessels were probably imported to Quoygrew from the time of the settlement's foundation until the end of the Middle Ages.

12.2.2. The steatite assemblage: a typological overview
The 299 finds of steatite (weighing *c.* 25.0 kg) from the Quoygrew excavations are summarized in Tables 12.2 and 12.3. The recognizable objects — 111 vessel sherds, 12 steatite spindle whorls and a single unfinished fishing line sinker — are all common to Viking Age and

Table 12.4. *Worked stone from Area G by detailed phase.*

Find	Phase			Total
	1.2	2–3	6	
Steatite vessel: hemispherical	3	7	1	11
Steatite vessel: four-sided	1	12		13
Steatite vessel: four-sided repaired		2		2
Steatite vessel: uncertain form	5	11		16
Steatite vessel: uncertain form handled		1		1
Steatite vessel fragment?	4	3		7
Steatite fragment	36	44		80
Steatite spindle whorl		3		3
Probable purple phyllite hone	1			1
Mica schist fragment	17	7		24
Sandstone quern?			1	1
Sandstone pounder	1			1
Pumice	3	5		8
Flint	2	3	1	6
Other		3		3
Total	73	101	3	177

medieval sites in the Northern Isles. The spindle whorls and sinker were all definitely or probably manufactured from recycled vessel sherds. Most or all of the vessel fragments represent cooking pots. A significant minority (29 sherds) were from circular or oval vessels with hemispherical profiles. A larger number (37 sherds) were from square or subrectangular (four-sided) vessels. A single example of a round or oval 'bucket-shaped' vessel, a circular form with flaring sides and a flat base, was also found. Twenty other fragments of steatite were clearly from worked objects, but were too badly preserved to be of certain artefact type. In addition, 155 small chips of steatite were recovered. Most or all are likely to represent debris from the reworking of vessel sherds, although some limited import of raw material is also likely (see below).

When weight is taken into account, the vessel sherds represent the most substantial part of the steatite assemblage (Table 12.2). Amorphous fragments make up 52% of the assemblage by number of finds, but only 0.8% by weight. In comparison, vessel fragments make up 96% of the assemblage by weight. Only a small number of other artefacts (spindle whorls and the single line sinker) from Quoygrew are of steatite. This pattern can also be observed at other sites in Orkney of a similar date (see Smith & Forster 2007, 433). It probably reflects the lack of local raw material — the main source of steatite for the manufacture of portable artefacts being sherds of imported vessels.

There are differences, however, in the make-up of steatite assemblages between Orkney and Shetland. In Shetland, steatite was more widely used for the manufacture of portable objects such as weights (both loom weights and fishing sinkers), spindle whorls and, more occasionally, lamps.

One difference between the material from Quoygrew and other sites in both Orkney and Shetland is the lack of steatite bake stones. These Shetland-made artefacts appear in ninth- to tenth-century deposits at Old Scatness Broch in Shetland (Forster 2010) and in *c.* eleventh-century contexts at Pool (Smith & Forster 2007, 418). In Phases 1 and 2 at Quoygrew there is no obvious explanation for this difference, but by Phase 3 the site's occupants clearly had access to alternatives manufactured of Norwegian schist (see below).

All of the steatite finds are summarized by general phase in Table 12.3. A breakdown by detailed phase is provided in Appendix 12.3. As noted above, the full catalogue appears in Appendix 12.1. Tables 12.4 and 12.5 subdivide the assemblage by area, plotting the finds from the Farm Mound and other deposits of Area G separately from the houses, middens and other contexts of Areas A to F, H and J near the shore.

Steatite is common at Quoygrew from the early occupation of the site in Phase 1.2 until the end of Phase 3. The greatest numbers of steatite finds from the site were from Phases 2 to 3, with substantial numbers also in Phases 1, 2 and 3. Finds as late as Phase 3.5 were from well-stratified contexts. Finds from Phase 4, including a well-made partial square vessel from Phase 4.2.1 (Sf. 60672), may imply limited continued use into the fifteenth to sixteenth centuries. However, the Phase 4 material was predominately from floor-levelling deposits and could simply be residual. Small quantities of residual material were also found in later phases. This chronological sequence must be understood in the context of the adoption of ceramic vessels at Quoygrew during Phases 3 and 4 (see Chapter 15). Spatially, the distribution of steatite is similar between the two main area groups — the Farm Mound (Area G) and Areas A to F, H and J near the shore.

12.2.3. The steatite vessels

The assemblage of vessels is the largest group of steatite artefacts at Quoygrew, a trend consistent throughout the stratigraphy and comparable with other sites in Orkney such as Pool (Smith & Forster 2007) and Skaill in Deerness (Porter 1997, 105–6). It is likely that the vessels were manufactured at source, in Shetland and Norway, arriving in Orkney as complete or partly finished objects. The curation of vessels on-site indicates that they were certainly worth repairing. Six examples had repair perforations, some with iron rivets still in place. There is morphological evidence that much of the material originates from the quarry at Catpund, Cunningsburgh (cf. Forster 2009a) — an observation corroborated by the REE characterization

Table 12.5. *Worked stone from Areas A to F, H and J by general phase.*

Find	Phase									Unphased	'Subsoil'	Total
	1	2	2–3	3	3–4	4	4–5	5–6	7			
Steatite vessel: hemispherical		4	4	6	1		1				1	17
Steatite vessel: hemispherical handled		1										1
Steatite vessel: four-sided		5	4	6		3					2	20
Steatite vessel: four-sided repaired			1	1								2
Steatite vessel: bucket-shaped		1										1
Steatite vessel: uncertain form	1	6	7	8		2					1	25
Steatite vessel: uncertain form repaired				1								1
Steatite vessel: uncertain form repaired or handled			1									1
Steatite vessel fragment?		2	7	1				1	1			12
Steatite fragment		24	21	18	1	5	1	1	4			75
Steatite spindle whorl		1	1	2	1	2	1		1			9
Mica schist spindle whorl						1						1
Sandstone spindle whorl				1	2	1	2					6
Steatite weight						1						1
Mica schist weight				1			1					2
Sandstone weight				3		2	1					6
Schist bake stone				2								2
Eidsborg schist hone		5		7		1			1			14
Probable Eidsborg schist hone						1						1
Sandstone hone				3		1			1			5
Sandstone hone or weight						1						1
Sandstone grinding slab						1						1
Mica schist quern				1		1						2
Mica schist quern?						1						1
Mica schist disc				1		1						2
Mica schist fragment				2		19		1		1		23
Sandstone quern?				1								1
Sandstone pounder				5	1	7	1		2	2		18
Sandstone anvil?						4						4
Pumice float						1						1
Pumice		3			4	3	2	1				13
Gunflint										1		1
Flint	1	1	2	5	1	3	3	8	6	3	2	35
Sandstone pivot		1						1				2
Sandstone vessel		1										1
Other		2	1	4		2	1	1	1			12
Total	**2**	**57**	**49**	**79**	**11**	**63**	**15**	**14**	**17**	**7**	**6**	**320**

study above. The substantial workings at Cunningsburgh are still visible at the excavated faces and as numerous pits and mounds across the amphitheatre-like hillside (see Turner *et al.* 2009).

The vessel forms present are illustrated in Figures 12.5 to 12.7. The chronological distribution of each type is summarized in Table 12.3. Forty-four of the vessel sherds could not be attributed to a particular form, but all of these were small fragments. As noted above, the majority of the vessels of recognizable shape were either four-sided or subrectangular, with hemispherical or curved vessels being slightly less frequent. These two forms — four-sided and hemispherical — are the main typological groups of the

period. It is now known that hemispherical forms can be either primary Norwegian imports or Norwegian forms manufactured in Shetland whereas four-sided vessels are a specifically Shetlandic form (see Forster 2004a; 2006; 2009a and Section 12.2.1 above).

The number of hemispherical vessels in relation to those of four-sided form can be a useful indicator of date in steatite assemblages from Atlantic Scotland. Early Viking Age assemblages show a large number of hemispherical vessels — often with few four-sided vessels recorded. Recent rescue excavations in Shetland recovered a large assemblage of early Viking Age material at Norwick, Unst, which illustrates the development of the four-sided form as a pragmatic

Profile **In Plan**

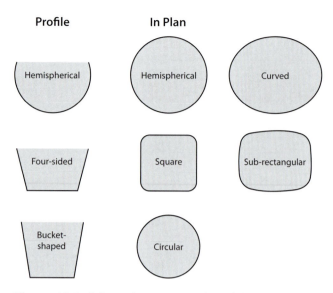

Figure 12.5. *Schematic representation of the steatite vessel forms represented at Quoygrew. (Image: Amanda Forster.)*

response to Shetland's more laminar stone (Forster unpublished). At Quoygrew, hemispherical vessels were only the most abundant form in Phase 1, reflecting the increased use of four-sided vessels in the late Viking Age and Middle Ages (Table 12.3). One atypical find is a bucket-shaped vessel with flaring sides and a flat base (Sf. 61989, see Fig. 12.6).

12.2.4. Hemispherical steatite vessels
Twenty-nine of the 111 vessel finds were from hemispherical pots: circular in plan with curving profiles, rounded bases and no distinct wall-to-base angle (Fig. 12.5). The 29 finds represent a total of 63 individual sherds weighing approximately 4.7 kg. This form of soapstone vessel occurred in well-stratified contexts from Phases 1 to 3 at Quoygrew (Table 12.3). A variety of rim forms were identified within the hemispherical group — tapering, flat, rounded, inward turning and everted — but none demonstrated observable stratigraphic patterning.

The rims came from bowls of a range of diameters. The irregularity of the hand-tooled vessels does not, however, make the assessment of diameters an exact science. There are a few small examples, perhaps in the region of 20 cm (for example Sf. 61131 from Phase 2 and Sf. 61545 from Phase 3.5). A few sherds may also be from large vessels (e.g. Sf. 62160 from Phase 3.2). At Norwick in Shetland, smaller hemispherical vessels were in the region of 160 mm in diameter whilst large examples tended to be between 360 and 480 mm (Forster unpublished). Large hemispherical vessels have also been noted elsewhere,

with sizes up to 50 cm identified. Examples include Gord, Fetlar (Batey unpublished) and the Brough of Birsay (Hunter 1986, 189). One of the largest recorded is from Hordaland, Norway, with a diameter of 57.5 cm (Graham-Campbell 1980, no. 40, 16). In the case of large vessels, it is likely that they were set in the fire rather than suspended above it during use. The variability in vessel sizes represented at Quoygrew probably reflects function and availability. No chronological trend is evident.

The thickness of the vessel walls is highly variable, ranging from a minimum of 13 mm, to a more standard range of 19 mm, to a maximum of 24 mm. The quality of steatite is also very varied, ranging from fine-grained examples (e.g. Sf. 61990, Phase 2, where a superior finish was possible) to thick and grainy pieces such as Sf. 61965 from a disturbed midden attributed to Phases 3 to 4. Other pieces were of more inferior-quality stone, which had fractured and disintegrated during use.

The hemispherical vessels sometimes had smoothed surfaces on both internal and external walls (e.g. Sfs. 6475 and 7966, both from Phases 2 to 3). A few sherds had also been worn after deposition, suggesting that they are residual. This evidence is scattered through the stratigraphy as single examples (e.g. Sf. 70086 from Phases 2 to 3).

One hemispherical vessel (Sf. 61998 from Phase 2) — and one vessel of uncertain form (Sf. 7927 from Phases 2 to 3) — had lug handles. Similar trapezoidal handles have been found in a medieval context at Jarlshof (Hamilton 1956, pl. XXXVIII no. 6) and in a late Viking Age or early medieval context at Pool (Smith & Forster 2007, 418).

12.2.5. Four-sided steatite vessels
Thirty-seven finds units represent 63 individual sherds of four-sided vessels weighing a total of 14.2 kg. These are the archetypal Shetland vessel, developed out of working with the very laminar structure of the archipelago's steatite. Earlier prehistoric vessels developed in much the same way, to the degree that it is sometimes difficult to distinguish Bronze Age vessels from medieval ones of similar form (see Forster & Sharman 2009). The form can be broadly described as four-sided with a flat base. Recognizable features include flared, straight walls and a sub-rectangular plan with either sub-rounded corners or very well-defined angles. Fragments without a wall or base angle can be easily confused with curved vessels as the larger examples are almost oval in plan.

It is often the case that four-sided vessels can be identified from tooling and manufacture as well as from the form itself. Several sherds have very distinc-

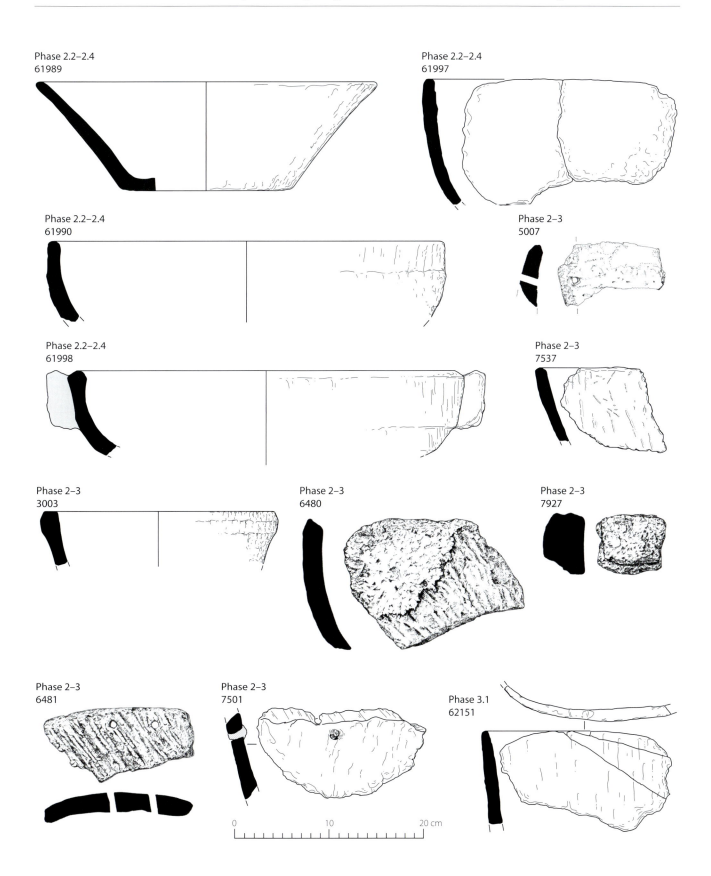

Figure 12.6. *A selection of the 111 steatite vessel sherds from Quoygrew. (Image: Vicki Herring, Jill Sievewright and Dora Kemp.)*

215

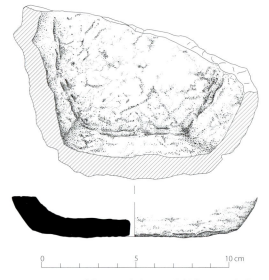

Figure 12.7. *Base of four-sided vessel (Sf. 60672) from a floor-levelling context of Phase 4.2.1 in Room 2 of House 1. (Image: Vicki Herring.)*

tive tooling — most commonly on the interior face using a narrow chisel. Often the grooving is at a slight angle to the rim, as observed on Sf. 62158 of Phase 3.1 and Sf. 60909 of Phase 4.1. In some examples (e.g. Sf. 6481 of Phases 2 to 3) there are signs of herringbone-like internal grooving.

The four-sided vessels recovered from Quoygrew provide a good example of the range of forms that can fall within this category. Previous work has identified two main types of four-sided vessels: large subrectangular pots with subrounded corners and a thinner-walled form which better fits the description 'square vessel'. Examples of both variants have been recovered widely across Atlantic Scotland where four-sided vessels remained the dominant form from their development during the ninth and tenth centuries through to the demise of using steatite as a material for pots in the region — probably in the fourteenth to fifteenth centuries based on the Quoygrew evidence (see also Forster 2006; 2009a). Examples of this form have also been recorded in the Faroe Islands (Forster 2004b).

Both thick-walled and thin-walled examples of the four-sided form are present in the Quoygrew assemblage. The former have wall thicknesses ranging from 18 mm to 25 mm, (or up to 30 mm at the wall to base angle). Thin-walled examples have thicknesses ranging from 12 mm to 17 mm and tend to be better made. Good examples include Sf. 7537 from Phases 2 to 3 and Sf. 61997 from Phase 2. However, the most significant example is a group of sherds (Sf. 60672) forming the lower part of such a vessel, recovered from the floor of Room 2 in Phase 4.2.1 (see Figs. 4.38

& 12.7). This vessel marks the end of steatite vessel use at Quoygrew, on the assumption that the few later finds are residual. As noted in Section 12.2.2 above, Sf. 60672 forms part of a levelling deposit, along with other stones, and may be residual itself. In this case the active use of steatite vessels at Quoygrew may have been restricted to Phases 1 to 3.

There are a number of parallels for square vessels in the Northern Isles, including Pool (Smith & Forester 2007, 432) and Tuquoy (Sharman 1990, cited in Smith *et al.* 1999, 132) in Orkney and The Biggings (Smith *et al.* 1999, 131–2), Jarlshof (Hamilton 1956, 165–6), Old Scatness (Forster 2010) and Sandwick South (Bigelow 1985, 107) in Shetland. Square vessels were once thought much later in date than hemispherical pots (Forster 2004a and references therein), but they have now been recognized in contexts dating as early as the tenth century at Pool (Smith & Forster 2007, 432). Nevertheless, they clearly continued to be produced well into the Middle Ages — as demonstrated by the finds from The Biggings, Sandwick South and now Quoygrew.

12.2.6. Bucket-shaped steatite vessel

Find 61989 is a large section of a vessel which has a flaring wall and a flat base (see Fig. 12.6). The profile is complete, including the rim. It could represent either a bucket-shaped form or one end of a larger oval vessel. Sharman (1999, 171–2) has recognized oval vessels at Kebister in Shetland, noting Viking Age parallels, but in these cases the pots were clearly round-based. The Quoygrew example has more affinity with the 'flowerpot' form identified by Smith *et al.* (1999, 132) at The Biggings and flat-based vessels known from Bergen (Vangstad 2003). However, these parallels are later in date than Phase 2 at Quoygrew, to which Sf. 61989 is attributed. It is possible that the context from which the find came, F785, has been incorrectly phased. This layer is immediately south of Room 3, and could thus relate to disturbance during the building or maintenance of this room in Phase 3 — rather than being contemporary with the underlying House 5 as thought during analysis of the stratigraphy (Chapter 4). However, other possible examples of the type were recovered from Norwick — which is thought to have an early Viking Age date (Forster unpublished; Ballin Smith 2007). This form is very rare in Atlantic Scotland. It is here tentatively interpreted as a Norwegian import.

12.2.7. Indeterminate steatite fragments

Small fragments, chips and flakes of steatite were scattered through all parts of the site and most phases. None indicate the finishing of pots and almost all probably derive from broken vessels (as indicated by

the presence of sooting and/or tooling on some) or from reworking of vessels. The recovery of so many small pieces is the result of the sieving programme rather than being indicative of large-scale working of steatite on site.

Some reuse and refashioning of pieces can be observed (see below), but not enough to imply careful curation of this imported medium — in contrast, for example, with finds recovered in Iceland where supply was far more limited (Forster 2004b; 2009b). Steatite must have been in satisfactory supply during the phases in which it was desirable. The identification of two unworked lumps, one from Phase 1.2 (Sf. 7896) and the other from Phases 2 to 3 (Sf. 70013), may represent the presence of raw material which, although minor in scale, is significant. All other finds represent the import or recycling of finished items.

12.2.8. Steatite spindle whorls and weight

Twelve steatite spindle whorls were recovered at Quoygrew (Table 12.3; see Fig. 12.8). Five were clearly made from reused vessel sherds. These include Sf. 61108 from Phase 2, Sf. 7089 from Phases 2 to 3, Sf. 61995 from Phase 3.2, Sf. 10024 from Phases 3 to 4 and Sf. 61708 from Phases 4 to 5. Find 10024 is probably manufactured from an imported thin-walled Norwegian vessel of very fine-grained steatite. Most of the remaining whorls probably also represent reworked material. Two whorls were unfinished and three had eccentric perforations. One of the partly made examples (Sf. 61108 from Phase 2) appears to have been lightly marked with incisions that were probably intended to include a cross and arc on one side, despite being early in the manufacture process. Almost all of the whorls were discoidal or irregular, essentially reflecting the thickness of the vessels from which they were made. However, Sf. 7955 from Phases 2 to 3 is bun-shaped and may have arrived at Quoygrew as a finished item (see Hansen 2005, 195 for examples from Bergen). The finished and undamaged whorls range in weight from 15 g to 36 g. Spindle whorls of other raw materials are considered in Section 12.3 below and in Chapter 13.

Only one probable fishing weight of steatite was recovered from Quoygrew, and it was unfinished (having been lost or discarded before being perforated) (see Fig. 12.9). This is consistent with a general trend in which Orcadian weights are of other kinds of stone (see below), whereas Shetlandic and Norwegian examples are typically manufactured from steatite (e.g. Bigelow 1985, 119; Olsen 2004, 35; Sørheim 2004, 119). The Quoygrew weight (Sf. 6557) was a reused vessel sherd, oval in shape, with a burnt exterior, grooved tooling on the interior, and a slightly curving profile.

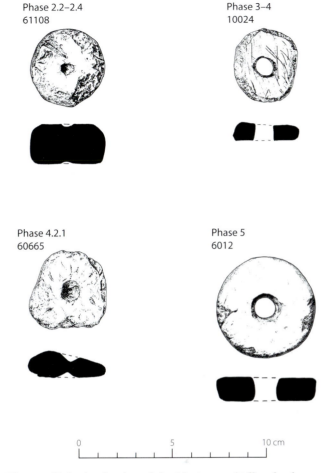

Figure 12.8. *A selection of the 18 stone spindle whorls from Quoygrew: Sfs. 61108 and 10024 are of steatite, Sf. 60665 is of mica schist and Sf. 6012.2 is of sandstone. (Image: Caitlin Evans and Dora Kemp.)*

Weighing 81 g, it is approximately 75 mm long and, 35 mm wide. It probably represents a weight for 'trolling', when a fishing line is dragged through the water at a relatively shallow depth (Sørheim 2004, 119). It was found in Room 1, from a poorly stratified Phase 4 context.

12.3. Spindle whorls and weights of other stone

In addition to the steatite examples, six stone spindle whorls (one found as two pieces, Sfs. 61984 and 61985) and eight or nine stone weights were found at Quoygrew (Table 12.3; see Figs. 12.8 & 12.9). Five of the whorls are made of local stone, mostly with eccentric perforations and rough edges. The sixth (Sf. 60665 from Phase 4.2.1) is also roughly shaped (and incomplete, with two partially drilled holes). However, it is made of a pale silvery grey mica schist that is not local to Orkney. It probably represents the reworking

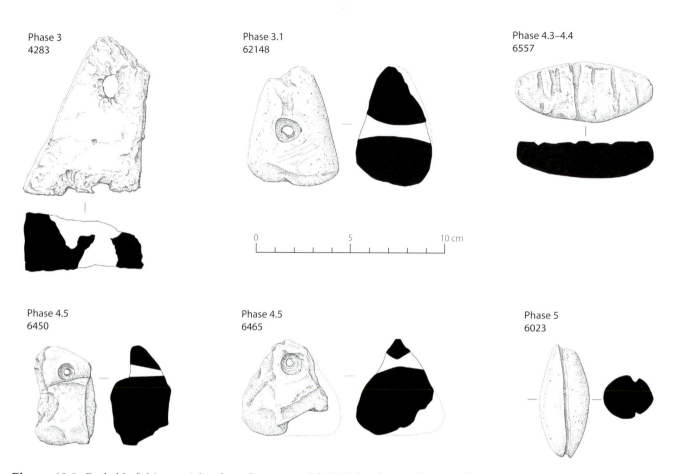

Phase 3
4283

Phase 3.1
62148

Phase 4.3–4.4
6557

0 5 10 cm

Phase 4.5
6450

Phase 4.5
6465

Phase 5
6023

Figure 12.9. *Probable fishing weights from Quoygrew. Sf. 6557 (unfinished) is recycled from a steatite vessel sherd. The rest are of local stone. (Image: Caitlin Evans, Vicki Herring and Dora Kemp.)*

of stone imported in the form of querns (see below). Although the numbers are very small, these six spindle whorls have a later chronological distribution than the steatite examples. Only one (Sf. 61577) is attributed to Phase 3, and it is from a disturbed context. The other five are from Phases 3 to 4, Phase 4 and Phases 4 to 5. Conversely, seven of the 12 steatite whorls were from Phases 2 and 3.

Two of the stone weights (Sfs. 62120 and 62147) were made of mica schist. Both are flattened ovals with central perforations — a form interpreted as evidence for use as warp-weights on an upright loom. Based on their shape and raw material they probably represent reused fragments of imported quern stone (see below). Find 62120 (of 616 g) is of pale to medium grey schist, finely crystalline (almost phyllite in places), consisting of moderately foliated muscovite with abundant small (less than 1 mm wide) black mineral, probably of hornblende type. After being used as a loom weight it served a tertiary function as a pivot stone (see below for pivot stones of other raw material), presumably for a door, until it was ultimately discarded in a late (Phase 4 to 5) midden fill of Room 3.

Find 62147 (of 482 g) is of pale silvery grey schist, medium to (less commonly) coarsely crystalline, consisting mainly of well-foliated muscovite, with a few small (up to 3 mm wide) dark grey masses that look like weathered garnet but are too soft (being only *c.* 4 on Moh's Scale, as distinct from 6.5 to 7.5 for garnet). There is also a magnetic mineral that is too minute to identify, but is almost certainly magnetite. This loom weight was recovered from Phase 3.1, the demolition of House 5 prior to the building of Room 3.

A third weight, Sf. 62152 of 6.9 kg, was also found in Phase 3.1. It may have served as a weight to secure simmens (ropes for retaining thatch) on the roof. However, given that only one was found an alternative use (perhaps as a boat anchor or counter-balance) is equally likely. This object, of local stone, is unlikely to be a fishing weight as the heaviest line and/or net weight from Borgund in Norway is 3.55 kg and it is an exception (Sørheim 2004, 122).

Find 6023 is a finely worked lenticular weight with a complete medial groove around its long axis rather than a perforation. Its dimensions are 60 × 28 × 23 mm and its mass is 64 g. Found in a disturbed

context of Phases 4 to 5, it may be residual from earlier occupation. A broken weight from Phase 3.1 (Sf. 62148) may originally have been similar in form, but with a perforation near the surviving end rather than a medial groove. It is also of much greater size (being 216 g in an incomplete state). The lighter example was possibly intended for trolling (see above), or for fishing in shallow water, whereas the heavier one could represent a weight for deep bait hand lining — in which bait and hook need to be dropped rapidly to a desired depth (Sørheim 2004, 119–21). Three other perforated stones represent more expedient weights: Sf. 4283 (138 g) from Phase 3, Sf. 6450 (90 g) from Phase 4.5 and Sf. 6465 (107 g) from Phase 4.5. All are broken, probably during manufacture. It is highly likely that they were also intended for line fishing. Lastly, a find of local sandstone with an incomplete perforation (Sf. 6451, weighing 305 g) may have been intended to be a weight or a hone. It is discussed further below.

12.4. Schist bake stones

Find 6631 (from the fill of a side bench built in Room 1 during Phase 3.4) is a substantial part of a thin circular schist bake stone of distinctive Norwegian type (Fig. 12.10). It is double-scored on one face and single-scored on the other. Unusually, it seems to have had a perforation at one edge. Find 61621 (from the floor of Room 1 in Phase 3.4) is not obviously from the same plate as Sf. 6631 and probably represents a second object. It has traces of deep incisions.

The thickness, style of finishing and raw material of these bake stones is characteristic of known quarries in the Hardanger region of western Norway. This type of Norwegian import is extensively discussed by Weber (1999, 134–9) in relation to similar finds from the medieval site at The Biggings in Shetland. Hardanger bake stones are also known from Jarlshof, Sandwick South and Kebister in Shetland and from Tuquoy in Orkney (Weber 1999, 138). Schist bake stones first appeared in Norway itself around 1100, and were soon exported across the Scandinavian North Atlantic (Weber 1999, 137–8). At Freswick Links in Caithness, however, there are no baking plates at all in the assemblage (Batey 1987, 231). This geographical distinction may resemble that of steatite vessels – ceramic rather than soapstone pots seem to have been the norm in late Viking Age and medieval Caithness (see Chapter 16).

Thicker steatite baking plates were already in production in Shetland prior to the advent of Norwegian schist bake stones. Examples of these more local products have been found at Pool in Orkney (Smith & Forster 2007, 432), but were not present at Quoygrew.

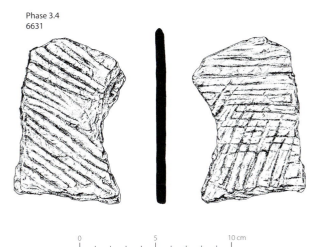

Phase 3.4
6631

0 5 10 cm

Figure 12.10. *Fragmented schist bake stone of Norwegian type. (Image: Alix Sperr.)*

Based on recent Norwegian rural custom it is assumed that baking plates were used for the production of unleavened flatbread, on which food was placed before being handed out during meals (Weber 1999, 138).

12.5. Hones of schist, phyllite and sandstone

Twenty-three hones, for sharpening iron tools, were recovered from Quoygrew (Fig. 12.11; Table 12.3). All were examined optically by one of the authors (Geoff Gaunt, formerly of British Geological Survey) who was of the opinion that 14 were undoubtedly of Eidsborg schist (also known as Norwegian ragstone or light grey schist), one was probably of Eidsborg schist, one was probably of purple phyllite (also known as blue phyllite or dark grey schist) and seven were of sandstone. Thin-section analysis, by Fiona Breckenridge and Judith Bunbury, was also conducted on three of the hones identified as 'definite' Eidsborg schist and one as 'probably' Eidsborg schist in order to confirm whether or not this group of material was indeed imported from Norway. It has been previously suggested that, without the benefit of thin sections, Eidsborg schist can be difficult to differentiate from the Dunrossness Phyllites of Shetland (Crosby & Mitchell 1987, 502).

Eidsborg schist is almost invariably a pale silvery grey, fine to medium crystalline, well-lineated but only poorly foliated, quartz-muscovite schist. It consists predominantly of parallel lines of quartz crystals (like beads on straight lengths of string), which give the impression of very thin parallel glassy rods (like pencils in a narrow box), hence the term lineation. The only other mineral that is commonly detectable with the naked eye is muscovite, the flakes

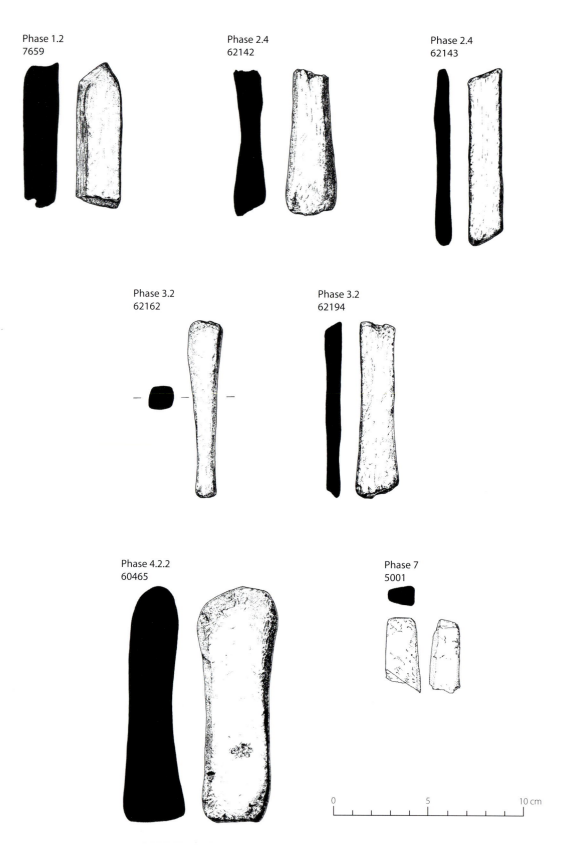

Figure 12.11. *A selection of the 23 hones from Quoygrew. Sf. 7659 is probably of purple phyllite. Sfs. 62142, 62143, 62162 and 62194 are of Eidsborg schist. Sfs. 5001 and 60465 are of local sandstone. (Image: Vicki Herring and Dora Kemp.)*

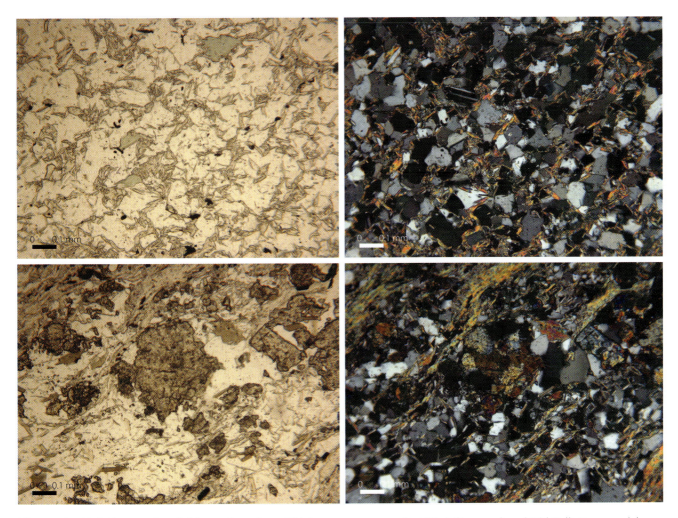

Figure 12.12. *Micrographs of thin sections from Eidsborg quarry samples Eid A (top row) and Eid B (bottom row) in plane- (left) and cross- (right) polarized light. (Image: Fiona Breckenridge and Judith Bunbury.)*

of which have mutually parallel planes. It is, however, insufficiently abundant to produce other than a vague foliation.

The 14 hones identified here as of Eidsborg schist are absolutely typical of this lithological type and although a few (notably Sfs. 61626, 61627 and 62133) are slightly more coarsely lineated than the rest they are still within the medium crystalline texture range of this schist. Previous research, based on thin-section petrology, potassium-argon dating and rubidium-strontium dating, has narrowed the source of the type to the Eidsborg quarries of southern Norway — from which hones were widely exported across northwestern Europe in both the Viking Age and Middle Ages (e.g. Ellis 1969; Mitchell *et al.* 1984; Crosby & Mitchell 1987; Askvik 2008 and references therein; Hansen 2011).

Three examples of this lithological type from Quoygrew were thin sectioned: Sf. 6079 (Phase 4.5),

Sf. 61571 (Phase 3.4) and Sf. 62133 (Phase 2.3). Find 6590 (residual in Phase 4.5 to 5), with a slightly different lithology, was also sectioned because it was originally classified as 'probably' rather than 'definitely' Eidsborg schist. The Quoygrew samples were compared with thin sections of two reference specimens collected on-site at the quarries in Eidsborg and of two samples from the Dunrossness Phyllite group. The Eidsborg samples were collected by Fiona Breckenridge and Judith Bunbury with help from Dag Rorgemoen of the Vest-Telemark Museum. The thin sections of Dunrossness Phyllite (from Dunrossness and Scousburgh in Shetland) were kindly supplied by Roy Fakes of the British Geological Survey.

One can compare the petrographic properties of the sections in Figures 12.12 to 12.15 and Table 12.6. There is clear concordance between three of the Quoygrew finds (Sfs. 6079, 61571 and 62133) and the two specimens collected from Eidsborg (A and B).

Table 12.6. *Descriptions of thin sections of reference samples of Eidsborg schist and Dunrossness Phyllite, and of four hones from Quoygrew.*

Sample	Quartz (percentage of sample and average diameter of grains)	Muscovite (percentage of sample and average size of grains)	Chlorite/ biotite	Epidote	Opaque minerals	Other
Eid A (Eidsborg quarry)	90% 0.1 mm	5% 0.2 mm-long needles arranged in grid formation	2% chlorite sparse biotite	1%	1%	Extremely rare plagioclase. Very rare feldspar. Extremely rare orthoclase. Sparse calcite.
Eid B (Eidsborg quarry)	50% 0.2 mm	40% 0.2 mm-long needles arranged in grid formation	2% chlorite trace biotite	10%	1%	Banded. Some mica rich bands, some epidote rich bands. Strong crenulation cleavage.
6079 (Quoygrew)	90% 0.1 mm	6% 0.2 mm-long needles arranged in grid formation	1% chlorite	1%	1%	Extremely rare plagioclase. Rare orthoclase. 2% calcite.
61571 (Quoygrew)	85% 0.1 mm	5–10% 0.2 mm needles arranged in grid formation	2% biotite	1%	1%	Rare plagioclase. Rare orthoclase.
62133 (Quoygrew)	90% 0.1 mm	5–10% 0.2 mm needles arranged in grid formation	2% biotite trace chlorite	2%	1%	Rare plagioclase. 1% calcite.
6590 (Quoygrew)	15–20% 0.05–0.5 mm	15–20% 0.2 mm long needles arranged in grid formation	1% chlorite 1% biotite	1%	1–2%	Bimodal distribution of grains. 2–3% calcite. One very small zircon grain. Sparse plagioclase. Sparse feldspar.
12404 (Dunrossness phyllites)	60% 0.5 mm	30% Crenulated texture	10% chlorite	none	Magnetite up to 0.3 mm	
27141 (Dunrossness Phyllites)	60% 0.05–0.5 mm	30% Strong cleavage. Strongly aligned and no grid formation	10% chlorite stronger cleavage than in Eidsborg samples	trace	Magnetite up to 0.5 mm	

The thin section of the fourth Quoygrew hone (Sf. 6590), originally classified as 'probably' rather than 'definitely' Eidsborg schist, exhibited slightly different petrology. For example, it had a higher percentage of muscovite and a lower amount of quartz than the other Quoygrew samples. Conversely, the two Dunrossness Phyllite samples exhibited considerably different petrology from all of the Quoygrew and Eidsborg samples. In particular, they contained magnetite and a greater amount of chlorite. Overall, these comparisons are consistent with the interpretation that the Eidsborg and Quoygrew samples share a source (with the possible exception of Sf. 6590). None of the Quoygrew stones shows concordance with the Dunrossness Phyllite samples.

Hones from the Eidsborg quarries were exported via Skien in southern Norway (Myrvoll 1982; Resi 2008, 65–6), but also travelled to western Norway. Thus their appearance at Quoygrew may relate to Orcadian trade with centres such as Bergen, where they first appeared

in Hansen's Horizon 3 (*c*. 1070–*c*. 1100) and became common by her Horizon 5 (1120s–*c*. 1170) (Hansen 2005, 210–17).

Most of the Quoygrew hones of Eidsborg schist were originally bar-shaped, with square or rectangular sections. The one exception (Sf. 62133) had a 'D'-shaped cross-section. Continual use led to the thinning of the central part of the objects and frequently also to breakage (Fig. 12.11). Thus few of the finds were complete and all were small. The largest (Sf. 61626 from Phase 3.3) was 215 mm long, but most were closer to 100 mm — albeit in a broken state. Their maximum thicknesses ranged from 13 mm to 31 mm. One hone (Sf. 61538, from Phase 3.5) was crenelated at one end, perhaps to facilitate a specialized sharpening function. None were perforated or grooved for suspension. The find classed as probably of Eidsborg schist (Sf. 6590 from Phases 4 to 5) is similar in both size and shape to the more definitive examples.

None of the Eidsborg hones were from midden contexts, perhaps implying that they were typically lost rather than discarded. Five of the Eidsborg hones are from Phase 2, all from the floor of House 5 (Table 12.5). Seven are from Phase 3, most of which are from the floor of Room 1. A single specimen (Sf. 6079) from demolition rubble in Phase 4.5 is probably residual, as is a single topsoil find (Sf. 6219). The 'probable' Eidsborg hone (Sf. 6590), from a demolition context of Phases 4 or 5, may also be residual.

Find 7659 was a small broken phyllite hone, 78 mm long and 27 mm by 17 mm across. It is medium grey and very finely to finely crystalline, consisting mainly of well-lineated quartz with subsidiary moderately foliated muscovite, and has a pale green short thin rod-like mass on one edge. This rod-like mass has a lineated texture parallel to the rest of the item and a hardness of approximately 7 on Moh's Scale, suggesting that it too consists mainly of quartz. Its pale green colour is suggestive of finely disseminated chlorite between the quartz. Except for the pale-green mass the lithology of this item is identical to a category of widely traded hones variously described as purple phyllite, blue phyllite or dark grey schist (Askvik 2008, 7 and references therein). Ellis (1969, 145) noted chlorite in some purple phyllite hones, but one of us (Geoff Gaunt) has not previously seen such a sharply defined green mass in other examples of the type. Thus this item is best referred to as probably purple phyllite.

Purple phyllite hones are common finds from Viking Age sites across northwestern Europe (e.g. Crosby & Mitchell 1987; Resi 2008, 57–66; Hansen 2011). Based on potassium-argon dating the type has been attributed to rocks of Caledonian age, limiting the likely sources to Norway, Scotland, Ireland or Greenland (Crosby & Mitchell 1987). However, based on the widespread archaeological association of hones of purple phyllite and Eidsborg schist a source or sources in western Norway is most probable (Crosby & Mitchell 1987; Askvik 2008, 7–8).

The paucity of purple phyllite hones from Quoygrew is likely to have a chronological dimension. The type co-occurs with Eidsborg schist in both Britain and Scandinavia until the eleventh century, after which only Eidsborg products are common (Crosby & Mitchell 1987, 489–90; Resi 2008, 57–66). It is thus relevant that Sf. 7659 is from Phase 1.2, whereas all the well-stratified Eidsborg hones are from Phases 2 and 3 as noted above.

Hones of purple phyllite and Eidsborg schist have been recognized from other Viking Age sites in Atlantic Scotland. Examples include the Brough of Birsay, the Brough Road and Pool in Orkney (Crosby & Mitchell 1987, 490; Batey 1989, 211; Breckenridge 2009), Jarlshof in Shetland (Breckenridge 2009), and Bornais (Sharples pers. comm.), Cille Pheadair (Parker Pearson *et al.* 2004a, 247) and Ardvonrig (Crosby & Mitchell 1987, 490) in the Western Isles. Hones from other sites in the Northern Isles (e.g. Clarke 1999, 160) merit further study in view of the possibility that some may also represent imported Norwegian purple phyllite and Eidsborg schist. However, it is important to recognize that alternative sources of metamorphic stone from Shetland were probably also used (Crosby & Mitchell 1987, 502; Ballin Smith & Allen 1999, 180–82).

Seven other probable hones from Quoygrew are entirely consistent with the Middle Devonian Rousay Flags which crop out on Westray and underlie the site. These local products began to complement Eidsborg schist examples in Phase 3 and probably completely replaced them in Phase 4. Of the seven finds, two are bar-shaped specimens — one heavily used — that were clearly hones (Sfs. 5001 and 60465). A third is a flat oval grinding slab (cf. Resi 2008) with extensive evidence of use for sharpening (Sf. 60561). A forth specimen (Sf. 6451) is also bar-shaped (and exhibits an abortive attempt to drill a perforation at one end), but has no evidence of wear. It may represent an unused hone or weight discarded during manufacture (see also Section 12.3 above). Three final specimens (Sfs. 61455, 61683 and 62184) are bar-shaped stones with slight traces of wear. Their identification as hones is tentative. Finds 6451, 60465 and 60561 were also used as pounders, being battered at one or both ends. Find 5001 is broken, but the complete examples vary in length from 105 mm (Sf. 61455) to 175 mm (Sf. 60561). Excluding the irregular grinding slab, they vary in maximum thickness from 16 mm to 42 mm.

12.6. Querns and other objects of mica schist

Several fragments of rotary hand querns were made of a distinctive pale grey schist (consisting mostly of well-foliated muscovite) that is not local to Orkney, but is different from that used for the hones and bake stones from Quoygrew. A few additional objects (including a spindle whorl and two loom weights noted above, and two stone discs discussed below) of the same raw material may represent the recycling of broken fragments of similar querns. Forty-seven finds of small chips of mica schist suggest that this stone was worked in some way in all phases of occupation (Table 12.3).

Two definite quern fragments (Sfs. 60707 and 61565) are both of pale silvery grey schist, fine to

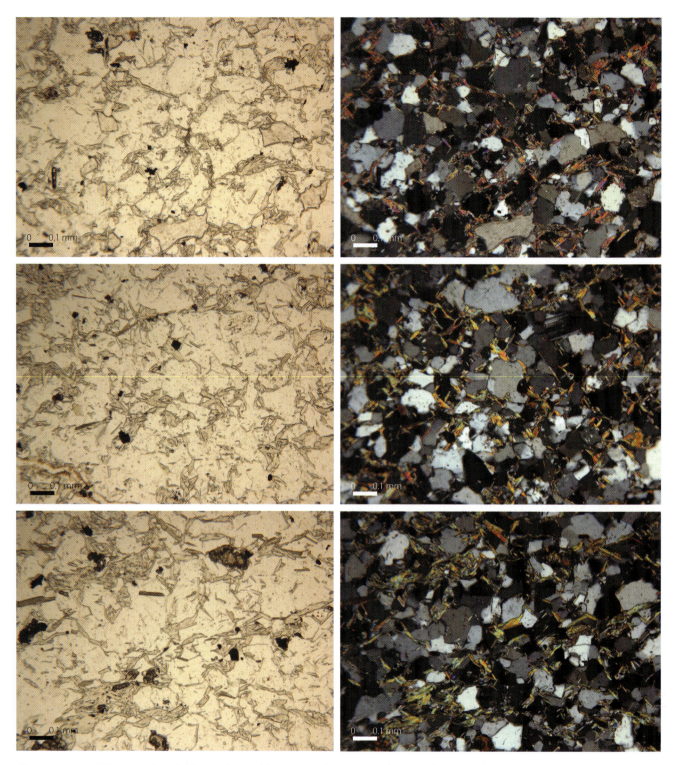

Figure 12.13. *Micrographs of thin sections of Quoygrew hones 6079 (top row), 61571 (middle row) and 62133 (bottom row) in plane- (left) and cross- (right) polarized light. (Image: Fiona Breckenridge and Judith Bunbury.)*

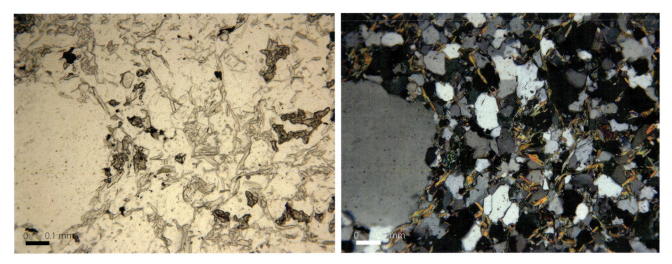

Figure 12.14. *Micrograph of thin section of Quoygrew hone 6590 in plane- (left) and cross- (right) polarized light. (Image: Fiona Breckenridge and Judith Bunbury.)*

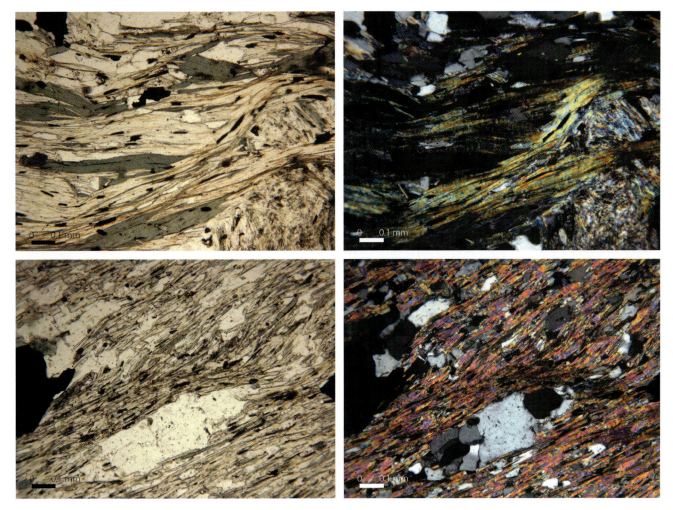

Figure 12.15. *Micrographs of thin sections of Dunrossness Phyllite samples 12404 (top row) and 27141 (bottom row) in plane- (left) and cross- (right) polarized light. (Image: Fiona Breckenridge and Judith Bunbury.)*

(mainly) medium crystalline, consisting of well-foliated muscovite, with appreciable small (up to 3.5 mm) greyish-pink garnet, a few finely crystalline masses of a black prismatic mineral (probably of hornblende type) and sparse probable quartz. Find 61565 has one grinding face visible and has been subject to heavy use. It was found in the fill of the side bench constructed in Room 1 during Phase 3.4. Find 60707 was a section of an upper(?) stone with traces of a large central perforation and extensive wear. It had been reused in a Phase 4.2.1 context as part of the curb inside a secondary entrance added to the north wall of Room 2.

An incompletely manufactured disc (Sf. 60934 from Phase 4.2) has been fashioned from raw material identical to that of Sf. 60707. If completed it would have had a diameter of *c.* 100 mm, and may possibly have been intended as a pot lid. Another fragment of mica schist (Sf. 61635 from Phase 3.3) has been roughly worked into a smaller irregular disc 60 mm in diameter and 14 mm thick. It is made of slightly different material: pale to medium silver grey schist, medium crystalline, consisting mainly of well-foliated muscovite with some probable biotite and a magnetic mineral, almost certainly magnetite. A fifth find (Sf. 60562, from Room 2 in Phase 4.2.1) is probably a quern fragment, but lacks an intact worked surface. It is made of mica schist identical to that used for loom weight 62147 described in Section 12.3 above.

There are metamorphic rocks in Orkney, but they are lithologically quite unlike any of the items noted here. The feasible sources for these mica schists include Norway, Shetland, the Scottish Highlands and the Western Isles. Quern stones of garnetiferous mica schist have been recovered from other Viking Age and medieval sites in the region. Examples include Jarlshof in Shetland (Hamilton 1956, 182) and Freswick Links in Caithness (Batey 1987, 162–3, 183–4). Large-scale Viking Age and medieval quarrying for export is known from Norway (at Hyllestad north of Bergen, for example) which may thus be the origin of some or all of this material (cf. Baug 2005; Grenne *et al.* 2008).

12.7. Possible querns of sandstone

Two objects of sandstone may also have been querns. Find 7079 from Phase 6 is a saddle quern made from a large beach cobble and is of typical prehistoric form. It is likely to be residual in the context from which it was recovered, and was probably introduced to the site as building stone. Find 61642 from a Phase 3.2 floor layer in Room 1 is difficult to interpret. It may be part of a small sandstone quern with an hour-glass perforation.

12.8. Pounders and anvils

Nineteen simple sandstone pounders (with evidence of battering on one or both narrow ends, and occasionally also on other surfaces) were recovered from Quoygrew (Table 12.3). These are in addition to the three possible sandstone hones noted above that were also employed as pounders. All are simple beach pebbles of local origin. There is one find from Phase 1.2 (Sf. 70117), five from Phase 3 (Sfs. 61457, 61458, 61687, 61967 and 62201), one from Phases 3 to 4 (Sf. 61846), seven from Phase 4 (Sfs. 6390, 6469, 60531, 60692, 60731, 60748 and 60891), one from Phases 4 to 5 (Sf. 61773) and four from topsoil or other unstratified contexts (Sfs. 69, 4007, 60540 and 60757). Many are from floor layers of Rooms 1 and 2. Thus their absence from Phase 2 (which is represented mostly by floors, from House 5) may be meaningful in chronological terms. It is conceivable that hones of Eidsborg schist fulfilled both pounding and sharpening functions in this earlier phase.

Multi-functional stone tools like the sandstone pounders from Quoygrew are ubiquitous finds in pre-Viking Age contexts from the Northern Isles (Clarke 2006, 45–6). They can be readily paralleled, for example, at St Boniface in Orkney (Clarke 1998a, 133–5) and Scalloway in Shetland (Clarke 1998b, 140–44). However, the form of these objects is probably too simple to suggest that their use implies the retention of an indigenous Pictish technology — particularly given their absence from Quoygrew during Phase 2. One purpose to which they may have been put is the removal of limpets from the stony foreshore — which requires some force.

In addition to the pounders discussed above, two stones from Quoygrew clearly served as anvils of some kind (Sfs. 60455 and 60449). They were found adjacent to each other, embedded in the floor of Room 2 during Phase 4.2.2 (when this space had been reconfigured as a workshop) (see Fig. 4.39). Find 60455 is roughly spherical whereas Sf. 60449 is a flatter oval. It is impossible to suggest the specific purposes to which they were put, but Sf. 60455 in particular is heavily pecked on its upper surface. Two further stones (Sf. 6385 from Phase 4.4 and Sf. 6566 from Phases 4.3 to 4.4, both in Room 1) may also have served as anvil stones based on wear. Both are smaller, perhaps portable, objects that were not found *in situ*.

12.9. Pumice

There are 22 finds of pumice, spread through most phases of the site (Table 12.3). The ultimate source of this material is almost certainly Iceland, but all of

the Quoygrew finds are water-worn and thus they were probably picked up from the adjacent seashore rather than purposefully imported. Find 61879 from Phase 4 is a partially perforated float (discarded in an unfinished state), presumably for line or net fishing. Six other pieces of pumice appear to have been utilized for smoothing: Sf. 62241 from Phase 2.2, Sf. 7971 from Phases 2 to 3, Sf. 60915 from Phase 4.2, Sf. 4168 from Phases 4 to 5, Sf. 61863 from Phases 4 to 5 and Sf. 60409 from Phases 5 to 6. It is important to note that, unlike layers of volcanic tephra, the presence of such material in a context is not a chronological marker, since pumice is readily available on nearby beaches and could have been used for any activity requiring an abrasive or a float. The incomplete nature of Sf. 61879 reinforces the view that this is expedient use of a local resource. Pumice is found naturally along the coasts of northern Scotland and the Northern Isles (e.g. Dugmore & Newton 1999, 167).

12.10. Flint

Forty-three finds of flint can be subdivided into unworked pieces and chips, struck pieces and flakes, a possible core (Sf. 61077 from Phase 3.5), a possible burin (Sf. 60446 from Phases 5 to 6) and a modern gun-flint (Sf. 105 from unphased layer H002). An unusual piece (Sf. 6377 from Phases 5 to 6) with a glassy adhesion may simply represent the burning of the flint in a sandy matrix. Overall, the flint is scattered through the different phases and areas of the site, indicating a lack of *in situ* working. The single possible core and burin may be reused prehistoric material. Most of the other material is irregular and is likely to represent a combination of natural inclusions and the residue of fire starting using strike-a-lights.

12.11. Miscellaneous stone objects

Two pivot stones were identified (in addition to Sf. 62120, the loom weight of mica schist reused for this purpose noted above). Find 62134 was incorporated into paving of the floor of House 5 in Phase 2.3. Find 6057 was from a post-abandonment fill of Room 1 attributed to Phases 5 to 6. These objects were almost certainly structural elements that served as swinging mechanisms for doorposts or similar. Two further finds, Sfs. 61698 and 61914, were also architectural

features. They were perforated flagstones laid immediately inside the southwest door of Room 1 during Phase 3.2. Their function is uncertain. The holes could have held pegs, or simply helped to drain excess water from the entryway.

Find 62242, from Phase 2.2 of House 5, appears to be part of a circular stone bowl with a thick base. It has clear external tooling and internal scratches and may be an attempt to produce a bowl or lamp in a local material which was much harder to work than steatite. This piece has similarities to hollowed stones from Pool for example (Clarke 2007, 369–74). Two semi-manufactured stone discs (Sf. 6482 from Phases 2 to 3 and Sf. 6040 from Phases 4 to 5) represent the ubiquitous 'pot lids' so commonly found on sites of all periods in Atlantic Scotland. Two additional stone discs (of imported mica schist, Sfs. 60934 and 61635) have been discussed above. Lastly, a perforated flagstone (Sf. 60612) from Phase 4.3.1 of Room 2 is probably part of a broken roof 'tile'. It is from a context interpreted as roof collapse and is the first clear evidence for the use of flagstone roofing at Quoygrew. Stone roofs, covered with a layer of thatch and/or turf, were used in Orcadian architecture of later centuries (Fenton 1978, 181–90).

12.12. Discussion

Studies of style and raw material demonstrate that many of the utilitarian stone objects at Quoygrew were imported: steatite vessels, mica schist querns, schist bake stones, Eidsborg schist hones and a probable purple phyllite hone. They probably came directly from Shetland (e.g. four-sided and hemispherical steatite vessels) and Norway (e.g. hemispherical steatite vessels, Eidsborg hones, schist bake stones and perhaps mica schist querns). Other objects, such as spindle whorls and loom weights, were manufactured from the broken fragments of the above. These imports were distributed unevenly through the stratigraphy of the site. They occurred in Phase 1, were well represented in Phase 2 and then began to be replaced by local alternatives (such as ceramic vessels and sandstone hones) in Phase 3. By Phase 4 it is likely that only residual examples remained. The socioeconomic implications of this shift are explored in Chapter 16, where it is interpreted as the cumulative result of changing networks, reduced long-range trade, reduced purchasing power and shifting expressions of insular identity.

Chapter 13

Evidence of Exchange Networks: the Combs and other Worked Skeletal Material

Steve P. Ashby

with a contribution by Colleen E. Batey

13.1. Introduction

The collection of combs (including a single comb case) entails 34 finds, equating to a minimum of 26 original objects when cross-mending pieces are taken into account. Few of the combs are complete and many are highly fragmented. Nevertheless, this small assemblage is informative insofar as it implies networks of exchange and stylistic influence incorporating both Scandinavia and the Irish Sea region. Single-sided, double-sided, composite and one-piece combs are all represented, but the majority are of single-sided composite form. Here they are classified and discussed using Ashby's (2006; 2007; 2009; 2011; see Section 13.2 below) typology, devised to illuminate the chronology, place of manufacture and social significance of the combs of northern Britain in the Viking Age and Middle Ages. Reference is also made to Wiberg's (1977) typology, based on finds from Oslo, in order to provide subdivisions of the broadly defined Ashby Types 9 and 13.

Each comb is described individually below, with cross-mending pieces recorded and considered together (see Appendix 12.1 for the original find by find record). The terminology of Galloway (1976) and MacGregor (1985; MacGregor *et al.* 1999) is employed. Most Viking Age and medieval combs were of composite construction, with either one row of teeth (termed 'single-sided') or two ('double-sided'). They consisted of at least two 'connecting plates' that ran along the length of the comb, and a variable number of 'billets' (herein termed 'tooth plates' and 'end plates') that were secured between the connecting plates with rivets. Raw materials, comb form, and ornament — as well as the materials and placement of rivets — have all been shown to be regionally and chronologically distinctive (e.g. MacGregor 1985; Riddler 1990; Smirnova 2005; Ashby 2006). These characteristics are recorded below where possible.

There has been on-going uncertainty regarding the identification of reindeer (*Rangifer tarandus*) antler combs in Scotland (cf. Weber 1993; Graham-Campbell & Batey 1998, 222; Bond 2007b, 214; discussion in Barrett 2008, 420). Thus the author has conducted a study of raw material analysis (Ashby 2006). Using only low magnification it has proven possible to tentatively differentiate worked red deer (*Cervus elaphus*) and reindeer antler objects in those few cases where a cross-section of the distinctive transition between compact outer and cancellous inner tissue has been preserved (Fig. 13.1). The antlers of these two species are the main candidates for comb manufacture in the North Sea and Irish Sea regions. Elk (or moose, *Alces alces*) antler was an effective alternative around the Baltic, but it can usually be recognized, given its distinctive surface texture, density, fine core porosity and scale (Ambrosiani 1981, 36, 102–3; Smirnova 2005, 11–15; Ashby 2006, 76–98; see also Carlé *et al.* 1976; Gostenčnik 2003; Bartosiewicz 2005). Its use in objects has yet to be recognized in early medieval Britain, and it was not evident at Quoygrew. The remaining (non-perishable) likely raw material for the combs from Quoygrew is postcranial bone, which can also be recognized when characteristic features survive (Penniman 1952; O'Connor 1987).

In the event, only probable reindeer antler, undifferentiated antler, postcranial bone and undifferentiated bone or antler were recognized at Quoygrew. The probable reindeer antler identifications (on characteristically Scandinavian Type 9 combs) are not surprising given the existence of large-scale reindeer hunting infrastructure in medieval Norway (e.g. Mikkelsen 1994; Indrelid & Hufthammer 2011). The absence of definite identifications of red deer antler *is* surprising. It may relate to the highly fragmented nature of the characteristically 'western' Type 8 combs, for which use of this raw material (and/or bone) is to be expected (see Section 13.2 below). With the advent

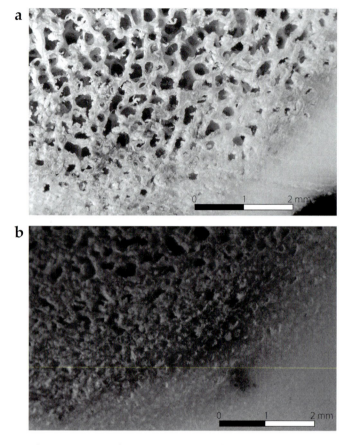

Figure 13.1. *Reference specimens of (a) red deer and (b) reindeer antler. Note the discrete core-compacta margin in (a), and the much more diffuse, semi-porous transition zone in (b). These criteria were noted by Smirnova (2005) and corroborated in blind tests by Ashby (2006). (Image: Steve Ashby, after Ashby 2009.)*

Table 13.1. *Distribution of comb finds by type, raw material and phase.*

Object type	Raw material	Phase 1	Phase 2	Phase 2–3	Phase 3	Phase 6	Total
Comb (Type 6)	Antler	1		1			2
Comb (Type 8a)	Bone or antler			2			2
Comb (Type 8a/9)	Bone or antler			1			1
Comb (Type 8c)	Bone			1			1
Comb (Type 8c)	Antler			8			8
Comb (Type 9)	Bone or antler		1				1
Comb (Type 9)	Antler		2		2		4
Comb (Type 9)	Probable reindeer antler		3	1	1		5
Comb (Type 13)	Antler				1		1
Comb (Type 14b)	Bone					1	1
Comb rivets (Type 9 or 13)	Copper alloy				1		1
Comb tooth	Bone or antler		1	4			5
Comb tooth?	Bone or antler			1			1
Comb case	Bone?			1			1
Total		**1**	**7**	**20**	**5**	**1**	**34**

of high-throughput biomolecular technologies, proteomic techniques such as ZooMS will soon provide a more reliable method for identifying bone/antler objects to species (van Doorn *et al.* 2011).

Table 13.1 shows the stratigraphic distribution of the Quoygrew comb fragments based on the number of registered finds. Table 13.2 provides both phasing and location information for the (smaller) number of individual combs recognized after cross-mends are taken into consideration. Raw material identifications are provided in both cases and the tables also include finds of isolated teeth (which are not otherwise discussed in the chapter). Most of the combs (and the comb case) were recovered from Phases 2 and 3 — with just single finds from Phase 1 and from a disturbed context of Phase 6.

13.2. The comb types

Before considering the combs in detail, it is appropriate to briefly consider the means of their classification. The typology developed by the author (Ashby 2006; 2007) is based on form (in profile and cross-section) and the raw material used for rivets. The original typology covers the period AD 700–1400, and includes 14 types, each with subtypes. For the present purpose, we need only discuss Types 6, 7, 8, 9, 13 and 14b (see Figs. 13.2 & 13.3). Each type has a defined geographical distribution (Fig. 13.2) and chronological range, and is further distinguished by trends in ornament and raw material use.

Type 6 combs are short (between 10 and 15 cm in length), with straight end plates, and have connecting plates that are plano-convex in profile, with a deep plano-convex cross-section. The type has been most famously discussed by Kristina Ambrosiani (1981), and has thus popularly been referred to as the 'Ambrosiani B' comb. Ambrosiani's chronological synthesis (Ambrosiani 1981, 62, 64) identified the type as characteristic of the tenth century, and subsequent studies have supported this position. However, the type is widely distributed between Ireland and northeastern Europe, and Ambrosiani did not comment in detail on regional variation. In England, Type 6 combs are most frequently fixed with iron rivets, but rivets of copper alloy are commonly used in Scandinavia, and at Birka these are ubiquitous. Thus, contrary to Ambrosiani's assumptions, there is evidence of regional variability in manufacturing practice in this form. Ambrosiani proposed that most examples from Scandinavian sites were manufactured in red deer antler, and this appears to hold true in England and Scotland.

Similarly, Type 7 combs are distinguished by a deep, plano-convex connecting plate section, but

Table 13.2. *Distribution of combs (after cross-mending) by type, raw material, phase and location.*

Comb type	Raw material	Farm Mound Phase 1.2	House 5 Phase 2.2	House 5 Phase 2.3	House 5 Phase 2.4	House 5 Phase 3.1	Farm Mound Phase 2–3	Fish Midden Phase 2–3	Room 1 Phase 3.2	Room 3 Phase 3.2	West of Room 3 Phase 3.2–3.6	Area G3 Phase 6	Total
Type 6	Antler	1					1						2
Type 8a	Bone or antler							2					2
Type 8a/9	Bone or antler							1					1
Type 8c	Bone						1						1
Type 8c	Antler						3						3
Type 9	Bone or antler			1									1
Type 9	Antler			2						1			3
Type 9	Probable reindeer antler					1	1				1		3
Type 13	Antler								1				1
Type 14b	Bone											1	1
Comb case	Bone?							1					1
Comb rivets (Type 9 or 13)	Copper alloy				1								1
Comb tooth	Bone or antler		1				4						5
Comb tooth?	Bone or antler						1						1
Total		1	1	3	1	1	11	4	1	1	1	1	26

they are significantly larger than Type 6, and manufactured to a less tightly-controlled template. Indeed, they have a range of irregular profiles, some being markedly plano-convex, while others are relatively straight. They bear simple ornament, and are invariably fixed with iron rivets. Based on an Irish sample, Type 7 combs fit into Dunlevy's (1988) Class F2, where they are dated to the late ninth to twelfth centuries. In England, on the basis of sites such as Coppergate, York, most examples can be assigned to the tenth and eleventh centuries. Like Type 6, in England and Scotland, Type 7 combs seem to be overwhelmingly manufactured from red deer antler, though no detailed survey of material in Scandinavia has been undertaken.

Type 8 combs are broadly similar to Types 6 and 7 in general appearance, but they differ from these in terms of both connecting plate section and ornament. Overall, Type 8 combs can be dated to an extended period between the tenth and thirteenth centuries, but higher resolution is possible if one considers within-group variation (Fig. 13.3). Type 8a (which is characterized by connecting plates of triangular section) and Type 8b (with connecting plates of trapezoidal section), date to the tenth to twelfth centuries. Types 8a and 8b are known in both England and Ireland, but their relative chronology is unclear, and though it is likely that Type 8a is the precursor to Type 8b, a detailed

chronological survey is required before their degree of contemporaneity may be confidently ascertained. Type 8c combs may be related to both of the above, and also show similarities with Type 6, as their connecting plates have a deep plano-convex section, while they feature a rather square, inelegant profile, and tend to lack ornament. In Dunlevy's Irish corpus, they fit into class G (Dunlevy 1988, 367–8), and are dated to the period between the ninth and thirteenth centuries. However, they seem much more common in the later half of this range, and most date to the period between c. AD 1100 and 1300. Interestingly, they seem to have been common in Ireland in the thirteenth century (see in particular the collections from Waterford and Cork: Hurley & Scully 1997, 656–7), though their manufacture and use in England by this date seems to have dwindled. In terms of distribution, Type 8 combs seem most common in England and Ireland, and while they are known in Scandinavia and northern Europe, they are undoubtedly much more common on the southern coast of the Baltic than they are to the north of the Kattegat. Key continental collections come from Hedeby (Tempel 1970, Taf. 25, 39) and Wolin (Cnotliwy 1973: e.g. Ryc. 38 g). A detailed study of Irish, continental and Scandinavian material is needed, but in England and Scotland Type 8 combs are very largely manufactured in red deer antler.

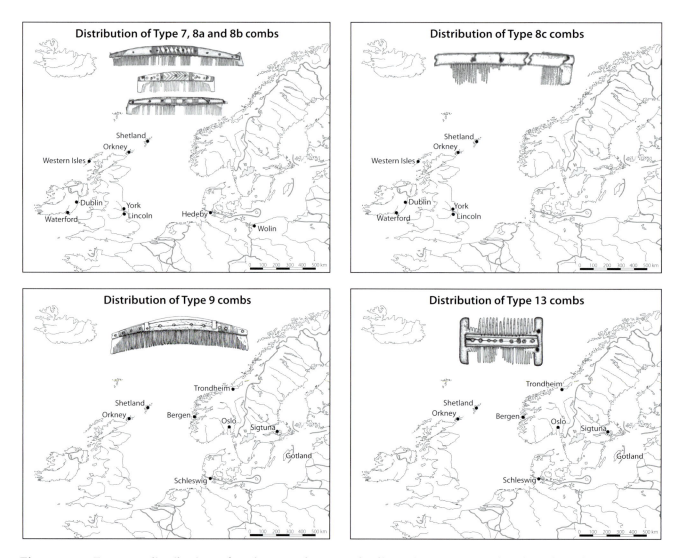

Figure 13.2. *European distributions of comb types relevant to the discussion. Types 6 and 14 (not shown) are widely distributed throughout northern Europe. The maps show only key sites with large collections, and indicate general trends. (Image: Steve Ashby and Dora Kemp.)*

Type 9 combs are well-made, single-sided combs, and are readily recognizable, according to two key traits: their lack of complex incised ornament, and the decorative use of copper-alloy rivets (occasionally combined with use of copper-alloy plate). Type 9 combs are frequent finds in Scandinavian contexts dating between the late-tenth and thirteenth centuries (see for example Ulbricht 1980; Flodin 1989), while they are well known in Atlantic Scotland (Curle 1982), and eastwards into western Russia (Smirnova 2005, fig. 3.36). Interestingly, the type is much more poorly represented in England and Ireland, and in these contexts examples are best interpreted as indicators of overseas trade and travel (Ashby 2006, 146–7). There is considerable diversity within the type (see Wiberg 1977; Flodin 1989), but no study has yet fully detailed

an internal chronology for this variation. The author's analyses of material in England, Scotland, and selected sites in Scandinavia, together with work undertaken by other researchers (e.g. Vretemark 1997) suggests the exploitation of both reindeer antler and post-cranial bone, but in order that such patterning may be meaningfully discussed, a more systematic raw material survey of combs from around the North Sea and Baltic regions is necessary.

Type 13 combs differ from all of the above-discussed types, as they feature two rows of teeth (commonly referred to as double-sided). Like Type 9, they are well-crafted objects, and their teeth are differentiated, with one set of coarse, and one set of fine teeth. The latter in particular are demonstrative of both access to specialist tools, and a high level of skill

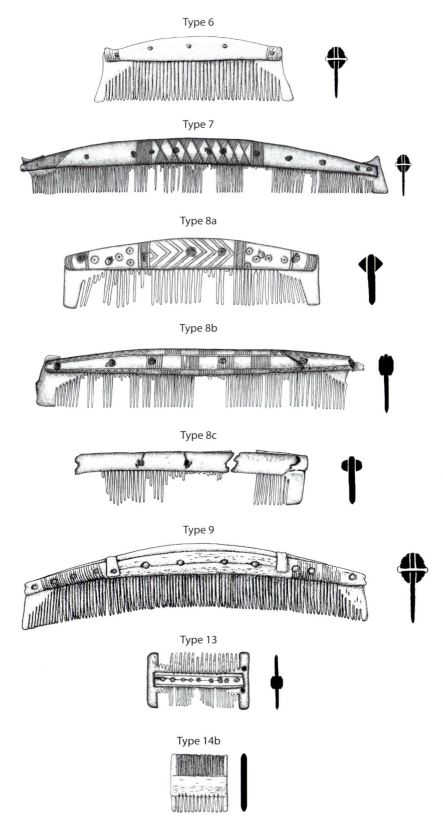

Figure 13.3. *Typical examples of comb Types 6 (Birka), 7 (York), 8a (York), 8b (York), 8c (Durham), 9 (Trondheim), 13 (Freswick Links, Caithness) and 14b (York), together with schematic representations of their cross-sections. Not to scale. (Image: Steve Ashby, Richard Jackson, Hayley Saul and Pat Walsh.)*

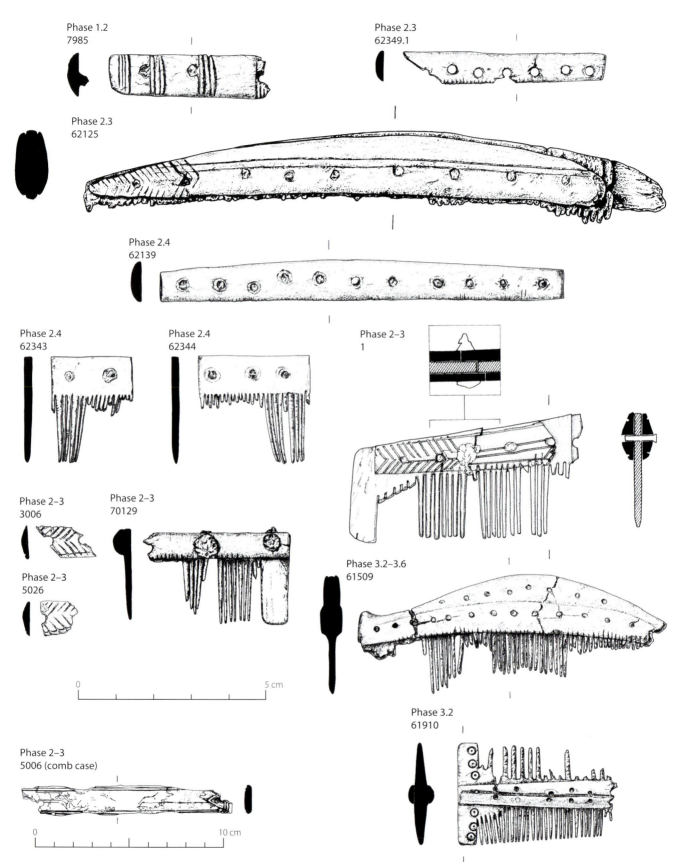

Phase 1.2
7985

Phase 2.3
62349.1

Phase 2.3
62125

Phase 2.4
62139

Phase 2.4
62343

Phase 2.4
62344

Phase 2–3
1

Phase 2–3
3006

Phase 2–3
70129

Phase 2–3
5026

Phase 3.2–3.6
61509

Phase 2–3
5006 (comb case)

Phase 3.2
61910

0 5 cm

0 10 cm

Figure 13.4. *A selection of the 34 antler and bone comb and comb case finds from Quoygrew. (Image: Caitlin Evans and Dora Kemp.)*

and experience. Type 13 combs are characterized by a restricted range of incised ornament. Instead, their ubiquitous copper-alloy rivets are often decoratively applied. They may be set at very short distances from one another, arranged in pairs, or in multiple rows. Like Type 9, this group is morphologically diverse, and in the absence of a satisfactory internal chronology, it suffices to say that the type emerged in Scandinavia in the twelfth century, and seems to have persisted as late as the fifteenth. Again, both reindeer antler and bone is known in the production of Type 13 combs, but we await a detailed systematic survey of raw material use.

Type 14 combs are also double-sided, but differ from Type 13 in that they are of one-piece (rather than composite) design. Three sub-types (14a–c) have been identified in northern Europe, but in the present context only one (14b) need concern us. Type 14b combs are small (generally less than 6 cm high) sub-rectangular combs with differentiated teeth. They are often referred to as nit combs. They seem to emerge in the fourteenth and fifteenth centuries, but really become numerically important in the post-medieval period, when they form the template for a diversity of combs in bone, horn, ivory, tortoiseshell, and a range of other materials. Most extant examples from the medieval period are of postcranial bone, but examples are also known in ivory (indeed, these are common in continental Europe), and it is likely that combs of analogous form were also produced in perishable materials such as horn and wood.

13.3. The comb finds

13.3.1. Phase 1
Sf. 7985
Find 7985 is a fragment of the terminal of an antler connecting plate from a Type 6 composite single-sided comb (Fig. 13.4). It is rather flattened in cross section relative to classic examples of Ambrosiani's (1981) B type, but is probably of comparable tenth- or eleventh-century date. It was secured with iron rivets, and is decorated with groups of incised vertical lines. Tooth cuts are indicative of a tooth gauge of 5 per cm. The cuts are not present all the way to the end of the connecting plate, suggesting that the teeth were graduated (getting shorter towards the end of the comb). The fragment is too small to assess riveting technique. It was found in Phase 1.2 of the Farm Mound midden and is thus (in stratigraphic terms) the earliest comb from the site.

13.3.2. Phase 2
Sf. 62125
Find 62125 is a large fragment of an antler single-sided composite comb of Ashby Type 9, Wiberg Type E5,

composed of two connecting plate fragments and seven tooth plates (Fig. 13.4). The antler has a woody texture that is suggestive of reindeer, but no definitive diagnostic criteria are preserved. The connecting plates are of plano-convex profile and complex, plano-piriform section. The better preserved of the two plates displays a pair of longitudinal incised lines and a field of oblique lines close to the terminal. It also features a row of eleven copper-alloy rivets (of which two have been lost, and are now represented only by perforations).

The comb is quite degraded, but as no teeth remain, comment on level of wear is inappropriate. Nonetheless, one may note that it would have had a relatively coarse tooth gauge. Measurement of tooth bases gives a density of 5 per cm. All in all, one might date the comb to between the late tenth and thirteenth centuries, and more likely towards the earlier end of this range. Close parallels from Trondheim date to the late tenth and eleventh centuries. This find was from the floor of House 5 in Phase 2.3.

Sfs. 62139, 62343 and 62344
Finds 62139, 62343 and 62344 represent the remains of a short, straight, single-sided composite comb, consisting of a single connecting plate (Sf. 62139) and two tooth plates (Sfs. 62343 and 62344) (Fig. 13.4). It is of Ashby Type 9, Wiberg Type E4. The comb is comparable with examples from Trondheim, where it is most common between the eleventh and twelfth centuries, though it does persist into the thirteenth. The raw material is antler, and the tooth plates preserve small areas of core margin that allow it to be identified as probable reindeer. The connecting plate is of shallow plano-convex section and plano-convex profile. It has no incised ornament, and its only decoration is a line of eleven closely-spaced copper-alloy rivets. Its teeth are very finely cut (9 per cm), and of straight profile, showing signs of moderate wear. The fragments of this comb were all found in the Phase 2.4 floor of House 5.

Sf. 62349.1
Find 62349.1 includes two small fragments from the antler connecting plate of a single-sided composite comb (probably Ashby Type 9, Wiberg Type E4) (Fig. 13.4). The single row of closely set perforations is suggestive of the decorative use of copper-alloy rivets, although no rivets or associated staining are extant. Tooth cuts indicate a gauge of 5 per cm, but are not present at the comb terminals, suggesting that the teeth were graduated. Based on Wiberg's typology, the comb is probably of eleventh- to thirteenth-century date and is of similar form to an example represented by Sfs. 62139, 62343 and 62344. It was found in a Phase 2.3 floor layer of House 5.

Sf. 62349.2

Find 62349.2 is a small fragment of single-sided composite comb (Ashby Type 9, Wiberg type unknown), consisting of three tooth plate fragments. Unfortunately, the degraded nature of the raw material precludes confident discrimination between bone and antler. The copper-alloy rivets are still present, and are closely set in a single row, but precise dating is not possible. As a Type 9 comb the find is nevertheless broadly consistent with a date between the late tenth and thirteenth centuries. It was found in a Phase 2.3 floor layer of House 5.

13.3.3. Phases 2 to 3

Sf. 1

Find 1 (Fig. 13.4) is a fragment of a composite single-sided comb that combines elements of two types. The comb's connecting plates have a gentle plano-convex profile, and triangular cross section. They are decorated with opposing oblique lines, forming chevron motifs. The rivets are arranged in a single, widely-spaced row, and consist of four copper-alloy rivets and one iron rivet. The latter probably represents a repair.

The comb is interesting, as it juxtaposes connecting plates of triangular section and incised chevron ornament (typical of Ashby Type 8a) with copper-alloy rivets (typical of Ashby Type 9). It thus combines the traditions of east and west (see Section 13.2). The find probably dates to sometime in the tenth to twelfth centuries, but it is difficult to suggest where it was manufactured. At least the repair, using an iron rivet, is likely to be a relatively local rather than Scandinavian modification. The comb was found eroding out of the Fish Midden at the shore-line.

Sf. 3006

Find 3006 is a small fragment of a connecting plate from a composite single-sided comb of Ashby Type 8a, dating to the tenth–twelfth centuries (Fig. 13.4). It is decorated with opposing oblique lines either side of the plate's median ridge. The fragment is blackened from burning, which, together with its high level of fragmentation, is indicative of the comb having found its way into a hearth before being disposed of in a midden. Given this state of preservation, it is impossible to identify the raw material beyond the level of 'bone/antler'. It is from Area C of the coastal Fish Midden.

Sf. 5006

Find 5006 is part of a (probably bone) connecting plate from a case for a single-sided composite comb (Fig. 13.4). There are roughly inscribed marginal lines along the plate edges, and iron rivets are present at the plate terminals, confirming its attribution as a comb case. In

its entirety, the case would have comprised four such connecting plates, secured to a pair of end plates. Such cases were popular across Scandinavian Europe in the tenth and eleventh centuries (e.g. Wiberg 1977, figs. 19–20; Smirnova 2005, 41–6), and there are good examples from Earl's Bu (see Batey & Freeman 1986; Batey & Morris 1992) and Skaill Bay, Sandwick (Lyasight 1971) in Atlantic Scotland. Many such cases were made for use with Type 6 combs. It was found in Area E of the coastal Fish Midden.

Sf. 5026

Find 5026 is a connecting plate fragment from a composite single-sided comb of Ashby Type 8a, decorated with chevrons, and dating to the tenth–twelfth centuries (Fig. 13.4). It is very similar to Sf. 3006, and is a fragment of similar size, but is unburned, and the contexts are so displaced from one another that it seems improbable that they relate to the same comb. The fragment is too small to preserve diagnostic raw material attributes, though its polished finish is suggestive of the use of postcranial bone. It is from Area E of the coastal Fish Midden.

Sf. 70007

Find 70007 is a fragment of connecting plate from a composite single-sided comb. It is undecorated, of straight profile, and has a rather flattened plano-convex section. Interestingly, the comb has copper-alloy (rather than iron) rivets. It is best classified as Ashby Type 6 in form, but it is not a classic Ambrosiani B comb. The surface is abraded. It is antler, but identification to deer species is not possible. The tooth density would have been 6 per cm, based on tooth cuts. It is from the Farm Mound midden.

Sf. 70083

Find 70083 is a tooth plate from a composite single-sided comb of Ashby Type 9. The plate's morphology is suggestive of an early form of the type (Wiberg Types E1, E2 or E5), and the teeth have a gauge of 6 per cm, which fits as an intermediate step between Viking Age (c. 5 per cm) and medieval (c. 8–9 per cm) forms (see below). The raw material is probably reindeer antler. The comb was found in the Farm Mound midden.

Sf. 70088

Find 70088 is a fragment of antler connecting plate from a composite single-sided comb of Ashby Type 8c (twelfth or thirteenth century in date). The fragment is of plano-convex section, and, other than a row of regular tooth cuts (8 per cm), is completely undecorated. There are traces of two rivet holes, which are fairly close together, perhaps suggesting that when

complete there was at least one rivet per tooth-plate. The comb is from the Farm Mound midden.

Sf. 70129

Find 70129 represents six fragments of connecting plate and two tooth-plates from a composite single-sided comb of Ashby Type 8c, which can be dated typologically to the twelfth or thirteenth centuries (Fig. 13.4). All of the fragments are probably made of antler. The connecting plate is straight and undecorated, and of plano-convex section. Tooth-cuts indicate a tooth density of 8 per cm, while the teeth display a distinctive tapering profile that is in marked contrast to the lentoid shape of the teeth of the other (particularly Type 9) combs from the site. Three iron rivets remain. The find is from the Farm Mound midden.

Sfs. 70189, 70190, 70191, 70192, 70193 and 70194

These finds represent pieces of connecting plate and tooth plate from an antler composite single-sided comb of Ashby Type 8c, dating to the twelfth or thirteenth centuries. The connecting plate fragments are straight, undecorated, with an uneven, almost 'unfinished' surface, and of shallow plano-convex section. There are seven iron rivets remaining. The comb is from the Farm Mound midden.

Sf. 70264

Find 70264 is an end plate from a composite bone comb, possibly of Ashby Type 8c (and thus probably dating to the twelfth or thirteenth centuries). The plate has a straight, gently sloping upper edge, and its face is recessed in order to help secure the connecting plates that would have been riveted to it. Based on the positioning of the recess, the connecting plate terminals would have been positioned *c.* 5 mm in from the edge of the comb. The find is from the Farm Mound midden.

13.3.4. Phase 3
Sf. 61509

Find 61509 is a mostly complete single-sided, round-backed composite comb (Ashby Type 9), made of antler (probably reindeer), and secured and decorated with rows of copper-alloy rivets (Figs. 4.26 & 13.4). According to Wiberg's (1977) classification of these combs, find 61509 fits into Type E5-3, a long-lived class in Scandinavia (common in contexts dating between the late tenth and thirteenth centuries, though most important in the twelfth century: see Flodin 1989, fig. 44; Hansen 2005, 181). The comb's connecting plate is of a form best described as 'false-ribbed' (see MacGregor 1985). That is to say that it is sculpted such that there is a thin, semi-circular field at the top of the comb,

with a raised slightly curved area just above the teeth, in effect mimicking a more conventional connecting plate. The margins of the entire connecting plate are lined with closely-set copper-alloy rivets. The teeth have a fine gauge (8 per cm), and though the comb has suffered some tooth loss, those still extant have a lentoid section, and show medium levels of beading, consistent with relatively frequent use over a period of time. This comb was found adjacent to the west gable of Room 3 in the uppermost layer of the coastal Fish Midden (context F647). It thus marks the typological end of the accumulation of this midden (see Chapter 4).

Close parallels can be found in Trondheim, Bergen, Oslo, Schleswig, and the other late Viking Age towns of Scandinavia (e.g. Wiberg 1977, 206–7; Grieg 1933, 233, fig. 196) — from which this comb was probably imported as a finished object. Other examples from Scottish sites are not well stratified. There is a similar comb from the 'upper Norse horizon' at the Brough of Birsay (Curle 1982, Ill 49, 230), and another from Freswick Links, Caithness (Batey 1987, 225, pl. 33A).

Sf. 61910

Find 61910 is a large fragment of a double-sided composite comb, composed of two connecting plate fragments and two tooth plates (Fig. 13.4). The material is antler, which has been highly polished. The connecting plates are straight, of deep plano-convex section, with a double line of copper-alloy rivets set either side of a central longitudinal groove. The rivets are arranged into vertical pairs, and the connecting plate's green staining is quite extensive. The comb's teeth are differentiated (9 per cm on one edge, 5 per cm on the other) and of lentoid section. The one remaining end plate is straight-ended, and decorated with short lines of ring-and-dot motifs. Typologically the comb fits into Ashby Type 13, Wiberg Type D2. It was found in a Phase 3.2 floor layer of Room 1, and is (in stratigraphic terms) one of the earliest datable objects from House 1.

Close parallels are known from Scandinavian towns such as Trondheim (Flodin 1989, Ill 29), Bergen (Grieg 1933, 234–41) and Oslo (Wiberg 1977, fig. 24), and from as far afield as Novgorod (Smirnova 2005, 250–309). In the British Isles there are examples from elsewhere in Atlantic Scotland, including Jarlshof (Hamilton 1956, pl. 32) and Freswick Links (Batey 1987, 227). Most can be dated to the period between the twelfth and fourteenth centuries.

Sf. 62161

Find 62161 represents tiny fragments of copper-alloy with bone or antler preserved in the corrosion product.

The fragments almost certainly relate to a copper-alloy riveted composite comb. However, it is impossible to discern whether the comb concerned was single-sided (Type 9) or double-sided (Type 13). It is from Phase 3.1, the levelling of House 5 in order to build Room 3 of House 1.

Sfs. 62185 and 62341

Finds 62185 and 62341 represent a fragmentary composite single-sided comb of Ashby Type 9, Wiberg Type E4, consisting of two degraded and incomplete fragments of connecting plate of rectangular profile and relatively flat section, marked by a pair of deep longitudinal grooves close to the plate margins. Roughly incised tooth-cuts are evident along one edge, and are suggestive of a fine gauge (8 teeth per cm). The plates are made of antler. No rivets are preserved, and there is no evidence of iron-staining. This, together with the close-set arrangement of rivet perforations, is consistent with the use of copper-alloy rivets. Both Sf. 62185 and Sf. 62341 were recovered from the fill of a drain in Room 3 dating to Phase 3.2.

In its entirety, the comb would have had a straight profile, and a relatively plain, unornamented appearance. Similar examples are known from Trondheim (Flodin 1989, Ill 18), while one might also compare it to similar iron-riveted examples (Ashby Type 8c) known from Ireland and England (though these lack the close-set arrangement of rivets indicated by the perforations visible on this piece; see Dunlevy 1988, fig 9.2; Hurley & Scully 1997, figs. 17.1 & 17.2; Carver 1979). Typologically this comb is consistent with production and use in the twelfth–thirteenth centuries.

13.3.5. Phase 6

Sf. 70306

Find 70306 is a fragment of a double-sided bone comb. The comb's section is flat, and the teeth are of approximately equal density on each side (10/11 per cm). It probably represents a one-piece, double-sided comb (Ashby Type 14b), which could be dated to the fourteenth or fifteenth centuries. The fragment is small and poorly preserved, and there are no traces of ornament. It is from a disturbed (Phase 6) context in Area G.

13.4. The Quoygrew combs: discussion

The most common comb form at Quoygrew is Type 9, with at least seven original objects represented by 10 find groups (Tables 13.1 & 13.2). A variety of Wiberg's subclasses of this type are represented. Type 8a and 8c combs are almost as abundant at the site, with at

least six examples represented by 11 finds. Types 6, 13, and 14b are also present, but are represented by only one or two combs each.

The combs are manufactured with proficiency, though highly elaborate examples are not present. They are fastened with either copper-alloy or iron rivets (in only one example, a repair, on the same find). The level of tooth beading and wear is consistent with normal use. The trend for Type 8 combs to have teeth of tapering rather than lentoid section is notable, and has not (to the author's knowledge) been observed previously. However, only future studies will confirm whether this distinction between the types is a widespread pattern. Although the sample size is small, there are changes in tooth gauge through (typological) time — from c. 5 teeth per cm in Type 6, through 6–9 teeth per cm in Type 9, and 10–11 teeth per cm in Type 14b.

A small number of combs were made of bone (or of undifferentiated bone/antler). Some may have been manufactured locally, but most or all were probably imported as finished objects. No comb-making residues, blanks or semi-manufactures were found at Quoygrew, nor have any been recorded at most other sites in the Northern Isles. The exceptions known to the author are two blanks from Trench 1, Castle of Snusgar in Skaill Bay, Orkney (David Griffiths pers. comm.) and one from the Brough of Birsay, Orkney (Batey pers. comm.). Although we must be careful to avoid over-interpretation of an absence of evidence, these pieces are not indicative of manufacture on any significant scale and may instead imply local repair.

The majority of the combs are of antler. However, this raw material could only occasionally be identified to species. The Type 9 and 13 combs were highly finished (and thus preserve few diagnostic features) and the Type 6 and 8 combs were highly fragmented. Nevertheless, several Type 9 finds were probably of reindeer antler and thus imports from Scandinavia — an interpretation consistent with the stylistic evidence.

The other antler combs could have been manufactured using material from either reindeer or red deer. In either case most are also likely to be imports, given both the lack of working debris and the observation that red deer were probably extirpated from Orkney during the Viking Age (Bond 2007b, 214; see Chapter 8). Apart from the combs there is only one definite find of antler from Quoygrew — a knife handle from Phases 2 to 3 (see Section 13.5 below). There was also one probable and one definite identification of red deer bone, but both specimens were from the earliest occupation of the site (Phase 1 of the Farm

Mound) (Chapter 8). Red deer did, however, remain regionally available elsewhere in Britain and Ireland. Thus the combs made of undifferentiated antler could have come from a broad range of potential sources based on raw material alone.

Overall, the absence of pre-Viking Age and early Viking Age comb types (e.g. 1c, 5, 11, and 12; see Ashby 2006) supports the site's late Viking Age to medieval date. The main period of comb import at Quoygrew was clearly between the tenth and fourteenth centuries based on the finds of Types 6, 8, 9 and 13. The predominance of Type 9 rather than Type 13 combs may further imply that this principal date range can be narrowed to the eleventh to thirteenth centuries. Only one late medieval comb was found (probably a Type 14b of fourteenth- to fifteenth-century date, but residual in a Phase 6 context).

The majority of the combs came from Phase 2 and 3 contexts, and no Type 8 or 9 combs were recovered outside of these phases. In fact the well-stratified combs are mostly from Phase 2 and the very beginning of Phase 3. Only four combs were found in Phase 3 contexts, of which three were from the earliest deposits of the phase (Table 13.2) and the third (Sf. 61509) is unlikely to date later than the thirteenth century on typological grounds. The absence of any well-stratified fragments of imported combs from later in Phase 3 or from Phase 4 is particularly significant given that the relevant strata are mostly house-floor deposits (otherwise a source of many comb finds) with good bone preservation. Presumably alternatives of perishable material were employed during the fourteenth to sixteenth centuries.

Many of the combs from Quoygrew evoke a vision of a northern- and eastern-facing society. The Type 9 and 13 examples are best interpreted as direct imports from Scandinavia or personal possessions acquired there. They were very probably manufactured in the towns of late Viking Age and medieval Norway, such as Bergen, Trondheim and Oslo.

The examples of Type 8a and 8c combs probably indicate that there was also contact with Ireland and/or England in the period between the tenth century (when the presence of Type 8a is first evidenced) and the thirteenth century (by which time both forms are uncommon in England, though Type 8c still appears to be an important product in Irish towns such as Waterford; see Hurley & Scully 1997, 656–7). However, the absence of Ashby Type 7 combs, found in Dublin (Dunlevy 1988, 364–6) and York (MacGregor et al. 1999, figs. 884, 889) is curious in this regard. It may imply another source, with the Outer Hebrides (Clarke et al. 2005, 171) or Whithorn (Nicholson 1997a) on the western seaways being two potential

candidates. However, the fact that Type 8b combs (which co-occur with Types 8a and 8c at sites like Whithorn) are similarly absent at Quoygrew reminds one that random chance will play an important role in the composition of such a small assemblage. Thus the Type 8 combs from Quoygrew indicate exchange with the west and south regardless of their specific source.

Although the combs were recovered from both house floors and middens (the two main kinds of deposit at Quoygrew) there is variation in the types recovered from each. All six of the Type 8a and 8c combs were from middens whereas five of the seven Type 9 combs were from interior deposits. It is very difficult to construe this as a chronological pattern. For example, the Fish Midden (with two Type 8 combs), accumulated around House 5 (containing four Type 9 combs) yet it was capped by a stratum including an almost complete Type 9 comb. Given the small numbers involved the distinction between middens and houses is probably more spurious than meaningful. Alternatively, the occupants of House 5 (and perhaps the earliest phase of House 1, which included one Type 9 and one Type 13 comb) had atypical access to Scandinavian imports — with other users of the settlement employing Type 8 combs of British or Irish provenance.

The overall paucity of Type 13 combs from Quoygrew is also interesting. Other sites in the Northern Isles and Caithness have yielded larger numbers (cf. Clarke & Heald 2002), and the author has recorded 49 examples from across Atlantic Scotland, with the majority (44) coming from Caithness and the Northern Isles. The fact that only a single Type 13 comb was found at Quoygrew may not in itself be significant, as recent excavations at sites of comparable date have similarly failed to recover large numbers of Type 13 combs (there are only three examples from Pool, Sanday, and, in western Scotland, only three in the large collection from Bornais, South Uist). However, the type is better represented at Jarlshof, Shetland (8), while the largest collection in Atlantic Scotland comes from Freswick Links, Caithness (17). Continuing access to Scandinavian imports is to be expected in Shetland, which came under direct Norwegian rule at the end of the twelfth century (Chapter 2), but the situation at Freswick Links (Batey 1987, 227) is harder to explain. The Caithness examples are viewed by Batey as part of a continuing close political link with Norway in the face of increasing Scottification of the north. Clearly there were very local differences in the networks of trade and/or personal connections along which these combs travelled.

13.5. Other worked skeletal materials
by Colleen E. Batey

In addition to the combs, 47 other objects of worked antler and bone were found at Quoygrew (Table 13.3). Thirty-three were of land mammal bone and 13 were of whale bone. One or two were of antler. The objects represented are diverse in form and chronology. Many are typical of Viking Age and medieval sites in Atlantic Scotland and were probably made locally. The reworked weaving sword is unusual for a Scottish settlement site and may be a Norwegian import.

13.5.1. Bone pins, points and needle
This collection of 14 finds can be sub-divided into a number of categories. The most numerous are simple pins, including rough-outs, with broad flat heads which in some cases are perforated (Sfs. 5003, 5009, 7678, 62232.1, 62232.2, 62233, 70108 and 70262). Two examples are illustrated in Figure 13.5. Most are small, roughly made and presumably expedient objects used for a variety of purposes. Simple bone pins with flat splayed heads (made from pig fibulae, for example) can be of any date, but are typical of Viking Age phases in sites from the Northern Isles (e.g. Hamilton 1956, fig. 59, 126; Smith 2007b, 472–83). Perforated examples are specifically characteristic of the Viking Age at Pool on Sanday (Smith 2007b, 481).

One larger and more finely manufactured bone pin was recovered in 1978 from a test pit dug in the Fish Midden by Sarah Colley (1983; pers. comm.). It is not included in Table 13.3, but is illustrated in Figure 13.5. The pin, 125 mm long, is complete and polished.

It has a flattened head with circular perforation and notched edges to form a roughly triangular upper area of the pin head. It has an almost identical parallel from medieval Oslo (Lie 1988, 190). One tip and shank from the 1997 to 2005 excavations (Sf. 70107, from Phase 1.2 of the Farm Mound) is well-formed and may also be from a large pin of this type, but it lacks its diagnostic head.

Two well-formed nail-headed pins (Sfs. 7686 and 7694), with round shanks and flat round heads, were recovered from Phase 1.2 of the Farm Mound (Fig. 13.5). These simple objects are interesting insofar as they may be characteristic of early Viking Age contexts in Atlantic Scotland. Similar examples are known from the transitional Pictish to Viking Age phases of Buckquoy in Birsay (Ritchie 1977, 193) and the Pictish to Scandinavian 'interface' phase (7.2) of Pool in Sanday (Smith 2007b, 478–9). The type has been tentatively dated to the tenth century in discussion of a similar find from Whithorn in southwest Scotland (Nicholson 1997b, 496–7). A single fine bone needle with a circular perforation, Sf. 70039 from Phases 2 to 3 of the Farm Mound, was also found (Fig. 13.5).

13.5.2. Miscellaneous worked antler and bone
A simple section of hollowed antler (Sf. 7963 from Phases 2 to 3 of the Farm Mound) is interpreted as a knife handle. Find 70188 from Phase 1.2 of the Farm Mound is half of a pointed object with a flat base. It is of antler or bone which has been cut and polished, perhaps to create a gaming piece. Small conical stone gaming pieces of Late Iron Age (Pictish) date are known from Scalloway and Old Scatness in Shetland

Table 13.3. *Distribution of other worked bone objects by type, raw material and phase.*

Object type	Raw material	1	2	2–3	3	3–4	4	4–5	5–6	6	7	Unphased	Total
Pin	Bone	5	3	2	1							1	12
Point	Bone		1										1
Needle	Bone			1									1
Knife handle	Antler			1									1
Gaming piece	Bone or antler	1											1
Gaming piece/whorl	Bone		1	1									2
Femur head spindle whorl	Bone				2		1						3
Button	Bone								1	3	3		7
Toggle	Bone						1						1
Worked bone	Bone					1		2	1			1	5
Vertebral disc (perforated)	Whale bone			3	1			1					5
Vertebral disc (unperforated)	Whale bone			1									1
Weaving sword	Whale bone		1										1
Spindle whorl	Whale bone				1						1		2
Rope shortener or swivel	Whale bone						1						1
Pivot?	Whale bone						1						1
Worked whale bone	Whale bone	1		1									2
Total		7	6	10	5	1	2	5	2	3	5	1	47

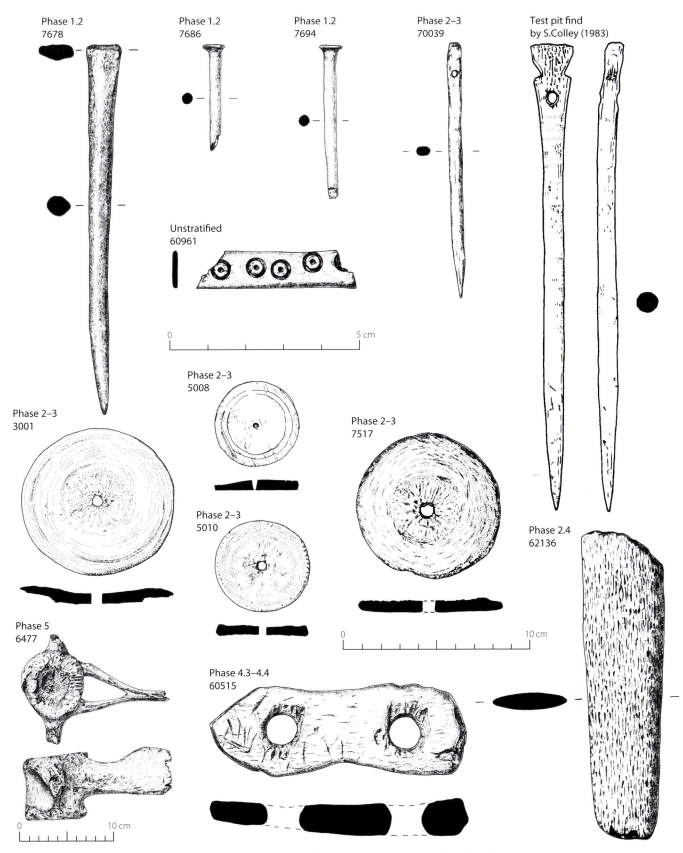

Figure 13.5. *A selection of the 47 worked bone objects from Quoygrew. (Image: Caitlin Evans and Dora Kemp.)*

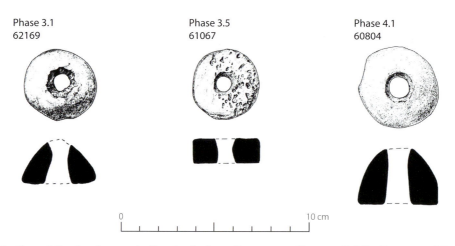

Phase 3.1
62169

Phase 3.5
61067

Phase 4.1
60804

0 10 cm

Figure 13.6. *A selection of the five bone spindle whorls from Quoygrew. (Image: Caitlin Evans and Dora Kemp.)*

(Wilson & Watson 1998; Forster 2010, 261). Poorly dated Iron Age examples in antler and bone were recovered from the Broch of Burrian in North Ronaldsay, Orkney (MacGregor 1974, 88–9). A second probable gaming piece (Sf. 5008, of bone) was a smooth flat disc, 45 mm in diametre, with a tiny perforation in the middle and two concentric rings incised around the outer edge (Fig. 13.5). It was from Phases 2 to 3 of the Fish Midden. An alternative interpretation as an incompletely manufactured spindle whorl is also possible. A simpler bone object of similar form (Sf. 62351) from Phase 2.2 of House 5 could also have been intended as either a gaming piece or a spindle whorl.

Three unambiguous spindle whorls of bone were made from femur heads: Sfs. 60804, 61851 and 62169, from Phases 3 and 4 (Fig. 13.6). Objects like these are known from sites of Iron Age to medieval date (e.g. Young & Richardson 1960, 155 no. 42; Batey 1987, 435; Mahany *et al.* 1982, 52 no. 6). Becker (2005, 157ff.) argues on the basis of Bronze Age examples that they may have functioned as buttons, although in this context the original identification of spindle whorl is preferred.

Find 60961, unstratified from Area G, is a small flat fragment of bone with incised ring-and-dot decoration on its upper face (Fig. 13.5). It is clearly not part of a comb and may have served as a mount, part of a box or even a trial piece (cf. MacGregor *et al.* 1999, 1952–63). Several other pieces of polished or perforated bone are of uncertain function (Sfs. 6035, 60403, 62047, 62113). Seven bone buttons from Quoygrew are all from Phases 5 to 6 or disturbed topsoil contexts (Table 13.3).

13.5.3. Worked whale bone
Thirteen finds of whale bone have been identified at Quoygrew. This material occurs in small quantities

in assemblages of all periods from Atlantic Scotland (Mulville 2002; Szabo 2008, 151). It provides an easily-worked and readily available resource suited to the production of items of several forms — for structural objects such as pivot blocks and for portable items ranging from spindle whorls to simple butchers' blocks. The Quoygrew assemblage includes epiphyseal discs from the vertebrae of small whales (which are in most cases perforated but otherwise unworked), a modified section of weaving sword, spindle whorls, a rope swivel, a possible pivot and worked fragments.

Six epiphyseal discs from the vertebrae of small whales were found, five with small central perforations (Sfs. 3001, 5010, 7517, 61793, 62155) and one without (Sf. 5013) (Fig. 13.5). They range in diameter from 50 mm to 88 mm. The perforated examples represent a local practice originally of pre-Viking Age origin. Similar examples have been recorded from Iron Age phases at Clickhimin Broch (Hamilton 1968, e.g. fig. 38 no. 22) and Jarlshof (Hamilton 1956, fig. 37 no. 9) in Shetland. At Pool on Sanday they were recovered from both pre-Viking Age and Iron Age to Viking Age 'interface' phases (Smith 2007, 506–8). An unstratified example is also known from the Pictish to medieval site of Freswick Links in Caithness (Batey 1987, 217). At Quoygrew, five of the six finds are from Phases 2 to 3. The sixth example may be residual in its Phase 4 to 5 context. Their function is uncertain, but these objects could have served as whorls or (with wooden handles) pot lids (Smith 2007b, 507).

A modified section of a whale bone weaving sword or 'batten' (Sf. 62136) was recovered from the Phase 2.4 floor of House 5 (Fig. 13.5). Complete objects of this type, used for beating the weft while weaving on an upright loom, are best known from Norwegian female graves of Viking Age date. A discussion of weaving battens focusing on the discovery of an iron

example from Scar on Sanday (Owen & Dalland 1999, 91–2) cites the recovery of 'swords made from the bone of a large fish' from Westray graves (presumed to be Pierowall) by Barry in 1805. Most whale bone weaving swords are from northern Norway, with iron examples more common in southern Norway. However, examples in whale bone are also known from medieval Bergen (Øye 1988, 70–72). The Quoygrew specimen has been shortened, with the narrower end of the tapering piece showing trimming to form a rounded edge, but it retains its smoothed broad surfaces and sharp long edges.

There are two whale bone spindle whorls, both in the form of flat discs: find 61067 (from a Phase 3.5 floor layer of Room 1 in House 1) and find 61561 (from a rabbit burrow west of House 1) (Fig. 13.6). The stratified example has been shaped crudely by a knife. The unstratified whorl is more carefully manufactured by trimming the epiphyseal disc of a small whale vertebra (see above). It is not common to use whale bone for this kind of item. In a study of bone whorls from Coppergate's Viking Age layers, of 56 examined none were of whale bone (MacGregor *et al.* 1999, 1964). At Freswick Links in Caithness a single whorl of whale bone was identified in an assemblage of 16 bone examples (Batey 1987, 201, fig. 38A). Flat whorls are common in Viking Age and medieval sites from the Northern Isles, but typically made of reused steatite vessel sherds (see Chapter 12).

Find 60515 is a rectilinear object 135 mm long with large perforations (with knife marks and signs of wear) at each end (Fig. 13.5). It would have served as a rope shortener or swivel. A close parallel has been noted from a Viking Age level at the Brough of Birsay (Curle 1982, ill. 50 no. 279). The Quoygrew example, however, is from Phase 4 and thus of fifteenth- to sixteenth-century date unless residual. Find 6477 (from a demolition layer in Room 1 of House 1) is a small whale vertebra that has been hollowed out on one surface (Fig. 13.5). It may have served as a door-pivot, although small for that function, or as a box (cf. Smith 1998, 137). Lastly, there are two pieces of incompletely worked whale bone: find 7907 from Phase 1.1 and find 7953 from Phases 2 to 3 (both of the Farm Mound).

Chapter 14

The Metal Finds and their Implications

Nicola S.H. Rogers, Colleen E. Batey, N.M.McQ. Holmes and James H. Barrett

14.1. Introduction

The metalwork from Quoygrew is mostly of iron (530 finds), with much smaller assemblages of copper alloy (33 finds) and lead (2 finds). In addition, five late medieval and post-medieval coins were found during the excavation. The largest category of copper-alloy objects — sheet metal from vessels — is informative as it probably indicates long-range exchange. Most of this chapter, however, focuses on the more abundant iron objects. The metal finds are summarized in Tables 14.1 (iron) and 14.2 (copper alloy and lead). The complete catalogues can be found in Appendices 12.1 and 14.1.[13]

Local iron production in Orkney (from bog ore) is likely — and local smithing a rural necessity — so much of the iron is likely to indicate local networks of supply. Perhaps surprisingly, however, some of the iron objects are probably imports (based on the presence of an oak handle and of distinctive plated mounts). It is not realistic to suggest a source for these prosaic objects, but urban centres in Norway, England or the Irish Sea region are likely candidates. Thus the iron, like most other categories of finds from the site, implies the existence of both small-scale and long-range networks of communication and trade. Although superficially an unrewarding category of material culture — poorly preserved and often identified only from x-ray — the iron from Quoygrew is also informative regarding the function of the settlement, and the character of the buildings.

Of the 530 iron finds many (including tiny finds from sieved sediment samples) were very fragmentary. Consequently, 248 remain unidentified. The identified objects are discussed in detail below, with

the exception of a few modern finds from poorly stratified contexts. There is no clear spatial patterning in the distribution of object types between Area G in the Farm Mound and the interventions of Areas A to F and J near the shore. Thus the finds are summarized by phase in Table 14.1. There are, however, some interesting spatial associations at a finer scale which help inform the function of both features and objects. These will be considered in the discussion below after the finds themselves have been described. Objects associated with craft activities are discussed first, followed by structural ironwork and fittings, accessories, horse equipment, and miscellaneous objects.

14.2. The iron

14.2.1. Woodworking tool
Find 61778 (from a Phase 4 to 5 context of Room 3) is incomplete, but may be part of a spoon bit, which would have been used to bore or enlarge holes in wood (Fig. 14.1). The form of these tools in the medieval period had scarcely changed from those used by the Romans (Manning 1985, 25–7, pl.12; Ottaway & Rogers 2002, 2726–7, figs.1335, 1337), typically having a flattened lanceolate tang, shaft of rectangular or circular section and scooped tip. Find 61778 retains part of the shaft and tang, but the tip has been broken off.

14.2.2. Possible metalworking tools
Both Sfs. 61153 (from Phase 4.5 of Room 1) and 6366 (from a topsoil context over Room 1) are incomplete, but may be fragments of tools. Both appear to have one bevelled end, such as might be found on a metalworking punch.

14.2.3. Needles
Two needles (Sf. 60363, from an unphased layer of Room 2, and Sf. 61016, from a Phase 5 to 6 layer of Room 3) and a third possible needle (Sf. 4257, from a

13. The cataloguing, identification and description of the finds was done by Nicola Rogers (iron), Colleen Batey (copper alloy and lead) and Nick Holmes (coins). The four authors are responsible for the text.

Table 14.1. *Iron finds from Quoygrew by phase.*

Find	Phase										Unphased	Total
	1	2	2–3	3	3–4	4	4–5	5–6	6	7		
Buckle						1	1					**2**
Clench bolt			1			5		1	1			**8**
Cutlery handle								1		1		**2**
Ferrule						1						**1**
Fish hook		1										**1**
Fitting		1				1						**2**
Hinge pivot?							1					**1**
Horseshoe (medieval)										1		**1**
Horseshoe (post-medieval)									1	3		**4**
Knife	1	4	4	1		7		1				**18**
Knife?		1										**1**
Mount	1	1				1						**3**
Nail	7	3	19	7	1	30	21	11	31	24	3	**157**
Nail or stud						3			1	1		**5**
Needle				1				1			1	**3**
Rove			1	2		4	1	2				**10**
Sickle?				1								**1**
Tack						1						**1**
Other objects	3		2	2		6	3	5	24	13	3	**61**
Fragments	33	10	49	12	2	45	18	6	39	17	17	**248**
Total	**45**	**19**	**78**	**25**	**4**	**105**	**45**	**28**	**96**	**60**	**25**	**530**

Phase 3 to 4 fill in the entrance to Room 3) were found on the site. Both Sfs. 60363 and 61016 have elongated oval eyes, which have probably been formed by splitting the end of the shaft, splaying out the bifurcated ends and then re-joining them with a weld (Ottaway & Rogers 2002, 2739) (Fig. 14.1). With a diameter of 3 mm and incomplete length of 76.5 mm, the large gauge of Sf. 61016 suggests that it may have been used with wool thread on woollen fabric, while the more slender Sf. 60363 would have been used on finer fabric (Walton Rogers 1997, 1785). No eye survives on Sf. 4257, which could have been a needle, or perhaps a pin.

14.2.4. Sickle?

Find 62170 represents a possible sickle — used to cut cereal crops — found in a Phase 3.2 layer of Room 3 (Fig. 14.1). Most of the tang has broken off, but the gently curved blade survives, apart from the extreme tip. Traces of mineral-preserved textile which were found on the tang at the join of the handle to the blade suggest some fabric had been used to wedge the tang into the handle socket. Medieval sickles rarely survive in complete form, but several examples have been found elsewhere in Britain (Goodall 2011, 81–2).

14.2.5. Fish hook

Only one certain fish hook has been identified in the assemblage. It is Sf. 62231 which came from a Phase 2.3 floor layer in House 5 (Fig. 14.1). The hook tip is pointed rather than barbed, and at the other end is a looped eye terminal. This find resembles other hooks from similarly dated deposits in York (Ottaway 1992, 600–601, fig. 248), and Yarmouth, Norfolk (Rogerson 1976, 166, fig .53). Fragments of at least two hooks were also found at Jarlshof, Shetland (Hamilton 1956, 153, no. 77, pl. XXXIII). Examples from Norway have also been recorded (Olsen 2004, 23–6). This hook would have been used to catch large fish, such as cod (Rogers 1993, 1319), which dominate the fish-bone assemblage from Quoygrew (Chapter 7).

14.2.6. Knives

Knives form one of the largest elements of the assemblage of iron artefacts, with 23 knives or probable knife fragments being recovered across the site. A small selection is illustrated in Figure 14.2. Many of the knives are fragmentary, and the original form can be ascertained in only five examples. All of these are whittle tang knives, with a solid tapering tang which would have been socketed into a handle. The other knife form has a scale tang, in which the tang was riveted to two handle plates, one on each side. Whittle tang knives have been recovered from sites of the Roman period onwards, but scale tang knives were not in use in Britain before the thirteenth century (Ottaway & Rogers 2002, 2751).

The most complete whittle tang knives from medieval deposits have been classified according to the typology created by Ottaway (1992, 559–61) in his study of Anglo-Scandinavian knives from 16–22

246

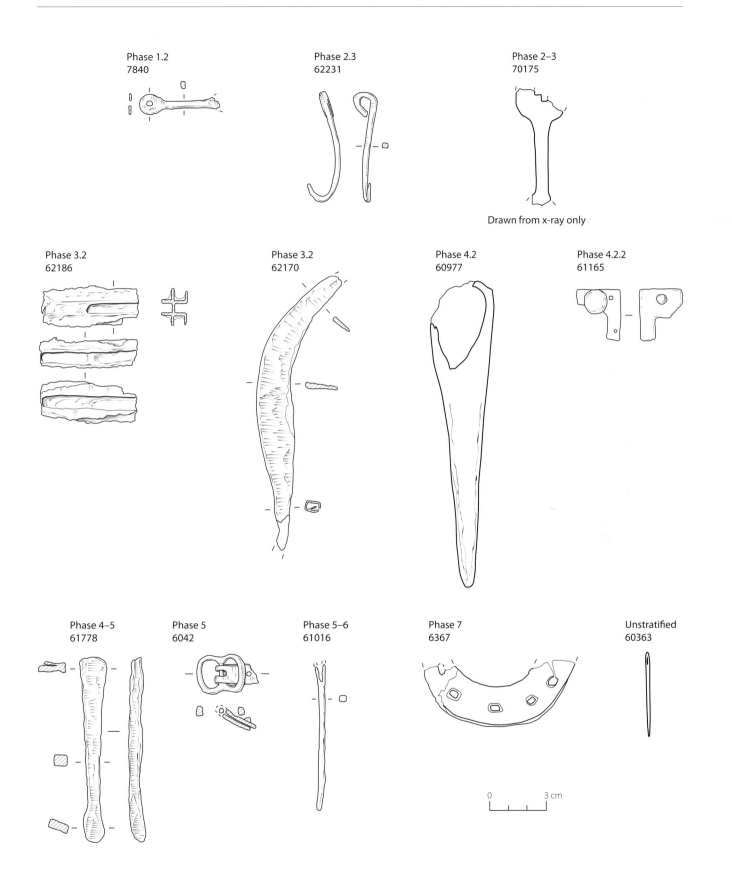

Phase 1.2
7840

Phase 2.3
62231

Phase 2–3
70175

Drawn from x-ray only

Phase 3.2
62186

Phase 3.2
62170

Phase 4.2
60977

Phase 4.2.2
61165

Phase 4–5
61778

Phase 5
6042

Phase 5–6
61016

Phase 7
6367

Unstratified
60363

0 3 cm

Figure 14.1. *A selection of the 530 iron finds from Quoygrew. (Image: Lesley Collett.)*

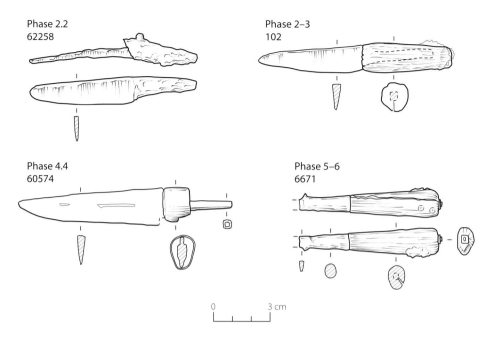

Figure 14.2. *A selection of the knife finds from Quoygrew. (Image: Lesley Collett.)*

Coppergate, York, and also applied to medieval knives from several sites across York (Ottaway & Rogers 2002, 2751–5). This typology was based primarily on the form of the blade back, and identified five groups, termed Forms A–E. Applying this typology to the Quoygrew knives, two of the five forms have been recognized: these are Type C (where the blade has a straight back close to the shoulder, or end of the tang, and is convexly curved towards the blade tip), and Type D (where the back of the blade is wholly curved). Two knives (Sf. 62258, from Phase 2.2 of House 5, and Sf. 60574, from Phase 4.4 of Room 1) are of Form C. Find 62258 is largely complete, and retains traces on its tang of an organic handle, probably of bone. Find 60574 has an iron hilt band at the join of the blade and tang.

Three knives are of Form D (Sfs. 62132, 7969 and 102). Find 62132, from Phase 2.3 of House 5, has traces of a possible bone handle. The other two knives of this form were found in middens. Find 102 is virtually complete with the remains of a hardwood wooden handle (see below), and was found in the Phase 2 to 3 Fish Midden on the cliff. The less well-preserved Sf. 7969 was retrieved from Phase 2 to 3 of the Farm Mound midden.

Five whittle tang knives which cannot be typed were also identified, the earliest in date being Sf. 70115, which was found in Phase 1.2 of the Farm Mound midden. Find 70094 came from Phase 2 to 3 of the Farm Mound midden. Two knives are composed of several fragments. Find 60708 may be part of the same knife

as Sf. 60678, both fragments being recovered from the same Phase 4.3 to 4.4 floor layer in Room 1. Finds 61569, 61825 and 61944 were all retrieved from the same Phase 4 midden fill in Room 4, and may similarly be parts of one knife. Finally, Sf. 60328 was found in a Phase 4.3.1 midden in Room 2.

Find 6671, from a Phase 5 to 6 layer south of Room 2, is of a post-medieval whittle tang form incorporating a bolster between the blade and tang. It also has a non-ferrous metal — possibly gold — end cap, and the remains of a bone handle with ring-and-dot decoration. The use of a bolster was an innovation of the mid-sixteenth century, which was in widespread use by the seventeenth century (Goodall 1993, 130).

The remaining knives are all too fragmentary to enable identification of form. Find 62235 (Phase 2.2) and 62126 (Phase 2.3) both come from House 5 floor layers. Finds 7548 and 7550 could be fragments of the same knife — both were found in the same Phase 2 to 3 Farm Mound midden layer. Find 61959 was recovered from a Phase 3 fill south of Room 3.

The two knife forms, C and D, represented at Quoygrew correspond to those recovered most frequently from both Anglo-Scandinavian and medieval deposits at Coppergate (Ottaway & Rogers 2002, 2753). Batey and Freeman (1996, 141, illus. 114, no. 193) note a whittle tang knife of similar shape from excavations at the Beachview Studio Site in Birsay, Orkney, and others from Freswick Links in Caithness (Batey 1987, 124–5, 5.3, fig. 27F).

Ottaway noted in his study of the Coppergate knives that form was unlikely to be the most significant element in any assessment of a knife's particular function, and that dimensions were probably more important (Ottaway 1992, 559). However, few of the Quoygrew knives survive in anything close to a complete state, and even where they appear complete, their original size may have been altered by wear. Measurements have been taken from the five whittle tang knives that were typed. These had blade lengths which ranged from 50 mm (Sf. 102) to 78 mm (Sf. 60574), and follow a similar pattern to the knives from Anglo-Scandinavian Coppergate where 89% of the measurable blades were of lengths between 45–85 mm (Ottaway 1992, 574). None of the complete or fragmentary knives from Quoygrew approaches the size of the largest Coppergate examples, nine of which had blade lengths in excess of 100 mm (Ottaway 1992, 575, fig. 237). In contrast, measurements of the ratio of blade width to blade length produce a different pattern to that found at Coppergate. At Quoygrew, three of the five knives had a blade length to width ratio of 3.5:1 or less, whereas at Coppergate, 81% of the knives had a blade length to width ratio of between 3.5:1 and 6.5:1. This may be an accident of survival, but could point to a different range of uses.

14.2.7. Knife handles

Two of the Quoygrew knives (Sfs. 102 and 60708) retain substantial wood-handle remains. That on Sf. 102, from Phase 2 to 3 of the Fish Midden, is a hardwood such as ash, willow, alder or hazel (potentially local raw material) (Fig. 14.2). That on Sf. 60708, from Phases 4.3 to 4.4 of Room 1, is oak (probably an import given the unlikelihood of finding oak, which has a high specific gravity, as driftwood). Three knives found in House 6 at Jarlshof (c. eleventh to thirteenth century) were also identified as having oak handles (Hamilton 1956, 183). Mineralized remains on Sf. 60574, from Phase 4.4 of Room 1, also indicate the possible use of wood for the handle of this knife. Bone and antler were also used to make handles. Find 6671, the post-medieval whittle tang knife discussed above, retains a decorated handle of bone (Fig. 14.2). Traces of osseous material on Sfs. 62258 (Phase 2.2 of House 5) and 62132 (Phase 2.3 of House 5) suggest that these knives also had bone or antler handles.

14.2.8. Other cutlery

Find 60650 from a Phase 5 to 6 fill of Room 1 is the decorative scale tang handle from a piece of cutlery, probably a knife (Fig. 14.3). Unfortunately, nothing survives beyond the lower end of the handle to indicate whether it belonged originally to a knife or fork.

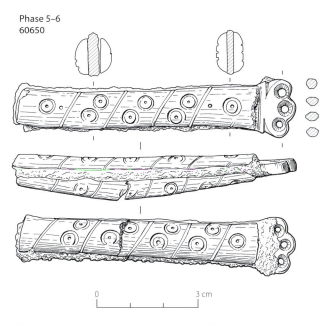

Phase 5–6
60650

0 3 cm

Figure 14.3. *The decorative handle of a post-medieval knife or fork from Quoygrew. (Image: Lesley Collett.)*

The handle is formed from a pair of osseous plates decorated with inscribed ring-and-dot and inset with a zigzag pattern of copper-alloy wire, and with a lobed copper-alloy terminal. Two copper-alloy rivets attach the plates to the scale tang. Another bone scale tang handle (Sf. 6001.2) and the remains of a three-tined fork (Sf. 6227) were both found in Phase 7 topsoil over Room 1, and might be two halves of the same piece of cutlery. Three tined forks became popular during the second half of the eighteenth century (Noël Hume 1978, 180).

14.2.9. Nails

Nails make up the single largest category of iron finds from the site, comprising 157 records (Table 14.1). Apart from a small group of five similar nails or studs discussed below, they are unremarkable. Nails were found in many types of contexts from all phases. Fifty-five came from Phase 6 to 7 contexts, particularly from the Phase 6 garden dug into the Area G Farm Mound. Many nails were also found in Phase 4 contexts of House 1, especially in Rooms 1 and 2. Presumably they secured structural timbers and internal fittings. Their abundance may relate to the decay and collapse of the building at the end of its use-life (large numbers being from Phases 4.5 and 5). Nails were not common finds in House 5, perhaps implying that this building was dismantled more carefully than House 1. This interpretation is strengthened by the observation that there were also few nails found in Phase 3 of House 1.

A smaller number of nails (19) came from Phases 2 to 3, almost all of which (15) were recovered from the Farm Mound midden of Area G rather than the contemporary Fish Midden at the shore. The Farm Mound finds may result from old structural timbers being discarded or (more likely) burnt for fuel (cf. Hamilton 1956, 116). This spatial patterning in the nail finds underscores the functional difference between the Farm Mound and Fish Midden previously inferred based on soil micromorphology (Simpson *et al.* 2005). The few nails from Phase 1 of the Farm Mound may also have derived from discarded or burned timbers.

14.2.10. Nails or studs
Five similar small nails or studs were recovered (Sfs. 61454, 61518, 61732, 61881 and 61895). All have flat sub-circular heads, the diameters ranging from 15 mm (Sf. 61895) to 17.5 mm (Sfs. 61518 and 61881), and their lengths range from 21.5 mm (Sf. 61732) to 28 mm (Sf. 61881). Three of the studs were found in Phase 4 midden fills associated with Room 3 (Sfs. 61881 and 61895) or Room 4 (Sf. 61518), and the other two (Sfs. 61454 and 61732) were found in Phase 7 (topsoil) deposits west of Room 3. It is not clear what particular function these nails or studs served, but it seems very likely that all five were originally used together, presumably in Room 3.

14.2.11. Clench bolts and roves
Eight clench bolts and ten roves were identified. Clench bolts were used to join overlapping timbers, and comprised a nail with a flattish head which, having been hammered through the timbers to be joined, then had a perforated plate or rove set over the tip. The bolt tip was usually hammered flat over the rove, which could be square, diamond-shaped or sometimes sub-rectangular (Ottaway 1992, 615).

Only three of the clench bolts appear complete (Sfs. 60524, 60594 and 60801), and their overall lengths range from 30 mm (Sf. 60524) to 33mm (Sf. 60594). All three are from Phase 4.2.1 of Room 2.

Six clench bolts still retain roves, or fragments of roves (Sfs. 7603, 7972, 60316, 60469, 60594 and 60801). All the forms of rove noted above are represented amongst the unattached roves, the most commonly found shapes being square (ten examples) and rectangular (four examples): only one diamond-shaped rove was identified. The roves range in length from 17 mm (Sf. 62377) to 31.5 mm (Sf. 70287). The clench bolts and roves all fit into the range of sizes noted at Coppergate (Ottaway 1992, 615–16).

The earliest levels in which clench bolts and roves were recovered date to the Phase 2 to 3 Farm Mound middens (Sfs. 7972 and 70287), but the majority (nine

examples) were retrieved from Phase 4 levels, with six being in contexts associated with Room 2. Five bolts and roves were found in Phase 4 to Phase 6 deposits.

Clench bolts were used in the construction of clinker-built boats and ships. They have been found in association with a number of excavated boats, such as the ninth- to tenth-century boat burials at Balladoole and Knoc y Doonee, both on the Isle of Man (Bersu & Wilson 1966, 13, 91–2), and that at Kiloran Bay, on Colonsay, off the west coast of Scotland (Bill 2005, 348–57). However, these bolts were also used on buildings, on elements such as doors, shutters and hatches, and well-covers (Goodall 1987, 181–2), as well as on carts (Ottaway 1992, 618). Given the coastal nature of Quoygrew, the clench bolts and roves found on the site could derive from boats, possibly in re-used timbers. However, use as structural fittings on dwellings at the site is equally plausible.

14.2.12. Tacks and rivets
Find 60349 (from Phase 4.3.1 of Room 2) is a tack. It might have been used on a box or casket, perhaps for attaching an edging strip (Ottaway 1992, 613). Rivet Sf. 70286, from Phases 2 to 3 of the Farm Mound midden, has become detached from its original setting. It may have been from a small iron fitting such as a buckle-plate or small hinge, although none were recovered in the excavations. Alternatively, it may be from an antler or bone comb (see Chapter 13).

14.2.13. Staples
Sf. 60959 is a fragmentary looped staple found in a Phase 4.1 floor layer in Room 2. Looped staples were used with hasps which secured the lids of chests, or to attach drop handles on boxes or chests (Ottaway 1992, 623, 643). Wood remains in the corrosion could derive from the chest to which it was originally attached.

The other staples recovered from the site are 'U'-shaped. Finds 7121 and 60828 were both recovered from Phase 7 topsoil deposits, and could be of recent date. The fragmentary Sf. 60430 was found in Phase 5 to 6 paving south of Room 1.

14.2.14. Possible hinge pivot
Find 6483, from Phase 4 to 5 fill in Room 1, may be the remnant of a hinge pivot, originally 'L'-shaped, and probably used for hanging a door or a shutter. One arm — the shank — would have been driven into a frame or wall, and the other — guide arm — would have been attached to a hinge strap.

14.2.15. Wall hook
Possibly of recent date, Sf. 70313 was found in a Phase 6 level in Area G. It appears to be a wall hook.

14.2.16. Mounts

Mounts made from strips with decorative terminals could be attached to small pieces of furniture such as caskets, and were more commonly made of non-ferrous metals than of iron (Goodall 1990a, 787). Two iron fittings of this type found at Quoygrew have traces of white metal plating, perhaps to give the appearance of more valuable material. Find 7840 from Phase 1.2 of the Farm Mound has a perforated flattened sub-oval terminal at one end, and probably had the same at the other, which is now incomplete (Fig. 14.1). Both ends of the much larger Sf. 70175, from Phases 2 to 3 of the Farm Mound, are incomplete, but the remains indicate a fitting similarly shaped to Sf. 7840 (Fig. 14.1). Sf. 61231, from Phase 4.2.1 of Room 2, is not plated, but is similar in size and form to Sf. 7840. It may be residual in floor-levelling material. Similar iron fittings were recovered from Anglo-Scandinavian levels at Coppergate (Ottaway 1992, 628–9), and from a twelfth-century level at Laugharne Castle, south Wales (Rogers unpublished data), while copper-alloy mounts of the same form have been found particularly in twelfth- and thirteenth-century deposits, for example in Norwich (Margeson 1993, 75).

14.2.17. Fittings

Miscellaneous fittings include the 'L'-shaped Sf. 61165, from Phase 4.2.2 of Room 2 (Fig. 14.1). It has a large nail with traces of plating on the head *in situ* on the broader arm, and a series of smaller perforations along the other arm. Find 61996, from a Phase 2 dump north of Room 5, may originally have been socketed, but both ends now appear broken. There are several nails still *in situ* on the fitting, all with mineralized wood attached.

14.2.18. Ferrule

Find 60977 is a large ferrule, which was found in a Phase 4.2 floor layer in Room 1 (Fig. 14.1). With their form unchanged from the Roman through to the medieval periods, ferrules were attached to the bases of wooden staffs or poles for protection against wear (Manning 1985, 141; Goodall 1984, 97). Although found in an unambiguously medieval context, at 156 mm in length, Sf. 60977 is particularly comparable to several large ferrules found in Late Saxon deposits at Thetford (Goodall 1984, 97, fig. 135).

14.2.19. Lock bolt from mounted lock

Recovered from the Phase 6 garden in Area G, Sf. 7435 is a substantial lock bolt, probably from a door.

14.2.20. Buckle

The only iron personal accessory recovered was a buckle, Sf. 6042, found in a Phase 4 to 5 demolition deposit (Fig. 14.1). It is a double-looped buckle, lacking its pin, and with part of a buckle plate for attachment to a belt. The buckle was originally plated with a non-ferrous metal. Double-looped buckles were more typically made of copper alloy, or sometimes of lead alloy (Ottaway & Rogers 2002, 2894–5), so Sf. 6042 was probably made in imitation of such buckles. The plating would also have offered protection from rusting (Goodall 1990b, 526). Double-looped buckles first appear during the fourteenth century but the form continued in use into the post-medieval period (Ottaway & Rogers 2002, 2895; Margeson 1993, 28).

14.2.21. Horse harness buckle

Find 61229, from Phase 4.2.1 in Room 2, is part of a buckle which had a revolving arm. It would have been used on horse harness, as the rotating arm would have reduced chafing from straps (Goodall 1990b, 526). The form is typically medieval, current from the eleventh to thirteenth centuries (Ottaway & Rogers 2002, 2894), so Sf. 61229 appears to be residual (perhaps in floor levelling deposits) in its Phase 4 deposit.

14.2.22. Horseshoes

Five horseshoes were found on the site, all coming from Phase 6 (Sf. 7582) or Phase 7 deposits (Sfs. 6367, 60419, 70267 and 70280). All but one are post-medieval or modern in form. Find 6367, however, is a residual medieval object (Fig. 14.1). It has countersunk nail holes and a smooth outer edge, typical of the thirteenth to fourteenth centuries (Clark 1995, 87, 96).

14.2.23. Perforated strips

Seven finds of perforated iron strip, some with nails *in situ*, were recovered. It is difficult to determine their original functions, but the larger strips such as Sf. 7371 (from the Phase 6 garden in Area G) may be fragments of hinge strap from doors or shutters, while smaller perforated strips such as Sf. 70146 (from Phase 2 to 3 of the Farm Mound) may have been parts of chest fittings or straps. Overall, the finds came from deposits ranging from Phase 1.2 (Sf. 70179) to Phase 7 (Sf. 7506).

14.2.24. Sheet fragments

Sheet fragments, some with nails or nail holes, were also found. Their original functions are unknown. Six fragments came from levels of medieval date, with 15 coming from post-medieval deposits and topsoil.

14.2.25. Unidentified objects

Several objects or fragments of objects that were recovered are of uncertain function. Sf. 7970 is a slightly curved strip or rod, and was found in Phases 2 to 3

of the Farm Mound midden. Find 62186, which was found in Phase 3.2 of Room 3, comprises six channels of rectangular section, set next to each other in a sub-circular arrangement, with copper-alloy brazing or plating all over (Fig. 14.1). Find 60631, from Phase 7 topsoil, is incomplete, and comprises a socket which at one end fits into a second socket, the whole being covered in non-ferrous plating or brazing.

14.3. Copper alloy

The copper-alloy assemblage from Quoygrew is small, comprising only 33 finds (excluding coins, which are considered below) (Table 14.2). Sixteen of these are fragments of sheet metal — probably parts of vessels — which have a common distribution on northern Scottish sites, such as Freswick Links in Caithness, dating from the twelfth century onwards (Batey 1987, 145–6), although earlier vessels (perhaps with more specialized functions) are known from Viking Age burials (e.g. Speed & Walton Rogers 2004; Stylegar 2007, 97–8). At Quoygrew, virtually all of this material is attributed to Phases 2 to 4. Such vessels needed regular repair in the form of patching, and their raw material can also be recycled. Both processes could have resulted in the small pieces, with and without evidence of riveting, found at the site.

Of the remaining part of the assemblage (17 finds, excluding copper-alloy coins), the variety of objects is greater. Two small discs with central perforations from Phase 2 to 3 contexts (Sf. 3002 from the Fish Midden and Sf. 60837 from north of Room 1) may have served as decorative mounts. Find 3002 was particularly well stratified and is dished in shape. A third perforated disc, Sf. 7253 from Phase 6 in Area G, is less well stratified and more ambiguous in func-

tion. It could simply be a modern washer. There are two simple wire-headed pins from poorly stratified contexts (Sf. 60358 which is unphased and Sf. 60598 from Phase 7) over Rooms 2 and 3 respectively. They are likely to derive from the late or post-medieval occupation of the settlement. The tiny shaft from a pin of unknown form (Sf. 61636) was also found in a Phase 3.3 context of Room 1. Given its small size this object may be intrusive.

Other copper-alloy finds include a belt slide of sheet metal (Sf. 7983 from Phases 2 to 3 of the Farm Mound) and two possible pipe-stem pieces (Sfs. 4293 and 4298 from Phase 4 to 5 middens near the cliff edge west of Room 3). The remaining copper-alloy finds include a possible comb rivet (Sf. 6387 from a Phase 2 to 3 context north of Room 1), a small ring with a circular cross section (Sf. 6228) found in the topsoil, a hook (Sf. 6063, probably from Phase 5) and a number of unidentified fragments (Sfs. 7434, 60652, 61050, 61654 and 62380).

14.4. Lead

Find 60936 is a corroded spindle whorl from a Phase 4.2 floor of Room 1. A similar find was recorded from the Brough of Birsay, Orkney (Curle 1982, ill. 53, nos. 504–6), from an earlier date, and the type has also been discussed in relation to examples from Freswick Links, Caithness, where a number of Scandinavian parallels are cited (Batey 1987, 136–7). Find 70185 is a piece of rolled lead which may have served as a fishing weight. Its mass is only 10.4 g, however, so it is unlikely to have been part of the equipment for hand-line fishing for large cod and related species from boats. It might, however, have served a more expedient purpose when catching small fish from the coast.

Table 14.2. *Copper-alloy and lead finds from Quoygrew by phase.*

Find	Phase									Unphased	Total
	2	2–3	3	3–4	4	4–5	5–6	6	7		
Copper alloy											
Belt slider?		1									1
Comb rivet?		1									1
Hook						1					1
Copper pin			1						1	1	3
Copper sheet	1	2	2	2	7	1			1		16
Mount		1									1
Object			3				1	1			5
Pipe-stem fragment?						2					2
Ring								1			1
Washer or mount		1					1				2
Lead											
Lead spindle whorl					1						1
Lead weight		1									1
Total	**1**	**7**	**6**	**2**	**8**	**4**	**1**	**2**	**3**	**1**	**35**

14.5. Coins

The disparate group of five coins from Quoygrew consists of small change denominations ranging in date from *c.* 1500 to 1891. James IV second issue pennies (Sf. 6634, of two coins together, dated 1500–10) are very common finds elsewhere in Scotland, and would have continued to circulate, one assumes, for approximately half a century. James V issued no pennies, and those of Mary are rare. The James IV coins would therefore not have been superseded as small change until the issuing of the lions/hardheads (1 1/2 pence) of Mary during the period 1555–60. Charles I third issue turners (Sf. 60506, dating to 1642–50) also circulated widely and for a very long time, including after the Union of the Parliaments in 1707 and the theoretical demonetization of pre-Union Scottish coins. Small change was never supplied to Scotland in sufficient quantities in the eighteenth century, so turners, bodles and bawbees were still circulating unofficially. Duits from the Netherlands (Sf. 60396, dated 1616–22) circulated in large numbers in Scotland in the seventeenth century and probably later. Their similar size and general configuration to turners made them acceptable as substitutes for them. The Victorian 6d (Sf. 70487, dated 1891) could have remained in circulation well into the twentieth century. None of these coins are tightly stratified, four being from the disturbed upper strata of the site and one (Sf. 60506) being a stray find.

14.6. Discussion

Collectively, the iron finds allow one to imagine a rural settlement of diverse economic activities, moderate wealth and wide-ranging networks of communication and/or exchange. In Phases 2 and 3, both the fish hook and the knives are consistent with the importance of fish processing implied by the zooarchaeological evidence (Chapter 7). The clench bolts and roves could all be from wooden elements of buildings, but it is more likely that many of them also relate to the maritime economy — being essential for the construction of clinker-built boats. The medieval horse equipment, like the small numbers of horse bones recovered from several phases (Chapter 8), indicates the presence of animals essential for land-based transportation. The find of a possible sickle from early in Phase 3 is consistent with the archaeobotanical evidence for cereal cultivation (Chapter 10). Craft activities, including woodworking, metalworking and sewing, are also indicated — albeit from the later phases of occupation.

The iron objects of medieval date imply only moderate wealth, but some aspiration to display. The decorative mounts with white metal plating (to imitate more valuable material) from Phases 1 to 3 are the best examples. The form of these objects can be paralleled in both urban centres such as Anglo-Scandinavian York (Ottaway 1992, 628–9) and a castle in Wales (Rogers unpublished data). Clearly the medieval inhabitants of Quoygrew had access to contemporary fashion when it came to emulating the fittings of cosmopolitan and wealthy contemporaries. It is not possible to suggest where these specific objects were produced, but at least information was travelling freely along the maritime networks into which the islanders were linked. A similar story of long-range connections, but without the intention to display, is evident from the knife with an oak handle. Even the most essential and utilitarian items could come from afar — although this example is later than the plated iron mounts, being from Phase 4.

The iron is also informative regarding the structural sequence. The paucity of nails from House 5, compared with the latest use and abandonment phases of House 1, may indicate that its timbers were dismantled for reuse rather than left to decay *in situ*. The finds also imply internal fittings and furnishings — like the possible hinge pivot (from a door or shutter) in Room 1 and the looped staple (probably from a chest) in Room 2.

Being fewer in number, the copper-alloy and lead finds are less informative. Both metals could have been worked locally (e.g. Hamilton 1956, 159–60). It is likely, however, that the copper-alloy sheet from vessels represents imported objects — potentially from Germany (Bigelow 1984, 214–15; 1989, 188) or Dublin (Wallace 1987, 203). It may also be relevant that the site lacks decorative copper-alloy dress fittings — like strap ends and ringed pins — known from other late Viking Age and early medieval settlements in Atlantic Scotland (e.g. Batey 1987, 108, 117, 137; Owen 1993, 327; Smith 2007a, 437; Gerrard *et al.* 2010, 13). This absence helps corroborate the interpretation that it was a settlement of modest wealth.

There are also no Viking Age or early medieval coins from Quoygrew. Moreover, the five late medieval and modern examples are of diverse dates and low denominations. Arguing from negative evidence is always problematic, but it may be appropriate to assume that most on-site economic transactions involved commodities rather than currency (cf. Skre 2011).

Chapter 15

Interpreting the Ceramics and Glass

Derek W. Hall, Lyn Blackmore, George Haggarty, Simon Chenery,
Dennis Gallagher, Colleen E. Batey and James H. Barrett

15.1. Introduction

The Viking Age and medieval Quoygrew sequence, from the tenth century (Phase 1) to the fifteenth to sixteenth centuries (Phase 4) spans the period in Northern Isles history when steatite vessels of Shetlandic and Norwegian origin were slowly replaced by both locally made and imported ceramics. The pottery from these phases thus informs our understanding of shifting patterns of trade and identity. Ceramics of seventeenth- and eighteenth-century date (Phase 5) were also recovered from the site, but these are fewer in number (being from superficial contexts that cut or covered the earlier ruins). Later still, many highly fragmented sherds of industrial ceramics were recovered from the nineteenth- to twentieth-century contexts of Phases 6 and 7, particularly in the post-medieval garden of Area G. A small number of clay pipe fragments, of seventeenth- to nineteenth-century date, were also recovered from the latest phases. This chapter summarizes the characteristics of this material and sets it within a regional comparative context. The small assemblage of glass from Quoygrew is also considered. Several beads of Viking Age and medieval date were recovered, but most of it is post-medieval vessel and window glass. The socio-economic implications of both the ceramics and glass are discussed further in Chapter 16.

15.2. Methodology

There were 3455 finds of pottery, 15 of clay pipes and 245 of glass from the excavations at Quoygrew (excluding 'off-site' discoveries, which are considered in Chapter 3). The basic unit of quantification employed here, the 'find', was either a single sherd/object or a small number of similar sherds/objects collected together from the same location. Only a few of the pottery and glass vessel sherds had cross-joins and the vast majority comprise body sherds rather than rims, bases or handles. Thus minimum number of vessels (MNV) and estimated vessel equivalents (EVE) statistics could not be employed. Nevertheless, a few probable ceramic vessel groups could be identified (see below).

The ceramic assemblage can be subdivided into four broad categories:

- medieval organic tempered wares of probable local manufacture (fabrics 1 to 5),
- imported medieval and post-medieval ceramics predating c. 1800 (fabrics 6 to 9),
- industrial ceramics of eighteenth-/nineteenth- to twentieth-century date,
- clay pipe fragments of seventeenth- to nineteenth-century date.

In all cases each sherd was examined by eye or under low magnification and assigned established fabric names where relevant and possible. Several sherds of probable Scottish redware (see below) were subsampled for ICP-MS analysis by Simon Chenery of British Geological Survey. However, further study will be required to reach a definitive conclusion regarding the provenance or provenances of this fabric (see Section 15.3.4; Haggarty et al. 2011). The glass also subdivides into four main categories: post-medieval vessels (202 sherds), window glass (20 pieces), beads (six or seven) and miscellaneous objects (16). It was examined by eye or under low magnification. Further analysis of the glass, which would be of primary relevance to Phases 5 and 6, remains a potential avenue for future research.[14]

The first and second ceramic groups were sub-

14. For the ceramics, the first category has been studied by Derek Hall, the second by both Derek Hall and Lyn Blackmore, the third by George Haggarty (with a few sherds also examined by Lyn Blackmore) and the fourth by Dennis Gallagher. Colleen Batey studied all four categories of the glass. James Barrett conducted the stratigraphic analysis and combined the results of the different contributors. All of the authors contributed to the discussion.

Table 15.1. *The pottery from Quoygrew by general phase.*

Fabric description	1	2	2–3	3	3–4	4	4–5	4–6	5–6	6	7	Unphased	'Subsoil'	Total
Medieval pottery														
Organic and quartz tempered (fabric 4a)	4		1											5
Organic tempered (fabric 3)		6	1	154	68	221	120		9		21	3	3	606
Organic tempered (fabric 1)		2	1	21	22	93	54	1	23		33	12		262
Organic tempered (fabric 2)		1	9	54	24	396	178	3	33		12	53	1	764
German proto-stoneware?				1										1
Scottish white gritty ware (fabric 8)			1	3	1	2								7
Scottish redware (fabric 6)			1	2		32	12		2		1			50
German stoneware (fabric 11)				1		3	2	1						7
Organic and quartz tempered (fabric 4b)			1	5	58	23	155		7		28			277
Wheel-made organic and quartz tempered (fabric 5)				4	3	14	4		2					27
Post-medieval pottery														
German/Scandinavian redware pipkin (fabric 9)									4	6	12			22
Industrial pottery														
Tin-glazed earthenware									1	3	2			6
Soft paste porcelain, 18th century										1				1
Creamware										1				1
Pearlwares							1		2	1	18	2		24
Lead-glazed redware				1			2		17	54	151	14		239
Bone china									2	4	15			21
White earthenware				2		1	7		18	57	168	12		265
Banded white earthenware									3	2	20			25
Hand painted white earthenware									1	9	16			26
Late dipped white earthenware										3	2			5
Late flow blue white earthenware											2			2
Lustre decoration white earthenware											4			4
Painted white earthenware											1			1
Shell edged white earthenware									4	1	15			20
Sponge decorated white earthenware									8	27	62			97
Transfer printed white earthenware			1				1		5	29	115	2		153
Porcelain, 19th century									1			4		5
Rockingham ware									3	2	44			49
Granite ware											2			2
Stoneware							1			6	32	1		40
Unidentified fragments			5	3		2	3	1	4	262	148	9		437
Unstudied pottery				1						1	1	1		4
Total	4	9	21	254	177	787	544	5	149	469	926	113	4	3455

divided into nine fabrics (numbered 1 to 6, 8 to 9 and 11) by Derek Hall. Lyn Blackmore recognized the same broad groups, with some subdivisions and the addition of German proto-stoneware. Appendix 15.1 provides outline descriptions of these ten fabric groups. In addition, George Haggarty recognized 20 categories of industrial ceramic based on fabric and/or decoration, the most important of which are discussed in this chapter.

The various medieval and post-medieval ware types are discussed below in approximate chronological order based on their appearance in the site stratigraphy. The distribution of all of the pottery finds by general phase is summarized in Table 15.1. A break-

Table 15.2. *Inferred vessel groups based on cross-joins, fabric and decoration.*

Fabric no.	Small finds	Contexts	Locations and phases	Identified by
3	61877, 62227	F668, F1028	Room 3 floor Phases 3–4, Room 3 midden fill Phase 4	Derek Hall
6	61118, 61122, 61094, 61055, 61092, 61093, 61128, 61481, 61483, 61487	F586, F620, F621, F637	Room 3 Phases 4–5, South Midden Phase 4	Lyn Blackmore
6	6672, 60226, 60227, ?60798	F096, F109, ?F053	North of Room 2 Phases 5–6, north of Room 2 Phase 4, north of Room 1 Phases 2–3?	Lyn Blackmore
6	60394, 60448, 60559, 60682, 60717, 60761	F164, F172, F194, F206, F006, F223	Room 2 Phases 4.2.1, 4.3.1 and 4.2–4.3, north of Room 1 Phases 4.5–6	Derek Hall
9	6276, 6282, 6293	F002	Room 1 Phase 7	Lyn Blackmore

Table 15.3. *The pottery from Area G by detailed phase.*

Fabric description	Phase					Unphased	Total
	1.1	1.2	2–3	6	7		
Medieval pottery							
Organic and quartz tempered (fabric 4a)	1	3	1				5
Organic tempered (fabric 2)			2				2
Scottish white gritty ware (fabric 8)			1				1
German stoneware (fabric 11)				1			1
Post-medieval pottery							
German/Scandinavian redware pipkin (fabric 9)				6			6
Industrial pottery							
Tin-glazed earthenware				3			3
Soft paste porcelain, 18th century					1		1
Creamware				1			1
Pearlwares				1		1	2
Lead-glazed redware				54	17	4	75
Bone china				4	5		9
White earthenware				57	29	1	87
Banded white earthenware				2	5		7
Hand painted white earthenware				9	2		11
Late dipped white earthenware				3			3
Late flow blue white earthenware					1		1
Shell edged white earthenware				1	3		4
Sponge decorated white earthenware				27	33		60
Transfer printed white earthenware			1	29	36		66
Rockingham ware				2	10		12
Granite ware					2		2
Stoneware				6	15		21
Unidentified fragments			5	262	73	1	341
Unstudied pottery				1			1
Total	**1**	**3**	**10**	**469**	**232**	**7**	**722**

down by detailed phase is provided in Appendix 15.2. Sherd by sherd records are provided in Appendix 15.3. Table 15.2 indicates which sherds exhibit cross-joins or are otherwise likely to be from the same vessels. Tables 15.3 and 15.4 subdivide the assemblage according to space, plotting the phase distributions of the Farm Mound and other deposits of Area G separately from the houses, middens and other contexts of Areas A to F, H and J near the shore. Table 15.5 summarizes a selection of comparative evidence. The raw data from ICP-MS analysis are provided in Appendix 15.4 for

future comparative research. The clay pipes and glass are summarized in Tables 15.6 and 15.7 respectively, and itemized in Appendix 12.1.

15.3. The ceramic ware types

15.3.1. Organic tempered wares (fabrics 1–5)

Variations of organic tempered wares make up the most common part of the assemblage, being represented by 1944 finds. The vessels in fabrics 1 to 4 appear to have been hand-made, apparently coil built, whereas fabric 5

Table 15.4. *The pottery from Areas A–F, H and J by general phase.*

Fabric description	Phase									Unphased	'Subsoil'	Total
	2	2–3	3	3–4	4	4–5	4–6	5–6	7			
Medieval pottery												
Organic tempered (fabric 3)	6	1	154	68	221	120		9	21	3	3	606
Organic tempered (fabric 1)	2	1	21	22	93	54	1	23	33	12		262
Organic tempered (fabric 2)	1	7	54	24	396	178	3	33	12	53	1	762
German proto-stoneware?			1									1
Scottish white gritty ware (fabric 8)			3	1	2							6
Scottish redware (fabric 6)		1	2		32	12		2	1			50
German stoneware (fabric 11)			1		3	2						6
Organic and quartz tempered (fabric 4b)		1	5	58	23	155		7	28			277
Wheel-made organic and quartz tempered (fabric 5)			4	3	14	4		2				27
Post-medieval pottery												
German/Scandinavian redware pipkin (fabric 9)								4	12			16
Industrial pottery												
Tin-glazed earthenware								1	2			3
Pearlwares						1		2	18			21
Lead-glazed redware			1			2		17	134	1		155
Bone china								2	10			12
White earthenware			2		1	7		18	139			167
Banded white earthenware								3	15			18
Hand painted white earthenware								1	14			15
Late dipped white earthenware									2			2
Late flow blue white earthenware									1			1
Lustre decoration white earthenware									4			4
Painted white earthenware									1			1
Shell edged white earthenware								4	12			16
Sponge decorated white earthenware								8	29			37
Transfer printed white earthenware						1		5	79	2		87
Porcelain, 19th century								1				1
Rockingham ware								3	34			37
Stoneware						1			17			18
Unidentified fragments			3		2	3	1	4	75	1		89
Unstudied pottery			1						1			2
Total	9	11	254	177	787	544	5	149	694	72	4	2699

was wheel-made. The definitions of fabrics 1 to 3 are based on minor differences in colour and inclusion. With a single exception noted below (Sf. 62083) they show no clear stylistic differences and are thus treated together hereafter (Fig. 15.1). Most examples of fabrics 4 and 5 can be regarded as organic tempered imitations of redwares (see below) with quartz inclusions — the former hand-made and the latter wheel-made (Fig. 15.2). A jug handle of fabric 4 (Sf. 61031) also implies local imitation of imported wheel-made forms.

In the main these fabrics are undecorated apart from a very distinctive vessel of fabric 2 which has stabbed decoration across its outer surface (Sf. 62083 from Phases 3 to 4, see Fig. 15.3). No parallel has yet been found for this in the published literature from Scotland. It may be an import despite being hand-made. Otherwise, it is assumed that fabrics 1 to 5 are locally

produced. The Quoygrew examples have not been the subject of scientific characterization, but similar fabrics are ubiquitous from medieval sites in the Northern Isles and Caithness and there is no reason to suspect that they were not produced there (Table 15.5). Combined petrological and elemental analyses of related ceramics from Pool on Sanday in Orkney were entirely consistent with local production (MacSween 2007).

Four finds of organic tempered fabrics found in subsoil contexts (Phase 0) are clearly intrusive. The earliest *in situ* ceramics from the site are thus four sherds of fabric 4 from Phase 1 of Area G. These have been designated fabric 4a in the tables, given that organic tempered pottery with quartz grits otherwise only appears later in the stratigraphy (being most common in Phases 4 to 5). The four sherds from Phase 1 may thus belong to an earlier ceramic tradi-

Table 15.5. *A selection of comparative evidence for the Quoygrew pottery assemblage.*

Site	Organic tempered wares	White gritty wares	Scottish redwares?	South and west English wares	Yorkshire type wares	Low Countries greyware	North German, Scandinavian and/or Low Countries redwares	German stonewares	French wares	Date	References
Quoygrew, Orkney	X	X	X				X	X		Medieval & post-medieval	This chapter
Beachview, Orkney	X									Medieval	Morris 1996
Brough of Deerness, Orkney	X		X							Medieval	Williams 1986
Kirkwall, Orkney	X	X	X		X		X	X	X	Medieval & post-medieval	MacAskill 1982
Pool, Orkney	X					X				Medieval	MacSween 2007
Freswick Links, Caithness	X	X								Medieval & post-medieval	Gaimster 1995
Robert's Haven, Caithness	X	X	X							Medieval	Hall unpublished
Scalloway Castle, Shetland							X		X	Post-medieval	Lindsay 1983
The Biggings, Shetland	X				X		X	X		Medieval & post-medieval	Ballin-Smith 1999a; Blackmore 1999a,b; Stephan 1999; Will 1999a,b
Bornais, South Uist, Outer Hebrides	X			X						Medieval	Sharples 2004; Lane 2005
Cille Pheadair, South Uist, Outer Hebrides	X			X						Medieval	Parker Pearson et al. 2004
Aberdeen		X	X		X		X	X	X	Medieval & post-medieval	Murray 1982; Cameron & Evans 2001
Rattray, Aberdeenshire		X	X		X		X		X	Medieval & post-medieval	Murray & Murray 1993
Perth		X	X		X		X	X	X	Medieval & post-medieval	MacAskill et al. 1987
Bryggen, Bergen		X			X		X	X	X	Medieval & post-medieval	Lüdtke 1989; Blackmore & Vince 1994; Hall unpublished
Oslo					X		X	X	X	Medieval & post-medieval	Molaug 1977; 1979; 1981; 1987
Trondheim		X			X		X	X		Medieval & post-medieval	Reed 1990
Isle of Man				X				X	X	Medieval & post-medieval	Davey 2002
Dublin				X			X	X	X	Medieval & post-medieval	Papazian 2000; McCutcheon 2006

tion, perhaps representing *very* limited local pottery production during the Viking Age. They are unlikely to be intrusive because Phase 1 was well sealed and more common fabrics were not found in the same layers. For example, ceramics of fabrics 1 to 3 were not found in Phase 1. A single sherd of fabric 4 from Phase 2 to 3 in Area G may also be from this early tradition.

A very few sherds of fabrics 1 to 3 then appear in Phase 2, and in the Phase 2 to 3 Farm Mound and Fish Midden deposits. If not intrusive, they may represent local ceramic production on an incidental scale

in the eleventh to twelfth centuries. It was in Phase 3, however, that finds of fabrics 1 to 3 became common. Clearly local potting first became well established in the thirteenth to fourteenth centuries. These ceramics remained popular in Phase 4, by which time small quantities of fabric 5 were present and fabric 4 (designated 4b) had also 'reappeared'.

Although there are no complete profiles from this assemblage, the vessels manufactured in fabrics 1 to 3 appear to have been jars with everted rims, slightly sagging bases and (with one exception noted above)

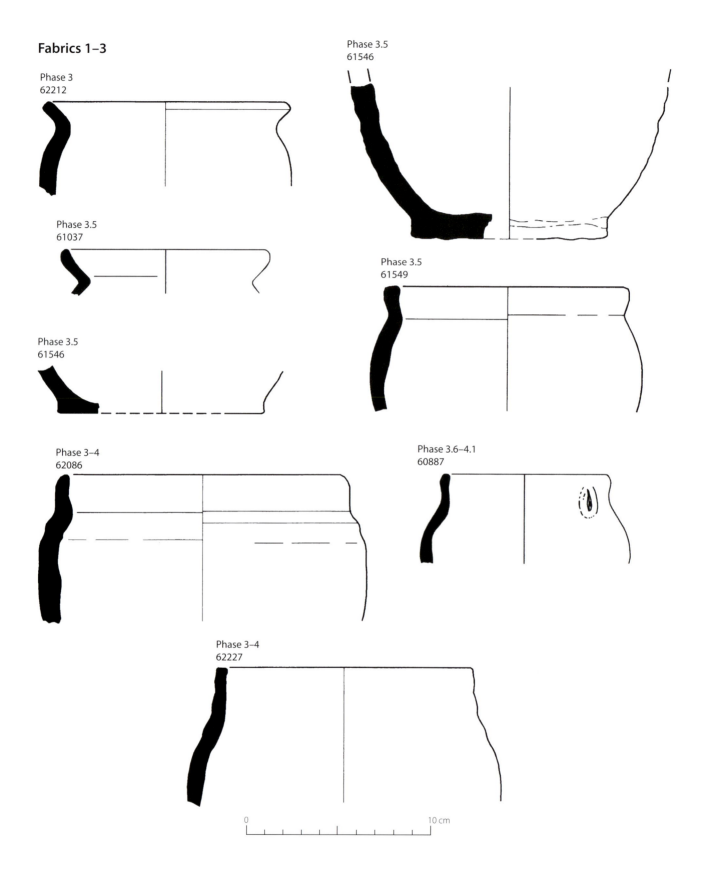

Fabrics 1–3

Phase 3
62212

Phase 3.5
61037

Phase 3.5
61546

Phase 3.5
61546

Phase 3.5
61549

Phase 3–4
62086

Phase 3.6–4.1
60887

Phase 3–4
62227

0 10 cm

Figure 15.1. *A selection of the 1632 finds of pottery fabrics 1 to 3 from Quoygrew. (Image: Dave Munro.)*

Fabrics 1–3

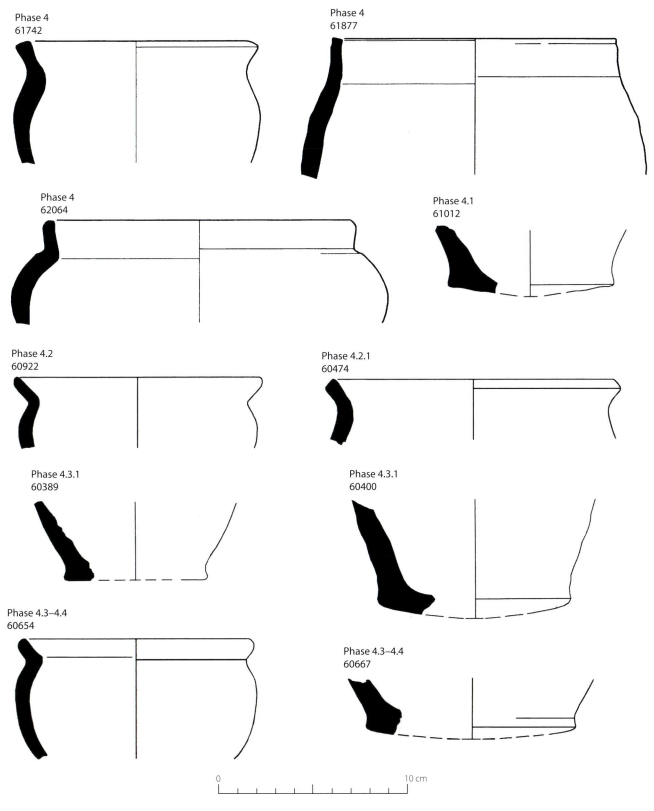

Phase 4
61742

Phase 4
61877

Phase 4
62064

Phase 4.1
61012

Phase 4.2
60922

Phase 4.2.1
60474

Phase 4.3.1
60389

Phase 4.3.1
60400

Phase 4.3–4.4
60654

Phase 4.3–4.4
60667

0 10 cm

Figure 15.1. *(cont.)*

Fabrics 1–3

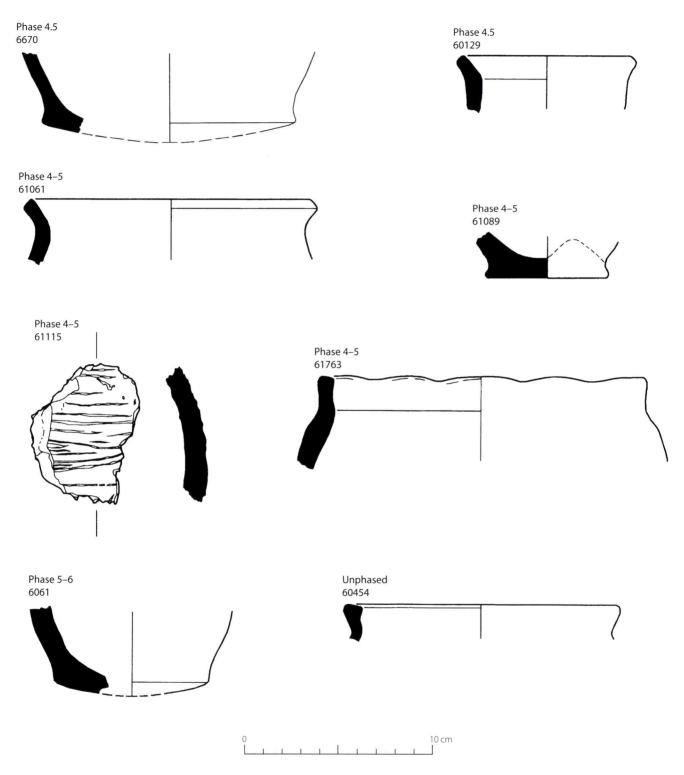

Phase 4.5
6670

Phase 4.5
60129

Phase 4–5
61061

Phase 4–5
61089

Phase 4–5
61115

Phase 4–5
61763

Phase 5–6
6061

Unphased
60454

0 10 cm

Figure 15.1. *(cont.)*

Fabric 5

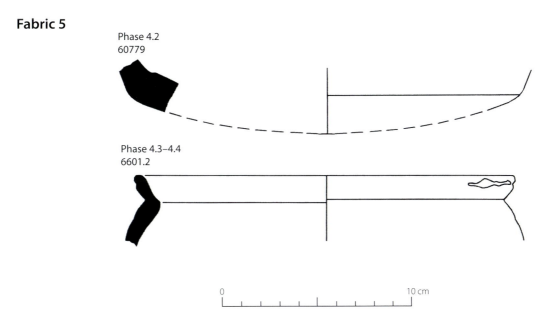

Phase 4.2
60779

Phase 4.3–4.4
6601.2

0 10 cm

Figure 15.2. *Example rim and base profiles of fabric 5. (Image: Dave Munro.)*

Phase 3–4
62083

0 10 cm

Figure 15.3. *Find 62083, the unique example of an organic tempered (fabric 2) sherd with stabbed decoration. (Image: Dave Munro.)*

German Proto-stoneware

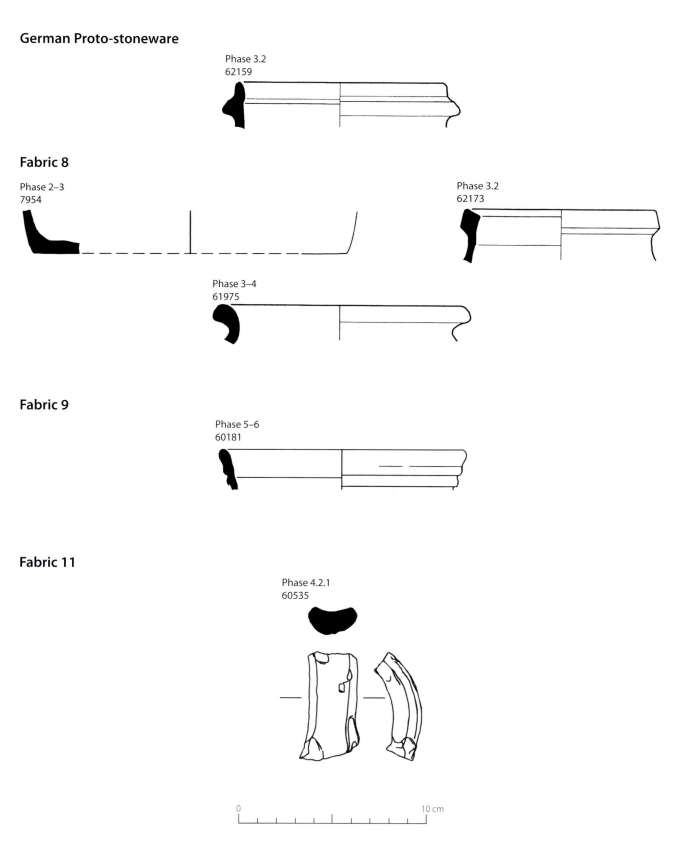

Fabric 8

Fabric 9

Fabric 11

Figure 15.4. *Examples of German proto-stoneware, fabric 8 (Scottish white gritty ware), fabric 9 (north German/Scandinavian redwares) and fabric 11 (German stoneware). (Image: Dave Munro.)*

no handles (Fig. 15.1). There is little sign of any change in vessel form across the phases. Similar handmade vessel forms, although in different fabrics, are present in the domestic settlement areas at the medieval burgh of Rattray in Aberdeenshire where they are dated to the fourteenth and fifteenth centuries (Murray & Murray 1993, fig. 29, 146–55).

Typological dating of fabrics 1 to 3 is very difficult as organic tempered wares existed at various periods in the Northern Isles. For example, they occurred in pre-Viking Age contexts at Kebister in Shetland and Pool in Orkney (MacSween 2007, 324–5 and references therein). The degree to which the Northern Isles experienced an aceramic horizon in the Viking Age and early Middle Ages — and the date when local ceramic production was re-adopted — have both been matters of uncertainty (e.g. Hunter 1986, 173, 185 regarding the Brough of Birsay). At Quoygrew, ceramics of these (and any) fabrics were *very rare* from its foundation in the tenth century until the thirteenth to fourteenth centuries. A virtually aceramic period was also noted at Jarlshof in Shetland, attributed (perhaps with overly optimistic precision given the wisdom of hindsight) to phases of ninth- to twelfth- or thirteenth-century date (Hamilton 1956, 187–8). Pottery was also infrequent in the tenth to twelfth centuries at Pool (MacSween 2007, table 8.1.6), absent in Viking Age phases at the Brough Road, Birsay (Batey 1989) and very rare in late Viking Age and early medieval phases at Beachview, Birsay (Batey & Freeman 1996, 136–9) — all in Orkney. In the case of multi-period sites, such as the Brough of Birsay and Pool, the small number of locally manufactured ceramic sherds that were found in strata of tenth- to twelfth-century date could easily represent residual material from very early Viking Age and/or Pictish levels.

Having established the argument for a virtually aceramic period in the Northern Isles between the tenth and twelfth centuries, it is important to observe that the use of pottery *was regionally variable* in the broader context of northern Scotland. Organic tempered fabrics (of different form) were abundant in a fish midden at Robert's Haven in Caithness (Hall unpublished data) in the eleventh to thirteenth centuries — broadly equivalent to the aceramic Phase 2 at Quoygrew (see Chapter 16).

15.3.2. Scottish white gritty ware (fabric 8)
There are seven finds attributed to the gritty hard-fired fabric which has long been identified as Scotland's earliest native industry, being in production from the mid-twelfth century until the fifteenth or sixteenth centuries (Haggarty 1984; Jones *et al.* 2003). The finds from Quoygrew are from vessels that have been used for cooking. There is a basal angle (Sf. 7954) from context G048, high in the stratigraphy of the Phase 2 to 3 Farm Mound midden, that is from a very distinctive straight-sided vessel of Scottish Borders type (Fig. 15.4). It is probably datable to the twelfth century. The remaining finds are mostly body sherds and were from Phases 3.2 (Sf. 62173), 3.3 (Sf. 61650), 3.4 (61629), 3 to 4 (a slightly everted rim, Sf. 61975) and 4.3 (Sfs. 61412 & 61413) of Rooms 1 and 3 in Area F. They are not diagnostic enough to accurately suggest precise vessel form or date. One rim sherd (Sf. 62173, see Fig. 15.4) in this fabric is atypical of the ware and could possibly derive from a different (unidentified) source.

The presence of sherds of this fabric at Quoygrew is of interest. When coupled with the evidence from Freswick Links and Robert's Haven in Caithness (Gaimster & Batey 1995; Hall unpublished data) and Trondheim and Bergen in Norway (Reed 1994; Hall unpublished data) it may suggest direct trade from the Scottish east coast to both Scandinavian Scotland and Norway.

15.3.3. German proto-stoneware?
One unglazed, deeply collared rim sherd with the edge of a handle attachment is from a highly fired jug, probably a German proto-stoneware (Sf. 62159, see Fig. 15.4). The form and colouring resemble that of early Siegburg ware (cf. Stephan 1983, fig. 8:3), although the presence of igneous rock makes this uncertain. It was found in an early floor layer of Room 3 (Phase 3.2), and probably dates to the last third of the thirteenth century or a little later (Lüdtke 1989, 32–3; Reed 1990, 35).

15.3.4. Scottish redware (fabric 6)
There are 50 finds in a sandy red-fired fabric which closely resembles the redware tradition that has been identified on the Scottish mainland as dating between the thirteenth and fifteenth centuries (Hall 1998, 170–78; Haggarty *et al.* 2011). Jugs are the most common vessel form represented and the finds exhibit traces of incised decoration, rouletting and thumbed basal angles (Fig. 15.5). They are occasionally splash-glazed brown. Three finds can be definitely identified as being from cooking vessels (Sfs. 60226, 60227 and 6672). A similar fabric identified in excavations on the Brough of Deerness in the 1970s exhibits similar types of incised decoration (Williams 1986, 335–8).

A single find (Sf. 60798) was from a poorly stratified (Phase 2 to 3) exterior layer north of Room 1. Otherwise, this fabric appears at the very end of Phase 3 (Sf. 61452, Phases 3.5 to 3.6) and the beginning of Phase 4 (Sf. 60851, Phases 3.6 to 4.1; Sf. 60790, Phase 4.1). It is most common in Phase 4.2 (18 finds, although several are probably from a single vessel,

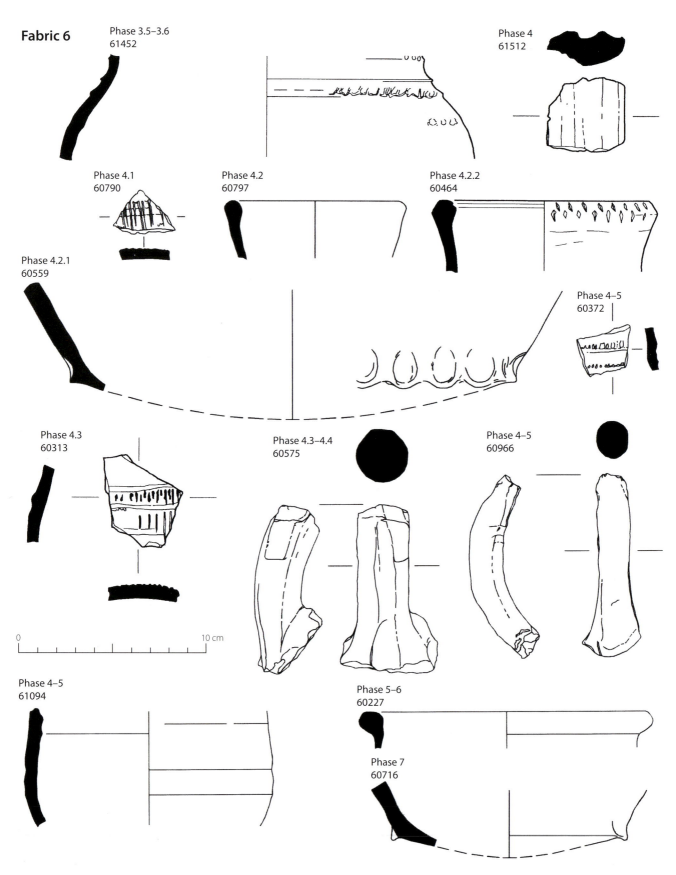

Figure 15.5. *A selection of the 50 finds of pottery fabric 6 (Scottish redware). (Image: Dave Munro.)*

see Table 15.2). After that it is notable for its absence from the latest subphases of Phase 4, but does also occur (perhaps as residual material) in poorly stratified Phase 4 to 5 layers.

Twenty finds exhibit cross-joins or can otherwise be attributed to three possible vessel groups based on fabric, decoration and form (Table 15.2). On the whole these groups are localized in both space and stratigraphic provenance. However, they do provide a meaningful link between the late fill of Room 3 (Phases 4 to 5) and the Phase 4 middens south of this room. Other dispersed sherds from vessel groups (e.g. Sfs. 60717 and 60798) are from poorly sealed layers and probably relate to post-depositional disturbance rather than discard patterns.

The results of ICP-MS analysis of 10 samples (Chenery 2006; Haggarty et al. 2011, 42–3) suggest diverse origins. Some probably derive from northeast Scotland and one of the analysed finds (Sf. 60448) matches control data from the Forth basin. The sherds attributed to fabric 6 could also be subdivided into several groups by eye. In the opinion of one co-author (DH), the chemically un-sourced finds probably derive from an unknown production site or sites within Scotland — based on fabric, form and decoration. In the view of another co-author (LB), however, this fabric group could conceivably also include some examples of Danish redware (e.g. Liebgott 1989; Klemensen 1996). It is not possible to resolve this uncertainty without a comprehensive programme of scientific characterization, but most of the material is here interpreted as of Scottish origin (based on fabric, form, decoration and the ICP-MS analyses).

Scottish redwares have been identified as locally produced pots for medieval burghs from Glasgow in the west to Inverness in the north (Hall 1998; Haggarty et al. 2011). Analysis of material from Dornoch (north of Inverness) has suggested that there may also be local redware production in that vicinity (Hall 1998, 170–78; Haggarty et al. 2011). The best parallel for the types of decoration being employed on these vessels is represented by the redwares that have been discovered from excavations at the medieval burgh of Rattray in Aberdeenshire (Murray & Murray 1993). Although there are redware fabrics from excavations in Kirkwall, none of them exhibit the incised styles of decoration (MacAskill 1982, 407, fig. 8). The Rattray redwares were manufactured in potting tenements within the burgh limits and are dated between the thirteenth and fifteenth centuries (Murray & Murray 1993, 143–7). There are examples of jugs that have similar decorative styles and thumbed bases to the material from Quoygrew (Murray & Murray 1993, fig. 18:1, 2).

15.3.5. German stoneware (fabric 11)

Seven finds of true stoneware from the Rhineland were also recovered, at least four of which were from drinking jugs. One (Sf. 6510) could be from Langerwehe (Hurst et al. 1986, 185–208) or Raeren, while three (Sfs. 6002.2, 60535 & 60660) are more definitely from Raeren (Hurst et al. 1986, 194–208). These include a typical strap handle (Sf. 60535, see Fig. 15.4) representing a form of small plain jug which was very widely exported between 1485 and 1550 (Hurst et al. 1986, 194, fig. 94:300, 301). In general terms, these wares became plentiful in mainland Scotland from the mid- to late fourteenth centuries and by the fifteenth to sixteenth centuries were amongst the most popular imported drinking vessels in the major Scottish burghs (Clark 1976). Within this group, Raeren pottery was first predominant in Scotland from the last quarter of the fifteenth century (Gaimster 1997, 87). In Norwegian towns, another potential source of the Quoygrew material, German stonewares represented an increasing proportion of the imported ceramics from the second half of the fourteenth century. By the fifteenth and sixteenth centuries they comprised 80% of the pottery from Bergen and 100% of the ceramics from Oslo (Gaimster 1997, 66).

The earliest well-stratified finds in this fabric (including the strap handle) came from Phase 4.2.1, with two further examples recovered from Phases 4.5 to 5 and a single residual example from Phase 6. One fragment of pale buff-coloured stoneware with a clear salt glaze (Sf. 62264) can only be identified as probably being of German origin. If so, it is most likely to be from Langerwehe (Hurst et al. 1986, 184–90), and of fourteenth- or fifteenth-century date. It was recovered from Phase 3.4, but as it is tiny (weighing only 0.6 g) is likely to be intrusive. No cross-joins were evident among the sherds of this fabric.

15.3.6. North German/Scandinavian redwares (fabrics 9, 18)

Twenty-two finds are of a type that has previously been classed as North European earthenware or possible Dutch redware, but which can now be identified as north German/Scandinavian redware. Similar wares have been found at Kirkwall in Orkney (MacAskill 1982) and at Scalloway Castle and Papa Stour in Shetland (Lindsay 1983; Blackmore 1999a). Finds of this fabric on the Scottish mainland have a coastal distribution, with examples from Leith, Anstruther, Pittenweem and the Isle of May in Fife, Montrose in Angus and Aberdeen (Lindsay 1983, 567; Hall 1997, 129; Blackmore 1999a; Will & Haggarty 2008). The continental background to these wares and their production centres, and earlier problems in distinguishing them from Scottish and Low Countries redwares

have been discussed elsewhere (Blackmore 1999a, 158–9, 166–7).

The Quoygrew finds are probably of seventeenth- to eighteenth-century date. Most sherds are from tripod pipkins (a form conventionally defined by the presence of a single looped or straight handle). The majority have a clear lead glaze internally, but a few have a darker brown or a green glaze (e.g. Sfs. 7747, 60177 & 60288). Six finds are from the post-medieval garden overlying the Farm Mound middens. The rest are from Phases 5 to 6, Phase 6 and Phase 7 of Area F. Thus none are very well stratified and all represent phases of occupation on the site from which buildings have not yet been excavated.

Until the late fifteenth century, all pipkins used within the kingdom of Denmark had a looped handle, usually of strap form (Liebgott 1979, 70–78; 1989, 299–300, figs. 208–9; Madsen 1986, 57, fig. 6). Straight-handled pipkins appeared sometime around *c.* 1480, with a distinctive tubular handle that was thrown as a cone and applied to the body (the *stjert*) that gave its name to the new forms, known in Denmark as *stjertpotten*, in Norway as *stjertepotter* and in Germany as *stielgrapen*. Although the precise dating of developments between *c.* 1480 and 1540 is unclear, the form became more common after *c.* 1500, and at some point in the first half of the sixteenth century production seems to have spread to north Germany (the present counties of Schleswig-Holstein and Holstein, see below). Pipkins were also exported to Norway. In Trondheim they first occur in deposits dated to pre-1540. In Lübeck the earliest finds are associated with the construction of part of the town wall, dated 1544 to 1560 (Schmitt 1996, 272–5). By the late seventeenth century numerous potteries in north Germany, Denmark, Sweden and Norway were making the same general forms (Blackmore 1999a, 158–9). As the clays used are extremely uniform, and little chemical analysis has been carried out, it is not possible to propose sources for the Quoygrew finds.

The following typochronology of rim forms is based on study of material from the Archbishop's Palace, Trondheim, (Blackmore unpublished data) and from Papa Stour, Shetland (Blackmore 1999a, 160–62). Group 1 rims, the earliest in the Trondheim sequence, are everted and lid-seated. They are probably from relatively shallow strap-handled pipkins (cf. Liebgott 1989, fig. 209, centre). One example of rim type 1B was found at Papa Stour (Blackmore 1999a, ill. 81.858), but these early forms are otherwise absent from, or very rare at Scalloway Castle, Kirkwall, The Biggings (Papa Stour) and Quoygrew.

Group 2 rims are inverted and internally thickened, while those of Group 3 are collared and lid-seated. These forms, which both date to the late fifteenth/early sixteenth century, are also absent at Quoygrew. Group 4 rims, which are generally more upright or everted, developed from Group 2 in the mid- to later sixteenth century (after 1540). From the late sixteenth century all have one or two grooves just below the top of the rim (Blackmore 1999a, 161). In the late seventeenth century, Group 4 evolved into Group 6, which has a more elongated profile. Both are absent from Quoygrew, but Group 4 rims have been found at Kirkwall and at Scalloway Castle (classed as rim form 3 or 5; MacAskill 1982, 409–10, fig 8:31, 32; Lindsay 1983, fig. 6:7–9, 12) and at The Biggings, Papa Stour (Blackmore 1999a, 161; fig. 81:778, 781, 849, 857, 860). Group 6 rims occur at Scalloway Castle (classed as rim forms 3, 4 or 5; Lindsay 1983, 568, fig. 6:10–11, 13) and possibly at Papa Stour (Blackmore 1999a, ill. 81:871). Group 5 rims, which probably developed from Group 3, are upright or slightly everted with three equally spaced narrow cordons (cf. Molaug 1981, figs. 7, 8). The collar can be short (type 5A) or deeper (type 5B), while the junction of the inner wall and neck can be smooth or have a marked kick. Group 7 rims are elongated variations of the Group 5 forms.

The one pipkin rim from Quoygrew (Sf. 60181, see Fig. 15.4) has two lower cordons but a deeper and flatter upper band, and is a hybrid of forms 5/7 — although not internally expanded like an otherwise very similar sherd (Sf. 962) from The Biggings, Papa Stour. Rim Group 5 (including its variant, Group 7) probably dates to the late seventeenth and/or eighteenth centuries. The dating of German parallels is hindered by the fact that most sites have been dug in spits (Schulz 1990, 228; Brabandt *et al.* 1993, 237), but there is no evidence for a date before the seventeenth century. In Oslo these forms are rare in contexts pre-dating the town fire of 1624, but represent the most common type in post-fire levels (Molaug 1981, 58–9). In Trondheim, the type was present in a context initially phased to *c.* 1640–1672 (Blackmore unpublished data). Group 5 rim forms were also found at Scalloway Castle and Kirkwall (MacAskill 1982, 410, fig. 8:24–7; Lindsay 1983, 567–8, fig. 6:1–2). At Scalloway, it was suggested that the type may not have been common until the eighteenth century (Lindsay 1983, 568). At Papa Stour, nine Group 5 rims were found (Blackmore 1999a, fig. 81:826/840, 836, 886, 937), while two were classed as Group 5/7. The latter both occur relatively early in the sequence (Blackmore 1999a, fig. 81:914, 962).

Other distinctive Quoygrew pipkin finds include the base of a handle (Sfs. 6276, 6282 & 6293) and a body sherd with the edge of the handle junction (Sf.

60096). Bases are rare in the assemblage and no feet survive, but they would probably have been of the straight pointed type. In addition to the above, there is a single slip-decorated sherd (Sf. 60067) with part of a scroll design, probably from a seventeenth- or eighteenth-century pipkin. Although assigned its own fabric code (18), it is likely to be from the same source areas as the above.

Also classified as north German/Scandinavian redware, although possibly different, are a small thin-walled, upright rim (Sf. 6288) and a small handle fragment (Sf. 7035). Both have a dark brown glaze with darker brown or opaque white flecks over both surfaces and may be from porringers of seventeenth- or eighteenth-century date.

15.3.7. Post-medieval industrial ceramics

The industrial ceramic assemblage from Quoygrew is highly fragmented. Where a sherd is distinctive it is hard to find another from the same vessel, suggesting that the material has been spread very widely across the site. These observations are consistent with the fact that most of the industrial pottery is from garden and topsoil contexts of Phases 6 and 7. A small number of sherds are also intrusive in contexts assigned to Phases 2 to 5 (Table 15.1).

A very small quantity of industrial pottery may have been deposited as early as the eighteenth century. White salt-glazed stoneware, which might have been expected in deposits of this date, is entirely absent from the assemblage. However, there was a single sherd of what is almost certainly eighteenth-century English soft paste porcelain (Sf. 70575, from a topsoil context in Area G). This sherd is undecorated, but may be from one of the latter Staffordshire factories and post 1770. There were also six finds of tin-glazed earthenware from the site. Three sherds from the Phase 6 garden in Area G (Sfs. 7722, 7780 & 7817) are likely to date between about 1720 and 1770. Three further finds, likely to post-date 1750, were from poorly stratified contexts of Area F. One of the tin-glazed finds (Sf. 7780) is of a plate probably made in the Netherlands or England. The two other finds from Area G may be from the same source. It is difficult to specify the location of manufacture of the rest, but in 1749 tin-glazed earthenware began to be produced on an industrial scale in Glasgow, and it is recovered fairly frequently from Scottish urban archaeological deposits of the period (G. Haggarty unpublished data). All of the tin-glazed pottery is likely to pre-date 1775, as by this time creamware had all but destroyed the market for these wares. This is borne out by evidence for the exporting of Delftware clay from Carrickfergus, where it fell from a high of 3247 tons in the period 1765–64 to a paltry 184 tons in 1775–78 (Black 2005, 12).

Only a single sherd of creamware (Sf. 7912) was found, from Phase 6 of Area G. Creamware was by far the dominant ceramic type for thirty years in Britain from *c.* 1760–90 and it was shipped in huge quantities to every major port in Europe. These markets were fiercely contested by numerous potteries based along the Rivers Forth, Tyne and Wear as well as in Yorkshire, Wales and Staffordshire. These good-quality wares had some status attached to them and very little material of this kind has been found in Scottish rural contexts. There is good archival evidence for a trade in creamware from the potteries of the Forth to Orkney and as far north as Russia (Haggarty unpublished data).

Pearlwares are undoubtedly the most common ceramic material found on Scottish sites of the late eighteenth and early nineteenth centuries. This is partly because they were the cheapest decorated pottery on the market, but also because they were widely produced by Scottish potteries of both the Forth and Clyde. Bowls are always by far the commonest vessels recovered on Scottish sites, with mugs, porringers, cups and saucers a long way behind. There are 24 finds from Quoygrew, mostly from topsoil contexts in Area F. They show many of the decorative elements one associates with this pottery which dominated the lower end of the British fine-ware market from *c.* 1790 to *c.* 1820.

By 1820 to 1825, pearlware was on its way out, being superseded by various forms of hard white body which are extremely difficult to date with any accuracy. In general, many of these white earthenwares are found decorated in a manner similar to pearlware. Noticeable, however, is the use of much brighter colours, more hand decoration (spongeware: 97 finds) and the increased use of transfer printing (153 finds) with the use of colours such as purple, yellow, red and green. The approximate date range of manufacture for whitewares is *c.* 1820–1900 or later. Variations of this material are very common in the industrial pottery assemblage from Quoygrew, predominately occurring in Phases 6 and 7 of Areas F and G.

Lastly, lead-glazed redwares were also frequent discoveries in Phases 6 and 7 of Areas F and G. These fabrics are common discoveries on the Scottish mainland and were being manufactured at many production centres in the eighteenth and nineteenth centuries. There is good documentary evidence for a trade in coarse redware from the Forth area, as far as South Carolina (Bell 2006, 19). However, English redware production sites such as Tyneside, Wearside and Yorkshire should also be considered as possible sources of this material.

Table 15.6. *Clay tobacco pipes.*

Small find	Context	Details	Bowls	Stems	Mouthpieces	Phase	Date
6009.2	F003			1		4–5	19th century
6144	F001			1		7	?
6245	F002			1		7	?
6267	F002			1		7	17th century
6746	F091	Two adjoining fragments; green glaze		1	1	7	19th century
6897	F090			1		7	19th century
60088	F091	Splash of glaze		2	1	7	19th century
60174	F098			1		5–6	17th century
60175	F095			1		7	17th century
60344	F094	Dutch-style fleur de lys stamps		1		5–6	*c.* 1625–1650
7001	G004	Adjoining bowl and stem, Dutch	1	1		6	1620–40
7791	G031			1		6	?17th century
7916	G036			1		6	17th century
7922	G018			1		6?	?19th century
7936	G018			1		6?	?17th century

15.4. Clay pipes

Of the 15 finds of clay pipes, the most complete is a biconical bowl and adjoining stem fragment (Sf. 7001) from the post-medieval garden of Area G. It is unmarked and of a form produced in many centres, but from its fabric is likely to be Dutch (cf. Duco 1987, 29 no. 21). It can be dated to *c.* 1620–40. The same garden produced other probable seventeenth-century pipe fragments (Sfs. 7936, 7791 and 7916) and also several finds of seventeenth- and eighteenth-century ceramics (e.g. redware pipkins and tin-glazed earthenware). Although predominately a Phase 6 feature (based on the overwhelming predominance of nineteenth- to early twentieth-century finds), the mixed sediments of the garden clearly also included Phase 5 material (see Chapter 4).

Another interesting find (Sf. 60344) came from a Phase 5 to 6 context in Area F. It is a small stem fragment dating to *c.* 1625–50, with three individually applied Dutch-style fleur-de-lys stamps (cf. Duco 1981, 248 no. 107). Although decorated, this is a low-quality product. Two of the stamps are on the top of the stem, while a third is on the side. They are carelessly applied, with some dragging of a worn die.

One cannot generalize from such a small group, but the Dutch-style pipes reflect the pattern of pipe distribution seen in other assemblages from northern Scotland. While Edinburgh was established as the major Scottish pipe-making centre from the first decades of the seventeenth century, it had little impact on the north. The latter had strong trading links with Holland, whilst the Dutch fishing fleet was an annual visitor to the Isles. This influence can be seen, for example, in the predominance of Dutch, low-quality export pipes, mainly of the moulded rose type, from excavations in Kirkwall (Caldwell 1982, 425) and Scalloway Castle (Davey 1983, 585–6).

The Quoygrew assemblage also contained a number of stems that, from their fabric and stem bore, are of probable nineteenth-century date. These specimens come from Phase 6 and 7 contexts in Areas F and G. Three fragments from F091 have areas of green-yellow glaze common on mouthpieces.

15.5. Glass

In general terms the glass finds from Quoygrew can be divided into beads, sherds of post-medieval bottles and fragments of modern window panes (Table 15.7). There are six or possibly seven glass beads (Fig. 15.6). Four definite examples (Sfs. 7701, 7855, 7857 and 7986) are from Phase 1.2 of the Farm Mound. Find 7701 is roughly half of a yellow bead of irregular globular shape. Find 7855 is a small (4 mm diameter) spherical bead also of yellow glass. Find 7857 is half a conical dark (possibly black) glass bead. Find 7986 is a complete annular bead in blue glass with a large perforation. A fifth 'bead' (Sf. 70199) from Phase 1.2 is a chip of black glass with an external curvature consistent with a small globular object. The sixth and last stratified example (Sf. 70289) is a complete circular bead of brown glass from Phases 2 to 3 of the Area G3 midden on the Farm Mound. Half of a modern green bead (Sf. 6372) was found in the topsoil. As an unstratified find it will not be discussed further.

The four or five beads from Phase 1.2 are consistent with their *c.* tenth-century context. They may be imports from Scandinavia — either as trade goods or the possessions of migrants — and parallels are known from elsewhere in the western 'Viking' world. For example, the simple blue annular bead (Sf. 7986)

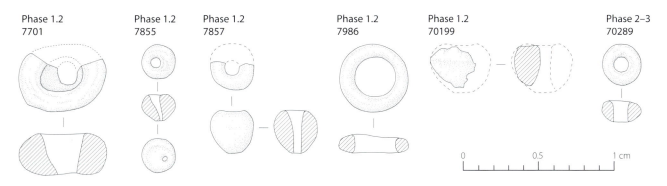

Figure 15.6. *Glass beads from Phase 1.2 and Phase 2–3. (Image: Vicki Herring.)*

Table 15.7. *Glass by general phase.*

Find	Phase								Unphased	Total
	1	**2–3**	**3**	**4**	**4–5**	**5–6**	**6**	**7**		
Glass bead	4	1							1	6
Glass bead?	1									1
Green vessel glass		1	2	1	4	7	56	63	5	139
Clear vessel glass						1	23	14		38
Vessel glass: heavily patinated						1	10	4		15
Blue vessel glass							1	4		5
Black vessel glass							2			2
Brown vessel glass							2			2
Cranberry vessel glass								1		1
Window glass			1	1	1		5	12		20
Glass fragments		1			1	1	4	6		13
Miscellaneous glass								2	1	3
Total	**5**	**3**	**3**	**2**	**6**	**10**	**103**	**107**	**6**	**245**

is a typical find. In a study of Viking Age beads from Iceland this form and colour (Type A) is common in pagan burial contexts likely to predate *c.* AD 1000 (Hreiðarsdóttir 2005, 8). Its simple form, in a range of monochrome colours including blue, is also known from the excavations at Coppergate in York where it dates from the mid-tenth century onwards (Mainman & Rogers 2000, 2591, fig. 1285 no. 10093). Similarly, the incomplete dark conical bead (Sf. 7857) resembles Type 2 at Coppergate from much the same date range (Mainman & Rogers 2000, 2592, fig. 1285 no. 10136, table 261).

The 202 sherds of glass vessels are mostly of green or other darkly-coloured material typical of post-medieval beer and wine bottles. Included in this part of the assemblage are fragments of cylinder-form bottles with distinctive 'kicked' or pushed in bases and string rims applied after blowing. Good examples are Sfs. 6790, 6796, 6820 and 6821 from Phase 7. They are probably wine bottles of late eighteenth- and/or early nineteeth-century date (cf. Noël Hume 1961; Oakley & Hunter 1979, 302; Ford 1998, 201–2). Most of the remaining vessel glass is not distinctive as to function, but the few blue sherds are from medicine bottles (e.g.

Sfs. 6345 and 60091 from Phase 7).

It is instructive to compare the paucity and relative simplicity of the Orcadian material with the vessel glass available to Viking Age, medieval and post-medieval urban markets (e.g. Henderson 2005; Gaut 2011). Firstly, there is *no* Viking Age or medieval vessel glass from Quoygrew. The few finds from early contexts (Table 15.7) are probably intrusive given that they closely resemble later examples in colour, thickness and form. Turning to the post-medieval assemblage, it lacks fine objects such as goblets and trailed vessels known from contemporary urban contexts. Only the single fragment of cranberry glass implies access to decorative pieces.

Aside from tiny fragments and curiosities (including a modern opaque white sheep head, Sf. 7104 from Phase 7), the rest of the glass from Quoygrew is probably from broken window panes. Seventeen of the relevant fragments are from nineteenth- to twentieth-century contexts and can be associated with the modern croft abandoned in 1937. The remaining three — from Phases 3, 4 and 4 to 5 — are probably intrusive, but could nevertheless imply very limited use of glazing at an earlier date.

15.6. Discussion

Phases 1 and 2 at Quoygrew produced very little pottery at all despite the excavation of large amounts of midden material and (in the case of Phase 2) a house. The few ceramic sherds from these phases may thus represent *very limited* local ceramic production or intrusive later medieval material. Organic tempered fabrics of local manufacture first became common in Phase 3, and remained so in Phase 4. The production of these wares probably ceased during Phase 4 or Phase 5, with later finds being residual in disturbed contexts. By Phase 4 (at the latest) some of these organic tempered wares were imitating characteristics of imported wheel-made fabrics. The earliest well-stratified imports are from Phase 3. A single tiny sherd of German ?Langerwehe stoneware from Phase 3.4 is almost certainly intrusive. However, sherds of probable Scottish white gritty ware from Phases 3.2, 3.3 and 3.4 are likely to be *in situ*. So is a probable German proto-stoneware find from Phase 3.2. The earliest well-stratified find of probable Scottish redware is from the very end of Phase 3, but this fabric is otherwise characteristic of Phase 4, from which a small number of German stoneware sherds of probable fifteenth- to sixteenth-century date were also recovered.

Phase 5 is not yet represented by well-stratified deposits at Quoygrew. Nevertheless, north German/ Scandinavian redwares and Dutch-style clay pipes do provide evidence of seventeenth- to eighteenth-century activity at the site. Very small quantities of early industrial pottery (e.g. tin-glazed earthenware) are also consistent with eighteenth-century occupation. Most pottery of seventeenth- to eighteenth-century manufacture was found as residual material in later phases, but it is likely that dwellings of this date do exist in the unexcavated areas of the settlement.

The disturbed contexts of Phases 6 and 7 are characterized by low-cost industrial ceramics of late eighteenth- to early twentieth-century manufacture. These phases can be associated with the unexcavated modern ruins of Quoygrew as visible on the ground and in nineteenth-century cartography (see Chapters 3 and 4).

It is notable that where anthrosol and garden contexts at Quoygrew produced pottery it was typically industrial material datable to Phases 5 and/or 6. This pattern could imply that earlier agricultural soils (e.g. the infield east of the Farm Mound) accumulated during Quoygrew's aceramic phases. However, such an interpretation is not entirely consistent with the radiocarbon and stratigraphic evidence (Chapter 4). An alternative possibility is that the manures used

during the Middle Ages did not include a high proportion of household refuse. Turf, byre waste and seaweed provided abundant alternatives (Simpson *et al.* 2005).

The organic tempered fabrics appear to have been used mostly for cooking. Similar pottery is ubiquitous from medieval sites in Orkney and Shetland (Table 15.5). Surprisingly, however, the vessel forms (if not the fabrics) present at Quoygrew appear to be distinctly different to those from across the Pentland Firth at Robert's Haven and Freswick in Caithness (Gaimster & Batey 1995; Hall unpublished data). For example, the vessels from Quoygrew have very distinctive everted rims and are of a bigger size than the forms from Robert's Haven (Hall unpublished data). There is also little to suggest that the Quoygrew organic tempered wares owe any influence to similar fabrics that were being produced in the Western Isles at a similar period (e.g. Lane 1990, 109–20; Campbell 2002, 139–45). This regional variability must be significant in social terms, an issue considered further in Chapter 16. The organic tempered material in this assemblage reinforces the need for analysis of this tradition which runs from the Northern Isles, down the Scottish west coast and islands (Dean forthcoming; Lane 1990; Campbell 2002).

The imported medieval ceramics found at Quoygrew are broadly consistent with those found at other contemporary sites in Orkney. Scottish white gritty ware and 'red sandy' wares were noted at Kirkwall (43 and *c.* 300 sherds respectively), where Scarborough ware (not present at Quoygrew) was also found (MacAskill 1982, 405). The presence of probable Scottish redware at the Brough of Deerness (Williams 1986, 335–8) has been mentioned above. It came mainly from the abandonment phases of the early medieval chapel and may thus be broadly contemporary with the Quoygrew finds. At Pool, Sanday, the only medieval import was a topsoil find of Low Countries greyware probably dateable to between the late twelfth and fourteenth centuries (MacSween 2007, 308). This find is contemporary with the end of the chronological sequence at Pool, which may explain why additional imported ceramics were not recovered there. The absence of imported pottery from medieval sites such as Beachview (Batey & Freeman 1996) and the Brough Road (Batey 1989) — both in Birsay — must also reflect abandonment by the thirteenth century. The rarity of imported ceramics at the high-status elite and ecclesiastical settlement on the Brough of Birsay (Curle 1982, 121; Hunter 1986, 183–6) can be similarly explained. However, the few imports that were found at this site do merit future re-examination in light of current knowledge.

The imported medieval ceramics from The Biggings, Papa Stour, Shetland, are unlike those from Quoygrew — despite temporal overlap. The finds included 13 sherds of probable English pottery, including a Yorkshire jug (Will 1999a), 13 sherds of Paffrath ware from the Rhineland (Blackmore 1999b) and early stoneware from Lower Saxony (Stephan 1999). Jarlshof (Hamilton 1956, 192–3) appears to have produced small numbers of imports, but like the Brough of Birsay the pottery requires physical re-examination before more can be said. The differences between Quoygrew and The Biggings are probably due largely to the fact that from c. 1195 Shetland was no longer part of the earldom of Orkney and more closely bound to Norway (Chapter 2). The Biggings was also a high-status farm, with Quoygrew interpreted as a more typical settlement. Both factors would have increased the range of ceramics available to the occupants of the Papa Stour site.

When the medieval ceramics from Quoygrew, and the Northern Isles in general, are compared with assemblages of similar date within a wider context the differences are notable (Table 15.5 and below). The first observation is that Quoygrew has a narrower range of finds than the town of Kirkwall, as might be expected of a rural farm. More generally, however, Kirkwall in turn received a narrower diversity of continental and English wares than contemporary towns in the kingdom of Scotland. For example, in the twelfth century (or earlier) London-type wares reached Perth, Aberdeen and a few other sites (Hall et al. 2005; Blackmore & Pearce 2010, 76–7, 81–2, 243–5), while Scarborough ware is probably the most widely traded English ware (Hurst 1983, 259; Thoms 1983, 255). The continental wares include Low Countries greywares, redwares and highly decorated ware, Andenne ware, Rhenish blue-grey ware and stonewares from Siegburg and Langerwehe, Rouen ware, Saintonge ware and other French wares, and occasional Spanish wares (e.g. Murray 1982; MacAskill et al. 1987, 101, 107–10; Hall 1995; 1997; 2000; Cameron & Evans 2001).

The ceramics imported to Quoygrew and elsewhere in the Northern Isles also differ from those circulating in the Irish Sea province. Medieval assemblages from Ireland are characterized by imported wares from France (especially, but not exclusively, from the Saintonge area), southern England and western England (e.g. Gahan & McCutcheon 1997; Papazian 2000; McCutcheon 2006 and references therein). The same applies to the Isle of Man (Davey 2002). Only small quantities of other ceramics, such as German stonewares, have been found in Ireland (e.g. McCutcheon 2006, 131, 168) and Man (Davey 2002, 376–81). The little imported pottery recovered from

medieval Hebridean sites probably also derives from this distinctive Irish Sea trade (e.g. Parker Pearson et al. 2004a, 248; Sharples 2004, 265).

Turning to Norway, there was no local pottery production from the end of the Viking Age until the seventeenth century — wood and stone being the preferred materials for household equipment. All medieval pottery was imported, and although including the same continental and English wares that are found in mainland Scotland, the range of fabrics and forms found in centres such as Bergen (Herteig 1969, 151–74; Lüdtke 1989; Blackmore & Vince 1994; Blackmore & Pearce 2010, 76–7, 81–2, 243–5) and Trondheim (Reed 1990) is much greater. Scottish white gritty ware does occur in Norway, but as a minor component of a diverse suite of imports (Reed 1994). Thus it seems likely that most of the Phase 3 and Phase 4 ceramic imports to Quoygrew arrived via mainland Scotland.

The comparatively low level of medieval continental and English wares on most sites from both Orkney and Shetland might be explained first by an aceramic cultural tradition (from the tenth to twelfth centuries) and later (from some point in the thirteenth century) by legal restrictions on direct Hanseatic trade with the Northern Isles. The latter were not systematically circumvented until the early fifteenth century (Chapter 2). At this date changes took place in the nature of pottery supply to Quoygrew, with the arrival of German stonewares in Phase 4 and Phases 4 to 5. These may have arrived directly from Germany, or indirectly via mainland Scotland, where they are more commonly found (e.g. Clark 1976; Haggarty & Jennings 1992; Gaimster 1997, 87). Dutch merchants also visited the Northern Isles in the sixteenth and seventeenth centuries (Smith 1984, 25), but perhaps surprisingly no definitely Dutch vessel forms are present at Quoygrew or among the illustrated items from excavated sites in Shetland and Orkney. Some contact may, however, be demonstrated by the Dutch-style clay pipes of seventeenth-century date.

Having moved into discussion of post-medieval finds, the north German/Scandinavian redwares (fabric 9) from Quoygrew and elsewhere in the Northern Isles almost certainly arrived via German merchants. Direct trade between northern Germany and the Northern Isles (particularly Shetland) continued into the seventeenth and eighteenth centuries (Friedland 1983). At Kirkwall, one sixteenth- to eighteenth-century assemblage included 106 sherds of north German/ south Scandinavian origin (classed as North European earthenware), four sherds of Weser slipware, a few sherds of Beauvais sgraffito, part of a possible Loire Valley jug and a sherd of Valencian lustreware (MacAskill 1982, 409–13). Stonewares amounted to

39 sherds, one from Martincamp, four from Siegburg, 15 from Langerwehe, eight from Raeren, four from Frechen and two from Westerwald. This urban post-medieval assemblage bears comparison with that from Scalloway Castle in Shetland, where Scottish and English wares were very much in the minority. Here the seventeenth- and eighteenth-century assemblage was dominated by north German/Scandinavian red-ware pipkins (868 sherds, plus nine slip decorated). A range of other post-medieval wares was also present at this site, reflecting its status. At The Biggings, north German/Scandinavian redwares amount to almost 100% of the post-medieval assemblage (356 sherds). Of these, 256 are from undecorated pipkins and 58 are from pipkins and possible porringers with slip decoration (Blackmore 1999a, 160–65). Imported slipwares have also been identified in ceramic assemblages from Breckin (Yell) and Jarlshof (Mainland) in Shetland and so redware pipkins might also be expected at these sites. The general scarcity of German stonewares compared to imported redwares led Lindsay (1983, 573) to suggest that the pottery reached the islands alongside other traded items rather than in its own right and that there was not a sufficient local market for higher quality ceramics.

To complete discussion of the ceramic sequence, the industrial pottery from Quoygrew is consistent with finds from other eighteenth- to twentieth-century rural settlements in Atlantic Scotland (e.g. Barker 2005). White earthenware dominates, with some pearl-ware and only occasional sherds of creamware and soft paste porcelain. This subset of industrial ceramics implies both access to contemporary international fashion and limited purchasing power.

Most of the glass from Quoygrew serves as only a footnote to the ceramic evidence. As with pottery there were probably few or no vessels in Phases 1 and 2, but in the case of glass this trend continued until the end of the Middle Ages. When adopted in Phases 5 and 6, the glass vessels from the site were mostly wine and beer bottles — implying a specific range of culturally mediated consumer choices! The small assemblage of window glass from Quoygrew is mostly attributed to the nineteenth and twentieth centuries, but (if not intrusive) a few fragments may imply earlier use of glazing on a very limited scale. The glass beads are different. The small cluster from Phase 1.2 of the Farm Mound speaks to a fashion characteristic of the Scandinavian diaspora of the Viking Age.

Chapter 16

Being an Islander

James H. Barrett

16.1. Introduction

Having surveyed the material remains of making a living at Quoygrew it is possible to return to the issues set out in Chapter 1. What were the changing relationships between economic production, long-range networks and expressions of insular identity in Viking Age and medieval Orkney? How might they inform our understanding of the socioeconomic watersheds of medieval Europe? To answer these questions the evidence of Chapters 2 to 15 must be combined to reconstruct the development of the settlement from its foundation in the tenth century to the end of the Middle Ages. First is a brief synopsis of the earliest settlement phase at Quoygrew, explaining how it represents the construction of a Scandinavian diaspora community in Viking Age Orkney. Second is an evaluation of economic intensification and exchange in the eleventh to thirteenth centuries — Quoygrew's boom years. A consideration of subsequent economic collapse follows, in which Orkney's relationship with wider European currents of the thirteenth to fifth-teenth centuries are explored. Fourth is a brief review of the archaeological traces of economic rebound in the sixteenth and seventeenth centuries. Lastly, I make an (inevitably partial) attempt to comprehend the complex relationship between heavily urbanized regions of medieval Europe and the insular communities of the rural north.

16.2. The beginning

When dwellings were first built at Quoygrew in the tenth century (as inferred by the Farm Mound middens) the inhabitants surrounded themselves with material culture that would not have suited their predecessors approximately a century earlier. They ate from imported soapstone vessels (Chapter 12), with only a few pots of earlier indigenous fabric left to be broken and discarded (Chapter 15). They used combs characteristic of the Scandinavian diaspora,

rather than local Pictish traditions (Chapter 13). Fishing and bait-collecting were part of daily life — when the season was right and the weather suitable — much more so than in the days of previous generations (Chapters 5 to 7). Flax was grown, perhaps for both cloth and oilseed, more in keeping with Scandinavian than previous local practice (Chapter 10). There are hints that Quoygrew's farmers sharpened their sickles on hones from Norway and ground their grain using querns of mica schist similar to that quarried from Hyllestad north of Bergen (observations that apply more definitively to later phases) (Chapter 12). The deer in Westray and elsewhere in Orkney were quickly hunted out — presumably because reindeer antler could now be easily sourced from Norway or red deer antler from elsewhere in the insular 'Viking' world (cf. Fairnell & Barrett 2007, 480; Mulville 2010, 49–50). The dead were probably buried in the pagan graves known from nearby Pierowall — with objects of Scandinavian style and/or provenance (Thorsteinsson 1968). The living wore jewellery such as beads consistent with cosmopolitan Scandinavian fashion (Chapter 15). Local chieftains may have celebrated their bloody escapades through the medium of skaldic poetry composed in Old Norse — if the verses nominally by Torf Einar, a semi-legendary tenth-century ancestor of the later earls of Orkney, are correctly attributed (Poole 1991, 161–3).

The memory of pre-Viking Age tradition had not entirely faded. The culling of newborn calves — for both direct consumption and to reserve milk and dairy products for human use — remained from local practice (Mulville *et al.* 2005; O'Connor 2010, 11). The mix of cattle, sheep and pigs would have been familiar to the elderly as reminiscent of the past (cf. Harland 2006; Gilmour & Cook 1998, 332) — as would the mix of barley and oats in field and kiln (cf. Dickson & Dickson 2000; Chapter 10). Thus an octogenarian — rare, but perhaps not unknown in the distant past (cf. Aykroyd *et al.* 1999; Owen & Dalland 1999, 154) — of local ancestry would have witnessed similar patterns

of land use to those of their youth in the first half of the ninth century. Meanwhile, their grandchildren and great-grandchildren would have learned their habits and prejudices from parents of diverse ancestry — be they local, Scandinavian or from the fluid world of the Irish Sea zone and North Atlantic where secondary migration of the late Viking Age, most obviously to Iceland, was the norm (Vésteinsson 2000; Goodacre *et al.* 2005). A surviving memory of local Christian practice may have inspired the foundation of tenth- or eleventh-century chapels at sites like the Brough of Deerness on the more distant island of Mainland (Morris & Emery 1986; Barrett & Slater 2009) — and must have informed the later re-establishment of medieval churches on Pictish ecclesiastical sites like St Boniface on Papa Westray, only a short sail from Quoygrew (Lowe 1998).

Nevertheless, the things around an elderly inhabitant of the tenth century had changed more rapidly than for their ancestors — when some styles of Pictish material culture (combs and pins, for example) had persisted from the mid-first millennium AD until the ninth century (Foster 1990; Ashby 2009). And the sea had changed. Always an agent (cf. Van de Noort 2011) — providing passage, stealing lives or simply providing lamp oil from small saithe caught along the shore — it was now an artery. It linked an emerging Scandinavian diaspora community around the North Atlantic and the North and Irish Seas (Hadley & Richards 2000; Barrett 2003b), while also providing a significant proportion of the local protein diet (Barrett & Richards 2004). Equally important, it was a road to wealth and prestige, hard won by piracy and mercenary service (Barrett 2007; Chapter 2; see below). Despite vacillating modern perspectives on the early medieval military economies of the north (e.g. Barrett 2004b and references therein), organized violence was a central if sometimes tragic part of the life cycle of the elite and upwardly mobile throughout northern and western Europe during the Viking Age (Halsall 2003).

The weather was warm — in spatial terms from many Norwegian points of view and in chronological terms from the perspective of the later Little Ice Age (Diaz *et al.* 2011; Surge & Barrett 2012). The land was productive — having been enhanced rather than depleted by millennia of careful use (Guttmann *et al.* 2006; Dockrill & Bond 2009). Although life expectancy was probably short (perhaps *c.* 40 years if one survived childhood), population may nevertheless have been increasing (cf. Benedictow 1996, 181; Roberts & Cox 2003, 226). Settlement in Westray, for example, probably expanded beyond the calcareous soils of the machair (Chapter 3). Growth by local

births may also have been augmented by immigration from the continued Scandinavian diaspora during the tenth century.

When founded, Quoygrew was probably one household within a multifocal settlement clustered around wetland meadows at the head of Rack Wick. It was later a tenant farm of a larger estate (known by the farm name Trenabie or the township name Rackwick) and may have been so from the start (Chapter 3). Yet its material culture, including imported combs and a plated iron mount, speaks of modest wealth rather than poverty (Chapters 13 and 14).

16.3. Economic intensification

We can understand Quoygrew better in the eleventh to thirteenth centuries than at any other date, having excavated two dwellings (Houses 1 and 5) and several areas of midden associated with differing activities (the Farm Mound, the Fish Midden, the North Midden and the South Midden). An octogenarian visiting in the eleventh century would have found the site and its landscape more recognizable from his or her youth than an equivalent visitor of *c.* 100 years before. The portable material culture was still almost all imported from Norway and the insular and littoral zones of the Viking Age diaspora. This applies to most objects of stone (e.g. steatite vessels from Shetland and Norway, Eidsborg hones from southern Norway and reworked quern fragments of mica schist of possible Norwegian origin) and many objects of bone (e.g. combs of probable reindeer antler in Norwegian styles) (Chapters 12 and 13). House 5 provides a distinctive example (Figs. 4.6 & 16.1). The objects from this building are virtually all of definite or probable Norwegian provenance. They include antler combs with close parallels in Norwegian towns, a whale-bone weaving sword of Norwegian type and hones quarried from Eidsborg. Either this farmer-fisher's house (not the only building in the settlement at the time) was occupied by migrants or (more likely) it had direct access to Norwegian imports through networks of kinship and/or exchange. It differs from the contemporary middens at Quoygrew and from settlements elsewhere in Orkney where 'insular' objects (here defined as from the Irish Sea province, in its broadest sense) are also found (e.g. Chapter 13; see below).

The construction of social space within House 5 also speaks of its occupants' cultural referents (cf. Price 1995; Burmeister 2000). It was built with the slightly raised internal side aisles ('benches') characteristic of Viking Age and medieval dwellings in Norway (e.g. Pilø 2007, 217; Molaug 2007, 25), the Faroe Islands (Stummann Hansen 2003b, 52; Mahler

Table 16.1. *Radiocarbon dates from other fish midden sites in Orkney and Caithness.*

Site	Context	Phase	Location	Lab code	Age BP ± 1σ	δ¹³C	Unmodelled AD (95.4%)	Modelled AD (95.4%)	Material	References
Cleat, Westray, Orkney	A005		Near top of fish midden sequence	SUERC-1425	985±45	−23.1	978–1163		barley	Barrett *et al.* 1998
			Range-finder sample from erosion face	TO-6344	980±110	not reported	782–1265		barley	Barrett *et al.* 1998
St Boniface, Papa Westray, Orkney	Block 104	8	Near base of fish midden sequence	GU-3067	920±60	not reported	1014–1238		cattle and sheep bone	Lowe 1998
	Block 104	8	Near base of fish midden sequence	SUERC-129	965±40	−25.0	995–1162		barley	Ascough *et al.* 2006
	Block 104	8	Near base of fish midden sequence	SUERC-130	995±40	−23.9	981–1156		barley	Ascough *et al.* 2006
	Block 104	8	Near base of fish midden sequence	SUERC-131	935±40	−24.8	1021–1186		barley	Ascough *et al.* 2006
	Block 104	8	Near base of fish midden sequence	SUERC-132	935±40	−23.5	1021–1186		barley	Ascough *et al.* 2006
Robert's Haven, Caithness	3019	1	Near base of fish midden in Column C	SUERC-243	910±45	−23.6	1028–1213	1044–1224	barley	Ascough *et al.* 2009; Russell *et al.* 2011
	3019	1	Near base of fish midden in Column C	SUERC-244	855±45	−24.9	1043–1265	1053–1264	barley	Ascough *et al.* 2009; Russell *et al.* 2011
	3019	1	Near base of fish midden in Column C	SUERC-245	855±50	−27.0	1042–1266	1054–1266	barley	Ascough *et al.* 2009; Russell *et al.* 2011
	3019	1	Near base of fish midden in Column C	SUERC-246	920±50	−25.0	1023–1213	1039–1225	barley	Ascough *et al.* 2009; Russell *et al.* 2011
	3004	1	Near top of fish midden in Column C	SUERC-254	655±50	−23.3	1273–1403	1275–1390	barley	Ascough *et al.* 2009; Russell *et al.* 2011
	3004	1	Near top of fish midden in Column C	SUERC-255	665±50	−23.2	1267–1401	1271–1391	barley	Ascough *et al.* 2009; Russell *et al.* 2011
	3004	1	Near top of fish midden in Column C	SUERC-256	650±50	−21.8	1275–1404	1276–1392	barley	Ascough *et al.* 2009; Russell *et al.* 2011
	3004	1	Near top of fish midden in Column C	SUERC-257	610±50	−25.1	1285–1414	1281–1397	barley	Ascough *et al.* 2009; Russell *et al.* 2011
	2012	1	Near base of fish midden in Column B	AA-14706	810±55	−25.9	1047–1286	1053–1290	barley	Barrett 1997
	2017	1	Near top of fish midden in Column B	AA-14707	590±65	−25.7	1285–1431	1280–1425	barley	Barrett 1997
Freswick Links Area 4, Caithness		T	Primary fish midden horizon	GU-2045	795±50	−21.3	1057–1289	1055–1261	bone	Morris *et al.* 1995
		U	Second fish midden horizon	GU-2232	870±50	−20.4	1040–1257	1159–1265	bone	Morris *et al.* 1995
		V	Third fish midden horizon	GU-2044	810±50	−22.2	1051–1284	1177–1278	bone	Morris *et al.* 1995
Freswick Links Area 5, Caithness		Y	Uppermost fish midden horizon	GU-2283	860±50	−22.8	1040–1264		bone	Morris *et al.* 1995
		Y	Uppermost fish midden horizon (residual?)	GU-2390	1490±150	−24.7	229–880		seed	Morris *et al.* 1995

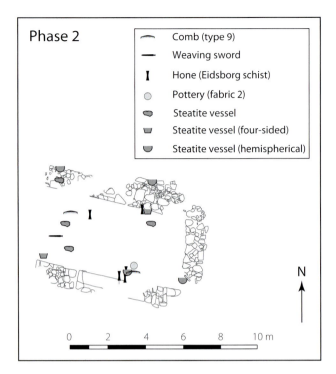

Figure 16.1. *The distribution of selected categories of artefact from House 5 in Phase 2 (the eleventh to twelfth centuries). The combs, hones and weaving sword are all probable Norwegian imports. The steatite represents both Shetlandic and Norwegian material. Only the single sherd of pottery is likely to be of local manufacture, and it is a rarity in Phase 2. (Image: Patrick Gibbs, David Redhouse and Dora Kemp.)*

2007, 447), Iceland (Ævarsson 2004, 114; Lucas 2009, 374–5), Greenland (Albrethsen & Ólafsson 1998, 21) and Ireland (Wallace 1992, 37–8; Mytum 2003, 119–21). These are not typical of the contemporary vernacular architecture of lowland Scotland (Dixon 2002) or England (Gardiner 2000).

In terms of portable material culture, the most remarkable observation is that Quoygrew was virtually aceramic during the whole of Phase 2, when House 5 was in use. Soapstone vessels of Norwegian and Shetlandic origin filled the physical and mental categories of 'pot'. Yet at the same date a similar fishing settlement across the Pentland Firth in Caithness at Robert's Haven (Barrett 1997; Table 16.1) was using locally made ceramics to the complete exclusion of soapstone vessels. Local ceramics are also known from other Viking Age and/or medieval sites in Caithness, such as Freswick Links (Gaimster & Batey 1995) and the relevant phases of Everley Broch (Heald & Jackson 2002, 32). The implications are that the networks of supply and the suites of activities and ideas associated with cooking and food differed

radically on either side of the Pentland Firth, a stretch of water only *c.* 12 km across. This observation holds despite the fact that the northern Scottish mainland (Caithness) adopted Scandinavian language in the Viking Age (Waugh 1993) and was often within the economic and military control of the earls of Orkney in the eleventh and twelfth centuries, when they emerged from the obscurity of origin myth to become historical powers in the north (Crawford 1987, 71–91; Barrett 2007; 2008).

It is reasonable to envision preferences for soapstone or ceramic vessels as active rather than passive expressions of very local oppositional identities — with references to differing networks over the horizon (Scandinavian and Scottish respectively, in geographical rather than political terms) (cf. Helms 1988). Yet this is not to argue that Orkney represented a transplanted Norwegian community. It was a *diaspora* community, using desirable materials and objects to which it could acquire access, sometimes in ways that implicitly or explicitly revealed its self-image as part of an extensive Scandinavian world. This self-image is captured in Old Norse skaldic poetry composed by and for historical (rather than legendary, as may have been the case with Torf Einar mentioned above) eleventh- and twelfth-century earls of Orkney: Rognvald Brusisson, Thorfinn Sigurdsson and Rognvald Kali Kolsson (Bibire 1988; Whaley 1998; Jesch 2009). It was materialized in its most dramatic form in the twelfth century by constructing St Magnus Cathedral to promote the cult of a local patron (the murdered Earl Magnus Erlendsson) — emulating and competing with the royal saints of Norway and Denmark (Crawford 1988; Antonsson 2007). At home and hearth the tenants of Quoygrew told similar stories in stone — by using pots of Shetlandic raw material sometimes made in Norwegian styles alongside a few actual Norwegian imports (Chapter 12). The mixture of Norwegian and insular combs at Quoygrew during the eleventh to thirteenth centuries suggests a similar interpretation. One particularly interesting example (Sf. 1) combines Scandinavian riveting practice with both an overall shape and repair of insular style (Chapter 13).

The construction of these local identities coexisted with a remarkable economic boom. The centuries around AD 1000 are often considered the height of the Medieval Warm Period (or Medieval Climate Anomaly) (Dahl-Jensen *et al.* 1998; Diaz *et al.* 2011; Surge & Barrett 2012) and the eleventh to thirteenth centuries in general represent one of Europe's main periods of demographic and economic expansion — a process thought to have reached its Malthusian limits shortly before the multiple crises of the fourteenth century (Biller 2000, 10; Hatcher & Bailey 2001; Hybel

& Poulsen 2007; Epstein 2009). The research underlying this book set out to ascertain whether a small farm on a small island in a small archipelago in the North Atlantic was influenced by these trends, which are best documented in regions of higher population density and urbanism such as the southern North Sea littoral (or even the Mediterranean). The answer is clearly yes. Our hypothetical elder would probably have found life a little too fast for his or her liking in the eleventh to thirteenth centuries. There was more bait collection, farther down the foreshore and more frequently (Chapter 6). There was much more fishing, for a greater range of fish sizes and more large individuals probably caught by rowing farther from shore. Many of these fish were dried (probably without salt) for later consumption. This would have been a labour-intensive process in Orkney, after the household rafters filled with drying fish. Unlike Arctic Norway, in the warm and wet climate of Scotland stockfish were cured inside, in specialized buildings (*skeos*) through which the wind could blow (Chapter 7).

There were more cattle (kept indoors during the winter and fed stored fodder in a very labour-intensive strategy) relative to sheep (that could fend for themselves most of the year) (Chapter 8). The sheep themselves were kept in new locations — perhaps including greater use of holms (small islands) or the foreshore — which may imply an increase in the absolute size of herds or their displacement from land now used for more cattle or cereal cultivation (Chapter 11). More barley may have been grown, and oats may now have been preferentially used for fodder rather than human consumption — a more intensive husbandry regime (Chapter 10). More cattle were killed as calves, increasing the supply of milk which had to be churned into butter (demanded for payment of renders such as tax, rent and tithe) (Chapter 8).

It would seem that almost all aspects of Quoygrew's household economy had become more extensive and/or intensive in the eleventh to thirteenth centuries than they had been before. This is in keeping with wider European trends, albeit expressed in distinctive local ways. Yet it remains to explain why this might be so. On present evidence, site-specific climate proxies show continuity (particularly regarding warm summer temperatures) with the preceding century (Surge & Barrett 2012). Was it a response to local demographic and social pressures, as population grew and more systematic renders (tithes and tax) were newly instituted by secular and ecclesiastical elites? Or, conversely, was it also because small worlds like Westray were active participants in long-range exchange networks ultimately supplying the growing needs of consumers in distant regions of very high

population density — particularly the towns of the southern North Sea coast?

Population densities in the rural North Atlantic could be surprisingly high during the Viking Age and Middle Ages (cf. Johansen 1982). It would be foolhardy to speculate on specific demographic patterns within the Northern Isles of Scotland in the complete absence of relevant documentation predating Henry Sinclair's 1492 rental (Thomson 1996). Nevertheless, it is reasonable in comparative perspective (and in light of the evidence from Quoygrew) to envision a scenario in which the islands were experiencing population growth. This growth may have been a cumulative effect of earlier Viking Age immigration and opportunities for new (or younger) households created by both boom-time economics and advantageous environmental conditions. A partially demographic explanation may seem mechanistic, but migration, reproduction and mortality are all ultimately social phenomena. Thus the causes of the postulated population rise must have been complex, entailing factors ranging from perceived economic opportunities to average age at marriage.

The evidence for the introduction of systematic taxation and tithe in Orkney is less speculative. Both were instituted by the middle decades of the twelfth century at the latest (Andersen 1991; Williams 2004; Gibbon 2007). These must have exerted local pressure for increased economic production at the household scale. The resulting need for more labour — on land and sea — could have been met in part by population growth, in part by changing or expanding gender roles (cf. Barrett & Richards 2004) and in part by more aggressive lordship.

But what of trade? Here the contemporary historical evidence is very thin (Barrett 2007, 313–15). Selecting the key examples, there are credible references to the export of cereal products to Iceland near the turn of the twelfth and thirteenth centuries (McGrew 1970, 129–30, 290–91) and *Orkneyinga saga* (Guðmundsson 1965, 130) places Orcadians in the eastern English fish market of Grimsby in the twelfth century. Direct references to trade with the kingdom of Scotland do not appear until the fourteenth century (e.g. Stuart & Burnett 1878, 239, 308), but ample evidence of travel for political and dynastic purposes from the eleventh to thirteenth centuries (Thomson 2008a, 69–147) makes earlier exchange with burghs such as Perth a reasonable possibility (cf. Hall *et al.* 2005). For Norway, the key reference is a speech against drunkenness attributed to King Sverre in a source of late twelfth- and/or early thirteenth-century date:

> We desire to thank the Englishmen who have come here, bringing wheat and honey, flour and cloth.

We desire also to thank those who have brought here linen or flax, wax or caldrons. We desire next to make mention of those who have come from the Orkneys, Shetland, the Færeys or Iceland; all those who have brought here such things as make this land the richer, and we cannot do without. But there are Germans who have come here in great numbers, with large ships, intending to carry away butter and dried fish, of which the exportation much impoverishes the land; and they bring wine instead ... (Sephton 1899, 129–30).

The archaeological finds from eleventh- to early thirteenth-century Quoygrew argue for strong networks of communication and exchange with one or more of Norway's towns. They also imply exchange within the western Scandinavian diaspora around the Irish Sea region — a pattern confirmed by finds of late Viking Age and early medieval Hiberno-Norse pins and combs at a variety of sites in Orkney (cf. Fanning 1983; 1994; Nicholson 1997a; 1997c, 364; Owen 2005, 200; Ashby 2009; 2011; Barrett & Slater 2009, 89–90; Griffiths & Harrison 2011, 18). Orkney's connections around the Scandinavian North Atlantic and Irish Sea worlds would thus seem to have been direct, as is also indicated by historically attested networks of kinship and other personal relationships (e.g. Barrett 2004a; Fidjestøl 1993; McGrew 1970, 130, 132). Direct links with the more heavily urbanized southern North Sea are far more tenuous — relying exclusively on *Orkneyinga saga*'s incidental mention of Grimsby. The explanation for this contrast may reside in the special status of Bergen, which was founded sometime between 1020 and 1070 (Hansen 2005, 238). It was recognized as one of Norway's major towns by Orderic Vitalis writing *c.* 1135 (Chibnall 1975, xi, 220–21), and rapidly became the kingdom's principal port for international commerce. This status was codified from 1294 by sequential royal policies preventing direct trade by foreigners beyond Bergen (DN V, 23). Thus goods from both Arctic Norway and the island communities of the North Atlantic were taken to this town before transhipment to English and continental markets (Andersson 2003, 334–5; Nielssen 2009, 84–5). English and other southern North Sea trade was initially the strongest, with Baltic centres such as Lübeck growing in importance in the thirteenth century and achieving dominance in the fourteenth (Dahlbäck 2003, 620–24).

In light of this evidence there was probably direct exchange between Orkney and other communities of the North Atlantic throughout the eleventh to thirteenth centuries — to Snorri Sturluson at Borg in Iceland for example (McGrew 1970, 129–30). By the late eleventh century, however, any trade with the urbanized southern North Sea littoral would predominately have been funnelled through Bergen, becoming

invisible in the historical records of consumer regions. Given the preference to retain northern traditions in Orkney — particularly the use of soapstone over ceramic vessels (see above) and the preference for bullion and commodities rather than coins as means of exchange (Williams 2004; Barrett 2007) — there is no surfeit of Scottish, English or continental goods from eleventh- to twelfth-century sites in Orkney (including Quoygrew), when the economic boom is most evident. The hypothetical trade thus remains obscure to archaeology as well as history.

If Quoygrew's inhabitants were supplying growing cities around the southern North Sea how could we ever expect to see it? The potential Orcadian exports are limited in diversity. Based on analogy with later centuries the Northern Isles produced mainly cereal products, meat, woollen cloth, hides, butter, dried fish and (fish and sea mammal) oil (Chapter 2). Cereals had local markets in the north, but can hardly be considered cost-effective exports beyond Iceland and Bergen. Meat may have been similarly limited in its distribution given the absence of a good supply of salt at this early date — it was later imported to the Northern Isles from southern Europe (Smith 1984, 76). Woollen cloth (*wadmal*) was an Icelandic and Shetlandic product (Smith 1984, 20; Þorláksson 1991, 507-8), but is not known as an Orcadian export and is thus of only indirect relevance to the occupants of Quoygrew. It was stockfish, fish oil, butter and hides for which Bergen, and thus presumably its suppliers, were best known in the fourteenth century when systematic custom accounts first appear (e.g. Nedkvitne 1976, 48–66). This trade is thought to have grown with Bergen in the eleventh and twelfth centuries, with Trondheim initially serving an overlapping role (Nielssen 2009, 84–5), but the textual evidence regarding northern trade is very limited at this early date.

An alternative approach has thus been to use zooarchaeological and biomolecular signatures to approximate where the fish — specifically cod — represented by bones recovered from archaeological sites around the southern North Sea and the Baltic were originally caught. In this way it has been possible to show that ninth- to eleventh-century cod from the western Baltic town of Hedeby/Haithabu *were* probably imported from the far north (perhaps Arctic Norway) and that a very small number of eleventh- to twelfth-century bones from centres such as London and York may be of cod imported from North Atlantic sources, potentially including the Northern Isles of Scotland (Barrett *et al.* 2008a; 2011; Orton *et al.* 2011; Fig. 16.2). In one slightly later example, two thirteenth- or fourteenth-century cod bones from Wharram Percy in Yorkshire also produced isotopic

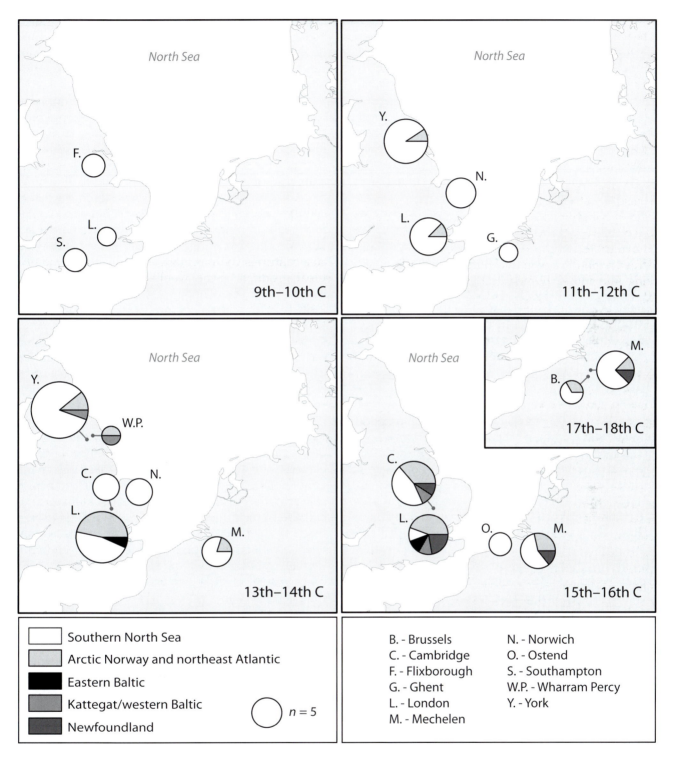

Figure 16.2. *Local (southern North Sea) and imported (other regions) cod bones in England and Flanders (Belgium) based on discriminant function analysis of δ¹³C and δ¹⁵N measurements on 129 archaeological vertebrae and cleithra dating between the ninth and eighteenth centuries. Any preserved fish from Orkney would be represented in the 'Arctic Norway and northeast Atlantic' category based on their isotopic signature. (Image: after Barrett et al. 2011.)*

signatures broadly consistent with Orcadian waters — and butchery marks identical to those on specimens from Quoygrew thought to be characteristic of stockfish production (cf. Barrett *et al.* 2008a; Chapter 7). It is tempting to treat these results as a link between economic intensification in eleventh- to thirteenth-century Orkney and growing demand in the south. They may well be pinpointing the fugitive surviving remains of imported northern stockfish (traditionally beaten with a hammer on preparation!) otherwise swamped by the more abundant remains of local fish (Barrett *et al.* 2011). Treated sceptically, however, the stable isotopic method is based on probabilities rather than absolutes, and butchery methods need not have been geographically distinctive. It is more conclusive that the biomolecular results imply that northern cod (perhaps increasingly of Norwegian and Icelandic origin) were important in subsequent centuries — in London by the thirteenth to fourteenth centuries and spreading to other centres by the fifteenth to sixteenth centuries (Barrett *et al.* 2011).

How then are we to interpret Quoygrew's (and Orkney's) economic boom in the eleventh to thirteenth centuries? It is probably safe to conclude that it resulted in part from local demand driven by both more mouths to feed and heightened elite demand. But what did Orcadian magnates, earls and bishops on the receiving end do with all the resulting butter, dried fish and fish oil? Based on the speech against drunkenness in Bergen (see above), and analogy with the fate of later renders from the Northern Isles of Scotland (e.g. DN II, 691), it is probably safe to assume that it was exported in exchange (directly or indirectly) for the trappings of elite life (e.g. textiles, weapons, building timber and the services of stone-masons and poets). Much of this exchange must have been through Bergen and/or other Norwegian towns, but the combs and pins of insular style in Orkney noted above suggest that western centres such as Dublin and/or Whithorn were sometimes an alternative. Concurrently, peasant farmer-fishermen may also have found direct commercial outlets for their produce via the catalysts of elite trade and client–patron relationships. A useful analogy is provided by the Hanseatic League's post-medieval fish trade in Shetland, which could reach directly to primary producers in addition to involving elite facilitators (Friedland 1983).

Taken at face value, the few eleventh- to twelfth-century cod bones from England with North Atlantic isotopic signatures could reflect this export. If so, they may be limited in number because even a large scale of production for a small community like Orkney would be difficult to see in an importing region — once

dispersed by trade, hammered during preparation, cooked, buried for approximately nine centuries and then excavated using recovery methods that only rarely entailed sieving large volumes of sediment with fine mesh.

It is a paradox that the archaeological evidence for a medieval fishing boom in Orkney predates the clearest evidence — from historical records and archaeological science — for large-scale fish trade (Barrett *et al.* 2011). Nevertheless, demography, lordship and urbanism must be critical pieces of the puzzle. Population growth in the eleventh to thirteenth century probably fuelled both local demand and the fugitive beginnings of long-range trade to distant consumers. The two were connected by local elites who required surplus products for export and coveted the resulting imports. The consolidation of a town at Kirkwall in the 1130s (Chapter 2) provided a precocious local node for this trade — predating Hanseatic towns such as Lübeck that were later to control the trade of staple commodities in the North Atlantic. Only later, having grown with time and Europe's population, did long-range fish trade clearly become visible in the records (and archaeological fish bone assemblages) of consumer regions.

If this interpretation were wide of the mark it would be very difficult to explain why the majority of Quoygrew's portable material culture between the eleventh and thirteenth centuries consisted of imports. Other potential exports, such as butter and grain, may also have been used for exchange, but of all activities capable of producing a tradable surplus it is fishing that shows the clearest evidence for intensification. Hones, antler combs, querns and soapstone pots are unlikely spoils of piracy and mercenary activity — the other planks of Orkney's political economy at this time (see below).

16.4. Collapse?

Perhaps counter-intuitively, the period when stable isotope analysis suggests that northern cod became common in London — the thirteenth to fourteenth centuries — is synchronous with the decline of fishing at Quoygrew. The Fish Midden and Farm Mound, with their high densities of marine shell and fish bone, ceased to accumulate. It seems that less bait was collected and fewer fish were caught. On present evidence this collapse appears to have occurred in the course of the thirteenth century in Orkney, rather than the fourteenth as one might at first expect (Chapters 4 to 7).

It could alternatively be argued that fish bone and shell were increasing used for manuring the

infield at Quoygrew, rather than being discarded around the houses as they had before (Simpson *et al.* 2005; Chapter 3). However, a late medieval decline in fishing is corroborated by other excavated fish midden sites of Orkney and Caithness: St Boniface, Cleat, Robert's Haven and Freswick Links (Table 16.1). The proportion of marine protein in the local diet also shows a concurrent cycle of increase and decline — based on stable isotope analysis of radiocarbon-dated human remains from Newark Bay (Barrett & Richards 2004) and St Thomas' Kirk (Barrett *et al.* 2008b) on the island of Mainland, Orkney. Moreover, it is clear that the character of fishing had indeed changed by the fifteenth century at the latest, when substantial midden deposits reappeared at Quoygrew. The species and sizes caught differed from the boom years of the eleventh to thirteenth centuries. Only small saithe, easily caught from the shore and not typically used as a trade good, were present in abundance (Chapter 7). Lastly, the infield soils are aceramic, suggesting that late medieval domestic refuse was not dumped there in abundance. They must instead have been manured with turf, byre waste and seaweed.

There is not enough mammal bone from post-thirteenth-century phases at Quoygrew to be certain how animal husbandry may have changed over the same period. It is just possible, however, that an increase in the ratio of charred oats to barley implies that oats were increasingly used for human rather than animal consumption (Chapter 10). These carbonized samples (from middens) are likely to result from accidents during drying by kiln — a process typically intended for the storage of food crops rather than fodder. This archaeobotanical pattern is consistent with a decrease in the relative abundance of cattle (admittedly based on small samples) evident by the fifteenth to sixteenth centuries (Chapter 8). The evidence is much more equivocal than for fishing, but cattle husbandry may thus also have been less intensive in the late Middle Ages than it had been in the eleventh to thirteenth centuries. If Quoygrew's infield was augmented at this time — as implied by the stratigraphy of the Farm Mound, the radiocarbon dates and the soil micromorphology (Simpson *et al.* 2005; Chapter 4) — Quoygrew's inhabitants may have retreated to an emphasis on small-scale arable agriculture.

In sum, it is likely that production decreased at Quoygrew, starting with the abandonment of intensive fishing in the thirteenth century. Economic discontinuities like the shift away from harvesting large cod — with its risk, discomforts and rewards — would have been major changes for elders of this new generation. They were not, however, the only transformations they would witness.

When House 1 was built over the levelled ruins of House 5 (and its surrounding fish midden), around AD 1200, its architectural referents were still within the tradition of domestic architecture in the western Scandinavian diaspora. The end-on-end layout, including a hall with side aisles, and an annex at right angles to the main axis, resemble contemporary 'row-house' floor plans in Iceland and Greenland that may ultimately have been influenced by Norwegian urban architecture (Skaaning Høegsberg 2009). A three-room plan is not meaningfully different from the typical layout of other medieval houses in Britain (e.g. Gardiner 2000), but the retention of side aisles, in particular, places the use of space into a northern milieu (Fig. 4.9). It is thus not surprising to discover that the earliest phases of House 1 continued to produce combs of Scandinavian style, Eidsborg hones and soapstone vessel fragments (Chapters 12–13; Fig. 16.3a).

However, the construction of House 1 was also associated with the introduction of ceramics at Quoygrew — both locally made and (in a very few cases) imported from the kingdom of Scotland and from Germany (Chapter 15; Fig. 16.3b). The use of soapstone and pottery vessels together was no longer outside the norms of social convention. In one particularly clear example the fill of a small subfloor pit (fill F548, cut F549) from Phase 3.5 included sherds of both soapstone and ceramic pot (Fig. 16.4). Hones of local stone also began to replace Eidsborg schist (Chapter 12).

Norwegian connections did continue — as indicated by the use of bake stones of schist (probably from the Hardanger region) for example. Nevertheless, the bulk of portable material culture at Quoygrew was of local rather than distant origin in the 1200s and 1300s — a major difference from earlier centuries. Only a trickle of exotic goods from Norway continued, gradually replaced by a similarly modest flow of objects from the south. Clear evidence for Quoygrew's (and Orkney's) economic connections with the Irish Sea region disappeared altogether.

The internal layout of House 1 also changed over this period. First the southern side aisle was replaced with a high seat. Later the northern side aisle also went out of use (Chapter 4). Thus by the end of Phase 3 (late in the fourteenth century) the interior of House 1 would probably have been as familiar to visitors from the kingdoms of Scotland or England as from Norway, Iceland or Greenland. North Atlantic Scandinavian architecture was diverging at the same time — with the very different 'passage houses' and 'conglomerate buildings' developing in Iceland and Greenland respectively (Skaaning Høegsberg 2009). Networks were changing.

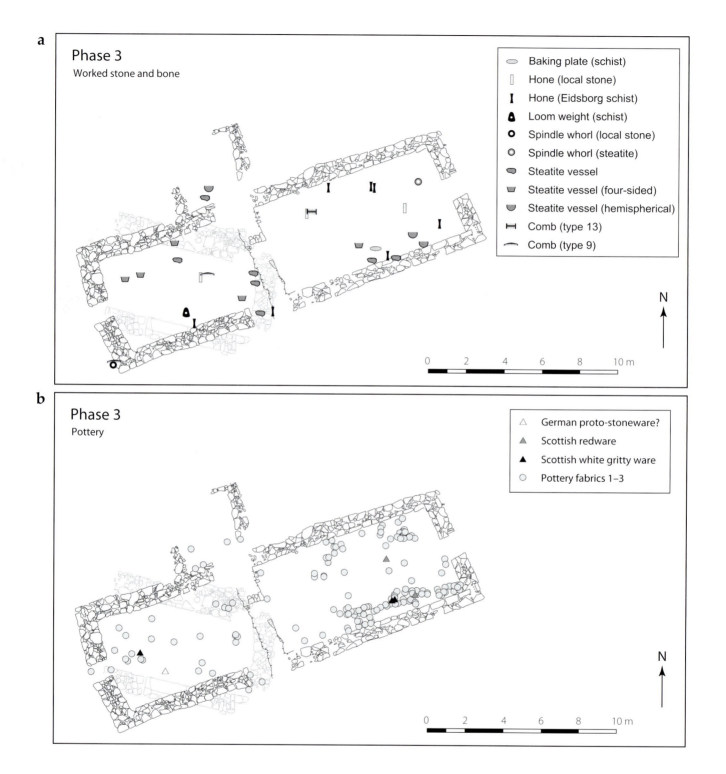

Figure 16.3. *The distribution of selected categories of artefact from House 1 in Phase 3 (the thirteenth to fourteenth centuries): (a) worked stone and bone; (b) pottery. The combs, Eidsborg hones, baking plate and schist loom weight are probable Norwegian imports. The steatite is probably from Norway and (predominantly) Shetland. (Image: Patrick Gibbs, David Redhouse and Dora Kemp.)*

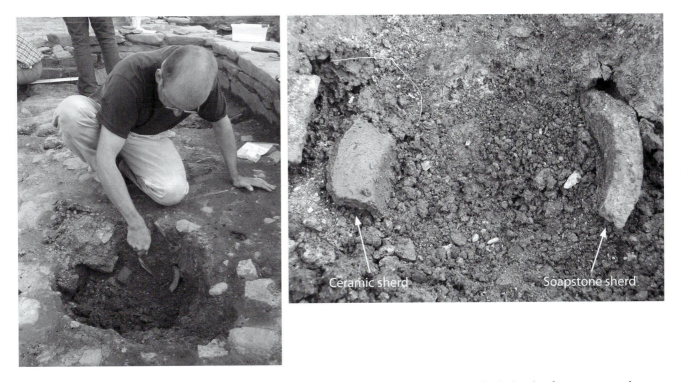

Figure 16.4. *A small subfloor pit (fill F548, cut F549) from Phase 3.5 of House 1 in which sherds of soapstone and ceramic vessels were deposited together. (Images: Tom Riley.)*

By the beginning of Phase 4, around AD 1400, this transformation was complete. House 1 was extended and remodelled entirely in keeping with the fashion of medieval longhouse architecture elsewhere in Britain — with hall (Room 1), chamber (Room 2), byre (Room 3) and store (Room 4) (Fig. 4.12; cf. Gardiner 2000). In the course of the fifteenth to sixteenth centuries the use of soapstone vessels and Eidsborg hones also ended. The few finds of these objects, and of mica schist querns, from Phase 4 at Quoygrew were from secondary contexts where they probably served as residual pieces of stone rather than functional tools (Chapter 12). Locally made pottery and (to a lesser degree) imported ceramics from Scotland and Germany became the norm (Chapter 15; Fig. 16.5). Lowland Scots was also increasingly spoken in the fourteenth and fifteenth centuries — introduced by economic migrants in the entourages of earls, bishops and other administrators with political and kinship networks rooted in the expanding kingdom of Scotland (Sandnes 2010, 15–23). These developments could be incremental or punctuated — as illustrated by the gradual abandonment of soapstone vessels during the thirteenth to fourteenth centuries on one hand (Chapter 12), and the drowning of the local Orcadian elite in a single shipwreck in 1232 on the other (Chapter 2).

That Quoygrew and Orkney experienced an economic downturn in the late Middle Ages would appear to be evidence of the continued interconnectedness of this rural community with the rest of Europe. The unprecedented crises of the fourteenth century — cattle murrain, famine, epidemic, climate change, economic contraction and social unrest — have long been central to the study of medieval history (e.g. Postan 1973, 3–27; Hatcher & Bailey 2001; Dyer 2002, 228–97; Epstein 2009, 159–89). The impact of the Great Plague on Norway was severe (Vahtola 2003) — and it may have been similarly calamitous in the Scottish Highlands (Oram & Adderley 2008).

Yet late medieval 'decline' was not a simple case of causal chains. Regional stories reveal complicated histories created by the interplay of secular trends and local contingencies. Iceland, for example, escaped plague until 1402–1404 (Vahtola 2003, 567). If the *Icelandic Annals* can be treated as a reliable source this was due in part to death on board the only Iceland-bound ship when plague struck Bergen in 1349 (Benedictow 2004, 146, 155). Epidemiological factors associated with Icelandic settlement patterns may of course also have played a role, but the lesson remains that grand narratives are seldom accurate at the local level. In Norway it is increasingly likely that

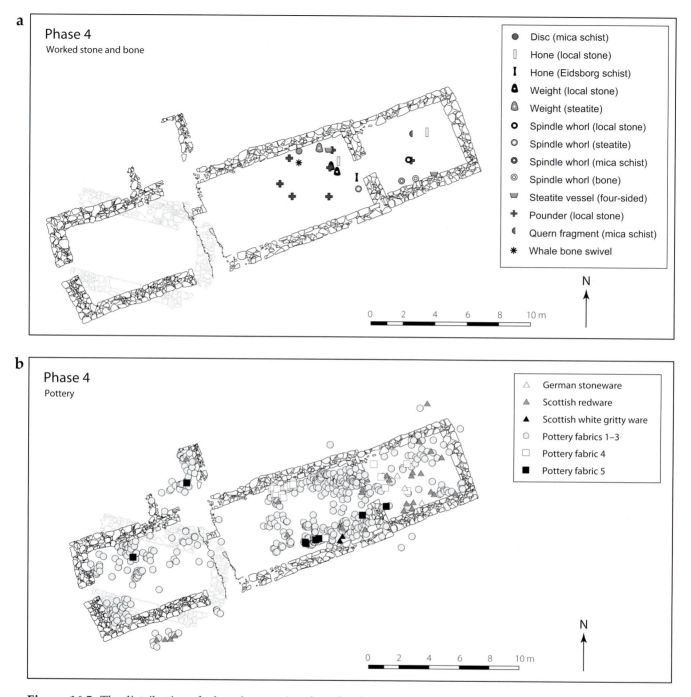

Figure 16.5. *The distribution of selected categories of artefact from House 1 in Phase 4 (the fifteenth to sixteenth centuries): (a) worked stone and bone; (b) pottery. The few Eidsborg schist, mica schist and steatite objects may be residual in this phase. (Image: Pat Gibbs, Lucy Farr and Dora Kemp.)*

large-scale iron production in the forest 'outlands' collapsed early in the fourteenth century (before the Black Death) — and that large-scale trapping of reindeer may have peaked in the thirteenth century (Larsen 2009, 55; Stene 2010; Indrelid & Hufthammer 2011).

Given this complexity, how did economic change unfold in medieval Orkney? To summarize the observations made thus far, networks of material flow were rapidly changing in the thirteenth century. Most significant was a reduction in the proportion of Norwegian imports. Concurrently, sea fishing (and

possibly also intensive cattle husbandry for butter production) declined. In sum, there was less production, less trade and a shifting network of economic connections. At Quoygrew these changes seem to have predated the cattle murrain of 1319–21, the Great Famine of 1315–22 and the Great Plague of 1349–50. They were probably reinforced by the crises of the fourteenth century. Much abandoned agricultural land in Orkney was still unused as late as 1492 (Thomson 1984) and in Caithness (which was increasingly under direct Scottish control) intensive fishing does seem to have continued until the fourteenth century at Robert's Haven (Table 16.1; see also Stuart & Burnett 1878, 239). Nevertheless, causation must first have been rooted in the thirteenth century.

To understand this transformation it may be helpful to first comprehend the wider political economy of early medieval Orkney. As discussed in Chapter 2, its wealth in the tenth to twelfth centuries was founded partly on primary economic production — agriculture and fishing — and partly on seaborne piracy and mercenary activity perpetrated by the earls of Orkney and an obstreperous stratum of semi-independent magnates on whom they depended. The classic example is Svein (Sweyn) Asleifsson, a historical (if semi-legendary) twelfth-century pirate. *Orkney-inga saga* includes a fictionalized account of his life:

> It was Sweyn's custom at that time to spend the winter at home in Gairsay, and he always kept eighty men there at his own expense. He had a drinking hall so large that there was not another to match it for size in the Orkneys. Sweyn always had a busy time in spring, and had a great deal of seed sown, and did a great deal of the work himself. But when the work was finished, he went every spring on a viking-cruise, and harried round the coasts of the Hebrides and Ireland, and came home after mid-summer; that he called his 'spring viking-cruise'. Then he was at home until the grain was cut, and the corn taken in. Then he went on a viking-cruise, and did not come home until a month after the beginning of winter; and that he called his 'autumn viking-cruise' (Taylor 1938, 338–9).

Not included in this passage, but equally important in light of the archaeological evidence, Svein was portrayed as having spent part of his youth fishing with his father's servants (Guðmundsson 1965, 150). Fishing, during which one acquires the skills of seamanship, and a military economy of piracy and mercenary activity, were interdependent in a world of water.

As the twelfth century became the thirteenth the freedom of Orkney's earls and magnates to continue this style of military economy was seriously curtailed — in the context of growing royal power in Scotland

and Norway. Piracy turned into open warfare between the islanders and both Scottish and Norwegian monarchs. The outcome was not good for the islanders. Sequential defeats (entailing death, mutilation, the payment of tribute and the loss of land and its income) limited their capacity to keep up the fight (Chapter 2). In 1231 the last of the ancestral earls was murdered in a dispute with followers of a Norwegian administrator, and in 1232 the surviving Orcadian elite was drowned *en masse* on return from the resulting court case in Bergen. The old order of the 'pirate fishermen' had ended.[15] A local elite in Orkney was only slowly re-established, leaving reduced demand for surplus, reduced wealth with which to intensify production and reduced ability to organize long-range trade.

Thus Quoygrew's tenant farmers and fishermen must have witnessed Orkney's political economy dissolve around them in the thirteenth century. Dues were still owed, but to distant kings or to earls with strong Scottish connections who were often absentees (Chapter 2). Briefly, perhaps, a tributary mode of production was replaced by a peasant mode of production (cf. Wickham 2005, 536–47). The pace of work slowed, buying power (and opportunities) declined and local goods were substituted for imports. Barley, malt and butter were no longer required to feast the court poets of the earls — poets who had continuously re-materialized legends of Scandinavian ancestry (Bibire 1988; Poole 1991, 161–72; Whaley 1998; Jesch 2009). The last of the known Orkney skalds, Bjarni Kolbeinsson, died in 1223 (Fidjestøl 1993). In the absence of this ideology to emulate there was little reason to continue an avoidance of ceramic vessels. There were also practical considerations. Shetland (the closest source of steatite and previously part of the earldom of Orkney) had been taken under direct Norwegian control in 1195, following defeat of the islanders by King Sverre the previous year (Imsen 2003). Acquiring soapstone pots was now more bother than worth.

The gradual dissolution of Orkney's military economy did not go unobserved by contemporaries. *Orkneyinga saga* (written around 1200) captured it in anecdotal form when describing the aftermath of Svein Asleifsson's death (probably in the 1170s). On receiving their inheritance his sons divided the drinking hall in which their father had maintained his retinue (Guðmundsson 1965, 289). This was not an anachronistic vision of the end of a Viking Age long past (cf. Pálsson & Edwards 1981, 15). Fictitious

15. The Hebrides at times supported a similar political economy, most famously represented by the Galloglass mercenaries who continued to fight in Ireland long after the military economy of medieval Orkney had ended (see Raven 2005; Caldwell 2007; Duffy 2007).

or not, it was a contemporary commentary on a major cultural change happening at the turn of the twelfth and thirteenth centuries.

Concurrent with the end of a military economy, pan-European trends in long-range trade must also have undermined the Orcadian political economy. It may not be a coincidence that Orkney was reducing its emphasis on fishing at the same time that stable isotope analysis suggests northern cod were first common in centres of consumption like London. During the course of the Middle Ages stockfish production probably became an increasingly specialized and localized industry — particularly in Arctic Norway and Iceland — on a scale sufficient to displace the produce of fishing elsewhere. The comparative ease of making this product in cooler northern latitudes would certainly have made it strong competition. Thirteenth-century Orcadians are unlikely to have found this challenge easy to overcome in the absence of a local elite with wealth to invest in special preservation facilities (e.g. *skeos*) or alternatively the large-scale importation of salt. Turning to cereal products (another of Orkney's known medieval exports), Baltic ports were displacing other suppliers as the 'bread basket' of the north by the thirteenth century (Gade 1951, 38–42; Dollinger 1999, 49; Helle 2003, 413).

Yet Shetland and Caithness responded differently to this enhanced competition. Formerly ruled by Orkney's earls, they were increasingly drawn under the direct political and economic control of Norwegian and Scottish magnates respectively during the late twelfth, thirteenth and fourteenth centuries (Chapter 2). Historical sources (e.g. Stuart & Burnett 1878, 239; Friedland 1983; Smith 1984), an abundance of (late medieval) Ashby Type 13 combs imported from Scandinavia (Clarke & Heald 2002; Chapter 13) and radiocarbon dates from fishing sites like Robert's Haven (Table 16.1) all suggest that exports of local products such as dried fish continued into the fourteenth century in Caithness and even later in Shetland. Orkney's earlier economic shift is thus all the more remarkable.

The proposed emergence of a peasant mode of production in thirteenth-century Orkney may not have been fleeting — intensive production and buying power (represented by plentiful imported goods) did not quickly reappear at Quoygrew. In the absence of local middlemen to press claims for rent and tax, however, the lot of peasant tenants and proprietors may well have improved despite a decrease in their ability to purchase exotic goods. This realignment of the political economy can only have been reinforced in the wake of fourteenth-century famine and plague, the 'great age of inheritance' when the survivors benefited from the wealth of the many dead (Epstein

2009, 184). Perhaps it is in these terms that one can best interpret the expansion and comprehensive renovation of House 1 at Quoygrew during Phase 4, around AD 1400 (Chapter 4; Figs. 4.12 & 16.5).

Over the long term, the collapse of Orkney's military economy in the thirteenth century and the pan-European crises of the fourteenth century had a cumulative effect that can be inferred from the material record at Quoygrew. At shorter time-scales, however, it is important to recognize the limits of archaeological precision. The intervening years were hardly a time of stasis. From the historical record it would seem that networks with Norway were intermittently strong in the late thirteenth and early fourteenth centuries despite their earlier disruption. As discussed in Chapter 2, Orkney served as a staging post for King Hakon Hakonsson's invasion of Scotland in 1263 and the Orcadian gentry still sought status as royal liegemen into the 1300s. Anecdotal evidence can sometimes be most telling. It is the elopement of Allicia, who seems to have left her Orcadian husband for a life in Bergen in 1325/26, that best encapsulates the re-emergence of routine voyages between the islands and Norway's main urban centre.

These re-emerging connections were not to continue indefinitely. The network probably lasted longer than the affair (there was a Norwegian royal administrator for Orkney in the 1360s (Chapter 2)), but by the fifteenth century Quoygrew's modest numbers of imports were mostly arriving from Scotland (or occasionally Germany) rather than Scandinavia. As previously mentioned, it is relevant that lowland Scots was concurrently replacing Old Norse as the language of record in Orkney (Sandnes 2010, 15–23). A community with a very strong sense of local identity continued — as evidenced by a written complaint against the excesses of a royal administrator, David Menzies of Weem, early in the fifteenth century (DN II, 691). Nevertheless, this community's material and immaterial culture now adopted rather than confronted the styles of the south.

16.5. Rebound

With David Menzies one sees the Orcadian peasantry hard pressed once again to produce a surplus for consumption and export by elite middlemen. By the time of the Stewart earls of Orkney, from 1581 to 1615, it is thus not surprising to observe another boom cycle of monumental architecture, commercial fishing, export trade, piracy and political ambition (Chapter 2) — which ultimately led Earl Patrick Stewart to the executioner's blade in Edinburgh (Anderson 1992, 139) and Orkney to another period of major socio-economic

change (Thomson 2008a). Economic recovery is clear from the material culture of the elite. In the sixteenth century Quoygrew's new landlords built nearby Noltland Castle, described as 'a smart house sitting on top of two floors of purposeful artillery fortification' (Gifford 1992, 343). Rebound is less evident at Quoygrew itself (perhaps because dwellings later than Phase 4 have not yet been excavated), but by the seventeenth century Dutch pipes and imported redware pipkins were being discarded by the site's inhabitants (Chapter 15).

16.6. Discussion: being an islander in the rural north

In 2008 urban dwellers outnumbered rural populations for the first time (Martine 2007, 1). Hitherto, the majority of the world's population had lived in the countryside. In the Viking Age and Middle Ages urban populations in northern and western Europe were very small. All estimates are informed guesswork based on imperfect evidence, but provide a useful impression of scale. Iceland probably supported 60,000 to 70,000 people in the eleventh century, all rural dwellers (Byock 2001, 55). The only town in early Viking Age Norway was Kaupang, and it is unlikely to have supported more than c. 600 people (Skre & Stylegar 2004, 9). After the founding of late Viking Age and medieval centres such as Trondheim, Bergen, Tønsberg, Oslo and Sarpsborg (among others) Norway's high medieval urban population is unlikely to have exceeded c. 3% of the total — perhaps c. 10,000 of c. 345,000 (Benedictow 2003, 237, 248).

In the Irish Sea region the earliest substantial town, Dublin, probably supported between 3000 and 5000 people around AD 1000, rising to c. 7000–8000 by AD 1100 (Holm in press). Viking Age markets at locations such as Whithorn (Hill 1997) and Meols (Griffiths et al. 2007) had some urban functions, but are unlikely to have supported large resident populations. Chester and Bristol (renewed and founded at the beginning and end of the tenth century respectively) increased the urban character of the Irish Sea region by the end of the Viking Age (Parker 1999, 325; Edmonds 2009, 6), with Glasgow and other western centres of the kingdom of Scotland becoming burghs by the twelfth century (Dennison & Coleman 1999; Driscoll 2002, 8). In general, however, the insular zone of the west was overwhelmingly rural throughout the Viking Age and Middle Ages. Elite centres served as alternative foci for exchange (e.g. Lane & Campbell 2000; Sheehan 2008; Redknap 2009; Caldwell 2010; see also Etchingham 2010 regarding 'monastic towns').

Turning to the North Sea, the earliest eastern Scottish burghs (such as Aberdeen and Perth) had begun to develop in the eleventh century and received particular impetus under King David I in the twelfth (Crone 2000; Dennison & Simpson 2000; Hall et al. 2005). Orkney's own small town of Kirkwall developed along a similar timeline. It was certainly extant by the 1130s when the relics of Magnus Erlendsson were moved there from Birsay and a cathedral founded in the saint's honour (Lamb 2010). A best-guess estimate of the number of Scottish town dwellers is first possible for the late Middle Ages, when c. 10% of a total population of c. 700,000 is conceivable (Dennison & Simpson 2000, 730–31).

It was, however, the southern North Sea region (particularly in the Low Countries and England) that was most heavily urbanized in the Viking Age and Middle Ages (Verhulst 1999). Using England as an example, London might have supported c. 20,000 people in AD 1100, rising to c. 40,000 by AD 1200 and c. 80,000 immediately prior to the crises of the fourteenth century (Keene 2000, 195–6). This alone may have been roughly equivalent to the entire contemporary urban population of the North Atlantic region. Norwich, a southern North Sea town of intermediate scale, has been estimated at c. 10,000 in 1066 (Ayers 2011, 90), and there was also a dense network of small towns (Astill 2009). Even so, England too was predominately a rural society in comparison with the Low Countries (cf. Verhulst 1999, 114–15). Based on the Domesday Book, town dwellers are unlikely to have comprised more than 10% of its c. 1.6 to 1.7 million people in 1086 (Holt 2000, 84; Hinde 2003, 18–19).

The implications of this brief review are simple. Any consideration of the political economy of Viking Age and medieval Europe must concurrently address rural production, the dialectic of town and country and inter-regional diversity (cf. Berggren et al. 2002; Giles & Dyer 2005; Holm et al. 2005; Brisbane et al. 2012; Christie & Stamper 2012). Yet these issues are complicated by significant biases inherent in our evidence base (Chapter 1). The greatest concentrations of archaeological material, the best preservation conditions and the finest chronological resolution (from dendrochronology, coins and deep stratigraphy) all occur in urban centres. Rural settlements, although much more frequent, had less concentrated deposits to begin with and have often been reduced to foundation features and plough zone scatters by centuries of agriculture. Thus it is not surprising that archaeological discussions of Viking Age and medieval trade often focus on towns and inter-urban networks, to the comparative neglect of the rural dimension.

This book, and the research project that underpins it, have sought to help redress the balance. Yet it would be naïve to swing the pendulum too far. Viking Age and medieval towns served as vortices of trade

that connected regions of differing population density and demand by funnelling staples, luxury goods and people over large distances to centres of perceived opportunity (cf. Verhulst 1999; Sindbæk 2005; Skre 2008; Barbier 2011, 195–7; Barrett *et al.* 2011). The resulting networks could connect Uppland (Sweden) or Greenland to Rome, for example, but were susceptible to sometimes rapid transformation (Roesdahl 1998; Sindbæk 2007b). The number and size of towns (and concomitantly the scale of production) increased dramatically between the eleventh and thirteenth centuries, only for economic production and demand to crash following famine and plague in the fourteenth century (Epstein 2009).

Having sketched the generalities of urban–rural interrelationships across time and space in the medieval north, what is the relevance of Quoygrew to these wider issues? The ultimate goal of this study was to improve our understanding of broad socio-economic trends by observing the so-called margin (reoriented as the rural 'centre') and answering four questions with potential implications for the connection between rural insular societies and urbanized consumer regions. The first question was whether the economic intensification that characterized densely populated areas of Europe (particularly the southern North Sea littoral) during the transition from the Viking Age to the Middle Ages was also evident in a rural island community of the North Atlantic? The answer from Quoygrew would appear to be yes. Virtually all observable aspects of production seem to have reached their apogee in the eleventh to thirteenth centuries.

The second question was whether this complementarity resulted from local responses to similar problems (e.g. population growth) or from direct communication and trade. The answer may well be both, but the evidence for systematic and sustained exchange is clear. Most of the artefacts from Phase 2 (the eleventh to twelfth centuries) at Quoygrew were from outwith the archipelago of Orkney. Some were sourced as nearby as Shetland, but many others were from Norway or (to a lesser degree) the Irish Sea province. The most important proximate trading partner was probably Bergen, with some of Orkney's exports then trans-shipped south.

The third question was how did Quoygrew's island community respond to the crises of the fourteenth century? It is here that the complex interplay of external and internal forces, of secular trends and historical contingency, are shown in sharpest relief. Orkney's late Viking Age and early medieval boom years appear to have ended in the thirteenth century rather than the fourteenth. To focus on the most obvious

evidence, intensive fishing ended and imported goods began to be replaced with locally made alternatives. As argued above, the causes are probably related to the disappearance of a local elite supported by a military economy — the 'pirate fishermen' — in the face of expanding Scottish and Norwegian royal power. Having weathered decades of warfare, most of it ending badly for the islanders, many of the surviving members of the Orcadian aristocracy were drowned in 1232. In the resulting power vacuum it is argued that Quoygrew's tenants (and their contemporaries elsewhere in the islands) reverted to a peasant mode of production — entailing less surplus production, less purchasing power and less extensive networks. A new elite emerged in the decades to follow, restoring old connections with Norway, only to be disrupted again by famine, plague and increasingly specialized European trade networks for products such as dried fish and cereals.

The final question was how did changing degrees of long-range interconnection influence the expression of distinctive insular identity? During the centuries of heightened economic production and long-range trade Quoygrew's occupants expressed their clearest material differences from near-neighbours across the Pentland Firth in Caithness. The islanders used soapstone vessels and the mainlanders pottery — almost exclusively in each case. This is despite (or perhaps in part because of) close dynastic and political engagement with the growing kingdom of Scotland to the south during the eleventh and twelfth centuries. To materialize this social boundary (significantly between two territories often jointly controlled by the earls of Orkney), Orcadians looked to the memory of Norse ancestry and thus over the horizon to Norway. Yet distinctiveness from Scandinavia was also made clear at all social levels. One could single out the preservation into the twelfth century of verses allegedly by the tenth-century earl Torf Einar, celebrating his victory over a son of Harald Fairhair (the semi-mythical founder of the Norwegian royal line) (Poole 1991, 161–72), or the elevation in the 1130s of Magnus Erlendsson as patron saint of the earldom (in emulation of and competition with the royal saints of Norway and Denmark) (Antonsson 2007). More subtle was the adoption of new styles of material culture, such as four-sided soapstone pots.

Things changed in the thirteenth century. As the economic boom subsided the imperative for local oppositional identities faded as well. Norwegian imports dried up and soapstone vessels were joined (later entirely replaced) by pottery. Most of the ceramic pots were locally made, but the inspiration was clearly from the Scottish kingdom (the source of

the medieval white gritty and redwares at Quoygrew, and likely the proximate source of the earliest German wares as well). In part this pattern may simply reflect decreasing availability of Norwegian imports (and perhaps also of steatite from Shetland, after it was taken under direct Norwegian control in 1195). However, the waning of intensive economic production and expressions of distinctive local identity must have been mutually reinforcing — particularly when combined with decimation and disenfranchisement of the local Orcadian elite.

History records turbulent efforts to re-establish a northern network in the late thirteenth and early fourteenth centuries (see above), but these evade the resolution of archaeology and were cut short by the crises of the fourteenth century. Moving forward, the importance of explicitly Scottish links is clear from artefacts of fifteenth- to sixteenth-century date (specifically Scottish redware pottery). Some German stoneware may have derived from direct Hanseatic trade at this time, but it too could have arrived via lowland Scotland (where it is a common find). House 1 at Quoygrew was also rebuilt in the fifteenth century, bringing it more in line with what is known of vernacular architecture in mainland Britain. A strong Orcadian community remained, as evidenced by the formal complaint against the rule of David Menzies early in the fifteenth century, but this group did not go out of its way to materialize its 'islandness'. Only when the conditions for sustained economic intensification returned, in the sixteenth and seventeenth centuries, were there new efforts to create a microcosm in the north. In sum, from the tenth century to the seventeenth, Orcadians — including Quoygrew's inhabitants — variously chose to emphasize or underplay their insularity within webs of changing economic, political and social networks.

16.6. Conclusions

At one scale, this has been a story about the emergence of long-range trade in commodities and the associated development of regional specializations in labour. At another, it has been about how one creates one's place in the world on a small island of the rural north. It is argued that medieval Orcadian society was most *insular* when heavily engaged in long-range maritime networks and *vice versa* — an observation that, although superficially counter-intuitive, may ring true to social anthropologists. It is likely to have global resonances across time and space. In concluding thus, it is worth asking what matters most in medieval archaeology? Is it our ability to make sweeping generalizations or to illuminate the contingencies of time *intersecting* space? Is it our study of (and therefore reification of) sometimes hegemonic centres of population, or our ability to reconstruct rural communities that variously challenged, evaded and fed them? Is it about fitting the right historical and typological analogies to our material record, or challenging received wisdom? Clearly it will always be about all of these things, but the value of focusing on small worlds should not be underestimated. In this book it is argued that the ebb and flow of long-range connections and insular identity as expressed at one farm in Orkney both reinforces and revises the broad trends of northern and western European 'history' — at various scales and over land and water, from the tenth to sixteenth centuries. Turning the Quoygrew lens on the drivers of medieval socioeconomic change one sees the contingent interplay of social, economic, demographic and environmental factors, all unfolding in the local world of lived experience yet interconnected on an ultimately supra-regional canvas.

Appendices

Appendix 4.1. *Concordance of context numbers assigned to the recorded wave-cut bank and Areas A to E.*

Wave-cut bank	Area A	Area B	Area C	Area D	Area E
1	A001	B001	C001		E001
1			C002		E002
2	A002				
3	A003				
3	A004				
5	A005				
5	A006				
5	A007				
6	A008				
7	A009	B006			
7	A010				
7	A011				
7	A012				
7	A013				
7	A014				
7	A015				
7	A016				
7	A017				
7	A018				
7	A019				
8	A026	B014	C018		E034
8			C020		E035
8			C021		E036
8			C022		
8			C023		
8			C024		
9	A027	B015	C025		E037
9			C026		
13		B002	C003		E003
13		B003	C004		
14		B004			
14		B005			
17	A020				
17	A021				
17	A022				
17	A023				

Wave-cut bank	Area A	Area B	Area C	Area D	Area E
18		B009			
18		B011			
18		B012			
22	A024	B013	C014		E030
22	A025		C016		E033
22			C017		
27		B007			
27		B008			
29			C005		E005
29			C006		E006
31					E021
32					E021
33			C015		
34					E028
35					E020
37			C009		E011
37			C010		E016
37			C011		E026
37			C012		
38			C013		E017
38					E028
39			C008		
40			C007		E005
48		B016			
102				D001	
102				D002	
110				D005	
111				D010	
111				D017	
111				D019	
111				D022	
111				D023	
D014				D014	
D015				D015	
D028				D028	

Appendix 4.2. *Phasing and brief descriptions of all recorded contexts at Quoygrew. The interim phase column provides terminology used during post-excavation analysis to facilitate cross-referencing with the site archive.*

Context no.	General phase	Detailed phase	Context description	Location	Interim phase	Context no.	General phase	Detailed phase	Context description	Location	Interim phase
1	7	7	Topsoil	Cliff	7	103	3	3	Fill	Cliff	3
2	7	7	Disturbed	Cliff	2	104	7	7	Disturbed	Cliff	8
3	2–3	2–3	Fish Midden	Cliff	2	105	3	3	Fill	Cliff	3
4	2–3	2–3	Fish Midden	Cliff	2	106	2–3	2–3	Fish Midden	Cliff	2
5	2–3	2–3	Fish Midden	Cliff	2	107	1	1	Palaeosol	Cliff	1.2
6	2–3	2–3	Fish Midden	Cliff	2	108	3	3	Fill	Cliff	1.2
7	2–3	2–3	Fish Midden	Cliff	2	109	3	3	Fill	Cliff	3
8	1	1	Palaeosol	Cliff	1.2	110	7	7	Disturbed midden	Cliff	5
9	0	0	Subsoil	Cliff	1.1						
10	5–6	5–6	Kelp pit	Cliff	6	111	3–5	3.2–5	Entrance fill	Cliff	4
11	5–6	5–6	Kelp pit	Cliff	6	112	7	7	Rabbit burrow	Cliff	8
12	7	7	Topsoil	Cliff	2	113	1	1	Palaeosol	Cliff	1.2
13	2–3	2–3	Fish Midden	Cliff	2	114	3	3	Fill	Cliff	3
14	2–3	2–3	Fish Midden	Cliff	2	115	2–3	2–3	Fish Midden	Cliff	2
15	5–6	5–6	Kelp pit	Cliff	6	116	2–3	2–3	Fish Midden	Cliff	2
16	5–6	5–6	Kelp pit	Cliff	6	117	2–3	2–3	Fish Midden	Cliff	2
17	2–3	2–3	Fish Midden	Cliff	2	118	7	7	Rabbit burrow	Cliff	8
18	2–3	2–3	Fish Midden	Cliff	2	119	0	0	Subsoil	Cliff	1.1
19	2–3	2–3	Fish Midden	Cliff	2	120	Unphased	Unphased	Disturbed midden	Cliff	5
20	2–3	2–3	Fish Midden	Cliff	2						
21	2–3	2–3	Fish Midden	Cliff	2	121	2–3	2–3	Fish Midden	Cliff	2
22	2–3	2–3	Fish Midden	Cliff	2	122	7	7	Rabbit burrow	Cliff	8
23	2–3	2–3	Fish Midden	Cliff	2	123	2–3	2–3	Fish Midden	Cliff	2
24	2–3	2–3	Fish Midden	Cliff	2	124	2–3	2–3	Fish Midden	Cliff	2
25	2–3	2–3	Fish Midden	Cliff	2	125	2–3	2–3	Fish Midden	Cliff	2
26	2–3	2–3	Fish Midden	Cliff	2	126	2–3	2–3	Fish Midden	Cliff	1.3
27	2–3	2–3	Fish Midden	Cliff	2	127	1	1	Palaeosol	Cliff	1.2
28	Unphased	Unphased	Disturbed	Cliff	7	128	7	7	Rabbit burrow	Cliff	8
29	2–3	2–3	Fish Midden	Cliff	2	150	3	3	Interface	Cliff	3
30	2–3	2–3	Fish Midden	Cliff	2	151	3	3	Cut	Cliff	3
31	2–3	2–3	Fish Midden	Cliff	2	152	7	7	Rabbit burrow	Cliff	8
32	2–3	2–3	Fish Midden	Cliff	2	153	7	7	Rabbit burrow	Cliff	8
33	2–3	2–3	Shell dump	Cliff	2	154	3	3	Cut	Cliff	3
34	2–3	2–3	Fish Midden	Cliff	2	155	7	7	Rabbit burrow	Cliff	8
35	2–3	2–3	Fish Midden	Cliff	2	156	3	3.2–3.6	Wall	Cliff	3
36	2–3	2–3	Fish Midden	Cliff	2	157	3	3.2–3.6	Wall	Cliff	3
37	2–3	2–3	Fish Midden	Cliff	2	159	3	3.2	Drain lintel	Cliff	3
38	2–3	2–3	Fish Midden	Cliff	2	A001	7	7	Topsoil	Cliff	7
39	2–3	2–3	Fish Midden	Cliff	2	A002	7	7	Topsoil	Cliff	2
40	2–3	2–3	Fish Midden	Cliff	2	A003	7	7	Disturbed midden	Cliff	2
41	2–3	2–3	Fish Midden	Cliff	2						
42	2–3	2–3	Fish Midden	Cliff	2	A004	2–3	2–3	Fish Midden	Cliff	2
43	2–3	2–3	Layer	Cliff	2	A005	2–3	2–3	Fish Midden	Cliff	2
44	2–3	2–3	Fish Midden	Cliff	2	A006	2–3	2–3	Fish Midden	Cliff	2
45	2–3	2–3	Fish Midden	Cliff	2	A007	2–3	2–3	Fish Midden	Cliff	2
46	2–3	2–3	Fish Midden	Cliff	2	A008	2–3	2–3	Fish Midden	Cliff	2
47	3	3	Fill	Cliff	3	A009	2–3	2–3	Fish Midden	Cliff	2
48	2–3	2–3	Fish Midden	Cliff	2	A010	2–3	2–3	Fish Midden	Cliff	2
101	7	7	Topsoil	Cliff	7	A011	2–3	2–3	Fish Midden	Cliff	2
102	7	7	Topsoil	Cliff	7	A012	2–3	2–3	Fish Midden	Cliff	2

Appendix 4.2. *(cont.)*

Context no.	General phase	Detailed phase	Context description	Location	Interim phase	Context no.	General phase	Detailed phase	Context description	Location	Interim phase
A013	2–3	2–3	Fish Midden	Cliff	2	C017	2–3	2–3	Fish Midden	Cliff	2
A014	2–3	2–3	Fish Midden	Cliff	2	C018	2–3	2–3	Fish Midden	Cliff	2
A015	2–3	2–3	Fish Midden	Cliff	2	C019	2–3	2–3	Fish Midden	Cliff	2
A016	2–3	2–3	Fish Midden	Cliff	2	C020	2–3	2–3	Fish Midden	Cliff	2
A017	2–3	2–3	Fish Midden	Cliff	2	C021	2–3	2–3	Fish Midden	Cliff	2
A018	2–3	2–3	Fish Midden	Cliff	2	C022	2–3	2–3	Fish Midden	Cliff	2
A019	2–3	2–3	Fish Midden	Cliff	2	C023	2–3	2–3	Fish Midden	Cliff	2
A020	2–3	2–3	Fish Midden	Cliff	2	C024	2–3	2–3	Fish Midden	Cliff	2
A021	2–3	2–3	Fish Midden	Cliff	2	C025	1	1	Palaeosol	Cliff	1.1
A022	2–3	2–3	Fish Midden	Cliff	2	C026	0	0	Subsoil	Cliff	1.1
A023	2–3	2–3	Fish Midden	Cliff	2	D001	7	7	Topsoil	Cliff	7
A024	2–3	2–3	Fish Midden	Cliff	2	D002	7	7	Topsoil	Cliff	7
A025	2–3	2–3	Fish Midden	Cliff	2	D003	5–6	5–6	Kelp pit	Cliff	6
A026	1	1	Palaeosol	Cliff	1.2	D004	5–6	5–6	Kelp pit	Cliff	6
A027	0	0	Subsoil	Cliff	1.1	D005	4–5	4–5	Midden	Cliff	5
B001	7	7	Topsoil	Cliff	7	D006	7	7	Topsoil	Cliff	7
B002	7	7	Disturbed midden	Cliff	2	D007	7	7	Rabbit burrow	Cliff	8
						D008	7	7	Rabbit burrow	Cliff	8
B003	2–3	2–3	Fish Midden	Cliff	2	D009	4–5	4–5	Midden	Cliff	3–5
B004	2–3	2–3	Fish Midden	Cliff	2	D010	3–4	3.2–4	Entrance fill	Cliff	4
B005	2–3	2–3	Fish Midden	Cliff	2	D011	3	3	Fill	Cliff	3
B006	2–3	2–3	Fish Midden	Cliff	2	D012	2–3	2–3	Fish Midden	Cliff	2
B007	2–3	2–3	Fish Midden	Cliff	2	D013	3	3	Fill	Cliff	3
B008	2–3	2–3	Fish Midden	Cliff	2	D014	3	3.2–3.6	Wall	Cliff	3
B009	2–3	2–3	Fish Midden	Cliff	2	D015	3	3.2–3.6	Wall	Cliff	3
B010	2–3	2–3	Fish Midden	Cliff	2	D016	3	3	Fill	Cliff	3
B011	2–3	2–3	Fish Midden	Cliff	2	D017	3–4	3.2–4	Entrance fill	Cliff	4
B012	2–3	2–3	Fish Midden	Cliff	2	D018	7	7	Rabbit burrow	Cliff	8
B013	2–3	2–3	Fish Midden	Cliff	2	D019	3–4	3.2–4	Entrance fill	Cliff	4
B014	1	1	Palaeosol	Cliff	1.2	D020	7	7	Rabbit burrow	Cliff	8
B015	0	0	Subsoil	Cliff	1.1	D021	7	7	Rabbit burrow	Cliff	8
B016	2–3	2–3	Fish Midden	Cliff	2	D022	3	3	Paving	Cliff	3–4
C001	7	7	Topsoil	Cliff	7	D023	3	3	Paving	Cliff	–
C002	7	7	Topsoil	Cliff	7	D024	2–3	2–3	Midden	Cliff	3
C003	7	7	Disturbed midden	Cliff	2	D025	7	7	Rabbit burrow	Cliff	8
						D026	7	7	Rabbit burrow	Cliff	8
C004	7	7	Disturbed midden	Cliff	2	D027	7	7	Rabbit burrow	Cliff	8
						D028	3	3.2	Drain lining	Cliff	3
C005	2–3	2–3	Fish Midden	Cliff	2	D029	3	3	Drain fill	Cliff	3.2
C006	2–3	2–3	Fish Midden	Cliff	2	D030	3	3	Drain fill	Cliff	3.2
C007	2–3	2–3	Fish Midden	Cliff	2	D031	2–3	2–3	Fish Midden	Cliff	2–3
C008	2–3	2–3	Fish Midden	Cliff	2	D032	0	0	Subsoil	Cliff	1
C009	2–3	2–3	Fish Midden	Cliff	2	D033	0	0	Subsoil	Cliff	1
C010	2–3	2–3	Fish Midden	Cliff	2	E001	7	7	Topsoil	Cliff	7
C011	2–3	2–3	Fish Midden	Cliff	2	E002	7	7	Topsoil	Cliff	7
C012	2–3	2–3	Fish Midden	Cliff	2	E003	7	7	Disturbed midden	Cliff	2
C013	2–3	2–3	Fish Midden	Cliff	2						
C014	2–3	2–3	Fish Midden	Cliff	2	E004	2–3	2–3	Fish Midden	Cliff	2
C015	2–3	2–3	Shell dump	Cliff	2	E005	2–3	2–3	Fish Midden	Cliff	2
C016	2–3	2–3	Fish Midden	Cliff	2	E006	2–3	2–3	Fish Midden	Cliff	2

Appendix 4.2. (*cont.*)

Context no.	General phase	Detailed phase	Context description	Location	Interim phase	Context no.	General phase	Detailed phase	Context description	Location	Interim phase
E007	2–3	2–3	Fish Midden	Cliff	2	F020	5–6	5–6	Layer	S Room 1	Q+
E008	2–3	2–3	Fish Midden	Cliff	2	F021	4–5 (5)	4.5–5	Fill	Room 1	Y
E009	2–3	2–3	Fish Midden	Cliff	2	F022	4	4.2–4.3	Midden	Room 1	V+
E010	2–3	2–3	Fish Midden	Cliff	2	F023	4–5 (5)	4.5–5	Layer	Room 1	Y
E011	2–3	2–3	Fish Midden	Cliff	2	F024	4	4.2–4.3	Stone	Room 1	V+
E012	2–3	2–3	Fish Midden	Cliff	2	F025	5–6	4.5–6	Layer	Room 1	Y–Z
E013	2–3	2–3	Fish Midden	Cliff	2	F026	4	4	Drain upright	N Room 1	Q+
E014	2–3	2–3	Fish Midden	Cliff	2	F027	4	4.3	Bench	Room 1	W
E015	2–3	2–3	Fish Midden	Cliff	2	F028	4	4.4–4.5	Stone	Room 1	X–Y
E016	2–3	2–3	Fish Midden	Cliff	2	F029	4–5 (5)	4.5–5	Cut	Room 1	Y
E017	2–3	2–3	Fish Midden	Cliff	2	F030	4	4.5	Layer	Room 1	Y
E018	2–3	2–3	Fish Midden	Cliff	2	F031	4–5 (5)	4.5–5	Demolition	Room 1	Y
E019	2–3	2–3	Fish Midden	Cliff	2	F032	4–5 (5)	4.5–5	Layer	Room 1	Y
E020	2–3	2–3	Fish Midden	Cliff	2	F033	4	4.5	Dump	Room 1	Y
E021	2–3	2–3	Fish Midden	Cliff	2	F034	4	4.2	Wall	Room 1	V
E022	2–3	2–3	Fish Midden	Cliff	2	F035	5–6	5–6	Plaggen soil	S Room 1	Q+
E023	2–3	2–3	Fish Midden	Cliff	2	F036	4	4.3–4.4	Floor layer	Room 1	X–W
E025	2–3	2–3	Fish Midden	Cliff	2	F037	4–5 (5)	4.5–5	Fill	Room 1	Y
E026	2–3	2–3	Fish Midden	Cliff	2	F038	4	4.3	Paving	Room 1	W
E027	2–3	2–3	Fish Midden	Cliff	2	F039	3–5	3–5	Layer	N Room 1	Q+
E028	2–3	2–3	Fish Midden	Cliff	2	F040	4	4.4	Midden	Room 1	X
E029	2–3	2–3	Fish Midden	Cliff	2	F041	3	3.2	Wall	Room 1	Q
E030	2–3	2–3	Fish Midden	Cliff	2	F042	4	4.4	Fill	Room 1	X
E031	2–3	2–3	Fish Midden	Cliff	2	F043	5–6	5–6	Layer	S Room 1	Q+
E032	2–3	2–3	Shell dump	Cliff	1.2	F044	4–5 (5)	4.5–5	Fill	Room 1	Y
E033	2–3	2–3	Fish Midden	Cliff	2	F045	4	4	Drain fill	N Room 1	Q+
E034	2–3	2–3	Fish Midden	Cliff	1.2	F046	4	4.4	Floor layer	Room 1	X
E035	2–3	2–3	Fish Midden	Cliff	1.2	F047	4–5 (5)	4.5–5	Fill	Room 1	Y
E036	1	1	Palaeosol	Cliff	1.2	F048	4	4.3–4.4	Floor layer	Room 1	X–W
E037	0	0	Subsoil	Cliff	1.1	F049	4	4.4	Paving	Room 1	X
F001	7	7	Topsoil	Room 1	Z	F050	4	4.4	Paving	Room 1	X
F002	7	7	Topsoil	Room 1	Z	F051	4	4.4	Paving	Room 1	X
F003	4–5 (5)	4.5–5	Demolition	Rooms 1–2	Y	F052	4	4.4	Paving	Room 1	X
F004	3	3.2	Wall	Room 1	Q	F053	2–3	2–3	Layer	N Room 1	Q+
F005	3	3.2	Wall	Room 1	Q	F054	2–3	2–3	Layer	N Room 1	Q+
F006	5–6	4.5–6	Layer	N Room 1	Y–Z	F055	4	4.3–4.4	Layer	Room 1	X–W
F007	5–6	5–6	Fill	Room 1	Z	F056	4	4.4	Stone	Room 1	X
F008	4–5 (5)	4.5–5	Layer	S Room 1	Y	F057	4	4.4	Dump	Room 1	X
F009	4–5 (5)	4.5–5	Demolition	Room 1	Y	F058	4	4.4	Paving	Room 1	X
F010	4	4.4	Hearth slab	Room 1	X	F059	4–5 (5)	4.5–5	Layer	Room 1	Y
F011	4	4.4	Hearth ash	Room 1	X	F060	4	4.4–4.5	Stone	Room 1	X–Y
F012	4	4.5	Demolition	Rooms 1–2	Y	F061	4	4.3	Layer	Room 1	W
F013	5–6	5–6	Paving	S Room 1	Q+	F062	3	3.4–3.5	Midden	Room 1	S+
F014	5–6	5–6	Layer	S Room 1	Q+	F063	4	4.4	Floor layer	Room 1	X
F015	4	4.3–4.4	Upright	Room 1	X–W	F064	4	4.4	Hearth slab	Room 1	X
F016	4	4.3–4.4	Upright	Room 1	X–W	F065	4	4.4	Stone	Room 1	X
F017	4	4.2	Wall	Room 1	V	F066	4	4.3	Pit fill	Room 1	W
F018	5–6	5–6	Layer	S Room 1	Q+	F067	3	3.6–4.1	Midden	Room 1	U
F019	5–6	5–6	Layer	S Room 1	Q+	F068	4	4.1	Drain fill	Room 1	U2
						F069	3	3.6–4.1	Drain fill	Room 1	U
						F070	4	4.2	Paving	Room 1	V

Appendix 4.2. *(cont.)*

Context no.	General phase	Detailed phase	Context description	Location	Interim phase	Context no.	General phase	Detailed phase	Context description	Location	Interim phase
F071	4	4.3	Hearth	Room 1	W	F135	4	4	Layer	N Room 2	–
F072	4	4.2	Pit cut	Room 1	V	F136	Unphased	Unphased	Layer	Room 2	–
F073	4	4.2	Floor layer	Room 1	V	F137	Unphased	Unphased	Cut	Room 2	–
F074	3	3.4	Bench	Room 1	S	F138	Unphased	Unphased	Layer	Room 2	–
F075	3	3.2	Stone	Room 1	Q	F139	4–5	4–5	Disturbed floor	Room 2	–
F076	3	3.3	Stone	Room 1	R	F140	4	4.2.1	Floor layer	Room 2	I.ii
F090	7	7	Topsoil	S Room 2	vii	F141	5–6	5–6	Paving	S Room 2	–
F091	7	7	Topsoil	Room 2	vii	F142	5–6	5–6	Paving	S Room 2	–
F092	7	7	Topsoil	Room 2	vii	F143	5–6	5–6	Paving	S Room 2	–
F093	Unphased	Unphased	Dump	Room 2	–	F144	4–6	4–6	Layer	S Room 2	–
F094	5–6	5–6	Layer	S Room 2	–	F145	4–6	4–6	Layer	S Room 2	–
F095	7	7	Disturbed	Room 2	vii	F146	4–6	4–6	Layer	Room 2	–
F096	5–6	5–6	Layer	N Room 2	–	F147	4	4.4	Paving	Room 2	v.ii
F097	5–6	5–6	Layer	Room 2	–	F148	4	4.4	Paving	Room 2	v.I
F098	5–6	5–6	Layer	N Room 2	–	F150	4	4.4	Paving	Room 2	v.I
F099	5–6	4.5–6	Demolition	Room 1	Y–Z	F151	4	4.3.1	Paving	Room 2	iii
F100	7	7	Backfill	Room 2	–	F152	4	4.3.1	Paving	Room 2	iii
F101	5–6	5–6	Layer	Room 2	–	F153	4	4.3.1	Midden	Room 2	iii
F102	5–6	5–6	Layer	Room 2	vii	F154	4	4.3.1	Paving	Room 2	iii
F103	5–6	5–6	Layer	Room 2	vii	F155	4	4.3.1	Paving	Room 2	iii
F104	5–6	5–6	Layer	Room 2	vii	F156	4	4	Drain fill	N Room 2	–
F105	5–6	5–6	Layer	S Room 2	vii	F157	0	0	Subsoil	N Room 2	–
F106	4–6	4–6	Layer	S Room 2	–	F158	Unphased	Unphased	Cut	Room 2	–
F107	5–6	5–6	Layer	Room 2	vii	F159	4–6	4–6	Dump	S Room 2	–
F108	4	4.2	Dump	N Room 2	–	F160	Unphased	Unphased	Cut	Room 2	–
F109	4	4	Layer	N Room 2	–	F161	4–6	4–6	Dump	S Room 2	–
F110	5–6	5–6	Layer	S Room 2	–	F162	4–6	4–6	Layer	S Room 2	–
F111	4	4.1	Wall	Room 2	I.I	F163	4–6	4–6	Layer	S Room 2	–
F112	4	4.5	Demolition	Room 2	vi	F164	4	4.3.1	Layer	Room 2	iii
F113	5–6	5–6	Layer	S Room 2	–	F165	4	4.2.2	Stone	Room 2	ii
F114	4–6	4–6	Layer	S Room 2	–	F166	4	4.2.2	Stone	Room 2	ii
F115	4	4.4	Paving	Room 2	v.ii	F167	4	4.2.2	Stone	Room 2	ii
F116	4	4.3	Upright	Room 2	iv	F168	4	4	Drain cut	N Room 2	–
F117	4	4.4	Paving	Room 2	v.ii	F169	4	4	Dump	N Room 2	–
F118	4	4	Upright	Room 2	–	F170	4–6	4–6	Layer	S Room 2	–
F119	4	4.3	Threshold	Room 2	iv	F171	4–6	4–6	Layer	S Room 2	–
F120	4	4.2–4.3	Upright	Room 2	–	F172	4	4.2–4.3	Layer	Room 2	–
F121	4	4.4	Paving	Room 2	v.ii	F173	Unphased	Unphased	Layer	Room 2	–
F122	Unphased	Unphased	Layer	Room 2	–	F174	0	0	Subsoil	Room 2	–
F123	Unphased	Unphased	Layer	Room 2	–	F175	4	4.2.1	Upright	Room 2	I.ii
F124	4	4.3	Threshold	Room 2	iv	F176	4	4.2.1	Dump	Room 2	I.ii
F125	4–6	4–6	Layer	Room 2	–	F177	4	4.2.1	Upright	Room 2	I.ii
F126	4	4.4	Floor layer	Room 2	v.ii	F178	4	4.2.1	Cut	Room 2	I.ii
F127	4	4.4	Paving	Room 2	v.I	F179	4	4.2	Cut	Room 2	–
F128	5–6	5–6	Layer	S Room 2	–	F180	4	4.2.1	Cut	Room 2	I.ii
F129	4	4.3.1	Midden	Room 2	iii	F181	4	4	Layer	Room 2	–
F130	4	4.2.2	Dump	Room 2	ii	F183	4	4.2.2	Dump	Room 2	ii
F131	4–6	4–6	Dump	S Room 2	–	F184	4	4.2.1	Floor layer	Room 2	I.ii
F132	Unphased	Unphased	Layer	Room 2	–	F185	4–6	4–6	Dump	S Room 2	–
F133	0	0	Subsoil	N Room 2	0	F186	4–6	4–6	Dump	S Room 2	–
F134	4	4.2.2	Dump	Room 2	ii	F187	4	4.2.2	Dump	Room 2	–

Appendix 4.2. *(cont.)*

Context no.	General phase	Detailed phase	Context description	Location	Interim phase
F189	4	4.2.1	Floor layer	Room 2	I.ii
F191	4	4.2.1	Floor layer	Room 2	I.ii
F192	4	4	Drain fill	S Room 2	–
F193	4	4.3.1	Paving	Room 2	iii
F194	4	4.2.1	Floor layer	Room 2	I.ii
F195	4–5	4–5	Dump	S Room 2	–
F196	4	4.2.1	Paving	Room 2	I.ii
F197	4	4.1	Floor layer	Room 2	I.ii
F198	4	4.1	Floor layer	Room 2	I.ii
F199	4–5	4–5	Layer	S Room 2	–
F200	4	4.1	Floor layer	Room 2	I.ii
F201	0	0	Subsoil	Room 2	0
F202	4	4	Drain cut	S Room 2	–
F203	0	0	Subsoil	Room 2	0
F204	4	4.3.2	Post/stake hole fill	Room 2	iv
F205	4	4	Drain fill	S Room 2	–
F206	4	4.2.1	Floor layer	Room 2	I.ii
F207	4	4.2.1	Cut	Room 2	I.ii
F208	4	4.2.1	Fill	Room 2	I.ii
F209	4	4	Drain fill	S Room 2	–
F210	4	4	Drain fill	S Room 2	–
F211	4	4	Midden	S Room 2	–
F212	0	0	Palaeosol	S Room 2	–
F213	4	4.2.1	Upright	Room 2	I.ii
F214	4	4.2.1	Upright	Room 2	I.ii
F215	4	4.2.1	Upright	Room 2	I.ii
F216	4	4.2.1	Fill	Room 2	I.ii
F217	Unphased	Unphased	Fill	Room 2	–
F218	Unphased	Unphased	Fill	Room 2	–
F219	Unphased	Unphased	Layer	Room 2	–
F220	Unphased	Unphased	Cut	Room 2	–
F221	4	4.1	Floor layer	Room 2	I.I
F222	4	4.2.1	Floor layer	Room 2	I.ii
F223	4	4.2.1	Floor layer	Room 2	I.ii
F224	4	4.2.1	Paving	Room 2	I.ii
F225	Unphased	Unphased	Cut	Room 2	–
F226	4	4.3.1	Midden	Room 2	iii
F227	Unphased	Unphased	Fill	Room 2	–
F228	4	4.3.2	Post/stake hole fill	Room 2	iv
F230	4	4.1	Floor layer	Room 2	I.I
F231	4	4.3.2	Post/stake hole cut	Room 2	iv
F232	Unphased	Unphased	Layer	Room 2	–
F233	4	4.1–4.2.1	Threshold	Room 2	I.I
F234	4	4.1	Floor layer	Room 2	I.I
F235	4	4.1–4.2.1	Stone	Room 2	I.I
F236	4	4.1	Floor layer	Room 2	I.I
F237	4	4.1	Floor layer	Room 2	I.I
F238	4	4.1	Layer	Room 2	I.I
F239	4	4.1	Layer	Room 2	I.I
F240	4	4.1	Drain fill	Room 2	I.I
F241	4	4.1	Layer	Room 2	I.I
F242	4	4.1	Cut	Room 2	I.I
F243	4	4.1	Layer	Room 2	I.I
F244	4	4.1	Drain fill	Room 2	I.I
F245	4	4.1	Drain cut	Room 2	I.I
F246	4	4.3.2	Post/stake hole fill	Room 2	iv
F247	4	4.2.1	Paving	Room 2	I.ii
F381	5–6	4.5–6	Fill	Room 1	Y–Z
F382	4	4.5	Fill	Room 1	Y
F383	4	4.2	Floor layer	Room 1	V
F384	4	4.3	Hearth	Room 1	W
F385	4	4.3	Upright	Room 1	W
F386	4	4.3	Fill	Room 1	W
F387	4	4	Drain fill	N Room 1	Q+
F388	4	4	Drain cut	N Room 1	Q+
F389	5–6	4.5–6	Fill	Room 1	Y–Z
F390	3	3.3	Layer	Room 1	R
F391	5–6	4.5–6	Plaggen soil	Room 1	Y–Z
F392	5–6	4.5–6	Cut	Room 1	Y–Z
F393	4	4.3	Paving	Room 1	W
F394	4	4.3	Fill	Room 1	W
F395	4	4.3	Cut	Room 1	W
F396	4	4.3	Fill	Room 1	W
F397	4	4.3	Cut	Room 1	W
F398	4	4.3	Fill	Room 1	W
F399	4	4.3	Cut	Room 1	W
F400	4	4.3	Fill	Room 1	W
F401	4	4.3	Cut	Room 1	W
F402	4	4.5	Fill	Room 1	Y
F403	4	4.5	Cut	Room 1	Y
F404	3	3.2	Floor layer	Room 1	Q
F405	4–5 (5)	4.5–5	Layer	Room 1	Y
F406	2	2.2–2.4	Layer	N House 5	P
F407	2	2.2–2.4	Layer	N House 5	P
F408	5–6	4.5–6	Fill	Room 1	Y–Z
F409	5–6	4.5–6	Fill	Room 1	Y–Z
F410	4	4.2	Dump	Room 1	V
F411	4	4.3	Dump	Room 1	W
F412	4	4.2	Hearth slab	Room 1	V
F413	4	4.4	Dump	Room 1	X
F414	4	4.4	Upright	Room 1	X
F415	4	4.2	Stone	Room 1	V
F416	4–5 (5)	4.5–5	Fill	Room 1	Y
F417	4	4.1	Drain fill	Room 1	U2
F418	4	4.1	Drain fill	Room 1	U2
F419	1–6	1–6	Pit fill	N Room 1	Q+
F420	1–6	1–6	Pit cut	N Room 1	Q+
F421	5–6	5–6	Plaggen soil	S Room 1	Q+

Appendix 4.2. *(cont.)*

Context no.	General phase	Detailed phase	Context description	Location	Interim phase	Context no.	General phase	Detailed phase	Context description	Location	Interim phase
F422	4	4.4	Dump	Room 1	X	F466	3	3.6–4.1	Floor layer	Room 1	U
F423	4	4.2	Floor layer	Room 1	V	F467	3	3.6–4.1	Upright	Room 1	U
F424	4	4.2	Floor layer	Room 1	V	F468	3	3.6–4.1	Fill	Room 1	U
F425	4	4.2	Floor layer	Room 1	V	F469	4	4.1	Floor layer	Room 1	U2
F426	4	4.4	Layer	Room 1	X	F470	4	4.1	Drain fill	Room 1	U2
F427	4	4.2	Pit fill	Room 1	V	F471	3	3.6–4.1	Cut	Room 1	U
F428	4	4.2	Post/stake hole fill	Room 1	V	F472	2	2.2–2.4	North Midden	N Room 1	Q+
						F473	4	4.1	Hearth	Room 1	U2
F429	4	4.2	Post/stake hole cut	Room 1	V	F474	3	3.6–4.1	Paving	Room 1	U
						F475	2	2.2–2.4	North Midden	N Room 1	Q+
F430	4	4.2	Dump	Room 1	V	F476	4	4.2	Pit fill	Room 1	V
F431	4	4.3–4.4	Paving	Room 1	X–W	F477	3	3.5	Fill	Room 1	T
F432	3	3.6–4.1	Floor layer	Room 1	U	F478	3	3.5	Paving	Room 1	T
F433.1	4	4.1–4.2.1	Paving	Room 2	I.I	F479	3	3.5	Floor layer	Room 1	T
F433.2	4	4.2	Paving	Room 1	V	F480	4	4.1	Upright	Room 1	U2
F434	4	4.1	Dump	Room 1	U2	F481	3	3.6–4.1	Fill	Room 1	U
F435	4	4.2	Pit cut	Room 1	V	F482	3	3.5	Fill	Room 1	T
F436	5–6	5–6	Paving	S Room 1	Q+	F483	3	3.6–4.1	Floor layer	Room 1	U
F437	5–6	5–6	Plaggen soil	S Room 1	Q+	F484	3	3.6	Floor layer	Room 1	U1
F438	4	4.1	Drain fill	Room 1	U2	F485	3	3.5	Cut	Room 1	T
F439	4	4.3	Paving	Room 1	W	F486	3	3.6–4.1	Cut	Room 1	U
F440	4	4.1	Drain fill	Room 1	U2	F487	3	3.5	Cut	Room 1	T
F441	4	4.1	Drain fill	Room 1	U2	F488	3	3	Paving	S Room 1	Q+
F442	3	3.6–4.1	Floor layer	Room 1	U	F489	3	3	Layer	S Room 1	Q+
F443	4	4.2	Stone	Room 1	V	F490	3	3.6–4.1	Floor layer	Room 1	U
F444	4	4.2	Post/stake hole fill	Room 1	V	F491	3	3.6–4.1	Upright	Room 1	U
						F492	3	3.4	Upright	Room 1	S
F445	4	4.2	Stone	Room 1	V	F493	3	3	Stone	S Room 1	Q+
F446	4	4.2	Stone	Room 1	V	F494	Unphased	Unphased	Pit fill	S Room 1	Q+
F447	4	4.2	Paving	Room 1	V	F495	Unphased	Unphased	Pit cut	S Room 1	Q+
F448	4	4.2	Stone	Room 1	V	F496	3	3.5	Post/stake hole fill	Room 1	T
F449	4	4.2	Dump	Room 1	V						
F450	5–6	5–6	Paving	S Room 1	Q+	F497	3	3.5	Post/stake hole cut	Room 1	T
F451	5–6	5–6	Plaggen soil	S Room 1	Q+						
F452	4	4.2	Post/stake hole cut	Room 1	V	F498	3	3.2	Drain fill	Room 1	Q
						F499	2	2.2–2.4	Paving	N House 5	P
F453	4	4.2	Paving	Room 1	V	F500	2	2.2–2.4	North Midden	N House 5	P
F453	4	4.1–4.2.1	Paving	Room 2	I.I	F501	3	3.2	Drain fill	S Room 1	Q
F454	4	4.2	Paving	Room 1	V	F502	3	3.2	Drain cut	S Room 1	Q
F455	3	3.6–4.1	Paving	Room 1	U	F503	3	3	Layer	S Room 1	Q+
F456	3	3.6–4.1	Floor layer	Room 1	U	F504	2	2.2–2.4	North Midden	N Room 1	Q+
F457	4	4.2	Floor layer	Room 1	V	F505	2	2.2–2.4	North Midden	N Room 1	Q+
F458	4	4.1	Drain fill	Room 1	U2	F506	2–3	2–3	Layer	N Room 1	Q+
F459	4	4.1	Drain cut	Room 1	U2	F507	3	3.2	Stone	S Room 1	Q
F459	4	4.1	Drain cut	Room 2	I.I	F508	3	3.2	Stone	S Room 1	Q
F460	3	3.6	Dump	Room 1	U1	F509	3	3.2	Stone	S Room 1	Q
F461	4	4.1	Stone	Room 1	U2	F510	0	0	Natural	Room 1	NAT
F462	3	3.6	Hearth	Room 1	U1	F511	3	3.3	Bench	Room 1	R
F463	3	3	Paving	S Room 1	Q+	F512	4	4.3–4.4	Bench	Room 1	W+
F464	3	3	Layer	S Room 1	Q+	F513	3	3	Wall	Room 1	Q+
F465	4	4.1	Drain fill	Room 1	U2	F514	3	3.4	Pit fill	Room 1	S

Appendix 4.2. *(cont.)*

Context no.	General phase	Detailed phase	Context description	Location	Interim phase
F515	3	3.4	Pit cut	Room 1	S
F516	3	3.5	Floor layer	Room 1	T
F517	3	3.5	Hearth slab	Room 1	T
F518	3	3.5	Hearth ash	Room 1	T
F519	3	3.5	Floor layer	Room 1	T
F520	3	3.5	Hearth slab	Room 1	T
F521	3	3.5	Floor layer	Room 1	T
F522	4	4.1	Drain cut	Room 1	U2
F523	3	3.5–3.6	Floor layer	Room 1	T+
F524	3	3.4–3.5	Layer	Room 1	S+
F525	4	4.2	Floor layer	Room 1	V
F526	3	3.4	Stone	Room 1	S
F527	3	3.5	Fill	Room 1	T
F528	3	3.5	Fill	Room 1	T
F529	3	3.5	Fill	Room 1	T
F530	3	3.5	Cut	Room 1	T
F531	3	3.5	Cut	Room 1	T
F532	3	3.5	Cut	Room 1	T
F533	3	3.5	Floor layer	Room 1	T
F534	3	3.4	Fill	Room 1	S
F535	3	3.5	Dump	Room 1	T
F536	3	3.5	Post/stake hole fill	Room 1	T
F537	3	3.5	Post/stake hole cut	Room 1	T
F538	3	3.5	Floor layer	Room 1	T
F539	3	3.5	Paving	Room 1	T
F540	3	3.5	Floor layer	Room 1	T
F541	3	3.5	Stone	Room 1	T
F542	3	3.5	Stone	Room 1	T
F543	3	3.5	Floor layer	Room 1	T
F544	3	3.5	Floor layer	Room 1	T
F545	3	3.5	Floor layer	Room 1	T+
F546	3	3.5	Dump	Room 1	T
F547	3	3.5	Paving	Room 1	T
F548	3	3.5	Pit fill	Room 1	T
F549	3	3.5	Pit cut	Room 1	T
F550	3	3.4	Pit fill	Room 1	S
F551	3	3.4	Pit cut	Room 1	S
F552	3	3.4	Post/stake hole fill	Room 1	S
F553	3	3.4	Post/stake hole cut	Room 1	S
F554	3	3.4	Post/stake hole fill	Room 1	S
F555	3	3.4	Post/stake hole cut	Room 1	S
F556	3	3.4	Post/stake hole fill	Room 1	S
F557	3	3.4	Post/stake hole cut	Room 1	S

Context no.	General phase	Detailed phase	Context description	Location	Interim phase
F558	3	3.4	Post/stake hole fill	Room 1	S
F559	3	3.4	Post/stake hole cut	Room 1	S
F560	3	3.4	Post/stake hole fill	Room 1	S
F561	3	3.4	Post/stake hole cut	Room 1	S
F562	3	3.4	Hearth ash	Room 1	S
F563	3	3.4	Hearth slab	Room 1	S
F564	3	3.5	Pit fill	Room 1	T
F565	3	3.4	Post/stake hole fill	Room 1	S
F566	3	3.4	Post/stake hole cut	Room 1	S
F567	3	3.5	Bench	Room 1	T
F568	3	3.4	Post/stake hole fill	Room 1	S
F569	3	3.4	Post/stake hole cut	Room 1	S
F570	3	3.4	Bench	Room 1	S
F571	3	3.2	Upright	Room 1	Q
F572	3	3.2	Cut	Room 1	Q
F573	3	3.4	Dump	Room 1	S
F574	3	3.4	Hearth ash	Room 1	S
F575	3	3.5	Fill	Room 1	T
F576	3	3.2	Cut	Room 1	Q
F577	0	0	Natural	Room 1	NAT
F578	3	3.4	Dump	Room 1	S
F579	3	3.4	Dump	Room 1	S
F580	3	3.4	Floor layer	Room 1	S
F581	7	7	Topsoil	Room 3	Z
F582	6	6	Stone	Room 3	Z
F583	6	6	Stone	Room 3	Z
F584	4–5	4–5	Fill	Room 3	Y
F585	7	7	Topsoil	Room 3	Z
F586	4–5	4–5	Room 3 midden fill	Room 3	Y
F587	4–5	4–5	Room 3 midden fill	Room 3	Y
F588	3	3.2	Wall	Room 3	Q
F589	4–5	4–5	Dump	Room 3	Y
F590	4–5	4–5	Room 3 midden fill	Room 3	Y
F591	4–5	4–5	Cut	Room 3	Y
F592	3	3.2	Wall	Room 3	Q
F593	4–5	4–5	Stone	Room 3	Y
F594	4–5	4–5	Fill	Room 3	Y
F595	4–5	4–5	Layer	Room 3	Y
F596	4 5	4 5	Fill	Room 3	Y
F597	4–5	4–5	Fill	Room 3	Y
F598	4–5	4–5	Cut	Room 3	Y
F599	4–5	4–5	Cut	Room 3	Y

Appendix 4.2. *(cont.)*

Context no.	General phase	Detailed phase	Context description	Location	Interim phase
F600	7	7	Topsoil	Room 3	Y
F601	4–5	4–5	Dump	Room 3	Y
F602	4	4	Room 4 midden fill	Room 4	Q–C
F603	3	3	Wall	Room 3	A
F604	4–5	4–5	Layer	Room 3	Y
F605	5–6	5–6	Layer	Room 3	Y–Z
F606	4–5	4–5	Stone	Room 3	Y
F607	4–5	4–5	Stone	Room 3	Y
F608	4–5	4–5	Stone	Room 3	Y
F609	4–5	4–5	Stone	Room 3	Y
F610	4–5	4–5	Layer	Room 3	Y
F611	4–5	4–5	Layer	Room 3	Y
F612	4–5	4–5	Layer	Room 3	Y
F613	4–5	4–5	Stone	Room 3	Y
F614	3	3.2	Wall	Room 3	Q
F615	4–5	4–5	Stone	Room 3	Y
F616	4–5	4–5	Stone	Room 3	Y
F617	4–5	4–5	Layer	Room 3	Y
F618	4–5	4–5	Room 3 midden fill	Room 3	Y
F619	2	2.2–2.4	Fish Midden	N Room 3	Q–C
F620	4–5	4–5	Layer	Room 3	Y
F621	4–5	4–5	Layer	Room 3	Y
F622	4–5	4–5	Layer	Room 3	Y
F623	3	3.2	Wall	Room 4	Q–C
F624	4–5	4–5	Room 3 midden fill	Room 3	Y
F625	3	3.2	Cut	Room 4	Q–C
F626	4–5	4–5	Layer	Room 3	Y
F627	4–5	4–5	Stone	Room 3	Y
F628	4–5	4–5	Dump	Room 3	Y
F629	2	2.2–2.4	Fish Midden	N Room 3	Q–C
F630	4–5	4–5	Cut	Room 3	Y
F631	4–5	4–5	Fill	Room 3	Y
F632	3–4	3–4	Stone	Room 3	Y
F633	4–5	4–5	Stone	Room 3	Y
F634	4–5	4–5	Room 3 midden fill	Room 3	Y
F635	4–5	4–5	Fill	Room 3	Y
F636	6	6	Fill	Room 3	Z
F637	4	4	South Midden	S Room 3	Q–C
F638	4–5	4–5	Fill	Room 3	Y
F639	4–5	4–5	Cut	Room 3	Y
F640	4–5	4–5	South Midden	S Room 3	Q–C
F641	6	6	Wall	W Room 3	Z
F642	3–4	3.2–4	South Midden	S Room 3	Q–C
F643	5–6	5–6	Fill	Room 4	Y
F644	5–6	5–6	Cut	Room 4	Y
F645	7	7	Topsoil	W Room 3	Z
F646	7	7	Topsoil	W Room 3	Z

Context no.	General phase	Detailed phase	Context description	Location	Interim phase
F647	3	3.2–3.6	Disturbed Fish Midden	W Room 3	Q–C
F648	4	4.5	Stone	W Room 3	Y
F649	3	3.2	Wall	Room 3	Q
F650	4	4.5	Stone	W Room 3	Y
F651	3	3.2	Wall	Room 3	Q
F652	3–4	3.2–4	Disturbed midden	W Room 3	Q–C
F653	3–4	3.2–4	South Midden	S Room 3	Q–C
F654	7	7	Rabbit burrow	W Room 3	Z
F655	4–5	4–5	Demolition	Room 3	Y
F656	4–5	4–5	Demolition	Room 3	Y
F657	4–5	4–5	Layer	Room 3	Y
F658	4–5	4–5	Layer	Room 3	Y
F659	3	3	South Midden	S Room 3	Q–C
F660	3	3.2	Wall	S Room 3	Q
F661	4	4	Room 4 midden fill	Room 4	Q–C
F662	4	4	Room 4 midden fill	Room 4	Q–C
F663	3	3.2	Wall	Room 4	Q–C
F664	3–4	3.2–4	Entrance fill	W Room 3	Q–C
F665	3	3.2	Fill	W Room 3	Q–C
F666	3	3.2	Fill	W Room 3	Q–C
F667	3	3.2	Cut	W Room 3	Q–C
F668	7	7	Rabbit burrow	W Room 3	Z
F669	4–5	4–5	Fill	Room 3	Y
F670	4–5	4–5	Cut	Room 3	Y
F671	3	3	South Midden	S Room 3	Q–C
F672	3	3	Wall	Room 3	A
F673	4–5	4–5	Room 3 midden fill	Room 3	y
F674	3	3	Stone	Room 3	A
F675	4–5	4–5	Room 3 midden fill	Room 3	Y
F676	4	4	Str 4 midden fill	Room 4	Q–C
F677	4	4	Str 4 midden fill	Room 4	Q–C
F678	4–5	4–5	Layer	Room 3	Y
F679	4–5	4–5	Dump	Room 3	Y
F680	3	3.1	South Midden	S House 5	O
F681	4–5	4–5	Stone	Room 3	Y
F682	4–5	4–5	Stone	Room 3	Y
F683	4–5	4–5	Stone	Room 3	Y
F684	4–5	4–5	Demolition	Room 3	Y
F685	2	2.2–2.4	South Midden	S House 5	L–N
F686	4–5	4–5	Rubble	Room 3	Y
F687	4–5	4–5	Demolition	Room 3	Y
F688	4	4	Room 3 midden fill	Room 3	C
F689	4	4	Room 4 midden fill	Room 4	Q–C
F690	4	4	Paving	Room 3	C

Appendix 4.2. *(cont.)*

Context no.	General phase	Detailed phase	Context description	Location	Interim phase
F691	4	4	Room 3 midden fill	Room 3	C
F692	4–5	4–5	Layer	Room 3	Y
F693	3–4	3–4	Paving	Room 4	Q–C
F694	4	4.5	Demolition	W Room 3	Y
F695	2	2.2	Wall	House 5	L
F696	3–4	3–4	Paving	Room 4	Q–C
F697	3	3	Fill	S Room 3	Q–C
F698	3	3.2	Cut	S Room 3	Q
F699	2	2.2–2.4	South Midden	S House 5	L–N
F700	2	2.2–2.4	South Midden	S House 5	L–N
F701	3	3.2	Wall	Room 4	Q–C
F702	3–4	3–4	Paving	Room 4	Q–C
F703	3–4	3–4	Paving	Room 4	Q–C
F704	4–5	4–5	Fill	Room 3	Y
F705	3–4	3.2–4	Entrance fill	W Room 3	Q–C
F706	4	4	Paving	Room 3	C
F707	4	4	Paving	Room 3	C
F708	3	3	Paving	Room 3	A
F709	4	4	Paving	Room 3	C
F710	4	4	Layer	Room 3	C
F711	3–4	3–4	Paving	Room 4	Q–C
F712	3	3.2–3.6	Entrance fill	W Room 3	Q–C
F713	4	4	Layer	Room 3	C
F714	4	4	Layer	Room 3	C
F715	4	4	Layer	Room 3	C
F716	4	4	Paving	Room 3	C
F717	4	4	Dump	Room 3	C
F718	3	3	Layer	Room 4	Q–C
F719	3–4	3.2–4	Drain lining	Room 3	A
F720	4	4	Stone	Room 3	C
F721	4	4	Stone	Room 3	C
F722	3	3.2	Paving	Room 3	Q
F723	3	3.2	Wall	W Room 3	Q–C
F724	3	3.2	Wall	W Room 3	Q–C
F725	4	4	Layer	Room 3	C
F726	3–4	3–4	Fill	N Room 3	Q–C
F727	3–4	3.2–4	Fill	Room 3	A
F728	3	3	Paving	Room 3	A
F729	3	3	Paving	Room 4	Q–C
F730	3	3.2	Paving	S Room 3	Q
F731	3	3	Layer	Room 3	A
F732	3–4	3–4	Fill	Room 3	B
F733	3	3	Dump	Room 4	Q–C
F734	3	3	Upright	Room 4	Q–C
F735	3	3	Upright	Room 4	Q–C
F736	3	3	Upright	Room 4	Q–C
F737	3–4	3–4	Cut	Room 3	B
F738	2	2.2–2.4	Drain lining	S House 5	L–N
F739	2	2.2–2.4	Drain cut	S House 5	L–N
F740	2	2.2–2.4	Fish Midden	S House 5	L–N

Context no.	General phase	Detailed phase	Context description	Location	Interim phase
F741	3	3	Fill	Room 4	Q–C
F742	3	3	Cut	Room 4	Q–C
F743	3	3	Fill	Room 4	Q–C
F744	3	3	Cut	Room 4	Q–C
F745	3	3	Fill	Room 4	Q–C
F746	3	3	Cut	Room 4	Q–C
F747	4	4	Stone	Room 3	C
F748	3	3	Layer	Room 3	A
F749	4	4	Upright	Room 3	C
F750	4	4	Fill	Room 3	C
F751	0	0	Subsoil	N Room 3	Q–C
F752	4	4	Drain cut	Room 3	C
F753	4	4	Paving	Room 3	C
F754	3	3.2	Drain lintel	S Room 3	Q
F755	3	3	Fill	Room 4	Q–C
F756	3	3	Cut	Room 4	Q–C
F757	3	3.2	Drain lintel	S Room 3	Q
F758	3–4	3–4	Disturbed	N Room 3	Q–C
F759	3–4	3–4	Disturbed midden	N Room 3	Q–C
F760	3–4	3–4	Disturbed midden	N Room 3	Q–C
F761	3–4	3–4	Dump	Room 3	B
F762	3	3	Stone	Room 3	A
F763	3–4	3–4	Layer	Room 3	B
F764	3	3	Fill	Room 4	Q–C
F765	3	3.2	Layer	S Room 3	Q
F766	3–4	3–4	Fill	Room 3	B
F767	2	2.2–3.1	Layer	S House 5	L–O
F768	3–4	3–4	Disturbed midden	N Room 3	Q–C
F769	2	2.2–3.1	Layer	S House 5	L–O
F770	3	3.2	Fill	Room 3	Q
F771	3–4	3–4	Disturbed	N Room 3	Q–C
F772	3–4	3–4	Disturbed midden	N Room 3	Q–C
F773	3–4	3–4	Cut	Room 3	B
F774	3	3.2	Cut	Room 3	Q
F775	3	3	Stone	Room 3	A
F776	3	3.2	Drain lining	S Room 3	Q
F777	3	3.2	Drain lining	S Room 3	Q
F778	3	3.2	Drain fill	S Room 3	Q
F779	3	3.2	Drain fill	S Room 3	Q
F780	3	3.2	Fill	Room 3	Q
F781	3–4	3–4	Dump	Room 3	B
F782	3–4	3–4	Dump	Room 3	B
F783	3–4	3–4	Dump	Room 3	B
F784	3	3.2	Upright	Room 3	Q
F785	2	2.2–2.4	South Midden	S House 5	L–N
F786	3	3.2	Fill	W Room 3	Q–C
F787	3	3.2	Cut	W Room 3	Q–C

Appendix 4.2. *(cont.)*

Context no.	General phase	Detailed phase	Context description	Location	Interim phase	Context no.	General phase	Detailed phase	Context description	Location	Interim phase
F788	3	3	Paving	Room 3	A	F835	3	3.4	Cut	Room 1	S
F789	3	3	Paving	Room 3	A	F836	5–6	4.5–6	Cut	Room 1	Y–Z
F790	3	3.2	Dump	Room 3	Q	F837	3	3.2	Pit fill	Room 1	Q
F791	3	3.2	Paving	Room 3	Q	F838	3	3.2	Pit fill	Room 1	Q
F792	3	3.2	Paving	Room 3	Q	F839	3	3.2	Pit cut	Room 1	Q
F793	3	3.2	Paving	Room 3	Q	F840	3	3.3	Hearth ash	Room 1	R
F794	3	3.2	Dump	Room 3	Q	F841	3	3.3	Fill	Room 1	R
F795	3	3.2	Paving	Room 3	Q	F842	3	3.3	Cut	Room 1	R
F796	3	3.2	Floor layer	Room 3	Q	F843	3	3.3	Pit fill	Room 1	R
F797	3	3.2	Upright	Room 3	Q	F844	3	3.3	Pit cut	Room 1	R
F798	3	3.2	Upright	Room 3	Q	F845	3	3.3	Floor layer	Room 1	R
F799	3	3.2	Upright	Room 3	Q	F846	3	3.3	Floor layer	Room 1	R
F800	3	3.4	Floor layer	Room 1	S	F847	3	3.3	Stone	Room 1	R
F801	3	3.4	Floor layer	Room 1	S	F848	3	3.3	Upright	Room 1	R
F802	3	3.4	Floor layer	Room 1	S	F849	3	3.3	Upright	Room 1	R
F803	3	3.4	Floor layer	Room 1	S	F850	3	3.2	Stone	Room 1	Q
F804	3	3.2	Floor layer	Room 1	Q	F851	3	3.3	Paving	Room 1	R
F805	3	3.3	Paving	Room 1	R	F852	3	3.3	Floor layer	Room 1	R
F806	3	3.4	Upright	Room 1	S	F853	3	3.2	Stone	Room 1	Q
F807	3	3.4	Paving	Room 1	S	F854	3	3.2	Upright	Room 1	Q
F808	3	3.4	Floor layer	Room 1	S	F855	3	3.3	Floor layer	Room 1	R
F809	3	3.4	Cut	Room 1	S	F856	3	3.3	Post/stake hole fill	Room 1	R
F810	3	3.4	Fill	Room 1	S	F857	3	3.2	Post/stake hole cut	Room 1	Q
F811	3	3.4	Paving	Room 1	S						
F812	3	3.4	Stone	Room 1	S	F858	3	3.2	Post/stake hole fill	Room 1	Q
F813	0	0	Natural	Room 1	NAT	F859	3	3.2	Post/stake hole cut	Room 1	Q
F814	3	3.5	Fill	Room 1	T						
F815	3	3.4	Fill	Room 1	S	F860	3	3.2	Post/stake hole fill	Room 1	Q
F816	3	3.4	Hearth slab	Room 1	S						
F817	3	3.3	Hearth ash	Room 1	R	F861	3	3.2	Fill	Room 1	Q
F818	0	0	Natural	Room 1	NAT	F862	3	3.2	Cut	Room 1	Q
F819	3	3.4	Cut	Room 1	S	F863	3	3.2	Stone	Room 1	Q
F820	3	3.2	Cut	Room 1	Q	F864	3	3.2	Stone	Room 1	Q
F821	3	3.4	Cut	Room 1	S	F865	3	3.2	Upright	Room 1	Q
F822	5–6	4.5–6	Fill	Room 1	Y–Z	F866	3	3.2	Upright	Room 1	Q
F823	3	3.3	Floor layer	Room 1	R	F867	3	3.2	Upright	Room 1	Q
F824	3	3.3	Hearth ash	Room 1	R	F868	3	3.3	Fill	Room 1	R
F825	3	3.3	Dump	Room 1	R	F869	3	3.2	Cut	Room 1	Q
F826	3	3.4	Post/stake hole fill	Room 1	S	F870	3	3.3	Pit fill	Room 1	R
F827	3	3.4	Post/stake hole cut	Room 1	S	F871	3	3.3	Pit cut	Room 1	R
						F872	3	3.2	Paving	Room 1	Q
F828	3	3.2	Hearth slab	Room 1	Q	F873	3	3.2	Paving	Room 1	Q
F829	3	3.4	Post/stake hole fill	Room 1	S	F874	3	3.3	Post/stake hole cut	Room 1	R
F830	3	3.4	Post/stake hole cut	Room 1	S	F875	3	3.2	Midden	Room 1	Q
F831	3	3.3	Hearth slab	Room 1	R	F876	3	3.3	Floor layer	Room 1	R
F832	3	3.3	Dump	Room 1	R	F877	3	3.3	Fill	Room 1	R
F833	3	3.4	Upright	Room 1	S	F878	3	3.3	Cut	Room 1	R
F834	3	3.4	Fill	Room 1	S	F879	3	3.2	Fill	Room 1	Q
						F880	3	3.2	Cut	Room 1	Q

Appendix 4.2. *(cont.)*

Context no.	General phase	Detailed phase	Context description	Location	Interim phase	Context no.	General phase	Detailed phase	Context description	Location	Interim phase
F881	3	3.2	Layer	Room 1	Q	F931	3	3.2	Post/stake hole cut	Room 1	Q
F882	3	3.3	Fill	Room 1	R	F932	3	3.2	Drain fill	Room 1	Q
F883	3	3.2	Cut	Room 1	Q	F933	3	3.2	Cut	Room 1	Q
F884	3	3.2	Floor layer	Room 1	Q	F934	3	3.2	Pit fill	Room 1	Q
F885	3	3.2	Floor layer	Room 1	Q	F935	3	3.2	Drain fill	Room 1	Q
F886	3	3.2	Paving	Room 1	Q	F936	3	3.2	Stone	Room 1	Q
F887	3	3.2	Floor layer	Room 1	Q	F937	3	3.3	Fill	Room 1	R
F888	3	3.2	Stone	Room 1	Q	F938	3	3.2	Cut	Room 1	Q
F889	2	2.2–2.4	North Midden	N House 5	P	F939	3	3.2	Pit cut	Room 1	Q
F890	2	2.2–2.4	Paving	N House 5	P	F940	3	3.2	Paving	Room 1	Q
F891	3	3.2	Paving	Room 1	Q	F941	3	3.2	Stone	Room 1	Q
F892	3	3.2	Stone	Room 1	Q	F942	3	3.2	Floor layer	Room 1	Q
F893	3	3.2	Stone	Room 1	Q	F943	3	3.2	Paving	Room 1	Q
F894	3	3.3	Upright	Room 1	R	F944	2	2.2–2.4	Floor layer	N House 5	P
F895	3	3.3	Cut	Room 1	R	F945	3	3.2	Stone	Room 1	Q
F896	3	3.3	Cut	Room 1	R	F946	3	3.2	Floor layer	Room 1	Q
F897	3	3.2	Stone	Room 1	Q	F947	3	3.2	Drain fill	Room 1	Q
F898	3	3.4	Upright	Room 1	S	F948	0	0	Natural	Room 1	NAT
F899	3	3.2	Fill	Room 1	Q	F949	3	3.2	Drain cut	Room 1	Q
F900	3	3.2	Stone	Room 1	Q	F950	3	3.2	Drain cut	Room 1	Q
F901	3	3.2	Stone	Room 1	Q	F951	2	2.2–2.4	Post/stake hole fill	N House 5	P
F902	3	3.2	Upright	Room 1	Q	F952	2	2.2–2.4	Post/stake hole cut	N House 5	P
F903	3	3.2	Midden	Room 1	Q	F953	2	2.2–2.4	Post/stake hole fill	N House 5	P
F904	3	3.2	Stone	Room 1	Q	F954	2	2.2–2.4	Post/stake hole cut	N House 5	P
F905	3	3.2	Paving	Room 1	Q	F955	2	2.2–2.4	Post/stake hole fill	N House 5	P
F906	3	3.2	Stone	Room 1	Q	F956	2	2.2–2.4	Post/stake hole cut	N House 5	P
F907	3	3.2	Stone	Room 1	Q	F957	3	3.2	Layer	Room 1	Q
F908	3	3.2	Paving	Room 1	Q	F958	3	3.2	Hearth ash	Room 1	Q
F909	3	3.2	Stone	Room 1	Q	F959	2	2.2–2.4	Floor layer	N House 5	P
F910	3	3.2	Floor layer	Room 1	Q	F960	3	3.2	Floor layer	Room 1	Q
F911	3	3.2	Floor layer	Room 1	Q	F961	2	2.2–2.4	Floor layer	N House 5	P
F912	3	3.2	Floor layer	Room 1	Q	F962	3	3.2	Post/stake hole fill	Room 1	Q
F913	3	3.2	Dump	Room 1	Q	F963	3	3.2	Post/stake hole cut	Room 1	Q
F914	3	3.2	Cut	Room 1	Q	F964	3	3.2	Floor layer	Room 1	Q
F915	3	3.2	Cut	Room 1	Q	F965	3	3.2	Fill	Room 1	Q
F916	3	3.2	Stone	Room 1	Q	F966	0	0	Natural	Room 1	NAT
F917	3	3.2	Drain fill	Room 1	Q	F967	3	3.2	Cut	Room 1	Q
F918	3	3.2	Stone	Room 1	Q	F968	2	2.2–2.4	Stone	N House 5	P
F919	3	3.2	Stone	Room 1	Q	F969	2	2.2–2.4	North Midden	N House 5	P
F920	3	3.2	Stone	Room 1	Q	F970	3	3.2	Wall	Room 1	Q
F921	3	3.2	Fill	Room 1	Q	F971	2	2.2–2.4	North Midden	N House 5	P
F922	3	3.2	Cut	Room 1	Q	F972	3	3.2	Stone	Room 1	Q
F923	3	3.2	Stone	Room 1	Q						
F924	3	3.2	Fill	Room 1	Q						
F925	3	3.2	Stone	Room 1	Q						
F926	3	3.2	Stone	Room 1	Q						
F927	3	3.2	Stone	Room 1	Q						
F928	3	3.2	Stone	Room 1	Q						
F929	3	3.2	Stone	Room 1	Q						
F930	5–6	4.5–6	Fill	Room 1	Y–Z						

Appendix 4.2. *(cont.)*

Context no.	General phase	Detailed phase	Context description	Location	Interim phase
F973	2	2.2–2.4	Post/stake hole fill	N House 5	P
F974	2	2.2–2.4	Post/stake hole cut	N House 5	P
F975	2	2.2–2.4	Dump	N House 5	P
F976	5–6	4.5–6	Fill	Room 1	Y–Z
F977	5–6	4.5–6	Cut	Room 1	Y–Z
F978	3	3.2	Stone	Room 1	Q
F979	3	3.2	Pit fill	Room 1	Q
F980	3	3.2	Pit cut	Room 1	Q
F981	2	2.2–2.4	North Midden	N Room 1	Q+
F982	2	2.2–2.4	North Midden	N Room 1	Q+
F983	2	2.2–2.4	North Midden	N Room 1	Q+
F984	2	2.2–2.4	Upright	N House 5	P
F985	2	2.2–2.4	Upright	N House 5	P
F986	2	2.2–2.4	Dump	N House 5	P
F987	2	2.2–2.4	Dump	N House 5	P
F988	2	2.2–2.4	Stone	N House 5	P
F989	2	2.2–2.4	Stone	N House 5	P
F990	2	2.2–2.4	Paving	N House 5	P
F991	2	2.2–2.4	Fill	N House 5	P
F992	2	2.2–2.4	Cut	N House 5	P
F993	2	2.2–2.4	Cut	N House 5	P
F994	2	2.2–2.4	Cut	N House 5	P
F995	2	2.2–2.4	North Midden	N House 5	P
F996	2	2.2–2.4	Post/stake hole fill	N House 5	P
F997	2	2.2–2.4	Post/stake hole cut	N House 5	P
F998	2	2.2–2.4	Paving	N House 5	P
F999	2	2.2–2.4	Stone	N House 5	P
F1000	0	0	Natural	Room 1	NAT
F1001	2	2.2	Wall	House 5	L
F1002	3	3.2	Upright	Room 3	Q
F1003	4	4.5	Cut	Room 1	Y
F1004	4	4.5	Cut	Room 1	Y
F1005	4	4.5	Cut	Room 1	Y
F1006	4	4.5	Cut	Room 1	Y
F1007	7	7	Topsoil	Room 3	Z
F1008	7	7	Topsoil	Room 3	Z
F1009	4–5	4–5	Demolition	Room 3	Y
F1010	4–5	4–5	Demolition	Room 3	Y
F1011	4–5	4–5	Stone	Room 3	Y
F1012	4–5	4–5	Layer	Room 3	Y
F1013	4–5	4–5	Layer	Room 3	Y
F1014	4–5	4–5	Room 3 midden fill	Room 3	Y
F1015	4–5	4–5	Stone	Room 3	Y
F1016	4	4	Room 3 midden fill	Room 3	C
F1017	4–5	4–5	Layer	Room 3	Y
F1018	4	4	Stone	Room 3	C

Context no.	General phase	Detailed phase	Context description	Location	Interim phase
F1019	4	4	Room 3 midden fill	Room 3	C
F1020	2	2.2	Wall	House 5	L
F1021	4	4	Stone	N Room 3	Q–C
F1022	4	4	Interface	N Room 3	Q–C
F1023	4	4	Drain fill	N Room 3	Q–C
F1024	4–5	4–5	Room 3 midden fill	Room 3	Y
F1025	4–5	4–5	Layer	Room 3	Y
F1026	4–5	4–5	Stone	Room 3	Y
F1027	4	4	Floor layer	Room 3	C
F1028	3–4	3–4	Floor layer	Room 3	B
F1029	4	4	Stone	Room 3	C
F1030	4	4	Room 3 midden fill	Room 3	C
F1031	3	3	Drain fill	Room 3	A
F1032	3–4	3–4	Floor layer	Room 3	B
F1033	3–4	3–4	Layer	Room 3	B
F1034	3	3	Stone	Room 3	A
F1035	3	3	Layer	Room 3	A
F1036	3	3	Drain fill	Room 3	A
F1037	4	4	Floor layer	Room 3	C
F1038	3–4	3–4	Fill	Room 3	B
F1039	3–4	3–4	Cut	Room 3	B
F1040	3	3	Fill	Room 4	Q–C
F1041	4	4	Stone	N Room 3	Q–C
F1042	4	4	Drain cut	N Room 3	Q–C
F1043	3	3	Floor layer	Room 3	A
F1044	3	3	Stone	Room 3	A
F1045	3	3	Dump	Room 3	A
F1046	2	2.1	Layer	N House 5	K
F1047	3	3	Stone	Room 3	A
F1048	3	3	Stone	Room 3	A
F1049	3	3	Cut	Room 4	Q–C
F1050	3	3	Stone	Room 3	A
F1051	3	3	Dump	Room 3	A
F1052	3	3	Dump	Room 3	A
F1053	3	3.2	Upright	Room 3	Q
F1054	3	3.1	Layer	House 5	O
F1055	3	3.2	Dump	Room 3	Q
F1056	3	3	Dump	Room 3	A
F1057	3	3.2	Fill	Room 3	Q
F1058	3	3	Dump	Room 3	A
F1059	3	3	Dump	Room 3	A
F1060	3	3	Dump	Room 3	A
F1061	3	3.2	Upright	Room 3	Q
F1062	3	3.2	Upright	Room 3	Q
F1063	3	3	Paving	Room 3	A
F1064	3	3.2	Paving	Room 3	Q
F1065	3	3.2	Paving	Room 3	Q
F1066	3	3.2	Stone	Room 3	Q

Appendix 4.2. *(cont.)*

Context no.	General phase	Detailed phase	Context description	Location	Interim phase	Context no.	General phase	Detailed phase	Context description	Location	Interim phase
F1067	3	3.2	Fill	Room 3	Q	F1118	2	2.4	Dump	House 5	N
F1068	3	3.2	Cut	Room 3	Q	F1119	2	2.3	Upright	House 5	M
F1069	3	3.2	Drain fill	Room 3	Q	F1120	2	2.4	Dump	House 5	N
F1070	3	3.2	Drain fill	Room 3	Q	F1121	2	2.4	Hearth ash	House 5	N
F1071	3	3.2	Cut	Room 3	Q	F1122	2	2.4	Post/stake hole fill	House 5	N
F1072	3	3.2	Stone	Room 3	Q						
F1073	3	3.2	Dump	Room 3	Q	F1123	2	2.2–2.4	South Midden	S House 5	L–N
F1074	3	3.2	Drain fill	Room 3	Q	F1124	2	2.2–2.4	Paving	S House 5	L–N
F1075	3	3.2	Floor layer	Room 3	Q	F1125	2	2.2–2.4	South Midden	S House 5	L–N
F1076	3	3.2	Fill	Room 3	Q	F1126	2	2.4	Paving	House 5	N
F1077	3	3.2	Cut	Room 3	Q	F1127	2	2.4	Paving	House 5	N
F1078	3	3.2	Fill	Room 3	Q	F1128	2	2.4	Post/stake hole cut	House 5	N
F1079	3	3.2	Cut	Room 3	Q						
F1080	3	3.2	Upright	Room 3	Q	F1129	2	2.4	Floor layer	House 5	N
F1081	3	3.2	Cut	Room 3	Q	F1130	2	2.4	Floor layer	House 5	N
F1082	3	3.2	Cut	Room 3	Q	F1131	2	2.2–2.4	South Midden	S House 5	L–N
F1083	3	3.2	Cut	Room 3	Q	F1132	2	2.4	Paving	House 5	N
F1084	3	3.1	Layer	House 5	O	F1133	2	2.4	Paving	House 5	N
F1085	3	3.2	Upright	Room 3	Q	F1134	2	2.4	Paving	House 5	N
F1086	3	3.2	Layer	Room 3	Q	F1135	2	2.3	Upright	House 5	M
F1087	2	2.2	Wall	House 5	L	F1136	2	2.4	Paving	House 5	N
F1088	3	3.2	Fill	Room 3	Q	F1137	2	2.4	Fill	House 5	N
F1089	3	3.2	Stone	Room 3	Q	F1138	2	2.4	Fill	House 5	N
F1090	3	3.2	Cut	Room 3	Q	F1139	3	3.2	Dump	Room 3	Q
F1091	3	3.2	Fill	Room 3	Q	F1140	2	2.4	Dump	House 5	N
F1092	3	3.2	Fill	Room 3	Q	F1141	2	2.4	Pit fill	House 5	N
F1093	3	3.1	Layer	House 5	O	F1142	2	2.4	Dump	House 5	N
F1094	3	3.2	Drain fill	Room 3	Q	F1143	2	2.4	Fill	House 5	N
F1095	3	3.2	Cut	Room 3	Q	F1144	2	2.4	Pit cut	House 5	N
F1096	3	3.1	Layer	House 5	O	F1145	2	2.1	South Midden	S House 5	K
F1097	2	2.2	Wall	House 5	L	F1146	2	2.4	Cut	House 5	N
F1098	3	3.1	Demolition	House 5	O	F1147	2	2.4	Cut	House 5	N
F1099	3	3.1	Demolition	House 5	O	F1148	2	2.4	Cut	House 5	N
F1100	3	3.1	Demolition	House 5	O	F1149	2	2.4	Cut	House 5	N
F1101	3	3.1	Layer	House 5	O	F1150	2	2.3	Midden	House 5	M
F1102	3	3.1	Layer	House 5	O	F1151	2	2.3	Floor layer	House 5	M
F1103	3	3.1	Layer	House 5	O	F1152	2	2.3	Floor layer	House 5	M
F1104	3	3.1	Paving	House 5	O	F1153	2	2.3	Dump	House 5	M
F1105	3	3.1	Dump	House 5	O	F1154	2	2.3	Stone	House 5	M
F1106	3	3.1	Dump	House 5	O	F1155	2	2.3	Fill	House 5	M
F1107	3	3.2	Floor layer	Room 3	Q	F1156	2	2.3	Paving	House 5	M
F1108	3	3.1	Stone	House 5	O	F1157	2	2.3	Upright	House 5	M
F1109	2	2.2–2.4	Stone	House 5	L–N	F1158	2	2.3	Upright	House 5	M
F1110	2	2.2–2.4	Dump	House 5	L–N	F1159	2	2.3	Floor layer	House 5	M
F1111	2	2.2–2.4	South Midden	S House 5	L–N	F1160	2	2.4	Paving	House 5	N
F1112	2	2.2–2.4	Paving	House 5	L–N	F1161	2	2.3	Hearth slab	House 5	M
F1113	2	2.4	Fill	House 5	N	F1162	2	2.3	Cut	House 5	M
F1114	2	2.4	Cut	House 5	N	F1163	2	2.3	Floor layer	House 5	M
F1115	2	2.4	Dump	House 5	N	F1164	2	2.3	Floor layer	House 5	M
F1116	3	3.2	Stone	Room 3	Q	F1165	2	2.3	Floor layer	House 5	M
F1117	2	2.4	Dump	House 5	N	F1166	2	2.3	Paving	House 5	M

Appendix 4.2. (*cont.*)

Context no.	General phase	Detailed phase	Context description	Location	Interim phase
F1167	2	2.2	Floor layer	House 5	L
F1168	2	2.3	Fill	House 5	M
F1169	2	2.3	Cut	House 5	M
F1170	2	2.3	Fill	House 5	M
F1171	2	2.2	Dump	House 5	L
F1172	2	2.2	Dump	House 5	L
F1173	2	2.2	Dump	House 5	L
F1174	2	2.2	Paving	House 5	L
F1175	2	2.2	Stone	House 5	L
F1176	2	2.3	Cut	House 5	M
F1177	2	2.3	Cut	House 5	M
F1178	2	2.2	Paving	House 5	L
F1179	2	2.2	Upright	House 5	L
F1180	2	2.2	Floor layer	House 5	L
F1181	2	2.2	Floor layer	House 5	L
F1182	2	2.2	Floor layer	House 5	L
F1183	2	2.2	Floor layer	House 5	L
F1184	2	2.2	Floor layer	House 5	L
F1185	2	2.2	Dump	House 5	L
F1186	2	2.2	Pit cut	House 5	L
F1187	2	2.2	Pit fill	House 5	L
F1188	2	2.2	Drain fill	House 5	L
F1189	2	2.2	Cut	House 5	L
F1190	2	2.2	Paving	House 5	L
F1191	2	2.2	Stone	House 5	L
F1192	2	2.1	Dump	House 5	K
F1193	2	2.1	Pit fill	House 5	K
F1194	2	2.1	Pit fill	House 5	K
F1195	2	2.1	Dump	House 5	K
F1196	2	2.2	Pit fill	House 5	L
F1197	2	2.2	Pit cut	House 5	L
F1198	2	2.2	Dump	House 5	L
F1199	2	2.4	Wall	House 5	N
F1200	2	2.1	Pit cut	House 5	K
F1201	2	2.1	Pit cut	House 5	K
F1202	2	2.1	Paving	House 5	K
F1203	2	2.2	Layer	House 5	L
F1204	2	2.1	Pit fill	House 5	K
F1205	2	2.1	Pit cut	House 5	K
F1206	2	2.1	Dump	House 5	K
F1207	2	2.1	Dump	House 5	K
F1208	0	0	Natural	House 5	NAT
F1209	2	2.2	Fill	House 5	L
F1210	2	2.2	Cut	House 5	L
F1211	2	2.2	Fill	House 5	L
F1212	2	2.2	Stone	House 5	L
F1213	2	2.1	Pit fill	House 5	K
F1214	2	2.1	Post/stake hole fill	House 5	K
F1215	2	2.2	Fill	House 5	L
F1216	2	2.2	Cut	House 5	L

Context no.	General phase	Detailed phase	Context description	Location	Interim phase
F1217	2	2.1	Pit fill	House 5	K
F1218	2	2.2	Fill	House 5	L
F1219	2	2.2	Cut	House 5	L
F1220	2	2.1	Pit cut	House 5	K
F1221	2	2.1	Post/stake hole cut	House 5	K
F1222	0	0	Natural	House 5	NAT
F1223	2	2.1	Layer	House 5	K
F1224	0	0	Natural	House 5	NAT
F1225	2	2.2	Cut	House 5	L
F1226	0	0	Natural	House 5	K
F1227	2	2.1	Cut	House 5	K
F1228	2	2.2	Layer	House 5	L
F1229	0	0	Natural	House 5	NAT
F1230	4–5	4–5	Demolition	Room 3	Y
F1231	4–5	4–5	Demolition	Room 3	Y
F1232	4–5	4–5	Layer	Room 3	Y
F1233	4–5	4–5	Layer	Room 3	Y
Fish midden	2–3	2–3	Fish Midden	Cliff	–
G001	7	7	Topsoil	Areas G1–2	vii
G002	6	6	Plaggen soil	Areas G1–2	v.iii
G003	6	6	Garden	Areas G1–2	v.iii
G004	6	6	Garden	Areas G1–2	v.iii
G005	2–3	2–3	Farm Mound midden	Areas G1–2	iii
G006	6	6	Stone	Areas G1–2	v.iii
G007	6	6	Garden	Areas G1–2	v.iii
G008	2–3	2–3	Farm Mound midden	Areas G1–2	iii
G009	6	6	Stone	Areas G1–2	v.iii
G010	7	7	Cut	Areas G1–2	–
G011	6?	6?	Cut	Areas G1–2	v.ii
G012	2–3	2–3	Farm Mound midden	Areas G1–2	iii
G013	2–3	2–3	Farm Mound midden	Areas G1–2	iii
G014	2–3	2–3	Farm Mound midden	Areas G1–2	iii
G015	2–3	2–3	Farm Mound midden	Areas G1–2	iii
G016	2–3	2–3	Stone	Areas G1–2	iii
G017	2–3	2–3	Layer	Areas G1–2	iii

Appendix 4.2. *(cont.)*

Context no.	General phase	Detailed phase	Context description	Location	Interim phase	Context no.	General phase	Detailed phase	Context description	Location	Interim phase
G018	6?	6?	Layer	Areas G1–2	v.ii	G045	7	7	Rabbit burrow	Areas G1–2	–
G019	2–3	2–3	Stone	Areas G1–2	iii	G046	Unphased	Unphased	Layer	Areas G1–2	–
G020	2–3	2–3	Farm Mound midden	Areas G1–2	iii	G047	Unphased	Unphased	Layer	Areas G1–2	–
G021	2–3	2–3	Farm Mound midden	Areas G1–2	iii	G048	2–3	2–3	Farm Mound midden	Areas G1–2	iii
G022	1	1.2	Farm Mound midden	Areas G1–2	ii	G049	6	6	Garden	Areas G1–2	v.iii
G023	1	1.1	Palaeosol	Areas G1–2	I	G050	6?	6?	Cut	Areas G1–2	v.ii
G024	0	0	Subsoil	Areas G1–2	0	G051	2–3	2–3	Farm Mound midden	Areas G1–2	iii
G025	3	3	Plaggen soil	Areas G1–2	iv	G052	2–3	2–3	Farm Mound midden	Areas G1–2	iii
G026	2–3	2–3	Farm Mound midden	Areas G1–2	iii	G053	2–3	2–3	Farm Mound midden	Areas G1–2	iii
G027	Unphased	Unphased	Layer	Areas G1–2	–	G054	2–3	2–3	Farm Mound midden	Areas G1–2	iii
G028	7	7	Cut	Areas G1–2	vi	G055	2–3	2–3	Farm Mound midden	Areas G1–2	iii
G029	7	7	Disturbed	Areas G1–2	vi	G056	2–3	2–3	Farm Mound midden	Areas G1–2	iii
G030	7	7	Topsoil	Areas G1–2	vii	G057	2–3	2–3	Farm Mound midden	Areas G1–2	iii
G031	6	6	Garden	Areas G1–2	v.iii	G058	2–3	2–3	Farm Mound midden	Areas G1–2	iii
G032	7	7	Disturbed	Areas G1–2	vii	G059	1	1.2	Farm Mound midden	Areas G1–2	ii
G033	5–6	5–6	Wall	Areas G1–2	v.I	G060	1	1.2	Farm Mound midden	Areas G1–2	ii
G034	1	1.2	Farm Mound midden	Areas G1–2	ii	G061	1	1.1	Palaeosol	Areas G1–2	I
G035	1	1.2	Farm Mound midden	Areas G1–2	ii	G063	1	1.2	Farm Mound midden	Areas G1–2	ii
G036	6	6	Garden	Areas G1–2	v.iii	G071	6	6	Wall	Area G3	–
G037	1	1.2	Farm Mound midden	Areas G1–2	ii	G072	7	7	Topsoil	Area G3	–
G038	1	1.2	Farm Mound midden	Areas G1–2	ii	G073	7	7	Topsoil	Area G3	–
G039	6	6	Layer	Areas G1–2	v.iii	G074	6	6	Dump	Area G3	–
G040	Unphased	Unphased	Layer	Areas G1–2	–	G075	3–6	3–6	Demolition	Area G3	–
G041	Unphased	Unphased	Layer	Areas G1–2	–	G076	6	6	Layer	Area G3	–
G042	1	1.1	Palaeosol	Areas G1–2	I	G077	2–3	2–3	Wall	Area G3	–
G043	Unphased	Unphased	Layer	Areas G1–2	–	G079	6	6	Layer	Area G3	–
						G080	3–6	3–6	G3 Midden	Area G3	–
G044	7	7	Rabbit burrow	Areas G1–2	–	G081	7	7	Fill	Area G3	–
						G082	3–6	3–6	G3 Midden	Area G3	–
						G083	2–3	2–3	Wall	Area G3	–
						G084	2–3	2–3	Wall	Area G3	–
						G085	3–6	3–6	Demolition	Area G3	–
						G086	7	7	Fill	Area G3	–
						G087	2–3	2–3	Wall	Area G3	–
						G088	7	7	Fill	Area G3	–

Appendix 4.2. *(cont.)*

Context no.	General phase	Detailed phase	Context description	Location	Interim phase
G089	2–3	2–3	Farm Mound midden	Area G3	–
G090	2–3	2–3	G3 Midden	Area G3	–
G091	7	7	Fill	Area G3	–
G092	2–6	2–6	Paving	Area G3	–
G093	2–3	2–3	G3 Midden	Area G3	–
G094	2–3	2–3	Cut	Area G3	–
G095	2–3	2–3	G3 Midden	Area G3	–
G096	2–3	2–3	G3 Midden	Area G3	–
G097	2–3	2–3	Paving	Area G3	–
G098	2–3	2–3	Wall	Area G3	–
G099	7	7	Fill	Area G3	–
G100	2–3	2–3	Hearth slab	Area G3	–
G101	2–3	2–3	Hearth ash	Area G3	–
G102	2–3	2–3	G3 Midden	Area G3	–
G103	2–3	2–3	Wall	Area G3	–
G104	2–3	2–3	Cut	Area G3	–
G105	2–3	2–3	Farm Mound midden	Area G3	–
G106	2–3	2–3	Layer	Area G3	–
G107	2–3	2–3	Hearth	Area G3	–
G108	3–6	3–6	Demolition	Area G3	–
G109	2–3	2–3	Wall	Area G3	–
G110	2–3	2–3	Hearth slab	Area G3	–
G111	2–3	2–3	Wall	Area G3	–
G112	6	6	Cut	Area G3	–
G113	2–3	2–3	Upright	Area G3	–
G124	5–6	5–6	Wall	Area G3	–
G125	7	7	Demolition	Area G3	–
G126	5–6	5–6	Upright	Area G3	–
G127	5–6	5–6	Paving	Area G3	–
G128	5–6	5–6	Paving	Area G3	–
G129	7	7	Topsoil	Area G3	–
G130	3–6	3–6	Demolition	Area G3	–
G131	2–3	2–3	Wall	Area G3	–
G132	2–6	2–6	Wall	Area G3	–
G133	2–3	2–3	Wall	Area G3	–
G134	2–6	2–6	Paving	Area G3	–
G135	2–6	2–6	Paving	Area G3	–
G136	2–3	2–3	Farm Mound midden	Area G3	–
G137	7	7	Topsoil	Area G3	–

Context no.	General phase	Detailed phase	Context description	Location	Interim phase
G138	7	7	Disturbed	Area G3	–
H001	7	7	Topsoil	Area H	–
H002	Unphased	Unphased	Layer	Area H	–
H003	0	0	Subsoil	Area H	–
H004	Unphased	Unphased	Stone	Area H	–
J001	7	7	Topsoil	Area J2	–
J002	7	7	Topsoil	Area J2	–
J003	5–6	5–6	Plaggen soil	Area J2	–
J004	5–6	5–6	Plaggen soil	Area J2	–
J005	3	3	Wall	Area J2	–
J006	3	3	Paving	Area J2	–
J007	3	3	Paving	Area J2	–
J008	4	4	Stone	Area J2	–
J009	3–4	3–4	Midden	Area J2	–
J010	3–4	3–4	Paving	Area J2	–
J011	0	0	Palaeosol	Area J2	–
J012	4–6	4–6	Layer	Area J2	–
J013	4–5	4–5	Layer	Area J2	–
J014	3	3	Paving	Area J2	–
J015	0	0	Palaeosol	Area J2	–
J016	0	0	Subsoil	Area J2	–
J017	3–4	3–4	Layer	Area J2	–
J018	3	3	Fill	Area J2	–
J019	3	3	Cut	Area J2	–
J100	7	7	Topsoil	Area J1	–
J101	7	7	Topsoil	Area J1	–
J102	5–6	5–6	Plaggen soil	Area J1	–
J103	0	0	Palaeosol	Area J1	–
J104	Unphased	Unphased	Layer	Area J1	–
J105	Unphased	Unphased	Layer	Area J1	–
J106	0	0	Subsoil	Area J1	–
J107	5–6	5–6	Plaggen soil	Area J1	–
J108	Unphased	Unphased	Layer	Area J1	–
J109	Unphased	Unphased	Layer	Area J1	–
J110	Unphased	Unphased	Upright	Area J1	–
J111	Unphased	Unphased	Layer	Area J1	–
J112	Unphased	Unphased	Layer	Area J1	–
J113	Unphased	Unphased	Paving	Area J1	–
J114	Unphased	Unphased	Layer	Area J1	–
J115	0	0	Natural	Area J1	–

Appendix 7.1. *Fish NISP for minor phases (recovery >2 mm).*

Species	Fish Midden Ph. 1		South Midden Ph. 2.1		Ph. 3	
Dogfish family						
Dogfish families						
Spurdog family						
Spurdog						
Ray family						
Cuckoo ray						
Herring family						
Salmon & trout family						
Eel						
Conger eel						
Needlefishes/ Sauries						
Garfish family						
Garfish						
Three-spined stickleback						
Hake						
Cod family	4	2.2%	2	5.3%	5	10.4%
Cod/Saithe/ Pollack	7	3.8%	2	5.3%	8	16.7%
Cod	69	37.3%	25	65.8%	10	20.8%
Haddock						
Whiting	1	0.5%				
Saithe/Pollack						
Saithe	74	40.0%	7	18.4%	21	43.8%
Pollack						
Norway pout/ Bib/Poor-cod						
Norway pout						
Bib						
Poor-cod						
Torsk	2	1.1%				
Rockling	2	1.1%				
Five-bearded/ Northern rockling						
Five-bearded rockling						
Four-bearded rockling	1	0.5%				
Three-bearded rockling						
Ling	2	1.1%	1	2.6%	4	8.3%
Seabass family						
Atlantic horse-mackerel/Scad	2	1.1%				
Sea bream family						
Black Sea bream						
Wrasse family						
Ballan wrasse						
Cuckoo wrasse						
Sand eel family	3	1.6%				
Mackerel family						
Dragonet						
Wolf-fish						
Snake blenny	4	2.2%				
Butterfish						
Eelpout family	2	1.1%				
Viviparous eelpout	1	0.5%				
Weever family						
Gurnard family						
Grey gurnard						
Tub gurnard	1	0.5%				
Sea scorpion family						
Bull-rout						
Sea scorpion						
Flatfish order	1	0.5%				
Turbot family	1	0.5%				
Halibut family	8	4.3%	1	2.6%		
Dab						
Lemon sole						
Flounder/Plaice						
Flounder						
Plaice						
Total identified	185	100%	38	100%	48	100%
Unidentified Fish	1125		283		87	
Total	**1310**		**321**		**135**	

Appendix 7.2. *Common and scientific names (or analytical categories) of identified fish taxa (after Whitehead* et al. *1986a,b; 1989; Harland* et al. *2003).*

Common name	Scientific name
Dogfish family	Scyliorhinidae
Dogfish families	Scyliorhinidae/Squalidae
Spurdog family	Squalidae
Spurdog	*Squalus acanthias*
Ray family	Rajidae
Cuckoo ray	*Raja naevus*
Herring family	Clupeidae
Salmon and trout family	Salmonidae
Eel	*Anguilla anguilla*
Conger eel	*Conger conger*
Needlefishes/sauries	Belonidae/Scomberesocidae
Garfish family	Belonidae
Garfish	*Belone belone*
Three-spined stickleback	*Gasterosteus aculeatus*
Hake	*Merluccius merluccius*
Cod family	Gadidae
Cod/saithe/pollack	*Gadus/Pollachius*
Cod	*Gadus morhua*
Haddock	*Melanogrammus aeglefinus*
Whiting	*Merlangius merlangus*
Saithe/pollack	*Pollachius*
Saithe	*Pollachius virens*
Pollack	*Pollachius pollachius*
Norway Pout/bib/poor-cod	*Trisopterus*
Norway pout	*Trisopterus esmarkii*
Bib	*Trisopterus luscus*
Poor-cod	*Trisopterus minutus*
Torsk	*Brosme brosme*
Rockling	*Ciliata/Gaidropsarus*
Five-bearded/northern rockling	*Ciliata*
Five-bearded rockling	*Ciliata mustela*
Four-bearded rockling	*Rhinonemus cimbrius*

Common name	Scientific name
Three-bearded rockling	*Gaidropsaurus vulgaris*
Ling	*Molva molva*
Seabass family	Percichthyidae
Atlantic horse-mackerel/scad	*Trachurus trachurus*
Sea bream family	Sparidae
Black Sea bream	*Spondyliosoma cantharus*
Wrasse family	Labridae
Ballan wrasse	*Labrus bergylta*
Cuckoo wrasse	*Labrus bimaculatus*
Sand eel family	Ammodytidae
Mackerel family	Scombridae
Dragonet	*Callionymus*
Wolf-fish	*Anarhichas lupus*
Snake blenny	*Lumpenus lampretaeformis*
Butterfish	*Pholis gunnellus*
Eelpout family	Zoarcidae
Viviparous eelpout	*Zoarces viviparus*
Weever family	Trachinidae
Gurnard family	Triglidae
Grey gurnard	*Eutrigla gurnardus*
Tub gurnard	*Trigla lucerna*
Sea scorpion family	Cottidae
Bull-rout	*Myoxocephalus scorpius*
Sea scorpion	*Taurulus bubalis*
Flatfish order	Heterosomata (Pleuronectiformes)
Turbot family	Scophthalmidae
Halibut family	Pleuronectidae
Dab	*Limanda limanda*
Lemon sole	*Microstomus kitt*
Flounder/plaice	*Pleuronectes flesus/platessa*
Flounder	*Pleuronectes flesus*
Plaice	*Pleuronectes platessa*

Appendix 7.3. *Cod total-length estimates (mm), determined using a regression equation applied to premaxilla measurement 2 (recovery >2 mm).*

Farm Mound Ph. 1 (>2 mm only)	Farm Mound Ph. 2–3	Fish Midden Ph. 2–3	Fish Midden Ph. 7	North Midden Ph. 2	South Midden Ph. 2.2–2.4	Room 4, Ph. 4 midden	House 5, Ph. 2 floors
569	462	280	228	121	311	202	468
570	468	336		425	327		822
595	516	501		434	471		929
598	519	546		454	552		955
675	526	565		459	552		
731	544	573		515	649		
794	549	599		522	688		
865	554	648		522	928		
891	565	715		540	939		
964	584	755		563	948		
1039	605	789		563	953		
	625	853		680	973		
	668	855		715	1045		
	668	895		730	1055		
	717	896		737	1068		
	738	931		748	1107		
	769	934		769	1161		
	811	944		769			
	822	948		774			
	823	952		778			
	843	975		779			
	867	995		784			
	874	1008		785			
	880	1043		796			
	885	1047		816			
	903	1056		851			
	917	1182		856			
	932			875			
	935			878			
	938			883			
	947			896			
	958			898			
	958			903			
	963			904			
	964			913			
	975			938			
	987			947			
	993			955			
	997			961			
	1047			980			
	1067			988			
	1072			997			
	1094			1016			
				1031			
				1038			
				1039			
				1063			
				1118			
				1164			
				1183			
				1214			

Appendix 7.4. *Saithe total-length estimates (mm) determined using a regression equation applied to quadrate measurement 1 (recovery >2 mm).*

Farm Mound Ph. 1 (>2 mm only)	Farm Mound Ph. 2–3	Fish Midden Ph. 2–3	Fish Midden Ph. 7	North Midden Ph. 2	South Midden Ph. 2.2–2.4	Rooms 1 & 2, Ph. 4 floors	Room 4, Ph. 4 midden	Room 4, Ph. 4 midden (cont.)	House 5, Ph. 2 floors
267	157	140	194	134	150	162	154	277	244
335	165	247	205	197	194	946	166	278	244
335	204	263	240	249	226		171	279	277
335	206	267	258	269	232		178	280	283
362	238	277	259	273	262		179	282	294
363	254	279	270	277	282		180	283	316
364	257	280	282	290	291		180	284	346
370	266	294	306	291	296		184	285	370
380	269	296	477	302	310		186	286	415
380	289	299		306	312		192	287	507
389	294	302		312	340		194	288	
396	305	319		317	393		196	291	
410	372	355		321	416		209	291	
415	381	395		321	453		212	291	
426	387	416		335	469		220	294	
436	1026	417		345			226	295	
437		422		346			227	297	
443		425		347			230	299	
490		430		380			232	300	
495		480		382			232	300	
498		483		422			234	300	
517		499		439			238	301	
686				460			242	303	
727							243	310	
							245	317	
							247	318	
							247	319	
							250	322	
							251	322	
							251	325	
							260	327	
							260	328	
							260	339	
							262	341	
							264	346	
							265	355	
							266	355	
							268	365	
							269	368	
							270	375	
							271	383	
							272	397	
							272	491	

Appendix 7.5. *Results of statistical tests of characteristics of the fish-bone assemblage that yielded significant differences between the deposit and phase groups compared (recovery >2 mm).*

Phase	Phase	Greatest difference	Kolmogorov-Smirnov Z value	Significance
Comparison of fish textures				
Farm Mound Ph. 1	Farm Mound Ph. 2–3	0.159	3.267	<0.001
Farm Mound Ph. 1	Fish Midden Ph. 2–3	0.145	2.880	<0.001
North Midden Ph. 2	Farm Mound Ph. 2–3	0.183	4.294	<0.001
North Midden Ph. 2	Fish Midden Ph. 2–3	0.179	4.073	<0.001
South Midden Ph. 2	Farm Mound Ph. 2–3	0.181	3.502	<0.001
South Midden Ph. 2	Fish Midden Ph. 2–3	0.177	3.355	<0.001
Comparison of fish percent completeness				
Farm Mound Ph. 1	Farm Mound Ph. 2–3	0.104	2.137	<0.001
Farm Mound Ph. 1	Fish Midden Ph. 2–3	0.233	4.638	<0.001
Farm Mound Ph. 1	North Midden Ph. 2	0.100	2.019	0.001
Farm Mound Ph. 1	South Midden Ph. 2	0.122	2.125	<0.001
North Midden Ph. 2	Farm Mound Ph. 2–3	0.058	1.367	0.048
North Midden Ph. 2	Fish Midden Ph. 2–3	0.162	3.688	<0.001
South Midden Ph. 2	Farm Mound Ph. 2–3	0.080	1.544	0.017
South Midden Ph. 2	Fish Midden Ph. 2–3	0.184	3.481	<0.001
Farm Mound Ph. 2–3	Fish Midden Ph. 2–3	0.136	3.168	<0.001
Comparison of cod ordinal sizes				
Farm Mound Ph. 1	Farm Mound Ph. 2–3	0.152	2.344	<0.001
Farm Mound Ph. 1	Fish Midden Ph. 2–3	0.099	1.412	0.037
Farm Mound Ph. 2–3	Fish Midden Ph. 2–3	0.189	3.558	<0.001
Farm Mound Ph. 2–3	North Midden Ph. 2	0.151	3.017	<0.001
Farm Mound Ph. 2–3	South Midden Ph. 2	0.137	2.096	<0.001
Comparison of saithe ordinal sizes				
Farm Mound Ph. 1	Farm Mound Ph. 2–3	0.498	5.161	<0.001
Farm Mound Ph. 1	Fish Midden Ph. 2–3	0.377	4.694	<0.001
Farm Mound Ph. 1	North Midden Ph. 2	0.136	1.643	0.009
Farm Mound Ph. 1	South Midden Ph. 2	0.156	1.717	0.005
Farm Mound Ph. 1	Room 4, Ph. 4 midden	0.513	8.105	<0.001

Appendix 8.1. *Common and scientific names (or analytical categories) of identified mammals.*

Common name	Scientific name
Seal	Phocidae
Pygmy shrew	*Sorex minutus*
Human	*Homo sapiens*
Cetacean	Cetacea
Carnivore	Carnivora
Dog	*Canis familiarus*
Cat	*Felis catus*
Horse	*Equus caballus*
Pig	*Sus domesticus*
Red deer	*Cervus elaphus*
Cattle	*Bos taurus*
Sheep/goat (Caprine)	*Ovis* or *Capra* (Caprinae)
Sheep	*Ovis aries*
Goat	*Capra hircus*
Vole/mouse	Microtinae/Murinae
Vole species	Microtinae
Orkney vole	*Microtus arvalis orcadensis*
Mouse species	Murinae
Wood mouse	*Apodemus sylvaticus*
House mouse	*Mus musculus*
Rabbit	*Oryctolagus cuniculus*

Appendix 8.2. *Bone surface texture data for identified mammal QC1 elements (major deposit and phase groups only), divided by ordinal age categories.*

Area	Phase	Age	Poor	Fair	Good	Excellent	Total
Farm Mound	Phase 1	Neonatal	54	59	4		117
		Juvenile	37	90	67	3	197
		Sub-adult	2	15	31	2	50
		Adult	9	31	181	29	250
		Total	**102**	**195**	**283**	**34**	**614**
	Phase 2–3	Neonatal	108	450	14		572
		Juvenile	31	276	144	3	454
		Sub-adult	1	22	57	1	81
		Adult	5	39	338	43	425
		Total	**145**	**787**	**553**	**47**	**1532**
Fish Midden	Phase 2–3	Neonatal	3	75	7		85
		Juvenile		23	35		58
		Sub-adult		2	6		8
		Adult		3	64	3	70
		Total	**3**	**103**	**112**	**3**	**221**
	Phase 7	Neonatal		3			3
		Juvenile		6	6		12
		Adult	1	4	17	1	23
		Total	**1**	**13**	**23**	**1**	**38**
Room 4 midden	Phase 4	Neonatal	1	6			7
		Juvenile	1	19	27		47
		Sub-adult			4		4
		Adult	3	6	47		56
		Total	**5**	**31**	**78**		**114**

Appendix 8.3. *Results of statistical tests of characteristics of the mammal-bone assemblage that yielded significant differences.*

Phase	Phase	Greatest difference	Kolmogorov-Smirnov Z value	Significance
Comparison of mammal textures, >4 mm				
Farm Mound Ph. 2–3	Farm Mound Ph. 1	0.223	2.244	<0.001
Farm Mound Ph. 2–3	Fish Midden Ph. 2–3	0.191	2.030	0.001
Farm Mound Ph. 2–3	Room 4, Ph. 4 midden	0.290	1.911	0.001
Comparison of mammal textures, hand collected				
Farm Mound Ph. 2–3	Farm Mound Ph. 1	0.107	2.064	<0.001
Comparison of mammal textures, >4 mm, neonatal and juvenile bone only				
Farm Mound Ph. 2–3	Fish Midden Ph. 2–3	0.307	2.519	<0.001
Farm Mound Ph. 2–3	Room 4, Ph. 4 midden	0.406	2.055	<0.001
Comparison of mammal textures, hand collected, neonatal and juvenile bone only				
Farm Mound Ph. 2–3	Farm Mound Ph. 1	0.240	3.198	<0.001
Comparison of mammal percent completeness, >4 mm				
Farm Mound Ph. 1	Farm Mound Ph. 2–3	0.182	1.827	0.003
Farm Mound Ph. 1	Room 4, Ph. 4 midden	0.217	1.421	0.035
Comparison of mammal percent completeness, hand collected				
Farm Mound Ph. 1	Farm Mound Ph. 2–3	0.127	2.433	<0.001
Comparison of cattle ages, >4 mm				
Farm Mound Ph. 1	Farm Mound Ph. 2–3	0.313	1.622	0.010
Farm Mound Ph. 1	Fish Midden Ph. 2–3*	0.401	1.998	0.001
Comparison of cattle ages, hand collected				
Farm Mound Ph. 1	Farm Mound Ph. 2–3	0.214	2.785	<0.001

*fully articulated neonatal calf given count of 1

Appendix 8.4. *Assessment of large and medium mammal bone fragmentation in Phases 1 and 2 to 3 of the Farm Mound. Hc indicates hand collected.*

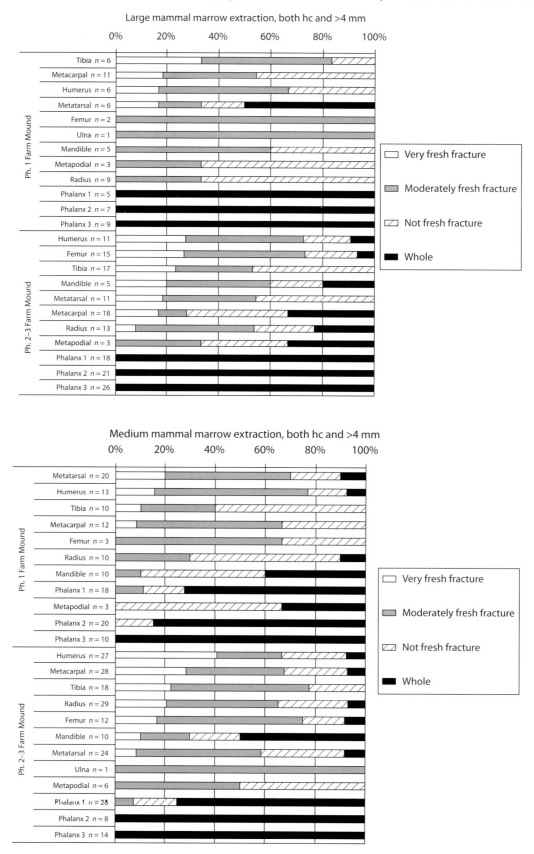

Appendix 8.5. *Cattle measurements (following von den Driesch 1976; Harland* et al. *2003). Hc indicates hand collected.*

Element	Phase	Recovery	Bd	Dl	GLl	GLm	LmT
Astragalus	Farm Mound Ph. 1	Hc	36.79	32.91	55.52	50.62	
		Hc	35.7	30	55.2	50.6	
		Hc				52.52	
		>4 mm	36.73	33.07	57.95	53.63	
	Farm Mound Ph. 2–3	Hc	31.77		51.82		
		Hc	34.56	31.84	55.66	50.33	
		Hc	39.43	34.4	59.39	53.41	
		Hc	37.08	33.05	59.24	54.24	
		Hc	36.96	31.97		52.35	56.42

Element	Phase	Recovery	C	C+D	DS	GL
Calcaneum	Farm Mound Ph. 1	>4 mm	21.56	43.5	40.54	125.21
	Farm Mound Ph. 2–3	Hc	22.9	42.24	34.21	113.46
		Hc	23.04	46.08	37.81	124.62
		Hc	20.63		38.24	

Element	Phase	Recovery	BT	HTC	HT
Humerus	Farm Mound Ph. 2–3	Hc	64.85	29.49	36.75

Element	Phase	Recovery	C_LM3	C_BM3
Mandible	Farm Mound Ph. 1	Hc		10.95
		Hc	35.61	12.04
		>4 mm	27.07	10.61
		>4 mm	34.67	14.11

Element	Phase	Recovery	BFp	DFp	BFd	Dd	Dem	Dvm	Dim	SD	GL	Bd
Metacarpal	Farm Mound Ph. 1	Hc					21.48	28.94	27.84			53.37
		Hc					20.15	27.41	24.71			47.65
	Farm Mound Ph. 2–3	Hc				30.64	24.45	31.09	27.8	31.64	181.6	58.61
		Hc					20.58	27.42	24.73			
		Hc	51.66				23.41	31.32	27.36	30.52	162	59.87
		>4 mm	45.53	27.37		17.5	20.34	27.55	24.06	24.33	163	47.66

Element	Phase	Recovery	Dem	Dvm	Dim
Metapodial	Farm Mound Ph. 1	Hc	20.69	27.26	24.46
		Hc	18.1		24.11

Element	Phase	Recovery	BFp	BFd	Dem	Dvm	Dim
Metatarsal	Farm Mound Ph. 1	Hc	42.31	36.73			
	Farm Mound Ph. 2–3	Hc		46.12	18.9		23.46
		Hc	47.11				
		Hc		34.95	18.1	24.78	23.4

Appendix 8.5. *(cont.)*

Element	Phase	Recovery	GL	SD	Bp	Dp	Bd	BFd	Glpe
Phalanx 1	Farm Mound Ph. 1	Hc	62.64	25.5	33.55	34.45	29.75	29.42	61.33
		Hc		22.86	24.74		25.33		50.34
		Hc		22.67		28.56	24.6		
		>4 mm		19.36	23.26		24.82		50.38
		>4 mm		18.81	24.82		21.79		43.04
	Farm Mound Ph. 2–3	Hc	45.31	19.48	25.84		24.14		
		Hc		22.53	29.59		25.84		53.58
		Hc	55.46	19.96	24.32		23.1		49.35
		Hc	52.16	17.87	21.21		19.97		47.08
		Hc	54.66	20.34	26		23.68		50.76
		Hc	49.41	18.99	24.21		21.46		44.79
		Hc	56.53	20.13	23.17		22.52		52.94
		Hc		19.89			23.05		
		Hc		20.9	23.81		24		47.62
		Hc		20.55	24.55		23.41		51.42
		Hc		20.93	24.51		25.52		47.45
		Hc		20.64	24.32		24.17		51.96
		Hc		20.74	25.87		24.39		45.94
		Hc		22.11			24.09		
		Hc		20.56	23.22		25.09		51.53
		Hc		21.61	24.67		24.64		
		Hc		21.23	24.23		26.04		48.97
		Hc		20.4	22.2		21.56		51.18
		Hc		19.88	23.03		22.68		48.85
		Hc		23.72	25.99		27.72		54.96
		>4 mm		20.58	22.36		23.25		52.33
		>4 mm		19.46	23.11		22.76		
		>4 mm		20.22	25.47		23.49		46.24
	Fish Midden Ph. 2–3	>4 mm		20.2	23.46		24.78	48.73	
		>4 mm		19.94	24.15				51.12
	South Midden Ph. 2	Hc		20.92	25.37		23.91		53.03
		>4 mm		21.61	25.08		24.28		53.7

Element	Phase	Recovery	Bp	BFp
Radius	Farm Mound Ph. 2–3	Hc	68.12	62.07

Element	Phase	Recovery	GLP	SLC	GL
Scapula	Farm Mound Ph. 2–3	Hc	60.33	46.88	51.5
		Hc	55.82	47.72	48.37
		Hc	56.55		47.71
		Hc	60.74	47.24	50.4

Element	Phase	Recovery	BC	41	42	43
Skull	Farm Mound Ph. 1	Hc				170
	Farm Mound Ph. 2–3	Hc	90	31.7	25.05	

Element	Phase	Recovery	Bd	Dd
Tibia	Farm Mound Ph. 1	Hc	51.54	37.99
		>4 mm	52.65	
	Farm Mound Ph. 2–3	Hc	54.37	
		Hc	52.62	

Element	Phase	Recovery	DPA
Ulna	Farm Mound Ph. 2–3	Hc	52.9

Appendix 8.6. *Caprine measurements (following von den Driesch 1976; Harland* et al. *2003). Hc indicates hand collected.*

Element	Phase	Recovery	Bd	Dl	GLl	GLm
Astragalus	Farm Mound Ph. 1	Hc		13.57		
		Hc	18.36	15.95	28.42	26.74
		Hc	17.49	14.57	26.38	24.99
		Hc		14.26	25.66	25.74
		>4 mm	16.91		26.06	24.65
		>4 mm	18.11	14.7	26.73	24.66
	Farm Mound Ph. 2–3	Hc	17.32	14.93	26.19	25.26
		Hc	16.74	14.32	26.08	24.22
		Hc	17.11	14.59	26.67	25.95
		Hc	16.85	13.84	25.66	24.34
		Hc	16.81	14.58	26.59	25.12
		Hc	17.24	14.46	25.54	24.98
		Hc	16.78	13.68	24.57	23.83
		Hc	16.77	14.92	26.89	25.6
		Hc	17.51	14.44	25.61	23.85
		Hc	17.78	15.12	26.68	25.64
		Hc	19.7	15.6	28.46	27.54
		Hc	18.72	15.68	28.02	26.26
		Hc	16.38	13.56	25.18	25.53
	Fish Midden Ph. 7	>4 mm		14.56	27.69	26.28

Element	Phase	Recovery	C	C+D	DS	GL
Calcaneum	Farm Mound Ph. 1	Hc	9.26	18.86	18.4	53.49
		Hc	9.1	18.67	15.89	
	Farm Mound Ph. 2–3	Hc	10.52	19.73	17.98	54.47
		Hc	9.29	17.43	4.99	45.24
		Hc	9.39	18.76	15.6	49.01

Element	Phase	Recovery	BT	HTC	HT
Humerus	Farm Mound Ph. 1	Hc	27.62		
		Hc	27.22	13.48	16.45
		Hc	27.24		
		>4 mm	26.25	12.48	16.12
	Farm Mound Ph. 2–3	Hc	24.7	12.53	16.3
		Hc	27.79	14.32	18.41
		Hc	25.11	13.56	16.17
		Hc	26.81	13.66	18.17
		>4 mm	24.09	11.71	14.41
	Fish Midden Ph. 7	>4 mm		12.41	14.64

Element	Phase	Recovery	S_LM3	S_BM3
Mandible	Farm Mound Ph. 1	Hc	19.69	7.74
	North Midden Ph. 2	Hc	21.22	8.96

Element	Phase	Recovery	BFp	DFp	Dd	Dem	Dvm	Dim	SD	Bd
Metacarpal	Farm Mound Ph. 1	Hc							17.25	
		Hc				10.27	14.67	12.9		22.85
		Hc				10.4	14.66	13.62		25.57
	Farm Mound Ph. 2–3	Hc	19.51	14.75						
		Hc			15.49	10.25	15.31	13.55		22.89
		Hc				10.2	15.26	12.91		
		Hc				9.68	14.12	12.26		23.93
		Hc				9.82	14.83	12.81		22.66
		>4 mm				10.3	15.01	12.43		22.56
		>4 mm				9.74	14.62	12.31		22.22

Appendix 8.6. *(cont.)*

Element	Phase	Recovery	Bd	Dem	Dvm	Dim
Metapodial	Farm Mound Ph. 1	Hc	22.14	9.77	15.3	13
		Hc		9.52	14.95	13.32
		Hc	22.99	10.49		12.93

Element	Phase	Recovery	SD	BFp	DFp	BFd	Dem	Dvm	Dim
Metatarsal	Farm Mound Ph. 1	Hc	13.59						
		Hc					19.3	27.4	25.3
		Hc		20.59	21.61				
	Farm Mound Ph. 2–3	Hc	18.25						
		Hc					9.97		13.29
		Hc				21.96	9.77	15.77	13.22
		>4 mm				20.92			
	Room 4, Ph. 4 midden	Hc				22.96			

Element	Phase	Recovery	GL	SD	Bp	Dp	Bd	BFd	Glpe
Phalanx 1	Farm Mound Ph. 1	Hc		9.05	11.31		10.45		34.92
		Hc		8.28	9.73		8.94		29.75
		Hc		9.47	10.55		12.07		33.24
		Hc		8.95	11.42		10.08		34.39
		Hc	37.15	9.08	11.73	13.72	9.89	35.96	
		Hc	32.94	9.06	11.43	13.47	10.39		32.96
		Hc	35.62	8.84	10.8	12.9	9.5		32.88
		Hc	36.19	10.99	12.35	14.76	11.55		34.05
		Hc	34.4	9.33	10.74	12.94	9.97		32.63
		Hc	31.2	9.27	10.98	12.61			30.61
		Hc			13.94	15.22			
		Hc					10.2		
		>4 mm		9.29	10.54		11.46		33.71
		>4 mm		8.91	11.47		10.67		31.04
	Farm Mound Ph. 2–3	Hc	36.5	10.77	12.06		11.88		35.49
		Hc	34.84	9.83	11.9		11.49		33.56
		Hc	35.44	9.44	11.95		11.24		34.57
		Hc	34.99	9.48	11.52		10.66		33.67
		Hc		8.43	10.23				
		Hc			11.24				
		Hc		9.05	10.99		10.5		34.17
		Hc		9.02	11.05		10.17		32.56
		Hc		7.86	9.44				
		Hc		9.1	10.5		11.07		32.75
		Hc		10.77	12.26		11.74		33.43
		Hc		8.23	9.78		10.29		30.68
		Hc		8.14	9.54		10.78		32.94
		Hc		8.4	10.04		9.97		32.05
		Hc		8.51	10.33		10.23		30.89
		>4 mm		9.83	11.8		10.96		30.78
	Fish Midden Ph. 2–3	>4 mm		8.74	10.15		10.26		28.03
		>4 mm			9.76				
	House 5, Ph. 2 Floors	>4 mm		7.77	10.5		9.27		33.02
		>4 mm		9.76	12.19		11.55		35.31
		>4 mm		10.49	12.83		12.29		35.49
		>4 mm			11.87				

Appendix 8.6. *(cont.)*

Element	Phase	Recovery	Bp	BFp	GL	SD	Ll	Bd	BFd
Radius	Farm Mound Ph. 1	Hc						26.81	
		>4 mm	25.71						
	Farm Mound Ph. 2–3	Hc	28.93	26.79					
		Hc						27.82	
		Hc	27.05	24.66	138.17	14.65		25.64	21.08
	Room 4, Ph. 4 midden	>4 mm	28.25	26.23					

Element	Phase	Recovery	GLP	SLC	Dic	GL
Scapula	Farm Mound Ph. 1	Hc	28.85	16.77		
		Hc		18.57		
		Hc	29.85	16.98		
	Farm Mound Ph. 2–3	Hc	30.43	16.28		
		Hc	32.96	21.06		25.48
		Hc	27.13	18.1		23.99
		Hc	28.2	18.03		22.03
		Hc	31.22			
		Hc	29.57	17.3		

Element	Phase	Recovery	Bd
Tibia	Farm Mound Ph. 1	Hc	21.01
		Hc	24.31
		Hc	22.96
		>4 mm	23.51
	Farm Mound Ph. 2–3	Hc	25.29
		Hc	21.65

Appendix 8.7. *Pig, horse and cat measurements (following von den Driesch 1976; Harland et al. 2003). Hc indicates hand collected.*

Pig:

Element	Phase	Recovery	Bd	Dl	GLl	GLm
Astragalus	Fish Midden Ph. 2–3	>4 mm	22.24	18.79	35.52	32.65

Element	Phase	Recovery	P_6	P_7	P_L
Mandible	Farm Mound Ph. 1	Hc	14.03	13.45	32.2

Element	Phase	Recovery	SD	Bp	Bd	Glpe
Phalanx 1	Farm Mound Ph. 2–3	Hc	11.81	14.86	14.01	30.93
		Hc	12.29	14.03	15.77	

Horse:

Element	Phase	Recovery	BT	SD	HTC	HT
Humerus	Farm Mound Ph. 2–3	Hc	70.96		34.24	45.82
	South Midden Ph. 2	Hc	73.33	36.72	36.76	47.5

Element	Phase	Recovery	Bd	Dd
Tibia	Farm Mound Ph. 1	Hc	64.54	40

Cat:

Element	Phase	Recovery	GL	SD	Bd
Tibia	Farm Mound Ph. 1	Hc	103.71	6.15	13.79

Appendix 9.1. *Common and scientific names (or analytical categories) of identified birds (after Snow & Perrins 1998a,b).*

Common name	Scientific name
Fulmar	*Fulmarus glacialis*
Manx shearwater	*Puffinus puffinus*
Gannet	*Morus bassanus*
Cormorant/Shag	*Phalacrocorax carbo/aristotelis*
Cormorant	*Phalacrocorax carbo*
Shag	*Phalacrocorax aristotelis*
Swan, goose & duck family	Anatidae
Geese (Anser)	*Anser*
Geese (Anser/Branta)	*Anser/Branta*
Greylag goose/Bean goose	*Anser anser/fabalis*
Domestic/Wild greylag goose	*Anser anser*
Brent goose	*Branta bernicla*
Shelduck	*Tadorna tadorna*
Ducks	*Anas*
Mallard	*Anas platyrhynchos*
Tufted duck	*Aythya fuligula*
Goldeneye	*Bucephala clangula*
Red-breasted merganser	*Mergus serrator*
White-tailed eagle/Golden eagle	*Haliaeetus albicilla/Aquila chrysaetos*
Grouse family	Tetraonidae
Fowl (domestic)	*Gallus gallus*
Wader	Haematopodidae/Charadriidae/Scolopacidae
Redshank	*Tringa totanus*
Plovers (Charadrius)	*Charadrius*
Plovers (Pluvialis)	*Pluvialis*
Golden plover	*Pluvialis apricaria*
Sandpiper & snipe family	Scolopacidae
Snipes	*Gallinago*
Skuas	*Stercorarius*
Gull family	Laridae
Common gull/Kittiwake	*Larus canus/Rissa tridactyla*
Common gull	*Larus canus*
Herring/Lesser black-backed gull	*Larus argentatus/fuscus*
Herring gull	*Larus argentatus*
Lesser black-backed gull	*Larus fuscus*
Great black-backed gull	*Larus marinus*
Black-headed gull	*Larus ridibundus*
Kittiwake	*Rissa tridactyla*
Guillemot/Razorbill	*Uria aalge/Alca torda*
Guillemot	*Uria aalge*
Razorbill	*Alca torda*
Little auk	*Alle alle*
Puffin	*Fratercula arctica*
Rock dove	*Columba livia*
Passerines	Passeriformes
Small passerines	Passeriformes
Blackbird/Thrush	Turdidae
Blackbird	*Turdus merula*
Redwing	*Turdus iliacus*
Starling	*Sturnus vulgaris*
Carrion crow	*Corvus corone*
Raven	*Corvus corax*

Appendix 12.2. *Concentrations (in ppm) of fourteen rare earth elements for a selection of steatite finds from Quoygrew (see Chapter 12 for methods).*

Find no.	ppm La	ppm Ce	ppm Pr	ppm Nd	ppm Sm	ppm Eu	ppm Gd	ppm Tb	ppm Dy	ppm Ho	ppm Er	ppm Tm	ppm Yb	ppm Lu
7535	0.0468	0.0776	0.0086	0.0319	0.0061	0.0026	0.0063	0.0010	0.0063	0.0016	0.0060	0.0012	0.0096	0.0020
7546	0.0352	0.0823	0.0132	0.0678	0.0226	0.0056	0.0269	0.0053	0.0344	0.0074	0.0223	0.0037	0.0243	0.0039
7640	0.0123	0.0220	0.0026	0.0097	0.0018	0.0011	0.0016	0.0002	0.0019	0.0006	0.0031	0.0009	0.0099	0.0024
7654	0.0085	0.0169	0.0024	0.0106	0.0030	0.0011	0.0036	0.0007	0.0053	0.0014	0.0052	0.0012	0.0101	0.0022
7929(1)	0.0643	0.1231	0.0154	0.0574	0.0106	0.0053	0.0086	0.0012	0.0068	0.0013	0.0045	0.0009	0.0065	0.0013
7929(2)	0.0365	0.0678	0.0084	0.0339	0.0069	0.0052	0.0068	0.0010	0.0068	0.0015	0.0052	0.0010	0.0080	0.0015
7952	0.1399	0.3443	0.0507	0.2363	0.0668	0.0138	0.0846	0.0161	0.1126	0.0250	0.0786	0.0134	0.0879	0.0141
7966	0.0206	0.0339	0.0040	0.0133	0.0026	0.0016	0.0026	0.0005	0.0028	0.0007	0.0026	0.0006	0.0058	0.0012
60604	0.0954	0.1326	0.0157	0.0656	0.0138	0.0056	0.0153	0.0025	0.0164	0.0038	0.0120	0.0021	0.0152	0.0027
60672A	0.0218	0.0346	0.0059	0.0261	0.0066	0.0034	0.0073	0.0013	0.0091	0.0019	0.0066	0.0013	0.0095	0.0020
60672B	0.0292	0.0561	0.0078	0.0340	0.0080	0.0033	0.0084	0.0014	0.0094	0.0020	0.0063	0.0012	0.0088	0.0017
60909	0.0332	0.0348	0.0064	0.0262	0.0054	0.0012	0.0055	0.0008	0.0058	0.0013	0.0046	0.0009	0.0070	0.0015
61132	3.9853	8.3174	1.0624	4.3425	0.8173	0.1056	0.6656	0.0829	0.4143	0.0717	0.1905	0.0292	0.1833	0.0283
61471	0.0875	0.1394	0.0174	0.0689	0.0134	0.0047	0.0138	0.0021	0.0126	0.0027	0.0081	0.0015	0.0100	0.0018
61545	0.0890	0.1863	0.0265	0.1217	0.0336	0.0059	0.0392	0.0071	0.0481	0.0109	0.0370	0.0068	0.0482	0.0083
61638	0.0752	0.1077	0.0137	0.0545	0.0107	0.0035	0.0115	0.0018	0.0110	0.0024	0.0080	0.0015	0.0116	0.0022
61639	0.0340	0.0490	0.0068	0.0282	0.0057	0.0026	0.0063	0.0009	0.0055	0.0013	0.0046	0.0007	0.0063	0.0013
61685	0.1081	0.1537	0.0176	0.0682	0.0130	0.0033	0.0138	0.0020	0.0125	0.0028	0.0095	0.0018	0.0131	0.0026
61998C1	0.0533	0.1586	0.0264	0.1342	0.0333	0.0035	0.0327	0.0050	0.0323	0.0077	0.0283	0.0055	0.0430	0.0087
61998C2	0.0570	0.1696	0.0277	0.1356	0.0331	0.0032	0.0313	0.0048	0.0311	0.0073	0.0271	0.0054	0.0423	0.0088
61998C3	0.1348	0.5428	0.1145	0.6652	0.1925	0.0150	0.1714	0.0221	0.1084	0.0185	0.0466	0.0065	0.0371	0.0066
61998D	0.1993	0.7412	0.1435	0.8104	0.2284	0.0179	0.2036	0.0262	0.1307	0.0227	0.0582	0.0087	0.0523	0.0091
62127	0.0219	0.0382	0.0046	0.0180	0.0038	0.0008	0.0044	0.0008	0.0058	0.0013	0.0045	0.0008	0.0054	0.0010
62137	0.3774	1.1465	0.1964	1.0464	0.3783	0.0610	0.5055	0.0996	0.6670	0.1385	0.4114	0.0636	0.3908	0.0584
62138	0.2142	0.7127	0.0446	0.1684	0.0334	0.0123	0.0342	0.0052	0.0302	0.0062	0.0185	0.0031	0.0211	0.0035
62151	0.1159	0.9316	0.0195	0.0657	0.0105	0.0076	0.0135	0.0014	0.0085	0.0022	0.0088	0.0018	0.0147	0.0028
62154	0.4485	1.1175	0.1694	0.8121	0.2250	0.0427	0.2877	0.0526	0.3534	0.0779	0.2429	0.0389	0.2616	0.0467
62158	0.0540	0.1037	0.0120	0.0460	0.0089	0.0030	0.0082	0.0014	0.0094	0.0021	0.0070	0.0014	0.0114	0.0023
62160	0.4233	1.1002	0.1722	0.8358	0.2716	0.0695	0.3256	0.0587	0.3696	0.0735	0.2160	0.0343	0.2226	0.0343
62234	0.0211	0.0376	0.0050	0.0204	0.0047	0.0018	0.0051	0.0008	0.0053	0.0011	0.0032	0.0006	0.0045	0.0009
62255	0.1219	0.2709	0.0372	0.1613	0.0414	0.0278	0.0399	0.0068	0.0420	0.0085	0.0272	0.0050	0.0360	0.0058
62459	0.0300	0.0584	0.0074	0.0314	0.0081	0.0071	0.0093	0.0016	0.0122	0.0027	0.0090	0.0017	0.0130	0.0024
70093	0.0106	0.0207	0.0025	0.0099	0.0025	0.0008	0.0025	0.0004	0.0033	0.0007	0.0026	0.0005	0.0045	0.0009
70101	0.0060	0.0108	0.0014	0.0049	0.0015	0.0006	0.0015	0.0003	0.0019	0.0004	0.0018	0.0004	0.0036	0.0008
70254	0.1073	0.1874	0.0223	0.0820	0.0155	0.0041	0.0138	0.0022	0.0149	0.0037	0.0142	0.0033	0.0278	0.0058
70095	0.0401	0.0746	0.0087	0.0328	0.0062	0.0031	0.0053	0.0008	0.0054	0.0013	0.0041	0.0009	0.0066	0.0013

Appendix 12.3. *Worked stone by detailed phase.*

Find	Phase 1	Phase 1.2	Phase 2.1	Phase 2.2	Phase 2.2-2.4	Phase 2.3	Phase 2.4	Phase 2-3	Phase 3	Phase 3.1	Phase 3.2	Phase 3.2-3.6	Phase 3.3	Phase 3.4	Phase 3.5	Phase 3.6	Phase 3-4	Phase 4	Phase 4.1	Phase 4.2	Phase 4.2.1	Phase 4.2.2	Phase 4.3	Phase 4.3.1	Phase 4.3-4.4	Phase 4.4	Phase 4.5	Phase 4.5-5	Phase 4.5-6	Phase 4-5	Phase 5-6	Phase 6	Phase 7	Unphased	'Subsoil'	Total
Steatite vessel: hemispherical		3		1	3			11	3		1				2		1															1			1	28
Steatite vessel: hemispherical handled					1																															1
Steatite vessel: four-sided		1	1	1	3		1	16	2	3	1								1		1				1										2	33
Steatite vessel: four-sided repaired						3				1																										4
Steatite vessel: bucket-shaped					1																															1
Steatite vessel: uncertain form	1	5		1	1	3		18	3	3			2												1		1							1	1	41
Steatite vessel: uncertain form handled								1																												1
Steatite vessel: uncertain form repaired										1																										1
Steatite vessel: uncertain form repaired or handled								1																												1
Steatite vessel fragment?		4			2			10					1				1	1	2		1								1				1	1		20
Steatite fragment		36	3	2	10	4	5	65		2	7			2	5	2	1	1	2		1				1		6						4			155
Steatite spindle whorl					1			4			1		1	1	1		1			1					1								1			12
Mica schist spindle whorl																					1															1
Sandstone spindle whorl												1					2				1				1			2								6
Steatite weight																									1											1
Mica schist weight									1	1																										2
Sandstone weight										2				1												2	2	1								6
Schist bake stone														2																						2
Eidsborg schist hone				1			3				2		2	1	2										1	1	1		1				1			14
Probable Eidsborg schist hone																									1											1
Probable purple phyllite hone																				1																1
Sandstone hone											2				1							1				1										5
Sandstone hone or weight																				1							1									1
Sandstone grinding slab																					1															1
Mica schist quern														1							1															2
Mica schist quern?																					1															1
Mica schist disc													1					1																		2
Mica schist fragment		17						7		2					1	1	1	1	2	2	3		1	2	1	1	6		1				1	1		47
Sandstone quern?											1																					1				2
Sandstone pounder		1							1		2		1		2		1	2		1	1		1		2		2	1					2	2		19
Sandstone anvil?																						2		1		1										4
Pumice float																		1																		1
Pumice		3		2	1			5										1	1	1				1			1		2	2	1					21
Gunflint				1																														1		1
Flint	1	2		1				5	2	1	1						1	2									1	2	3	1	5	1	6	4	2	42
Sandstone pivot				1		1																														2
Sandstone vessel			1																																	1
Other				1	1	1		4			3				1			1			1			1			1	1	1		1		1	1		16
Total	2	73	3	11	23	10	10	150	12	14	21	5	6	6	16	3	7	6	5	6	12	3	2	3	9	2	15	7	5	8	9	3	17	10	6	500

Appendix 15.1. *Summary description of pre-industrial pottery fabrics.*

Organic tempered fabric (fabric 1) Grey-brown organic tempered fabric with grey-brown core and brown-black external surface.
Organic tempered fabric (fabric 2) Brown hard-fired organic tempered fabric with grey core and light brown external surface.
Organic tempered fabric (fabric 3) Grey organic tempered fabric with grey-black core and light brown external surface.
Organic tempered fabric with quartz grits (fabrics 4a and 4b) Grey organic tempered fabric with large white quartz grits and red-brown external surface (note variant of this with grey-black surface). Fabric 4a designates a group of five sherds from Area G (four from phase 1 and one from phase 2–3). Fabric 4b represents the remainder of this material, which is first common in the late Middle Ages.
Wheel-made organic tempered fabric with quartz grits (fabric 5) Organic tempered orange-red fabric with white quartz grits from wheel-made vessels.
Scottish white gritty ware (fabric 8) Hard white-brown fabric with small quartz inclusions.
German proto-stoneware? Highly fired streaky orange-brown fabric with abundant coarse angular quartz, igneous rock and ovoid inclusions of soft crystalline matter giving pimply surfaces. The fabric is similar to that of the German/Scandinavian redware (fabric 9) but much coarser and with a higher proportion of ferruginous concretions (?igneous rock), which makes its origin uncertain, but it may be from Siegburg. Date range *c.* 1200/50–1300.
Scottish redware (fabric 6) Medium to hard red-brown fabric with very occasional quartz inclusions.
German salt-glazed stoneware (fabric 11) This category comprises salt-glazed stoneware sherds from pottery production centres in the Rhineland, mainly from Raeren, but possibly also from Langerwehe. For summaries of the industries and fabric types see Clark (1974), Hurst *et al.* (1986, 185–208) and Gaimster (1997).
North German/Scandinavian redwares (plain and slip-decorated) (fabric 9) A detailed fabric description of this form of redware can be found in the report on the finds from The Biggings (Blackmore 1999a, 159–60) and the following summarizes the key features. The German/Scandinavian redwares from Quoygrew are evenly fired to a high temperature. They are harder and thinner walled than Dutch redwares. Most sherds are orange-red in colour, but a few are reduced. They have a clear or green glaze internally, but are rarely glazed externally. Microscopic examination (x20) of the larger sherds shows a fine micaceous matrix, in most cases with rounded darker red clay pellets and often with fine streaks of lighter-coloured clay. The dominant inclusions are mica silt (both biotite and muscovite), quartz silt, abundant very fine angular quartz sand, and rounded or sub-rounded clear, yellow or rose-coloured quartz grains (mainly 0.2–0.5 mm but up to 1 mm across and occasionally up to 2 mm across); angular quartz occurs more rarely. Also present are igneous rock and flint, of which the latter can occur as flakes or small rounded inclusions coated in an iron-rich compound (or cement). Find 7035 contains a large fragment of feldspar or biotite. Although the number of finds is small, it is possible to identify a range of textures resulting from the varying combination and size of the different inclusions. The equivalent finds from Kirkwall and from Scalloway Castle also contain variable amounts of sand, mica and 'ferruginous' inclusions (MacAskill 1982, 409; Lindsay 1983, 567). A few sherds from pipkins appear to have a self-slip externally, giving a dark red surface. These are Sfs. 6216, 6276/6282/6293 and 60228. This feature has also been noted at Papa Stour (Blackmore 1999a, 160) and in Trondheim (Blackmore unpublished). One sherd in a finer version of the above fabric has a lead glaze on both surfaces with external slip decoration (Sf. 60067).

Appendix 15.2. *The pottery from Quoygrew by detailed phase.*

Type	Fabric description	Total	'Subsoil'	Unphased	Ph. 7	Ph. 6	Ph. 5-6	Ph. 4-6	Ph. 4-5	Ph. 4.5-6	Ph. 4.5-5	Ph. 4.5	Ph. 4.4	Ph. 4.3-4.4	Ph. 4.3.1	Ph. 4.3	Ph. 4.2-4.3	Ph. 4.2.2	Ph. 4.2.1	Ph. 4.2	Ph. 4.1	Ph. 4	Ph. 3-4	Ph. 3.6-4.1	Ph. 3.6	Ph. 3.5-3.6	Ph. 3.5	Ph. 3.4-3.5	Ph. 3.4	Ph. 3.3	Ph. 3.2-4	Ph. 3.2-3.6	Ph. 3.2	Ph. 3.1	Ph. 3	Ph. 2-3	Ph. 2.4	Ph. 2.2-2.4	Ph. 1.2	Ph. 1.1
Medieval pottery	Organic and quartz tempered (fabric 4a)	5																																		1			3	1
	Organic tempered (fabric 3)	606	3	3	21		3		119	6	1	2	1	6		12			2		1	197	59	1		18	52	1	29	5	9	1	22	1	24	1		6		
	Organic tempered (fabric 1)	262		12	33		19	1	50	4	4	13	6	19	7	7		2	5	22	8	4	7	7	6		5	7			22	3	4	2	3	1	1	2		
	Organic tempered (fabric 2)	764	1	53	12		25	3	132	8	46	124	36	61	24	6	1	10	29	71	19	15	7	22	3		6	7	7		17		4	2	3	9	1			
	German proto-stoneware?	1																															1							
	Scottish white gritty ware (fabric 8)	7														2							1						1	1			1			1				
	Scottish redware (fabric 6)	50			1		2		12				1	1		2	2	5	11	2	1	6		1		1	1								1					
	German stoneware (fabric 11)	7				1					2								3										1											
	Organic and quartz tempered (fabric 4b)	277			28		2		155	5			10	1				1	7	2	1	6	2	1			1		1	1	56	1	1	1	1	1				
	Wheel-made organic and quartz tempered (fabric 5)	27					1		4	1			7	2			1		1	1	1	2	2				1				1	1		1	1					
Post-medieval pottery	German/Scandinavian redware pipkin (fabric 9)	22			12	6	4																																	
Industrial pottery	Tin-glazed earthenware	6			2	3				1																														
	Soft paste porcelain, 18th century	1			1																																			
	Cream ware	1				1																																		
	Pearlwares	24		2	18	1	2				1																													
	Lead-glazed redware	239		14	151	54	16			1	2																								1					
	Bone china	21			15	4	2																																	
	White earthenware	265		12	168	57	18				7					1									1			1												
	Banded white earthenware	25			20	2	3																																	
	Hand painted white earthenware	26			16	9	1																																	
	Late dipped white earthenware	5			2	3																																		

Appendix 15.2. (*cont.*)

Type	Fabric description	Ph. 1.1	Ph. 1.2	Ph. 2.2-2.4	Ph. 2.4	Ph. 2-3	Ph. 3	Ph. 3.1	Ph. 3.2	Ph. 3.2-3.6	Ph. 3.2-4	Ph. 3.3	Ph. 3.4	Ph. 3.4-3.5	Ph. 3.5	Ph. 3.5-3.6	Ph. 3.6	Ph. 3.6-4.1	Ph. 3-4	Ph. 4	Ph. 4.1	Ph. 4.2	Ph. 4.2.1	Ph. 4.2.2	Ph. 4.2-4.3	Ph. 4.3	Ph. 4.3.1	Ph. 4.3-4.4	Ph. 4.4	Ph. 4.5	Ph. 4.5-5	Ph. 4.5-6	Ph. 4-5	Ph. 4-6	Ph. 5-6	Ph. 6	Ph. 7	Unphased	'Subsoil'	Total
Industrial pottery (cont.)	Late flow blue white earthenware																																				2			2
	Lustre decoration white earthenware																																				4			4
	Painted white earthenware																																				1			1
	Shell edged white earthenware																																		4	1	15			20
	Sponge decorated white earthenware																																		8	27	62			97
	Transfer printed white earthenware					1																									1				5	29	115	2		153
	Porcelain, 19th century																																		1			4		5
	Rockingham ware																															2			1	2	44			49
	Granite ware																																				2			2
	Stoneware																													1						6	32	1		40
	Unidentified fragments					5	1		2											2											1	2		1	2	262	148	9		437
Unstudied pottery	Unstudied pottery								1																											1	1	1		4
	Total	1	3	8	1	21	30	5	32	6	106	7	39	9	66	19	10	31	71	226	30	98	58	18	5	30	32	90	61	139	67	30	477	5	119	469	926	113	4	3455

Appendix 15.4. *Concentration of elements in redware (fabric 6) samples based on ICP-MS analysis by Simon Chenery (2006) of British Geological Survey.*

Sample no.	BGS code	Small find	mg/kg Li	mg/kg Be	mg/kg Na	mg/kg Mg	mg/kg Al	mg/kg P	mg/kg K	mg/kg Ca	mg/kg Sc	mg/kg V	mg/kg Cr	mg/kg Fe
ORK-1	10759-1	60600	45.6	3.21	19,647	8362	84,112	5019	31,516	9291	16.8	96	72	43,773
ORK-2	10759-2	60706	54.8	2.43	8624	11,711	71,523	695	30,254	2904	15	96	90	36,332
ORK-3	10759-3	60770	45.1	3.21	20,085	8176	85,424	14,253	33,274	20,439	17.1	84	84	43,344
ORK-4	10759-4	60770	40.3	2.13	8100	7571	61,471	11,149	26,793	12,356	13.5	73	62	30,424
ORK-5	10759-5	60664	50.6	4.01	18,426	10,899	100,409	6596	33,639	10,606	20.7	122	116	57,096
ORK-6	10759-6	60564	59.3	2.55	9831	14,515	80,217	2931	33,851	6380	16.7	107	90	36,146
ORK-7	10759-7	60615	46.7	2.65	6896	10,966	71,109	2584	31,958	12,226	14.4	101	100	32,342
ORK-8	10759-8	60448	71.8	2.16	1192	5632	101,627	1665	18,073	4222	17.1	103	111	40,164
ORK-9	10759-9	60761	58.2	2.7	10,516	15,369	81,187	1907	34,216	4836	16.9	101	95	44,770
ORK-10	10759-10	60851	47.5	2.2	9074	11,743	65,591	2759	29,993	5050	13.7	87	85	39,144

Sample no.	BGS code	Small find	mg/kg Co	mg/kg Ni	mg/kg Cu	mg/kg Zn	mg/kg Ga	mg/kg As	mg/kg Rb	mg/kg Sr	mg/kg Y	mg/kg Zr	mg/kg Nb	mg/kg Mo
ORK-1	10759-1	60600	15.7	48.9	49.8	133	28.1	11.1	146	574	22	53	3.1	1.414
ORK-2	10759-2	60706	16.9	58.8	30.9	88	21.7	15.2	137	133	17	61	14.9	0.367
ORK-3	10759-3	60770	14.7	45.9	40	136	28.4	23.1	150	1386	24	54	4.7	1.069
ORK-4	10759-4	60770	10.9	41.8	41.8	67	19.4	22.9	114	910	15	44	3.1	0.661
ORK-5	10759-5	60664	22.4	72.5	62.2	179	34.6	21.8	164	683	28	72	17.4	1.32
ORK-6	10759-6	60564	19.4	65.3	34.5	92	23.8	11.2	162	265	19	70	15.8	0.914
ORK-7	10759-7	60615	17.5	53.6	38.3	61	20.9	12.2	163	1429	13	57	13.5	0.785
ORK-8	10759-8	60448	5.1	23.8	23.6	36	28.5	19.8	130	148	16	76	15.2	0.57
ORK-9	10759-9	60761	19.9	67.3	33.4	94	23.9	12	154	208	22	97	16.3	0.599
ORK-10	10759-10	60851	16.7	58.5	29.7	79	21.4	12.1	126	182	16	80	14.5	0.791

Sample no.	BGS code	Small find	mg/kg Ag	mg/kg Cd	mg/kg Sn	mg/kg Sb	mg/kg Cs	mg/kg Ba	mg/kg La	mg/kg Ce	mg/kg Pr	mg/kg Nd	mg/kg Sm	mg/kg Eu
ORK-1	10759-1	60600	0.266	0.261	0.28	0.17	5.19	1017	41.5	94	10.3	39.3	7.16	1.65
ORK-2	10759-2	60706	0.288	0.007	12.5	1.38	12.11	687	32.6	81	8.23	31.6	5.76	1.31
ORK-3	10759-3	60770	0.287	0.495	0.65	0.36	5.65	1076	45	102	11.05	42.4	7.78	1.76
ORK-4	10759-4	60770	0.244	0.327	0.47	0.23	7.68	702	30.6	69	7.03	26.4	4.54	1.05
ORK-5	10759-5	60664	0.323	0.445	4.48	0.99	7.16	1191	59.1	129	13.92	52.4	9.24	2.1
ORK-6	10759-6	60564	0.376	0.159	3.53	1.44	13.82	785	38.8	87	9.34	35.3	6.39	1.54
ORK-7	10759-7	60615	0.301	0.119	1.69	2.47	20.36	642	29.8	70	7.16	26.9	4.91	1.07
ORK-8	10759-8	60448	0.306	0.159	3.57	1.43	9.2	464	46.8	91	9.77	35.1	5.55	1.13
ORK-9	10759-9	60761	0.458	0.068	4.32	1.48	12.82	782	39.6	91	9.7	36.9	6.68	1.5
ORK-10	10759-10	60851	0.232	0.099	2.56	1.32	10.13	653	29.6	73	7.12	27.2	4.82	1.1

Sample no.	BGS code	Small find	mg/kg Tb	mg/kg Gd	mg/kg Dy	mg/kg Ho	mg/kg Er	mg/kg Tm	mg/kg Yb	mg/kg Lu	mg/kg Hf	mg/kg Ta	mg/kg W	mg/kg Tl	mg/kg Pb	mg/kg Th
ORK-1	10759-1	60600	0.89	6.18	4.69	0.893	2.47	0.361	2.34	0.347	1.44	1.04	0.36	1.18	516.4	15.37
ORK-2	10759-2	60706	0.71	5.03	3.67	0.723	2	0.277	1.8	0.259	2.36	2.22	0.56	0.88	306.6	11.64
ORK-3	10759-3	60770	0.95	6.56	5.16	1.002	2.81	0.399	2.6	0.399	1.38	0.78	0.4	1.14	128.2	15.55
ORK-4	10759-4	60770	0.56	3.84	3.1	0.598	1.77	0.262	1.77	0.266	1.14	0.6	0.32	0.66	52.1	10.49
ORK-5	10759-5	60664	1.17	8.11	6.25	1.135	3.12	0.444	2.83	0.422	2.12	1.77	1.09	1.41	358.1	18.62
ORK-6	10759-6	60564	0.78	5.59	4.05	0.764	2.2	0.302	2	0.299	2.07	1.53	0.92	0.93	216.3	11.59
ORK-7	10759-7	60615	0.57	4.08	3.06	0.56	1.65	0.232	1.57	0.218	1.67	1.21	0.8	0.75	16.7	9.76
ORK-8	10759-8	60448	0.6	4.32	3.19	0.615	1.81	0.28	1.9	0.297	2.38	1.53	1.21	0.84	1741.1	16.32
ORK-9	10759-9	60761	0.85	5.96	4.47	0.868	2.49	0.33	2.26	0.355	2.76	1.37	1.25	0.97	322	12.11
ORK-10	10759-10	60851	0.62	4.29	3.27	0.632	1.87	0.284	1.85	0.266	2.38	1.24	1.05	0.85	83.3	10.04

References

Abrams, L., 2007. Conversion and the church in the Hebrides in the Viking Age: 'A very difficult thing indeed', in *West Over Sea: Studies in Scandinavian Sea-borne Expansion and Settlement before 1300*, eds. B.B. Smith, S. Taylor & G. Williams. Leiden: Brill, 169–93.

Aðaldbjarnarson, B. (ed.), 1941. *Heimskringla*, vol. I. Reykjavík: Hið Íslenzka Fornritafélag.

Aðaldbjarnarson, B. (ed.), 1945. *Heimskringla*, vol. II. Reykjavík: Hið Íslenzka Fornritafélag.

Aðaldbjarnarson, B. (ed.), 1951. *Heimskringla*, vol. III. Reykjavík: Hið Íslenzka Fornritafélag.

Adams, C.T., 2003. Paleoethnobotanical Analysis of 20 Samples from a Farm Midden at Quoygrew, Orkney, Scotland. Unpublished MA thesis, Washington University, Saint Louis, Missouri.

Adams, C.T., 2009. *Surplus Production and Socio-political Change during the Viking/Medieval Transition: a Paleoethnobotanical Investigation of Quoygrew Farm, Orkney*. PhD thesis, Washington University, Saint Louis, Missouri. ProQuest/UMI Catalogue number AAT 3369509, http://disexpress.umi.com.

Ævarsson, U., 2004. Gröf: methods and interpretation. *Archaeologia Islandica* 3, 112–20.

Albrethsen, S.E. & G. Ólafsson, 1998. A Viking Age hall, in *Man, Culture and Environment in Ancient Greenland: Report on a Research Project*, eds. J. Arneborg & H.C. Gulløv. Copenhagen: The Danish National Museum & Danish Polar Center, 19–26.

Aldred, O., 2010. Time for fluent landscapes, in *Conversations with Landscape*, eds. K. Benediktsson & K.A. Lund. Farnham: Ashgate, 59–78.

Allaby, R.G., F.R. Friedlaender, F.A. Reed *et al.*, 2010. Prehistory of Pacific population movements, in *The Global Origins and Development of Seafaring*, eds. A. Anderson, J.H. Barrett & K.V. Boyle. (McDonald Institute Monographs.) Cambridge: McDonald Institute for Archaeological Research, 143–57.

Allen, A., 2002. L'archéologie des sépultures à bateaux dans les Orcades, in *L'Héritage Maritime des Vikings en Europe de L'Ouest*, eds. E. Ridel & P. Bouet. Caen: Presses Universitaires de Caen, 247–66.

Ambrose, S.H. & L. Norr, 1993. Experimental evidence for the relationship of the carbon isotope ratios of whole diet and dietary protein to those of bone collagen and carbonate, in *Prehistoric Human Bone: Archaeology at the Molecular Level*, eds. J.B. Lambert & G. Grupe. Berlin: Springer-Verlag, 1–37.

Ambrosiani, K., 1981. *Viking Age Combs, Comb Making and Comb Makers in the Light of Finds from Birka and Ribe*. (Stockholm Studies in Archaeology 2.) Stockholm: Department of Archaeology, University of Stockholm.

Andersen, P.S., 1988. The Orkney church of the twelfth and thirteenth centuries: a stepdaughter of the Norwegian church?, in *St Magnus Cathedral and Orkney's Twelfth Century Renaissance*, ed. B. Crawford. Aberdeen: Aberdeen University Press, 56–68.

Andersen, P.S., 1991. When was regular annual taxation introduced in the Norse Islands of Britain: a comparative study of assessment systems in north-western Europe. *Scandinavian Journal of History* 16, 73–83.

Anderson, A., J.H. Barrett & K.V. Boyle (eds.), 2010. *The Global Origins and Development of Seafaring*. (McDonald Institute Monographs.) Cambridge: McDonald Institute for Archaeological Research.

Anderson, P.D., 1982. *Robert Stewart: Earl of Orkney, Lord of Shetland 1533–1593*. Edinburgh: John Donald.

Anderson, P.D., 1992. *Black Patie: the Life and Times of Patrick Stewart, Earl of Orkney, Lord of Shetland*. Edinburgh: John Donald.

Anderson, P.D., 1999. Earl Patrick and his enemies. *New Orkney Antiquarian Journal* 1, 42–52.

Andersson, E., 1999. *The Common Thread: Textile Production during the Late Iron Age–Viking Age*. Lund: KFSAB.

Andersson, H., 2003. Urbanisation, in *The Cambridge History of Scandinavia*, vol. I: *Prehistory to 1520*, ed. K. Helle. Cambridge: Cambridge University Press, 312–42.

Andersson, H., 2011. Towns, in *The Archaeology of Medieval Europe*, vol. 2: *Twelfth to Sixteenth Centuries*, eds. M. Carver & J. Klápště. Aarhus: Aarhus University Press, 370–75.

Andersson, H., L. Ersgård & E. Svensson (eds.), 1998. *Outland Use in Preindustrial Europe*. Stockholm: Almqvist & Wiksell International.

Andersson, H., G. Hansen & I. Øye (eds.), 2008. *De Første 200 Årene: Nytt blikk på 27 Skandinaviske middelalderbyer*. Bergen: University of Bergen.

Andersson, T.M. & K.E. Gade (eds.), 2000. *Morkinskinna: the Earliest Icelandic Chronicle of the Norwegian Kings (1030–1157)*. London: Cornell University Press.

Anderton, M., 1999. *Anglo-Saxon Trading Centres: Beyond the Emporia*. Glasgow: Cruithne Press.

Andrén, A., 1985. *Den Urbana Scenen*. Bonn: Rudolf Habelt Verlag.

Andrews, J.I., 2005. MAP II and Environmental Specialists: Assessing the Benefits of an Alternative Approach to Stratigraphy. Unpublished MSc thesis, University of York.

Antonsson, H., 2007. *St Magnús of Orkney: a Scandinavian Martyr-cult in Context*. Leiden: Brill.

Archibald, M.M. & P. Woodhead, 1975. Mediaeval and modern hoards. *Coin Hoards* 1, 85–110.

Arge, S.V., 1995. Mersogin bein — ein aldargamal matsiður. *Fróðskaparrit* 43, 59–65.

Arge, S.V., M.J. Church & S.D. Brewington, 2009. Pigs in

the Faroe Islands: an ancient facet of the islands' paleoeconomy. *Journal of the North Atlantic* 2, 19–32.

Armitage, P.L., 1982. A system for ageing and sexing the horn cores of cattle from British post-medieval sites (17th to early 18th century) with special reference to unimproved British longhorn cattle, in *Ageing and Sexing Animal Bones from Archaeological Sites*, eds. B. Wilson, C. Grigson & S. Payne. (British Archaeological Reports 109.) Oxford: BAR, 37–54.

Arneborg, J., 1998. The High Arctic 'utmark' of the Norse Greenlanders, in *Outland Use in Preindustrial Europe*, eds. H. Andersson, L. Ersgård & E. Svensson. Stockholm: Almqvist & Wiksell International, 156–66.

Arneborg, J., 2003. Norse Greenland: reflections on settlement and depopulation, in *Contact, Continuity and Collapse: the Norse Colonization of the North Atlantic*, ed. J.H. Barrett. (Studies in the Early Middle Ages.) Turnhout: Brepols, 163–82.

Ascough, P.L., G.T. Cook, M.J. Church, A.J. Dugmore, S.V. Arge & T.H. McGovern, 2006. Variability in North Atlantic marine radiocarbon reservoir effects at *c.*1000 AD. *The Holocene* 16, 131–6.

Ascough, P.L., G.T. Cook & A.J. Dugmore, 2009. North Atlantic marine [14]C reservoir effects: implications for late-Holocene chronological studies. *Quaternary Geochronology* 4, 171–80.

Ashby, S.P., 2006. Time, Trade and Identity: Bone and Antler Combs in Northern Britain *c.* AD 700–1400. Unpublished PhD thesis, University of York.

Ashby, S.P., 2007. Bone and antler combs. *The Finds Research Group* AD 700–1700 Datasheet 40, 1–6.

Ashby, S.P., 2009. Combs, contact and chronology: reconsidering hair combs in early-historic and Viking-Age Atlantic Scotland. *Medieval Archaeology* 53, 1–33.

Ashby, S.P., 2011. An atlas of medieval combs from northern Europe. *Internet Archaeology* 30, http://intarch.ac.uk/journal/issue30/ashby_index.html.

Askvik, H., 2008. Whetstones from Kaupang: petrographic description and provenance, in *The Kaupang Finds: Whetstones and Grindstones in the Settlement Area; the 1956–1974 Excavations*, ed. E. Mikkelsen. Oslo: Kulturhistorisk Museum, University of Oslo, 5–17.

Astill, G., 2009. Medieval towns and urbanization, in *Reflections: 50 Years of Medieval Archaeology, 1957–2007*, eds. R. Gilchrist & A. Reynolds. Leeds: Maney, 255–70.

Ayers, B., 2011. The growth of an urban landscape: recent research in early medieval Norwich. *Early Medieval Europe* 19, 62–90.

Aykroyd, R.G., D. Lucy, A.M. Pollard & C.A. Roberts, 1999. Nasty, brutish, but not necessarily short: a reconsideration of the statistical methods used to calculate age at death from adult human skeletal and dental age indicators. *American Antiquity* 64, 55–70.

Bailey, G.N. & A.S. Craighead, 2003. Late Pleistocene and Holocene Coastal palaeoeconomies: a reconsideration of the molluscan evidence from northern Spain. *Geoarchaeology: an International Journal* 18, 175–204.

Bailey, M., 1989. The concept of the margin in the medieval English economy. *Economic History Review* 42, 1–17.

Baker, J. & D.R. Brothwell, 1980. *Animal Diseases in Archaeology*. London: Academic Press.

Balasse, M., A. Tresset, K. Dobney & S.H. Ambrose, 2005. The use of isotope ratios to test for seaweed eating in sheep. *Journal of Zoology* 266, 283–91.

Baldwin, J.R., 1974. Sea bird fowling in Scotland and Faroe. *Folk Life* 12, 60–103.

Baldwin, J.R., 1978. Norse influences in sheep husbandry on Foula, Shetland, in *Scandinavian Shetland, an Ongoing Tradition?*, ed. J.R. Baldwin. Edinburgh: Scottish Society for Northern Studies, 97–127.

Ballantyne, J.H. & B Smith (eds.), 1999. *Shetland Documents 1195–1579*. Lerwick: Shetland Islands Council & The Shetland Times Ltd.

Balasse, M., I. Mainland & M. Richards, 2009. Stable isotope evidence for seasonal consumption of marine seaweed by modern and archaeological sheep in the Orkney archipelago (Scotland). *Environmental Archaeology* 14, 1–14.

Ballin Smith, B., 1999. Locally made coarsewares, in *The Biggings, Papa Stour, Shetland: the History and Excavation of a Royal Norwegian Farm*, eds. B.E. Crawford & B. Ballin Smith. (Monograph Series 15.) Edinburgh: Society of Antiquaries of Scotland, 144–56.

Ballin Smith, B., 2007. Norwick: Shetland's first Viking settlement?, in *West Over Sea: Studies in Scandinavian Seaborne Expansion and Settlement before 1300*, eds. B.B. Smith, S. Taylor & G. Williams. Leiden: Brill, 287–98.

Ballin Smith, B. & J.W. Allen, 1999. Whetstones, in *The Biggings, Papa Stour, Shetland: the History and Excavation of a Royal Norwegian Farm*, eds. B.E. Crawford & B. Ballin Smith. (Monograph Series 15.) Edinburgh: Society of Antiquaries of Scotland, 180–82.

Barbier, E.B., 2011. *Scarcity and Frontiers: How Economies have Developed through Natural Resource Exploitation.* Cambridge: Cambridge University Press.

Barker, D., 2005. Pottery usage in a crafting community: an overview, in *From Clan to Clearance: History and Archaeology on the Isle of Barra c. 850–1850 AD*, ed. K. Branigan. Oxford: Oxbow Books, 111–22.

Barnes, M.P., 1998. *The Norn Language of Orkney and Shetland*. Lerwick: The Shetland Times.

Barrell, A.D.M., 2000. *Medieval Scotland*. Cambridge: Cambridge University Press.

Barrett, J.H., 1995. 'Few Know an Earl in Fishing-clothes.' Fish Middens and the Economy of the Viking Age and Late Norse Earldoms of Orkney and Caithness, Northern Scotland. Unpublished PhD thesis, University of Glasgow.

Barrett, J.H., 1997. Fish trade in Norse Orkney and Caithness: a zooarchaeological approach. *Antiquity* 71, 616–38.

Barrett, J.H., 2003a. Christian and pagan practice during the conversion of Viking Age Orkney and Shetland, in *The Cross Goes North*, ed. M. Carver. Woodbridge: Boydell Press, 207–26.

Barrett, J.H., 2003b. Culture contact in Viking Age Scotland, in *Contact, Continuity and Collapse: the Norse Colonization of the North Atlantic*, ed. J.H. Barrett. (Studies in the Early Middle Ages.) Turnhout: Brepols, 73–111.

Barrett, J.H. (ed.), 2003c. *Contact, Continuity and Collapse: the Norse Colonization of the North Atlantic*. Turnhout:

Brepols, Studies in the Early Middle Ages.

Barrett, J.H., 2004a. Swein Asleiffson, in *Oxford Dictionary of National Biography*, eds. H.C.G. Matthew & B. Harrison. Oxford: Oxford University Press. http://www.oxforddnb.com/view/article/49359.

Barrett, J.H., 2004b. Beyond war or peace: the study of culture contact in Viking-age Scotland, in *Land, Sea and Home: Proceedings of a Conference on Viking-period Settlement*, eds. J. Hines, A. Lane & M. Redknap. (Society for Medieval Archaeology Monograph 20.) Leeds: Maney, 207–18.

Barrett, J.H., 2005a. Economic intensification in Viking Age and medieval Orkney, Scotland: excavations at Quoygrew, in *Viking and Norse in the North Atlantic: Select Papers from the Proceedings of the Fourteenth Viking Congress, Tórshavn, 19–30 July 2001*, eds. A. Mortensen & S.V. Arge. (Annales Societatis Scientiarum Færoensis Supplementum XLIV.) Tórshavn: Føroya Fróðskaparfelag, 264–83.

Barrett, J.H., 2005b. Svein Asleifarson and 12th-century Orcadian society, in *The World of Orkneyinga Saga*, ed. O. Owen. Kirkwall: The Orcadian, 213–23.

Barrett, J.H., 2007. The pirate fishermen: the political economy of a medieval maritime society, in *West over Sea: Studies in Scandinavian Sea-borne Expansion and Settlement before 1300*, eds. B.B. Smith, S. Taylor & G. Williams. Leiden: Brill, 299–340.

Barrett, J.H., 2008. The Norse in Scotland, in *The Viking World*, eds. S. Brink & N.S. Price. London: Routledge, 411–27.

Barrett, J.H., 2010. Rounding up the usual suspects: causation and the Viking Age diaspora, in *The Global Origins and Development of Seafaring*, eds. A. Anderson, J.H. Barrett & K.V. Boyle. (McDonald Institute Monographs.) Cambridge: McDonald Institute for Archaeological Research, 289–302.

Barrett, J.H., 2011. Navigating crisis and collapse: a commentary. *Archaeological Review from Cambridge* 26.1, 137–43.

Barrett, J.H. & A. Anderson, 2010. Histories of global seafaring: a discussion, in *The Global Origins and Development of Seafaring*, eds. A. Anderson, J.H. Barrett & K.V. Boyle. (McDonald Institute Monographs.) Cambridge: McDonald Institute for Archaeological Research, 305–14.

Barrett, J. & J. Oltmann, 2000. The Zooarchaeology of Sandwick North, Unst, Shetland. Unpublished report.

Barrett, J.H. & M.P. Richards, 2004. Identity, gender, religion and economy: new isotope and radiocarbon evidence for marine resource intensification in Early Historic Orkney, Scotland, UK. *European Journal of Archaeology* 7(3), 249–71.

Barrett, J.H. & A. Slater, 2009. New excavations at the Brough of Deerness: power and religion in Viking Age Scotland. *Journal of the North Atlantic* 2, 81–94.

Barrett, J., I. Simpson & A. Davis, 1998. Cleat, Loch of Burness, Quoygrew-Nether Trenabie and Trenabie. *Discovery & Excavation in Scotland* 1997, 61.

Barrett, J.H., R.A. Nicholson & R. Cerón-Carrasco, 1999. Archaeo-ichthyological evidence for long-term socio-economic trends in northern Scotland: 3500 BC to AD 1500. *Journal of Archaeological Science* 26, 353–88.

Barrett, J., R. Beukens, I. Simpson, P. Ashmore, S. Poaps & J. Huntley, 2000a. What was the Viking Age and when did it happen? A view from Orkney. *Norwegian Archaeological Review* 33, 1–39.

Barrett, J., T. O'Connor & S. Dobson, 2000b. Evertaft, Orkney (Westray Parish), Iron Age settlement mound. *Discovery and Excavation in Scotland*, New Series 1, 68.

Barrett, J.H., R.P. Beukens & D.R. Brothwell, 2000c. Radiocarbon dating and marine reservoir correction of Viking Age Christian burials from Orkney. *Antiquity* 74, 537–43.

Barrett, J.H., R.P. Beukens & R.A. Nicholson, 2001. Diet and ethnicity during the Viking colonisation of northern Scotland: evidence from fish bones and stable carbon isotopes. *Antiquity* 75, 145–54.

Barrett, J.H., A.M. Locker & C.M. Roberts, 2004. 'Dark Age economics' revisited: the English fish bone evidence AD 600–1600. *Antiquity* 78, 618–36.

Barrett, J., A. Hall, C. Johnstone, H. Kenward, T. O'Connor & S. Ashby, 2007. Interpreting the plant and animal remains from Viking-age Kaupang, in *Kaupang in Skiringssal*, ed. D. Skre. Aarhus: Aarhus University Press, 283–319.

Barrett, J., C. Johnstone, J. Harland *et al.*, 2008a. Detecting the medieval cod trade: a new method and first results. *Journal of Archaeological Science* 35, 850–61.

Barrett, J., M. Melikian & M. Richards, 2008b. 'The dietary study', in Excavation of medieval graves at St Thomas' Kirk, Hall of Rendall, Orkney, ed. R. Toolis. *Proceedings of the Society of Antiquaries of Scotland* 138, 252–5.

Barrett, J.H., D. Orton, C. Johnstone *et al.*, 2011. Interpreting the expansion of sea fishing in medieval Europe using stable isotope analysis of archaeological cod bones. *Journal of Archaeological Science* 38, 1516–24.

Barth, F., 1969. Introduction, in *Ethnic Groups and Boundaries: the Social Organization of Culture Difference*, ed. F. Barth. Boston (MA): Little, Brown and Company, 9–38.

Bartlett, R., 1993. *The Making of Europe: Conquest, Colonisation and Cultural Change 950–1350*. London: Penguin Books.

Bartosiewicz, L., 2005. Worked elk (*Alces alces* L. 1758) antler from central Europe, in *From Hooves to Horns, from Mollusc to Mammoth. Proceedings of the 4th Meeting of the Worked Bone Research Group, Tallinn, Estonia, August 2003*, eds. H. Luik, A.M. Choyke, C.E. Batey & L. Lõugas. (Muinasaja teadus 15.) Tallinn: Tallinn Book Printers Ltd, 339–50.

Bately, J. & A, Englert (eds.), 2007. *Ohthere's Voyages: a Late 9th-century Account of Voyages along the Coasts of Norway and Denmark and its Cultural Context*. Roskilde: Viking Ship Museum.

Batey, C.E., 1987. *Freswick Links, Caithness: a Reappraisal of the Late Norse Site in its Context*. (British Archaeological Reports, British Series 179.) Oxford: BAR.

Batey, C.E., 1989. Excavations beside the Brough Road, Birsay: the artefact assemblage, in *The Birsay Bay Project*, vol. 1: *Coastal Sites beside the Brough Road, Birsay, Orkney, Excavations 1976–1982*, ed. C.D. Morris. (Monograph Series 1.) Durham: University of Durham, Department of Archaeology, 191–229.

Batey, C.E., 1991. Archaeological aspects of Norse settlement in Caithness, north Scotland. *Acta Archaeologica* 61, 29–35.

Batey, C.E. & C. Freeman, 1986. Lavacroon, Orphir, Orkney. *Proceedings of the Society of Antiquaries of Scotland* 116, 285–300.

Batey, C.E. & C. Freeman, 1996. The artefactual assemblage,in *The Birsay Bay Project,* vol. 2: *Sites in Birsay Village and on the Brough of Birsay, Orkney,* by C.D. Morris. (Monograph Series 2.) Durham: University of Durham, Department of Archaeology, 133–47.

Batey, C.E. & C.D. Morris, 1992. Earl's Bu, Orphir, Orkney: excavation of a Norse horizontal mill, in *Norse and Later Settlement and Subsistence in the North Atlantic,* eds. C.D. Morris & D.J. Rackham. Glasgow: Department of Archaeology, University of Glasgow, 33–41.

Baug, I., 2005. Who owned the products? Production and exchange of quernstones, Hyllestad in Sogn, western Norway, in *'Utmark': the Outfield as Industry and Ideology in the Iron Age and the Middle Ages,* eds. I. Holm, S. Innselset & I. Øye. Bergen: University of Bergen, 99–108.

Baug, I., 2011. Soapstone finds, in *Things from the Town: Artefacts and Inhabitants in Viking-age Kaupang,* ed. D. Skre. Aarhus: Aarhus University Press, 311–37.

Beatty, J., 1992. *Sula, the Seabird Hunters of Lewis.* Lewis: Michael Joseph.

Becker, C., 2005. Spindle whorls or buttons? Ambiguous bone artefacts from a Bronze Age castelliere on Istria, in *From Hooves to Horns, from Mollusc to Mammoth. Proceedings of the 4th Meeting of the Worked Bone Research Group, Tallinn, Estonia, August 2003,* eds. H. Luik, A.M. Choyke, C.E. Batey & L. Lõugas. (Muinasaja teadus 15.) Tallinn: Tallinn Book Printers Ltd, 157–74.

Beijerink, W., 1947. *Zandenatlas der Nederlandsche Flora.* Wageningen: H. Veenman.

Bell, J., 2006. *Nine Potteries in Kirkcaldy: a History.* Fife: Fife Pottery Society.

Benedictow, O.J., 1996. The demography of the Viking age and the high middle ages in the Nordic countries. *Scandinavian Journal of History* 21, 151–82.

Benedictow, O.J., 2003. Demographic conditions, in *The Cambridge History of Scandinavia,* vol. I: *Prehistory to 1520,* ed. K. Helle. Cambridge: Cambridge University Press, 237–49.

Benedictow, O.J., 2004. *The Black Death 1346–1353: the Complete History.* Woodbridge: The Boydell Press.

Beresford, M.W., 1954. *The Lost Villages of England.* London: Lutterworth Press.

Beresford, M. & J. Hurst, 1990. *Wharram Percy: Deserted Medieval Village.* London: Batsford/English Heritage.

Berggren, L., N. Hybel & A. Landen (eds.), 2002. *Cogs, Cargoes, and Commerce: Maritime Bulk Trade in Northern Europe, 1150–1400.* Toronto: Pontifical Institute of Mediaeval Studies.

Bergsåker, J., 1978. The keeping and milking of sheep in the old subsistence economy of Scandinavia, Iceland and northern Europe, in *Scandinavian Shetland: an Ongoing Tradition?,* ed. J.R. Baldwin. Edinburgh: Scottish Society for Northern Studies, 85–96.

Berry, R.J., 2000. *Orkney Nature.* London: T. & A.D. Poyser Natural History.

Berson, B., 2002. A contribution to the study of the medieval Icelandic farm: the byre. *Archaeologia Islandica* 2, 34–60.

Bersu, G. & D.M. Wilson, 1966. *Three Viking Graves in the Isle of Man.* (Monograph Series 1.) London: Society for Medieval Archaeology.

Bertelsen, R. & R.G. Lamb, 1993. Settlement mounds in the North Atlantic, in *Caithness, Orkney and the North Atlantic in the Viking Age,* eds. C.E. Batey, J. Jesch & C.D. Morris. Edinburgh: Edinburgh University Press, 544–53.

Beuermann, I., 2009. Sveinn Ásleifarson and the Irish Sea, in *Scandinavian Scotland: Twenty Years After,* ed. A. Woolf. (Paper 12.) St Andrews: St John's House, 131–68.

Bhabha, H.K., 1994. *The Location of Culture.* London: Routledge.

Bhattacharyya, B. & B.M. Johri, 1998. *Flowering Plants: Taxonomy and Phylogeny.* Delhi: Narosa Publishing House.

Bibire, P., 1988. The poetry of Earl Rognvald's court, in *St Magnus Cathedral and Orkney's Twelfth Century Renaissance,* ed. B.E. Crawford. Aberdeen: Aberdeen University Press, 208–40.

Bigelow, G.F., 1984. Subsistence in Late Norse Shetland: an Investigation into a Northern Island Economy of the Middle Ages. Unpublished PhD thesis, University of Cambridge.

Bigelow, G.F., 1985. Sandwick, Unst and Late Norse Shetland economy, in *Shetland Archaeology: New Work in the 1970s,* ed. B. Smith. Lerwick: The Shetland Times, 95–127.

Bigelow, G.F., 1987. Domestic architecture in medieval Shetland. *Review of Scottish Culture* 3, 23–38.

Bigelow, G.F., 1989. Life in medieval Shetland: an archaeological perspective. *Hikuin* 15, 183–92.

Bigelow, G.F., 1992. Issues and prospects in Shetland Norse archaeology, in *Norse and Later Settlement and Subsistence in the North Atlantic,* eds. C.D. Morris & D.J. Rackham. Glasgow: University of Glasgow, Department of Archaeology, 9–32.

Bigelow, G.F., 1993. Archaeological and ethnohistoric evidence of a Norse island food custom, in *The Viking Age in Caithness, Orkney and the North Atlantic,* eds. C.E. Batey, J. Jesch & C.D. Morris. Edinburgh: Edinburgh University Press, 441–53.

Bill, J., 2002. The cargo vessels, in *Cogs, Cargoes, and Commerce: Maritime Bulk Trade in Northern Europe, 1150–1400,* eds. L. Berggren, N. Hybel & A. Landen. Toronto: Pontifical Institute of Mediaeval Studies, 92–112.

Bill, J., 2005. Kiloran Bay revisited: confirmation of a doubtful boat-grave, in *Viking and Norse in the North Atlantic: Select Papers from the Proceedings of the Fourteenth Viking Congress, Tórshavn, 19–30 July 2001,* eds. A. Mortensen & S.V. Arge. Tórshavn: Føroya Fróðskaparfelag, 345–58.

Biller, P., 2000. *The Measure of Multitude: Population in Medieval Thought.* Oxford: Oxford University Press.

Birth, K., 2008. The creation of coevalness and the danger of homochronism. *Journal of the Royal Anthropological Institute* (NS) 14, 3–20.

Black, J., 2005. The decline and fall of Delftware production in the British Isles. *Journal of the Northern Ceramic Society* 21, 9–14.

Blackmore, L., 1999a. The north German/south Scandinavian redwares, in *The Biggings, Papa Stour, Shetland: the History and Excavation of a Royal Norwegian Farm*, eds. B.E. Crawford & B. Ballin Smith. (Monograph Series 15.) Edinburgh: Society of Antiquaries of Scotland, 157–67.

Blackmore, L., 1999b. Paffrath ware, in *The Biggings, Papa Stour, Shetland: the History and Excavation of a Royal Norwegian Farm*, eds. B.E. Crawford & B. Ballin Smith. (Monograph Series 15.) Edinburgh: Society of Antiquaries of Scotland, 156.

Blackmore, L. & J. Pearce, 2010. *Medieval Coarsewares of the London Area. A Dated Type Series of London Medieval Pottery*, part 5: *Shelly-sandy Ware and the Greyware Industries*. (MoLAS Monograph Series 49.) London: Museum of London.

Blackmore, L. & A. Vince, 1994. Medieval pottery from south east England found in the Bryggen excavations 1955–68, in *The Bryggen Papers* Supplementary Series no. 5, eds. A.E. Herteig, K. Helle & S. Indrelid. Bergen: Scandinavian University Press, 9–160.

Blumenschine, R.J., C.W. Marean & S.D. Capaldo, 1996. Blind tests of inter-analyst correspondence and accuracy in the identification of cut-marks, percussion marks, and carnivore tooth marks on bone surfaces. *Journal of Archaeological Science* 23, 493–507.

Boardman, S. & G. Jones, 1990. Experiments on the effects of charring on cereal plant components. *Journal of Archaeological Science* 17, 1–11.

Bogaard, A., T.H.E. Heaton, P. Poulton & I. Merbach, 2007. The impact of manuring on nitrogen isotope ratios in cereals: archaeological implications for reconstruction of diet and crop management practices. *Journal of Archaeological Science* 34, 335–43.

Bond, J.M., 1998. Beyond the fringe? Recognising change and adaptation in Pictish and Norse Orkney, in *Human Settlement in Marginal Areas*, eds. C.M. Mills & G. Coles. (Monograph 100.) Oxford: Oxbow Books, 81–90.

Bond, J.M., 2007a. The bioarchaeological evidence, in *Investigations in Sanday, Orkney*, vol. 1: *Excavations at Pool, Sanday Multi-period Settlement from Neolithic to Late Norse Times*, eds. J. Hunter, J.M. Bond & A.N. Smith. Kirkwall: The Orcadian/Historic Scotland, 169–286.

Bond, J.M., 2007b. The mammal bone, in *Investigations in Sanday, Orkney*, vol. 1: *Excavations at Pool, Sanday Multi-period Settlement from Neolithic to Late Norse Times*, eds. J. Hunter, J.M. Bond & A.N. Smith. Kirkwall: The Orcadian/Historic Scotland, 207–62.

Bond, J.M. & J.R. Summers, 2010. Macrobotanical remains, in *Excavations at Old Scatness, Shetland*, vol. 1: *The Pictish and Viking Settlement*, eds. S.J. Dockrill, J.M. Bond, V.E. Turner, L.D. Brown, D.J. Bashford, J.E. Cussans & R.A. Nicholson. Lerwick: Shetland Heritage Publications, 178–95.

Bond, J.M., E. Guttmann & I.A. Simpson, 2004. Bringing in the sheaves: farming intensification in the post-broch Iron Age, in *Atlantic Connections and Adaptations: Economies, Environments and Subsistence in Lands Bordering the North Atlantic*, eds. R.A. Housley & G. Coles. (Symposia for the Association of Environmental Archaeology 21.) Oxford: Oxbow Books, 138–45.

Bond, J.M., A.C. Larson & V.E. Turner, 2008. Hamar, Belmont and Underhoull. *Discovery and Excavation in Scotland, New Series* 9, 162–4.

Bond, J.M., J.R. Summers & J.E. Cussans, 2010. Macrobotanical remains, in *Excavations at Old Scatness, Shetland*, vol. 1: *The Pictish and Viking Settlement*, eds. S. Dockrill, J. Bond, V. Turner, L. Brown, D. Bashford, J. Cussans & R. Nicholson. Lerwick: Shetland Heritage Publications, 178–95.

Boomert, A. & A. Bright, 2007. Island archaeology: in search of a new horizon. *Island Studies Journal* 2, 3–26.

Booth, C. & J. Booth, 1994. *The Mammals of Orkney*. Kirkwall: The Orcadian Limited.

Booth, C. & J. Booth, 1998. *Status and Checklist of the Vertebrate Fauna of Orkney*. Kirkwall: The Orcadian.

Booth, C., M. Cuthbert & P. Reynolds, 1984. *The Birds of Orkney*. Kirkwall: The Orkney Press.

Bowden, G.R., P. Balaresque, T.E. King *et al.*, 2007. Excavating past population structures by surname-based sampling: the genetic legacy of the Vikings in northwest England. *Molecular Biology and Evolution* 25, 301–9.

Bowman, A., 1990. Boat naust survey on Papa Westray, Orkney. *International Journal of Nautical Archaeology* 19, 317–25.

Brabant, J., H. Brandenburg, U. Buchhop-Kolbow *et al.*, 1993. *Spätmittelalterliche und Neuzeitliche Keramik aus einer Kloake auf dem Grundstück Schüsselbuden 6/Alfstrasse 1 in Lübeck*. (Lübecker Schriften zur Archäologie und Kulturgeschichte 23.) Schleswig: Archäologisch-Zoologische Arbeitsgruppe (AZA), 219–76.

Brand, J., 1883 [1701]. *A Brief Description of Orkney, Zetland, Pightland-Firth and Caithness*. Edinburgh: William Brown.

Breckenridge, F.J., 2009. Vikings in Atlantic Scotland: a Study in the Trade of Norwegian Whetstones as an Indicator of Viking Migration and Identity. Unpublished MPhil thesis, University of Cambridge.

Brink, S., 2001. Mythologizing landscape: place and space of cult and myth, in *Kontinuitäten und Brüche in der Religionsgeschichte*, ed. M. Stausberg. Berlin: Walter de Gruyter, 76–112.

Brisbane, M., N. Makarov & E. Nosov (eds.), 2012. *The Archaeology of Medieval Novgorod in Context: Studies in Centre/Periphery Relations*. Oxford: Oxbow Books.

Britton, K., G. Müldner & M. Bell, 2008. Stable isotope evidence for salt-marsh grazing in the Bronze Age Severn Estuary, UK: implications for palaeodietary analysis at coastal sites. *Journal of Archaeological Science* 35, 2111–18.

Broderick, G. (ed.), 1996. *Chronica Regum Mannie et Insularum [Chronicles of the Kings of Man and the Isles]*. Douglas: Manx National Heritage.

Brody, H., 1988. *Maps and Dreams: Indians and the British Columbia Frontier*. Vancouver: Douglas & McIntyre.

Bronk Ramsey, C., 2009. Bayesian analysis of radiocarbon dates. *Radiocarbon* 51, 337–60.

Broodbank, C., 2008. Not waving but drowning. *Journal of Island and Coastal Archaeology* 3, 72–6.

Broun, D., 1994. The origin of Scottish identity in its European context, in *Scotland in Dark Age Europe*, ed. B.E. Crawford. St Andrews: The Committee for Dark Age Studies, University of St Andrews, 21–32.

Brown, T.A., D.E. Nelson, J.S. Vogel & J.R. Southon, 1988. Improved collagen extraction by modified Longin method. *Radiocarbon* 30, 171–7.

Brughmans, T., 2010. Connecting the dots: towards archaeological network analysis. *Oxford Journal of Archaeology* 29, 277–303.

Buckley, T.E. & J.A. Harvie-Brown, 1891. *A Vertebrate Fauna of the Orkney Islands*. Edinburgh: David Douglas.

Burmeister, S., 2000. Archaeology and migration: approaches to an archaeological proof of migration. *Current Anthropology* 41, 539–68.

Burnett, G. (ed.), 1878. *The Exchequer Rolls of Scotland*, vol. II. Edinburgh: H.M. General Register House.

Butler, V.L. & J.C. Chatters, 1994. The role of bone density in structuring prehistoric salmon bone assemblages. *Journal of Archaeological Science* 21, 413–24.

Byock, J., 2001. *Viking Age Iceland*. London: Penguin.

Caldwell, D., 1982. 'Clay pipes', in Excavations in Kirkwall, 1978, by N.A. McGavin. *Proceedings of the Society of Antiquaries of Scotland* 112, 422–6.

Caldwell, D.H., 2007. Having the right kit: West Highlanders fighting in Ireland, in *The World of the Galloglass: Kings, Warlords and Warriors in Ireland and Scotland, 1200–1600*, ed. S. Duffy. Dublin: Four Courts Press, 144–68.

Caldwell, D.H., 2010. *Finlaggan Report 1: Introduction and Background*. Edinburgh: National Museums Scotland. http://repository.nms.ac.uk/214/. (Consulted 8 November 2011.)

Cambridge, E., 1988. The architectural context of the Romanesque cathedral at Kirkwall, in *St Magnus Cathedral and Orkney's Twelfth Century Renaissance*, ed. B. Crawford. Aberdeen: Aberdeen University Press, 111–26.

Cameron, A. & D.H. Evans, 2001. Pottery, in *Aberdeen: an Indepth View of the City's Past*, eds. A.S. Cameron & J.A. Stones. (Monograph Series 19.) Edinburgh: Society of Antiquaries of Scotland, 153–92.

Campbell, E., 2002. The Western Isles pottery sequence, in *In the Shadow of the Brochs: the Iron Age in Scotland*, eds. B. Ballin Smith & I. Banks. Stroud: Tempus, 139–44.

Campbell, J., 2002. The millennium herring, in *East Anglia's History*, eds. C. Harper-Bill, C. Rawcliffe & R.G. Wilson. Woodbridge: Boydell, 5–17.

Cannon, D.Y., 1987. *Marine Fish Osteology: a Manual for Archaeologists*. Burnaby, BC: Archaeology Press, Simon Fraser University.

Card, N., 2005. Assessment of the prehistoric periods, in *The Heart of Neolithic Orkney World Heritage Site Research Agenda*, eds. J. Downes, S.M. Foster, C.R. Wickham-Jones & J. Callister. Edinburgh: Historic Scotland, 46–65.

Carlé, P., D. Sigurdh & K. Ambrosiani, 1976. *Preliminary Results of Proton-Induced X-ray Analysis of Archaeologic Antler Findings*. Stockholm: Annual Reports from Research Institute of Physics.

Carter, S., 1998. 'Farm mounds' and the formation of the Area 1 sediments, in *St Boniface Church, Orkney: Coastal Erosion and Archaeological Assessment*, ed. C. Lowe. Edinburgh: Sutton Publishing and Historic Scotland, 187–99.

Carver, M.O.H., 1979. Three Saxo-Norman tenements in Durham city. *Medieval Archaeology* 23, 1–80.

Carver, M., 2002. Marriages of true minds: archaeology with texts, in *Archaeology: the Widening Debate*, eds. B. Cunliffe, W. Davies & C. Renfrew. Oxford: Oxford University Press, 465–96.

Cerón-Carrasco, R., 1998. Fish bone, in *St Boniface Church, Orkney: Coastal Erosion and Archaeological Assessment*, ed. C. Lowe. Edinburgh: Sutton Publishing and Historic Scotland, 149–55.

Cerón-Carrasco, R., 2005. *'Of Fish and Men', De iasg agus dhaoine. A Study of the Utilization of Marine Resources as Recovered from Selected Hebridean Archaeological Sites*. Oxford: Tempus Reparatum.

Challinor, C., 2004. Butter as an economic resource in the Northern Isles, in *Atlantic Connections and Adaptations: Economies, Environments and Subsistence in Lands Bordering the North Atlantic*, eds. R.A. Housley & G. Coles. Oxford: Oxbow Books, 163–74.

Champion, T.C. (ed.), 1989. *Centre and Periphery: Comparative Studies in Archaeology*. London: Unwin Hyman.

Chase-Dunn, C. & T.D. Hall, 1991. Conceptualizing core/periphery hierarchies for comparative study, in *Core/Periphery Relations in Precapitalist Worlds*, eds. C. Chase-Dunn & T.D. Hall. Boulder (CO): Westview Press, 5–44.

Chase-Dunn, C. & K.M. Mann, 1998. *The Wintu and their Neighbors: a Very Small World-system in Northern California*. Tucson (AZ): University of Arizona Press.

Chenery, S., 2006. Summary Report on Chemo-typing some Redware Pottery Sherds from Orkney. Unpublished report.

Chibnall, M. (ed.), 1975. *The Ecclesiastical History of Orderic Vitalis*, vol. V: *Books IX and X*. Oxford: Clarendon Press.

Christensen, T., 1991. Lejre beyond legend — the archaeological evidence. *Journal of Danish Archaeology* 10, 163–85.

Christensen, T., 2010. Odin fra Lejre. *ROMU* 2010, 7–25.

Christiansen, R., 1962. The people of the north. *Lochlann* 2, 137–64.

Christie, N. & P. Stamper (eds.), 2012. *Medieval Rural Settlement: Britain and Ireland, AD 800–1600*. Oxford: Windgather Press.

Church, M.J. & C. Peters, 2004. Application of mineral magnetism in Atlantic Scotland archaeology, part 2: magnetic susceptibility and archaeobotanical taphonomy in West Lewis, Scotland, in *Atlantic Connections and Adaptations: Economies, Environments and Subsistence in Lands Bordering the North Atlantic*, eds. R.A. Housley & G. Coles. Oxford: Oxbow Books, 99–113.

Church, M.J., S.V. Arge, S. Brewington *et al.*, 2005. Puffins, pigs, cod, and barley: palaeoeconomy at Undir Junkarinsfløtti, Sandoy, Faroe. *Environmental Archaeology* 10, 179–97.

Claassen, C., 1986. Temporal patterns in marine shellfish-

species use along the Atlantic coast in the South-eastern United States. *Southeastern Archaeology* 5, 120–37.

Claassen, C., 1998. *Shells*. Cambridge: Cambridge University Press.

Clark, J. (ed.), 1995. *The Medieval Horse and its Equipment: c.1150–c.1450*. London: HMSO.

Clark, P.V., 1976. 'German stoneware', in Excavations south of Edinburgh High Street, 1973–4, by J. Schofield. *Proceedings of the Society of Antiquaries of Scotland* 107, 206–11.

Clarke, A., 1998a. The coarse stone, flint and pumice, in *St Boniface Church Orkney: Coastal Erosion and Archaeological Assessment*, ed. C. Lowe. Edinburgh: Sutton Publishing and Historic Soctalnd, 133–9.

Clarke, A., 1998b. Cobble tools, in *Scalloway: a Broch, Late Iron Age Settlement and Medieval Cemetery in Shetland*, ed. N. Sharples. (Oxbow Monograph 82.) Oxford: Oxbow Books, 140–44.

Clarke, A., 1999. The coarse stone tools, in *Kebister: the Four-thousand-year-old Story of One Shetland Township*, eds. O. Owen & C. Lowe. (Monograph Series 14.) Edinburgh: Society of Antiquaries of Scotland, 151–64.

Clarke, A., 2006. *Stone Tools and the Prehistory of the Northern Isles*. Oxford: Archaeopress.

Clarke, A., 2007. Coarse stone, in *Investigations in Sanday, Orkney*, vol. 1: *Excavations at Pool, Sanday. Multi-period Settlement from Neolithic to Late Norse Times*, eds. J. Hunter, J.M. Bond & A.N. Smith. Kirkwall: The Orcadian/Historic Scotland, 353–89.

Clarke, A., P. Macdonald & A. Smith, 2005. Artefact classes, in *A Norse Farm in the Outer Hebrides: Excavations at Mound 3, Bornais, South Uist*, ed. N. Sharples. Oxford: Oxbow Books, 171–4.

Clarke, D. & A. Heald, 2002. Beyond typology: combs, economics, symbolism and regional identity in Late Norse Scotland. *Norwegian Archaeological Review* 35, 81–94.

Clouston, J.S., 1914. *Records of the Earldom of Orkney*. Edinburgh: The Scottish History Society.

Clutton-Brock, J. & A. MacGregor, 1988. An end to medieval reindeer in Scotland. *Proceedings of the Society of Antiquaries of Scotland* 118, 23–35.

Cnotliwy, E., 1973. *Rzemiosło Rogownicze na Pomorzu Sczesnośredniowiecznym [Antler Handicraft in Early Medieval Pomerania]*. Wrocław: Polska Akademia Nauk Instytut Historii Kultury Materialnej.

Colley, S.M., 1983. The Role of Fish Bone Studies in Economic Archaeology: with Special reference to the Orkney Isles. Unpublished PhD thesis, University of Southampton.

Colley, S.M., 1984. Some methodological problems in the interpretation of fish remains from archaeological sites in Orkney, in *2nd Fish Osteoarchaeology Meeting*, ed. N. Desse-Berset. (Notes et Monographies Techniques 16.) Paris: Centre National de la Recherche Archéologique, 117–31.

Colley, S.M., 1986. Site formation and archaeological fish remains: an ethnohistorical example from the Northern Isles, Scotland, in *Fish and Archaeology*, eds. D.C. Brinkhuizen & A.T. Clason. (British Archaeological Reports, International Series 294.) Oxford: BAR, 34–41.

Cooke, B., C. Christiansen & L. Hammarlund, 2002. Viking woollen square-sails and fabric cover factor. *International Journal of Nautical Archaeology* 31, 202–10.

Corbet, G.B. & S. Harris, 1991. *The Handbook of British Mammals*. 3rd edition. Oxford: Blackwell.

Coull, J.R., 1996. *The Sea Fisheries of Scotland: a Historical Geography*. Edinburgh: John Donald.

Cox, E., O. Owen & D. Pringle, 1998. The discovery of medieval deposits beneath the Earl's Palace, Kirkwall, Orkney. *Proceedings of the Society of Antiquaries of Scotland* 128, 567–80.

Craig, O.E., G. Taylor, J. Mulville, M.J. Collins & M. Parker Pearson, 2004. The identification of prehistoric dairying activities in the Western Isles of Scotland: an integrated biomolecular approach. *Journal of Archaeological Science* 32, 91–103.

Craighead, A.S., 1995. Marine Mollusca as Palaeoenvironmental and Palaeoeconomic Indicators in Cantabrian Spain. Unpublished PhD thesis, University of Cambridge.

Crawford, B., 1974. Peter's Pence in Scotland, in *The Scottish Tradition: Essays in Honour of Ronald Gordon Cant*, ed. G.W.S. Barrow. Edinburgh: Scottish Academic Press, 14–22.

Crawford, B.E., 1982. Scots and Scandinavians in medieval Caithness: a study of the period 1266–1375, in *Caithness a Cultural Crossroads*, ed. J.R. Baldwin. Edinburgh: Scottish Society for Northern Studies, 61–74.

Crawford, B.E., 1985a. William Sinclair, Earl of Orkney, and his family: a study in the politics of survival, in *Essays on the Nobility of Medieval Scotland*, ed. K.J. Stringer. Edinburgh: John Donald, 232–51.

Crawford, B.E., 1985b. The earldom of Caithness and the kingdom of Scotland, 1150–1266, in *Essays on the Nobility of Medieval Scotland*, ed. K.J. Stringer. Edinburgh: John Donald, 25–43.

Crawford, B.E., 1987. *Scandinavian Scotland*. Leicester: Leicester University Press.

Crawford, B.E. (ed.), 1988. *St Magnus Cathedral and Orkney's Twelfth-century Renaissance*. Aberdeen: Aberdeen University Press.

Crawford, B.E., 1993. Norse earls and Scottish bishops in Caithness: a clash of cultures, in *Caithness, Orkney and the North Atlantic in the Viking Age*, eds. C.E. Batey, J. Jesch & C.D. Morris. Edinburgh: Edinburgh University Press, 129–47.

Crawford, B.E., 1995a. *Earl and Mormaer: Norse–Pictish Relationships in Northern Scotland*. Rosemarkie: Groam House Museum.

Crawford, B.E. (ed.), 1995b. *Scandinavian Settlement in Northern Britain*. London: Leicester University Press.

Crawford, B.E., 1999. Papa Stour in history, in *The Biggings, Papa Stour, Shetland: the History and Excavation of a Royal Norwegian Farm*, eds. B.E. Crawford & B. Ballin Smith. (Monograph Series 15.) Edinburgh: Society of Antiquaries of Scotland, 24–46.

Crawford, B.E., 2003. The bishopric of Orkney, in *Ecclesia Nidrosiensis 1153–1537: Søkelys på Nidaroskirkens og Nidarosprovinsens historie*, ed. S. Imsen. Trondheim: Tapir Akademisk Forlag, 143–58.

Crawford, B.E., 2005. Thorfinn, Christianity and Birsay: what the saga tells us and archaeology reveals, in *The World of Orkneyinga Saga*, ed. O. Owen. Kirkwall: The Orcadian, 88–110.

Crawford, B.E., 2006. Kongemakt og jarlemakt, stedsnavn som bevis? Betydningen av Houseby, Harry og *-staðir* navn på Orknøyenes West Mainland. *Viking* 69, 195–214.

Crawford, B.E. & B. Ballin Smith (eds.), 1999. *The Biggings, Papa Stour, Shetland: the History and Excavation of a Royal Norwegian Farm.* (Monograph Series 15.) Edinburgh: Society of Antiquaries of Scotland.

Critch, A., 2011. Churning the Economy: the Production and Export of Butter in the Medieval North Atlantic. Unpublished MPhil dissertation, Department of Archaeology and Anthropology, University of Cambridge.

Crone, A., 2000. Native tree-ring chronologies from some Scottish medieval burghs. *Medieval Archaeology* 44, 201–16.

Crosby, D.D.B. & J.G. Mitchell, 1987. A survey of British metamorphic hone stones of the 9th to 15th centuries AD in the light of Potassium-Argon and Natural Remanent Magnetization studies. *Journal of Archaeological Science* 14, 483–506.

Curle, C.L., 1982. *Pictish and Norse Finds from the Brough of Birsay 1934–74.* (Monograph Series 1.) Edinburgh: Society of Antiquaries of Scotland.

Cutting, C.L., 1955. *Fish Saving.* London: Leonard Hill.

Dahl-Jensen, D., K. Mosegaard, N. Gundestrup *et al.*, 1998. Past temperatures directly from the Greenland ice sheet. *Science* 282, 268–71.

Dahlbäck, G., 2003. The towns, in *The Cambridge History of Scandinavia*, vol. I: *Prehistory to 1520*, ed. K. Helle. Cambridge: Cambridge University Press, 611–34.

Dalglish, C., 2002. Highland rural settlement studies: a critical history. *Proceedings of the Society of Antiquaries of Scotland* 132, 475–98.

Dalglish, C., 2012. Scotland's medieval countryside: evidence, interpretation, perception, in *Medieval Rural Settlement: Britain and Ireland, AD 800–1600*, eds. N. Christie & P. Stamper. Oxford: Windgather Press, 270–86.

Dalglish, C. & P. Dixon, 2007. *A Research Framework for Historic Rural Settlement Studies in Scotland. Historic Rural Settlement Group.* http://www.molrs.org.uk/downloads/HRSG%20research%20framework%20071108.pdf viewed March 2011.

Darwin, T., 1996. *The Scots Herbal: the Plant Lore of Scotland.* Edinburgh: Mercat Press.

Dasent, G.W., 1894a. *The Saga of Hacon.* London: HMSO.

Dasent, G.W., 1894b. *The Orkneyingers' Saga.* London: HMSO.

Davey, P.J., 1983. 'Appendix 3: the clay pipes', in Excavations at Scalloway Castle, 1979 and 1980, by D. Hall & W.J. Lindsay. *Proceedings of the Society of Antiquaries of Scotland* 113, 578–87.

Davey, P.J., 2002. Pottery, in *Excavations on St Patrick's Isle, Peel, Isle of Man, 1982–88: Prehistoric, Viking, Medieval and Later*, ed. D. Freke. Liverpool: Liverpool University Press, 363–427.

Davies, K.M., 2004. Important rare plant pigments, in *Plant Pigments and their Manipulation*, ed. K.M. Davies. Oxford: Blackwell Publishing, 214–41.

Davis, S.J.M., 1996. Measurements of a group of adult female Shetland sheep skeletons from a single flock: a baseline for zooarchaeologists. *Journal of Archaeological Science* 23, 593–612.

Davis, S.J.M., 2000. The effect of castration and age on the development of the Shetland sheep skeleton and a metric comparison between the bones of males, females and castrates. *Journal of Archaeological Science* 27, 373–90.

Day, D., 2008. *Conquest: How Societies Overwhelm Others.* Oxford: Oxford University Press.

Dean, V., forthcoming. The pottery, in *Excavations at Finlaggan, Islay*, ed. D. Caldwell.

Defelice, M.S., 2004. Common chickweed, *Stellaria media* (L.) Vill.1 - 'Mere chicken feed?'. *Weed Technology* 18, 193–200.

DeNiro, M.J., 1985. Post-mortem preservation and alteration of *in vivo* bone collagen isotope ratios in relation to paleodietary reconstruction. *Nature* 317, 806–9.

Dennison, E.P. & G.G. Simpson, 2000. Scotland, in *The Cambridge Urban History of Britain*, vol. 1, *600–1540*, ed. D.M. Palliser. Cambridge: Cambridge University Press, 715–37.

Dennison, P. & R. Coleman, 1999. *Historic Dumbarton: the Archaeological Implications of Development.* Edinburgh: Historic Scotland/Scottish Cultural Press.

Diamond, J., 1999. *Guns, Germs, and Steel: the Fates of Human Societies.* London: W.W. Norton.

Diaz, H.F., R. Trigo, M.K. Hughes, M.E. Mann, E. Xoplaki & D. Barriopedro, 2011. Spatial and temporal characteristics of climate in medieval times revisited. *Bulletin of the American Meteorological Society* 92, 1487–500

Dickson, C., 1998. Past uses of turf in the Northern Isles, in *Life on the Edge: Human Settlement and Marginality*, eds. C.M. Mills & G. Coles. (Monograph Series 100.) Oxford: Oxbow Books, 105–9.

Dickson, C., 1999. The plant remains, in *The Biggings, Papa Stour, Shetland: the History and Excavation of a Royal Norwegian Farm*, eds. B.E. Crawford & B. Ballin Smith. (Monograph Series 15.) Edinburgh: Society of Antiquaries of Scotland, 104–18.

Dickson, C. & J.H. Dickson, 1984. The botany of the Crosskirk Broch site, in *Excavations at Crosskirk Broch, Caithness*, ed. H. Fairhurst. (Monograph Series 3.) Edinburgh: Society of Antiquaries of Scotland, 147–55.

Dickson, C. & J. Dickson, 2000. *Plants and People in Ancient Scotland.* Charleston (SC): Arcadia Publishing.

Dickson, J., 1992. North American driftwood, especially *Picea* (spruce), from archaeological sites in the Hebrides and Northern Isles of Scotland. *Review of Palaeobotany and Palynology* 73, 49–56.

Ditchburn, D., 2009. Maritime ports and transport, c. 1200–1560, in *Scottish Life and Society: Transport and Communications*, ed. K. Veitch. Edinburgh: John Donald, 23–50.

Dixon, P., 2002. The medieval peasant building in Scotland: the beginning and the end of crucks, in *The Rural*

House from the Migration Period to the Oldest Still Standing Buildings, ed. J. Klápště. (Ruralia IV.) Turnhout: Brepols, 187–200.

DN (Diplomatarium Norvegicum), 1847–2011. *Diplomatarium Norvegicum*, vols. 1 to 21. Oslo: Dokumentasjonsprosjektet. http://www.dokpro.uio.no/dipl_norv/diplom_field_eng.html. Consulted 15 February 2011 and 17 November 2011.

Dobney, K. & D. Jaques, 2002. Avian signatures for identity and status in Anglo-Saxon England. *Acta Zoologica Cracoviensia* 45, 7–21.

Dobney, K., A.R. Hall, H.K. Kenward & A. Milles, 1992. A working classification of sample types for environmental archaeology. *Circaea* 9, 24–6.

Dobney, K., D. Jaques, J. Barrett & C. Johnstone, 2007. *Farmers, Monks and Aristocrats: the Environmental Archaeology of an Anglo-Saxon Estate Centre at Flixborough, North Lincolnshire, UK*. Oxford: Oxbow Books.

Dockrill, S.J. & J.M. Bond, 2009. Sustainability and resilience in prehistoric North Atlantic Britain: the importance of a mixed paleoeconomic system. *Journal of the North Atlantic* 2, 33–50.

Dodgshon, R., 1998. *From Chiefs to Landlords: Social and Economic Change in the Western Highlands and Islands*. Edinburgh: Edinburgh University Press.

Dolley, M., 1981. The palimpsest of Viking settlement on Man, in *Proceedings of the Eighth Viking Congress*, eds. H. Bekker-Nielsen, P. Foote & O. Olsen. Odense: Odense University Press, 173–82.

Dollinger, P., 1999. *The German Hansa*. London: Routledge.

Donaldson, A.M. & S. Nye, 1989. The botanical remains, in *The Birsay Bay Project: Coastal Sites beside the Brough Road, Birsay, Orkney. Excavations 1976–1982*, ed. C.D. Morris. (Monograph Series 1.) Durham: University of Durham, 262–7.

Donaldson, G. (ed.), 1974. *Scottish Historical Documents*. Edinburgh: Scottish Academic Press.

Downes, J. & C.R. Wickham-Jones, 2005. Structure of The Heart of Neolithic Orkney Research Agenda, in *The Heart of Neolithic Orkney World Heritage Site Research Agenda*, eds. J. Downes, S.M. Foster, C.R. Wickham-Jones & J. Callister. Edinburgh: Historic Scotland, 24–5.

Downes, J., S.M. Foster, C.R. Wickham-Jones & J. Callister (eds.), 2005. *The Heart of Neolithic Orkney World Heritage Site Research Agenda*. Edinburgh: Historic Scotland.

Downham, C., 2007. *Viking Kings of Britain and Ireland: the Dynasty of Ívarr to A.D. 1014*. Edinburgh: Dunedin Academic Press.

Driscoll, M.J. (ed.), 1995. *Ágrip af Nóregskonungasǫgum*. London: Viking Society for Northern Research.

Driscoll, S.T., 1998. Church archaeology in Glasgow and the kingdom of Strathclyde. *The Innes Review* 49, 95–114.

Driscoll, S.T., 1998. Picts and prehistory: cultural resource management in early medieval Scotland. *World Archaeology* 30, 142–58.

Driscoll, S. (ed.), 2002. *Excavations at Glasgow Cathedral 1988–1997*. Leeds: Maney.

Duco, D.H., 1981. The clay tobacco pipe in seventeenth century Netherlands, in *The Archaeology of the Clay Tobacco Pipe*, vol. V: *Europe*, ed. P.J. Davey. (British Archaeological Reports, International Series 106.) Oxford: BAR, 111–468.

Duco, D.H., 1987. *De Nederlandse Kleipijp: Handboek voor dateren en determineren*. Leiden: Pijpenkabinet.

Duffy, S., 2007. The prehistory of the galloglass, in *The World of the Galloglass: Kings, Warlords and Warriors in Ireland and Scotland, 1200–1600*, ed. S. Duffy. Dublin: Four Courts Press, 1–23.

Dugmore, A. & A. Newton, 1999. Origins of the material, in *Kebister: the Four-thousand-year-old Story of One Shetland Township*, eds. O. Owen & C. Lowe. (Monograph Series 14.) Edinburgh: Society of Antiquaries of Scotland, 167.

Dugmore, A.J., M.J. Church, P.C. Buckland *et al.*, 2005. The Norse landnám on the North Atlantic islands: an environmental impact assessment. *Polar Record* 41, 21–37.

Dunlevy, M.M., 1988. A classification of early Irish combs. *Proceedings of the Royal Irish Academy* 88, 341–422.

Dyer, C., 1989. *Standards of Living in the Later Middle Ages: Social Change in England c. 1200–1520*. Cambridge: Cambridge University Press.

Dyer, C., 2002. *Making a Living in the Middle Ages*. London: Yale University Press.

Earle, T., 1997. *How Chiefs Come to Power: the Political Economy in Prehistory*. Stanford (CA): Stanford University Press.

Edmonds, J., 1998. *The History of Woad and the Medieval Woad Vat*. (Historic Dyes Series 1.) Little Chalfont: J. Edmonds.

Edmonds, F., 2009. History and names, in *The Huxley Viking Hoard: Scandinavian Settlement in the North west*, eds. J. Graham-Campbell & R. Philpott. Liverpool: National Museums Liverpool, 3–12.

Edwards, K.J., P.C. Buckland, A.J. Dugmore, T.H. McGovern, I.A. Simpson & G. Sveinbjarnardóttir, 2004. Landscapes circum-Landnám: Viking settlement in the North Atlantic and its human and ecological consequences — a major new research programme, in *Atlantic Connections and Adaptations: Economies, Environments and Subsistence in the North Atlantic*, eds. R. Housley & G. Coles. Oxford: Oxbow Books, 260–71.

Ekaratne, S.U.K. & D.J. Crisp, 1982. Tidal micro-growth bands in intertidal gastropod shells, with an evaluation of band-dating techniques. *Proceedings of the Royal Society, London* B214, 305–23.

Ekaratne, S.U.K. & D.J. Crisp, 1984. Seasonal growth studies of intertidal gastropods from shell micro-growth band measurements, including a comparison with alternative methods. *Journal of the Marine Biological Association of the United Kingdom* 64, 183–210.

Ekrem I. & L. Boje Mortensen (eds.), 2003. *Historia Norwegie*. Copenhagen: Museum Tusculanum Press, University of Copenhagen.

Ellis, S.E., 1969. The petrography and provenance of Anglo-Saxon and medieval English honestones, with notes on some other hones. *Bulletin of the British Museum (Natural History), Mineralogy* 2, 135–87.

Emery, N. & C.D. Morris, 1996. The excavations on the Brough of Birsay, 1934–9, in *The Birsay Bay Project*, vol. 2: *Sites in Birsay Village and on the Brough of Birsay, Ork-*

ney, eds. C.D. Morris. (Monograph Series 2.) Durham: University of Durham, Department of Archaeology, 209–56.

Enghoff, I.B., 1994. Fishing in Denmark during the Ertebølle Period. *International Journal of Osteoarchaeology* 4, 65–96.

Enghoff, I.B., 2003. *Hunting, Fishing and Animal Husbandry at the Farm Beneath The Sand, Western Greenland: an Archaeozoological Analysis of a Norse Farm in the Western Settlement.* (Man and Society 28.) Copenhagen: Danish Polar Centre, Meddelelser om Grønland.

Epstein, S.A,. 2009. *An Economic and Social History of Later Medieval Europe, 1000–1500.* Cambridge: Cambridge University Press.

Etchingham, C., 2001. North Wales, Ireland and the Isles: the insular Viking zone. *Peritia* 15, 145–87.

Etchingham, C., 2010. *The Irish 'Monastic Town': Is This a Valid Concept?* Cambridge: Department of Anglo-Saxon, Norse and Celtic, University of Cambridge.

Evans, J., N. Boulton, C. Chenery & M. Melikian, 2008. 'The origins study', in Excavation of medieval graves at St Thomas' Kirk, Hall of Rendall, Orkney, ed. R. Toolis. *Proceedings of the Society of Antiquaries of Scotland* 138, 252–5.

Fabian, J., 1983. *Time and the Other: How Anthropology Makes its Object.* New York (NY): Colombia University Press.

Fairnell, E.H. & J.H. Barrett, 2007. Fur-bearing species and Scottish islands. *Journal of Archaeological Science* 34, 463–84.

Fanning, T., 1983. Some aspects of the bronze ringed pin in Scotland, in *From the Stone Age to the 'Forty-Five'*, eds. A. O'Connor & D.V. Clarke. Edinburgh: John Donald, 324–42.

Fanning, T., 1994. *Viking Age Ringed Pins from Dublin.* Dublin: Royal Irish Academy.

Fawcett, R., 1988. Kirkwall Cathedral: an architectural analysis, in *St Magnus Cathedral and Orkney's Twelfth Century Renaissance*, ed. B. Crawford. Aberdeen: Aberdeen University Press, 88–110.

Fenton, A., 1978. *The Northern Isles: Orkney and Shetland.* Edinburgh: John Donald.

Fenton, A., 1982. The longhouse in northern Scotland, in *Vestnordisk Byggeskikk Gjennom to Tusen År: Tradisjon og forandring fra Romertid til det 19 århundre*, eds. B. Myhre, B. Stoklund & P. Gjærder. (AmS-skrifter 7.) Stavanger: Arkeologisk Museum, 231–40.

Fenton, A., 1985. *The Shape of the Past*, vol. 1: *Essays in Scottish Ethnology.* Edinburgh: John Donald.

Fenton, A., 1986. *The Shape of the Past*, vol. 2: *Essays in Scottish Ethnology.* Edinburgh: John Donald.

Fereday, R.P., 1990. *The Orkney Balfours 1747–99.* Oxford: Tempvs Reparatvm.

Fernie, E., 1988. The church of St. Magnus, Egilsay, in *St Magnus Cathedral and Orkney's Twelfth Century Renaissance*, ed. B. Crawford. Aberdeen: Aberdeen University Press, 140–62.

Fidjestøl, B., 1993. Bjarni Kolbeinsson, in *Medieval Scandinavia*, ed. P. Pulsiano. London: Garland Publishing, 48 .

Finlay, A. (ed.), 2004. *Fagrskinna, a Catalogue of the Kings of Norway: a Translation with Introduction and Notes.* Leiden: Brill.

Fisher, I., 1993. Orphir Church in its south Scandinavian context, in *Caithness, Orkney and the North Atlantic in the Viking Age*, eds. C.E. Batey, J. Jesch & C.D. Morris. Edinburgh: Edinburgh University Press, 375–80.

Fiskerinæringens Landsforening, n.d. *Quality Regulations Relating to Fish and Fishery Products.* Oslo: Fiskerinæringens Landsforening.

Fitzhugh, B. & D.J. Kennett, 2010. Seafaring intensity and island–mainland interaction along the Pacific Coast of North America, in *The Global Origins and Development of Seafaring*, eds. A. Anderson, J.H. Barrett & K.V. Boyle. (McDonald Institute Monographs.) Cambridge: McDonald Institute for Archaeological Research, 69–80.

Fitzpatrick, E., 2009. Native enclosed settlement and the problem of the Irish 'ring-fort'. *Medieval Archaeology* 53, 271–307.

Fitzpatrick, S.M. (ed.), 2004. *Voyages of Discovery: the Archaeology of Islands.* London: Praeger.

Fitzpatrick, S.M., 2008. Islands of isolation: archaeology and the power of aquatic perimeters. *Journal of Island and Coastal Archaeology* 3, 4–16.

Fitzpatrick, S.M. & A. Anderson, 2008. Island worlds apart: interactions and remoteness on seas and oceans. *Journal of Island and Coastal Archaeology* 3, 1–3.

Fleming, A., 2005. *St Kilda and the Wider World: Tales of an Iconic Island.* Macclesfield: Windgather Press.

Fleming, A., 2008. Island stories, in *Scottish Odysseys: the Archaeology of Islands*, eds. G. Noble, T. Poller, J. Raven & L. Verrill. Stroud: Tempus, 11–22.

Flodin, L., 1989. *Kammakeriet i Trondheim ca. 1000–1600.* (Folkebibliotekstomten, Meddelelse 14.) Trondheim: Riksantikvarien, Fortiden i Trondheim bygrunn.

Flood, R.J. & G.C. Gates, 1986. *Seed Identification Handbook.* Cambridge: National Institute of Agricultural Botany.

Fojut, N. & D. Pringle, 1993. *The Ancient Monuments of Shetland.* Edinburgh: Historic Scotland.

Ford, B.A., 1998. Glass, in *Scalloway: a Broch, Late Iron Age Settlement and Medieval Cemetery*, ed. N. Sharples. (Oxbow Monograph 82.) Oxford: Oxbow Books, 201–2.

Forster, A.K., 2004a. Steatite vessels in the Norse North Atlantic. *The Finds Research Group AD 700–1700 Datasheet* 34, 1–8.

Forster, A.K., 2004b. Shetland and the Trade of Steatite Goods in the North Atlantic Region during the Viking and Early Medieval Period. Unpublished PhD thesis, University of Bradford.

Forster, A.K., 2006. Steatite, resource control and the Orkney earldom, in *The World of Orkneyinga Saga: 'The Broad-cloth Viking Trip'*, ed. O. Owen. Kirkwall: The Orcadian, 55–74.

Forster, A.K., 2009a. Viking and Norse steatite use in Shetland, in *Kleber: Shetland's Oldest Industry. Shetland Soapstone Since Prehistory*, eds. A.K. Forster & V.E. Turner. Lerwick: Shetland Amenity Trust, 58–69.

Forster, A.K., 2009b. Soapstone, in *Hofstaðir: Excavations of a Viking Age Feasting Hall in North-eastern Iceland*, ed. G. Lucas. Reykjavik: Institute of Archaeology, 297–301.

Forster, A.K., 2010. Steatite, in *Excavations at Old Scatness, Shetland*, vol. 1: *The Pictish and Viking Settlement*, eds. S. Dockrill, J. Bond, V. Turner *et al.* Lerwick: Shetland Heritage Publications, 258–303.

Forster, A.K. & P. Sharman, 2009. Use in early prehistoric Shetland: from the Neolithic to the early Iron Age, in *Kleber: Shetland's Oldest Industry. Shetland Soapstone Since Prehistory*, eds. A.K. Forster & V.E. Turner. Lerwick: Shetland Amenity Trust, 27–36.

Fossier, R., 1999. Rural economy and country life, in *The New Cambridge Medieval History*, vol. 3: c. *900–c. 1024*, ed. T. Reuter. Cambridge: Cambridge University Press, 27–63.

Foster, S.M., 1990. Pins, combs and the chronology of later Atlantic Iron Age settlement, in *Beyond the Brochs*, ed. I. Armit. Edinburgh: Edinburgh University Press, 143–74.

Fox, H., 2001. *The Evolution of the Fishing Village: Landscape and Society along the South Devon Coast, 1086–1550.* Oxford: Leopard's Head Press.

Frank, A.G., 1966. The development of underdevelopment. *Monthly Review* 18, 17–31.

Frank, A.G., 1979. *Dependent Accumulation and Underdevelopment.* New York (NY): Monthly Review Press.

Frank, A.G., 1993. Bronze Age world system cycles. *Current Anthropology* 34, 383–429.

Frank, A.G. & B.K. Gills, 1993. *The World System: Five Hundred Years or Five Thousand.* London: Routledge.

Freeland, J.M. & M.L. Dutton (eds.), 2005. *Aelred of Rievaulx: the Historical Works.* Kalamazoo: Cistercian Publications.

Friðriksson, A. & G. Lucas, 2011. Fornleifastofnun Íslands og hlutverk fornleifafræðinnar í samtímanum, in *Upp á Yfirborðið: Nýjar rannsóknir í íslenskri fornleifafræði*, eds. G. Lucas & O. Vésteinsson. Reykjavík: Fornleifastofnun Íslands, 5–15.

Friðriksson, A. & O. Vésteinsson, 2003. Creating a past: a historiography of the settlement of Iceland, in *Contact, Continuity and Collapse: the Norse Colonization of the North Atlantic*, ed. J.H. Barrett. (Studies in the Early Middle Ages.) Turnhout: Brepols, 139–62.

Friedland, K., 1973. Der Hansische Shetlandhandel, in *Stadt und Land in der Geschichte des Ostseeraums*, ed. K. Friedland. Lübeck: Verlag Max Schmidt-Römhild, 66–79.

Friedland, K., 1983. Hanseatic merchants and their trade with Shetland, in *Shetland and the Outside World 1469–1969*, D.J. Withrington. Oxford: Oxford University Press, 86–95.

Gabra-Sanders, T., 1998. A review of Viking-Age textiles and fibres from Scotland: an interim report, in *Textiles in European Archaeology: Report from the Sixth NESAT Symposium*, eds. L. Bender Jørgensen & C. Rinaldo. Gothenburg: Gothenburg University, 177–85.

Gade, J.A., 1951. *The Hanseatic Control of Norwegian Commerce during the Late Middle Ages.* Leiden: E.J. Brill.

Gade, K.E. (ed.), 2009. *Poetry from the Kings' Sagas 2.* Turnhout: Brepols.

Gahan, A. & C. McCutcheon, 1997. Medieval pottery, in *Late Viking Age and Medieval Waterford: Excavations 1986–1992*, eds. M.F. Hurley & O.M.B. Scully. Waterford: Waterford Corporation, 285–336.

Gaimster, D., 1997. *German Stoneware 1200–1900: Archaeology and Cultural History.* London: British Museum Press.

Gaimster, D.R.M. & C.E. Batey, 1995. The pottery, in *Freswick Links, Caithness: Excavation and Survey of a Norse Settlement*, eds. C.D. Morris, C.E. Batey & D.J. Rackham. New York (NY): North Atlantic Biocultural Organisation, 136–48.

Galloway, P., 1976. Notes on the description of bone and antler combs. *Medieval Archaeology* 20, 154–6.

Gardiner, M., 2000. Vernacular buildings and the development of the later medieval domestic plan in England. *Medieval Archaeology* 44, 159–79.

Gardiner, M. & N. Mehler, 2007. English and Hanseatic trading and fishing sites in medieval Iceland: report on initial fieldwork. *Germania* 85, 385–427.

Gaut, B., 2011. Vessel glass and evidence of glassworking, in *Things from the Town: Artefacts and Inhabitants in Viking-age Kaupang*, ed. D. Skre. Aarhus: Aarhus University Press, 169–279.

Gaynor, K., 2006. The vegetation of Irish machair. *Biology and Environment: Proceedings of the Royal Irish Academy*, 106, 311–21.

Geary, P.J., 2002. *The Myth of Nations: the Medieval Origins of Europe.* Princeton (NJ): Princeton University Press.

Geraghty, S., 1996. *Viking Dublin: Botanical Evidence from Fishamble Street.* (Medieval Dublin Excavations 1962–81.) Dublin: Royal Irish Academy.

Gerrard, J. & J. Barrett, 2010. An enigmatic Viking-Age nucleated settlement in Orkney. *Medieval Archaeology* 54, 423–9.

Gerrard, J., J. Barrett & M. Saunders, 2010. The Brough of Deerness Excavations 2009: Annual Data Structure Report. Unpublished report, McDonald Institute for Archaeological Research, Cambridge.

Gibbon, S.J., 2007. Medieval parish foundation in Orkney, in *West Over Sea: Studies in Scandinavian Sea-borne Expansion and Settlement before 1300*, eds. B.B. Smith, S. Taylor & G. Williams. Leiden: Brill, 235–50.

Gibson, J., 2008. *Rising Tides: the Loss of Coastal Heritage in Orkney.* Orkney: Northings Publications.

Gibson, R., B. Hextall & A. Rogers, 2001. *Photographic Guide to the Sea and Shore Life of Britain and North-west Europe.* Oxford: Oxford University Press.

Gifford, J., 1992. *The Buildings of Scotland: Highlands and Islands.* London: Penguin Books in association with The Buildings of Scotland Trust.

Gilchrist, R., 2009. Medieval archaeology and theory: a disciplinary leap of faith, in *Reflections: 50 Years of Medieval Archaeology, 1957–2007*, eds. R. Gilchrist & A. Reynolds. Leeds: Maney, 385–408.

Giles, K. & C. Dyer (eds.), 2005. *Town and Country 1100–1500.* Leeds: Society for Medieval Archaeology/Maney Publishing.

Gilmour, S. & M. Cook, 1998. Excavations at Dun Vulan: a reinterpretation of the reappraised Iron Age. *Antiquity* 72, 327–37.

Given, M., 2004. *The Archaeology of the Colonized.* London: Routledge.

Goodacre, S., A. Helgason, J. Nicholson *et al.*, 2005. Genetic evidence for a family-based Scandinavian settlement

of Shetland and Orkney during the Viking periods. *Heredity* 95, 129–35.

Goodall, I.H., 1984. 'Iron objects', in Excavations in Thetford 1948–59 and 1973–80, by A. Rogerson & C. Dallas. *East Anglian Archaeology* 22, 76–106.

Goodall, I.H., 1987.'Objects of iron', in *Goltho: the Development of an Early Medieval Manor c. 850–1150*, ed. G. Beresford. (English Heritage Archaeological Report 4.) London: Historic Buildings & Monuments Commission for England.

Goodall, I.H., 1990a. Iron binding strips and mounts, in *Object and Economy in Medieval Winchester*, vol. 2, ed. M. Biddle. (Winchester Studies 7.) Oxford: Clarendon Press, 787–9.

Goodall, I.H., 1990b. Iron buckles and belt fittings, in *Object and Economy in Medieval Winchester*, vol. 2, ed. M. Biddle. (Winchester Studies 7.) Oxford: Clarendon Press, 526–38.

Goodall, I.H., 1993. 'Iron knives', in Norwich households: the medieval and post-medieval finds from Norwich survey excavations 1971–78, by S. Margeson. *East Anglian Archaeology* 58, 124–33.

Goodall, I.H., 2011. *Ironwork in Medieval Britain: an Archaeological Study*. (Monograph 31.) London: Society for Medieval Archaeology.

Gosden, C., 1994. *Social Being and Time*. Oxford: Blackwell.

Gosden, C., 2004. *Archaeology and Colonialism: Cultural Contact from 5000 bc to the Present*. Cambridge: Cambridge University Press.

Gostenčnik, K., 2003. Elk antler as a material of manufacture. Finds from Late Roman/Early Imperial 'Old Virunum' on the Magdalensberg in Carinthia, southern Austria, in *Materials of Manufacture: the Choice of Materials in the Working of Bone and Antler in Northern and Central Europe during the First Millennium AD*, ed. I.D. Riddler. (British Archaeological Reports, International Series 1193.) Oxford: BAR, 1–14.

Graham-Campbell, J., 1980. *Viking Artefacts: a Select Catalogue*. London: British Museum Publications.

Graham-Campbell, J., 1993. The northern hoards of Viking-Age Scotland, in *The Viking Age in Caithness, Orkney and the North Atlantic*, eds. C.E. Batey, J. Jesch & C.D. Morris. Edinburgh: Edinburgh University Press, 173–86.

Graham-Campbell, J., 1995. *The Viking-Age Gold and Silver of Scotland*. Edinburgh: National Museums of Scotland.

Graham-Campbell, J., 2003. The Vikings in Orkney, in *The Faces of Orkney: Stones, Skalds and Saints*, ed. D.J. Waugh. Edinburgh: The Scottish Society for Northern Studies, 128–37.

Graham-Campbell, J. & C.E. Batey, 1998. *Vikings in Scotland: an Archaeological Survey*. Edinburgh: Edinburgh University Press.

Grant, A., 1982. The use of tooth wear as a guide to the age of domestic ungulates, in *Ageing and Sexing Animal Bones from Archaeological Sites*, eds. B. Wilson, C. Grigson & S. Payne. (British Archaeological Reports 109.) Oxford: BAR, 91–108.

Grayson, D.K., 1984. *Quantitative Zooarchaeology*. London: Academic Press.

Greco, G.L. & C.M. Rose, 2009. *The Good Wife's Guide (Le Ménagier de Paris): a Medieval Household Book*. Ithaca (NY): Cornell University Press.

Grenne, T., T. Heldal, G.B. Meyer & E.G. Bloxam, 2008. From Hyllestad to Selbu: Norwegian millstone quarrying through 1300 years, in *Geology for Society*, ed. T. Slagstad. (Special Publication 11.) Oslo: Geological Survey of Norway, 47–66.

Grieg, S., 1933. *Middelalderiske Byfund fra Bergen og Oslo*. Oslo: Norske Videnskaps Akademi.

Griffin, K., 1988. Plant remains, in *'Mindets Tomt' – 'Søndre Felt': Animal Bones, Moss-, Plant-, Insect- and Parasite Remains*, ed. E. Schia. (De Arkeologiske Utgravninger i Gamlebyen, Oslo, Bind 5.) Øvre Ervik: Alvheim & Eide Academisk Forlag, 15–108.

Griffiths, D. & J. Harrison, 2011. Settlements under the sand: new Viking discoveries in Orkney. *Current Archaeology* 253, 12–19.

Griffiths, D., R.A. Philpott & G. Egan, 2007. *Meols: the Archaeology of the North Wirral Coast*. (Monograph 68.) Oxford: Oxford University School of Archaeology.

Groundwater, W., 1974. *Birds and Mammals of Orkney*. Kirkwall: The Kirkwall Press.

Guðmundsson, F. (ed.), 1965. *Orkneyinga Saga*. Reykjavík: Hið Islenzka Fornritafélag.

Guttmann, E.B., I.A. Simpson, D.A. Davidson & S.J. Dockrill, 2006. The management of arable land from prehistory to the present: case studies from the Northern Isles of Scotland. *Geoarchaeology* 21, 61–92.

Hadley, D.M. & J.D. Richards (eds.), 2000. *Cultures in Contact: Scandinavian Settlement in England in the Ninth and Tenth Centuries*. Turnhout: Brepols.

Haggarty, G., 1984. 'Observations on the ceramic material from phase 1 pits BY and AQ', in Excavations at Kelso Abbey, by C.J. Tabraham. *Proceedings of the Society of Antiquaries of Scotland* 114, 395–7.

Haggarty, G. & S. Jennings, 1992. The imported pottery from Fast Castle, near Dunbar, Scotland. *Medieval Ceramics* 16, 45–54.

Haggarty, G., D. Hall & S. Chenery, 2011. *Sourcing Scottish Redwares*. (Occasional Paper 5.) London: Medieval Pottery Research Group.

Hall, A., 2002. *Recognition and Characterization of Turves in Archaeological Occupation Deposits by means of Macrofossil Plant Remains*. London: English Heritage.

Hall, A. & H. Kenward, 2003. Can we identify biological indicator groups for craft, industry and other activities?, in *The Environmental Archaeology of Industry*, eds. P. Murphy & P.E.J. Wiltshire. Oxford: Oxbow Books, 114–30.

Hall, D.W., 1995. 'Pottery', in Four excavations in Perth, 1979–84, by D. Bowler, A. Cox & C. Smith. *Proceedings of the Society of Antiquaries of Scotland* 125, 952–9.

Hall, D.W., 1997. 'Pottery', in An archaeological excavation at Tolbooth Wynd, Anstruther, by A. Cox. *Tayside and Fife Archaeological Journal* 3, 119–42.

Hall, D.W., 1998. The Scottish medieval pottery industry: a pilot study. *Tayside and Fife Archaeological Journal* 4, 170–78.

Hall, D.W., 2000. 'The pottery', in Excavations at 110 High

Street, Perth, by M. Roy & C. Falconer. *Tayside and Fife Archaeological Journal* 6, 95–8.

Hall, D.W., 2009. The pottery, in *Early Medieval Settlement and Ironworking in Dornoch, Sutherland: Excavations at The Meadows Business Park*, eds. R. Coleman & E. Photos-Jones. (Scottish Archaeological Internet Reports 28.) Edinburgh: The Society of Antiquaries of Scotland, 9–10. http://www.sair.org.uk/sair28/ Accessed 18 May 2011.

Hall, M., D. Hall & G. Cook, 2005. What's cooking? New radiocarbon dates from the earliest phases of the Perth High Street excavations and the question of Perth's early medieval origin. *Proceedings of the Society of Antiquaries of Scotland* 135, 273–85.

Hall, T.D., P.N. Kardulias & C. Chase-Dunn, 2011. World-systems analysis and archaeology: continuing the dialogue. *Journal of Archaeological Research* 19, 233–79.

Hallsson, S.V., 1964. The uses of seaweed in Iceland, in *Compte Rendus du IV Congres International des Sigues Marines, 1961*. New York (NY): Pergamon, 398–405.

Halsall, G., 2003. *Warfare and Society in the Barbarian West 450–900*. London: Routledge.

Hamilton, J.R.C., 1956. *Excavations at Jarlshof*. Edinburgh: HMSO.

Hamilton, J.R.C., 1968. *Excavations at Clickhimin, Shetland*. Edinburgh: HMSO.

Hamilton-Dyer, S., 2007. Exploitation of birds and fish in medieval and post-medieval Ireland: a brief review of the evidence, in *Environmental Archaeology in Ireland*, eds. E.M. Murphy & N.J. Whitehouse. Oxford: Oxbow Books, 102–18.

Hansen, G., 2005. *Bergen c. 800–1170: the Emergence of a Town*. (The Bryggen Papers: Main Series 6.) Bergen: Fagbokforlaget.

Hansen, S.C.J., 2011. The Icelandic whetstone material: an overview of recent research. *Archaeologica Islandica* 9, 65–76.

Harland, J.F., 2006. Zooarchaeology in the Viking Age to Medieval Northern Isles, Scotland: an Investigation of Spatial and Temporal Patterning. Unpublished PhD thesis, University of York.

Harland, J., 2007. Status and space in the 'Fish Event Horizon': initial results from Quoygrew and Earl's Bu, Viking Age and medieval sites in Orkney, Scotland, in *The Role of Fish in Ancient Time*, ed. H.H. Plogmann. Rahden: Verlag Marie Leidorf, 63–8.

Harland, J.F., J. Barrett, J. Carrott, K. Dobney & D. Jaques, 2003. The York System: an integrated zooarchaeological database for research and teaching. *Internet Archaeology* 13.

Harland, J.F., C.J. Johnstone & A.K.G. Jones, 2008. A case study from the Medieval Origins of Commercial Sea Fishing Project: zooarchaeological results from York (UK), in *Archéologie du poisson. 30 ans d'archéo-ichtyologie au CNRS. Hommage aux travaux de Jean Desse et Nathalie Desse-Berset*, eds. P. Béarez, S. Grouard & B. Clavel. Antibes: Éditions APDCA, 15–26.

Harrison, R., H.M. Roberts & W.P. Adderley, 2008. Gásir in Eyjafjörður: international exchange and local economy in medieval Iceland. *Journal of the North Atlantic* 1, 99–119.

Hastrup, K., 2008. Icelandic topography and the sense of identity, in *Nordic Landscapes: Region and Belonging on the Northern Edge of Europe*, eds. M. Jones & K.R. Olwig. Minneapolis (MN): University of Minnesota Press, 53–76.

Hatcher, J. & M. Bailey, 2001. *Modelling the Middle Ages*. Oxford: Oxford University Press.

Hather, J., 1993. *An Archaeobotanical Guide to Root and Tuber Identification*, vol. 1: *Europe and Southeast Asia*. Oxford: Oxbow Books.

Heald, A. & A. Jackson, 2002. Caithness Archaeological Project: excavations at Everley Broch, Freswick. *Antiquity* 76, 31–2.

Heaton, T.H.E., 1999. Spatial, species, and temporal variations in the $^{13}C/^{12}C$ ratios of C_3 plants: implications for palaeodiet studies. *Journal of Archaeological Science* 26, 637–49.

Hedeager, L., 1994. Warrior economy and trading economy in Viking-Age Scandinavia. *Journal of European Archaeology* 2, 130–47.

Hedges, J.W., 1987. *Bu, Gurness and the Brochs of Orkney*, part 2: *Gurness*. (British Archaeological Reports, British Series 164.) Oxford: BAR.

Hedges, R.E.M., J.G. Clement, C.D.L. Thomas & T.C. O'Connell, 2007. Collagen turnover in the adult femoral mid-shaft: modeled from anthropogenic radiocarbon tracer measurements. *American Journal of Physical Anthropology* 133, 808–16.

Helle, K., 1988. The organisation of the twelfth-century church in Norway, in *St Magnus Cathedral and Orkney's Twelfth Century Renaissance*, ed. B. Crawford. Aberdeen: Aberdeen University Press, 46–55.

Helle, K., 2003. Growing inter-Scandinavian entanglement, in *The Cambridge History of Scandinavia*, vol. I: *Prehistory to 1520*, ed. K. Helle. Cambridge: Cambridge University Press, 411–20.

Helle, K., 2005. The position of the Faeroes and other 'tributary lands' in the medieval Norwegian dominion, in *Viking and Norse in the North Atlantic: Select Papers from the Proceedings of the Fourteenth Viking Congress, Tórshavn, 19–30 July 2001*, eds. A. Mortensen & S.V. Arge. Tórshavn: Føroya Fróðskaparfelag, 11–21.

Helms, M.W., 1988. *Ulysses' Sail: an Ethnographic Odyssey of Power, Knowledge, and Geographical Distance*. Princeton (NJ): Princeton University Press.

Henderson, J., 2005. Medieval and post-medieval glass finewares from Lincoln: an investigation of the relationships between technology, chemical compositions, typology and value. *The Archaeological Journal* 162, 256–322.

Herteig, A.E., 1969. *Kongers Havn og Handels Sete*. Oslo: Aschehaug & Co.

Hicks, D., 2010. The material-culture turn: event and effect, in *The Oxford Handbook of Material Culture Studies*, eds. D. Hicks & M.C. Beaudry. Oxford: Oxford University Press, 25–98.

Hill, M.O., C.D. Preston & D.B. Roy, 2004. *Plantatt: Attributes of British and Irish Plants: Status, Size, Life History, Geog-

raphy and Habits. Monks Wood: Centre for Ecology and Hydrology.

Hill, P. (ed.), 1997. *Whithorn and St Ninian: the Excavation of a Monastic Town 1984–91*. Stroud: The Whithorn Trust & Sutton Publishing.

Hillerdal, C., 2010. Early urbanism in Scandinavia, in *The Urban Mind: Cultural and Environmental Dynamics*, eds. P.J.J. Sinclair, G. Nordquist, F. Herschend & C. Isendahl. Uppsala: African and Comparative Archaeology, Department of Archaeology and Ancient History, Uppsala University, 499–525.

Hillman, G., 1984. Interpretation of archaeological plant remains: the application of ethnographic models from Turkey, in *Plants and Ancient Man*, eds. W. Van Zeist & W.A. Casparie. Rotterdam: Balkema, 1–41.

Hillman, G., S. Mason, D. de Moulins & M. Nesbitt, 1996. Identification of archaeological remains of wheat: the 1992 London workshop. *Circaea* 12(2), 195–209.

Hinde, A., 2003. *England's Population: a History Since the Domesday Survey*. London: Hodder Arnold.

Hjaltalín, T., 2009. The historic landscape of the Saga of the People of Vatnsdalur: exploring the saga writer's use of the landscape and archaeological remains to serve political interests. *Medieval Archaeology* 53, 243–70.

Hobsbawm, E. & T. Ranger (eds.), 1992. *The Invention of Tradition*. Cambridge: Cambridge University Press.

Hodges, R., 1982. *Dark Age Economics: the Origins of Towns and Trade AD 600–1000*. London: Duckworth.

Hoffmann, R.C., 1996. Economic development and aquatic ecosystems in medieval Europe. *The American Historical Review* 101, 631–69.

Holm, I., S. Innselset & I. Øye (eds.), 2005. *'Utmark': the Outfield as Industry and Ideology in the Iron Age and the Middle Ages*. Bergen: University of Bergen.

Holm, I., K. Stene & E. Svensson, 2009. Liminal landscapes — a brief overview, in *Liminal Landscapes: Beyond the Concepts of 'Marginality' and 'Periphery'*, eds. I. Holm, K. Stene & E. Svensson. Oslo: Unipub/Oslo Academic Press and Institute for Archaeology, Conservation and History, University of Oslo, 9–22.

Holm, P., in press. Manning and paying the Hiberno-Norse Dublin fleet, in *Clerics, Kings and Vikings: Essays on Medieval Ireland*, eds. E. Purcell, P. MacCotter, J. Nyhan & J. Sheehan. Dublin: Four Courts Press.

Holmboe, J., 1927. Nytteplanter og ugræs i Osebergfundet, in *Osebergfundet*, vol. V, ed. A.W. Brøgger, H. Falk & H. Schetelig. Kristiania, 1–78.

Holsinger, B.W., 2002. Medieval studies, postcolonial studies, and the genealogies of critique. *Speculum* 77, 1195–227.

Holt, R., 2000. Society and population 600–1300, in *The Cambridge Urban History of Britain*, vol. 1: 600–1540, ed. D.M. Palliser. Cambridge: Cambridge University Press, 79–104.

Hope, R. & C. Wickham-Jones, 1977. Biggings Farm, middens and structures. *Discovery and Excavation in Scotland* 1977, 25.

Hreiðarsdóttir, E.O., 2005. Íslenskar perlur fra Víkingaöld. Unpublished MA thesis, University of Iceland.

Hubbard, R.N.L.B. & A. al Azm, 1990. Quantifying pres-ervation and distortion in carbonized seeds and investigating the history of *friké* production. *Journal of Archaeological Science* 17, 103–6.

Hudson, B.T., 1998. 'The Scottish Chronicle'. *Scottish Historical Review* 77, 129–61.

Hudson, B., 2005. *Viking Pirates and Christian Princes: Dynasty, Religion and Empire in the North Atlantic*. Oxford: Oxford University Press.

Hufthammer, A.K., 2003. Med kjøtt og fisk på menyen, in *Middelalder-Gården i Trøndelag*, ed. O. Skevik. Verdal: Stiklestad Nasjonale Kultursenter, 182–96.

Hufthammer, A.K., H. Høie, A. Folkvord, A.J. Geffen, C. Andersson & U.S. Ninnemann, 2010. Seasonality of human site occupation based on stable oxygen isotope ratios of cod otoliths. *Journal of Archaeological Science* 37, 78–83.

Hufthammer, A.K., C. Johnstone, D. Orton, M. Richards & J. Barrett, forthcoming. Fish trade in Norway AD 800–AD 1400: zooarchaeological and stable isotope evidence, in *Cod and Herring: the Chronology, Causes and Consequences of Medieval Sea Fishing*, eds. J.H. Barrett & D. Orton. Oxford. Oxbow Books.

Hunter, J.R., 1986. *Rescue Excavations on the Brough of Birsay 1974–82*. (Monograph Series 4.) Edinburgh: Society of Antiquaries of Scotland.

Hunter, J., 2007a. The interface and Scandinavian settlement, in *Investigations in Sanday, Orkney*, vol. 1: *Excavations at Pool, Sanday Multi-period Settlement from Neolithic to Late Norse Times*, eds. J. Hunter, J.M. Bond & A.N. Smith. Kirkwall: The Orcadian/Historic Scotland, 121–45.

Hunter, J., 2007b. Later Norse settlement, in *Investigations in Sanday, Orkney*, vol. 1: *Excavations at Pool, Sanday Multi-period Settlement from Neolithic to Late Norse Times*, eds. J. Hunter, J.M. Bond & A.N. Smith. Kirkwall: The Orcadian/Historic Scotland, 147–68.

Hunter, J.R. & C.D. Morris, 1982. Appendix: excavation of Room 5 clifftop settlement Brough of Birsay 1973–4, in *Pictish and Norse Finds from the Brough of Birsay 1934–74*, ed. C.L. Curle. Edinburgh: Society of Antiquaries of Scotland, 124–38.

Huntley, J.P., 1990. Earl's Bu, Orphir, Orkney: Interim Report upon Carbonised Plant Remains from EB79/80. Unpublished report, University of Durham.

Huntley, J.P., 1994. Some botanical aspects of a Norse economy in northern Scotland. *Botanical Journal of Scotland* 46, 538–41.

Huntley, J.P., 2000. Robert's Haven: Charred Plant Remains from Norse and Later Deposits. Unpublished report, University of Durham.

Huntley, J.P. & J. Turner, 1995. Carbonized plant remains, in *Freswick Links, Caithness: Excavation and Survey of a Norse Settlement*, eds. C.D. Morris, C.E. Batey & D.J. Rackham. Inverness: Highland Libraries, 220–24.

Hurley, M.F. & O.M.B. Scully, 1997. *Late Viking Age and Medieval Waterford: Excavations 1986–1992*. Waterford: Waterford Corporation.

Hurry, J.B., 1973. *The Woad Plant and its Dye*. London: Oxford University Press.

Hurst, J., 1983. The trade in medieval pottery around the

North Sea, in *Ceramics and Trade*, eds. P. Davey & R. Hodges. Sheffield: Department of Prehistory and Archaeology, University of Sheffield, 257–60.

Hurst, J.G., D.S. Neal & H.J.E. van Beuningen, 1986. *Pottery Produced and Traded in North-west Europe 1350–1650*. (Rotterdam Papers VI.) Rotterdam: Museum Boymans-van Beuningen.

Hvass, S., 1993. Bebyggelsen, in *Da Klinger i Muld: 25 års arkæologi i Danmark*, eds. S. Hvass & B. Storgaard. Aarhus: Aarhus Universitetsforlag, 187–94.

Hvid, C., 2007. *Skipper's Logbook*. Roskilde: Viking Ship Museum. http://www.vikingeskibsmuseet.dk/en/the-sea-stallion-past-and-present/the-voyage-2007/logbook-diaries/skippers-logbook/. Consulted 24 April 2012.

Hybel, N. & B. Poulsen, 2007. *The Danish Resources c. 1000–1550*. Leiden: Brill.

Immonen, V., 2007. Defining a culture: the meaning of Hanseatic in medieval Turku. *Antiquity* 81, 720–32.

Imsen, S., 1999. Public life in Shetland and Orkney *c.*1300–1550. *New Orkney Antiquarian Journal* 1, 53–65.

Imsen, S., 2003. Earldom and kingdom: Orkney in the realm of Norway 1195–1379, in *The Faces of Orkney: Stones, Skalds and Saints*, ed. D.J. Waugh. Edinburgh: The Scottish Society for Northern Studies, 65–80.

Imsen, S., 2009. The Scottish–Norwegian border in the Middle Ages, in *Scandinavian Scotland: Twenty Years After*, ed. A. Woolf. (Paper 12.) St Andrews: St John's House, 9–29.

Indrelid, S. & A.K. Hufthammer, 2011. Medieval mass trapping of reindeer at the Hardangervidda mountain plateau, south Norway. *Quaternary International* 238, 44–54.

Ingold, T., 2007. Materials against materiality. *Archaeological Dialogues* 14, 1–16.

Ingrem, C., 2005. The sea 1: fish, in *A Norse Farm in the Outer Hebrides: Excavations at Mound 3, Bornais, South Uist*, ed. N. Sharples. Oxford: Oxbow Books, 157–8.

Izat, J., 1791–99. Parish of Westray, in *The Statistical Account of Scotland*, vol. 16, ed. Sir John Sinclair, 251–64. http://stat-acc-scot.edina.ac.uk/link/1791-99/Orkney/Westray/ (consulted 2 April 2011).

Jacomet, S., 2006. *Identification of Cereal Remains from Archaeological Sites*, trans. J. Greig. 2nd edition. Basel: Archaeobotany Lab IPAS, Basel University.

Jennings, A., 1996. Historical and linguistic evidence for Gall-Gaidheil and Norse in western Scotland, in *Language Contact Across the North Atlantic*, eds. P.S. Ureland & I. Clarkson. (Linguistische Arbeiten 359.) Tübingen: Max Niemeyer, 66–9.

Jennings, A. & A. Kruse, 2005. An ethnic enigma — Norse, Pict and Gael in the Western Isles, in *Viking and Norse in the North Atlantic: Select Papers from the Proceedings of the Fourteenth Viking Congress, Tórshavn, 19–30 July 2001*, eds. A. Mortensen & S.V. Arge. Tórshavn: Føroya Fróðskaparfelag, 284–96.

Jesch, J., 1992. Narrating Orkneyinga saga. *Scandinavian Studies* 64(3), 336–55.

Jesch, J., 1996. Presenting traditions in Orkneyinga saga. *Leeds Studies in English* 27, 69–86.

Jesch, J., 2001. *Ships and Men in the Late Viking Age*. Woodbridge: Boydell.

Jesch, J., 2009. Lausavísur, in *Poetry from the Kings' Sagas*, vol. 2, ed. K.E. Gade. Turnhout: Brepols, 575–609.

Johansen, O.S., 1982. Viking Age farms: estimating the number and population size. *Norwegian Archaeological Review* 15, 45–69.

Johnson, A. & T. Earle, 1987. *The Evolution of Human Societies*. Stanford (CA): Stanford University Press.

Johnston, J.L., 1999. *A Naturalist's Shetland*. London: T & AD Poyser.

Jones, A.K.G. 1991. The Fish Remains from Excavations at Freswick Links, Caithness. Unpublished DPhil thesis, University of York.

Jones, R. & C. Dyer (eds.), 2010. *Deserted Villages Revisited*. Hatfield: University of Hertfordshire Press.

Jones, R., R. Will, G. Haggarty & D.W. Hall, 2003. Sourcing White Gritty Ware. *Medieval Ceramics* 26–7, 45–84.

Jones, R.E., V. Olive, V. Kilikoglou *et al.*, 2007. A new protocol for the chemical characterisation of steatite. Two case studies in Europe: the Shetland Isles and Crete. *Journal of Archaeological Science* 34, 626–41.

Jones, S., 2004. *Early Medieval Sculpture and the Production of Meaning, Value and Place*. Edinburgh: Historic Scotland.

Jonsson, L., 1986. Finska gäddor och Bergenfisk — ett försök att belysa Uppsalas fiskimport under medeltid och yngre Vasatid, in *Från Östra Aros till Uppsala: En samling uppsatser kring det medeltida Uppsala*, eds. N. Cnattingius & T. Neréus. (Uppsala stads historia 7.) Uppsala: Historiekomm, 122–39.

Jørgensen, L., 2003. Manor and market at Lake Tissø in the sixth to eleventh centuries: the Danish 'productive' sites, in *Markets in Early Medieval Europe: Trading and 'Productive' Sites 650–850*, eds. T. Pestell & K. Ulmschneider. Macclesfield: Windgather Press, 175–207.

Kaland, S.H.H., 1982. Some economic aspects of the Orkneys in the Viking period. *Norwegian Archaeological Review* 15, 85–95.

Kaland, S.H.H., 1993. The settlement of Westness, Rousay, in *The Viking Age in Caithness, Orkney and the North Atlantic*, eds. C.E. Batey, J. Jesch & C.D. Morris. Edinburgh: Edinburgh University Press, 308–17.

Kaland, S.H.H., 1996. En vikingtidsgård og -gravplass på Orknøyene, in *Nordsjøen: Handel, religion og politikk*, eds. J.F. Krøger & H. Naley. Karmøy Kommune: Vikingfestivalen, 63–8.

Kardulias, P.N. (ed.), 1999. *World-systems Theory in Practice*. Oxford: Rowman & Littlefield Publishers.

Katz, N.J., S.V. Katz & M.G. Kiplani, 1965. *Atlas and Keys of Fruits and Seeds Occurring in the Quaternary Deposits of the U.S.S.R.* Moscow: Nauka.

Keene, D., 2000. London from the post-Roman period to 1300, in *The Cambridge Urban History of Britain*, vol. 1: *600–1540*, ed. D.M. Palliser. Cambridge: Cambridge University Press, 187–216.

Keller, C., 2010. Furs, fish and ivory: medieval Norsemen at the Arctic fringe. *Journal of the North Atlantic* 3, 1–23.

Kent, M., R. Weaver, D. Gilbertson, P. Wathern & B. Brayshay, 1996. The present-day machair vegetation of

the southern Outer Hebrides, in *The Outer Hebrides: the Last 14,000 Years*, eds. D. Gilbertson, M. Kent & J. Grattan. Sheffield: Sheffield Academic Press, 133–45.

Kenward, H.K. & A.R. Hall. 1995. *Biological Evidence from Anglo-Scandinavian Deposits at 16–22 Coppergate*. (The Archaeology of York 14/7.) York: Council for British Archaeology.

Khan, A., 2007. Good to think? Creolization, optimism, and agency. *Current Anthropology* 48, 653–73.

Kilroy, J., 2006. *Otters, Owls and German Merchants: an Investigation of Faunal Remains from Knowe of Skea, Westray, Orkney*. York: University of York.

Klápšt, J. & P. Sommer (eds.), 2009. *Medieval Rural Settlement in Marginal Landscapes*. (Ruralia VII.) Turnhout: Brepols.

Klemensen, M.F., 1996. Production of highly decorated pottery in medieval Denmark. *Nord-Ouest Archaeologie* 7, 131–40.

Knooihuizen, R., 2005. The Norn-to-Scots language shift: another look at socio-historical evidence. *Northern Studies* 39, 105–17.

Komber, J., 2002. Viking Age architecture in space and time, in *The Rural House from the Migration Period to the Oldest Still Standing Buildings*, ed. J. Klápště. (Ruralia IV.) Turnhout: Brepols, 13–29.

Krag, C., 2003. The early unification of Norway, in *The Cambridge History of Scandinavia*, vol. 1, ed. K. Helle. Cambridge: Cambridge University Press, 184–201.

Kristiansen, K., 1998. *Europe Before History*. Cambridge: Cambridge University Press.

Kristjánsdóttir, S., 2010. The tip of the iceberg: the material of Skriðuklaustur monastery and hospital. *Norwegian Archaeological Review* 43, 44–62.

Kruse, S.E., 1993. Silver storage and circulation in Viking-Age Scotland: the evidence of silver ingots, in *The Viking Age in Caithness, Orkney and the North Atlantic*, eds. C.E. Batey, J. Jesch & C.D. Morris. Edinburgh: Edinburgh University Press, 187–203.

Krzywinski, K., S. Fjelldal & E. Soltvedt, 1983. Recent Palaeoethnobotanical work at the medieval excavations at Bryggen, Bergen, Norway, in *Site, Environment and Economy*, ed. B. Proudfoot. (British Archaeological Reports, International Series 173.) Oxford: BAR, 145–69.

Lamb, R., 2010. Kirkwall revisited, in *The Viking Age: Ireland and the West*, eds. J. Sheehan & D. Ó Corráin. Dublin: Four Courts Press, 199–203.

Lane, A., 1990. Hebridean pottery: problems of definition, chronology, presence and absence, in *Beyond the Brochs*, ed. I. Armit. Edinburgh: Edinburgh University Press, 108–30.

Lane, A., 2005. Pottery, in *A Norse Farm in the Outer Hebrides: Excavations at Mound 3, Bornais, South Uist*, by N. Sharples. Oxford: Oxbow Books, 194.

Lane, A. & E. Campbell, 2000. *Dunadd: an Early Dalriadic Capital*. Oxford: Oxbow Books.

Lange, M.A., 2006. Bleeding history: attitudes toward heritage and tourism in Orkney. *Anatolia* 17, 139–54.

Larsen, A.-C., 1996. Belmont (Unst parish). *Discovery and Excavation in Scotland*, New Series 1996, 95.

Larsen, J.H., 2009. *Jernvinneundersøkelser*. Oslo: Kulturhistorisk Museum.

Larsson, L. & B. Hårdh, 2007. *Uppåkra: Lund före Lund*. Lund: Föreningen Gamla Lund.

Latour, B., 2005. *Reassembling the Social: an Introduction to Actor-network-theory*. Oxford: Oxford University Press.

Lau, G.F., 2005. Core–periphery relations in the Recuay hinterlands: economic interaction at Chinchawas, Peru. *Antiquity* 79, 78–99.

Laurie, E., 2008. *An Investigation of the Common Cockle* (Cerastoderma edule *(L)): Collection Practices at the Kitchen Midden Sites of Norsminde and Krabbesholm, Denmark*. (British Archaeological Reports, International Series 1834.) Oxford: BAR.

Lee-Thorp, J.A., 2008. On isotopes and old bones. *Archaeometry* 50, 925–50.

Legge, T., 2005. Milk use in prehistory: the osteological evidence, in *The Zooarchaeology of Fats, Oils, Milk and Dairying*, eds. J. Mulville & A.K. Outram. Oxford: Oxbow Books, 8–13.

Lewis, C., 2007. New avenues for the investigation of currently occupied medieval rural settlement: preliminary observations from the Higher Education Field Academy. *Medieval Archaeology* 51, 133–63.

Lie, R.W., 1988. Animal bones, in *'Mindets Tomt' – 'Søndre Felt': Animal Bones, Moss-, Plant-, Insect- and Parasite Remains*, ed. E. Schia. (De Arkeologiske Utgravninger i Gamlebyen, Oslo, Bind 5.) Øvre Ervik: Alvheim & Eide Academisk Forlag, 153–96.

Liebgott, N.-K., 1979. *Stakhaven. Arkæologiske undersøgelser i senmiddeladerens Dragør*. (Nationalmuseets Skrifter, Arkæologisk-historisk række XIX.) Copenhagen: Nationalmuseet.

Liebgott, N.-K., 1989. *Dansk Middelalder Arkæologi*. Copenhagen: G.E.C GADs Forlag.

Lillehammer, G., 2007. The past in the present: landscape perception, archaeological heritage and marginal farmland in Jæren, southwestern Norway. *Norwegian Archaeological Review* 40, 159–78.

Lindsay, W.J., 1983. 'The pottery', in Excavations at Scalloway Castle, 1979 and 1980, by D. Hall & W.J. Lindsay. *Proceedings of the Society of Antiquaries of Scotland* 113, 565–77.

Ljungqvist, F.C., 2005. The significance of remote resource regions for Norse Greenland. *Scripta Islandica* 56, 13–54.

Loveluck, C., 2007. *Rural Settlement, Lifestyles and Social Change in the Later First Millennium AD: Anglo-Saxon Flixborough in its Wider Context*. Oxford: Oxbow Books.

Loveluck, C. & K. Dobney, 2001. A match made in heaven or a marriage of convenience? The problems and rewards of integrating palaeoecological and archaeological data, in *Environmental Archaeology: Meaning and Purpose*, eds. U. Albarella. Amsterdam: Kluwer Press, 149–76.

Low, G., 1813. *Fauna Orcadensis or The Natural History of the Quadrupeds, Birds, Reptiles, and Fishes of Orkney and Shetland*. Edinburgh: George Ramsay and Company.

Low, G., 1879 [1774]. *A Tour Through the Islands of Orkney and Shetland Containing Hints Relative to their Ancient*

Modern and Natural History Collected in 1774. Kirkwall: William Peace & Son.

Lowe, C. (ed.), 1998. *St Boniface Church, Orkney: Coastal Erosion and Archaeological Assessment*. Edinburgh: Sutton Publishing and Historic Scotland.

Lowenthal, D., 1985. *The Past is a Foreign Country*. Cambridge: Cambridge University Press.

Lucas, A., 1989. *Cattle in Ancient Ireland*. Kilkenny: Boethius Press.

Lucas, G. (ed.), 2009. *Hofstaðir: Excavations of a Viking Age Feasting Hall in North-eastern Iceland*. Reykjavík: Institute of Archaeology.

Lüdtke, H., 1989. *The Bryggen Pottery*, vol. 1: *Introduction and Pingsdorf Ware*. (The Bryggen Papers Supplementary Series 4.) Bergen/Oslo: University of Bergen/Norwegian University Press.

Lunden, K., 2004. Recession and new expansion 1350–1814, in *Norwegian Agricultural History*, ed. R. Almås. Trondheim: Tapir Academic Press, 144–232.

Lyasight, A.M., 1971. Note on a grave excavated by Joseph Banks and Geoge Low at Skaill in 1772. *Proceedings of the Society of Antiquaries of Scotland* 104, 285–9.

Lydon, J. & U.Z. Rizvi (eds.), 2010. *Handbook of Postcolonial Archaeology*. Walnut Creek (CA): Left Coast Press.

MacAirt, S. & G. MacNiocaill (eds.), 1983. *The Annals of Ulster (to A.D. 1131)*. Dublin: Dublin Institute for Advanced Studies.

MacAskill, N.L., 1982. 'The pottery', in Excavations in Kirkwall, by N.A. McGavin. *Proceedings of the Society of Antiquaries of Scotland* 112, 405–13.

MacAskill, N.L., J. Brittain & C. Scott, 1987. Pottery, in *Excavations in the Medieval Burgh of Perth, 1979–81*, ed. P. Holdsworth. (Society of Antiquaries of Scotland Monograph 5.) Edinburgh: National Museum of Antiquities of Scotland, 89–120.

MacCarthy, B. (ed.), 1893. *Annals of Ulster*, vol. II. Dublin: Her Majesty's Stationery Office.

MacGregor, A., 1974. The Broch of Burrian, North Ronaldsay, Orkney. *Proceedings of the Society of Antiquaries of Scotland* 105, 63–118.

MacGregor, A., 1985. *Bone, Antler, Ivory and Horn: the Technology of Skeletal Materials Since the Roman Period*. London: Croom Helm.

MacGregor, A., A.J. Mainman & N.S.H. Rogers, 1999. *Craft, Industry and Everyday Life: Bone, Antler, Ivory and Horn from Anglo-Scandinavian and Medieval York*. (The Archaeology of York 17/2.) York: Council for British Archaeology.

Mackenzie, M., 1750. *Orcades, or a Geographic and Hydrographic Survey of the Orkney and Lewis Islands*. London: M. Say.

MacSween, A., 2007. The pottery, in *Excavations at Pool, Sanday: a Multi-period Settlement from Neolithic to Late Norse Times*, eds. J. Hunter, J. Bond & A.N. Smith. Kirkwall: The Orcadian/Historic Scotland, 287–353.

Madsen, P.K., 1986. A survey of the research of Danish medieval pottery. *Medieval Ceramics* 10, 57–84.

Mahany, C., A. Burchard & G. Simpson, 1982. *Excavations in Stamford, Lincolnshire 1963–69*. (Monograph Series 9.) London: Society for Medieval Archaeology.

Mahler, D.L., 2007. *Sæteren ved Argisbrekka: Økonomiske forandringer på Færøerne i Vikingetid og tidlig Middelalder*. Tórshavn: Faroe University Press.

Mainland, I. & P. Halstead, 2005. The economics of sheep and goat husbandry in Norse Greenland. *Arctic Anthropology* 42(1), 103–20.

Mainman, A.J. & N.S.H. Rogers, 2000. *Craft, Industry and Everyday Life: Finds from Anglo-Scandinavian York*. (The Archaeology of York 17/14.) York: Council for British Archaeology.

Maleszka, M., 2003. A Viking Age weight from Cleat, Westray, Orkney. *Proceedings of the Society of Antiquaries of Scotland* 133, 283–91.

Malkin, I., 2003. Networks and the emergence of Greek identity. *Mediterranean Historical Review* 18, 56–74.

Malmros, C., 1994. Exploitation of local, drifted and imported wood by the Vikings on the Faroe Islands. *Botanical Journal of Scotland* 46, 552–8.

Mann, M., 1986. *The Sources of Social Power*, vol. 1. Cambridge: Cambridge University Press.

Mann, M., 2006. The sources of social power revisited: a response to criticisms, in *An Anatomy of Power: the Social Theory of Michael Mann*, eds. J.A. Hall & R. Schroeder. Cambridge: Cambridge University Press. 343–96.

Manning, W.H., 1985. *Catalogue of the Romano-British Iron Tools, Fittings and Weapons in the British Museum*. London: British Museum.

Mannino, M.A. & K.D. Thomas, 2001. Intensive Mesolithic exploitation of coastal resources? Evidence from a shell deposit on the Isle of Portland (southern England) for the impact of human foraging on populations of intertidal rocky shore molluscs. *Journal of Archaeological Science* 28, 1101–14.

Mannino, M.A. & K.D. Thomas, 2002. Depletion of a resource? The impact of prehistoric human foraging on intertidal mollusc communities and its significance for human settlement, mobility and dispersal. *World Archaeology* 33, 452–74.

Margeson, S., 1993. *Norwich Households: the Medieval and Post-medieval Finds from Norwich Survey Excavations 1971–78*. Norwich: East Anglian Archaeology 58.

Martens, I., 1998. Some cultural aspects of marginal settlement and resource utilization in south Norway, in *Outland Use in Preindustrial Europe*, eds. H. Andersson, L. Ersgård & E. Svensson. Stockholm: Almqvist & Wiksell International, 30–39.

Martin, A.C. & W. D. Barkley, 1961. *Seed Identification Manual*. Berkeley (CA): University of California Press.

Martin, A.C. & W.D. Barkley, 1973. *Seed Identification Manual*. Berkeley (CA): University of California Press.

Martin, M., 1703. *A Description of the Western Islands of Scotland*. London: Andrew Bell.

Martine, G., 2007. *State of World Population 2007: Unleashing the Potential of Urban Growth*. New York (NY): UNFPA United Nations Population Fund.

Marwick, H., 1952. *Orkney Farm-names*. Kirkwall: W.R. Mackintosh.

Mason, S. & J. Hather, 2000. Parenchymatous plant remains, in *Hunter-gatherer Landscape Archaeology: the Southern*

Hebrides Mesolithic Project 1988–1998, ed. S. Mithen. (McDonald Institute Monographs.) Cambridge: McDonald Institute for Archaeological Research, 415–25.

McCobb, L.M.E., D.E.G. Briggs, W.J. Carruthers & R.P. Evershed, 2003. Phosphatisation of seeds and roots in a Late Bronze Age deposit at Potterne, Wiltshire, UK. *Journal of Archaeological Science* 30, 1269–81.

McCormick, F., 1992. Early faunal evidence for dairying. *Oxford Journal of Archaeology* 11, 201–9.

McCormick, F., 1998. Calf slaughter as a response to marginality, in *Life on the Edge: Human Settlement and Marginality*, eds. C.M. Mills & G. Coles. Oxford: Oxbow Books, 49–51.

McCormick, F. & P.C. Buckland, 1997. The vertebrate fauna, in *Scotland: Environment and Archaeology, 8000 BC–AD 1000*, eds. K.J. Edwards & I.B. Ralston. New York (NY): John Wiley & Sons, 83–103.

McCormick, F. & E. Murray, 2007. *Excavations at Knowth*, vol. 3: *Knowth and the Zooarchaeology of Early Christian Ireland*. Dublin: Royal Irish Academy.

McCutcheon, C., 2006. *Medieval Pottery from Wood Quay, Dublin*. Dublin: Royal Irish Academy.

McDonald, R.A., 2003. *Outlaws of Medieval Scotland: Challenges to the Canmore Kings, 1058–1266*. Phantassie, East Linton: Tuckwell Press.

McDonald, R.A., 2007. *Manx Kingship in its Irish Sea Setting 1187–1229: King Rognvaldr and the Crovan Dynasty*. Dublin: Four Courts Press.

McDougall, D. & I. McDougall (eds.), 1998. *Theodoricus Monachus: the Ancient History of the Norwegian Kings*. London: Viking Society for Northern Research.

McGavin, N.A., 1982. Excavations in Kirkwall, 1978. *Proceedings of the Society of Antiquaries of Scotland* 112, 392–436.

McGovern, T.H., 2009. The archaeofauna, in *Hofstaðir: Excavations of a Viking Age Feasting Hall in North-eastern Iceland*, ed. G. Lucas. Reykjavik: Institute of Archaeology, 168–252.

McGregor, A., 1880. Notes on some old customs in the Island of Sky. *Proceedings of the Society of Antiquaries of Scotland* 14, 143–8.

McGrew, J. (ed.), 1970. *Sturlunga Saga*, vol. 1. New York (NY): American-Scandinavian Foundation.

McGrew, J. & R.G. Thomas (eds.), 1974. *Sturlunga Saga*, vol. 2. New York (NY): American-Scandinavian Foundation.

McGuire, R.H., 2002. *A Marxist Archaeology*. Clinton Corners (NY): Percheron Press.

McNeill, G.P. (ed.), 1901. *The Exchequer Rolls of Scotland*, vol. XXI: *A.D. 1580–1588*. Edinburgh: H.M. General Register House.

Mellars, P.A. & M.R. Wilkinson, 1980. Fish otoliths as indicators of seasonality in prehistoric shell middens: the evidence from Oronsay (Inner Hebrides). *Proceedings of the Prehistoric Society* 46, 19–44.

Mikkelsen, E., 1994. *Fangstprodukter i Vikingtidens og Middelalderens Økonomi: Organiseringen av massefangst av villrein i Dovre*. Oslo: Universitetets Oldsaksamlings.

Milek, K., 2006. Geoarchaeological Analyses of Soils and Sediments in Area F, Quoygrew, Westray, Orkney: First Report. Unpublished Report, McBurney Geoarchaeology Laboratory, Department of Archaeology, University of Cambridge.

Miller, J.D., 1859. Copy Plan of the Commonty of Wall in the Island of Westray. Manuscript map, Orkney Archives D7/4/29.

Miller, J.D., 1866. The Estate of Trenabie, Westray: the Property of David Balfour Esq. of Balfour. Manuscript map held in Westray Heritage Centre.

Milner, N., 2002. *Incremental Growth of the European Oyster,* Ostrea edulis: *Seasonality Information from Danish Kitchen Middens*. (British Archaeological Reports, International Series 1057.) Oxford: BAR.

Milner, N., 2009. Mesolithic middens and marine molluscs: procurement and consumption of shellfish at the site of Sand, in *Mesolithic and Later Sites around the Inner Sound, Scotland: the Work of the Scotland's First Settlers Project 1998–2004*, eds. K. Hardy & C. Wickham-Jones. Edinburgh: Society of Antiquaries of Scotland. http://www.sair.org.uk/sair31.

Milner, N. & E. Laurie, 2009. Coastal perspectives on the Mesolithic–Neolithic transition, in *Mesolithic Horizons, Papers Presented at the 7th International Conference on the Mesolithic in Europe, Belfast 2005*, eds. S. McCartan, R. Schulting, G. Warren & P. Woodman. Oxford: Oxbow Books, 134–9.

Milner, N., J. Barrett & J. Welsh, 2007. Marine resource intensification in Viking Age Europe: the molluscan evidence from Quoygrew, Orkney. *Journal of Archaeological Science* 34, 1461–72.

Minagawa, M. & E. Wada, 1984. Stepwise enrichment of ^{15}N along food chains: further evidence and the relation between δ^{15}N and animal age. *Geochimica et Cosmochimica Acta* 48, 1135–40.

Minnis, P.E., 1981. Seeds in archaeological sites: sources and some interpretive problems. *American Antiquity* 46, 143–51.

Mitchell, J.G., H. Askvik & H.G. Resi, 1984. Potassium-argon ages of schist hone stones from the Viking Age sites at Kaupang (Norway), Aggersborg (Denmark), Hedeby (West Germany) and Wolin (Poland), and their archaeological implications. *Journal of Archaeological Science* 11, 171–6.

Mitchell, S.A., 1993. Óðinn, in *Medieval Scandinavia*, ed. P. Pulsiano. London: Garland Publishing, 444–5.

Molaug, P., 1977. Leirkarmaterialet fra 'Mindets tomt', in *Feltet 'Mindets tomt': Stratigrafi, topografi, daterende funngrupper*, ed. I. Høeg. (De Arkeologiske Utgravninger i Gamlebyen, Oslo, Bind 1.) Øvre Ervik: Alvheim & Eide Academisk Forlag, 72–120.

Molaug, P., 1979. Leirkarmaterialet, in *Feltene 'Oslogate 3 og 7': Bebyggelsesrester og funngrupper*, ed. E. Schia. (De Arkeologiske Utgravninger i Gamlebyen, Oslo, Bind 2.) Øvre Ervik: Alvheim & Eide Academisk Forlag, 33–46.

Molaug, P., 1981. Blyglassert Leirgods, in *Fra Christianias byggrunn*, ed. E. Schia. (Riksantikvarens Skrifter 4.) Øvre Ervik: Alvheim & Eide Academisk Forlag, 53–110.

Molaug, P., 1987. Leirkarmaterialet, in *'Søndre Felt': Stratigrafi, Bebyggelsesrester og Daterende Funngrupper*, ed. E. Schia. (De Arkeologiske Utgravninger i Gamlebyen,

Oslo, Bind 3.) Øvre Ervik: Alvheim & Eide Academisk Forlag, 229–328.

Molaug, P.B., 2007. Tuft 3, in *Vesle Hjerkinn: Kongens gård og sælehus*, ed. B. Weber. Oslo: Universitetets Kulturhistoriske Museer, 24–39.

Montgomery, F.H., 1977. *Seeds and Fruits of Plants of Eastern Canada and the Northeastern United States*. Toronto: University of Toronto Press.

Moore, H. & G. Wilson, 1998. Orkney Coastal Zone Assessment Survey 1998. Unpublished report. Edinburgh: EASE Archaeological Consultants.

Moore, H. & G. Wilson, 2003. Langskaill. *Discovery and Excavation in Scotland*, New Series 4, 103.

Moore, H. & G. Wilson, 2005a. The Langskaill Souterrain. *Current Archaeology* 199, 333–5.

Moore, H. & G. Wilson, 2005b. Knowe of Skea: an Iron Age 'shrine' on Westray? *Current Archaeology* 199, 328–32.

Morales, A. & K. Rosenlund, 1979. *Fish Bone Measurements: an Attempt to Standardize the Measuring of Fish Bones from Archaeological Sites*. Copenhagen: Steenstrupia.

Moran, N.C. & T.P. O'Connor, 1994. Age attribution in domestic sheep by skeletal and dental maturation: a pilot study of available sources. *International Journal of Osteoarchaeology* 4, 267–86.

Morris, C.D., 1985. Viking Orkney: a survey, in *The Prehistory of Orkney*, ed. C. Renfrew. Edinburgh: Edinburgh University Press, 210–42.

Morris, C.D (ed.), 1996a. *The Birsay Bay Project*, vol. 2: *Sites in Birsay Village and on the Brough of Birsay, Orkney*. (Monograph Series 2.) Durham: University of Durham, Department of Archaeology.

Morris, C.D., 1996b. Church and monastery in Orkney and Shetland: an archaeological perspective, in *Nordsjøen: Handel, religion og politikk*, eds. J.F. Krøger & H. Naley. Karmøy Kommune: vikingfestivalen, 185–206.

Morris, C.D., 1996c. From Birsay to Tintagel: a personal view, in *Scotland in Dark Age Britain*, ed. B.E. Crawford. Aberdeen: Scottish Cultural Press, 37–78.

Morris, C.D., 1998. Raiders, traders and settlers: the early Viking Age in Scotland, in *Ireland and Scandinavia in the Early Viking Age*, eds. H. Clarke, M. Ní Mhaonaigh & R. Ó Floinn. Dublin: Four Courts Press, 73–103.

Morris, C.D. & N. Emery, 1986. The chapel and enclosure on the Brough of Deerness, Orkney: survey and excavations, 1975–1977. *Proceedings of the Society of Antiquaries of Scotland* 116, 301–74.

Morris, C.D., C.E. Batey & D.J. Rackham (eds.), 1995. *Freswick Links, Caithness: Excavation and Survey of a Norse Settlement*. Inverness: Highland Libraries and the North Atlantic Biocultural Organisation.

Morris, J., 2005. Red deer's role in social expression on the isles of Scotland, in *Just Skin and Bones: New Perspectives on Human–Animal Relations in the Historic Past*, ed. A.G. Pluskowski. (British Archaeological Reports International Series 1410.) Oxford: BAR, 9–18.

Morrison, I., 1992. Traditionalism and innovation in the maritime technology of Shetland and other North Atlantic communities, in *Scotland and the Sea*, ed. T.C. Smout. Edinburgh: John Donald, 114–36.

Moss, M.L., 2004. Island societies are not always insular:

Tlingit territories in the Alexander Archipelago and the adjacent Alask mainland, in *Voyages of Discovery: the Archaeology of Islands*, ed. S.M. Fitzpatrick. Westport (CT): Praeger, 165–83.

Müldner, G. & M.P. Richards, 2005. Fast or feast: reconstructing diet in later medieval England by stable isotope analysis. *Journal of Archaeological Science* 32, 39–48.

Mullally, E. (ed.), 2002. *The Deeds of the Normans in Ireland [La geste des Engleis en Yrlande]: a New Edition of the Chronicle Formerly Known as The Song of Dermot and the Earl*. Dublin: Four Courts Press.

Mulville, J., 2002. The role of cetacea in prehistoric and historic Atlantic Scotland. *International Journal of Osteoarchaeology* 12, 34–48.

Mulville, J., 2010. Red deer on Scottish Islands, in *Extinctions and Invasions: a Social History of British Fauna*, eds. T. O'Connor & N. Sykes. Oxford: Windgather Press, 43–50.

Mulville, J. & H. Smith, 2004. Resource management in the Outer Hebrides: an assessment of the faunal and floral evidence from archaeological investigations, in *Atlantic Connections and Adaptations: Economies, Environments and Subsistence in Lands Bordering the North Atlantic*, eds. R.A. Housley & G. Coles. Oxford: Oxbow Books, 48–64.

Mulville, J., J. Bond & O. Craig, 2005. The white stuff, milking in the outer Scottish Isles, in *The Zooarchaeology of Fats, Oils, Milk and Dairying*, eds. J. Mulville & A.K. Outram. Oxford: Oxbow Books, 167–82.

Mulville, J., R. Madgwick, R. Stevens *et al.*, 2009. Isotopic analysis of faunal material from South Uist, Western Isles, Scotland. *Journal of the North Atlantic* 2, 51–9.

Munch, G.S., O.S. Johansen & E. Roesdahl (eds.), 2003. *Borg in Lofoten: a Chieftain's Farm in North Norway*. Trondheim: Tapir Academic Press.

Murray, H.K & J.C. Murray, 1993. Excavations at Rattray, Aberdeenshire: a Scottish deserted burgh. *Medieval Archaeology* 37, 109–218.

Murray, J.C., 1982. The pottery, in *Excavations in the Medieval Burgh of Aberdeen 1973–81*, ed. J.C. Murray. (Monograph Series 2.) Edinburgh: Society of Antiquaries of Scotland, 116–76.

Myhre, B., B. Stoklund & P. Gjærder (eds.), 1982. *Vestnordisk Byggeskikk Gjennom to Tusen År*. (AmS-skrifter 7.) Stavanger: Arkeologisk Museum i Stavanger.

Mykura, W., 1976. *British Regional Geology: Orkney and Shetland*. Edinburgh: Her Majesty's Stationary Office.

Myrvoll, S., 1982. Excavations in the town of Skien, Telemark, Norway. *PACT: Journal of the European Study Group on Physical, Chemical and Mathematical Techniques Applied to Archaeology* 7, 329–40.

Mytum, H., 2003. The Vikings in Ireland: ethnicity, identity, and culture change, in *Contact, Continuity and Collapse: the Norse Colonization of the North Atlantic*, ed. J.H. Barrett. (Studies in the Early Middle Ages.) Turnhout: Brepols, 113–37.

Naum, M., 2010. Re-emerging frontiers: postcolonial theory and historical archaeology of the borderlands. *Journal of Archaeological Method and Theory* 17, 101–31.

Naum, M., 2012. Difficult middles, hybridity and ambiva-

lence of a medieval frontier: the cultural landscape of Lolland and Falster (Denmark). *Journal of Medieval History* 38, 56–75.

Nedkvitne, A., 1976. Handelssjøfarten mellom Norge og England i Høymiddelalderen. *Sjøfartshistorisk Årbok* 1976, 7–254.

Ní Mhaonaigh, M., 2007. *Brian Boru: Ireland's Greatest King?* Tempus: Stroud.

Nicholson, A., 1997a. The antler, in *Whithorn and St Ninian: the Excavation of a Monastic Town 1984–91*, ed. P. Hill. Stroud: Sutton, 474–95.

Nicholson, A., 1997b. The bone and horn objects, in *Whithorn and St Ninian: the Excavation of a Monastic Town 1984–91*, ed. P. Hill. Stroud: Sutton, 495–9.

Nicholson, A., 1997c. The copper alloy, in *Whithorn and St Ninian: the Excavation of a Monastic Town 1984–91*, ed. P. Hill. Stroud: The Whithorn Trust & Sutton Publishing, 360–89.

Nicholson, R.A., 1992a. Bone survival: the effects of sedimentary abrasion and trampling on fresh and cooked bone. *International Journal of Osteoarchaeology* 2, 79–90.

Nicholson, R.A., 1992b. An assessment of the value of bone density measurements to archaeoichthyological studies. *International Journal of Osteoarchaeology* 2, 139–54.

Nicholson, R.A., 1996. Bone degradation, burial medium and species representation: debunking the myths, an experiment-based approach. *Journal of Archaeological Science* 23, 513–34.

Nicholson, R.A., 2004. Iron-Age fishing in the Northern Isles: the evolution of a stored product, in *Atlantic Connections and Adaptations: Economies, Environments and Subsistence in Lands Bordering the North Atlantic*, eds. R.A. Housley & G. Coles. Oxford: Oxbow Books, 155–62.

Nicholson, R.A., 2005. Oil from troubled waters: historical and archaeological investigations into the use of fish and sea mammal oil in the Northern Isles of Scotland, in *The Zooarchaeology of Fats, Oils, Milk and Dairying*, eds. J. Mulville & A.K. Outram. Oxford: Oxbow Books, 142–9.

Nicholson, R.A., 2007. The fish remains, in *Investigations in Sanday, Orkney*, vol. 1: *Excavations at Pool, Sanday. A Multi-period Settlement from Neolithic to Late Norse Times*, eds. J. Hunter, J.M. Bond & A.N. Smith. Kirkwall: The Orcadian, 263–78.

Nicholson, R.A., 2010. Fish and fishing from the Pictish to the Norse centuries, in *Excavations at Old Scatness, Shetland*, vol. 1: *The Pictish and Viking Settlement*, eds. S.J. Dockrill, J.M. Bond, V.E. Turner, L.D. Brown, D.J. Bashford, J.E. Cussans & R.A. Nicholson. Lerwick: Shetland Heritage Publications, 156–67.

Nicholson, R.A., P. Barber & J.M. Bond, 2005. New evidence for the date of introduction of the house mouse, *Mus musculus domesticus* Schwartz & Schwartz, and the field mouse, *Apodemus sylvaticus* (L.), to Shetland. *Environmental Archaeology* 10, 143–51.

Nicolaisen, W.F.H., 1976. *Scottish Place-names*. London: B.T. Batsford.

Nielssen, A.R., 2009. Norwegian fisheries c.1100–1850, in *A History of the North Atlantic Fisheries*, vol. 1: *From Early Times to the Mid-nineteenth Century*, eds. D.J.

Starkey, J.T. Thór & I. Heidbrink. Bremen: Verlag H. M. Hauschild, 83–109.

Niven, K.J., 2003. Viking-Age Hoards in Scotland: a GIS-based Investigation of their Landscape Context and Interpretation. Unpublished MSc thesis, University of York.

Noble, G., T. Poller, J. Raven & L. Verrill (eds.), 2008. *Scottish Odysseys: the Archaeology of Islands*. Stroud: Tempus.

Noddle, B.A., 1976–77. 'The animal bones from Buckquoy, Orkney', in Excavation of Pictish and Viking-age farmsteads at Buckquoy, Orkney, ed. A. Ritchie. *Proceedings of the Society of Antiquaries of Scotland* 108, 201–9.

Noël Hume, I., 1961. The glass wine bottle in colonial Virginia. *Journal of Glass Studies* 3, 91–117.

Noël Hume, I., 1978. *Guide to Artifacts of Colonial America*. New York (NY): Knopf.

Norr, S. & D. Fewster, 2003. Borg II, in *Borg in Lofoten: a Chieftain's Farm in North Norway*, eds. G.S. Munch, O.S. Johansen & E. Roesdahl. Trondheim: Tapir Academic Press, 109–18.

Oakley, G.E. & J.R. Hunter, 1979. The glass, in *St Peter's Street, Northampton, Excavations 1973–1976*, ed. J.H. Williams. Northampton: Northampton Development Corporation, 296–302.

O'Connor, S., 1987. The identification of osseous and keratinaceous materials at York, in *Archaeological Bone, Antler and Ivory*, eds. K. Starling & D. Watkinson. (Occasional Papers 5.) London: The United Kingdom Institute for Conservation of Historic and Artistic Works, 9–21.

O'Connor, T.P., 1989. *Bones from Anglo-Scandinavian Levels at 16–22 Coppergate*. (The Archaeology of York 15/3.) York: Council for British Archaeology.

O'Connor, T.P., 1991. *Bones from 46–54 Fishergate*. (The Archaeology of York 15/4.) York: York Archaeological Trust.

O'Connor, T.P., 1993. Birds and the scavenger niche. *Archaeofauna* 2, 155–62.

O'Connor, T.P., 2000. *The Archaeology of Animal Bones*. Stroud: Sutton.

O'Connor, T.P., 2004. Animal bones from Anglo-Scandinavian York, in *Aspects of Anglo-Scandinavian York*, eds. R.A. Hall, D.W. Rollason, M. Blackburn *et al.* (Archaeology of York 8/4.) York: Council for British Archaeology, 427–45.

O'Connor, T., 2010. Livestock and deadstock in early medieval Europe from the North Sea to the Baltic. *Environmental Archaeology* 15, 1–15.

Ólafsson, G., 1982. *Torfbærinn: Frá eldaskála til Burstabæjar*. Reykjavik: Farandsýningar Útnorðursafnsins.

Oleson, T.J., 1966. Zeno, Nicolò and Antonio, in *Dictionary of Canadian Biography*, vol. I: *1000 to 1700*, ed. G.W. Brown. Toronto: University of Toronto Press, 680–81.

Olsen, B., 2003. Material culture after text: re-membering things. *Norwegian Archaeological Review* 36, 87–104.

Olsen, B., 2010. *In Defense of Things: Archaeoloogy and the Ontology of Objects*. Lanham (MD): Altamira Press.

Olsen, O.M., 2004. Medieval fishing tackle from Bergen, in *Medieval Fishing Tackle from Bergen and Borgund*, ed. I. Øye. (The Bryggen Papers: Main Series 5.) Bergen: Forbokforlaget, 11–106.

Olson, C. & Y. Walther, 2007. Neolithic cod (*Gadus morhua*) and herring (*Clupea harengus*) fisheries in the Baltic Sea, in the light of fine-mesh sieving: a comparative study of subfossil fishbone from the late Stone Age sites of Ajvide, Gotland, Sweden and Jettböle, Åland, Finland. *Environmental Archaeology* 12, 175–85.

Onnela, J., T. Lempiäinen & J. Luoto, 1996. Viking Age cereal cultivation in SW Finland: a study of charred grain from Pahamäki in Pahka, Lieto. *Annales Botanici Fennici* 33, 237–55.

Oram, R., 2008. *David I: The King Who Made Scotland*. Stroud: The History Press.

Oram, R. & W.P. Adderley, 2008. Lordship and environmental change in central Highland Scotland c.1300–c.1400. *Journal of the North Atlantic* 1, 74–84.

Ordnance Survey, 1882a. *First edition 1:10560 Orkney & Shetland (Orkney) Sheet LXX*. Southampton: Ordnance Survey.

Ordnance Survey, 1882b. *First edition 1:10560 Orkney & Shetland (Orkney) Sheets LXXIV & LXXV*. Southampton: Ordnance Survey.

Ordnance Survey, 1903. *Second edition 1:10560 Orkney & Shetland (Orkney) Sheets LXXIV & LXXV*. Southampton: Ordnance Survey.

Orton, D.C., D. Makowiecki, T. de Roo *et al.*, 2011. Stable isotope evidence for late medieval (14th–15th C) origins of the eastern Baltic cod (*Gadus morhua*) fishery. *PLoS ONE* 6(11):e27568. doi:10.1371/journal.pone.0027568.

Orton, J., 1928. Observations on *Patella vulgata*, part 1: Sex-phenomena, breeding and shell growth. *Journal of the Marine Biological Association of the United Kingdom* 15, 851–62.

Østmo, E. & L. Hedeager (eds.), 2005. *Norsk Arkeologisk Leksikon*. Oslo: Pax Forlag A/S.

Ottaway, P.J., 1992. *Anglo-Scandinavian Ironwork from 16–22 Coppergate*. (The Archaeology of York 17/6.) York: York Archaeological Trust.

Ottaway, P.J. & N.S.H. Rogers, 2002. *Medieval Finds from York*. (The Archaeology of York 17/15.) York: York Archaeological Trust.

Outram, A.K., 2001. A new approach to identifying bone marrow and grease exploitation: why the 'indeterminate' fragments should not be ignored'. *Journal of Archaeological Science* 28, 401–10.

Outram, Z. & C.M. Batt, 2005. Archaeomagnetic Dating of the Features from Excavations at Quoygrew, Westray, Orkney. Unpublished Report, Department of Archaeological Sciences, University of Bradford.

Owen, N., M. Kent & P. Dale, 1996. The machair vegetation of the Outer Hebrides: a review, in *The Outer Hebrides: the Last 14,000 Years*, eds. D. Gilbertson, M. Kent & J. Grattan. Sheffield: Sheffield Academic Press, 123–31.

Owen, O.A., 1993. Tuquoy, Westray, Orkney: a challenge for the future?, in *Caithness, Orkney and the North Atlantic in the Viking Age*, eds. C.E. Batey, J. Jesch & C.D. Morris. Edinburgh: Edinburgh University Press, 318–39.

Owen, O., 2002. Les Vikings en Écosse: quel type de maison les colons vikings construisaient-ils?, in *L'héritage maritime des Vikings en Europe de l'Ouest*, eds. E. Ridel & P. Bouet. Caen: Presses Universitaires de Caen, 137–70.

Owen, O., 2004. The Scar boat burial — and the missing decades of the early Viking Age in Orkney and Shetland, in *Scandinavia and Europe 800–1350: Contact, Conflict and Co-existence*, eds. J. Adams & K. Holman. Turnhout: Brepols, 3–33.

Owen, O., 2005. History, archaeology and *Orkneyinga Saga*: the case of Tuquoy, Westray, in *The World of Orkneyinga Saga*, ed. O. Owen. Kirkwall: The Orcadian, 193–212.

Owen, O. & M. Dalland, 1999. *Scar: a Viking Boat Burial on Sanday, Orkney*. Phantassie: Tuckwell Press.

Owen, O. & C. Lowe (eds.), 1999. *Kebister: the Four-thousand-year-old Story of One Shetland Township*. (Monograph Series 14.) Edinburgh: Society of Antiquaries of Scotland.

Øye, I., 1988. *Textile Equipment and its Working Environment, Bryggen in Bergen c.1150–1500*. Oslo: Norwegian University Press.

Øye, I., 2004. Farming systems and rural societies *ca.* 800–1350, in *Norwegian Agricultural History*, ed. R. Almås. Trondheim: Tapir Academic Press, 80–140.

Palla, G., I. Derényi, I. Farkas & T. Vicsek, 2005. Uncovering the overlapping community structure of complex networks in nature and society. *Nature* 435, 814–18.

Palla, G., A.-L. Barabási & T. Vicsek, 2007. Quantifying social group evolution. *Nature* 446, 664–7.

Pálsson, H. & P. Edwards, 1981. *Orkneyinga Saga: the History of the Earls of Orkney*. London: Penguin Books.

Papazian, C., 2000. The medieval pottery, in *The Port of Medieval Dublin Archaeological Excavations at the Civic Offices, Winetavern Street, Dublin 1993*, ed. A. Halpin. Dublin: Four Courts Press, 103–17.

Parker, A.J., 1999. A maritime cultural landscape: the port of Bristol in the Middle Ages. *The International Journal of Nautical Archaeology* 28, 323–42.

Parker Pearson M., N. Sharples & J. Mulville, 1996. Brochs and Iron Age society: a re-appraisal. *Antiquity* 70, 57–67.

Parker Pearson, M., H. Smith, J. Mulville & M. Brennand, 2004a. Cille Pheadair: the life and times of a Norse-period farmstead c. 1000–1300, in *Land, Sea and Home: Proceedings of a Conference on Viking-period Settlement*, eds. J. Hines, A. Lane & M. Redknap. (Society for Medieval Archaeology Monograph 20.) Leeds: Maney, 235–54.

Parker Pearson, M., N. Sharples & J. Symonds, 2004b. *South Uist: Archaeology and History of a Hebridean Island*. Stroud: Tempus.

Parks, R. & J. Barrett, 2009. The zooarchaeology of Sand, in *Mesolithic and Later Sites around the Inner Sound, Scotland: the Work of the Scotland's First Settlers Project 1998–2004*, eds. K. Hardy & C. Wickham-Jones. Edinburgh: Society of Antiquaries of Scotland. http://www.sair.org.uk/sair31.

Payne, S., 1973. Kill-off patterns in sheep and goats: the mandibles from Asvan Kale. *Anatolian Studies* 23, 281–303.

Payne, S., 1987. Reference codes for wear stages in the mandibular cheek teeth of sheep and goats. *Journal of Archaeological Science* 14, 609–14.

Penniman, T.K., 1952. *Pictures of Ivory and Other Animal Teeth, Bone and Antler*. (Occasional Papers on Technology 5.) Oxford: Pitt-Rivers Museum.

Perdikaris, S. & T.H. McGovern, 2008. Codfish and kings, seals and subsistence: Norse marine resource use in the North Atlantic, in *Human Impacts on Ancient Marine Ecosystems: a Global Perspective*, eds. T. Rick & J. Erlandson. Berkeley (CA): University of California Press, 187–214.

Pestell, T. & K. Ulmschneider (eds.), 2003. *Markets in Early Medieval Europe: Trading and 'Productive' Sites, 650–850*. Macclesfield: Windgather Press.

Pilø, L., 2007. The settlement: character, structures and features, in *Kaupang in Skiringssal*, ed. D. Skre. Aarhus: Aarhus University Press, 191–222.

Pluskowski, A., A.J. Boas & C. Gerrard, 2011. The ecology of crusading: investigating the environmental impact of holy war and colonisation at the frontiers of medieval Europe. *Medieval Archaeology* 55, 192–225.

Poaps, S.L., 2000. Palaeoethnobotanical Analysis of the Norse Period Midden at Quoygrew, Orkney, Scotland: Local Production or Importation of Economic Taxa? Unpublished MSc thesis, University of Toronto.

Poaps, S.L. & J.P. Huntley, 2001a. Quoygrew 1997: Palaeoethnobotanical Analysis. Unpublished report, University of Toronto and University of Durham.

Poaps, S.L. & J.P. Huntley, 2001b. Cleat 1997: Paleoethnobotanical Analysis. Unpublished report, University of Toronto and University of Durham.

Poole, R.G., 1991. *Viking Poems on War and Peace: a Study in Skaldic Narrative*. Toronto: University of Toronto Press.

Porter, D., 1997. Small finds, in *Settlements at Skaill, Deerness, Orkney*, ed. S. Buteux. (British Archaeological Reports, British Series 260.) Oxford: BAR, 96–132.

Porter, J., 1994. *Bandamanna Saga*. Felinfach: Llanerch.

Postan, M.M. 1973. *Essays on Medieval Agriculture and General Problems of the Medieval Economy*. Cambridge: Cambridge University Press.

Power, E., 1928. *The Goodman of Paris (Le Ménagier de Paris): a Treatise on Moral and Domestic Economy by a Citizen of Paris (c.1393)*. London: George Routledge and Sons.

Power, R., 1986. Magnus Barelegs' expeditions to the West. *Scottish Historical Review* 65, 2(180), 107–32.

Power, R., 1994. The death of Magnus Barelegs. *Scottish Historical Review* 73, 2(196), 216–22.

Price, N.S., 1995. House and home in Viking Age Iceland: cultural expression in Scandinavian colonial architecture, in *The Home: Words, Interpretations, Meanings and Environment*, ed. D. Benjamin. Aldershot: Avebury, 109–29.

Pringle, D., 1999. The houses of the Stewart earls in Orkney and Shetland. *New Orkney Antiquarian Journal* 1, 17–41.

Pringle, D., J.H. Lewis & B. Ballin Smith, 1996. The Earl's Palace, Birsay, in *The Birsay Bay Project*, vol. 2: *Sites in Birsay Village and on the Brough of Birsay, Orkney*, ed. C.D. Morris. (Monograph Series 2.) Durham: University of Durham, Department of Archaeology, 193–208.

Rackham, D.J., 1996. Beachview, Birsay: the biological assemblage, in *The Birsay Bay Project*, vol. 2: *Sites in Birsay Village and on the Brough of Birsay, Orkney*, ed. C.D. Morris. (Monograph Series 2.) Durham: University of Durham, Department of Archaeology, 161–91.

Rackham, D.J., E. Allison, S. Colley, B. Lamden, S. Nye &

M. Owen, 1996a. Excavations at Beachview Burnside Area 2: the biological assemblage, in *The Birsay Bay Project*, vol. 2: *Sites in Birsay Village and on the Brough of Birsay, Orkney*, ed. C.D. Morris. (Monograph Series 2.) Durham: University of Durham, Department of Archaeology, 64–74.

Rackham, D.J., E. Allison, S. Colley, B. Lamden, S. Nye & M. Owen, 1996b. Excavations at Beachview Studio Site, Area 1: The biological assemblage, in *The Birsay Bay Project*, vol. 2: *Sites in Birsay Village and on the Brough of Birsay, Orkney*, ed. C.D. Morris. (Monograph Series 2.) Durham: University of Durham, Department of Archaeology, 147–56.

Rainbird, P., 2007. *The Archaeology of Islands*. Cambridge: Cambridge University Press.

Ralston, I., 1997. Pictish homes, in *The Worm, the Germ and the Thorn: Pictish and Related Studies presented to Isabel Henderson*, ed. D. Henry. Balgavies, Angus: The Pinkfoot Press, 19–34.

Raven, J.A., 2005. *Medieval Landscapes and Lordship in South Uist*. Glasgow: University of Glasgow.

Redknap, M., 2009. Silver and commerce in Viking-Age north Wales, in *The Huxley Viking Hoard: Scandinavian Settlement in the North West*, eds. J. Graham-Campbell & R. Philpott. Liverpool: National Museums Liverpool, 29–41.

Reed, I.W., 1990. *1000 Years of Pottery: an Analysis of Pottery Trade and Use*. Trondheim: Riksantikvaren, Utgravningskontoret for Trondheim.

Reed, I., 1994. Late medieval ceramics in Norway. *Medieval Ceramics* 18, 59–65.

Reimer, P.J., M.G.L. Baillie, E. Bard *et al.*, 2009. IntCal09 and Marine09 radiocarbon age calibration curves, 0–50,000 years cal BP. *Radiocarbon* 51, 1111–50.

Renfrew, J.M., 1973. *Palaeoethnobotany: the Prehistoric Food Plants of the Near East and Europe*. New York (NY): Columbia University Press.

Resi, H.G., 2008. Whetstones and grindstones used in everyday life at Kaupang, in *The Kaupang Finds: Whetstones and Grindstones in the Settlement Area; the 1956–1974 Excavations*, ed. E. Mikkelsen. Oslo: Kulturhistorisk Museum, University of Oslo, 19–149.

Reuter, T., 1985. Plunder and tribute in the Carolingian Empire. *Transactions of the Royal Historical Society* 35, 75–94.

Reuter, T., 2006. Whose race, whose ethnicity? Recent medievalists' discussions of identity, in *Medieval Polities and Modern Mentalities*, eds. T. Reuter & J.L. Nelson. Cambridge: Cambridge University Press, 100–108.

Reynolds, A. & A. Langlands, 2011. Travel *as* communication: a consideration of overland journeys in Anglo-Saxon England. *World Archaeology* 43, 410–27.

Richards, M.P. & R.E.M. Hedges, 1999. Stable isotope evidence for similarities in the types of marine foods used by Late Mesolithic humans at sites along the Atlantic coast of Europe. *Journal of Archaeological Science* 26, 717–22.

Richards, M.P., B.T. Fuller & T.I. Molleson, 2006. Stable isotope palaeodietary study of humans and fauna from the multi-period (Iron Age, Viking and Late Medieval)

site of Newark Bay, Orkney. *Journal of Archaeological Science* 33, 122–31.

Richer, S., 2003. The Patterns of the Past: Settlement Patterns on Westray, Orkney. Unpublished BA dissertation, University of York.

Riddler, I., 1990. Saxon handled combs from London. *Transactions of the London and Middlesex Archaeological Society* 41, 9–20.

Ritchie, A., 1977. Excavation of Pictish and Viking-Age farmsteads at Buckquoy, Orkney. *Proceedings of the Society of Antiquaries of Scotland* 108, 174–227.

Ritchie, A., 1983. Birsay around AD 800. *Orkney Heritage* 2, 46–66.

Robberstad, K., 1983. Udal law, in *Shetland and the Outside World 1469–1969*, ed. D.J. Withrington. Oxford: Oxford University Press, 49–68.

Roberts, C. & M. Cox, 2003. *Health and Disease in Britain: From Prehistory to the Present Day*. Stroud: Sutton Publishing.

Robinson, R., 2009. The fisheries of Northwest Europe, c.1100–1850, in *A History of the North Atlantic Fisheries*, vol. 1: *From Early Times to the Mid-nineteenth Century*, eds. D.J. Starkey, J.T. Thór & I. Heidbrink. Bremen: Verlag H.M. Hauschild GmbH, 127–71.

Roesdahl, E., 1998. L'ivoire de morse et les colonies norroises du Groenland. *Proxima Thule* 3, 9–48.

Rogers, N.S.H., 1993. *Anglian and Other Finds from 46–54 Fishergate*. (The Archaeology of York 17/9.) York: York Archaeological Trust.

Rogerson, A., 1976. 'Excavations on Fuller's Hill, Great Yarmouth', in *Norfolk*, ed. P. Wade-Martins. *East Anglian Archaeology* 2, 131–245.

Roussell, A., 1934. *Norse Building Customs in the Scottish Isles*. London: Williams & Norgate Ltd.

Rowe, E.A., 2002. *The Flateyarbók Annals* as a historical source: a response to Eldbjørg Haug. *Scandinavian Journal of History* 27, 233–42.

Rowe, E.A., 2009. Helpful Danes and pagan Irishmen: saga fantasies of the Viking Age in the British Isles. *Viking Age and Medieval Scandinavia* 5, 1–21.

Rowlands, M.J., M.T. Larsen & K. Kristiansen (eds.), 1987. *Centre and Periphery in the Ancient World*. Cambridge: Cambridge University Press.

Rowley-Conwy, P., 1983. 'The animal and bird bones', in Trial excavations on Pictish and Viking settlements at Saevar Howe, Birsay, Orkney, by J.W. Hedges. *Glasgow Archaeological Review* 4, 109–11.

Royal Commission on the Ancient and Historical Monuments of Scotland (RCAHMS), 2010. *Canmore*. Edinburgh: Royal Commission on the Ancient and Historical Monuments of Scotland. http://www.rcahms.gov.uk/canmore.html. Site accessed 15 November 2010.

Rundberget, B. (ed.), 2007. *Jernvinna i Gråfjellområdet. Gråfjell Prosjektet*, Bind I. Oslo: Kulturhistorisk Museum.

Russell, N.J., C. Bonsall & D.G. Sutherland, 1995. The exploitation of marine molluscs in the Mesolithic of western Scotland: evidence from Ulva Cave, Inner Hebrides, in *Man and the Sea in the Mesolithic*, ed. A. Fischer. Oxford: Oxbow Books, 273–88.

Russell, N., G.T. Cook, P. Ascough, J.H. Barrett & A. Dugmore, 2011. Species-specific marine radiocarbon reser-

voir effect: a comparison of ΔR values between *Patella vulgata* (limpet) shell carbonate and *Gadus morhua* (Atlantic cod) bone collagen. *Journal of Archaeological Science* 38, 1008–15.

Said, E.W., 1994. *Culture and Imperialism*. London: Vintage Books.

Sandnes, B., 1999. Place-names in Orkney as evidence for language contact. *Northern Studies* 34, 23–34.

Sandnes, B., 2010. *From Starafjall to Starling Hill: an Investigation of the Formation and Development of Old Norse Place-names in Orkney*. Edinburgh: Scottish Place-Name Society.

Sawyer, P.H., 1976. Harald Fairhair and the British Isles, in *Les Vikings et Leur Civilisation*, ed. R. Boyer. Paris: Mouton, 105–12.

Sawyer, P., 1988. Dioceses and parishes in twelfth-century Scandinavia, in *St Magnus Cathedral and Orkney's Twelfth Century Renaissance*, ed. B. Crawford. Aberdeen: Aberdeen University Press, 36–45.

Sawyer, P., 1991. Konger og kongemagt, in *Fra Stamme til Stat i Danmark*, vol. 2: *Hovdingsdamfund of kongemagt*, eds. P. Mortensen & B.M. Rasmussen. (Jysk Arkaeologisk Selskabs Skrifter XXII:2.) Aarhus: Aarhus Universitetsforlag, 277–88.

Schäfer, D., 1888. *Hanserecesse, Dritter Band*. Leipzig: Verlag Von Duncker & Humblot.

Schmitt, G., 1996. Der frühneuzeitliche 'Moor- oder Dreckwall' von 1554 bis 1560, in Lübeck. *Lübecker Schriften zur Archäologie und Kulturgeschichte* 24, 265–308.

Schulz, C., 1990. Keramik der 14 bis 16 Jahrhunderts aus der Fronerei, in Lübeck. *Lübecker Schriften zur Archäologie und Kulturgeschichte* 19, 163–264.

ScotlandsPeople, 2011. *ScotlandsPeople: the Official Scottish Genealogy Resource*. Edinburgh: General Register Office for Scotland, the National Archives of Scotland and the Court of the Lord Lyon. http://www.scotlandspeople.gov.uk/?gclid=CKym0rSG6KcCFQuEzAodv3pFcA. Consulted 25 January 2011.

Scott, A.B. & F.X. Martin (eds.), 1978. *Expugnatio Hibernica*. Dublin: Royal Irish Academy.

Scott, N., C. Stevenson & A. Stout (eds.), 2003. *The Buildings of Westray 'fae Quoy tae Castle': an Orkney Island's Snapshot in Time*. Pierowall, Westray: Westray Buildings Preservation Trust.

Screen, E., 2009. The Norwegian coin finds of the early Viking Age. *Nordisk Numismatisk Årsskrift* 2003–2005, 93–121.

Searle, J.B., C.S. Jones, I. Gündüz *et al.*, 2009. Of mice and (Viking?) men: phylogeography of British and Irish house mice. *Proceedings of the Royal Society* Series B 276, 201–7.

Sellar, T., S.M. Colley, A.K.G. Jones & G. Turner, 1986. 'Animal bone material', in *Rescue Excavations on the Brough of Birsay 1974–1982*, ed. J.R. Hunter. Edinburgh: Society of Antiquaries of Scotland, 208–16.

Semple, S.J., 2009. Recycling the past: ancient monuments and changing meanings in early medieval Britain, in *Antiquaries and Archaists: the Past in the Past and the Past in the Present*, eds. M. Aldrich & R.J. Wallis. Reading: Spire Books, 29–45.

Sephton, J. (ed.), 1899. *The Saga of King Sverri of Norway*. London: David Nutt.

Serjeantson, D., 1988. Archaeological and ethnographic evidence for seabird exploitation in Scotland. *Archaeozoologia* 2, 209–24.

Serjeantson, D., 1998. Birds: a seasonal resource. *Environmental Archaeology* 3, 23–33.

Serjeantson, D., 2001. The great auk and the gannet: a prehistoric perspective on the extinction of the great auk. *International Journal of Osteoarchaeology* 11, 43–55.

Serjeantson, D., 2007. The bird bones, in *Investigations in Sanday, Orkney*, vol. 1: *Excavations at Pool, Sanday. A Multi-period Settlement from Neolithic to Late Norse Times*, eds. J. Hunter, J.M. Bond & A.N. Smith. Kirkwall: The Orcadian, 279–85.

Sharman, P., 1990. Tuquoy Steatite Report. Unpublished report for Historic Scotland.

Sharman, P.M., 1999. The steatite, in *Kebister: the Four-thousand-year-old Story of One Shetland Township*, eds. O. Owen & C. Lowe. (Monograph Series 14.) Edinburgh: Society of Antiquaries of Scotland, 168–78.

Sharples, N., 2004. A find of Ringerike art from Bornais in the Outer Hebrides, in *Land, Sea and Home: Proceedings of a Conference on Viking-period Settlement*, eds. J. Hines, A. Lane & M. Redknap. (Society for Medieval Archaeology Monograph 20.) Leeds: Maney, 255–72.

Sharples, N., 2005. The shore, part 1: shellfish, in *A Norse Farm in the Outer Hebrides: Excavations at Mound 3, Bornais, South Uist*, ed. N. Sharples. Oxford: Oxbow Books, 159–61.

Sharples, N. & M. Parker Pearson, 1999. Norse settlement in the Outer Hebrides. *Norwegian Archaeological Review* 32, 41–62.

Shaw, F.J., 1980. *The Northern and Western Islands of Scotland: their Economy and Society in the Seventeenth Century*. Edinburgh: John Donald.

Sheehan, J., 2008. The longphort in Viking Age Ireland. *Acta Archaeologica* 79, 282–95.

Sibbald, R., 1845 [1711]. *Description of the Islands of Orkney and Zetland by Robert Monteith of Eglisha and Gairsa, 1633*. Edinburgh: Thomas G. Stevenson.

Sigurdsson, J.V., 2008. *Det Norrøne Samfunnet: Vikingen, kongen, erkebiskopen og bonden*. Oslo: Pax Forlag A/S.

Silver, I.A., 1969. The ageing of domestic animals, in *Science in Archaeology, a Survey of Progress and Research*, eds. D.R. Brothwell & S. Higgs. London: Thames & Hudson, 283–302.

Simpson, I.A., 1993. The chronology of anthropogenic soil formation in Orkney. *Scottish Geographical Magazine* 109, 4–11.

Simpson, I.A., 1997. Relict properties of anthropogenic deep top soils as indicators of infield management in Marwick, West Mainland, Orkney. *Journal of Archaeological Science* 24, 365–80.

Simpson, I.A., S.J. Dockrill, I.D. Bull & S.J. Evershed, 1998. Early anthropogenic soil formation at Tofts Ness, Sanday, Orkney. *Journal of Archaeological Science* 25, 729–46.

Simpson, I.A., J.H. Barrett & K.B. Milek, 2005. Interpreting the Viking Age to medieval period transition in Norse Orkney through cultural soil and sediment analyses. *Geoarchaeology* 20, 355–77.

Simpson, W.D., 1961. *The Castle of Bergen and the Bishop's Palace at Kirkwall: a Study in Early Norse Architecture*. Edinburgh: Oliver and Boyd.

Sindbæk, S.M., 2005. *Ruter og rutinisering: Vikingetidens fjernhandel i Nordeuropa*. Copenhagen: Multivers Academic.

Sindbæk, S.M., 2007a. Networks and nodal points: the emergence of towns in early Viking Age Scandinavia. *Antiquity* 81, 119–32.

Sindbæk, S.M., 2007b. The small world of the Vikings: networks in early medieval communication and exchange. *Norwegian Archaeological Review* 40, 59–74.

Skaaning Høegsberg, M., 2009. Continuity and change: the dwellings of the Greenland Norse. *Journal of the North Atlantic* Special Volume 2, 82–101.

Skene, W.F. (ed.), 1872. *John of Fordun's Chronicle of the Scottish Nation*. Edinburgh: Edmonston and Douglas.

Skov, H., 2002. The development of rural house types in the old Danish region 800–1500 A.D, in *The Rural House from the Migration Period to the Oldest Still Standing Buildings*, ed. J. Klápště. (Ruralia IV.) Turnhout: Brepols, 30–33.

Skre, D., 2001. The social context of settlement in Norway in the first millennium AD. *Norwegian Archaeological Review* 34, 1–34.

Skre, D., 2008. Post-substantivist towns and trade: AD 600–1000, in *Means of Exchange: Dealing with Silver in the Viking Age*, ed. D. Skre. Aarhus: Aarhus University Press, 327–41.

Skre, D., 2010. Centrality and places: the central place at Skiringssal in Vestfold, Norway, in *Trade and Communication Networks of the First Millennium AD in the Northern Part of Central Europe*, eds. B. Ludowici, H. Jöns, S. Kleingärtner, J. Scheschkewitz & M. Hardt. Hannover: Niedersächsisches Landesmuseum Hannover, 220–31.

Skre, D., 2011. Commodity money, silver and coinage in Viking-age Scandinavia, in *Silver Economies, Monetisation and Society in Scandinavia, AD 800–1100*, eds. J. Graham-Campbell, S.M. Sindbæk & G. Williams. Aarhus: Aarhus University Press, 67–91.

Skre, D. & F.-A. Stylegar, 2004. *Kaupang: the Viking Town*. Oslo: University of Oslo.

Small, A., 1966. Excavations at Underhoull, Unst, Shetland. *Proceedings of the Society of Antiquaries of Scotland* 98, 225–48.

Small, A., 1968. The historical geography of the Norse Viking colonization of the Scottish Highlands. *Norsk Geografisk Tidsskrift* 22, 1–16.

Smirnova, L., 2005. *Comb-Making in Medieval Novgorod (950–1450): an Industry in Transition*. (British Archaeological Reports, International Series 1369.) Oxford: BAR.

Smith, A.B. & J. Kinahan, 1984. The invisible whale. *World Archaeology* 16, 89–97.

Smith, A.N., 1998. Bone vessels, in *Scalloway: a Broch, Late Iron Age Settlement and Medieval Cemetery in Shetland*, ed. N. Sharples. (Monograph 82.) Oxford: Oxbow Books, 137–8.

Smith, A.N., 2007a. Copper alloy objects, in *Investigations*

in Sanday, Orkney, vol. 1: *Excavations at Pool, Sanday Multi-period Settlement from Neolithic to Late Norse Times*, eds. J. Hunter, J.M. Bond & A.N. Smith. Kirkwall: The Orcadian/Historic Scotland, 433–9.

Smith, A.N., 2007b. Worked bone, in *Investigations in Sanday, Orkney*, vol. 1: *Excavations at Pool, Sanday. Multi-period Settlement from Neolithic to Late Norse Times*, eds. J. Hunter, J.M. Bond & A.N. Smith. Kirkwall: The Orcadian/Historic Scotland, 459–514.

Smith, A.N. & A. Forster, 2007. Steatite, in *Investigations in Sanday, Orkney*, vol. 1: *Excavations at Pool, Sanday. Multi-period Settlement from Neolithic to Late Norse Times*, eds. J. Hunter, J.M. Bond & A.N. Smith. Kirkwall: The Orcadian/Historic Scotland, 412–33.

Smith, A.N., S. Buttler & B. Weber, 1999. Steatite: vessels, bakestones and other objects, in *The Biggings, Papa Stour, Shetland: the History and Excavation of a Royal Norwegian Farm*, eds. B.E. Crawford & B. Ballin Smith. (Monograph Series 15.) Edinburgh: Society of Antiquaries of Scotland, 129–44.

Smith, B., 2001. The Picts and the martyrs or did Vikings kill the native population of Orkney and Shetland. *Northern Studies* 36, 7–32.

Smith, B., 2002. Earl Henry Sinclair's fictitious trip to America. *New Orkney Antiquarian Journal* 2, 3–18.

Smith, C., 1994. Howe: animal bone report, in *Howe: Four Millennia of Orkney Prehistory*, ed. B. Ballin Smith. (MF1:D3–G7.) Edinburgh: Society of Antiquaries of Scotland, 139–53.

Smith, C., 1998. Dogs, cats and horses in the Scottish medieval town. *Proceedings of the Society of Antiquaries of Scotland* 128, 859–85.

Smith, H.D., 1984. *Shetland Life and Trade: 1550–1914*. Edinburgh: John Donald.

Smith, H. & J. Mulville, 2004. Resource management in the Outer Hebrides: an assessment of faunal and floral evidence from archaeological investigations, in *Atlantic Connections and Adaptations: Economies, Environments and Subsistence in Lands Bordering the North Atlantic*, eds. R.A. Housley & G. Coles. Oxford: Oxbow Books, 48–64.

Snow, D.W. & C.M. Perrins, 1998a. *The Birds of the Western Palearctic Concise Edition*, vol. 1: *Non-passerines*. Oxford: Oxford University Press.

Snow, D.W. & C.M. Perrins, 1998b. *The Birds of the Western Palearctic Concise Edition*, vol. 2: *Passerines*. Oxford: Oxford University Press.

Sobey, D.G., 1981. *Stellaria media* (L.) Vill. *The Journal of Ecology* 69(1), 311–35.

Solli, B., 1996. *Narratives of Veøy: an Investigation into the Poetics and Scientifics of Archaeology*. Oslo: Universitetets Oldsaksamling.

Solli, B., 2006. Kokegroper fra eldre jernalder og et langhus fra middelalderen på Borg i Lofoten, in *Historien i Forhistorien: Festskrift til Einar Østmo på 60-års dagen*, eds. H. Glørstad, B. Skar & D. Skre. (Skrifter 4.) Oslo: Kulturhistorisk Museum, 281–97.

Solli, B., 2011. Some reflections on heritage and archaeology in the anthropocene. *Norwegian Archaeological Review* 44, 40–54.

Sommerville, A.A., 2003. Luminescence Dating of Wind-blown Sands from Archaeological Sites in Northern Scotland. Unpublished PhD thesis, Department of Geography and Topographic Science, University of Glasgow.

Sommerville, A.A., J.D. Hansom, D.C.W. Sanderson & R.A. Housley, 2003. Optically stimulated luminescence dating of large storm events in northern Scotland. *Quaternary Science Reviews* 22, 1085–92.

Sørheim, H., 2004. Borgund and the Borgundfjord fisheries, in *Medieval Fishing Tackle from Bergen and Borgund*, ed. I. Øye. (The Bryggen Papers: Main Series 5.) Bergen: Forbokforlaget, 107–33.

Speed, G. & P. Walton Rogers, 2004. A burial of a Viking woman at Adwick-le-Street, South Yorkshire. *Medieval Archaeology* 48, 51–90.

Stace, C., 1997. *New Flora of the British Isles*. 2nd edition. Cambridge: Cambridge University Press.

Staecker, J., 2005. Concepts of *imitatio* and *translatio*: perceptions of a Viking-Age past. *Norwegian Archaeological Review* 38, 3–28.

Starkey, D.J., J.T. Thor & I. Heidbrink (eds.), 2009. *A History of the North Atlantic Fisheries*, vol. 1: *From Early Times to the Mid-nineteenth Century*. Bremerhaven: Deutsches Schiffahrtsmuseum.

Stein, G.J., 1999. Rethinking world-systems: power, distance, and diasporas in the dynamics of interregional interaction, in *World-Systems Theory in Practice*, ed. P.N. Kardulias. Oxford: Rowman & Littlefield, 153–77.

Stene, K., 2010. Crisis — for Which Part of the Society? A Study of Socio-economic Relations in Medieval Norway through the Exploitation of Liminal Landscapes in the 11th–13th Centuries, Unpublished MPhil thesis, Department of Archaeology, University of Cambridge.

Stephan, H.-G., 1983. The production and development of medieval stoneware in Germany, in *Ceramics and Trade*, eds. P. Davey & R. Hodges. Sheffield: Department of Prehistory and Archaeology, University of Sheffield, 95–120.

Stephan, H.-G., 1999. Lower Saxon stoneware and near-stoneware, in *The Biggings, Papa Stour, Shetland: the History and Excavation of a Royal Norwegian Farm*, eds. B.E. Crawford & B. Ballin Smith. (Monograph Series 15.) Edinburgh: Society of Antiquaries of Scotland, 15–17.

Stoker, K.G., D.T. Cooke & D.J. Hill, 1998. Influence of light on natural indigo production from woad (*Isatis tinctoria*). *Plant Growth Regulation* 25, 181–5.

Storm, G., 1888. *Islandske Annaler Indtil 1578*. Christiania: Grøndahl & Søns Bogtrykkeri.

Stout, M., 1997. *The Irish Ringfort*. Dublin: Four Courts Press.

Stuart, J. & G. Burnett (eds.), 1878. *The Exchequer Rolls of Scotland*, vol. I. Edinburgh: H.M. General Register House.

Stummann Hansen, S., 2003a. Scandinavian building customs of the Viking Age: the North Atlantic perspective, in *Vinland Revisited: the Norse World at the Turn of the First Millennium*, ed. S. Lewis-Simpson. St John's: Historic Sites Association of Newfoundland and Labrador, 241–54.

Stummann Hansen, S., 2003b. The early settlement of the Faroe Islands: The creation of cultural identity, in *Contact, Continuity and Collapse: the Norse Colonization of the North Atlantic*, ed. J.H. Barrett. (Studies in the Early Middle Ages.) Turnhout: Brepols, 33–71.

Stummann Hansen, S. & D. Waugh, 1998. Scandinavian settlement in Unst, Shetland: archaeology and place-names, in *The Uses of Place-names*, ed. S. Taylor. Edinburgh: Scottish Cultural Press, 120–46.

Stylegar, F.-A., 2004. 'Central places' in Viking Age Orkney. *Northern Studies* 38, 5–30.

Stylegar, F.-A., 2007. The Kaupang cemeteries revisited, in *Kaupang in Skiringssal*, ed. D. Skre. Aarhus: Aarhus University Press, 65–101.

Stylegar, F.-A., 2009. Township and 'gard': a comparative study of some traditional settlement patterns in southwest Norway and the Northern Isles. *New Orkney Antiquarian Journal* 4, 29–46.

Surge, D. & J.H. Barrett, 2012. Marine climatic seasonality during medieval times (10th to 12th centuries) based on isotopic records in Viking Age shells from Orkney, Scotland. *Palaeogeography, Palaeoclimatology, Palaeoecology* 350–52, 236–46.

Svanberg, F., 2003. *Decolonizing the Viking Age*, vol. 1. Stockholm: Almqvist & Wiksell International.

Sveinsson, E.Ó. (ed.), 1954. *Brennu-Njáls Saga*. Reykjavík: Hið Íslenzka Fornritafélag.

Sveinsson, E.Ó. & M. Þórðarson (eds.), 1935. *Eyrbyggja saga með Brands þáttr orva — Eiríks saga rauða — Groenlendinga saga — Groenlendinga þáttr*. Reykjavík: Hið Íslenzka Fornritafélag.

Svensson, E., 2007. Before a world-system? The peasant-artisan and the market, in *Arts and Crafts in Medieval Rural Environment*, eds. J. Klápšt & P. Sommer. (Ruralia VI.) Turnhout: Brepols, 189–99.

Svensson, E., N. Makarov, M. Emanuelsson, A. Johansson, S. Nilsson & S. Pettersson, 2001. Different peripheries: two examples from Russia and Sweden. *Lund Archaeological Review* 7, 123–37.

Szabo, V.E., 2008. *Monstrous Fishes and the Mead-Dark Sea: Whaling in the Medieval North Atlantic*. Leiden: Brill.

Talbot, E., 1974. Scandinavian fortifications in the British Isles. *Scottish Archaeological Forum* 6, 37–45.

Taylor, A.B., 1938. *The Orkneyinga Saga*. Edinburgh: Oliver and Boyd.

Taylor, S., 2004. Scandinavians in central Scotland — *bý*-place-names and their context, in *Sagas, Saints and Settlements*, eds. G. Williams & P. Bibire. Leiden: Brill, 125–45.

Tempel, W.-D., 1970. *Die Kämme aus Haithabu (Ausgrabungen 1963-64)*. (Berichte über die Ausgrabungen in Haithabu 4.) Neumünster: Karl Wachhotlz Verlag.

Terrell, J.E., 2004. Island models of reticulate evolution: the 'ancient lagoons' hypothesis, in *Voyages of Discovery: the Archaeology of Islands*, ed. S.M. Fitzpatrick. Westport (CT): Praeger, 203–22.

Terrell, J.E., 2010. Language and material culture on the Sepik coast of Papua New Guinea: using social network analysis to simulate, graph, identify, and analyze social and cultural boundaries between communities. *Journal of Island and Coastal Archaeology* 5, 3–32.

Terrell, J.E., T.L. Hunt & C. Gosden, 1997. The dimensions of social life in the Pacific: human diversity and the myth of the primitive isolate. *Current Anthropology* 38, 155–95.

Thoms, L., 1983. Preliminary list of North European pottery in Scotland, in *Ceramics and Trade*, eds. P. Davey & R. Hodges. Sheffield: Department of Prehistory and Archaeology, University of Sheffield, 254–5.

Thomson, W.P.L., 1983. *Kelp-making in Orkney*. Kirkwall: The Orkney Press.

Thomson, W.P.L., 1984. Fifteenth century depression in Orkney: the evidence of Lord Henry Sinclair's rentals, in *Essays in Shetland History*, ed. B.E. Crawford. Lerwick: The Shetland Times, 125–42.

Thomson, W.P.L., 1995. Orkney farm-names: a re-assessment of their chronology, in *Scandinavian Settlement in Northern Britain*, ed. B.E. Crawford. London: Leicester University Press, 42–63.

Thomson, W.P.L., 1996. *Lord Henry Sinclair's 1492 Rental of Orkney*. Kirkwall: Orkney Press.

Thomson, W.P.L., 2002. Ouncelands and pennylands in the West Highlands and Islands. *Northern Scotland* 22, 27–43.

Thomson, W.P.L., 2008a. *The New History of Orkney*. 3rd edition. Edinburgh: Birlinn.

Thomson, W.P.L., 2008b. *Orkney Land and People*. Kirkwall: Kirkwall Press.

Þorláksson, H., 1991. *Vaðmál og Verðlag: Vaðmál í utanlandsviðskiptum og búskap Íslendinga á 13. og 14. öld*. Reykjavík: University of Iceland.

Thorsteinsson, A., 1968. The viking burial place at Pierowall, Westray, Orkney, in *The Fifth Viking Congress*, ed. B. Niclasen. Tórshavn: Føroya Landsstyri, 150–73.

Todd, J.H. (ed.), 1867. *Cogadh Gáedhel re Gallaibh: the War of the Gaedhil with the Gaill or the Invasions of Ireland by the Danes and Other Norsemen*. London: Longmans Green & Co.

Topping, P., 1983. Harald Maddadson, Earl of Orkney and Caithness, 1139–1206. *Scottish Historical Review* 62, 105–20.

Torrence, R. & P. Swadling, 2008. Social networks and the spread of Lapita. *Antiquity* 82, 600–616.

Towsey, K. (ed.), 2002. *Orkney and the Sea: an Oral History*. Kirkwall: Orkney Heritage.

Tschan, J. (ed.), 2002. *Adam of Bremen: History of the Archbishops of Hamburg-Bremen*. New York (NY): Columbia University Press.

Turner, V.E., P. Sharman & S. Carter, 2009. Excavations at Catpund, Cunningsburgh, in *Kleber: Shetland's Oldest Industry. Shetland Soapstone since Prehistory*, eds. A.K. Forster & V.E. Turner. Lerwick: Shetland Amenity Trust, 70–84.

Turner, W.H.K., 1972. Flax cultivation in Scotland: an historical geography. *Transactions of the Institute of British Geographers* 55, 127–43.

Ulbricht, I., 1980. Middelalderlig kamproduktion i Slesvig. *Hikuin* 6, 147–52.

United Kingdom Hydrographic Office (Admiralty Publications), 1993. *Orkney Islands Western Sheet 1:75000*. Taunton: United Kingdom Hydrographic Office.

Urbanczyk, P., 2007. What was 'Kaupang in Skiringsal'? Comments on Dagfinn Skre (ed.): *Kaupang in Skiringssal. Kaupang Excavation Project Publication Series*, vol. 1, Aarhus University Press, Århus (2007). *Norwegian Archaeological Review* 41, 176–212.

Vahtola, J., 2003. Population and settlement, in *The Cambridge History of Scandinavia*, vol. I: *Prehistory to 1520*, ed. K. Helle. Cambridge: Cambridge University Press 559–80.

Van de Noort, R., 2011. *North Sea Archaeologies: a Maritime Biography, 10,000 BC–AD 1500*. Oxford: Oxford University Press.

van der Veen, M., 1992. *Crop Husbandry Regimes: an Archaeobotanical Study of Farming in Northern England*. (Sheffield Archaeological Monographs.) Sheffield: J.R. Collis Publications.

van der Veen, M., A. Hall & J. May, 1993. Woad and the Britons painted blue. *Oxford Journal of Archaeology* 12, 367–71.

van Doorn, N.L., H. Hollund & M.J. Collins, 2011. A novel and non-destructive approach for ZooMS analysis: ammonium bicarbonate buffer extraction. *Archaeological and Anthropological Sciences* 3, 281–9.

Van Neer, W., A. Ervynck, L. Bolle, R.S. Millner & A.D. Rijnsdorp, 2002. Fish otoliths and their relevance to archaeology: an analysis of medieval, post-medieval and recent material of plaice, cod and haddock from the North Sea. *Environmental Archaeology* 7, 61–76.

Vangstad, H., 2003. Kleberkarene fra Bryggen i Bergen: en arkeologisk analyse av kleberkarene funnet på Bryggen i Bergen fra middelalder og etterreformatorisk tid. Unpublished Hovedfagsoppgave i Arkeologi thesis, University of Bergen.

Venkatesan, S., 2009. Rethinking agency: persons and things in the heterotopia of 'traditional Indian craft'. *Journal of the Royal Anthropological Institute* (NS) 15, 78–95.

Verhulst, A., 1999. *The Rise of Cities in North-west Europe*. Cambridge: Cambridge University Press.

Vésteinsson, O., 2000. The archaeology of Landnám: early settlement in Iceland, in *Vikings: the North Atlantic Saga*, eds. W.W. Fitzhugh & E.I. Ward. Washington (DC): Smithsonian Institution Press, 164–74.

Vésteinsson, O., 2004. Icelandic farmhouse excavations: field methods and site choices. *Archaeologia Islandica* 3, 71–100.

Vésteinsson, O., 2010. On farm mounds. *Archaeologia Islandica* 8, 13–39.

Viklund, K., 1998. *Cereals, Weeds, and Crop Processing in Iron Age Sweden*. (Archaeology and Environment.) Umeå: University of Umeå.

Vollan, O., 1959. Fisketilvirkning. *Kulturhistorisk Leksikon for Nordisk Middelalder* 4, 343–4.

von den Driesch, A., 1976. *A Guide to the Measurement of Animal Bones from Archaeological Sites*. (Bulletin 1.) Cambridge (MA): Peabody Museum.

von den Driesch, A. & J. Boessneck, 1974. Kritische Anmerkungen zur Widerristhohenberechnung aus Längenmassen vor- und frühgeschichtlicher Tierknochen. *Säugetierkundliche Mitteilungen* 22, 325–48.

van Dommelen, P., 2006. Colonial matters: material culture and postcolonial theory in colonial situations, in *Handbook of Material Culture*, eds. C. Tilley, W. Keane, S. Küchler, M. Rowlands & P. Spyer. London: Sage Publications, 104–24.

Vretemark, M., 1997. Raw materials and urban comb manufacturing in medieval Scandinavia. *Anthropozoologica* 25–6, 201–6.

Wainwright, F.T., 1962. The Scandinavian settlement, in *The Northern Isles*, ed. F.T. Wainwright. Edinburgh: Thomas Nelson and Sons, 117–62.

Wallace, P.F., 1987. The economy and commerce of Viking Age Dublin, in *Untersuchungen zu Handel und Verkehr der vor — und frühgeschichtlichen Zeit in Mittel- und Nordeuropa*, Teil IV: *Der Handel der Karolinger- und Wikingerzeit*, ed. K. Düwel. Göttingen: Vandenhoeck and Ruprecht, 200–245.

Wallace, P.F., 1992. *The Viking Age Buildings of Dublin, Medieval Dublin Excavations 1962–81*, part 1: *Text*. Dublin: Royal Irish Academy.

Wallerstein, I.M., 1974. *The Modern World-system: Capitalist Agriculture and the Origins of the European World-economy in the Sixteenth Century*. New York (NY): Academic Press.

Wallerstein, I., 1993. World system versus world-systems, in *The World System: Five Hundred Years or Five Thousand*, eds. A.G. Frank & B.K. Gills. London: Routledge, 292–6.

Walton, P., 1988. Dyes and wools in Iron Age textiles from Norway and Denmark. *Journal of Danish Archaeology* 7, 144–58.

Walton, P., 1989. *Textiles, Cordage, and Fibre from 16–22 Coppergate*. (The Archaeology of York 17/5.) Dorchester: The Council for British Archaeology and the Dorset Press.

Walton Rogers, P., 1997. *Textile Production at 16–22 Coppergate*. (The Archaeology of York 17/11.) York: York Archaeological Trust.

Watt, J., G.J. Pierce & P.R. Boyle, 1997. *A Guide to the Identification of North Sea Fish Using Premaxillae and Vertebrae*. Copenhagen: International Council for the Exploration of the Sea.

Watts, D.J. & S.H. Strogatz, 1998. Collective dynamics of 'small-world' networks. *Nature* 393, 440–42.

Waugh, D., 1993. Caithness: an onomastic frontier zone, in *Caithness, Orkney and the North Atlantic in the Viking Age*, eds C.E. Batey, J. Jesch & C.D. Morris. Edinburgh: Edinburgh University Press, 120–28.

Weber, B., 1993. Norwegian reindeer antler export to Orkney. *Universitetets Oldsaksamling Årbok* 1991/1992, 161–74.

Weber, B., 1999. Bakestones, in *The Biggings, Papa Stour, Shetland: the History and Excavation of a Royal Norwegian Farm*, eds. B.E. Crawford & B. Ballin Smith. (Monograph Series 15.) Edinburgh: Society of Antiquaries of Scotland, 134–9.

Westman, A. (ed.), 1994. *Archaeological Site Manual*. 3rd edition. London: Museum of London Archaeology Service.

Whaley, D., 1998. *The Poetry of Arnórr jarlaskáld: an Edition and Study*. Turnhout: Brepols.

Wheeler, A., 1969. *The Fishes of the British Isles and North-west Europe*. London: Macmillan.

Wheeler, A. & A.K.G. Jones, 1989. *Fishes*. Cambridge: Cambridge University Press.

Whitehead, P.J.P., M.L. Bauchot, J.C. Hureau, J. Nielsen & E. Tortonese (eds.), 1986a. *Fishes of the North-eastern Atlantic and the Mediterranean*, vol. 2. Paris: United Nations Educational, Scientific and Cultural Organization.

Whitehead, P.J.P., M.L. Bauchot, J.C. Hureau, J. Nielsen & E. Tortonese (ed.), 1986b. *Fishes of the North-eastern Atlantic and the Mediterranean*, vol. 3. Paris: United Nations Educational, Scientific and Cultural Organization.

Whitehead, P.J.P., M.L. Bauchot, J.C. Hureau, J. Nielsen & E. Tortonese (eds.), 1989. *Fishes of the North-eastern Atlantic and the Mediterranean*, vol. 1. Paris: United Nations Educational, Scientific and Cultural Organization.

Whitelock, D., D.C. Douglas & S.I. Tucker (eds.), 1961. *The Anglo-Saxon Chronicle*. London: Eyre & Spottiswoode.

Wiberg, C., 1977. Horn og beinmaterialet fra 'Mindets tomt', in *Feltet 'Mindets tomt': Stratigrafi, topografi, daterende funngrupper*, ed. I. Høeg. (De Arkeologiske Utgravninger i Gamlebyen, Oslo, Bind 1.) Øvre Ervik: Alvheim & Eide Academisk Forlag, 202–13.

Wickham, C., 2005. *Framing the Early Middle Ages: Europe and the Mediterranean, 400–800*. Oxford: Oxford University Press.

Wickham-Jones, C., 2003. The tale of the limpet. *British Archaeology* 71, 23.

Wienberg, J., 2009. Romanske runde kirketårne: et skandinavisk perspektiv. *Hikuin* 36, 101–20.

Will, R., 1999a. Other medieval ceramics, in *The Biggings, Papa Stour, Shetland: the History and Excavation of a Royal Norwegian Farm*, eds. B.E. Crawford & B. Ballin Smith. (Monograph Series 15.) Edinburgh: Society of Antiquaries of Scotland, 157.

Will, R., 1999b. Other post-medieval and modern ceramics, in *The Biggings, Papa Stour, Shetland: the History and Excavation of a Royal Norwegian Farm*, eds. B.E. Crawford & B. Ballin Smith. (Monograph Series 15.) Edinburgh: Society of Antiquaries of Scotland, 168.

Will, R. & G. Haggarty, 2008. The medieval and later pottery, in *Excavations at St Ethernan's Monastery, Isle of May, Fife 1992–7*, eds. H.F. James & P. Yeoman. Perth: Tayside and Fife Archaeological Committee, 136–48.

Williams, D., 1973. Flotation at Sīrāf. *Antiquity* 47, 288–92.

Williams, D.F., 1986. 'The pottery', in The chapel and enclosure on the Brough of Deerness, Orkney: survey and excavations, 1975–1977, by C.D. Morris & N. Emery. *Proceedings of the Society of Antiquaries of Scotland* 116, 335–8.

Williams, G., 2004. Land assessment and silver economy of Norse Scotland, in *Sagas, Saints and Settlements*, eds. G. Williams & P. Bibire. Leiden: Brill, 65–104.

Wills, N.T., 1970. *Woad in the Fens*. Lincoln: Society for Lincolnshire History and Archaeology.

Wilson, D.M., 1976. Scandinavian settlement in the north and west of the Bitish Isles — an archaeological point-of-view. *Transactions of the Royal Historical Society* 5th series 26, 95–113.

Wilson, G. & P.M. Watson, 1998. Conical gaming pieces, in *Scalloway: a Broch, Late Iron Age Settlement and Medieval Cemetery in Shetland*, ed. N. Sharples. (Monograph 82.) Oxford: Oxbow Books, 174–5.

Wolf, E.R., 1982. *Europe and the People without History*. Berkeley (CA): University of California Press.

Woolf, A., 2000. The 'Moray question' and the kingship of Alba in the tenth and eleventh centuries. *Scottish Historical Review* 79, 145–64.

Woolf, A., 2007. *From Pictland to Alba: 789–1070*. Edinburgh: Edinburgh University Press.

Wright, P.J., F.C. Neat, F.M. Gibb, I.M. Gibb & H. Thordarson, 2006. Evidence for metapopulation structuring in cod from the west of Scotland and North Sea. *Journal of Fish Biology* 69, 181–99.

Yalden, D. & U. Albarella, 2008. *The History of British Birds*. Oxford: Oxford University Press.

Young, A. & K.M. Richardson, 1960. A Cheardach Mhor, South Uist. *Proceedings of the Society of Antiquaries of Scotland* 93 (1959–60), 135–73.

Zech-Matterne, V. & L. Leconte, 2010. New archaeological finds of *Isatis tinctoria* L. (woad) from Iron Age Gaul and a discussion of the importance of woad in ancient time. *Vegetation History and Archaeobotany* 19, 137–42.

Zohar, I. & M. Belmaker, 2005. Size does matter: methodological comments on sieve size and species richness in fishbone assemblages. *Journal of Archaeological Science* 32, 635–41.

Zohar, I., T. Dayan, E. Galili & E. Spanier, 2001. Fish processing during the early Holocene: a taphonomic case study from coastal Israel. *Journal of Archaeological Science* 28, 1041–53.

Index

Note: Alphabetization is word by word. A page number in italics refers to an illustration. Historical persons are alphabetized by first name.

A

Aberdeen (Scotland) *2*, 259, 267, 273, 289
Aberdeenshire (Scotland) 259, 265, 267
actor-network-theory 9
Adam of Bremen 12, 13
Aelred of Rievaulx 13
aerial photographs *37*
age determination 149–52
agriculture 4, 22, 30, 97, 161–97, 287
Aikerness (Westray) *26, 27, 31*, 202
Akershus (Norway) 209
alder 249
ale 97, 165, 180
Allicia of Orkney 288
Ambrosiani, Kristina 230
anchors 218
Anglo-Saxon silver 182
Anglo-Scandinavian
 fittings 251
 knives 246, 248, 249
Angus (Scotland) 267
 earls of 20
animal(s)
 husbandry 139–54, 199, 202, 205, 279, 283
 see also under common names of individual species
Anstruther (Scotland) 267
anthrosols 30, 31, *33*, 38, 41, 43–6, 52–3, 58, 64, 70, 80, 82, 99, 101, 161, 182, 272
antler 229–32, *230*, 236–42
 combs 13, 63, *83*, 229, 250, 282
 handles 249
 reindeer 275, 276
anvils 73, *89*, 207, 211, 213, 226
Applecross (Scotland) 108
archaeological survey 30–43, *32–6, 39–42*
Archbishop's Palace (Trondheim) 268
architecture 13, 15–18, 23, 52, 59, 63–4, 73, *94, 95*, 227, 275–6, 278, 283, 285, 288, 291
Ardvonrig (Western Isles) 223
arm rings 15

Arnor *jarlaskáld* 12
artefacts 4, 6
 phasing 53, 56–7
 see also under names of individual types and materials
ash (fuel) 52, 59, 63, 66–7, 70, 73, 77, 94, 98, 162–4, 169, 172–9, 183–5, 197
ash (tree) 249
Ashby, Steve P. 229

B

bait 112, 113, 118, 219, 275, 279, 282
bake stones 56–7, 67, 207, 211–13, 219, *219*, 223, 227, 283, *284*
baking plates *see* bake stones
Bakkaunet (Norway) *208*, 209, *210*
Balladoole (Isle of Man) 250
Baltic Sea region 8, 15, 229, 231, 232, 280, 288
barley 53, 73, 82, 93, 97, 165–8, *167*, 170, 173–82, *175, 177*, 184, 186, 192, 275, 277, 279, 283, 287
barnacles 105
Barvas Machair (Lewis) 179
baskets 165, 166, 168, 180
Batenburg (The Netherlands) 73
battles
 Clontarf 13, 17
 Flodden 22
 Florvåg 20
bawbees 253
Beachview (Birsay, Orkney) 15, 64, 153, 176, 179, 248, 259, 265, 272
beads 255, 271, 274, 275
beer 22, 165
 bottles 271
beetles 178, 179
Belgium *281*
bell heather 168, 170, 188, 194
Belmont (Shetland) *2*, 15, 63, *208*
belt slides 252
benches 67, 73, 219, 226, 276
Bergen (Norway) *2*, 18, 20, 22, 63, 209, 216–17, 222, 226, 237, 239, 243, 259, 265, 267, 273, 275, 280, 282, 285, 287–90
berries 168, 183
bib 119
Biggings (Orkney) *26*, 30, 31, 46, 93, 166
Biggings, The (Shetland) *2*, 184, 216, 219, 259, 268, 273, 274

bilberries 170, 188, 194
biometry 152–3
birds 99, 122, 155–9, 322; *see also under common names of individual species*
Birka (Sweden) 230, 233
Birsay (Mainland, Orkney) *2*, 13, 15, 17, 18, 23, 64, 153, 176, 179, 184, 214, 223, 237–8, 240, 243, 248, 252, 265, 272–3, 289
bishops 20, 21, 22, 23, 26
bivalves *see* molluscs; shell(s)/shellfish
Bjarni Kolbeinsson 287
black bindweed 168, 170, 187, 193
Black Death *see* Great Plague
blackbirds 157
bladderwrack 169
blinks 169, 171, 173, 174, 190, 196
boats 27, 218, 250, 253
bodles 253
bog hay 30
bolsters 248
bolts 251
bone artefacts 229–43, *241, 242*, 276
 combs 250
 handles 248, 249
 see also antler
bones
 perforated 148
 see also under common names of individual species
Borg (Norway) *2, 5*, 280
Borgund (Norway) 218
Bornais (Outer Hebrides) *2*, 223, 239, 259
botanical evidence 53, 161–97; *see also* plant remains
bottles 271
bowls 227, 269
boxes 250
bread 168, 180, 181, 207, 219
Breckin (Shetland) 274
Bressay (Shetland) *2*
Bristol (England) *2*, 289
Britain *2*, 154, 159, 182, 183, 223
 combs 229
 knives 246
 red deer 239
 see also England; Scotland; Wales
Broch of Burrian 242
brochs 27, 31, 181, 212, 240, 242, 278; *see also* brough
Bronze Age 31
 spindle whorls 242

broth 180
Brough of Birsay (Mainland, Orkney) 13, 15, 18, 153, 184, 214, 223, 237–8, 243, 252, 265, 272–3
Brough of Deerness (Mainland, Orkney) 13, 18, *19*, 212, 259, 265, 272, 276
Brough Road (Birsay, Orkney) 179, 223, 265, 272
Bryggen (Bergen) 259
buckies *see* whelks
buckles 246, 251
Buckquoy (Orkney) 13, 153, 240
bull-rout 120
bullion 6, 15, 280
burghs 123, 265, 267, 279, 289
burials 13, 16, 17, 22, 26, 31, 145, 252, 271
 dates *14*
 ship 182, 250
Burran (Shetland) 2
Burrian *see* Broch of Burrian
butchers' blocks 242
butchery 139, 145–8, 153
 birds 155
 cattle *146*
 fish 117, 126–37, *129*, 282
 horses 144
 marine mammals 145
butter 17, 18, 20–22, 26, 153–4, 279–80, 282, 287
buttercups *167*, 168–71, 187, 190–91, 194, 196–7
butterfish 120
buttons 240, 242
byres 64, 66, 67, 73, 76, *86*, 165, 178–80, 183–5, 272, 283

C

cabbages 93, 169, 170, 171, 190, 196
cairns, chambered 31, 46
Caithness (Scotland) 2, 6, 12, 20, 21, 26, 124, 128, 135, 137, 153, 173, 179, 219, 226, 233, 237, 239, 242–3, 248, 252, 258–9, 265, 272, 277–8, 287, 288, 290
Canmore dynasty 20
capitalism 7
caprines 139–43, 145–6, *149*, 150–54, *150*, *151*, 199, 319–21
 cut marks *147*
 isotope analysis 200, 202, *203*, 205
 perforated bone 148, *148*
 see also goats; sheep
Carrickfergus (Northern Ireland) 269
carrion beetle 178
carts 250
caskets 251

castles
 Laugharne 251
 Noltland 23, 289
 Old Wick 16
cathedrals 15–16, *16*, 18, 23 278, 289
Catpund (Shetland) 212
cats 141–4, 153, 155, 321
cattle 15, 17, 52, 53, 76, 139, 140–43, 148–50, *148–51*, 152–4, 168, 199, 275, 277, 279, 283, 317–18
 cut marks 145, *146*, 147
 fodder 30
 isotope analysis 200–202, *204*, 205
 murrain 21, 285, 287
cemeteries 26, 31; *see also* burials
ceramics *see* pottery
cereals 11, 18, 64, 70, 164, 166, 170, 173–5, 177–80, 186, 192, 279, 280, 288, 290
 chaff 162, 163
 cultivation 39
 taphonomy 165
 see also under common names of individual species
cetaceans 141–3, 145, 152
chaff 162, 163, 166, 172–4, 179, 180
chamomile 171
chapels 276
charcoal 59, 63, 66, 161, 162, 178
Charles I, coins 253
cheese 151, 153, 154
Chester (England) 2, 289
chests 250, 251
chickens 144, 155, 157, 159
chickweed 164–5, *167*, 168, 170, 173–5, 177–9, 182, 187, 193
chiefdoms 7
chieftains 275; *see also* earls; kings; queens
chlorite 222, 223
Christian I 22
Christianity 148, 276
chronology 47, 48, 53, 58
 worked stone 211
Church of the Holy Sepulchre, Jerusalem 16
churns 153
Cille Pheadair (Western Isles) 2, 148, 223, 259
citadels 18, *19*
clams 105, 106, 108
clay pipes 53, 56–7, 77, 83, 255, 270, 272–3
Cleat (Orkney) 26, 31, 166, 179, 181, 277, 283
Cleberswick (Shetland) *208*, 209, *210*
Clemmil Geo (Shetland) *208*
clench bolts 246, 250, 253
Clibberswick (Shetland) *208*, 209, *210*
Clickhimin Broch (Shetland) 242

Clontarf (Ireland) 13, 17
cloth 154, 275, 279; *see also* textiles
clothing 181
clubmoss 182
Clyde, Firth of 123
Cnut Sveinsson 17
coal 185
cockles 73, 104–8, 113
cod 17, 112–13, 116–19, 121, *121*, 122, *123*, 124, *125*, 126, 129–31, *132–4*, 134, 138, 154, 246, 252, 280, *281*, 282, 288, 312
 cut marks 135, 137
 dried 127–8, 135–6
 isotope analysis 202
 salt *127*, 128
coins 4, 6, 15, 73, 76, 78, 245, 253, 280, 289
Colley, Sarah 3
Colonsay (Scotland) 250
comb(s) 13, 18, 56–7, 63, 66, *83*, 229–43, *234*, 275–6, 278, *278*, 280, 282–3, *284*, 288
 cases 229, 230, 231, *234*, 236
 making 1
 typology 230–35, *232*, *233*
connectedness 5, 6, 11, 21, 47
cooking 165, 265, 272, 278
 pots 212
copper alloy 245, 252, 253
 mounts 251
 plating 252
 rivets 230–32, 235–8, 249
 wire 249
Coppergate (York) 182, 231, 243, 248–51, 271
Cork (Ireland) 231
cormorants 155, 156, 159
corn spurrey 168, 170, 187, 193
Corrigall Farm Museum 87
cottids 122
cottongrass 169, 171, 189, 195, 196
cowrie shells 104, 106
crofts 92–3, *93*, 96
crops 165, 169, 173, 174, 180, 182, 185; *see also under common names of individual species*
Crosskirk Broch (Orkney) 26, 181
crowberry 168–70, 173, 179, 183, 188, 194
crows 157
Cunningsburgh (Shetland) *208*, 209, *210*, 212, 213
cups 269
curing 127
cut marks 139–40
 caprines *147*
 cattle *146*
 fish 135–7
cutlery 246, 249; *see also* forks; knives

D

dab 120
dairying 18, 140, 151, 153, 154, 180,
 185, 199
Dál Riata kingdom 17
Dammins (Shetland) *208*
dates *14*
 OSL 30, 31, 58, 82, 83, 92
 plant remains 163
 radiocarbon *14*, 31, 52–5, 59, 64, 67,
 73, 76–7, *78–9*, 277, 288
David I 20, 289
David Menzies of Weem 22, 288, 291
decoration
 combs 235–7
 handles 248, 249
 pottery 265, 267, 269
Deer Park Farm (Northern
 Ireland) 182
Deerness *see* Brough of Deerness
demography 1, 17, 278, 279, 282,
 289, 290
dendrochronology 289
Denmark 59, 154, 268
dependency theory 7
deposition patterns 97–101
despotic societies 7
diet 53, 121, 138, 181, 201, 276, 283
discs 211, 223, 226, 227, 252
docks 171
dogfish 118, 119, 122
dogs 141–5, 153
dogwhelks 104–8
doits *see* duits
Domesday Book 289
Dornoch (Scotland) 2, 20, 267
dragonet 120
drains 52, 59, 63, 66–7, 70, 73, 76, 80, *90*
Drever, Bessie 93
Drever, Christina and George 93
Drever, George and Margaret 3, 27
driftwood 165, 249
drinking vessels 267
Dublin (Ireland) 2, 12, 20, 123, 239,
 253, 259, 282, 289
ducks 155, 156, 159
duits 73, 253
Dumbarton (Scotland) *2*
Dunfermline (Scotland) *2*, 16
dung 165, 168, 177, 183, 185; *see also*
 fertilizer; manure
Dunlevy, M.M. 231
Dunrossness Phyllites 219, 221, 222,
 225
Durham (England) *2*, 16, 233
Dutch
 coins 73, 78, 253
 merchants 273
 pipes 289

dye 27, 80, 166, 168, 182–4

E

eagles 155, 156, 157
Earl's Bu 153, 179, 236
earls of Angus 20
earls of Orkney 10, 11, 12, 17–18,
 21–2, 25, 273, 275, 282, 287–8, 290
 Hakon Paulsson 18
 Harald Maddadsson 20
 Henry Sinclair I 21, 22
 Henry Sinclair II 22
 John Haraldsson 12
 Magnus Erlendsson 18, 278, 289,
 290
 Magnus Gilbertsson 20
 Patrick Stewart 11, 23, 288
 Paul Hakonsson 18
 Robert Stewart 23
 Rognvald Brusisson 10, 17, 278
 Rognvald Kali Kolsson 18, 20, 278
 Sigurd Hlodversson 12, 17
 Thorfinn Sigurdsson 12, 17, 18, 278
 Torf Einar 275, 278, 290
 William Sinclair 21, 22
earls of Ross 127
earls of Strathearn
 Malise 20, 21
East Anglia 16
ecofacts 4, 6, 15, 97–101
economy
 collapse 80, 138, 275, 282–8
 intensification 276–82
 maritime 103–13, 115–38
 production 1, 4, 8, 11, 18, 97, 275,
 287, 290, 291
 recovery 23
Eday (Orkney) *2*, 185
Edinburgh (Scotland) *2*, 11, 23, 288
eelpout 120
eels 119, 122
eggs 155, 159
Egilsay (Orkney) *2*
Eidsborg (Norway) *2*
 schist hones 53, 56–7, 63, 67, 207,
 211, 213, 219–23, *220–21*, 226–7,
 276, 283, *284*, 285, *286*
elk (moose) 1, 229
 antler 229
England 11, 15, 18, 182, 239, 283, 289
 antler 230
 cod trade 127, *281*
 combs 230, 231, 232, 238
 eastern 123
 iron artefacts 245
 pottery 269, 273
 silver 15
 trade 280
ethnohistory 165, 180, 183

Everley Broch (Scotland) 278
Evertaft (Westray) *26*, 31, 46
excavation history 43–6
exchange *see* trade
exotic goods 283, 288

F

famine 21, 22, 27, 168, 285, 287–8,
 290
farms 20, 21, 26–9, 45–6, 82, 93–4,
 96–7, 138, 153, 182, 184, 273, 275,
 276, 279, 291
Faroe Islands 5, 148, 202, 216, 276
fat-hen 168, 170, 193
Fauna Orcadensis 126
faunal remains 99, *100*, 101, *101*,
 139–54; *see also under common
 names of individual species*
feathers 22, 159
Fergus family 93
 John and Mary 93
 William and Margaret 93
ferrules 246, 251
fertilizer 18, 39, 101, 165, 168, 173,
 176, 179, 181–5; *see also* dung;
 manure
Fetlar (Shetland) 2, 209, 214
fields 70, 80, 82, 92, 93, 165, 168, 201
Fife (Scotland) 267
figs 183
Finland 8, 181
fire 183–4
fireplaces 67; *see also* hearths
fish 53, 310, 311, 314
 bone 13, 15, 30, 43, 56–9, 63–4, 73,
 94, 97, 99, *100*, 101, *101*, 105,
 113, *115*, 115–38, 172
 dried 11, 18, 21, 22, 279, 280, 282,
 288, 290
 as fodder 199, 201, 205
 livers 59, 94, 121, 137, 165, 184
 oil 185, 280, 282
 waste 59
 *see also under common names of
 individual species*
fishing 4, 17, 18, 22, 96, 97, 112,
 115–38, 153, 180, 219, 227, 275, 279,
 282, 283, 286–8, 290
 commercial 122, *281*
 floats 211
 hooks 63, 246, 253
 line 181
 villages 9
 weights/sinkers 212, 217, *218*, 252
fittings 246, 251
flagstones 52, 63, 64, 66, 67, 70, 73,
 76, *85*, *86*, 177, 227
Flanders (Belgium) 23, *281*
flatfish 118, 120

flax 15, 17, 162, 166, *167*, 168, 170, 173–7, 181–4, 186, 192, 275, 280
flies 178
flint 207, 211–13, 227
Flodden (England) 22
floors 52, 53, 70, 73, *76*, 98, 99, 162, 165, 175–8, 239
 fish remains 116, 121, 137
Florvåg (Norway) 20
flotation 98, *98*, 99, 161–2
flounder 120
flour 279; *see also* bread
Fluetjern (Norway) 209, 210, *210*
fodder 30, 53, 66, 153, 165–6, 168, 174, 178–85, 199, 202, 205, 279, 283
Folvelseter (Norway) *208*, 209, *210*
forks 249, *249*
Forth, Firth of 123, 267, 269
Foula (Shetland) 159
fowling 97, 155–9
France 127
Frankia 15
Frechen (Germany) 274
Freswick Links (Caithness) 2, 219, 226, 233, 237, 239, 242–3, 248, 252, 259, 265, 272, 277–8, 283
friké 181
fruits 162, 164, 169, 183
fuels 29, 31, 59, 137, 161, 164–6, 168, 172, 175–80, 183–5, 250
fulmars 156, 157
funerary monuments 31
fungus 169, 178
fur trapping 1

G

gadids 118, *121*, 122–3, 128, 130, 134, 137
Gaelic language 27
Gairsay (Orkney) 287
Galloglass mercenaries 287
gaming pieces 240, 242
gannets 156, 157, 159
gardens 53, 58, 64, 82, 83, *91*, 93, 181, 255, 272
garfish 119, 122
garnet 226
geese 156, 157, 159
genocide 17
Germany 16, 253, 283, 288
 merchants 22
 pottery 268, 285
germination 165
Gibson, Julie 3
Gilbert Balfour 23, 26
girnel 73
Glasgow (Scotland) 2, 267, 269, 289
glass 27, 184, 257, 270–71
 beads *271*, 274

industry 80
 vessels 271
 window 271
goats 139, 141–3, 199
gold 248
gold-of-pleasure 166, *167*, 168, 170, 174, 181, 184, 186, 192
Gord (Shetland) 214
Gorsendi Geo (Shetland) *208*
graddaning 178
gradiometer survey *40, 42*
grasses 170, 173, 174, 178
grasslands 144, 168
grave(s) 46, 275
 goods 13, 26
 Viking Age *26*, 154, 181, 242
 Westray 243
 see also burials
grazing 199, 205
great auks 157, 159
Great Plague 21, 285, 286, 287
Greenland 1, 5, 6, 20, 223, 278, 283, 290
Grimsby (England) 18, 279, 280
grinding slabs 211, 213, 223
Grobust beach (Westray) *26, 27*
grouse 156
Grunnes (Norway) *208*, 209, *210*
guillemots 155, 156, 159
gulls 155, 156, 159
gunflint 211, 213, 227
gurnards 120, 122

H

hack-silver 15, 181
haddock 119, 122, 128, 154
Haithabu *see* Hedeby (Germany)
hake 119
Hakon Hakonsson 12, 20, 288
Hakon Jonsson 21
Hakon VI Magnusson 21
Hakon of Lade 12
halibut 120
Halkirk (Scotland) 2, 20
Haltoy (Norway) *208*, 209, *210*
Hamar (Shetland) 2, 15
handles 246, 248–9, *249*, 253, 267
Hanseatic League 8, 9, 11, 13, 22, 23, 128, 138, 273, 282, 291
Harald Fairhair 12, 290
Harald Maddadsson 20
Hardanger region 219, 283
harness 251
harvesting 165
hazel 249
hazelnuts 183
hearths 53, 58, 59, 63, 64, 66–7, 70, 73, 77, *80, 83*, 98, 162, 164–5, 175–6, 183; *see also* fireplaces

heather 53, 70, 165, 168–70, 173–4, 178, 188, 194
heathlands 165, 168
 grasses 168, 170
 leaves 173
Hebrides 7, 12, 287
Hedeby (Germany) *2*, 231, 280
hemp 22, 171, 181
hen houses 93
Henry Sinclair I 21, 22
Henry Sinclair II 22
Henry Sinclair (Lord) 25, 279
heritage tourism 4
herring 23, 118, 119, 123, 127
Hiberno-Norse pins 280
hides 280
Hillswick Ness (Shetland) *208*
hinges 250, 251, 253
Hirdskrá 13, 20
historical
 materialism 4
 sources 12–17
hoards 13, 15, *15*, 17, 181
Hofstaðir (Iceland) 5
holms 202, 279
Holstein (Germany) 268
hones, Eidsborg 53, 56–7, 63, 67, 207, 211–13, 219–23, *220*, *224–5*, 226–7, 275–6, *278*, 282–3, *284*, 285
honey 279
Hordaland (Norway) 214
horn
 combs 235
 cores 151
hornblende 226
horses 52, 53, 64, 139, 141–4, 152–3, 321
 butchery 148
 cut marks 147
 harness 251, 253
horseshoes 246, 251
Houseby settlements 28
houses 13, 15, 52, 59, 63–4, 275–6, 283
Howe (Mainland, Orkney) 181
Hoy (Orkney) 2
Hull (England) 2
human remains 15, 26, 31, 145, 283; *see also* burials; grave(s)
'hybrid' cultures 9
Hyllestad (Norway) 2, 226, 275

I

Iceland 5, 7, 8, 18, 20, 22, 59, 127, 148, 154, 217, 226, 276, 278, 279, 280, 283, 285, 288, 289
 beads 271
 sagas 12, 13
Icelandic Annals 12, 285

ICP-MS (inductively coupled plasma mass spectrometry) analysis 207, 267
identity 1, 4–6, 9, 10, 17, 22, 47, 227, 255, 275, 278, 290–91
immigration 276, 279
indigotin 166, 182
industrial ceramics *see* pottery, industrial
Ingibjorg of Orkney 17
Ingold, Tim 5
insects 169, 178, 179
insular societies *see* island societies
intensification 5, 11, 103, 154, 199, 202, 276–82
Inverness (Scotland) 267
Ireland 5, 11, 18, 59, 154, 159, 183, 223, 278, 287
 combs 230–32, 238
 pottery 273
 red deer 239
 silver 15
Irish annals 12, 13
Irish Sea region 11, 12, 18, 144, 229, 245, 273, 276, 280, 283, 289
Iron Age 31, 94, 138, 155, 159, 181, 182
 gaming pieces 240, 242
 Gaul 182
 red deer 144
 whale bone 242
iron artefacts 22, 245, *247*, 253, 286
 fish hooks 63
 mounts 56–7, 276
 rivets 212, 230, 231, 235–7
 weaving swords 242
Islamic world, silver 15
island societies 5–10
Isle of Man 7, 12, 250, 259, 273
Isle of May (Scotland) 267
isotope analyses 13, *14*, 15, 113, 126–7, 138, 199–205, *203*, 280, *281*, 282, 283, 288
ivory 1, 235

J
James III 22
James IV 22, 76, 253
James V 23, 253
jarl 12
Jarlshof (Shetland) 2, 13, 15, 23, 214, 216, 219, 223, 226, 237, 239, 242, 246, 249, 265, 273, 274
jars 259
Jerusalem 10, 18
jewellery 15, 154, 275
John Balfour 26, 28
John Haraldsson 12
John of Fordun 13

jugs 265, 267, 273
Junkarinsfløttur (Faroe Islands) 202

K
Kalf Arnesson 17
Kalmar Union 22
Kattegat 231
Kaupang (Norway) 2, 182, *208*, 209, 289
Kebister (Shetland) 216, 219, 265
kelp 80, *91*, 184
kettles 22
kilns 64, 176, 275, 283
Kiloran Bay (Colonsay) 250
King's Lynn (England) 2
kings
 Charles I 253
 Christian I 22
 Cnut Sveinsson 17
 David I 20, 289
 Hakon Hakonsson 12, 20, 288
 Hakon VI Magnusson 21
 Harald Fairhair 12, 290
 James III 22
 James IV 22, 76, 253
 James V 23, 253
 Magnus I Olafsson 17
 Magnus III Olafsson Barelegs 18
 Malcom II 17
 Malcom III 17
 Malcom *Mac Máel Brigti* 17
 Norway and Scotland 12
 Sigurd Magnusson *Jórsalafari* 20
 Sverre Sigurdsson 20, 279, 287
Kirkwall (Mainland, Orkney) 5, 16, *16*, 23, *127*, 259, 267–8, 272–3, 282, 289
kittiwakes 156
klino bread 168
klippfisk *see* salt cod
Klungen (Norway) *208*, 209, *210*
knives 246–9, *248*, *249*, 253
 handles 238, 240
Knoc y Doonee (Isle of Man) 250
knotgrasses 168, 170–71, 178, 187, 193
Knowe of Skea (Westray) 138
Kolbein Hruga 16

L
lamps 212, 227
 oil 59, 121, 137, 276
land use 27–9, 276
landscape of Quoygrew 25–46
Langerwehe (Germany) 267, 272–4
Langskaill (Westray) 15, *26*, 31
latrines 181, 183
Laugharne Castle 251
law books 13, 22

Layerthorpe Bridge (York) 168
lead 245, 252, 253
 alloy 251
Leith (Scotland) 267
Lejre (Denmark) 5
lemon sole 120
Leon (Shetland) *208*
Lewis (Western Isles) 164, 179
life expectancy 9, 276
lime 184
 plaster 66
liminal landscapes 1, 6, 7, 9
limpets 94, 97, 101, 103–4, *104–5*, 106–12, *109–12*, 118
line sinkers 210–12
linen 17, 181, 182, 280
ling 118, 120, *121*, 122, 126, *126*, 131, 135–6
 cut marks 135, 137
 dried 128
little auks 156
Little Ice Age 138, 276
livers, fish 59, 94, 121, 137, 165, 184
locks 251
Logie family 93
 Betty 93
 James and Betsy 93, *93*
 John 93
Loire Valley (France) 273
London (England) 2, 127, 280, 282, 288, 289
loom weights 181, 212, 218, 223, 227, *284*
Low, George 126, 128
Low Countries 289
Lower Saxony 273
lowland Scots 285, 288
Lübeck (Germany) 268, 280, 282
lutefisk 184
lye 64, 176, 184

M
machair environments 168–9, 178, 181–4, 276
mackerel 120
Maes Howe (Mainland, Orkney) 4
magnetite 218, 222, 226
Magnus Erlendsson 278, 289, 290
Magnus I Olafsson 17
Magnus III Olafsson Barelegs 18
Mainland (Orkney) 4, 5, 22, *87*, 121, 122, 128, 137, 153, 179, 181, 276, 283
 hoards *15*
Malcom II 17
Malcom III 17
Malcom *Mac Máel Brigti* 17
Malise, earl of Strathearn 20, 21
malt 287

mammals 139–54, 315–16; *see also under common names of individual species*
manure 97, 178, 180–81, 272, 282–3; *see also* dung; fertilizer
Manx shearwater 155, 156, 159
maps 27–9, 82, 93
Margaret Hepburn 23
Margaret of Denmark, Queen of Scotland 22
marine resources 103–13
markets 7, 123, 269, 271, 279, 280, 289
Martincamp (France) 274
Mary of Scotland 23, 253
masons 16, 282
materiality 5, 9
mats 166
mayweeds 168, 171, 178, 179, 189, 195
meat 22, 26, 184, 280
medicine 183
 bottles 271
medieval *see* Middle Ages
Medieval Climate Anomaly 278
Medieval Warm Period *see* Medieval Climate Anomaly
Mediterranean 279
meiths 31
Meols (England) 2, 289
mercenary activity 7, 11, 18, 20, 23, 276, 282, 287
merchants 273
mergansers 156
metal artefacts 245–53
 jewellery 154
 see also under names of individual types and materials
metalworking 4, 13, 73, 165
mica schist 207, 211–13, 217–18, 223–7, 275–6, 285, *286*
mice 139, 141–4
micromorphology 13, 52, *52*, 59, 98, 101, 173, 250, 283
middens 3, 15, 30, *33*, 36, 44–6, 58, 63–4, 67, 70, 73, 78, 80, *90*, 94, 98–9, 101, 104, 106–7, 115–16, 121, 161, 165, 239, 276, 277
 plant remains 172–5
Middle Ages 1, 4–6, 9, 10, 12, 13, 18, 47, 64, 103, 113, 127, 153, 155, 180, 255, 289, 290
 archaeology 4, 5, 7, 291
 bone artefacts 240
 buildings 63, 64, 276, 283, 285
 cattle husbandry 283
 cereals 179
 churches 276
 coins 245
 combs 229, 239

demography 279
economy 97, 285
fishing 123, 128, 137–9, 282
glass 271
harness 251
hones 221
knives 246, 248
migration 8
Orkney 11–23, 138
pottery 67, 256–8, 265, 272–3, 278
quarries 207, 209, 226
settlements 121, 148, 154
sickles 246
spindle whorls 242
steatite vessels 212, 214, 216
trade 59
whale bone 242
woodworking tool 245
Middle Devonian Rousay Flags 223
migration 276, 279
military economy 11, 20, 276, 287, 288
milk 151, 153, 154, 165, 180, 184, 201, 275, 279
millet 201
Mindets tomt 181
mineralization 164–5
minting 4
mobility 21, 22
molluscs 103–13, 118, 137; *see also* shell(s)/shellfish
monasteries 18
Montrose (Scotland) 267
moose *see* elk (moose)
Moray dynasty 17
moss 163, 164, 169, 173–4, 177–9, 191, 197
mother-of-pearl 105
mounts 246, 251, 253, 276
mouse-ears 169, 171, 178, 190, 196, 197
mugs 269
Murdoch Mackenzie 27, 29, 31
muscovite 218, 219, 222, 223, 226
mussels 104–8

N

nails 246, 249–51, 253
Narr Ness (Westray) *26*, 27
nausts 27, 29
needlefishes 118, 119, 122
needles 240, 245–6
Neolithic 27, 181
 cairn 31, 46
Nether Trenabie (Westray) 27, 28, 93
Netherlands, The
 coins 73, 78, 253
 merchants 273
 pipes 289
 pottery 269

nets 123
nettles 168, 171, 189, 195
network theory 8–11, 21
Newark Bay (Mainland, Orkney) 2, *14*, 283
nit combs 235
Noltland Castle (Westray) 23, *26*, 289
Norfolk 246
Norn 27
Norse 181, 290
 colonies 59
 law 112
North Atlantic 6, 11, 15, 22, 59, 127, 276, 279, 280, 282, 290
North Haven (Westray) *26*, 30
North Ronaldsay (Orkney) 2, 199, 201, 242
North Sea region 5, 11, 137, 229, 232, 276, 279, 280, *281*, 289, 290
Northern Ireland 182
Norway 6, 10, 11, 59, 63, 153–4, 159, 182, *208*, 223, 227, 246, 265, 273, 276, 284, 289, 290
 architecture 283
 combs 278
 earls 13
 graves 242
 Great Plague 285
 hones 275
 iron artefacts 245
 kings 12, 18
 magnates 17, 288
 medieval 207, 239
 mica schist 226
 pottery 267, 268
 quarries 207, 219, 221
 reindeer hunting 229
 schist 207
 steatite 207, 209, 214, 278
 trade 22, 127, 280, 282
 weaving swords 243
 weights 218
Norway pout 119
Norwich (England) 2, 251, 289
Norwick (Shetland) 213, 214, 216
Noup Head (Westray) *26*, 155, 157, *158*, 159
Novgorod (Russia) 17, 237
nutshell 162

O

oak 249
 handles 245, 253
oats 162, 166, *167*, 170, 173–5, *175*, 176–7, *177*, 178–80, 182–4, 186, 192, 199, 275, 279, 283
 charred 53, 59, 63
occupation phases 58–92
Odin 157

offal, fish 201; *see also* livers, fish
oil 22, 26, 94, 121, 137, 181, 276, 280
 fish 59, 165, 184, 185, 282
 seal and whale 145
oilseed 275
Old Norse 275, 278, 288
 prose 17
Old Scatness (Shetland) 2, 181, 212, 216, 240
oraches 165, 168, 170, 177–9, 188, 194
oral
 history 27, 92
 tradition 6
Orderic Vitalis 280
Orkney Islands Council 3
Orkneyinga saga 10, 12, 18, 25, 26, 279, 280, 287
ornamentation *see* decoration
Orphir (Mainland, Orkney) 2, 16, 121, 122, 128, 137
Orra Wick (Shetland) *208*
Oseberg ship burial 182
Oslo (Norway) *2*, 63, 181, 229, 237, 239, 240, 259, 267, 268, 289
Østfold (Norway) 209
Ottaway, Patrick J. 246
Outer Hebrides 31, 123, 239, 259

P

paganism 18
palaeosols 58, 70, 105–14
Papa Stour (Shetland) 2, 184, 185, 267, 268, 273
Papa Westray (Orkney) *2, 26*, 31, 128, 276, 277
parishes 20, 26
passerines 157
pastoralism 4
Patrick Stewart 11, 23, 288
Paul Hakonsson 18
paving 59, 64, 66–7, 70, 73, 76, 80, *86*
peat 29, 53, 59, 66, 77, 161, 164–5, 168, 173, 175–6, 183–5
pendant crosses 148
pennies 253
pennylands 25, 27
Pentland
 Firth 2, 272, 278, 290
 Skerries 21
periwinkles 103–10, *105, 111*, 112
Perth (Scotland) 2, 259, 273, 279, 289
phosphatization 164
phyllite 219–223
Picts 17, 179, 181, 240, 242, 265, 275
 ecclesiastical sites 276
 pottery 58
 settlement 13
 technology 226

Pierowall (Westray) 2, 26, *26*, 27, 31, 243, 275
Piggåssen (Norway) *208*, 209, *210*
pigment 182
pigs 53, 139, 140–43, 145, 148–9, 152, 153, 199, 201, 240, 275, 321
 cut marks 147, *149*
 isotope analyses 201, 202, *204*
pigsty 93
pins 13, 18, 56–7, 240, 246, 252, 276, 280, 282
pipes 255, 272, 273, 289
 clay 53, 56–7, 77, 83, 257, 270
 stems 252
pipkins 30, 56–7, 73, 77–8, 83, 256–8, 268, 274, 289
piracy 11, 18, 20, 23, 276, 282, 287, 288, 290
Pittenweem (Scotland) 267
pivots 207, 211, 213, 218, 227, 240, 242, 243, 246, 250, 253
place-names 17, 27, 28
plaggen soils *see* anthrosols
plague 21, 285, 286, 287, 288, 290
plaice 120
plant remains 161–97, *167*
 distribution 172–9
 wild 183
 see also under common names of individual species
plantains 164, 168–71, 187–8, 193, 195
plovers 156
poetry 12, 275, 278
 skaldic 17, 18
poets 282, 287
political economy 11, 287, 288
pollack 118, 119, *121*, 122, 134
 cut marks 135
pondweeds 169, 171, 190, 196
Pool (Sanday) 2, 13, 15, 151, 153, 157, 179, 181, 212, 214, 216, 219, 223, 227, 239, 240, 242, 258, 259, 265, 272
poor-cod 119
population growth *see* demography
porringers 269, 274
Portugal 127
postcolonial theory 8–10
pot lids 207, 226, 227, 242
potatoes 82, 93
pottery 6, 22, 53, 56–8, 63, 96, 212, 227, 255–75, *260–63*, 278, *278*, 283, *284*, 285, *285–6*, 290–91, 325–8
 Andenne ware 273
 bone china 257, 258
 creamwares 256, 257, 269
 Danish redware 267
 Delftware clay 269
 Dutch redware 267

earthenwares 256, 257, 258, 267, 269, 274
 English wares 259
 French wares 259, 273
 German proto-stoneware 56–7, 256, 258, *264*, 265, 272
 German/Scandinavian redwares 256–9, *264*, 267–9, 272, 274
 German stonewares 67, 73, 256–9, *264*, 267, 272–4, 291
 granite ware 256–7
 industrial 58, 64, 78, 80, 83, 92, 255–8, 269, 272; *see also under individual types*
 lead-glazed redwares 56–7, 256–8, 269
 Low Countries: greywares 259, 272, 273; redwares 273
 organic tempered wares 256–65, *263*, 272
 Paffrath ware 273
 pearlwares 56–7, 256–8, 269
 porcelain 256–8, 269
 Rhenish blue-grey ware 273
 Rockingham ware 256–8
 Rouen ware 273
 Saintonge ware 273
 Scarborough ware 272–3
 Scottish redwares 56–7, 70, 73, 76, 255–6, 258–9, 265–7, *266*, 272, 291
 Scottish white gritty ware 256–8, *264*, 265, 272–73
 Siegburg ware 265
 Spanish wares 273
 tin-glazed earthenware 56–7, 77, 83
 Valencian lustreware 273
 white earthenwares 56–7, 77, 83
 white gritty wares 18, 30, 56–7, 67, 259
 Yorkshire type wares 259
poultry-keeping 159
pounders 207, 211–13, 223, 226
prestige 276
 goods 4
protein, marine 15, 17, 113; *see also* diet
puffins 155, 156, 159
pumice 211–13, 226–7
punches 245
pygmy shrews 141–3

Q

quarries 207, 209, 211, 219, 221, 226
quartz 219, 222, 223, 226
Queena Howe (Westray) *26*, 31, 46

queens
 Margaret of Scotland 22
 Mary of Scotland 23, 253
querns 207, 211, 213, 218, 223–7,
 275–6, 282, 285
Quoys (Shetland) *208*

R

rabbits 141–3, 145
Rackwick (Westray) 25–7, *26–9*, 31,
 46, 276
radiocarbon dates *see* dates,
 radiocarbon
radishes *see* wild radishes
Raeren (Belgium) 267, 274
raiding 17, 22; *see also* piracy;
 warfare
raised soils *see* anthrosols
rare earth elements (REE) 208–10,
 210, 323
Rattray (Scotland) 259, 265, 267
ravens 155, 157
rays 119
razor shells 104–6, 108
razorbills 155, 156, 159
red deer 141–4, 153, 275
 antler 229–31, *230*, 238
redshanks 156, 170
redwings 157
reindeer 1, 275, 276, 286
 antler 229, *230*, 232, 235–8
Renaissance buildings 23
Rendall family 93
rennet 151
resistivity survey 39–41, *39–42*
retting 166, 181
Rhineland (Germany) 273
 pottery 267
rhizomes 162
ridge and furrow 40, 82
rinderpest 21
ring forts 5
Ring of Brodgar (Mainland,
 Orkney) 4
ring-money 12, 15
ringed pins 13
rings 17, 252
rivets 212, 229–32, 235–8, 249–52,
 278
Robert Monteith of Egilsay and
 Gairsay, Orkney 127
Robert Sibbald 127
Robert Stewart 23
Robert's Haven (Caithness) 2, 128,
 135, 137, 173, 179, 259, 265, 272,
 277, 278, 283, 287, 288
rock doves 155, 157
rocklings 119, 120, 122
Rognvald Brusisson 10, 17, 278

Rognvald Kali Kolsson 18, 20, 278
Romans 4, 245, 246
Rome 290
roofing 183, 227
rope 168
 swivels *see* swivels
rotskjaer 128, 131, 135, 137
Rousay (Orkney) 2, 36
roves 246, 250, 253
ruderal taxa 168–9
rushes 168, 170, 188, 194
Russia 1, 6, 232, 269

S

Saevar Howe (Birsay) 153
sagas 12, 25
sail cloth 181
St Boniface church (Papa Westray) 2,
 26, 31, 128, 153, 226, 276, 277, 283
St John's-worts 168, 170, 188, 194
St Kilda 159
St Magnus (Egilsay) 16
St Magnus Cathedral (Kirkwall) 15–
 16, *16*, 18, 23, 278
St Mary's parish (Westray) 26, *26*
St Thomas' church (Mainland,
 Orkney) 2, 22, 283
saints 278, 290
saithe 112, 113, 117–19, 121, *121*, 122,
 124, *125*, 126, 130, *132–4*, 134–8,
 276, 283, 313
 cut marks 135
 dried 128
salmon 119
salmonid 122
salt 123, 127, 288
 cod *127*, 128
sand eels 118, 120, 122
sand horizons 58
Sanday (Orkney) 2, 179, 239, 240,
 242, 243, 258, 272
sandpipers 156
sandstone 40, 59, 77, 177, 211–13,
 219–23, 226, 227
Sandwick (Shetland) 2, 15, 236
 North 151, 153
 South 151, 153, 216, 219
sandworts 169, 171, 190, 196
Sarpsborg (Norway) 289
saucers 269
sauries *see* needlefishes
Saxon ferrules 251
scad 120
scallops 104–6, 108
Scalloway (Shetland) 226, 240
 Castle 23, 259, 267, 268, 274
Scandinavia 1, 5, 6, 7, 15, 16, 21, 181,
 182, 183, 223, 276, 288, 290
 architecture 59, 283

Christianization 148
combs 235, 237: cases 236
diaspora 275, 276, 280, 283
language 278
rivets 230
textiles 182
trade 229
see also Denmark; Faroe Islands;
 Greenland; Iceland; Norway;
 Sweden
Scar (Sanday) 2, 243
'sceatta' coinage 4
schist 207, 212–13, 218–23, *221*, 227,
 283, *284*, *286*
 bake stones 56–7, 67, 207, 211–13,
 219, *219*, 223, 227, 283, *284*
 see also Eidsborg hones; mica schist
Schleswig (Germany) 237
Schleswig-Holstein (Germany) 268
Scotland 11, 15, 18, 138, 181, 223,
 250, 279, 283, 289
 antler 229, 230
 cod 280
 combs 231, 232, 236, 237
 fish 123
 Great Plague 285
 kings 12
 language 27
 magnates 288
 mica schist 226
 peat 164
 pottery 265, 285: sources 267
 reformation 23
 salt 127
 schist 207
 silver 15
Scousburgh (Shetland) 221
Screen, Elina 6
sea bream 120
sea scorpion 120
sea urchins 105, 106, 108
seabass 120
seafaring 10: *see also* boats; fishing;
 ships
seals (mammal) 141–3, 145, 152
seasonality
 bird 159
 fishing 126
Seater family 93
seaweed 27, 53, 80, 104–5, 162–5,
 167, 168–9, 172–8, 184–5, 191, 197,
 199, 201, 202, 205, 272, 283
sedges 169, 171, 173–4, 178, 189–90,
 195–6
seeds 163–5, 168–174, 179, 184
 carbonized 162
settlement(s) 13, 17
 earliest at Quoygrew 275–6
 patterns 27–29
 sequence 47–96

shags 155, 156, 159
Shapinsay (Orkney) *2*
shearwaters 155, 156, 159
sheep 53, 139–43, 152–4, 184, 199,
 199, 201, 275, 277, 279
 cut marks *147*
 isotope analysis 202
sheet metal 251, 252
shelducks 156
shell(s)/shellfish 30, 58–9, 63–4, 97,
 99, *100*, 101, *101*, 103–13, 282
 cockles 73, 104–8, 113
 cowrie 104, 106
 limpets 94, 97, 101, 103–4, *104–5*,
 106–12, *109–12*, 118
 mussels 104–8
 periwinkles 103–10, *105, 111*, 112
 razor shells 104–6, 108
 scallops 104–6, 108
shepherd's-purse 164, 166, 170, 178,
 186, 192
Shetland 2, 5, 7, 11, 12, 17, 20, 23, 26,
 63, 124, 127, 148, 151, 181, 184–5,
 208, 223, 227, 239, 240, 242, 246,
 259, 267, 268, 272–4, 276, 284, 288,
 290, 291
 bake stones 219
 cloth 154, 280
 fishing 122, 128, 138, 282
 mica schist 226
 pottery 265, 278
 quarries 207, 209, 211
 steatite 207, 209, 212–14, 278
 trade 22
ship(s) 10, 20, 250
 burial 182
 timbers 15
 -wrecks 285, 287, 290
 see also boats
shoreweed 169, 171, 189, 196
shortages, food *see* famine
shutters 250, 251
sickles 246, 253, 275
Siegburg (Germany) 273, 274
sieving 98, 99, *99*
Sigurd Hlodversson 12, 17
Sigurd Magnusson *Jórsalafari* 18, 20
silver 181
 bullion 4
 hoards 15, 17
simmens 218
Skaill (Deerness) 153, 212
Skaill (Westray) *26*, 31
Skaill Bay (Sandwick) 236, 238
Skaill hoard 15, *15*
skaldic poetry 275, 278
skalds 287
Skara Brae (Mainland, Orkney) 4
skeos 127, 138, 279, 288
Skien (Norway) 222

Skriðuklaustur (Iceland) 8
skuas 156
Skuldelev 2 ship 10
Slipsteinberget (Norway) *208, 209,
 210*
smithing 245
smoking, fish 127
snails 105, 108
snake blenny 120
snipes 156
Snorri Sturluson 280
Snusgar (Mainland, Orkney) 13
soap 27, 80, 184
soapstone *see* steatite
Solerudberget (Norway) *208, 209,
 210*
Søndre felt 181
South Carolina 269
South Ronaldsay (Orkney) *2*, 21
South Uist (Western Isles) 239, 259
sowing 180
Spain 127
speedwells 169, 171, 191, 197
spindle whorls 154, 181, 210–13,
 217–19, *217*, 223, 227, 240, *242,
 242–3*, 252
spoon bit 245
spurdogs 119
Staffordshire pottery 269
stalls 66, 67, *87*
staple goods 4, 6, 11, 153, 282, 290
staples (metal) 250
starlings 157
state formation 4, 7
steading 93, *93*
steatite 6, 207–17, *210*, 287, 291
 sources *208*
 vessels 53, 56–7, 63, 67, 73, *89*,
 211–13, *214–16*, 243, 255, 275,
 276, 278, *278*, 280, 282–3, *284–6*,
 285, 287, 290
sticklebacks 119
Stinear, Betty *93*
stockfish 97, 127–8, *127*, 137, 184,
 279, 280, 282, 288
stone(s) 324
 edge-set 59, 63, 66, 67, 70, 73, *85*,
 87
 pivot 59, 207
 robbing 52, 67, 73, 77, *77*, 78, 80
 worked 207–27
 *see also under names of individual
 artefact and stone types*
stonemasons 16, 282
Stones of Stenness (Mainland,
 Orkney) 4
stoneware *see* pottery
storage 64, 66, 73, 93, 283
strap handles 267, 268
Strathclyde (Scotland) 17

stratigraphic methods 48–52
straw 165, 166, 181
strike-a-lights 207
Stromness (Mainland, Orkney) 2,
 5, 126
Stronsay (Orkney) *2*
studs 246, 250
Sturlunga saga 12
Sule Stack (Scotland) 157
Sumburgh House (Shetland) 23
surplus goods 4, 18
survey 30–43, *32–6, 39–42*, 82
Sutherland (Scotland) 6, 12, 20, 27
Svein Asleifsson 18, 20, 287
Sverre Sigurdsson 20, 279, 287
Sverris saga 18
swans 156
Sweden 6, 154, 290
 pottery 268
swivels 240, 242, 243

T

tacks 246, 250
taphonomy
 bird 155
 fish 117–18
 mammal 140–41
 plant remains 164–5
tar 22
taxation 8, 11, 21, 22, 23, 25, 97, 137,
 151, 153, 182, 279, 288
teeth
 cattle 150, 152
 mammal 140
textiles 165, 181–3, 246, 282
textual sources 6
thatch 166, 180, 218, 227
The Biggings (Shetland) *see* Biggings,
 The (Shetland)
Thetford (England) 251
Thomson, Bessie *see* Drever, Bessie
Thorfinn Sigurdsson 12, 17, 18, 278
thresholds 63, 73
thrushes 157
Thurso (Caithness) 2, 16, 20
tiends *see* taxation
tiles, Dutch 23
timber 20, 282
Tissø (Denmark) 5
tithes *see* taxation
toggles 240
Tønsberg (Norway) *2*, 289
topshells 104–8
Torf Einar 275, 278, 290
torsk 119
tortoiseshell combs 235
towns 6, 9, 21, 63, 148, 181, 237, 239,
 267, 268, 273, 276, 279, 280, 282,
 289, 290

townships 25–9, 31, 46, 276
trade 1, 4–7, 10, 13, 15, 18, 22, 23, 70, 123, 137, 151, 221–2, 227, 229–43, 245, 253, 255, 275–83, 286–91
 fish 126–36
Treaty of Perth 20
Trenabie (Westray) *26*, 26–30, 46, 82, 92, 93, 276
tribute 12, 153, 287
Tromsø (Norway) *127*
Trondheim (Norway) 2, 63, 209, 233, 235, 237–9, 259, 265, 268, 273, 280, 289
trough shells 104, 106
trout 119
tubers 168, 169
Tuquoy (Westray) 2, 15, *26*, 31, 154, 178, 216, 219
turbot 120
turf 59, 73, 161, 164–5, 168, 172, 176–9, 183–5, 227, 272, 283
turners 253
Tyneside (England) 269
typological analogy 7, 8
typology
 artefact 53, 56–7
 combs 229
 knife 248

U

Underhoull (Shetland) 2, 15
Union of the Parliaments 253
Unst (Shetland) 2, 213
Uppåkra (Sweden) 5
Uppland (Sweden) 290
urbanism 1, 4, 279, 282
urbanization 289
utmark 1, 6
Uyeasound (Shetland) *208*

V

vaðmál see wadmal
Vaval (Westray) *26*, 31
Vere (Westray) *26*, 31, 46
Victorian coins 253
Viking Age 3, 5, 6, 9, 10, 11–23, 46–7, 53, 94, 97, 113, 121–4, 153–4, 157, 180–84, 238, 255, 273, 280, 287, 289–90
 beads 271
 bone artefacts 240
 burials 252
 cereals 179
 combs 229, 237, 239

diaspora 276
fishing 128, 137
graves *26*, 181, 242
hones 221, 223
house mice 144
houses 276
migration 276
population density 279
pottery 58, 259, 265, 278
quarries 207, 209, 226
red deer 144
steatite 207, 211, 213, 214
textiles 182
violence 276
whale bone 242
Viking Age Transitions Project 1, 43
voles 139, 141–3

W

waders 156
wadmal 11, 154
Wales 11, 18, 251, 253, 269
wall hooks 250
walnuts 183
walrus hunting 1
Walter Scott 23
warfare 17, 18, 276, 287, 290
warships 20
warty venus 105, 108
Waterford (Ireland) 231, 239
wave-cut bank 3, *3*, 36, 43, *43*, 46, 48, *51*, 58, 63, 66, *78*, 80, *84*, 98, 293
wax 22, 280
wealth 4, 8, 15, 23, 154, 276, 287, 288
weapons 282
Wearside (England) 269
weaving swords 63, 240, 242, 243, 276, *278*
weeds 165, 172, 174–5, 178, 180, 182–4
 arable 166–8
weever 120
weights 211–13, 217–19, 252
well-covers 250
Western Isles (Scotland) 12, 20, 27, 148, 202, 223, 272
 fish 123
 mica schist 226
 schist 207
Westerwald (Germany) 274
Westness (Rousay) 2, *14*, 15
Westray (Orkney) 1, 3, 4, 23, 25, *26*, 31, 122, 138, 178, 179, 181, 185, 275–6, 279
 dates 277

early modern 123
 graves 243
 maps 27
Westray Development Trust 3
whale bone 240, 242–3, 276
 weaving sword 63
whales 145
Whalsay (Shetland) 2
Wharram Percy (England) 2, 137, 280
wheat 166, 170, 186, 192, 279
 meal 22
whelks, common 104–8
whey 202
Whithorn (Scotland) 2, 239, 240, 282, 289
whiting 119
Wiberg, Christina 229
'wic' sites 4
Wick (Caithness) 2
Wickham, Chris 8
wild radishes 168, 171, 188, 195
William III, bishop 21
William IV, bishop 21
William Balfour 27
William Sinclair 21, 22
willow 249
wine 280
 bottles 271
woad 162, 166, *167*, 168, 170, 174, 181–2, 184, 186, 192
Wolf, Eric R. 7, 8
wolf-fish 120
Wolin (Poland) 231, *232*
wood 15, 162, 165, 173–9
 combs 235
 handles 248, 249
 -working 165, 245
wool 22, 151, 154, 181–2, 184, 246
 cloth 11, 26, 280
world-systems theory 7–8
wrasse 120, 122
Wyre (Orkney) 2, 16

Y

Yarmouth (England) 246
Yell (Shetland) 2, 274
York (England) 137, 168, 182, 231, 233, 239, 246, 248, 253, 271, 280
Yorkshire (England) 269, 273, 280

Z

ZooMS 230